JEAN-BAPTISTE CARPEAUX

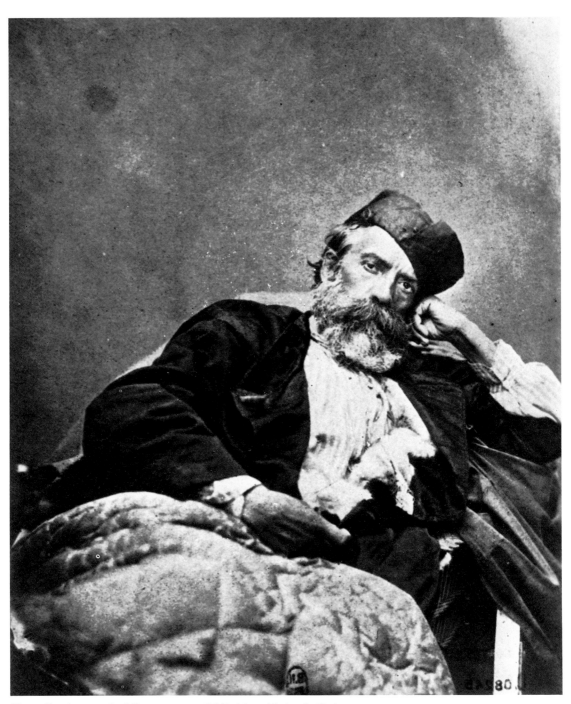

Numa fils, photograph of Carpeaux, 1874. Bibliothèque Nationale, Paris.

JEAN-BAPTISTE
CARPEAUX

SCULPTOR OF THE SECOND EMPIRE

Anne Middleton Wagner

Yale University Press · New Haven & London

Designed by Faith Brabenec Hart
Filmset in Monophoto Garamond and printed in Great Britain by
BAS Printers Limited, Over Wallop, Hampshire

The passage from C. H. Sisson's translation of Dante Alighieri,
The Divine Comedy (Chicago: Regnery Gateway, 1981), Canto XXXIII,
lines 1–78, pp. 186–88, is used by kind permission of the publisher.

A slightly different version of Chapter V appeared as "Art and
Property: Carpeaux's Portraits of the Prince Imperial," *Art History*,
vol. 5, no. 4, December, 1982, pp. 447–71.

Library of Congress Cataloging-in-Publication Data

Wagner, Anne M. (Anne Middleton), 1949–
 Jean-Baptiste Carpeaux: sculptor of the Second Empire.

 Bibliography: p.
 Includes index.
 1. Carpeaux, Jean-Baptiste, 1827–1875. 2. Sculptors—
France—Biography. 3. Carpeaux, Jean-Baptiste, 1827–
1875—Criticism and interpretation. I. Title.
NB553.C3W33 1986 730'.92'4 [B] 85–26545

ISBN 0–300–03605–1 (cloth)
ISBN 0–300–04751–7 (pbk)

In memory of my mother
Mary Lane Womack Chappell

ACKNOWLEDGEMENTS

This book has profited particularly from the guidance of three people: Jacques de Caso, who introduced me to Carpeaux's sculpture; Henri Zerner, who with him directed my first work on the artist; and Tim Clark, who has criticized most of the text in all of its incarnations. They have my thanks. I am equally grateful for the cooperation of Anne Pingeot and Antoinette LeNormand-Romain, Conservateurs de Sculpture, Musée d'Orsay; their assistance has been generously given. M. Paul Duwez, the late André Hardy, and Mme Colas eased my work in Valenciennes. For other aid and counsel I would like to thank Andrew Lincoln, John Barrell, Gerhard Fries, Laura Slatkin, Raphael Fischler, Amy Kurlander, Neil Levine, Rob Wagner, and George Wagner. Howard Averbach, Judith Randolph, and Deanna Dalrymple took over the task of typing the manuscript; without them there probably would be no book.

I am indebted to the National Gallery of Art, Washington, D.C., and the Samuel Kress Foundation, New York, for fellowships which funded two years of research in Europe; to a grant awarded by the Committee on Research, Vassar College, for additional research abroad; and to the generous support of the Department of Architecture, Massachusetts Institute of Technology, to help meet the cost of producing the final manuscript and index and of collecting the photographs.

CONTENTS

	List of Illustrations	xi
I.	BEING A SCULPTOR	1
II.	WORKERS AND ARTISTS	29
III.	LEARNING A LANGUAGE	63
IV.	"UN DÉFI À LA SCULPTURE"	109
V.	ART AND PROPERTY	175
VI.	ART AND PROPRIETY	209
VII.	CONCLUSION	257
	Chronology	273
	Notes to the Text	277
	Bibliography	309
	Index	321

LIST OF ILLUSTRATIONS

Dimensions are given in centimeters except where noted. Height precedes width.

COLOUR ILLUSTRATIONS
Facing page 151
I. Jean-Baptiste Carpeaux, *Studies after Michelangelo and for Ugolino*, 1858, pen and brown ink on folded blue-grey stationery paper (27 × 20.5). Art Institute of Chicago (Photo: Courtesy of The Art Institute of Chicago).

Facing page 166
II. Jean-Baptiste Carpeaux, *Ugolin et ses fils*, 1857–61, bronze (h. 194). Musée d'Orsay, Paris (Photo: Cliché des Musées Nationaux).

Facing page 174
III. Jean-Baptiste Carpeaux, *Ugolin et ses fils*, detail of Ugolino's back (Photo: Cliché des Musées Nationaux).

Facing page 207
IV. Facade of the Opéra, Paris, detail (Photo: T. Prat).

Facing page 215
V. Eugène Guillaume, *La Musique instrumentale*, 1865–69, Echaillon stone (h. 330). Paris, Opéra (Photo: T. Prat).

Facing page 230
VI. Jean-Baptiste Carpeaux, *La Danse*, 1865–69, Echaillon stone (h. 330). Musée d'Orsay, Paris (Photo: Cliché des Musées Nationaux).

Frontispiece, Numa fils, photograph of Carpeaux, 1874. Bibliothèque Nationale, Paris.

1. A. Delsart, photograph of Carpeaux, 1864. Bibliothèque Nationale, Paris.
2. *La Maison mortuaire de Carpeaux*, wood engraving. *L'Illustration*, 1875.
3. *Carpeaux sur son lit de mort*, wood engraving, after Ferdinandus, source unknown, 1875. Bibliothèque Nationale, Paris.
4. *Les Funérailles de Carpeaux à Valenciennes*, wood engraving, *Le Monde Illustré*, 1875. Bibliothèque Nationale, Paris.
5. *Histoire vivante: Carpeaux*, cartoon, *Bonnes Soirées*, February 17, 1957. Musée d'Orsay, Paris (Photo: Musée d'Orsay).
6. James Pradier, *Autoportrait*, c. 1815, pen and pencil on white paper (18 × 12.5). Musée d'Art et d'Histoire de Genève, Geneva (Photo: Musée).
7. Gustave Courbet, *Le Sculpteur*, 1845, oil on canvas (55 × 42). Private collection.
8. Eugène Delacroix, *Michelange dans son atelier*, 1850, oil on canvas (40 × 32). Musée Fabre, Montpellier (Photo Giraudon).
9. Jean-Baptiste Carpeaux, *Autoportrait*, 1862, oil on canvas (56 × 46). Musée des Beaux-Arts, Valenciennes (Photo Giraudon).
10. Joseph Soumy, *J.-B. Carpeaux*, 1860, oil on cardboard (24 × 21). Musée Bonnat, Bayonne (Photo: © Arch. Phot. Paris/S.P.A.D.E.M.).
11. Alexandre Falguière, *J.-B. Carpeaux*, c. 1860, pencil on paper (21.3 × 14). Musée des Beaux-Arts, Dijon, Collection Granville.
12. Bruno Chérier, *J.-B. Carpeaux dans l'atelier de Chérier, bd. Saint Jacques, Paris*, 1875, oil on canvas (161 × 121). Musée des Beaux-Arts, Valenciennes (Photo: Cliché des Musées Nationaux).
13. Albert Maignan, Sketch for *Carpeaux—"A l'artiste mourant les Etres nés de son Génie viennent donner le baiser d'adieu,"* 1892, oil on canvas (42.5 × 52.5). Musée de Picardie, Amiens.
14. Sculpture at the Salon of 1843, wood engraving. *L'Illustration*, 1843.
15. Pierre-Jean David d'Angers, *Aux Grands Hommes La Patrie Reconnaissante*, 1837, stone (6m × 30m80). Panthéon, Paris (Photo: Giraudon).
16. François Jouffroy, pediment, 1840, stone. Institution des Jeunes Aveugles, Paris.
17. Pierre-Jules Cavelier, *La Verité*, 1849–53, marble. Destroyed (Photo: Giraudon).
18. Engraving of a lost statue by Ernest Christophe, *La Douleur*, 1855, Bibliothèque Nationale, Paris.
19. Auguste Préault, *La Tuérie*, 1850, bronze cast from a model of 1834 (109 × 140). Musée des Beaux-Arts, Chartres (Photo: Bulloz).
20. Auguste Clésinger, *Femme piquée par un serpent*, 1847, marble (56.5 × 180 × 70). Musée du Louvre, Paris (Photo: Cliché des Musées Nationaux).
21. François-Anne David, introductory lesson,

engraving, from *Elémens du dessin*, 1798. Bibliothèque Nationale, Paris.

22. François-Anne David, *Mercure*, engraving, from *Elémens du dessin*, 1798. Bibliothèque Nationale, Paris.

23. Bernard-Romain Julien, *Studies of Eyes*, lithograph, from *Cours de dessin*, c. 1860. Bibliothèque Nationale, Paris.

24. Félix Trezel, *Académie d'un homme*, lithograph, pl. 9 in *Suite graduée de figures académiques*, 1844. Bibliothèque Nationale, Paris.

25. Félix Trezel, *Académie d'un homme*, lithograph, pl. 5 in *Suite graduée de figures académiques*, 1844. Bibliothèque Nationale, Paris.

26. Henri Guillaume Chatillon, *Académie d'une femme*, lithograph, pl. 28 in *Cours élémentaire de dessin*, c. 1835. Bibliothèque Nationale, Paris.

27. Nicolas Rouillet, *Standing Man*, 1843, pencil on white paper (39.7 × 26.3), drawn from life by means of the "procédé Rouillet." Archives Nationales, Paris.

28. Nicolas Rouillet, *Man leaning on his Elbow*, 1843, pencil on white paper (36.5 × 37.8), drawn from life by means of the "procédé Rouillet." Archives Nationales, Paris.

29. Adolphe Itasse, *Jean-Hilaire Belloc, 1783–1866*, 1868, bronze (h. 58). Cimetière Père Lachaise, Paris.

30. Entry to the Rotonda, Ecole Gratuite de Dessin, wood engraving. *L'Illustration*, 1848.

31. Beginners' class in the figure and ornament, Ecole Gratuite de Dessin, wood engraving. *L'Illustration*, 1848.

32. Class in drawing and modelling from casts, Ecole Gratuite de Dessin, wood engraving. *L'Illustration*, 1848.

33. Modelling from figures, ornaments and living plants, Ecole Gratuite de Dessin, wood engraving. *L'Illustration*, 1848.

34. Jean-Baptiste Carpeaux, *Page from a Notebook*, c. 1847–48, pencil on white wove paper (20.3 × 12.5). Ecole Nationale Supérieure des Beaux-Arts, Paris (Photo: Ecole Nationale Supérieure des Beaux-Arts).

35. Henri Chapu, *Tige Végétale*, c. 1850, black chalk and crayon on white paper (61.2 × 47.2). Musée, Melun.

36. Henri Chapu, *Tige Florale*, c. 1850, black chalk and crayon on white paper (61.2 × 47.2). Musée, Melun.

37. Jean-Baptiste Carpeaux, *Vase statuettes*, c. 1845, porcelain. Location unknown; reproduced from A. Mabille de Poncheville, *Carpeaux inconnu, ou la tradition recueillie*, 1921.

38. Frieze, Cité des Italiens, 1839. Rue Lafitte, Paris.

39. T. Lemaire et al., Cité des Italiens, 1839. Rue Lafitte, Paris.

40. Window, Cité des Italiens, 1839. Rue Lafitte, Paris.

41. Entrance doorway, detail, Cité des Italiens, 1839. Rue Lafitte, Paris.

42. Jean-Baptiste Carpeaux, *Les Quatre Saisons: le Printemps et l'Eté*, 1848–49, plaster (98 × 130). Musée des Beaux-Arts, Valenciennes.

43. Jean-Baptiste Carpeaux, *Les Quatre Saisons: l'Automne et l'Hiver*, 1848–49, plaster (98 × 130). Musée des Beaux-Arts, Valenciennes.

44. Postcard showing *Les Quatre Saisons* in place, Rue de Famars, Valenciennes, destroyed 1918. Bibliothèque Municipale, Valenciennes.

45. Jean-Baptiste Carpeaux, *Sketches of Concours Sculptures*, 1850, pencil on writing paper. Bibliothèque Nationale, Paris.

46. Engraving after Charles Guméry, *Achille blessé au talon*, 1850, plaster. Reproduced from *L'Illustration*, 1850.

47. Jean-Baptiste Carpeaux, *Achille blessé au talon*, 1850, painted plaster (h. 122.5). Musée des Beaux-Arts, Valenciennes.

48. A model and an armature demonstrating Rude's sculptural system. From M. Legrand, *François Rude, sa vie, ses oeuvres, son enseignement*, 1856.

49. Guy Lhomme de Mercey, *Le Démon du jour*, 1846, plaster. Destroyed.

50. Jean-Jacques Feuchère, *Satan*, 1850, bronze from a model of c. 1833. Los Angeles County Museum of Art. Purchased with funds donated by the Times Mirror Foundation (Photo: Museum).

51. Francisque Duret, *Mercure inventant la lyre*, 1828–31, plaster (h. 150). Musée des Beaux-Arts, Valenciennes.

52. Francisque Duret, *Jeune Pêcheur dansant la tarentelle*, 1832–33, bronze (h. 158). Musée du Louvre, Paris (Photo: Cliché des Musées Nationaux).

53. François Rude, *Mercure rattachant ses talonnières*, 1827, bronze. Musée du Louvre, Paris (Photo: Cliché des Musées Nationaux).

54. François Rude, *Petit Pêcheur napolitain*, 1833, marble (h. 77). Musée du Louvre, Paris (Photo: Cliché des Musées Nationaux).

55. Francisque Duret, *Jeune Pêcheur dansant la tarentelle*, detail.

56. François Rude, *Petit Pêcheur napolitain*, detail (Photo: Cliché des Musées Nationaux).

57. Francisque Duret, *Molière*, c. 1834, marble (h. 150). Comédie Française, Paris.

58. Jean-Baptiste Carpeaux, after Duret's *Molière*, c. 1851, pencil on white paper (12.8 × 7.5). Musée des Beaux-Arts, Valenciennes.

59. Francisque Duret, *Venus au milieu des roseaux*, 1840, bronze (h. 250). Fontaine des Ambassadeurs, Champs-Elysées, Paris.

60. Jean-Baptiste Carpeaux, after Duret's *Venus*, c. 1851, pencil on white paper (13 × 7.5). Musée des Beaux-Arts, Valenciennes.

61. Francisque Duret, *Christ se révélant au monde*, 1835–40, marble (h. 250). Eglise de la Madeleine, Paris (Photo: T. Prat).

62. Jean-Baptiste Carpeaux, after Duret's *Christ*, c. 1860, pencil on white paper (15.4 × 8.7). Ecole Nationale Supérieure des Beaux-Arts, Paris (Photo: Ecole Nationale Supérieure des Beaux-Arts).

63. Francisque Duret, ceiling of the Salle des Sept Cheminées, finished 1857, polychromed and gilded plaster. Musée du Louvre, Paris (Photo: Cliché des Musées Nationaux).

64. Francisque Duret, *Chateaubriand*, 1849–54, marble (h. 155). Institut de France, Paris (Photo: Giraudon).

65. Francisque Duret, *Study for Chateaubriand*, c. 1850, pencil on white paper (10.5 × 6.4). Musée des Arts Décoratifs, Paris (Photo: Musée des Arts Décoratifs).

66. Francisque Duret, *Chateaubriand*, c. 1850–51, terra cotta. Location unknown.

67. Henri Lemaire, *Froissart*, c. 1852, terra cotta (h. 28). Musée des Beaux-Arts, Valenciennes.

68. James Pradier, *Le Duc d'Orléans*, c. 1842, plaster with terra cotta colored patination (h. 42.5). Musée des Beaux-Arts, Valenciennes.

69. Jean-Baptiste Carpeaux, *Philoctète à Lemnos*, sketch, 1852, patinated plaster (h. 38). Musée des Beaux-Arts, Valenciennes.

70. Jean-Baptiste Carpeaux, *Philoctète à Lemnos*, sketch, rear.

71. Pierre-Jules Cavelier, *La Contemplation céleste*, 1841, plaster. Ecole Nationale Supérieure des Beaux-Arts, Paris.

72. Pierre-Jules Cavelier, *La Contemplation céleste*, 1841, plaster. Ecole Nationale Supérieure des Beaux-Arts, Paris.

73. François-Alfred Grevenich, *La Pudeur*, 1826, plaster. Ecole Nationale Supérieure des Beaux-Arts, Paris.

74. Henri Lemaire, *La Douleur de l'âme*, 1820, plaster. Ecole Nationale Supérieure des Beaux-Arts, Paris.

75. Jean-Antoine Idrac, *Mater Dolorosa*, 1868, plaster. Ecole Nationale Supérieure des Beaux-Arts, Paris.

76. Guillaume Bonnet, *L'Attention*, 1849, plaster. Ecole Nationale Supérieure des Beaux-Arts, Paris.

77. Jean-Baptiste Carpeaux, *Coriolan chez Tullus*, 1850, clay. Destroyed (Photo: Bulloz).

78. Central courtyard, Palais des Etudes, Ecole Nationale Supérieure des Beaux-Arts, Paris (Photo: Giraudon).

79. Francisque Duret, *La Douleur d'Evandre sur le corps de Pallas*, 1823, plaster (122 × 155). Ecole Nationale Supérieure des Beaux-Arts, Paris.

80. Jean-Baptiste Carpeaux, after Duret's *La Douleur d'Evandre*, 1847–50, pen, ink, and pencil on white paper (5.1 × 9.2). Musée des Beaux-Arts, Valenciennes.

81. Augustin Dumont, *La Douleur d'Evandre sur le corps de Pallas*, 1823, plaster (122 × 155). Ecole Nationale Supérieure des Beaux-Arts, Paris (Photo: Giraudon).

82. Jean-Baptiste Carpeaux, after Dumont's *La Douleur d'Evandre*, 1847–50, pen, ink, and pencil on white paper (5.1 × 9.2). Musée des Beaux-Arts, Valenciennes.

83. Théodore Gruyère, *Serment des sept chefs devant Thèbes*, 1839, plaster (123 × 154). Ecole Nationale Supérieure des Beaux-Arts, Paris.

84. Jean-Baptiste Carpeaux, after Gruyère's *Serment des sept chefs*, 1847–50, pen, ink, and pencil on white paper (5.1 × 9.2). Musée des Beaux-Arts, Valenciennes.

85. Henri Chapu, *Le Départ d'Ulysse et Pénélope*, 1853, clay. Musée Chapu, Le Mée.

86. Jean-Baptiste Carpeaux, after Chapu's *Le Départ d'Ulysse*, c. 1853, pen, ink, and pencil on white paper (5.1 × 9.2). Musée des Beaux-Arts, Valenciennes.

87. Engraving after Alexandre Falguière, *Mézence blessé*, 1859. Reproduced from *Gazette des Beaux-Arts*, 1859 (Photo: Los Angeles County Museum of Art).

88. Engraving after Léon Cugnot, *Mézence blessé*, 1859. Reproduced from *L'Illustration*, 1859 (Photo: Los Angeles County Museum of Art).

89. Ambroise René Maréchal, *La Mort d'Epaminondas*, 1843, plaster. Reproduced from a photograph in the Ecole Nationale Supérieure des Beaux-Arts, Paris.

90. Hubert Lavigne, *La Mort d'Epaminondas*, 1843, plaster (120 × 147). Musée des Beaux-Arts, Nancy (Photo: Gilbert Magnin).

91. Jean-Baptiste Carpeaux, after Maréchal's *La Mort d'Epaminondas*, 1847–50, pencil on white paper (5.5 × 9.2). Musée des Beaux-Arts, Valenciennes.

92. Pierre-Jean David d'Angers, *La Mort d'Epaminondas*, 1811, plaster. Ecole Nationale Supérieure des Beaux-Arts, Paris (Photo: Bulloz).

93. Jean-Baptiste Carpeaux, *Hector et son fils Astyanax*, 1854, painted plaster (h. 132.5). Musée des Beaux-Arts, Valenciennes.

94. Jean-Baptiste Carpeaux, *Hector et son fils Astyanax*, side view.

95. Amédée-Donatien Doublemard, *Hector et son fils Astyanax*, 1854, plaster. Musée des Beaux-Arts, Laon (Photo: Conway Library, Courtauld Institute of Art).

96. Jean-Baptiste Carpeaux, *Study for "Hector et son fils Astyanax,"* 1854, pencil on white paper (8.8 × 15.5). Musée des Beaux-Arts, Valenciennes.

97. Jean-Baptiste Carpeaux, *Philoctète à Lemnos*, 1852, painted plaster (h. 127.5). Musée des Beaux-Arts, Valenciennes.

98. Garden facade of the Villa Medici, Rome.

99. Henri Chapu, *Study of the Artist's Bedroom at the Villa Medici*, c. 1859–60, pencil. Musée, Melun.

100. Jean-Marie-Bienaimé Bonnassieux, *David tendant la fronde*, 1840–43, bronze (h. 200). Jardins de Chevreuse, Troyes (Photo: Musées de la Ville de Troyes).

101. Eugène Guillaume, *Anacréon*, 1852, marble (h. 185). Musée d'Orsay, Paris.

102. Pierre-Charles Simart, *Oreste réfugié à l'autel de Pallas*, 1839–40, marble (h. 128). Musée des Beaux-Arts, Rouen (Photo: Musée).

103. Wood engraving after Louis Chambard, *Oreste poursuivi par les Furies*, 1843, marble. Reproduced from *L'Illustration*, 1843.

104. Raymond Berthélémy, *Oreste se réfugiant à l'autel de Minerve*, 1860, plaster. Ecole Nationale Supérieure des Beaux-Arts, Paris.

105. Henri Chapu, *Le Christ mort aux anges*, 1856, plaster. Musée Chapu, Le Mée.

106. Henri Chapu, *Etude pour la pose de l'ange*, pen, pencil, and brown ink with brown wash (44 × 57.7). Musée, Melun.

107. Edouard Manet, *The Dead Christ with Angels*, 1864, oil on canvas (179.4 × 149.9). Metropolitan Museum of Art, New York. The H. O. Havemeyer Collection. Bequest of Mrs. H. O. Havemeyer, 1929 (29.100.51).

108. Henri Chapu, *Triptolème* or *Le Semeur*, 1859, plaster; 1865, bronze (h. 170). Destroyed; formerly Park Monceau, Paris (Photo: Giraudon).

109. Henri Chapu, *Mercure inventant le caducée*, 1859, plaster model; 1860–61, marble (h. 110). Musée d'Orsay, Paris (Photo: © Arch. Phot. Paris/S.P.A.D.E.M.).

110. Jean-Joseph Perraud, *Télémaque apportant à Phalante les cendres d'Hippias*, 1847, plaster. Reproduced from a photograph in the Bibliothèque Nationale, Paris.

111. Jean-Joseph Perraud, *Les Adieux*, 1848–49, plaster (c. 221 × 214). Musée des Beaux-Arts, Lons-le-Saunier.

112. Jean-Joseph Perraud, *Adam*, 1853, marble. Dépôt des Musées Nationaux, Château de Fontainebleau.

113. Jean-Joseph Perraud, *Adam*, side view.

114. Antoine Etex, *La Résistance*, 1833–36, stone (h. 11m60). Arc de Triomphe de l'Etoile, Paris.

115. Auguste Préault, *Guerrier Gaulois*, 1850–53, stone. Pont d'Iéna, Paris (Photo: Giraudon).

116. Jean-Joseph Perraud, *Soldat gaulois avant la domination romaine*, c. 1850–53, pen and ink on white paper. Musée des Beaux-Arts, Lons-le-Saunier.

117. Henri Chapu, *Head of a Man*, c. 1858, black chalk on white paper. Musée, Melun.

118. Jean-Baptiste Carpeaux, *Head of a Woman*, 1857–59, black chalk, stomped, on blue wove paper (43.3 × 29). Ecole Nationale Supérieure des Beaux-Arts, Paris (Photo: Ecole Nationale Supérieure des Beaux-Arts).

119. Henri Chapu, *Two Studies of an Italian Woman*, late 1850s, black chalk on white paper. Cabinet des Dessins, Musée du Louvre (Photo: Cliché des Musées Nationaux).

120. Joseph Soumy, *La Carolina*, 1860, oil on canvas (49 × 39). Musée des Beaux-Arts, Marseilles.

121. Jean-Joseph Perraud, *Head of an Italian Woman*, c. 1850, black chalk. Musée des Beaux-Arts, Lons-le-Saunier.

122. Henri Chapu, *Etude de modèle*, late 1850s, pencil (33.6 × 25.7). Musée, Melun.

123. Jean-Baptiste Carpeaux, *Study of a Seated Boy*, c. 1858, pencil on white paper (46.3 × 32). Ecole Nationale Supérieure des Beaux-Arts, Paris (Photo: Ecole Nationale Supérieure des Beaux-Arts).

124. John G. Chapman, *Pifferari playing before a Shrine of the Virgin*, 1852, etching (22.2 × 17.2). Print Collection, New York Public Library. Astor, Lenox and Tilden Foundations.

125. Jean-Baptiste Carpeaux, *Pifferari*, late 1850s, black crayon on blue paper (27 × 19). Ecole Nationale Supérieure des Beaux-Arts, Paris (Photo: Ecole Nationale Supérieure des Beaux-Arts).

126. Jean-Baptiste Carpeaux, *Studies of Italian Peasants*, late 1850s, pencil on blue paper (9.1 × 15.5). Musée des Beaux-Arts, Valenciennes.

127. Jean-Baptiste Carpeaux, *Tuérie des Porcs*, c. 1860, red chalk on white paper (16.5 × 22.5). Musée des Beaux-Arts, Valenciennes.

128. Jean-Baptiste Carpeaux, *Scene in a Tavern*, c. 1858, pen and ink (17.6 × 22.2). Metropolitan Museum of Art, New York. Rogers Fund, 1961 (61.136.2).

129. Jean-Baptiste Carpeaux, *Study of a Singer*, c. 1858, pencil on white paper (9.1 × 15.6). Musée des Beaux-Arts, Valenciennes.

130. Jean-Baptiste Carpeaux, *Study of a Man, Woman, and Dogs*, c. 1850–51, pencil on white paper. Musée des Beaux-Arts, Valenciennes.

131. Jean-Baptiste Carpeaux, *Study of Women and Children*, c. 1850–51, pencil on white paper. Musée des Beaux-Arts, Valenciennes.

132. Jean-Baptiste Carpeaux, *Jeune Pêcheur à la coquille*, 1859, plaster (h. 92). Musée des Beaux-Arts, Valenciennes.

133. Jean-Baptiste Carpeaux, *Jeune Pêcheur à la coquille*, detail.

134. Engraving after Jules Klagmann, *Enfant jouant avec des coquillages*, 1847, marble. Reproduced from *L'Illustration*, 1847.

135. Engraving after Pierre Hébert, *Enfant jouant avec une tortue*, 1849, plaster. Reproduced from *L'Illustration*, 1849.

136. Engraving after Barthélémy Frison, *Le Pêcheur des coquillages*, 1852, plaster. Reproduced from *L'Illustration*, 1852.

137. Engraving after Gustave Nast, *Pêcheur et son chien*, 1857, plaster. Reproduced from *L'Illustration*, 1857.

138. Antoine Sopers, *Jeune Napolitain jouant à la rauglia*, 1859, marble. Institut Royal du Patrimoine Artistique, Brussels (Photo: Copyright A.C.L. Bruxelles).

139. Engraving after Charles-Henri Maniglier, *Pêcheur ajustant ses filets*, 1860. Reproduced from *L'Illustration*, 1860.

140. Jean-Baptiste Carpeaux, *Jeune Pêcheur à la coquille*, rear view, 1857–58, plaster (h. 92). Musée du Louvre, Paris (Photo: Giraudon).

141. Joseph Soumy, *The Creation of Adam*, after Michelangelo, c. 1857, exh. 1861, drawing (54 × 118). Musée des Beaux-Arts, Lyons.

142. Jean-Baptiste Carpeaux, *Portrait of Alphonse Roussel*, 1859–60, lead or zinc with bronze patination (18.4 × 14.8 × 4). Private collection, Los Angeles (Photo: Los Angeles County Museum of Art).

143. Jean-Baptiste Carpeaux, *Tête de faune, d'après Michelange*, 1858–60, pen, ink, and red chalk on white paper (35 × 28). Musée des Beaux-Arts, Valenciennes.

144–56. Jean-Baptiste Carpeaux, studies in a notebook used in Rome and Florence, 1858, pencil (9.1 × 15.8). Musée des Beaux-Arts, Valenciennes.

157. Michelangelo, *Lorenzo de' Medici*, 1524–34, marble (h. 178). Medici Chapel, S. Lorenzo, Florence (Photo: Alinari).

158. Michelangelo, *Lorenzo de' Medici*, detail (Photo: Andersen).

159. Caricature of Carpeaux at work in his Villa Medici studio, 1860–61, black crayon heightened with white. Bibliothèque Nationale, Paris.

160. Jean-Baptiste Carpeaux, *Projet du bas-relief cintré*, 1858, pencil on white paper (11.7 × 14.6). Ecole Nationale Supérieure des Beaux-Arts, Paris (Photo: Ecole Nationale Supérieure des Beaux-Arts).

161. Jean-Baptiste Carpeaux, *Reclining Figures in Lunettes*, 1858, black ink on wove paper (29.1 × 22). Art Institute of Chicago (Photo: Courtesy of The Art Institute of Chicago).

162. Jean-Baptiste Carpeaux, *Ugolin rampant sur les corps de ses enfants*, 1858, black crayon, pen, ink, and wash on blue paper (14 × 21.5). Musée des Beaux-Arts, Valenciennes.

163. Jean-Baptiste Carpeaux, *Study for Ugolino*, 1858, pencil and ink on white paper (9.2 × 12.4). Metropolitan Museum of Art, New York. Gift of Daniel Wildenstein, 1975 (1975.93.3).

164. John Flaxman, *Ugolino and his Sons*, 1793, engraving. Fine Arts Library, Harvard University (Photo: J. Cook).

165. Pierino da Vinci, *La Morte del Conte Ugolino*, terra cotta, Museo Nazionale, Florence (Photo: Alinari).

166. Jean-Baptiste Carpeaux, *Ugolin et ses fils*, 1860, terra cotta (h. 56). Musée d'Orsay, Paris (Photo: Cliché des Musées Nationaux).

167. Jean-Baptiste Carpeaux, *Ugolin et ses fils*, 1857–61, bronze (h. 194). Musée d'Orsay, Paris (Photo: Cliché des Musées Nationaux).

168. Jean-Baptiste Carpeaux, *Ugolin et ses fils*, side view (Photo: Cliché des Musées Nationaux).

169. Jean-Baptiste Carpeaux, *Ugolin et ses fils*, rear view (Photo: Cliché des Musées Nationaux).

170. Jean-Baptiste Carpeaux, *Ugolin et ses fils*, detail, visage (Photo: Cliché des Musées Nationaux).

171. Jean-Baptiste Carpeaux, *Ugolin et ses fils*, detail, feet and chains (Photo: Cliché des Musées Nationaux).

172. Cham, caricature of *Ugolin et ses fils*, 1863, wood engraving. *Le Charivari*, 1863.

173. Bertall, caricature of *Ugolin et ses fils*, 1863, wood engraving. *Le Journal Amusant*, 1863.

174. Cham, caricature of Préault's *Hecuba*, 1863, wood engraving. *Le Charivari*, 1863.

175. Jean-Baptiste Carpeaux, *Le Prince Impérial et son chien Néro*, 1867, marble; from model of 1866 (h. 140.2). Musée d'Orsay, Paris (Photo: Cliché des Musées Nationaux).

176. Jean-Baptiste Carpeaux, *Le Prince Impérial et son chien Néro*, side view (Photo: Cliché des Musées Nationaux).

177. Jean-Baptiste Carpeaux, *Le Prince Impérial et son chien Néro*. side view (Photo: Cliché des Musées Nationaux).

178. Jean-Baptiste Carpeaux, *Le Prince Impérial et son chien Néro*, rear view (Photo: Cliché des Musées Nationaux).

179. Jean-Baptiste Carpeaux, *Le Prince Impérial*, 1865–66, marble (h. 65). Musée National du Château de Compiègne (Photo: Cliché des Musées Nationaux).

180. Photograph of the display of the Carpeaux atelier, Salle des Céramiques, Exposition Universelle, 1878 (Photo: Musée d'Orsay).

181. Atelier stamp: PROPRIÉTÉ CARPEAUX (Photo: Art Gallery of Ontario).

182. Atelier stamp: ATELIER DEPOT 77 RUE BOILEAU AUTEUIL PARIS (Photo: Courtesy A. Beale).

183. Jean-Baptiste Carpeaux, *Studies for Bas-reliefs*, 1852, pencil on paper. Musée des Beaux-Arts, Valenciennes.

184. Jean-Baptiste Carpeaux, *La Sainte Alliance des Peuples*, 1848–49, plaster (99 × 360). Musée des Beaux-Arts, Valenciennes (Photo: Hauchard).

185. Jean-Baptiste Carpeaux, *L'Empereur reçoit Abd el-Kader au palais de Saint Cloud*, model, 1852–53, marble (155 × 298). Musée des Beaux-Arts, Valenciennes (Photo: Hauchard).

186. Jean-Baptiste Carpeaux. *L'Impératrice Eugénie protégeant les orphelins et les arts*, 1853–55, plaster (h. 86.5). Musée des Beaux-Arts, Valenciennes.

187. Jean-Baptiste Carpeaux, *Study of Classical Statuary*, c. 1853, pencil on white paper (6.5 × 11.5). Musée des Beaux-Arts, Valenciennes.

188. Jean-Baptiste Carpeaux, *Study of the central group for the Abd el-Kader relief*, 1853, pencil on paper (6.5 × 11.5). Musée des Beaux-Arts, Valenciennes.

189. Jean-Baptiste Carpeaux, *Le Prince Impérial et son chien Néro*, sketch model, 1865, plaster (h. 43.8). Musée d'Orsay, Paris (Photo: Cliché des Musées Nationaux).

190. Jean-Baptiste Carpeaux, *Le Prince Impérial et son chien Néro*, sketch model, rear (Photo: Cliché des Musées Nationaux).

191. Levitsky, photograph of the Imperial family, c. 1865. Bibliothèque Nationale, Paris.

192. François-Joseph Bosio, *Henri IV enfant*, 1822–24, silver (h. 125). Musée du Louvre, Paris (Photo: Cliché des Musées Nationaux).

193. François Rude, *Louis XIII*, c. 1843, silver. Château de Dampierre (Photo: Braun).

194. Franz-Xaver Winterhalter, *Albert, Prince of Wales*,

oil on canvas. Royal Collection (Reproduced by gracious permission of Her Majesty the Queen).

195. Auguste Clésinger, *Hercule enfant*, 1856–57, marble. Believed destroyed; reproduced from a photograph in the Musée des Arts Décoratifs, Paris.

196. Wood engraving after Auguste Clésinger, *Les Enfants de M. le Marquis de Las Marismas*, 1847, marble. Reproduced from *L'Illustration*, 1847.

197. Jules Franceschi, *Jeune Garçon*, 1868, marble. Musée National du Château de Compiègne.

198. C. Micheloz, photograph of the sculpture installation in the Palais d'Industrie, Salon of 1866. Archives Nationales, Paris.

199. "Renewing the Lease," caricature from *Punch*, May, 1870.

200. Photograph of *Le Prince Impérial et son chien Néro*, installed in the Tuileries, 1867–70. Bibliothèque Nationale, Paris.

201. Jean-Baptiste Carpeaux, *Proportions de la statue du Prince Impérial*, 1865, pen on blue writing paper (21 × 13). Archives Nationales, Paris.

202. Jean-Baptiste Carpeaux, *Le Prince Impérial et son chien Néro*, late 1860s, silvered bronze on red marble base (h. 66). Collection of Mr. and Mrs. Christopher Forbes (Photo: Los Angeles County Museum of Art).

203. Display of Christofle et cie., Exposition Universelle, 1867, wood engraving. Reproduced from *L'Illustration*, 1867 (Photo: New York Public Library).

204. Jean-Baptiste Carpeaux, *Le Prince Impérial en uniforme des Grenadiers de la Garde*, c. 1868, plaster (h. 64). Tannenbaum Collection.

205. Jean-Baptiste Carpeaux, *Le Prince Impérial*, 1869–70, biscuit de Sèvres. Manufacture Nationale de Sèvres.

206. Jean-Baptiste Carpeaux, *La Danse*, 1865–69, Echaillon stone (h. 330). Formerly Opéra, Paris; now Musée d'Orsay, Paris.

207. Charles Garnier, Nouvel Opéra de Paris, 1861–75 (Photo: Bodleian Library, Oxford).

208. Jean-Baptiste Carpeaux, *La Danse*, side view (Photo: J. Roubier).

209. Jean-Baptiste Carpeaux, *La Danse*, detail (Photo: J. Roubier).

210. Jean-Baptiste Carpeaux, *La Danse*, detail (Photo: J. Roubier).

211. Jean-Baptiste Carpeaux, *La Danse*, detail (Photo: J. Roubier).

212. "Les Curieux devant le groupe de la Danse, de M. Carpeaux," 1869, wood engraving. *L'Illustration*, 1869. Bibliothèque Nationale, Paris.

213. "Potins du Jour," *Le Bouffon Politique*, 1869. Bibliothèque Nationale, Paris.

214. Cham, "C'est Splendide!" 1875, wood engraving. *Le Charivari*, 1875.

215. Delmaet and Durandelle (?) photograph of the Opéra, rue le Pelletier, Paris, before 1873. Bibliothèque de l'Opéra, Paris.

216. Delmaet and Durandelle, photograph of the Opéra under construction, c. 1865. Bibliothèque

217. Delmaet and Durandelle, photograph of ornamental sculptors at work on the Opéra, c. 1867. Bibliothèque Nationale, Paris.

218. Delmaet and Durandelle, photograph of a capital for the Opéra, c. 1867. Bibliothèque Nationale, Paris.

219. Charles Garnier, *Preliminary Project for the Facade of the Opéra*, 1861, pen, ink, wash, and pencil on paper. Bibliothèque Nationale, Paris.

220. Charles Garnier, *Preliminary Project for the Right Pavilion of the Opéra Facade*, 1861, pen, ink, wash, and pencil on paper. Bibliothèque Nationale, Paris.

221. Comte G. Roussäy, *Simple esquisse d'un projet de plan pour la construction du grand Opéra*. 1861, pencil, pen and ink. Archives Nationales, Paris.

222. E. Ladrey, photograph of François Jouffroy, *L'Harmonie*, c. 1869. Bibliothèque Nationale, Paris.

223. J. Raudnitz, photograph of Eugène Guillaume, *La Musique instrumentale*, c. 1869. Bibliothèque Nationale, Paris.

224. E. Ladrey, photograph of Jean-Joseph Perraud, *Le Drame lyrique*, c. 1869. Bibliothèque Nationale, Paris.

225. Charles Garnier, *Scheme for an Opéra Group, full face*, 1865, pen and ink on graph paper (26 × 20.3). Cabinet des Dessins, Musée du Louvre, Paris (Photo: Cliché des Musées Nationaux).

226. Charles Garnier, *Scheme for an Opéra Group, profile*, 1865, pen and ink on graph paper (29.3 × 20.9). Cabinet des Dessins, Musée du Louvre, Paris (Photo: Cliché des Musées Nationaux).

227. Jean-Baptiste Carpeaux, *Study of La Musique*, c. 1866, black pencil on graph paper (24 × 17.1). Cabinet des Dessins, Musée du Louvre, Paris (Photo: Cliché des Musées Nationaux).

228. Jean-Baptiste Carpeaux, *Study of Le Drame lyrique*, c. 1866, black pencil on cream paper (14 × 9). Musée des Beaux-Arts, Valenciennes.

229. Jean-Baptiste Carpeaux, *Le Drame lyrique et la Comédie légère*, c. 1865, plaster (103.2 × 44.5 × 28.5). Musée d'Orsay, Paris (Photo: Cliché des Musées Nationaux).

230. Jean-Baptiste Carpeaux, *Study of an Opéra Group*, 1865, pencil heightened with white (20.4 × 13.4). Musée des Beaux-Arts, Valenciennes.

231. Delmaet and Durandelle, photograph of a ceiling boss for the Opéra, c. 1867. Bibliothèque Nationale, Paris.

232. Delmaet and Durandelle, photograph of the Opéra under construction, c. 1865. Bibliothèque Nationale, Paris.

233. Delmaet and Durandelle, photograph of the dome of the Opéra, c. 1867. Bibliothèque Nationale, Paris.

234. Cham, "Ne les regarde donc pas!" 1869, wood engraving. *Le Charivari*, 1869.

235. Gilbert, "Ah! ma fille . . .!" 1869, wood engrav-

ing. *Le Charivari,* 1869.

236. Cham, "Tiens, mon ami," 1869, wood engraving. *Le Charivari,* 1869.

237. Gilbert, "La furia de la Danse," 1869, wood engraving. *Le Charivari,* 1869.

238. Gustave Courbet, *La Source,* 1868, oil on canvas (128 × 97). Musée du Louvre, Paris (Photo: Cliché des Musées Nationaux).

239. Jean-Baptiste Carpeaux, *La Danse,* detail (Photo J. Roubier).

240. E. Appert, photograph of *La Danse* stained with ink, August, 1869. Bibliothèque Nationale, Paris.

241. Gill, "L'Accident Carpeaux," *L'Eclipse,* 1869. Bibliothèque Nationale, Paris.

242. Charles Guméry, *La Danse,* 1870, marble. Musée des Beaux-Arts, Angers.

243. Lithograph after Augustin Courtet, *La Danse Ionnienne,* marble. Reproduced from *L'Artiste,* 1866 (Photo: J. Cook).

244. Gilbert, "Les sculpteurs remplaçant le marbre par le charbon de terre . . .," 1869, wood engraving. *Le Charivari,* 1869.

245. Jean-Baptiste Carpeaux, *Plusieurs croquis pour la Danse,* c. 1866, pen on cream coloured paper (19.8 × 30.4). Musée des Beaux-Arts, Valenciennes (Photo: Cliché des Musées Nationaux).

246. Jean-Baptiste Carpeaux, *Sketches of Three Female Figures,* c. 1866, black crayon on greyish white laid paper (20.5 × 26.8). Art Institute of Chicago (Photo: Courtesy of The Art Institute of Chicago).

247. Jean-Baptiste Carpeaux, *Five Dancing Female Figures,* c. 1866, pencil, red and black chalks (20.5 × 12.8). Art Institute of Chicago (Photo: Courtesy of The Art Institute of Chicago).

248. Jean-Baptiste Carpeaux, *Etude pour la Danse,* c. 1866, pencil on white paper (13.8 × 9.3). Musée des Beaux-Arts, Valenciennes (Photo: Cliché des Musées Nationaux).

249. Jean-Baptiste Carpeaux, *La Danse: sketch,* c. 1866, plaster (54.5 × 34 × 29.8). Musée d'Orsay, Paris (Photo: Cliché des Musées Nationaux).

250. François Rude, *Le Départ des Volontaires en 1792,* 1833–36, stone (h. 12m70). Arc de Triomphe de l'Etoile, Paris (Photo: Photographie Bulloz).

251. Jean-Baptiste Carpeaux, *Study after Rude's "Le Départ des Volontaires,"* c. 1866–67, black chalk on cream paper (12.7 × 8.7). Musée des Beaux-Arts, Valenciennes (Photo: Cliché des Musées Nationaux).

252. Jean-Baptiste Carpeaux, *La Danse,* detail (Photo: J. Roubier).

253. Gian Lorenzo Bernini, *Pluto and Persephone,* detail, 1621–22, marble. Galleria Borghese, Rome (Photo: Galleria Nazionale Fotographica).

254. Jean-Baptiste Carpeaux, *Study of a Dancer,* c. 1866, black chalk on cream colored notebook paper. Musée des Beaux-Arts, Valenciennes (Photo: Cliché des Musées Nationaux).

255. Photograph of Alice la Provençale, 1860. Bibliothèque de l'Opéra, Paris.

256. Disderi, photograph of Rigolboche, 1859. Bibliothèque de l'Opéra, Paris.

257. Photograph of Finette, c. 1860. Bibliothèque de l'Opéra, Paris.

258. Jean-Baptiste Carpeaux, *Jean-Léon Gérôme,* 1871, bronze (h. 60.2). Ecole Nationale Supérieure des Beaux-Arts, Paris (Photo: Ecole Nationale Supérieure des Beaux-Arts).

259. Photograph of the Fontaine de l'Observatoire in the course of installation, 1874. Musée d'Orsay, Paris (Photo: Musée d'Orsay)

260. Jean-Baptiste Carpeaux, *Les Quatre Parties du Monde,* detail, 1868–72, terra cotta. Musée d'Orsay, Paris (Photo: Cliché des Musées Nationaux).

261. Photograph of the sculpture installation, Salon of 1872 (Photo: Courtesy A. Pingeot; Documentation du Musée d'Orsay).

262. Jules Dalou, *Caryatids: The Four Continents,* c. 1867, patinated plaster (h. 89). Los Angeles County Museum of Art. Gift of Leona Cantor Palmer (Photo: Los Angeles County Museum of Art).

263. Jean-Baptiste Carpeaux, *Le Docteur Batailhé,* 1863–64, plaster (h. 46.5). Musée des Beaux-Arts, Valenciennes (Photo: Cliché des Musées Nationaux).

264. Jean-Baptiste Carpeaux, *Le Docteur Achille Flaubert,* 1874, plaster (h. 36). Musée des Beaux-Arts, Valenciennes (Photo: Cliché des Musées Nationaux).

265. Jean-Baptiste Carpeaux, *Le Docteur Achille Flaubert,* side view (Photo: Cliché des Musées Nationaux).

266. Jean-Baptiste Carpeaux, *Projet pour la maquette avec le socle,* 1867–68, black chalk (16.8 × 13). Musée du Louvre, Paris (Photo: Cliché des Musées Nationaux).

267. Bodmer or Pannelier(?) photograph of *Rodin's "Seated Ugolino,"* 1877, albumen print with ink notations (17 × 12.9). Musée Rodin, Paris (Photo: Musée. Rodin).

268. Bodmer or Pannelier, photograph of *Rodin's "Seated Ugolino,"* back view, 1877, albumen print (14.5 × 10). Musée Rodin, Paris (Photo: Musée Rodin).

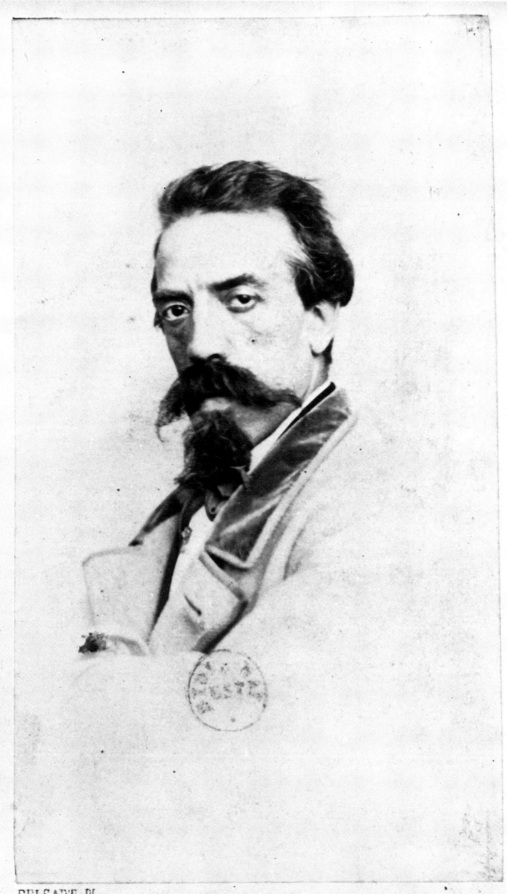

DELSART. Phot.

CHAPTER ONE

BEING A SCULPTOR

Thursday, March 16, 1865

We spent the day at Burty's, rue du Petit-Banquier, in a lost and rural *quartier* which smells of the horse fair and stockyard. An interior filled with art, heaps of books, lithographs, painted sketches, drawings, faience. A little house, a little garden, women, a little girl, a little dog. Hours, in which one leafed through portfolios, and a fat young singer called Mlle Hermann appeared, laughed, flirted, touched us with her dress. A certain atmosphere of cordiality, of wholesome childhood, of a happy family. All this made us think of various eighteenth-century circles of artists and bourgeois. At times, there glimmered a resemblance to Fragonard's house.

In the evening, after dinner, three men came to the door, and seeing a salon and women, recoiled, and fled gauchely, making awkward bows. We followed them to the studio, where they went to give Burty some information about someone called Soumy, one of their dead friends.

By the light of the lamp, they seemed to us sinister and impoverished. They had soft hats and the old overcoats of stagecoach travellers. Hands in their pockets, backs wedged up against pieces of furniture, they went on standing, like people who didn't know how to sit down. They had the voices of workers out in the world, the debased, mannered accent of some young comedian who pours out his words without being sure of their spelling, or of a pimp who rolls his r's. Everything about them breathed a lack of education; they stank of pretentious gutter language corrupted by who knows what proud ideal. They uttered phrases about art like sentences in slang, things learned, dogma wheezed out. Their faces, pale and lined with poverty, seemed dirtied by rough stubble, the beards the people wear. In them could be read an indefinable wretchedness, a withdrawal, a past in the bohemia that embitters.

One above all had a quarryman's ugly head, hacked out rough and rude, with a police sergeant's mustaches and protruding eyes.

"When we left the Ecole," he said, "we were skinny as rails. It was only over there in Rome that we filled out a bit." That one was Carpeaux, an enormously talented sculptor. The other two were examples of those great nameless men; there are many of them in art.[1]

This passage, an entry in the journal kept by Edmond and Jules de Goncourt, records the brothers' first meeting with the sculptor Jean-Baptiste Carpeaux. It does so in a way rather different from the simple formula, "Today we met Carpeaux at Burty's," which

1. A. Delsart, photograph of Carpeaux, 1864. Bibliothèque Nationale, Paris.

would have sufficed and to which even such subtle observers as the Goncourts often resorted. The passage is more than a record, then. It is a vivid piece of writing, similar in tone and movement to many of the crucial set pieces in the journal, and like them carefully structured to convey disjunction and contrast. We are quickly led deep into the pleasures of Philippe Burty's bourgeois household—its piles of books and prints, its little garden, girl, and dog—and thus into an ideal existence far from the center of Paris, and far from the present. Its distance from the world is made clear abruptly when three men intrude on the warm family circle. They shy away at once from its pleasures and retreat through the night to Burty's atelier. Even there, in a man's world, they are not comfortable. These are men who have never learned to sit down.

All three are artists, though two remain nameless; their importance is their anonymity. And only after the Goncourts have measured the depth of the social abyss which separates them from the visitors; listened to their debauched, uneducated workers' voices repeating ill-digested artistic dogma; examined their pale faces dirtied by "popular" beards, soured by life in the real bohemia, do they reveal that one of these wretches is the gifted sculptor Carpeaux. Like his companions, like their dead friend Soumy, this man with the worker's voice and face is a member of an artistic elite, a winner of the Prix de Rome, an inheritor of the artistic tradition the Goncourts valued so highly. The writers do not add that, despite Carpeaux's worker's accent and manner, he had spent the winter in a Tuileries studio modelling a portrait of the Emperor's son.

The Goncourts themselves were perhaps not entirely sure how pointed a conclusion to draw from this carefully described scene. It offered a lesson about past and present; that much was certain. The passage continues, "Modern gilding resembles these adventurers with their shoddy golden wrappings. Everything is just the same: once there was Lucas's Taverne Anglaise, real roast beef with no frills, in keeping with the reign of Louis Philippe; now there's Peters the humbug, and bad meat butchered with Anglo-American chic, corresponding to the present regime." The gist is clear, certainly, but the power has been leeched from these two added sentences; they come close to nostalgia by rote. But the chronicle is not quite finished. A final axiom follows, which, cryptic though it is, contains a final oblique reference to Carpeaux, as if he cannot quite be banished from thought: "Men with those protruding eyes are seers, dupes, or religious fanatics." These *are* strong words; the whole passage later gave Edmond de Goncourt such discomfort that in 1887 he added a conciliatory protestation of his tremendous regard for Carpeaux's art. "I give our first impression of Carpeaux as I find it in our journal; but I should state that this impression was much modified by the relations we had with him later and that we consider him the greatest French artist of the second half of the nineteenth century."

By this time Jules de Goncourt had been dead for nearly two decades; Edmond was speaking for himself. And, despite his protest, he nonetheless neglected to modify other references in the journal. These reveal the extent to which the brothers continued to be sensitive to what they saw as a kind of schizophrenia in the man: "Two men exist inside Carpeaux: a talented sculptor and a marble worker." The sculptor was evident in Carpeaux's talent, in his "fevered genius," and above all in the absolute modernity of his art. But the writers still recognized a worker in Carpeaux's flesh, in his truculent gaze, his unlettered brain and pimp's voice.[2] Even their real admiration for his sculpture could not erase this impression.

The surviving photographs of Carpeaux—the frontispiece and figure 1 are examples—neither entirely confirm nor refute the Goncourts' description. Intensity and aggression

do stare out at the camera, but the worker's voice and fevered genius could not be recorded. We cannot read conflicting identities in Carpeaux's visage, nor, I suspect, are we equipped to discern them were Carpeaux standing before us. This is not to say, however, that the Goncourts' opinion was based on their prejudices alone. Other evidence indicates that this was a common reading of Carpeaux's features. The critic Charles Blanc, for example, recorded having received a similar impression when he first met the sculptor, then in his early twenties, in the atelier of his teacher Francisque Duret. Blanc too misread Carpeaux, mistaking him for a worker on the theory that such small size and stylelessness could belong only to a *praticien*, a sculptor's helper.[3] Charles Garnier's reminiscences stretch even further back into Carpeaux's childhood, to the early 1840s, when the two were students at the Petite Ecole in Paris. In those days, the architect recalled, Carpeaux was a Parisian *gamin*—not some fictional street urchin, but a *"vrai gamin, almost a faubourien."*[4] The distinction was necessary. To make a working-class background real, not romantic, it had to be tied to concrete details, to the workers' quarter, the *faubourg*, and to its accent and stature.

Anecdotes like these report only one aspect of Carpeaux's identity. They focus not just on his working-class origins, but on the ways those origins continued to be legible in—or relevant to—his demeanor long after his artistic success. (After all, it was only his success that made his origins noteworthy.) Other accounts naturally took a different tack, relating instead Carpeaux's path towards fame, the prizes won and works completed. Inevitably the two were sometimes combined, as in the tale of a stay at Compiègne, where, simultaneously "gauche" and "brilliant," he filled his bedroom with a modelling stand and mounds of clay, and ruined the furniture.[5]

This whole mass of lore, fact and fiction alike, began to be codified after Carpeaux's

2. *La Maison mortuaire de Carpeaux*, wood engraving. *L'Illustration*, 1875.

LA MAISON MORTUAIRE DE CARPEAUX. — VUE PRISE DU JARDIN.

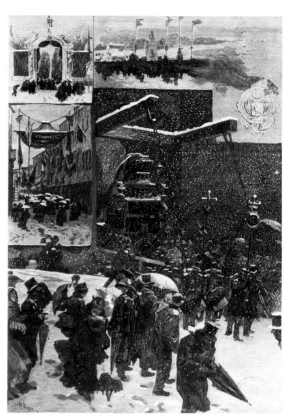

3. *Carpeaux sur son lit de mort*, wood engraving, after Ferdinandus, source unknown, 1875. Bibliothèque Nationale, Paris.

4. *Les Funérailles de Carpeaux à Valenciennes*, wood engraving, *Le Monde Illustré*, 1875. Bibliothèque Nationale, Paris.

death on October 12, 1875. Obituaries, reminiscences, more straightforward critical articles—all took up as characteristic the confusion of identities which the Goncourts had observed, and fed versions of that view to a receptive readership. (Accounts of the artist's marital troubles had made his name all too familiar in the few years preceding.) These stories were liberally laced with the pathetic details of the sculptor's final agony; a cancer of the prostate had been diagnosed two years before. The house, even the room in which he died, were illustrated (figs. 2–3). The grisly details of casting the death mask—it plucked out quantities of beard—were retailed. His last words—"La vie, la vie!"—and final will were made public. The funeral cortege, with its "thousands" of artists (including Edouard Manet but apparently not the surviving Goncourt brother, Edmond), its throng of *praticiens*, and immense crowd of peasants, was described in detail, and its slow progress to the cemetery at Courbevoie plotted step by step. And when, local pride having finally won out, Carpeaux's body was finally reinterred in Valenciennes under dreary November snow, that ceremony too was reported and illustrated (fig. 4).[6]

In short, the dead Carpeaux was treated like a popular hero, and given honors such as few artists receive. His demise opened debate about his contribution to French sculpture and the merits of his individual works. Not surprisingly, he was credited with tremendous achievements. They were solemnly enumerated over his bier by the government's representative, the Marquis de Chennevières, Surintendant des Beaux-Arts, and repeated next day in the papers:

When a school begins to turn towards coldness and insipidity, if one man survives who recalls that *life* means something in the representation of human beings, and that a society as turbulent as our own can express itself only with movement; if by the example of

4

his work he can return this school to the unspoken tradition of the most illustrious artists of his country: we can proclaim loudly what he deserves from this country: that his name should be inscribed on the list of its most glorious offspring. He has the right to immortality, to the eternally grateful memory of our school, that man who in art—his passion—recalls life – life the supreme aim of his too brief, yet productive career – life, the final cry, final vision of poor Carpeaux in his hour of agony.[7]

Carpeaux, in other words, created a body of work perfectly suited to contemporary life, and in so doing resuscitated the art of sculpture in France, returned it to a more vital tradition. The judgement is an important one, even though it is almost hidden behind its author's heavy (and barely grammatical) graveside rhetoric. Important, because it argues for the modernity of Carpeaux's art from both a formal and a (tentatively) social point of view, well before the same argument is made to give Rodin's work the extraordinary place it holds in intellectual circles in the late 1880s and 1890s. And such an opinion, unusual though it may seem on the lips of a government servant, was echoed elsewhere. Henry James, who thought that Carpeaux's busts were "the most modern things in all sculpture," put forward a similar judgement of the merits of Carpeaux's work. To the readers of the *New York Daily Tribune* he wrote: "Carpeaux had immense talents and if to seize and impress in clay or marble the look of life and motion is the finest part of an artist's skill, he was a very great artist."[8]

The tribute was generous, though a trifle double-edged. Some contemporary readers must have noticed that James's syntax left room for doubts and disagreement around the issue of what in fact did constitute "the finest part of an artist's skill"—doubts which were voiced more emphatically by other critics. Paul Mantz, who regularly reviewed sculpture for an increasingly stodgy *Gazette des Beaux-Arts*, was a conspicuous example. His assessment, which appeared there in 1876, months after Carpeaux's demise, was free, so its author claimed, from the emotionalism that colored other, earlier reactions. In his more "dispassionate" view, there was one fatal failing in Carpeaux's art.

> Now that time has covered the bitter memories of that long agony . . . it is permissible to judge Carpeaux and to establish which vigorous qualities link him to art, what imperfections or lacunae separate him from great sculpture. He possessed—admirably so—a talent for truthful movement, accurate, appropriate gesture, supple, trembling life: yet the ways of pure beauty were closed to him. Did he know what he lacked? Perhaps.[9]

For Mantz, this was Carpeaux's tragedy: despite his talents, he could not create pure beauty. And this lack of purity was a problem other critics saw. It loomed as large for them as did his "vital modernity" for his supporters. Mantz put it carefully, subtly, to qualify rather than destroy a reputation. Other journalists were not always so measured. Of *La Danse*, Carpeaux's decorative group for the Paris Opéra, the *Art Journal* wrote, "This is probably the most impure work by which modern sculpture has been desecrated. Carpeaux should have lived longer to realize a reputation of unequivocal goodness."[10]

Whether a longer life would have helped is not the question; Carpeaux's reputation was not unequivocally good. Reservations centered on his breach of sculptural decorum, as we shall see. Yet a coherent image of Carpeaux was soon established, objections and all, and its elements remained remarkably constant: he was a genius, born into the working class, whose struggles as an artist led to masterpieces and then to premature, painful death. The image is fashioned out of a finite set of facts and stories which turn up in criticism and biography alike. With small variations and frequent errors, they map out a life, tracing

1. — A Valenciennes, on l'appelait Crapaud, par déformation, et plus tard il dut intervenir pour faire rectifier. La ville lui envoyait un soutien financier sous ce nom-là. Il faisait illusion, physiquement. Rude, le grand sculpteur du *Chant du Départ*, raconte : « J'ai vu entrer dans mon atelier un adolescent de treize ou quatorze ans ... Or à cette époque Jules Carpeaux (c'est plus tard seulement qu'il se prénommera Jean-Baptiste) avait déjà dix-huit ans. Mais la misère au foyer paternel, l'errance affamée dans Paris, les luttes, avaient miné cet enfant. D'ailleurs Carpeaux mourra tôt : sa jeunesse avait été trop misérable.

2. — Valenciennes est une ville qui est fière de ses artistes. Elle avait donné naissance à Watteau, et depuis lors elle soutenait ses concitoyens qui avaient des dispositions artistiques. C'est ainsi que le petit Carpeaux, fils de maçon, quatrième enfant d'une famille de huit, vit un jour l'entrée triomphale d'Henri Lemaire, sculpteur, qui à l'époque était considéré comme un grand homme. En fait, son habileté résidait surtout dans ses capacités à se glisser dans les cabinets de ministres. N'importe. Carpeaux voit le triomphe de ce sculpteur et il sent sa vocation s'éveiller. Depuis toujours il pétrit des animaux dans la glaise.

5. — Belloc l'encourage ; il sent qu'il pourrait faire quelque chose de bien s'il était aidé. C'est alors qu'il pense au grand sculpteur officiel Lemaire. Il est aussi de Valenciennes. Il y a même un très vague lien de parenté entre eux. Carpeaux lui demande de le recevoir. Que se passe-t-il ce jour-là dans l'esprit de Lemaire, sculpteur arrivé, officiel, vaniteux ? Devina-t-il que son art n'était rien à côté des éclairs de génie de Carpeaux ? Ou fut-il vexé que Valenciennes ait pu produire un autre sculpteur que lui ? Il ne regarde même pas l'ouvrage que Carpeaux lui présente. Il ricane : « Il est trop petit ; on n'en fera qu'un appareilleur. »

6. — Un enfant de seize ans à qui un grand officiel de la sculpture, vénéré partout, dit en se moquant qu'il ne vaut rien, devrait être démonté, découragé. Carpeaux serre les dents et lutte. Tout au long de sa vie, il retrouvera ce Lemaire, tenace, haineux, jaloux, furieux. Il devra se présenter quatre fois au concours pour être reçu Prix de Rome, tout simplement parce que Lemaire est membre du jury. Quand il sollicitera des travaux de l'Etat, des bourses d'étude, Lemaire empêchera qu'on les lui accorde. Lemaire tentera — vainement — de détourner l'attention de Napoléon III, un des rares hommes à comprendre Carpeaux.

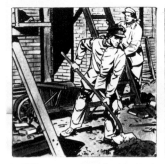

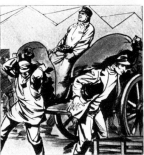

3. — Mais le papa maçon ne comprend pas les vocations de ses fils. La vie est dure à l'époque (Carpeaux est né en 1827) et dès onze ans le fils Carpeaux doit quitter l'école pour devenir manœuvre sur les chantiers de son père : coltiner les briques et le ciment au long des échafaudages. Maman Carpeaux comprendrait peut-être mieux, elle qui a été dentellière pendant sa jeunesse. Ils ont usé et les est sans réactions. Pourtant quelques professeurs étaient intervenus, et grâce à leur assistance Carpeaux put commencer à suivre des cours de dessin, luttant contre son père qui veut le ramener au chantier.

4. — Les Carpeaux ont déménagé et se sont installés à Paris. Carpeaux entre à l'atelier de Belloc. Hélas ! la famille déménage encore. Que faire ? Suivre les parents à Versailles et retourner à la maçonnerie ou rester à Paris, tout seul ? Carpeaux hésite pas. Il a quinze ans, il se sent capable de gagner sa vie. Il reste à Paris. La nuit il travaille aux Halles, colline de sacs de pommes de terre, des bottes de légumes. Le jour il étudie dans l'atelier Belloc. Il se nourrit d'un quignon de pain. Déjà il fait de jolis groupes de plâtre qu'il vend de porte à porte ou dans les magasins. Mais il en retire un ou deux francs à peine.
(Voir suite page suivante.)

7. — Luttant dans la misère noire, Carpeaux se débat sur le pavé de Paris, porteur aux Halles la nuit, élève en sculpture le jour. Un matin, il se présente chez Rude, le grand maître. Rude s'émerveille de ce que fait l'adolescent, le conseille, l'aide et obtient que Valenciennes lui donne une bourse pour soulager sa misère. Pour la première fois quelqu'un comprend tout le génie qui est en Carpeaux. Est-ce la réussite ? Non. Toute sa vie de Jean-Baptiste Carpeaux sera une suite d'efforts rudes, difficiles. Il échoue trois fois au Prix de Rome alors qu'il a besoin de celui-ci. Mais ces échecs ne l'empêchent pas d'ontinuer et de lutter.

8. — Des journalistes parlent de Carpeaux. Celui-ci, qui est la ténacité même, a appris que l'Empereur s'est intéressé à l'un de ses bas-reliefs. Transportant celui-ci, il poursuit Napoléon III à travers trois départements pour le lui montrer à nouveau et obtenir un mot de recommandation. Il enlève enfin le Prix de Rome à vingt-sept ans. A Rome, il trouve l'amour : une belle fille d'un village voisin qu'il voudrait épouser. Mais le père et les frères ne veulent pas d'un étranger ni surtout d'un artiste. Ils séquestrent la fille, la battent, et celle-ci finit par mourir. Carpeaux n'a pu la voir qu'une seule fois, car les Italiens lui ont interdit le village.

the line from Carpeaux's birth in Valenciennes in 1827 and early training there, to his Paris teachers and successes in the Ecole Gratuite de Dessin and Ecole des Beaux-Arts, to the culmination of his studies in the Prix de Rome, to the stay in Italy and his first Salon successes, to his public commissions, and thus to the debates and controversies which his work provoked. It is a career which conforms to the nineteenth-century formula for artistic success. Even in 1957 a cartoonist wanting to turn Carpeaux's life into "Living History" for the readers of *Bonnes Soirées* fitted these same elements into just twelve frames, tracing economically, though in glamorous graphic style, the familiar trajectory—from birth to gaunt-cheeked, repentant death (fig. 5).[11]

If there is such remarkable consistency in the identity and biography assigned Carpeaux, this is because of the meanings which his life and work have been thought to convey. Carpeaux's career can stand for—and has been taken as—a kind of paradigm of the biography of the nineteenth-century French sculptor.[12] Establishing its pattern often leads to larger subjects. No sooner did Charles Blanc, for example, confess to mistaking the young artist for a *praticien*, than he launched into an explanation of how such an error could occur. He did so by exploring the nature of the sculptor's profession. "It is certainly remarkable," he wrote, "that a genius for the kind of sculpture whose mission is to decorate temples and public buildings, the most magnificent palaces and the most beautiful gardens, customarily appears in the heart of families without fortune. Made to work for the pleasure of the rich, sculptors are ordinarily born poor. And it is natural that this is so. How many men would like to embrace as harsh a career as that of the sculptor?"[13]

These observations are not original with Blanc—they are the century's received ideas about sculpture. What is remarkable is that they appear in the context of an obituary,

6

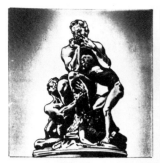

9 — Jean-Baptiste Carpeaux, jusqu'alors, n'avait fait que des essais, des tentatives, des recherches. Ses sculptures étaient jolies, pas géniales. Soudain il s'enferme dans son pavillon de la « Villa Médicis » et il modèle « Ugolin ». Cet homme puissant, muré dans une tour avec ses quatre enfants, dévorant ses mains en regardant mourir de faim ses fils autour de lui, inspire à Carpeaux une œuvre étonnante. C'est d'angoisse pure qu'Ugolin se dévore les mains, vigoureux et réduit à l'inutilité devant ses enfants qui meurent. L'administration veut refuser l'œuvre au Salon. Mais cette fois le public a enfin compris, et c'est le triomphe.

10 — Napoléon III l'aime beaucoup et le défend. Car l'Administration des Beaux-Arts continue à être suffoquée par ce petit homme malingre qui fait de la sculpture non conformiste. On veut lui faire abattre le groupe de Flore qu'il taille au fronton d'un palais, face à la Seine. Napoléon III vient à l'improviste, admire et le défend. Ce sera encore Napoléon III qui, devenant l'amour de Carpeaux (42 ans) pour Mlle de Montfort (22 ans), fille d'un général, le comte de Montfort, intervient en faveur du sculpteur, qui n'osait se prononcer. Pour la première fois de sa vie peut-être, le sculpteur tourmenté trouve un peu de paix et de sérénité.

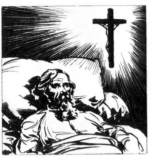

11 — Il est d'ailleurs lancé dans une grande œuvre : un groupe de la danse pour le fronton de l'Opéra. Mais les jaloux n'ont pas désarmé. Le maire donne le branle, et c'est un hurlement déchaîné dans les journaux. Personne ne veut de ce groupe de la danse (qui est maintenant l'un des plus purs joyaux de Paris). Un journaliste dit que « comme la danseuse de gauche va être amenée au poste de police pour ivresse manifeste, tout le groupe s'écroulera ». On accumule les pires méchancetés. Carpeaux lutte de toutes ses forces, mais son cœur saigne. Heureusement sa femme et ses enfants (il en aura quatre) soutiennent son courage.

12 — Pourtant Carpeaux fera encore de grandes œuvres, mais il entrera aussi dans une période de souffrance. L'Empereur émigre. Le sculpteur doit recommencer à solliciter comme un apprenti-sculpteur. Une effroyable maladie le saisit à quarante-cinq ans, et pendant deux ans il va agoniser, ayant atrocement mal, mais consacrant à s'ins anti de répit à a sculpture. Dans son agonie, il regarde le christ qu'on lui tend et dit : « Comme ils l'ont arrangé. Si j'avais la santé je ferais un Christ mieux que celui-là. » Il mourut le 12 octobre 1875, n'ayant jamais eu dans sa vie une heure de répit, de fierté de son œuvre et obligé de lutter toujours.

FIN

85

5. *Histoire vivante : Carpeaux*, cartoon, *Bonnes Soirées*, February 17, 1957. Musée d'Orsay, Paris.

so that Carpeaux's career is made to circle round the contradictions central to his art. Sculpture's products may be noble, its clients equally so, but its status as a profession is anything but. Its practitioners are necessarily working-class—or at least "born poor," as Blanc puts it—since no one else would be willing to work so hard. It is no accident, I believe, that Blanc produced these grim clichés in the course of a grand commemorative account of the successful career of a great artist. They apply to Carpeaux as much as to some poor failed sculptor, even though while he lived Carpeaux was often credited with leadership of his art, and at his death, with revitalizing it.

In this book, I have followed the lead suggested by accounts like these, which see an irresolvable gap between man and artist, and which take his career as being somehow paradigmatic, if paradoxically so. I have wanted to understand and explain in terms other than the triumph of "genius" Carpeaux's progress from worker's son to eminent sculptor, though I too am convinced of his artistic talent. I am more interested in finding the basis of the clichés and controversies which surrounded his art. Why should Carpeaux's career be seen as an archetype and his sculpture, "great" or "modern"? My attention to these questions does not mean that I wish somehow to "normalize" Carpeaux, though it does indicate, I hope, that I will present his work in terms of the views of sculpture and sculptors which made such judgements possible.

* * *

Before the nineteenth century the demanding physical nature of sculptural practice helped define the profession and set it apart from its rival, painting, in the endless see-saw of

7

the *paragone*. Both laborer and artist were traditionally understood to be united in one body, the sculptor's body (even if much of his actual work was performed by assistants and students, as was often the case). That body worked, used its muscles, and got dirty while making art. In the nineteenth century, however, a separation of workman and artist was accomplished, a true division of labor, and the change was widely acknowledged. The profession of sculptor split, then splintered, so that the sculptor was separated from both the full measure of physical labor his craft had previously demanded, and certain kinds of commissions it had once included. New branches of the art were acknowledged, and simultaneously the boundaries among them began to shift. A prospective client now could scan a professional directory not just for the sculptor, but for the specialist he needed. In 1830 the Paris *Almanach du Commerce* listed three kinds of sculptors—*statuaires, ornemanistes*, and *sculpteurs sur bois*—under the general rubric of *sculpteurs*. Within each category further divisions were made according to the genre or material or process in which each man claimed expertise. A *sculpteur statuaire*, traditionally a producer of statues of the human figure, might also distinguish himself as a *fabricant de bronzes*; if so he could be listed among the *bronziers* as well. Or he might signal his talents as a portraitist. *Sculpteurs ornemanistes* were similarly divided, by medium (plasterworker, *marbrier*, etc.) or by skill (moldmaker, tin caster) or by the type of building, a church or a theater, for example, for which his work was designed. The *sculpteur sur bois* too would let it be known if his carvings were particularly meant for mirror frames or carriages or furniture, or if he used some new mechanical process to execute them. By 1830, in other words, the listings were complicated and specific, reflecting increasing specialization within the sculpting trades; and thirty years later the process had gone even further. Six different categories of sculptors, each with numerous distinctions within it, are given in the Paris *Almanach* for 1860. There are literally hundreds of names: the ornamentalists, the stonemasons, the sculptors in wood, those who produced for furniture and objets d'art, those who worked exclusively in ivory, and the few who designed for carriages alone. *Sculpteurs-statuaires* continued to be listed as a separate group, but some began to advertise their services in other commercial directories, like the one published by the Réunion des Fabricants de Bronzes.[14]

Yet, despite differences in media and market, artists and artisans who practiced these métiers were all "sculptors" and could be so classified. The splintering of their profession in the nineteenth century, evident even in the banality of trade listings (and there only in outline, since the names given are most often employers, not employees) indicates not so much radical change in the basic techniques and concerns of sculpture, as the modification in scale and procedure demanded by growth and industrialization. These were developments that answered an expanding luxury trade and a burgeoning building industry. They redefined sculpture's character as a commodity, its nature as a profession, and the identity of its practitioners.

Although in the 1860s a sculptor might still himself carve or polish a marble rather than hire a *praticien*, the nineteenth-century redefinition of the profession turned on a concept of absolute difference between the two states: "The *praticien* is linked to the life of an artist, shares all his uncertainties, suffers all his pains, is often the victim of his boredom and his whims, without having, as the sculptor does, either fame or hope to help him bear these burdens."[15] Despite his close involvement with the sculptor's often difficult lot, hope and fame are denied the worker in sculpture, because he executes the statue rather than conceives it. There the difference lies. The dismal description just quoted is by Antoine Etex, a sculptor himself, and qualified to pass judgement on his trade. In fact, the publisher Edouard Charton employed him to define the sculptor's livelihood for the *Guide pour le*

choix d'un état; ou, Dictionnaire des professions which he put out in 1842. Etex emphasized that, like the ornamental sculptor and molder, the *praticien* belonged to an inferior branch of the profession. In his opinion, a man should take up these lesser careers only when exhausted by failure, after prolonged attempts to succeed in a more elevated sphere. But according to another view set out in Pierre Larousse's endlessly useful *Dictionnaire universel*, failure produced fewer *praticiens* than did lack of initial capital: "all kinds of expenses, almost always very heavy . . . are insurmountable obstacles for a fairly large number of sculptors whom fortune has not favored, who cannot pursue their own inspiration and work for personal gain. . . . They become *praticiens*, and work at the expense of those more fortunate and richer men who can pursue pure art."[16]

These two descriptions cite the factors which separate sculptor and *praticien*: not birth, not training, but money and genius—the same factors at the root of Blanc's and the Goncourts' observations about Carpeaux. There are two results: the *praticien* does the work of sculpting and is paid for it, and the sculptor (at least in theory) is released to exercise his genius in the creation of pure art. But these descriptions also suggest that the sculptor and the *praticien* begin their careers from similar points. Why would they take up sculpture in the first place? In Charton's *Guide*, Etex gave one explanation, a rather standard one at that: the existence of a vocation or natural disposition. And, true to the practical aims of his employer, he offered criteria to test its existence (these in addition to his basic requirement, a disdain for making money). The budding sculptor should be mentally suited to taking up the chisel, a disposition best demonstrated by a taste for modelling and whittling or an interest in *forme*; the fledgling painter, on the other hand, could be detected by his penchant for *lumière*. But taste and inclination alone were not enough. The young sculptor must have a robust constitution and the energy to sustain a daily struggle with matter, tangible stuff, a form of work which is physically tiring, if not mentally arduous.[17]

The idea of a natural disposition for an artistic career seems on the face of it a sensible argument, even given the *Guide*'s warning that a serious vocation does not necessarily exist even when all the signs are there. And it is true that artists' recollections and biographers' accounts both like to discover evidence of precocious talent in the childhoods they describe, with the result that their evidence tends to support the rule.[18] But few sources exist which indisputably demonstrate the accuracy of Etex's criteria or their actual decisiveness for young men's lives. His prescription, like the whole of the *Guide*, was written to counsel the concerned bourgeois parent investigating possible professions for a son whose future was not limited to the road his father had followed before him. Sculpture was not often the choice. The path leading to it was narrow, and it was taken most often as part of a traditional, inevitable pattern—a conservative one, if we accept the formulation in which "conservative" means adopting a father's profession, or one related to it.[19] About sixty percent of the men who won the Prix de Rome in sculpture between 1806 and 1863 had fathers who were sculptors or *ciseleurs* or plasterers or masons or *menuisiers*—in short, who were artisans working with the materials and tools a sculptor manipulates. Sculptors' fathers were thus not the sort of people to be reading Charton's *Guide*. Many youths—their numbers are not included in this statistic—began as apprentices in trades related to their future work. The young Jean-Jacques Perraud, for example, who was to win the Prix de Rome in 1847, was apprenticed and then employed as a cabinetmaker (an *ébéniste*) in Lyons and in Paris. According to his own account, a visit to the Lyons Ecole des Beaux-Arts, where student competition sculpture was on exhibition, made him decide to become a *sculpteur-artiste*.[20] His story parallels that of François Rude's awakening to sculpture forty-five years before. Apprenticed to his father, a cooper and locksmith, Rude was attracted

to his future career when he wandered into the award ceremony at the Dijon Académie.[21]

Even if a future sculptor entered an Ecole des Beaux-Arts, he could do so not to become an artist, but rather to add a final polish to his training as an artisan. The two careers required not different curricula, but different levels of concentration. This is clear from a description by Jules Salmson of the aims he and a fellow student, Albert Carrier-Belleuse, shared at the outset of their stay at the Paris Ecole:

> Like me, Carrier did not attend the Ecole to pursue the profound studies which a *statuaire* follows, but simply to acquire some general knowledge and the manual flair and polish necessary for his profession of chaser, and for mine of engraver. . . . But bit by bit, we developed a taste for sculpture for itself alone.[22]

Most sculptors came from the working class. When the Goncourts saw an *ouvrier* in Carpeaux, they were first of all speaking literally. The son and grandson of masons (the trade called "la parodie de la sculpture"), the boy was initially apprenticed to a Valenciennes plasterer, Debaisieux. When, like so many other working-class families from the north of France, the Carpeaux household moved to Paris about 1839, he found work as a porter at Les Halles and at the porcelain factory run by Michel Aaron. His background is typical.[23] What is atypical is that Carpeaux maintained his working-class identity into manhood, in contrast to his professional persona, and that it distinguished him even after his entry into the *arriviste* milieu which became his habitat and sustenance.

<p style="text-align:center">* * *</p>

Literary and visual imagery produced in nineteenth-century France recapitulates these same figurations, the sculptor's genius and his professional plight. In painting and sculpture,

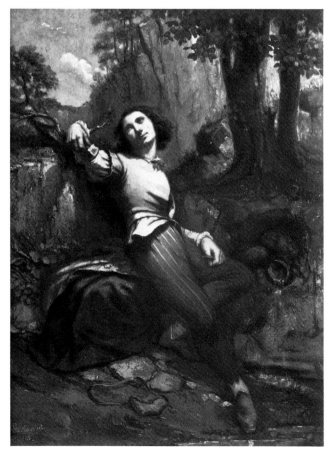

the first is emphasized. In a self-portrait drawn about 1815, the young James Pradier—later one of France's leading sculptors—styles himself as the very embodiment of genius, besmocked and brooding in the inevitable landscape with ruins (fig. 6). If only half-consciously, the drawing mobilizes notions of creativity and artistic personality current in Europe: a close parallel can be found in the pen and ink self-portraits drawn by Caspar David Friedrich in his Dresden studio. The same concepts survive for decades. They are there, for example, in Gustave Courbet's small picture *Le Sculpteur* (1845; fig. 7). In it the landscape is both mise-en-scène and artist's medium: the sculptor has begun to carve a classical head, his subject and his muse, from the living rock. Although he holds tools, he is not working. He is dreaming, and his posture is meant to convey that such reverie is the activity of genius. Although the canvas is partly the result of Courbet's shortlived apprenticeship to the pictorial conventions of the 1840s, its clichés are nonetheless geared to the myth of sculptural creativity. This is clear if the comparison is made with a more masterly treatment of a generically similar theme, Eugène Delacroix's *Michelange dans son atelier* (1850; fig. 8). Here too the labor depicted is not toil, but thought. The image complies with the dictum that the sculptor's genius, unlike that of the painter, functions not in action but in contemplation. A brilliant painter should be shown painting, a musician playing, but a sculptor thinking—and thus removed from bodily exertion, as was increasingly the case. This is surely one reason Delacroix presented Michelangelo in meditation, listening to his "muse violente, mais silencieuse et secrète."[24]

Carpeaux was never portrayed by as good an artist as Delacroix, but the images of him which do exist conform to the convention of showing a sculptor's genius as brilliance divorced from work. His own self-portraits, probably the best of these likenesses, omit the attributes of craft entirely. His identity both as man and as artist lies in his features

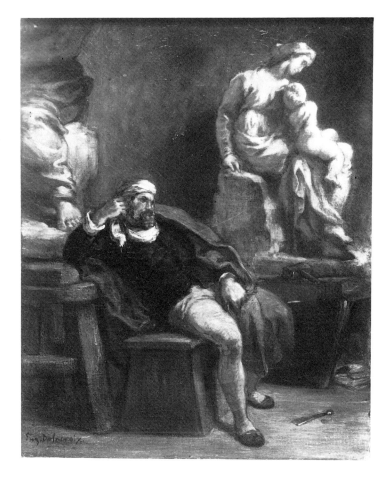

6. James Pradier, *Autoportrait*, c. 1815, pen and pencil on white paper (18 × 12.5). Musée d'Art et d'Histoire de Genève, Geneva.

7. Gustave Courbet, *Le Sculpteur*, 1845, oil on canvas (55 × 42). Private collection.

8. Eugène Delacroix, *Michelange dans son atelier*, 1850, oil on canvas (40 × 32). Musée Fabre, Montpellier.

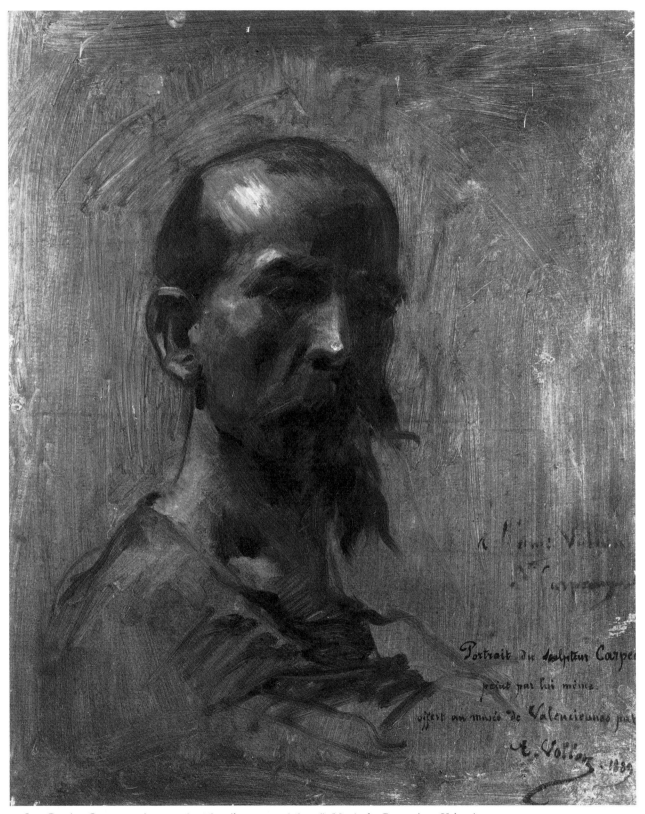

9. Jean-Baptiste Carpeaux, *Autoportrait*, 1862, oil on canvas (56 × 46). Musée des Beaux-Arts, Valenciennes.

alone, which are hollowed out of the surrounding darkness with a heavy, competent stroke (fig. 9). Portraits of him by friends—the fine canvas by Joseph Soumy (c. 1858; fig. 10) and the equally vivid drawing by the sculptor Alexandre Falguière (1862; fig. 11) are important examples—follow his lead in focusing on personality rather than profession. When Carpeaux is shown specifically as a sculptor, as in Bruno Chérier's 1875 portrait (which, though a likeness by a friend, was destined for the Salon and refused there), the tools he holds convey neither the illusion nor the possibility of work. The maquette of *La Danse* names the sculptor, nothing more (fig. 12). And in a final example, this one a posthumous portrait by Albert Maignan, *Le Rêve de Carpeaux* (1892; fig. 13), Carpeaux is still shown as a genius, even though his imagination now dwells only on past triumphs.

Against even the loftiest representations of the sculptor's calling were always weighed his professional difficulties, the burdens of being a sculptor. What good was genius if you could not make a living from it? Talent, so ran the contemporary wisdom, was more a curse than a blessing.

> Oh, what a dog of a métier sculpture is! The most lowly mason is better off. A figure which the administration buys for three thousand francs has already cost its author almost two thousand for the model, the clay, the marble or bronze—all kinds of expenses, and all to stay shut up in some official cellar, with the excuse that there is not enough room for it; never mind that the niches of monuments are empty, bases are waiting in the public garden, so what! There's never enough room. There's no hope of work from private folks, hardly a bust or two, or once in a while, a statue polished off at a reduction, for a subscription. The noblest of arts, the most virile, yes. But the art where you have the best chance of dying from hunger.[25]

10. Joseph Soumy, *J.-B. Carpeaux*, 1860, oil on cardboard (24 × 21). Musée Bonnat, Bayonne.

11. Alexandre Falguière, *J.-B. Carpeaux*, c. 1860, pencil on paper (21.3 × 14). Musée des Beaux-Arts, Dijon, Collection Granville.

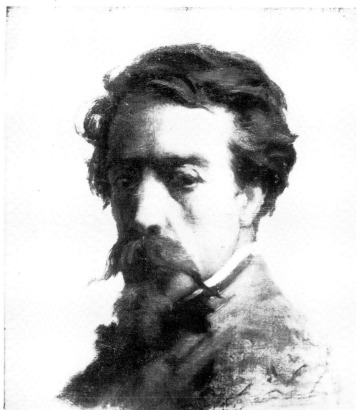

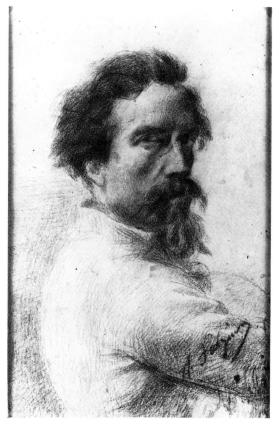

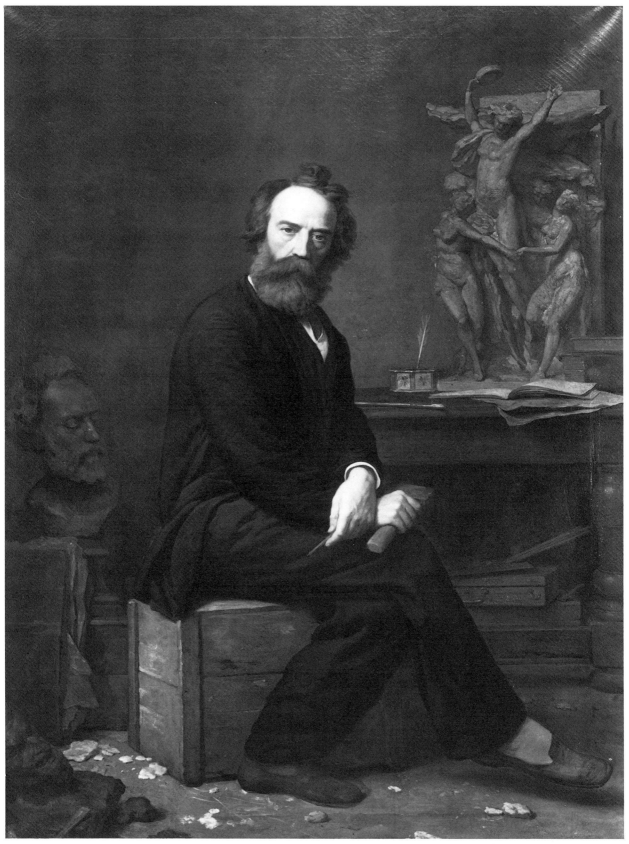

12. Bruno Chérier, *J.-B. Carpeaux dans l'atelier de Chérier, bd. Saint Jacques, Paris*, 1875, oil on canvas (161 × 121). Musée des Beaux-Arts, Valenciennes.

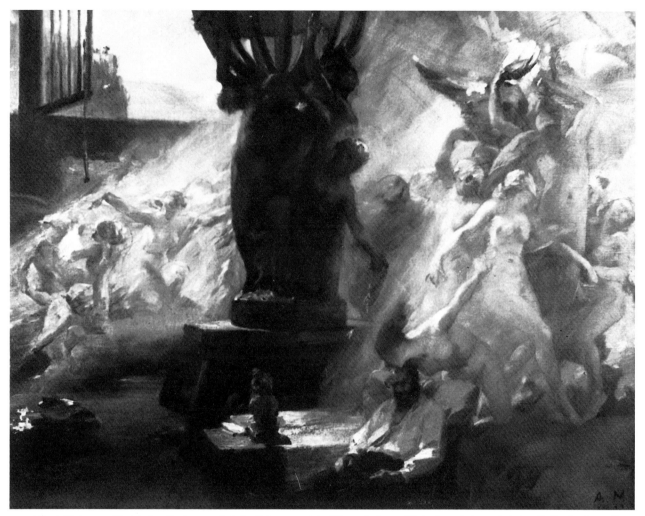

13. Albert Maignan, Sketch for *Carpeaux—"A l'artiste mourant les Etres nés de son Génie viennent donner le baiser d'adieu,"* 1892, oil on canvas (42.5 × 52.5). Musée de Picardie, Amiens.

So says the wretched sculptor Mahoudeau, in Emile Zola's novel *L'Oeuvre*. He reels off his bitter version of the sculptor's plight with an almost automatic anger, a disgruntled accompaniment to the mundane business of lighting his atelier stove. Both speech and act are the preamble to disaster: the unaccustomed warmth melts the frozen clay flesh of his huge *Baigneuse*—his sole hope for the success which had so far eluded him. The destruction is one of the dramatic high points in an overly dramatic novel, yet like other details of the plot it may have had its basis in the Parisian art world of the 1860s, where much of the action is supposed to take place. Zola seems to be reshaping for his own purposes an often-reported incident of the winter of 1864, when the sculptor J. L. Brian, a former winner of the Prix de Rome, was found frozen in his atelier, his few bedclothes wrapped around the *Mercury* which he planned to submit to the Salon that spring.

Mahoudeau survived the winter that killed his *Baigneuse*; if an actual incident helped Zola fashion his character, its larger contours were dictated, almost necessarily, by the notions about sculpture we have been outlining. Take this description, which marks Mahoudeau's first appearance in *L'Oeuvre*:

He was little, thin, with a bony face already furrowed with wrinkles at twenty-seven, with a mane of black hair matted down over his low forehead. In this yellow mask, ferociously ugly, opened a child's eyes, clear and empty, which smiled with a charming

15

youthfulness. The son of a stonecutter from Plassans, he had terrific success in the competitions of the Musée. Then he came to Paris as the prize winner from the city, with an 800 franc pension which Plassans dished out for four years. But in Paris, he lived defenseless, away from home, losing out at the Ecole des Beaux-Arts, using his pension to do nothing but eat, so that at the end of four years he was forced to hire himself out to one of those men who sell figures of saints, and to spend ten hours a day scratching out St. Josephs, St. Louis, Magdalens—the whole parochial calendar.[26]

One writer has suggested that Mahoudeau may be based on Carpeaux, perhaps rightly, since Zola knew the artist's work and wrote well about it.[27] But the resemblance between the sculptor and his fictional counterpart lies not so much in a direct biographical correspondence but rather in a shared relationship to the patterns of the sculptor's career. In *L'Oeuvre*, details like the laborer father, the provincial successes and scholarships, the time served in commercial sculpture, contribute to the sense of "scientific" observation essential to Zola's view of fiction as "natural history". For Carpeaux, these details were his life. But Carpeaux, of course, was a success at the Ecole des Beaux-Arts, after ten years of trying, and his stipends never quite ran out. Even so, he knew the exigencies of his career. His letters again and again describe its punishing conditions, long after he had obtained a success poor Mahoudeau never reached.[28]

So the question comes again: why be a sculptor? Like Mahoudeau, Carpeaux maintained that his was the noblest of the arts, even while he cursed the sacrifices it demanded. Sculpture would allow him to "leave to his age a body of work fully commensurate with his talent," Carpeaux wrote; he conveyed the sentiment to Napoléon III, his chosen protector.[29] And once more he associated himself with another dominant conception of the sculptor's role, which presented him as one of "a handful of men who uphold, at their risk and peril, a sublime form of human thought."[30] This phrase comes from Théophile Gautier. For him, as well as for many other critics, sculptors were martyrs to their noble art. Its exalted nature demanded self-sacrifice and priest-like devotion. There ought to be some irony behind notions like these. Instead they were repeated with apparent sincerity by Salon reviewers wanting to make some sense out of sculpture's sorry state. The writer François de Mercey, for example, made a list of the qualities the art required from its devotees: self-abnegation, immense force of will, and the courage to renounce life's pleasures and the satisfactions of *amour propre*.[31] He might be reciting the vow of some monastic order; by these lights, Brian's unhappy death and Mahoudeau's shivering body seem like extreme examples of the self-mortification its initiates were required to practice.

Myth and melodrama? Yes, yet woven from the complicated actualities that shaped the profession. In his review of the Salon of 1847, the critic Théophile Thoré could declare that only five sculptors in France were free from financial dependence on the Salon and the state.[32] (Ninety-eight sculptors showed that year, so by Thoré's reckoning roughly one-twentieth were "independent.") His choices, and the reasons behind them, are an excellent, grim index to sculpture's possible patronage at mid-century. There was David d'Angers, whose "Salon was the world"; commissions awarded by provincial cities released him from dependence on the art machinery of the capital. There was James Pradier, who had created a market for his erotic bronzes which was self-perpetuating. There were the counts Marochetti and Nieuwerkerke, who had private fortunes—money is always the easiest escape. And Auguste Clésinger had won instant success with his *Femme piquée par un serpent*; for him Thoré predicted the endless commissions which notoriety brings in its wake. Thoré's list covers the options: without any of these markets or means of support, sculptors fell back on the state or Salon.

Not without protests, however; Thoré's list was drawn up to strengthen an argument urging artists to unite in self-defense against the tyranny of the system that controlled them. His voice was one among many. The year before, in 1846, the *Journal des Artistes*, which throughout the 1840s had been increasingly adamant in its demands for change, reprinted several articles from the radical periodical *La Liberté* (1823–33), in the process adopting their slogan "Mort à l'Institut! Mort au professorat!"[33] It was easy to espouse the destruction of these two venerable bodies—a precedent was already there, in the dissolution of 1793. But when revolution came again in 1848, and the regime changed, the patronage problem continued. Under the Second Republic the same Charles Blanc, then Directeur des Beaux-Arts for the new government, urged broader state support for art. His proposal emphasized the particular professional plight of the sculptor: "In today's society, if a sculptor is not lucky in his birth, what can he do about it? Why should he undertake such a difficult and unrewarding career?"[34] In 1849 the suicide of Antonin Moine, in the early 1830s considered one of the most promising younger sculptors, was taken as further proof of the callousness of the system. On this occasion it was Victor Hugo who pleaded the cause of the arts in a speech to the Assemblée Nationale.[35] Moine's death was his chief example.

If we put them alongside Moine's thwarted career and growing desperation, Thoré's five sculptors seem blessed indeed. Between 1831, the year of his Salon debut, and 1849, Moine exhibited only three times. After 1834, when he carved two elegant stoups as part—a minor part—of the fittings for the new Madeleine, he received no major public commission. His biographer explained the problem by citing an anecdote reported in *L'Artiste*, describing Moine's visit to the Direction des Beaux-Arts in search of work: "'Monsieur, did you go to Rome?' asked the clerk in charge of the list of awards. When the artist, who could not understand the reason behind the question, replied in the negative, the clerk continued, 'Well, Monsieur, to be perfectly frank, you should hold no hopes for any government work.'"[36]

True or not, stories like this one helped to establish a set of assumptions about the sculptor's profession, part of the negative climate in which artists worked. Their identity, their very existence, was decided by the commissions they won and the Salons at which they showed. And from the early 1830s until the open Salon of 1848, their reliance on the annual exhibition as a means of exposure was compromised by an almost systematically implemented policy of refusal by the jury. Its strategy was simple: it discriminated against innovative sculpture, even if its authors had public support. Critics deplored the exclusion in 1837 of A. L. Barye, for example, whose reputation had been established at his first two Salons, in 1831 and 1833, before the jury took action against him. Auguste Préault was treated even more harshly, victimized by an unwavering censorship, relentlessly maintained from 1835 until 1848, despite the opposition of Salon critics. The same writers decried the policies which underlay state patronage; they voiced objections which, taken together, add up to a detailed picture of official discrimination. Awards were made on the basis of success in the Académie-controlled system of education, with results which did not always justify that policy; this was the argument against the choice of Henri Lemaire, a Prix de Rome winner in 1821, to execute the pediment sculpture for the Madeleine, once his stiffly posed solution had been unveiled. Too often, one artist would receive a large share of work, which, it was said, could better have been portioned out to several sculptors: here the two *trophées* for the Arc de Triomphe de l'Etoile given to Etex (1833) and the twelve Victories for Napoleon's tomb allotted to Pradier (begun in 1843) were favorite examples. Sometimes the choice of artist was simply wrong, and insulting to

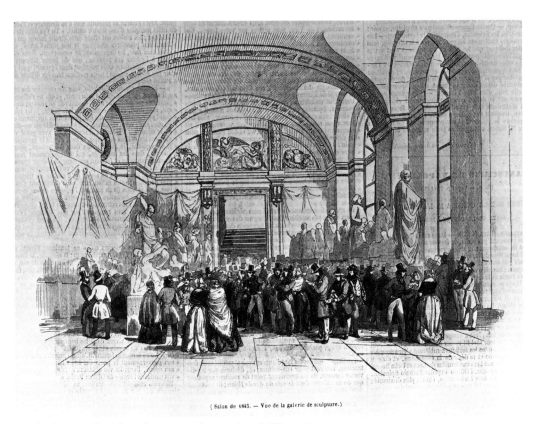

(Salon de 1843. — Vue de la galerie de sculpture.)

14. Sculpture at the Salon of 1843, wood engraving. *L'Illustration*, 1843.

Frenchmen. Marochetti, an Italian-born nobleman, was the prime target of such charges.

To make matters worse, those sculptors who did exhibit showed under the most negative conditions. At best, the critics scolded, the space allotted sculpture in the Louvre cellars was a *cave obscure, humide, froide et meurtrière*.[37] It seemed no wonder that the public avoided such a dank and deadly environment (fig. 14). If we believe the engraving from *L'Illustration*, visitors were dwarfed by the vaulted ceiling and by the statues themselves. Plasters and marbles were drawn up in rows facing the light, rather like invalids sunning themselves. To Théophile Gautier, viewing sculpture there was a funereal, almost necrophiliac pastime: "Never do I enter the rooms to which the sculptors' works have been relegated without experiencing a profound sentiment of sadness; it is clear that this is a dead art, so much so that its products are exhibited in a crypt. Nothing is more dismal to look upon than this kind of sculptural morgue, where under one pale damp ray of light are laid out the marble cadavers of former gods which their heavenly relatives have failed to collect."[38]

Like Gautier, other critics periodically proclaimed not just the death of sculpture, but its anachronistic status in the modern world. Take Thoré's unequivocal statement: "Our epoch is not the age of marble or of bronze."[39] In fact Gautier himself put it rather more histrionically: "Sculpture . . . is the art of gods and kings; the gods are gone, and the kings soon will be." He amplified the idea with relish: "In our industrial and civilized world, who gives a thought fot the purity and whiteness of marble? In this age of hydrogen gas and steam engines, who is still thinking of the day when Venus came naked from the sea?"[40] Plenty of people, if the Salon is any evidence; but Gautier's point, need it be said, was that sculpture was anachronistic, a casualty of modernity. Was not its marmorean whiteness better suited to Mediterranean sun than Parisian rain? And what

had its satyrs and thunderbolts to do with the new powers at man's disposal? By 1839 Etex at least seemed to grasp the point. His maquette for a Paris fountain—it was destined for the Place de l'Europe—represented the *Génie du XIXème siècle*, holding a locomotive and an electrically powered machine, a beacon shining from his hair, and dictating laws to a nature which scientific discovery had finally subdued.[41]

Modern subjects alone do not, however, make modern sculpture. Etex does not really seem to have understood the essence of Thoré's and Gautier's arguments. It was certainly true that sculpture had lost the social conditions which formerly had decided its main tasks. Its subject matter, consequently, was somehow in abeyance, exhausted, but yet to be replaced. But even worse, the materiality of sculpture, its defining characteristic, seemed to some the factor which would seal its doom.

Certainly sculpture's inescapable physicality was at the root of Charles Baudelaire's view of it.[42] Its materiality meant that sculpture was the first of the arts, the one closest to nature—a primitive art, incapable of controlling the viewer's sensations as could the illusionism of painting. So in his *Salon de 1846* Baudelaire called sculpture "boring," crippling it with a label that would stick, despite Baudelaire's own retraction thirteen years later. It might have been possible to argue from Baudelaire that sculpture in the nineteenth century, as the most tedious of the arts, was the bourgeois art *par excellence*, the representation, in its finite forms, of the world's yawning emptiness. But that was an argument Baudelaire himself never mounted. Sculpture for him was still potentially a grand and elevating matter. By 1859 we find him in full retreat from his earlier iconoclasm, chastising sculpture now for not being well enough executed—not capitalizing on its materiality—and thus not answering to its high destiny.

We are back in the world of the *Encyclopédie*, back with Falconet's entry under *sculpture*: "Sculpture is the most durable repository of the virtues and weaknesses of men. . . . Considered from this moral viewpoint, its most worthy aim is this perpetuation of the memory of illustrious men and the provision of models of virtue so efficacious that those who are virtuous will no longer be envied."[43] These ideas died hard, their echoes resound into the twentieth century. Sculpture was durable; it worked effectively on the grand scale; it spoke the language of public places. It was the great provider of *exempla virtutis*: moral lessons and model lives which would educate men and women while perpetuating the past.

So while economic necessity forced sculptors to produce for the public domain, the physical nature of the art also demanded that role. Sculptors concurred. Préault wanted to carve mountains into colossi; the aspiration, critics said, was common to all young sculptors. David d'Angers considered his art "a powerful means to teach the masses morality," and peopled the city squares of France with monuments designed to do just that.[44] Carpeaux's ambition was similar, as his career attests. And although Rodin was universally acknowledged as a "modern" artist, he nonetheless accepted a civic commission as the highest challenge. Public works like the *Porte de l'Enfer*, the *Bourgeois de Calais*, and the *Balzac* absorbed and tested his energies. The idea that this destiny was inescapable, however, further imprisoned sculptors in contradictions and conflicts. As a public art, it could exist only as the servant of neglectful, embattled institutions. Like Tantalus, it was condemned to do what it could not.

When in the 1830s and 1840s sculptors sought an outlet from the closure of the system they had inherited, they were attacked for venturing outside these preordained limitations. Their favorite tactic was the bronze statuette, whose subjects, scale, and medium appealed to a bourgeoisie developing its taste in these decades.[45] Collaboration with a commercial

founder allowed a sculptor to loosen the economic stranglehold of government and private patronage. Moine, for example, sold models for twelve statuettes to the Susse foundry, seeking there the support the government did not offer. Even an officially successful sculptor like Pradier profited from this growing market, as Thoré suggested, turning out laundresses and Ledas, *pifferari* and voluptuous little ladies undressing, all cast in bronze and plaster editions by one Salvador Marchi. Barye was his own founder, manufacturing and selling casts until financial difficulties forced him to surrender control of his operation. Carpeaux followed the same path, contracting with founders to reproduce various works until he launched his own commercial venture to market his designs more widely. Yet commercialization was escape into another trap, since sculpture's descent from its pedestal into the bourgeois salon did not go uncensured. In some eyes its noble purity was cheapened by availability: "sculpture cannot reduce its size without abdicating its position; it cannot accommodate itself in any way to bourgeois taste; it cannot serve industry without becoming its degraded slave. In corrupting their art, sculptors corrupt themselves."[46]

In considering nineteenth-century sculpture, and Carpeaux's place in it, we must be aware of how hope and discouragement existed side by side; how sculpture's death was mourned and its rebirth awaited; how dogma dictated that sculpture should and could teach, though much of its audience thought it compromised by that educative role; how critics could condemn the art but appreciate its individual manifestations; how sculpture was simultaneously a marble corpse and an animate body; how sculptors were at once guardians of tradition, venal businessmen, martyrs, workers, and potential giants. It seems that sculpture did not go unchallenged on any front, or appear wholly acceptable to any audience. Except perhaps to sculptors, of course. The fact remains that despite its difficulties and its position of inferiority to painting, men—and a very few women—did continue to become sculptors. They did so less frequently than they became painters, it is true. Yet many *were* successful at it; some might have disavowed entirely the view of the profession which I am setting forth. Once a sculptor began professional life, however, and started to participate in the institutions which inevitably shaped that life in mid-nineteenth-century France, it is impossible to think that he would have remained ignorant of the problems his profession faced. Anyone who became involved in sculpture in the late 1840s and 1850s found it at this difficult juncture in its history. Carpeaux was no exception, and the pattern of his career provides the best evidence of his conscious effort to surmount or circumvent that situation.

Sculpture's problems persisted as Carpeaux's generation reached its maturity. The arrival of another Napoléon on the French throne did not change matters, though the ambitious building programs he instituted did provide employment on an unprecedented scale. Sculpture nonetheless still seemed at a low ebb. The Exposition Universelle held in Paris in 1855 only helped to prove the point. This is how Maxime Du Camp put it; his tone is unmistakably that of the 1840s: "The sculpture exhibition is manifestly mediocre; the sight of it is as depressing as the spectacle of a dying man so weakened and conscious of his approaching end that he no longer makes even the slightest effort to hold fast to life. Even more than painters, sculptors live outside their age." In eminently modern fashion, Du Camp thought that the situation could best be shown by statistics, and reproduced this analysis of the 380 pieces of French sculpture to set his readers straight:

Fanciful subjects, such as: *Study of a Young Girl*; *The Siesta*; *The Birdnester*; *Young Girl with a Seashell*, etc. ... 65
Allegorical subjects, such as: *Rose of the Alps*; *L'Amour clairvoyant*; *Ingenuity*, etc. .. 34

Religious subjects, from both the Old and the New Testaments: *Christ on the Cross* as well as *Suzanne* or *Cain*.. 29

Statues of famous men, from Jesus Christ to today................................ 23

Statues of heroic and historic personages, such as: *Hyacinthe mourant, Calypso, Cornelia* .. 20

Archeological reconstruction.. 1

Public monument.. 1

Animals .. 35

Busts, ancient as well as modern....................................... 115

Modern subjects .. 5

[Du Camp did not enumerate the 62 medals and cameos which make up the total.][47]

Du Camp meant his list to be dismal, and it is. Even the five modern subjects were disappointing. They were all the work of one sculptor, Emmanuel Frémiet, examples of the painstakingly accurate statuettes of French soldiers—artillery men, cuirassiers, and the like—which he was modelling at the behest of Napoléon III. Du Camp considered them no better than dolls.

Unlike the painting display, which offered a survey of the art in France since the Revolution, and gave retrospective shows to its living masters, Ingres, Delacroix, Vernet, and Decamps, the sculpture section was dominated neither by the present nor by the past. There was no historical survey; no sculptor was presented as a master. Absences from the show were more important than inclusions. Pradier had died in 1852; David d'Angers did not exhibit, and Rude was represented only by two works from the early 1830s and a marble bust.

David and Rude both died within a year, making the situation suggested by the Exposition a reality. Their loss, coupled with Pradier's death, left sculpture leaderless. No one discerned among the younger generation, either the Prix de Rome winners or the also rans, the talent necessary to succeed them. Yet there was still speculation about what the new sculpture would be like. Du Camp, for example, repeated the time-worn demand that it should treat modern subjects, though what they were he did not say. Nonetheless, he was taking sides on another of the critical questions for nineteenth-century sculpture, that of its proper relationship to the newly important business of representing contemporary life. How it was posed and answered is as relevant for our understanding of the profession as the material conditions we have been exploring, since it helped to determine the context of expectation and assumption within which sculptors fashioned their art and the public received it.

The Académie and Baudelaire both assumed, albeit for very different reasons, that sculpture was unable to depict modern life. Yet some of the most convinced supporters of a modern sculpture gave it a place in their formulation of the future of art, and often for serious reasons. Victor Schoelcher, for example, a vocal campaigner against slavery and in 1848 a member of the Assemblée Nationale, set forth a view of sculpture's future in the pages of *L'Artiste*. In its tangible material form he saw, *pace* Baudelaire, a claim to superior power: "Painting is an art, a magic spell; it is all illusion; sculpture is a science; it is all reality"—where reality, in both physicality and subject, is tantamount to scientific truth, and illusion is a dead and lying language.[48]

But how real a reality? And, more important, how should sculpture give access to the reality it chose? It would be decades before togas disappeared entirely from sculpture. As eternal presences, statues were supposed to avoid the possibility of becoming dated

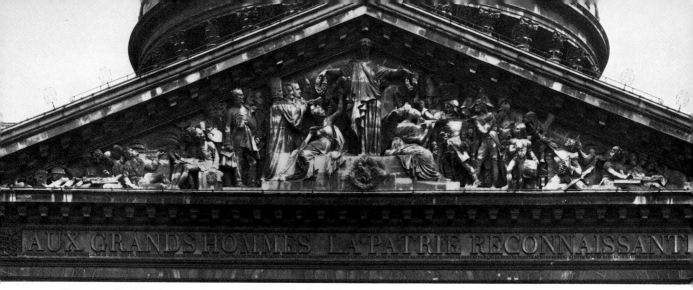

15. Pierre-Jean David d'Angers, *Aux Grands Hommes La Patrie Reconnaissante*, 1837, stone (6m × 30m80). Panthéon, Paris.

by a change in fashion. For this reason, among others, David d'Angers's use of contemporary garb for the generals and students in his Panthéon pediment (1830–37) provoked dismay, even though his worth as an artist was widely acknowledged (fig. 15), and his ambitions not limited by a desire for contemporaneity alone. Pedimental sculpture, with its all too evident history, seemed to be a particular testing ground for such questions. The design which François Jouffroy conceived for the central facade of the Institution des Jeunes Aveugles (1840; fig. 16), showing simply dressed blind children practicing the skills they learned inside, was thought to be a brave gesture towards modernity in the face of the attacks against David.[49] Yet instances like these are slightly misleading, in that the realism at issue in sculpture did not simply concern the literal transcription of costume and physical incident. Sculptural realism had no definitive standard of a kind to be measured in warts and button holes. What was really at issue was the matter of how, through form or subject or both, a sculpture opened up the possibility of reference to contemporary experience—the experience of the everyday world.

The problem, for most of the nineteenth century, was not so much how reference could be secured, but how it could be avoided, or at least blunted. Sculpture's domain was inevitably and invariably the human body, despite Barye, and it is sculpture's fate even now to be read in comparison to the body of the viewer. It is measured, explored, judged against a standard which the viewer carries about at all times—his or her own body, I mean—so that the sculptor is forced, at least until abstraction, to maintain a certain bedrock level

16. François Jouffroy, pediment, 1840, stone. Institution des Jeunes Aveugles, Paris.

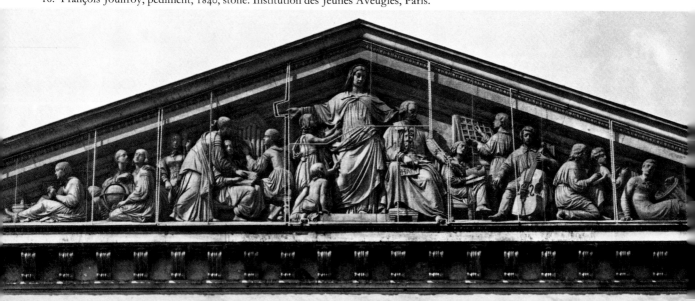

of mimesis. In an age when anatomical knowledge was a secure and solid branch of science, the artist knew more than ever about how a body *ought* to look. So the business of sculpting and of looking at sculpture became more and more the matter of relating the requirements of a "correct" figure to a concept of "appropriateness" defined, not *in* the sculpture, but external to it, by the title or subject the work was asked to express.

This is a simple description of how sculpture is seen, I realize, but proof of its accuracy is available almost ad infinitum in contemporary Salon reviews. Its credibility is only contingent on accepting the premise that the Salon review is in some sense the record of a process of seeing, even if that process is embedded in, even obscured by, effects and meanings which are proper to a literary genre. We can sometimes read past the conceits and banalities which abound within the form to the mental and visual expectations at its root. To show how this is true, let me cite two passages by Maxime Du Camp from that same study of the sculpture at the Exposition Universelle. Both are perhaps remarkable in their length, but not at all so in their vocabulary, their judgements, the ways they approach questions of meaning or express enthusiasm. Both describe what we might call "standard" Salon entries, in that neither was the work of a particularly well known or successful artist. The first concerns a figure by a pupil of David d'Angers, Jules Cavelier, while the second describes a work by Ernest Christophe, who had studied with Rude (figs. 17–18).

> In Cavelier's *Truth* must be praised a precious search for line, grandeur, and style. Despite its faults, this statue has a serious, masterly appearance which is praiseworthy, though it is still a too obvious recollection of tradition. *Truth* is standing. With her right arm raised above her head, she lifts her divine mirror, and with a bent left arm she pushes her drapery behind her, to reveal herself to men in all her imposing nudity. The movement, extremely simple as it is, is well understood, and would leave nothing to be desired if the statue's head were not manifestly lacking in intelligence. To represent the face of Truth, it is not enough to reproduce a type which is more or less handsome, more or less Roman, more or less Greek. Instead every feature of the visage must help to express the allegory; the eyes must show that piercing lucidity which penetrates to their depths; the mouth must expose on its inflexible lips the deepest hatred of falsehood; the straight nose, fine chiselled, and raised slightly by the nostrils, proclaims firmness, and links itself to a square and firm cut chin.[50]

The passage continues, inevitably, not to inventory more necessary features, but to reproach Cavelier for not having given any of them to his work. Yet the sculptor comes off well in Du Camp's estimation: he is granted the critical consolation prize, promise. What is important about the passage, however, is not the well-worn series of labels so easily affixed to Cavelier and his *Truth*—the "recherche précieuse de la ligne," the "style," the "apparance magistrale," and so forth. These are the staples of the critics' phrasebook: the merest hack would have known how to deploy them in Cavelier's case—and did. Instead, the interest of Du Camp's paragraph lies in the basic process of naming, seeing, and assessing which it reveals. Critics were endlessly measuring the differences between an individual work and a mental image of how its subject ought to be rendered. I say *naming* before *seeing* because it is clear from this passage (and the hundreds of others it represents) that Du Camp's mental activity assigned the same priorities. With the name of Cavelier's statue in mind, he formed a notion of the features—lips, nose, mouth— appropriate to Truth. He compared Cavelier's statue to that formula, and found it lacking.

Through all of this, however, the sculpture remains an object, a representation, a thing. But when disappointment gives way to enthusiasm—as it regularly does, even in sculpture

criticism—something very different takes place. Du Camp really admired Christophe's colossal statue *La Douleur*. Here is how he presented it:

> An enormous woman who, if she stood up, would be at least eighteen feet tall, sits on a rock; her huge naked limbs seem crushed, and, as if weakened by a nameless sorrow, broken by desolation, she hides her face between clenched fists, and on her knees has sought a support for a head overwhelmed and hidden by long hair—the last shudderings of a sob are fading from her shoulders and still seem to make her vast breast sigh. Behind her closed hands one senses features darkened by despair and contorted by unspoken angers, and even so, seeing her thus folded over on herself, collecting herself in her affliction, one understands that someday she will lift herself up again, full of force and victorious violence.[51]

The description begins, it is true, in a way similar to the passage just cited. In one a woman stands, in the other, a woman sits: both are sculptures. But in the first there is a movement away from the personification of the subject to relate it instead to an abstract, pre-existing ideal. In the other, an opposite process is at work. The statue is made *more* of a person. It becomes animate, is seen to move, has its future actions predicted. The critic has established a kind of empathetic relationship with the object he is viewing, and verbally becomes it for a moment. The identification may be shortlived, it is true. Du Camp ends by reproaching Christophe for hiding his figure's face too completely in its hands, since the features are the traditional index to emotional content. Yet the critic raises this objection only after he demonstrates that this "fault" has made no difference to his reading of the piece. The thing came to life as he looked at it; it moved, and completed the action implicit in its form. The process of vision and the analysis it provoked are thus markedly different from that produced by other works, by Cavelier's *Truth*, for example. The one closes the imaginative distance between subject and object, between viewer and viewed. The other remains distant, its mode entirely objective, its success measured against an idea of the best means of rendering a given theme.

These two passages are not particularly good writing or original criticism, and it is important that they are not. Nor do they circumscribe the possible critical reactions to sculpture: critics can be very brief, and very bored. What they do suggest, I think, are the two most important attitudes towards sculpture, that which measures it against pre-existing standards and that which treats it as an independent active animated body. Examples of the two are endless; they can exist simultaneously within the work of one author, as in Du Camp's case, and he would probably not prefer one mode to the other. The first keeps concept and representation at arm's length, so to speak, the better to measure the one against the other. The second marks a different engagement with a sculpture, the critic's empathy with the actions and sensations the sculpted body mimics. He becomes involved with what the sculpture *does* or *is*, as much or more than with what it represents. This kind of seeing seems to accept the sculpture as the body it imitates and to allot it an independent identity.

The process of identification or reading which I am describing is not always to the advantage of a sculpture and its author. Take the case where the completion of a sculpture's action leads the viewer into a realm of meaning ordinarily closed to the art by the system of tacit constraints we have been outlining—into the Ignoble, for example, or the Immoral, or the Everyday. A kind of entry into the sculpture is made through a reading of its form, only to find that it leads to dangerous territory. This is manifestly the case in critical views of two of the most controversial sculptures of the mid-nineteenth century, Préault's *La*

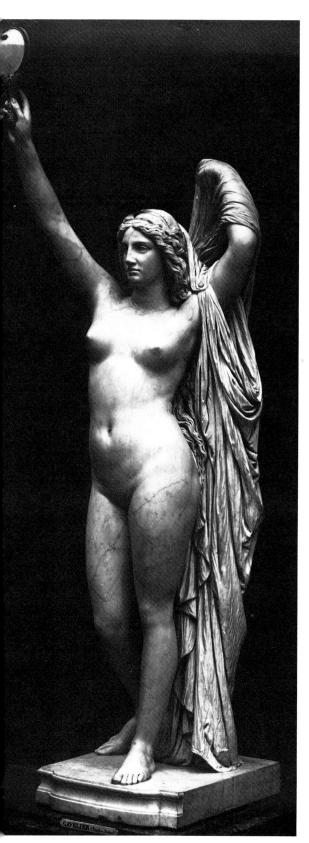

17. (left) Pierre-Jules Cavelier, *La Verité*, 1849–53, marble. Destroyed.

18. Engraving of a lost statue by Ernest Christophe, *La Douleur*, 1855, Bibliothèque Nationale, Paris.

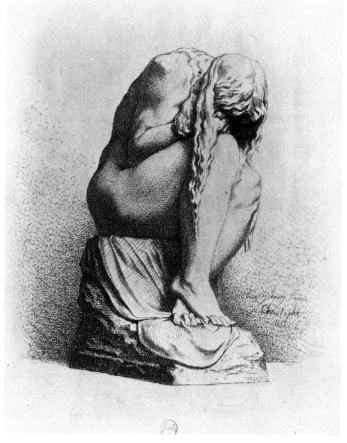

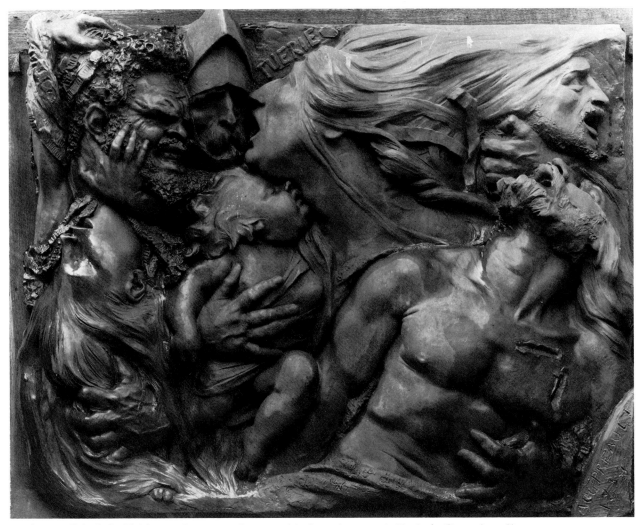

19. Auguste Préault, *La Tuérie*, 1850, bronze cast from a model of 1834 (109 × 140). Musée des Beaux-Arts, Chartres.

Tuérie and Clésinger's *Femme piquée par un serpent* (figs. 19–20). One a bas-relief, the other a near life-size marble figure, the two are obviously very different in form and content. Yet entry into either of them gives access to bodily states and mental conditions far outside the range of meanings proper to sculpture—violence, pain, and death in the one, sexual ecstasy in the other. *La Tuérie* depicts the terrors, the illogicality, the brutality of killing, with a kaleidoscopic, fragmented focus on its most terrible manifestations; this to an audience certainly accustomed to seeing bas-reliefs of battles, and thus to reading battle as serried ranks of men whose bodies are opposed as angular patterns within a tightly ordered composition. Clésinger's work deals with subject matter even more familiar in sculpture, the female nude. But here the exploration of a woman's naked body is not masked by a mythological name, not hidden behind the protection such a verbal fig leaf would offer. "Is it a Eurydice? Is it a Cleopatra? No. It is, quite simply, a woman bitten by a snake."[52] Such apparent lack of specificity of meaning only provoked discontent in this critic, even though it meant an updating of tired formats to other eyes. It placed the viewer in a realm where meanings were produced by the sculptured body alone. Clésinger had taken pains to have his figure's surface carved into a tissue of individual incident, its belly

26

and thighs made flesh-like, in imitation of the casts from life which were his starting point. Seduced by its dimpled contours, most critics seemed to think that the work became its model as they watched.[53]

It might be objected that the distinction I am outlining, between a sculpture that *is* and one that *represents*, is a false one—that all sculptures both *are* and *represent*. I would grant that objection, but simultaneously repeat my earlier statement, that this distinction is meant to isolate how sculpture was seen in the mid-nineteenth century, how identifications were made and meanings deciphered.

We must also consider how meanings were established. How did a sculptor determine the ways in which his work would *mean* to its audience? Clésinger's message is established primarily through anatomical description and exaggeration, Cavelier's through reference to the tradition which equates Truth with a woman holding a mirror. Their methods are obvious; each artist must have been aware of the choice he had made, and clear about secondary vehicles of meaning within his composition: the careful realism of Cavelier's modelling of *Truth*'s belly, for example, or Clésinger's inclusion of a snake twined round the wrist of his swooning woman. Cavelier's way was that of tradition, of the Académie, though he himself was not identified as an Académie man. And Clésinger, though he did not go on to make sculpture consistently identified as modern, was thought to do so here.

At this juncture it may be helpful to cite a passage from a review which Zola wrote in 1868 for *L'Evénement Illustré*. Though he did not often comment on sculpture, this piece is enough to demonstrate the extent to which he had absorbed the arguments I have been outlining. A pessimistic description of the plight of contemporary sculpture, the passage begins with a restatement of the view that it is the transformation of collective intellectual and social life which had made sculpture outmoded:

Our age is given over to mental speculation; our religion hardly tolerates in its churches a few emaciated images of male and female saints; we no longer have time to dream about dolls; we know, what is more, that the ideal is a lie, and thus prefer to search fiercely through science to discover the laws of reality. As a result, sculpture as Greece meant it has become a dead language for us, an artistic expression which we do not

20. Auguste Clésinger, *Femme piquée par un serpent*, 1847, marble (56.5 × 180 × 70). Musée du Louvre, Paris.

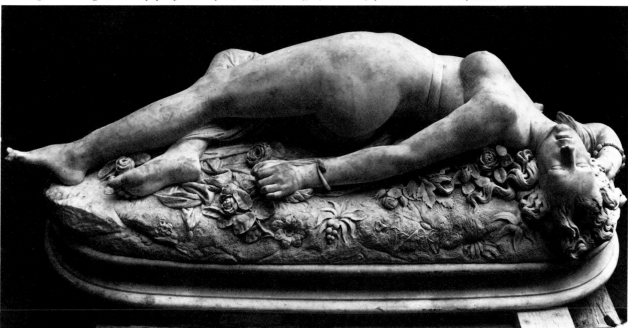

know how to use naturally. Our artists speak Greek art as sixth form students speak Latin, with a dictionary, without a true accent and with frightful barbarisms.[54]

The sculpture Zola sees around him is not noble but corrupt, exercises in a dead language which sculptors learn—incorrectly. And its presence in the world only points up the problem: "If you group the modern bourgeoisie around some skimpy statue by one of our artists, a flat pretentious imitation of a Greek idol, the spectacle becomes agonizing; such a stupid idealization of nature in the face of contemporary truths seems childishness, a grotesque and petty stubbornness." Zola's recommendation thus seems simple, an obvious development from this analysis: "It is time, if we wish to save sculpture from its death throes, to reconcile it with modern times, to make it the offspring of our civilization. The Greeks, with their ideal, their dream of rounded forms, must get left at home; we must speak our own artistic language, our contemporary tongue of reality and analysis. . . . There is only one way to make us appreciate nude sculpture—that is, to make it live. Life will touch the crowd, when absolute beauty will not stir it."

In 1868 Zola could only write in general terms about the naturalist sculpture which would revitalize the art. He knew only one sculptor, Philippe Solari, whom he could call a naturalist, and Solari did not live up to the promise which his friend Zola saw in his art. Two years later, however, Zola found a work which, like Henry James, he saw as eminently contemporary, one which spoke a modern language, which, in James's phrase, *was* characteristic of its time and place. The work, of course, was *La Danse*; Zola relished the irony of the fact that it was carved to ornament the facade of the Paris Opéra.

It is Zola's earlier discussion of sculpture which is useful to us here, however; we shall come to his analysis of *La Danse* in due course. The *Evénement* column restates, with typical Zolaesque bite, the problems sculpture seemed to face at mid-century, the problems we have been examining. We have mapped its themes using other evidence: the discrepancy between current sculptural language and contemporary concerns; between the different rewards granted *artiste* and *praticien*, though their background and training were often the same; between sculpture's new audience and the kinds of objects its producers knew how to supply; between the language it sought to employ and its practitioners' ability to use that language; between approved form and the reactions provoked by nonconforming works. If awareness of such problems first began to surface in the 1830s, they stayed current well into the 1860s.

What I have tried to do in this first chapter is to formulate a notion of the range and attitudes towards sculpture in mid-nineteenth-century France. It should be understood that this formulation does not define individual experience or practice, even if it may be said to inform it. Nor does it offer explanations with the historical specificity necessary to understand and interpret the individual case. That is the task which this book takes on. This chapter has mapped out the several areas and questions which will concern us; the rest of the book seeks to explore and answer them.

One final preliminary point: in stating my purpose in this way, I want also to explain what some readers may consider as the book's too blatant selectivity. I have named my study for its principal character; it is a book about Jean-Baptiste Carpeaux. But let me be the first to say that the book does not exhaust its subject: it is neither a catalogue nor a survey out of the life-and-works mold. I have given short shrift to a number of commissions, both public and private; Carpeaux's paintings have been excluded entirely. The main difficulty I envision as a result of my approach is that the reader may feel too hazy about the facts of Carpeaux's career. I have tried to mitigate this by means of the brief chronology which follows the conclusion.

CHAPTER TWO

WORKERS AND ARTISTS

Alone, with no other teacher than an engraving by Poussin, the head of the Apollo Belvedere, and a reduction of the antique gladiator, Carpeaux learned drawing.

J. B. Foucart, in a draft of a letter to F. Sabatier, c. 1860[1]

I had an enormous passion for drawing on walls, with charcoal from the family hearth as my crayon, and with red and yellow earth which I hunted up on Mont-de-Vergue as my colors, horses, soldiers, and all kinds of grotesque figures. I was the greatest wall-dirtier in my village.

The fellows who boarded *chez* Pourtales slept two to a bed per room and paid five francs each a month if they didn't take drawing, and six if they did. A month of drawing thus cost only one franc—almost nothing.

We were building a shoe shop. The sideboards and cupboards were in place, we had to top the whole with a cornice. The *patron*, who gave us no plan at all, and with a reason, came over to me and said: "Do you know how to draw?" "Yes, *patron*, a bit." "Do you know a cornice that's in style?" "I don't know what style you're talking about." "Draw me any kind of a cornice." I obeyed him. And a minute later the *patron* said to me, "That's it, exactly right. Do it."

Agricol Perdiguier, *Mémoires d'un compagnon*, 1854[2]

What these passages say about how Jean-Baptiste Carpeaux and Agricol Perdiguier learned drawing is misleading. Neither Carpeaux nor Perdiguier was a self-taught draughtsman. Despite Foucart's description of his friend's first attempts at drawing, the young Carpeaux did not assimilate the skill in reverent emulation of the great masters of art. And, despite Perdiguier's reminiscence of innocent sketches on blank rural walls, his memories of his later studies, which he undertook to become a *maître compagnon*, tell a truer story of how he learned. Both accounts rely on familiar stereotypes, yet neither was written with intent to deceive. The lawyer Foucart, recounting the story of his friend's early life in a way appropriate to both his high esteem for Carpeaux's artistic talent and his desire to convey it to his reader, took his cue from familiar myths of artists' careers.[3] Perdiguier, writing in exile, gave a nostalgic picture of an earlier way of life, work, and learning, which by 1854 had all but vanished from France.

I cite these passages to introduce a discussion of rudimentary drawing instruction in

nineteenth-century France and Carpeaux's place in it. My aim, in the pages that follow, is the exploration of the ways an initial vocabulary of visual expression was acquired by Carpeaux and by other youngsters of his age and station. Why begin by comparing Carpeaux and Perdiguier, artist and worker? Because at this stage budding artist, whether painter or sculptor, and future worker were often the same person—in many cases they received the same instruction in how to draw, and they got it for the same reasons, at the same institutions. This is not to say that many future artists and artisans did not draw after commercial versions of Poussin and the antique, or cover whole houses with horses daubed in earthen colors. But after 1830 in France, "learning to draw" often had little to do with art. It was usually an institutionalized experience, not an informal one, and the institutions where drawing was taught were administered according to a new understanding about the social role of the skill they were disseminating. What students learned and how they learned it were hotly debated and gradually defined over some thirty years. Drawing instruction was beginning to change in the 1820s, at just about the time that Perdiguier was copying the studies given him by M. Pourtales, using his rented bed as a table.

The teaching tradition of *compagnonnage* was not the sole factor which determined the form Perdiguier's education would take. Equally influential was the fact that before 1830 there were few other formal opportunities for drawing instruction, at least for workers, in the French provinces. Carpeaux, by contrast, learned in the late 1830s and early 1840s, when drawing was a more widely acknowledged and encouraged skill. Yet as a mason's son, like other workers' boys, like Perdiguier, Carpeaux studied drawing as a tool necessary for his future trade. The knowledge was a passport; it was important for a young artisan to be able to answer yes when the *patron* asked him if he could draw. The boy might have gotten similar training as an apprentice, but here that *might* is significant, since after 1830 apprentice contracts were increasingly unfulfilled and the arrangement less frequently employed.[4] Instead Carpeaux was enrolled as a student first in the Académie de Peinture, Sculpture et Architecture in his native Valenciennes, and later, after his family's move to Paris in the late 1830s, at the Ecole Gratuite de Dessin (often called the Petite Ecole). Only with his inscription in 1844 at the Paris Ecole des Beaux-Arts did he begin the "artist's" career which eventually made his name. His first contacts with the rudiments of a visual formation nonetheless date earlier, to the years at the Valenciennes Académie and the Petite Ecole. That these two schools were open to instruct boys like Carpeaux in drawing is the result of a consciously implemented policy towards drawing instruction, administered both locally and nationally. The means and goals of this instruction, as exemplified by these two institutions, form one subject of this chapter. Its impact on students—artists and workers—is the other.

<p style="text-align:center">* * *</p>

When we think today about drawing, our initial conception most often includes an idea of immediate creative expression of vision and emotion. We value drawings for their spontaneity, their suggestions and ellipses, and we take these qualities to be the essence of draughtsmanly representation. Carpeaux's drawings, unlike those of most sculptors, fit easily under this rubric. Literally thousands of sheets are stamped by his roughly energetic, yet deftly coherent, markings. His public has been increasingly responsive to those characteristic qualities. In his 1876 article Paul Mantz could only regret the general ignorance of Carpeaux's drawings and reproduce an ambitious selection of twenty-three sketches

to begin to fill the void.[5] A century later Carpeaux's drawings are familiar and important enough to be assigned a crucial role in defining his art:

> For Carpeaux, drawing is at the root of everything from the moment that sight releases the reflex towards plastic appropriation of a subject. [His drawing] possessed the instantaneity of photography which with equal facility surprises both an expression fleeting across a countenance and a gesture in the street, but could also trace the reflective line of modelling in light. His approach to the problems posed by the elaboration of his great sculpted works was in no way different.[6]

In nineteenth-century France, however, the qualities of freedom and immediacy, though evident in practice, were not integral to most descriptions and systems of drawing (let alone to sculpture). *Dessin* was limited to no one inclusive formula and had no single class of practitioners. Draughtsmen thus attributed a variety of powers to their skill. It could have moral qualities, for example, like irreproachable rectitude; here one of Ingres's favorite aphorisms, "Le dessin c'est la probité de l'art," comes to mind.[7] Perdiguier too gave drawing metaphysical attributes: "Le dessin est l'âme de la menuiserie."[8] Ingres would not have agreed. The two men held conflicting concepts of *dessin*, each with its own sphere of application. And theirs were only two opinions. Drawing could also have sex, masculinity—inevitably opposed to the femininity of color. In Charles Blanc's handbook on the "arts du dessin," the consequences of this view follow all too clearly: "The superiority of drawing over color is written in nature's laws. . . . A great number of objects, whether inanimate or alive, have the same color, while no two have exactly the same form. All negroes are black; how to distinguish them except by the proportions of their limbs?"[9] No wonder that this view of drawing as the necessary precondition of the arts became pervasive in the nineteenth century. It filtered from its formulation in aesthetic theory into the realm of *idées reçues*, the clichés of salon reviews and popularizing descriptions of the artist's task.[10] (Here Flaubert's definition of drawing is apposite: "DRAWING (ART OF) consists of three things: line, stippling, and fine stippling. There is also the master stroke; but the master stroke can only be given by the master."[11] And the master, of course, is male.) Perdiguier too considered drawing fundamental to mastery, but for him it led not to art but to craftsmanship—another order of *maîtrise*.

These definitions are only partly at odds. Each sees drawing as the essential skill, the *sine qua non* of art and métier. But what do these ideas have to do with the new drawing of the 1830s and 1840s, drawing as it was taught in schools? In that arena, another definition held sway. Speaking in 1834 at the annual prize day of the Ecole Gratuite de Dessin, the Comte de Rambuteau, Préfet de la Seine, summed up the characteristics of the skill taught there:

> The art of drawing becomes each day a more important branch of popular instruction. Soon it will be, like reading, writing, and arithmetic, an indispensable necessity for the worker who wishes to abandon the nagging routine of ignorance.[12]

But how was the *art* of drawing supposed to instruct the people? What kind of drawing did Rambuteau mean? Drawing taught in the meticulous way of Ingres instructing his pupils, or according to the one-franc scheme Perdiguier got from Maître Pourtales? Based on the traditions of art, that is, or on those of craft? Lending itself to one kind of use more than another?

I want to argue that this idea of drawing for workers was, in its most widespread manifestation, a peculiar, hybrid conception, rooted in artistic tradition and practice but nonethe-

less different from that practice in significant ways. This statement of course implies the possibility of identifying purely "artistic" drawing instruction, so that the various links to it may be demonstrated. That impulse is misleading. Important here is *not* a range of actual examples which would show how future artists learned drawing, but how such "artistic" experience was represented in the culture, and what kinds of generalizations were drawn from it. It is important that, for all the post-Enlightenment emphasis on rationalism, certain myths refused to die—mythologies of art and its origins, in particular. The legend of Dibutades, for example, could still be offered as a figure not just of art's imitative purpose, but of the role of drawing as art's prerequisite. The tale, as Pliny the Elder tells it, is simple enough: a Corinthian maiden, Dibutades, cannot bear to contemplate the loss of a lover, just off to the wars. To ease her pain, she turns to drawing to capture his image, tracing his silhouette from the shadow cast by lamplight. The drawing which resulted, Pliny says, was filled with clay by the girl's potter father, and sculpture was born.

The late eighteenth century preferred to vary the legend so that it told of painting's origins, but in either version it provided evidence of a sort for drawing as a necessary precondition to art.[13] Schemes of artistic instruction invariably observed that axiom, and devised methods of developing a level of skill that Dibutades never imagined. They began from a principle which nonetheless is not far distant from the Corinthian maiden's first crisp silhouette. Any novice, so most schemes argued, needed a clearly presented formula which could be quickly grasped and easily retained. The many laborious steps of the most popular method of instruction (here summarized as it was formulated by Claude-Henri Watelet, First Painter to Louis XV, for the *Encyclopédie*) insured that aim.[14] The first exercise asked the student to make parallel lines in all directions; achieving regular, consistent strokes assured muscular coordination and control. When he could govern his hand, he passed to imitation of a drawing executed from nature by a master. For the student this was again an exercise in control of hand, eye, and drawing implement, in which the visual decisions demanded were limited in scope to understanding how accurately he had reproduced the system his teacher had already established. Even at this level, imitation could not be achieved all at once; the beginner first copied each part of the model drawing, and then the whole. When he could manage integration of the ensemble, he moved to drawing from a plaster cast, "*après la bosse*," which, though still perceived in terms of unbreathing white and shadowed grey, nonetheless has solid, tangible volume. Drawing from casts was thought of as a link between replicating a two-dimensional model and reproducing living nature; having characteristics of both, it was meant to ease the passage between the two. Again, the same process, part to whole, detail to ensemble, till finally the young draughtsman arrived at the living model, properly armed with a battery of lines, hatchings, and shadings which he could execute in chalk, crayon, and charcoal, and which allowed him to transcribe material form independent of guidance.

That this was an effective, widely practiced method is best demonstrated by the extent to which it became formulaic. Watelet had described a relationship between master and student, but his method became the norm for drawing handbooks meant as substitutes for individual instruction. Take the guide *Elémens du dessin*, published by F. A. David in 1798.[15] Unlike the *Encyclopédie* account, it is more than a description; it is meant to be used; it is meant to teach. Subtitled "A Catechism," the manual was written as a series of questions and answers, a litany of learning which begins, appropriately enough, "Question: Who was the inventor of drawing? Answer: The invention of drawing is attributed to Dibutades, daughter of a potter from Sicyon." Further groundwork is laid by means of the same antiphony: "Question: What is drawing? Answer: Drawing is the art of imitat-

ing what objects present to our eyes." And so on, through the steps which Watelet set out: "Question: What are the first drawings which should be copied? Answer: The first drawings which one ordinarily imitates are those which a skillful master has made from nature. One draws each part of the body in detail, before drawing a whole one."

The difference between Watelet's description and David's catechism—the different way each pretends to offer some "truth" about drawing—points to the development of what might be called the "normalization" of drawing instruction. David's *Elémens du dessin* is an early, halting step in that process. Its text has boiled down the work of learning about drawing and its history into pithy precepts, but the accompanying plates are barely adequate substitutions for the master's drawings they are meant to replace. The first plate, for example, a jumble of body parts, summarizes all the laborious dissection of form into a single example (fig. 21). And the rest of the illustrations are equally vague. One group, a lumpen collection of Olympians engraved after antique statuary—the *Mercury* is a typical example (fig. 22)—was also meant to play the part of a "drawing" of a skillful master. Never mind the fact that they were hardly skillful, and imitable only in the most general way, since their hatchings and stipplings, marks made by a graver, are not easily replicated in the crayon and chalk the book recommends. Perhaps David sensed these lessons were less than helpful; his manual is fleshed out by a few plates giving reproductions *and* detailed measurements of other antique statues, as if knowing the exact length of the *Discobolus*'s throwing arm might aid the learning process. *How* it might help, however, is left to the student to decide; the text never breaks the stride of its simple litany to discuss them.

21. François-Anne David, introductory lesson, engraving, from *Elémens du dessin*, 1798. Bibliothèque Nationale, Paris.

22. François-Anne David, *Mercure*, engraving, from *Elémens du dessin*, 1798. Bibliothèque Nationale, Paris.

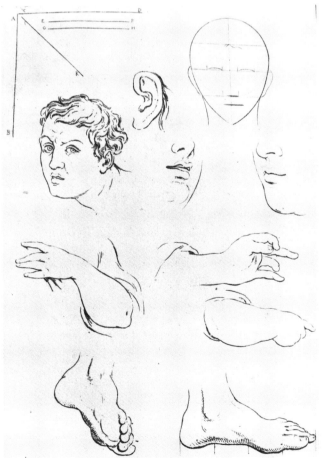

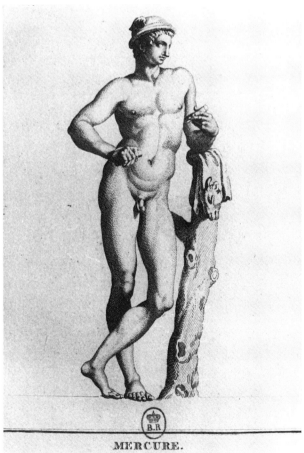

However tentatively, books like David's inaugurate a new phase in a drawing instruction aimed more widely than ever before. While the title suggests hopefully that the book is meant for "ceux qui se destinent aux beaux-arts," the title page adds the more certain information that it is "utile à toutes les écoles"—for eight francs. It was one of two drawing books that appeared in 1798 and one of more than 650 *cours de dessin* or supplements to them published between 1790 and 1889.[16] So while it is difficult to know exactly what devotee of the *beaux-arts* actually paid his or her eight francs for David's *Elémens*, it is clear that a public existed for it and the manuals which succeeded it—a public which increased rapidly during the nineteenth century. After 1810 the number of new courses or supplements grew by about thirty per decade; between 1850 and 1859, 153 were published.[17] They became a primary tool for rudimentary drawing instruction throughout France, and thus a visual demonstration of some of the most widely accepted ideas about teaching methods.

Nineteenth-century *cours de dessin* bear a generic resemblance to predecessors like the *Elémens*. They are printed, and present figures after antique or modern masters meant to serve as models for students—hence the term *modèles estampes*. They were published as series of detached sheets in several formats, octavo, quarto, or folio. The unbound plates, easily set on an easel before one or several students, were more conveniently used than bound books into which sheets were firmly tied. The flimsy paper cover often supplied to hold the plates was sometimes the sole source of further information. There was a title, of course: "Cours élémentaire de dessin" or "Principes de dessin"; and then the author and his qualifications, "H. G. Chatillon, professeur de dessin à l'Ecole militaire de Saint-Cyr"; his intended audience, "Aux jeunes élèves de toutes les écoles"; perhaps a dedication, "A Monsieur le Ministre de l'Instruction Publique."

After 1817 lithography replaced the lines and stipples of engraving as the process most commonly used to print *cours de dessin*. The change in technique is significant, because lithography allows a more direct, easier, and cheaper transfer of the drawn line from the printing surface, the lithographic stone, to paper. The result, in this case a *modèle estampe*, retains more of its characteristics as drawing—texture, color, thickness and modulation of line—characteristics a student could expect to approximate with the materials at his disposal. This means that the student copied not just the form of a model, but its technique as well. His drawing was controlled by the greater imitability of the information supplied by the lithographed model, and thus faithful imitation was more easily achieved. "*Bien copier*" was the goal of drawing instruction: the sculptor Eugène Guillaume, in a speech to the Union Centrale des Beaux-Arts, summed up the attitude which prevailed in academic circles throughout the century: "Drawing must be considered above all in terms of correctness, of exactitude—it must be envisaged, in a word, in terms of the practical aspect, which consists first of all, in copying well [*bien copier*]."[18] But while Guillaume saw fidelity to a model as a necessary first step, for a drawing course it was the final purpose. And another modification in printing technique, the substitution of cheaper quality paper with a rougher surface which takes ink more irregularly—a texture more like the cheap paper students used—made the model that much easier to imitate exactly.

Such changes in printing processes made the plates closer visual approximations (in some respects, at least) to the *dessin du maître* which was the traditional model for the beginner. In fact the *cours de dessin* was meant at least partially to replace the drawing instructor, or at least to relieve the burden on him as a teacher. His role became more supervisory; his own work need no longer be the exemplar students were to follow.[19] The tendency was for the printed course not just to replace the instructor, but to supplant the academy

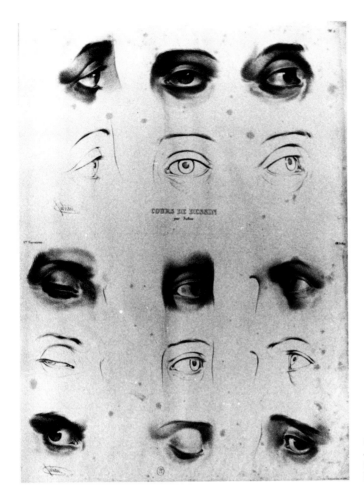

23. Bernard-Romain Julien,
Studies of Eyes, lithograph, from
Cours de dessin, c. 1860.
Bibliothèque Nationale, Paris.

as the locus of drawing instruction. Unlike their late eighteenth-century forbears, a complete *cours de dessin*, like those published by Chatillon or Julien, ended by committing to print the entire academic educational experience. The discrepancy between text and illustration was now a thing of the past; in fact text was most often omitted. In the new package, drawings of body parts made up the first lesson (fig. 23). Next came casts of body parts, reproduced as prints, then copies of antique statues, reproduced as prints, then the *tête d'expression*, again a print, and finally the entire nude body, often posed as if on a model stand. In a drawing academy, a student would normally produce a rendering of each of these motifs, working from the thing itself—the cast, the posing model. The *cours de dessin* transposed that process of imitation to a different level: a pre-determined graphic language was the "object" to be imitated.

If the printed drawing course recapitulated academic drawing instruction by imitating its progressive sequence, it did so on its own terms, controlled by its physical qualities as a packaged series of printed images. Lithographs after the antique or the old masters look decidedly different from their originals in form, color, graphic language, sometimes in character or sentiment. The lithograph interprets rather than replicates its model, and the discrepancy between the model's original style and the version in the *cours de dessin* was often so great that its identity and source were unclear. Frequently a print after a statue or a detail of a painting was presented unlabelled; its importance was not as a motif extracted from David's *Brutus* or as a reproduction of the *Spinario*, but rather as a preselected, acceptable model. All the images in a *cours* were drawn in the same style, no

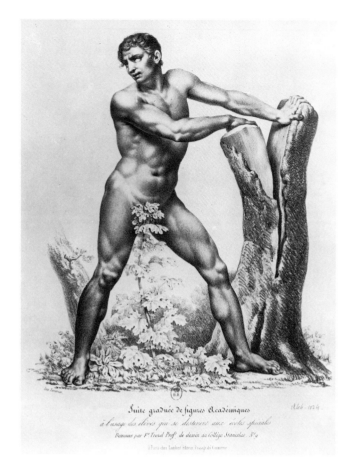

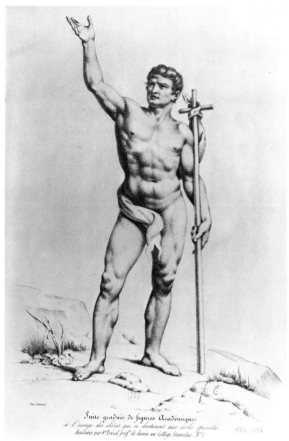

matter what their source; how they were done was the issue, not what they were of. All were examples to be imitated, with the result that the specific stylistic characteristics of the original motif, its qualities as the work of David or Poussin, were suppressed by the fact of incorporation into a course of drawing.

The homogeneity of the lithograph nonetheless left room for plates of nudes to establish their own relationship to artistic conventions. Some were simply meant to be substituted for the academic *séance* from a living model: they show bodies in traditional academic stances, with the customary shot hips, striding legs, and staff-supported arms. But others, though drawn from nature in the same system of careful shadings, assumed mythical or religious identities—Milo of Crotona or St. John the Baptist, Psyche or Venus (figs. 24– 26)—identities communicated by stock poses and attributes. The conventions of "Art" were thus imposed on nature, dignifying the nude, while the imperfections of a naked human model were smoothed over, generalized by an approach which suggests that nature be seen in terms supplied by art.

Within the context of the *cours de dessin*, then, images of nature and art were both distanced and isolated from their sources, and the boundaries between the two often obscured. They were packaged, made uniform, fitted together into a whole. The qualities of the individual human body, living and breathing on the model stand, were occluded by the use of attributes and typical poses, and the neutralizing artificiality of a uniform drawing style—so that the body became a generic type. References to exemplary works of art were made equally uniform, because they were presented to the student as equivalent images. He did not need to know the source of the plate he was copying, since his task was to reproduce *it*—not David or Raphael—exactly.

36

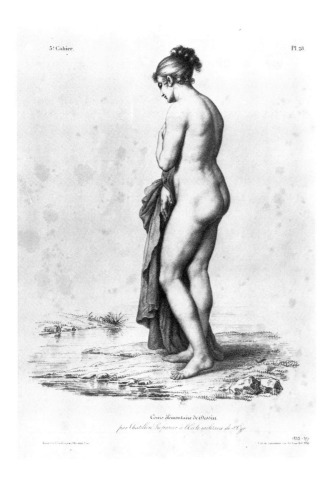

24. Félix Trezel, *Académie d'un homme*, lithograph, pl. 9 in *Suite Graduée de figures académiques*, 1844. Bibliothèque Nationale, Paris.

25. Félix Trezel, *Académie d'un homme*, lithograph, pl. 5 in *Suite graduée de figures académiques*, 1844. Bibliothèque Nationale, Paris.

26. Henri Guillaume Chatillon, *Académie d'une femme*, lithograph, pl. 28 in *Cours élémentaire de dessin*, c. 1835. Bibliothèque Nationale, Paris.

To this uniformity of models was added the strict conception of what success in drawing meant; the goal was exact imitation, no more, no less, with changes in the system providing the fine tuning needed to achieve that end. Yet here was the point at which the printed *cours de dessin* were most vulnerable to criticism. Where was the line between slavishness and exactitude? Did not some kinds of copying lead nowhere? "Experience has shown me"—so wrote one drawing teacher at the time—"that students are more inclined to copy an engraving with its printing faults, than the object which it represents, always concerning themselves more with means than with the end, and so it is that their progress slows down."[20]

These are the comments of Amédée Faure, Professeur du Dessin des Plantes at the Ecole Gratuite. Their context was a Report to the school's director which proposed a solution to the problem he outlined. Faure counselled a radical reorientation of students' attention away from the minutiae of faithful reproduction of a printed model. As *his* initial exercises, he required not parts, but wholes—"d'abord, beaucoup d'ensembles"—to reveal the underlying formal logic of a design. Only on that basis could detail be added. On its own, however, even this change of emphasis would not suffice; Faure also urged the replacement of two-dimensional models by relief. In other words, he suggested that the telescoped system of the printed drawing course be expanded once again:

I should think relief would be useful, since there every insertion and inflection of line and actual shadow make forms better understood and allow them to be drawn with more intelligence. Having explained reading to them, we will teach them punctuation by showing them real plaster casts. Soon they will abandon the pretentious hatchings

they use in their exercises, those stripes which express shadow everywhere too much the same, and which render light in the same way—falsely. In a word, they will concern themselves more with the purpose of the form being expressed, visible in the light, mysterious in shadow. Eventually, an understanding of relief will give them a variety of means to express diverse effects.[21]

What is striking about Faure's proposal is the clear aim it takes at the weaknesses of printed models. This is no doubt because as a drawing teacher he had had plenty of opportunity to study their faults. His report, moreover, though dated 1848, was some four years in the making. But criticism of the *cours de dessin* spread well outside the walls of drawing schools. As great a draughtsman as Eugène Delacroix, for example, was not above regretting his childhood contact with them; he presented his reminiscences as the painful collective memory of a generation.

Those eyes, divided methodically into three equal parts, with the middle filled by a pupil represented by a circle, that inevitable oval which was the starting point for drawing the head—which is neither oval nor round, as everyone knows; finally all those parts of the human body, copied endlessly and always separately, from which, at the end, it was necessary to construct, like some new Prometheus, a perfect man—these are the notions which greeted beginners and which are for a lifetime the source of errors and confusion. Why be surprised at the aversion which everyone feels for the study of drawing?[22]

The rhetorical nature of Delacroix's question is meant to be disarming. The reader is quickly enlisted in the business of recollecting or imagining youthful sufferings in front of pages clogged with noses and ears. Yet the comradely tone does not alter the fact that quite specific criticism is being levelled at the *cours*'s dreary, sequential approach to drawing, which calls a body human even when it is assembled from a collection of unrelated parts. In fact, Delacroix is being more strategic than comradely; the context of his "memories" is a review of a new drawing system, *Le Dessin sans maître*, published in 1850 by his old friend Mme Cavé. She too believed in ensembles rather than parts, and proposed a method to instill them. So did other teachers, among them Antoine Etex, whose wide-ranging interests brought him to the problem of instruction almost as a matter of course.[23] Other reformers—the notorious Horace Lecoq de Boisbaudran, for example—replaced the insistence on part to whole with a more integrated emphasis on working from simple to complex.[24]

None of these systems, however, relinquished its hold on the goal of *bien copier*. Mme Cavé went so far as to recommend a *calque vérificateur*, a tracing of the "true outline" against which student efforts were to be measured. Even Lecoq, in his initial publication of his method, was not above stressing the importance of faithful imitation: "I am seizing this occasion," he wrote, "to insist on this essential point, that in the very interest of the development of the memory, it is this same exact, naive resemblance which it is necessary to obtain from the beginner—it is the only way to shape the accuracy and naiveté of the memory."[25]

All of these methods were offered as correctives to the *modèle estampe*; all substituted their own models for the customary lithographs and asked that they be approached in a different way. The substitution might be the series of bas-reliefs proposed by Faure, or the cast plaster heads advocated by A. Dupuis—one-time professor at the Collège St. Louis, but by 1838 director of his own drawing school.[26] They could be objects in the real world, as in Lecoq's system. Or they might simply be a new crop of printed models,

as suggested by Etex and Cavé. Their complexity varied, and the differences were determined by the audience each was intended for and the level of proficiency users were meant to attain. Certainly there is a great difference between the exact and naive resemblance Lecoq required students to achieve from memory and that aimed at by Mme Cavé with her verifying tracing (Lecoq's students were the boys at the Ecole Gratuite, while Cavé taught disadvantaged orphan girls).

Even this short description should suggest that in the mid-nineteenth century drawing instruction comprised its own small area of research. Under investigation were varied means to produce a single end. The worrying about which model a student ought to study, the advocacy of a plaster head over a printed one, are directed not just at promoting the skill of *bien copier*, but teaching a student to be at home with various means of visual communication. Drawing instruction was a process of familiarization with an all-important medium, since there was no reason to assume that such familiarity had already been acquired.

Drawing was therefore a skill in which both the Académie des Beaux-Arts and the Ministère de l'Intérieur took an active interest. New methods were usually submitted for examination to one or other of these bodies, or sometimes both. In each investigation, a commission was named, experiments made, reports read, the possible contribution of the method assessed. All this with a (sometimes comic) gravity of purpose indicative of the importance assigned *dessin* by the July Monarchy. (It should be said that a favorable report also meant advantages for the author; approval could ensure publication of the method, or at the least, payment of prize money "en titre d'encouragement.")

Government and Académie reactions to drawing methods were not identical, however, and the differences between them measure the ideological positions of both towards drawing and drawing instruction. A telling—if extreme—example is the case of the "procédé Rouillet."[27] When in 1843 Nicolas Amaranthe Rouillet presented his "Procédé du Dessin pour faciliter l'Etude des arts" to the Ministère de l'Intérieur, it had already been rejected once by the Académie. The Secrétaire d'Etat, however, named a commission, which included architects like Jean-Baptiste-Antoine Lassus, and Félix Duban, painters like Hippolyte Flandrin and Leon Cogniet, and men of letters like Prosper Mérimée and Ludovic Vitet, to undertake an investigation. Some inquiry was necessary, since Rouillet's claims were sweeping, and they were being asserted, moreover, for a process that the author insisted be kept secret even from its examiners.[28] With his apparatus, Rouillet maintained, a person who did not know how to draw could "copy in outline, *in the most exact fashion*, pictures or animate figures" (my italics). The novice could also enlarge these drawings indefinitely, without trouble. Finally (best of all?), the whole system was easily portable and cost no more than a franc.

The commission tested Rouillet's system in a series of experiments conducted at the Ministère de l'Intérieur and the Bibliothèque Royale. With an assistant, the artist was shut away for varying lengths of time to accomplish set tasks, like drawings of the assistant as posed by the commission (figs. 27–28) or an elevation of a window, seen obliquely. The latter task was a complete failure, but the commission marvelled at the results their draughtsman Hercules obtained after only ten minutes of effort at his first labor. His *esquisse* seemed, they reported, "remarkably exact. We do not believe that in the same length of time the most skillful draughtsman could have obtained such a satisfactory result."[29] It is easy to see why the commission was satisfied; Rouillet's drawings are totally legible, if slightly naive, as drawings go. As the commission noted, they capture the difficult foreshortenings which were the point of the exercise.

28. Nicolas Rouillet, *Man Leaning on his Elbow*, 1843, pencil on white paper (36.5 × 37.8). Archives Nationales, Paris.

27. (left) Nicolas Rouillet, *Standing Man*, 1843, pencil on white paper (39.7 × 26.3). Archives Nationales, Paris.

Rouillet was set five problems, and only the first drawings of his assistant illustrated here were judged totally successful. Yet the commission recommended the process despite its less than perfect score. The "procédé Rouillet" was duly published. But what did all this mean—these tests, recommendations, and rewards? What utility did Mérimée et al. see for this procedure? The answers are found in part in their conclusions. The superiority of Rouillet's method—and remember that even at this point in the investigation the details of the method were still a secret—lay in its immediacy, its rapidity of execution, and the clarity of its results. These advantages avoided, the committee concluded, all manner of bother: it eliminated lengthy transfer processes and the long-handled clumsy wand painters sometimes used; it was so simple anyone could do it, and it facilitated the tedious process of enlargement which was the stock in trade of decorative painters.[30]

Clearly the *dessin* allowed by Rouillet's method (or any *cours de dessin*, for that matter) had its own particular definition. Delacroix may have remembered childhood exposure to this kind of drawing, but it was not meant to produce artists. Rather it was basically a process of transcription, a way to transfer information in the form of a design. In the Académie's eyes, the method was anathema, non-drawing, a corrosive influence which contradicted its whole conception of drawing's purity and primacy. The horror such a process inspired in the academic breast is nowhere so evident as in a letter which Raoul Rochette, then secrétaire perpetuel of the Académie, wrote to the Ministre de l'Intérieur. The Académie was convinced, he thundered in a desperately assertive paragraph,

> that all these inventions, whose aim is to make the practice of drawing easier, more prompt, more expeditious, produce only mediocrity, and harm art more than they help it. The Académie is unanimously of the opinion that the exercise of the art of drawing

must remain surounded by all its difficulties, which will yield only to real vocation and to persevering study, which will elude lazy mediocrity, but will never stop real talent.[31]

This drawing, academic drawing, is an exclusive practice to which only the most devoted and talented are admitted. In defending it, the Académie showed itself threatened by the various assaults on its province and nonetheless adamant in the face of the threat. Rochette continued:

> And as a result of the deep conviction which it holds, the Académie has always refused, and will steadfastly refuse its approbation to abbreviating processes, no matter what their character, which tend to dispense with study and knowledge, which make art a métier and the artist a machine, which belong to industry, and which encourage only impotence.

The tone of these words is emphatic, to say the least, and revealing: impotence, even the artistic kind, is always a loaded term. Yet in his fulminations Raoul Rochette did manage to express both the reason why the Ministère de l'Intérieur supported Rouillet's process (and a range of other printed drawing methods and courses) and the reason that the Académie felt threatened. Both point to a widening disagreement about drawing—what it is, what it does, and who practices it. It seems clear that the sanction given Rouillet's process by the state commission was granted because the method did in fact "belong to industry," as charged, and could be used by anyone, whatever the level of their previous instruction, to facilitate industrial processes. To the Académie, by contrast, drawing's assistance of such ends meant its prostitution. Availability encouraged mediocrity; facility replaced the demanding novitiate the young artist served, and Art became métier.

<p style="text-align:center">* * *</p>

Raoul Rochette spelled out certain doom in his letter to the minister, and he was reading from characters already written plainly before him. Certainly not every drawing course that the Académie reviewed provoked such a strong reaction; both Rouillet's method and the commentary it aroused are extreme. But it is also true that Rochette's vehemence was not directed solely at this method but at the general phenomenon which it represented— changes in the means and motives for teaching the elements of "art," changes which challenged art's most conservative institutions. Ingres, who by the 1850s had become the symbol of the old order and values, felt the threat with equal chagrin: "Nowadays they want to mix art with industry! Industry! We'll have none of it! Let it stay in its place, and not come establishing itself on the steps of our school [the Ecole des Beaux-Arts], which is truly Apollo's temple. Doesn't Industry have its own schools, like the Ecole des Arts et Métiers, and many others, to shape its students?"[32]

Ingres was right. Industry *did* have its own means for teaching—not only the Ecole des Arts et Métiers, but the *écoles de dessin,* the *cours du soir,* and even provincial *académies.* They used printed drawing courses as staple fodder, and made drawing education their goal. Some were privately run; others were encouraged by the municipalities in which they were located. By 1858, for example, Paris was paying subventions totalling 11,750 francs to four schools so that free sessions might be scheduled as well as paying lessons.[33] One of these, the school maintained by a M. Lequien, was also supported by an industrial group, the Réunion des Fabricants de Bronzes, since it served their interests directly.[34] Lequien's student clientele was limited to chasers in the bronze industry. And why did

these workers need drawing lessons? A contemporary observer reported Lequien's rationale: "The execution of bronze work for ornament, he considers a kind of translation of art into a different language, and it is a thorough knowledge of the language only that he proposes to impart. With this view, his pupils are merely taught the art of copying accurately and with understanding what is placed before them, the ultimatum of their studies being the reproduction on any assigned scale of a given design adapted to their particular purpose."[35]

It should be clear by now that Lequien's opinions on copying, modified only by the trade to which it was applicable, were shared by teachers and pupils all over France—and on a rapidly increasing scale. Night courses opened, and in some locations, Sunday sessions. By 1848, according to J. P. Quénot, 6,913 night courses were teaching 117,175 adults whose trades demanded a knowledge of *dessin*.[36] Children and adolescents too received more systematic training in drawing. Schools like the Collège Chaptal or the Collège St. Louis acted as testing grounds for new ways of teaching drawing, ways which soon spread to other institutions. And in 1853 drawing was made a required part of the curriculum of the *lycée*.[37]

But if Ingres *was* right—and these facts and statistics seem to indicate he was—what accounts for his near-hysterical tone? If industry had its own schools, why did he hold his values to be threatened? The specific context of his remarks supplies part of the answer. He was writing in 1863, when the reorganization of the Ecole des Beaux-Arts was underway, bringing its curriculum ever-so-slightly into contact with the workaday world.[38] The changes shook him to the core. Surely the danger seemed more pronounced, however, because of modifications that had already been made in other art schools. The new drawing with its new purposes had already affected other academies. If Ingres's temple continued inviolate, other art schools were ready to open their doors to curricular change.

One of these was the Académie in Valenciennes which Carpeaux (Foucart's "self-taught" artist) attended as a boy in the late 1830s. The transformations in this school necessarily touched the future sculptor's experience there, as well as that of the some 250 other students the school handled yearly. These changes were gradually achieved, shaped by local as well as national conditions, but always in response to the redefinition of drawing instruction we are describing. They echo reforms undertaken in provincials schools throughout France.

Had Carpeaux attended classes at the Valenciennes Académie even a decade earlier, he would have studied at a different school, one considerably closer to the institution founded by the Baron Pujol de Mortry, recognized by the city in a declaration of March 15, 1777, and granted its charter and rules by the French crown in 1785—at the moment when academies were being formed in many provincial French cities. The royal statutes defined the aim of the Valenciennes institution: it was to be "an academy in which the arts of painting, sculpture, and the other subsidiaries of drawing shall be cultivated and taught."[39] Even after the dissolution of all academies in 1793 and the reformulation of the school's rules in 1811, this stated purpose survived intact.[40] When in 1813 architecture was added to the curriculum—until then limited to drawing from prints, casts, and the living model—its incorporation was a first concession to "professionalism."

This history contributed to Valenciennes's nineteenth-century reputation as the "Athens of the North." The city clung proudly to the epithet, though its incongruity must have been uncomfortably apparent on grey winter days. It provided a kind of counterweight, the leaven of culture, to the city's growing reputation for industry and business. Already in 1824 a guidebook which summarized local industry in a single sentence—"here one sees women working relentlessly at lacemaking or spinning linen for manufacturers"—was

well behind the times.[41] The mines on the city's outskirts, at Anzin, were already open, and by 1851 factories were milling several kinds of cloth, from batiste to flannel. Nails were being cast; chicory roasted; soap, beet sugar, and oil refined.[42] Healthy businesses traded these products in an expanding market. Yet this eminently commercial city maintained a national reputation for prizing and fostering its artists and funding their further study in Paris. Successful students returned like conquerors when they won the Prix de Rome. They were fed, feted, and toasted with punch; their student works were exhibited. In Carpeaux's case, such attentions were prolonged for decades after his death: local historians traditionally made chronicling his career their self-appointed task.[43]

The premium Valenciennes placed on its artistic heritage did not stop far-reaching changes in its artists' Académie. Beginning in the early 1830s (a date which coincides with the educational reforms of Louis Philippe's minister Guizot) a new program was initiated: worn out equipment was replaced and new teachers hired. In 1833 the school's three professors had all been there for twenty years. The first to go was the painter, Momal. His replacement, Jules Potier, a pupil of Guérin, won his position from a field of eight contestants.[44] In 1835 J.-B. Bernard—already the municipal architect, with Paris training to his credit—replaced Albert Parent, a student of Chalgrin and Percier. And in 1840 the sculptor Léonce de Fieuzal, the last vestige of the pre-1830 staff, was succeeded by Laurent Séverin Grandfils, who since 1834 had been teaching in Paris at the Petite Ecole. The Valenciennes school had no director. As a municipal institution, it was administered by the mayor, to whom the teachers were accountable.

It is one of the teachers' reports to the mayor which signals the beginning of change at the school, and, equally important, makes clear the complicated factors which contributed to it.[45] Written by Jules Potier in 1833, the report is an account of a trip to Paris which the painter made with Henri Lemaire, the Valenciennes-born sculptor. The narrative is particular, almost humdrum, in the kind of detail it provides, and thus manages to conjure up the expedition vividly. The two men had limited funds and basic purchases to make: they were shopping for equipment like benches, modelling stands, and a stove for the classroom. But most of their money was to go towards the purchase of a collection of plaster models for the class in ornamental drawing—this was the real purpose of their trip. They made a choice of fifty or sixty casts of bits of decoration from the inventory of the plaster atelier at the Ecole des Beaux-Arts. It was only a third of what was available; the whole collection was more than they could afford. Lemaire (whose successes as a sculptor gave him some influence in the capital) tried to get a government promise of funds to pay for the entire group, to no avail; resources, so they were told, had been spent on the celebration to commemorate the July Revolution.

Potier and Lemaire also purchased prints in Paris, some *modèles estampes* and others after the masters, a selection to which Potier himself attached the most importance:

This collection of works, joined with what the professor of the Académie [Potier himself] possesses, will give young students the possibility of undertaking decent study, and of forming their taste. . . . They will abandon completely that profound ignorance which makes them total strangers to the advanced kind of study which they must assimilate to become history painters and follow the career of Grand Prix winners in the capital. If someday the administration can devote some money to the ornamentation of its museum, all the outlay should be focused on the purchase of handsome engravings after Raphael. There [in Valenciennes] no one has the least idea of the sublimity of his genius and talent. . . . Because of the high price of these engravings, we can hope only for a gift from the administration or the munificence of rich local art lovers.[46]

Potier never did get the collection of engravings he wanted. They *were* expensive; a nineteenth-century engraving after Raphael could cost from fifteen to sixty times the one franc usually paid for a lithographed plate from a *cours de dessin*. But more important was the fact that the taste Potier espoused and the instruction he advocated were already ceding to other priorities: a new view of art teaching and different equipment to put it in action. Drawing after lithographs was soon preferred in Valenciennes; by 1838 the old engraved *modèles* were being sold to students.[47] They were replaced by the standard drawing courses of Chatillon and Julien, the plates of *premiers principes, grandes académies, petites académies, petites têtes, grandes têtes*, ordered from dealers in Paris who sent catalogues to prospective clients in the provinces and who supplied the Valenciennes school throughout the 1830s and 1840s. Inventories drawn up in 1834 and 1845 give a clear idea of the school's teaching equipment—and the teaching that went with it.[48] There were, of course, *modèles estampes*, and painted studies by former students ("mort de Virginie, par M. Crauck; 1 Figure peinte, par M. Chérier"). There were plaster casts of *Antinous*, and a cupid; there was an *Apollo Belvedere*, a *Discobolus*, a *Germanicus*, a *Laocoön*, and a *Spinario*, and heads of gods, fauns, and emperors; there were casts of (ideal) human heads and hands and ears, an *écorché*, and fragments of human anatomy cast from nature. (In 1845 seventy-nine of the 150 casts were judged so dirty and broken that they were virtually useless, "except for the sculptors.") The eighteenth-century origin of the academy was still vestigially evident, even in 1834: 114 prints *au crayon rouge*, in the manner of Bouchardon and Greuze, hung on as part of the store.

Despite the difficulties which Potier and Lemaire met at the Ministère de l'Intérieur in 1833, the government policy was not intended to slight the Valenciennes Académie. On the contrary, it kept up a steady dole of prints and casts as part of a general effort to endow and influence art education in provincial cities. Printed courses such as Emile le Conte's *L'Album de l'ornemaniste*, engraved by Chenavard, were dispatched northward.[49] Prizewinning student drawings executed in the competitions at the Ecole des Beaux-Arts were supplied to provincial schools on demand. Valenciennes, like Vesoul, Lille or Dole, asked the Ecole directly for such drawings or petitioned the ministry; the Valenciennes inventory lists twenty-four examples in the school's possession.[50] It was taken for granted that drawings of this kind were ideal teaching instruments. Had they not earned their makers a medal? Were they not therefore indisputably "correct"? They were perfectly adequate substitutes for *modèles estampes* or the drawings of a master: the student from the provinces would learn by aping—line for line, shadow for shadow—the approved *académie* of his metropolitan cousin.

Most of the equipment acquired in the 1830s was rather different. Emphasis now seemed to fall on simple step-by-step copying of the elements of drawing, and ornamental motifs became part of that elementary world of form. As Potier soon found out, he was not teaching students who would "become history painters and follow the career of Grand Prix winners in the capital." What the city needed after 1830—what the school began to provide—was a supply of skilled workers, men with learning geared to the new requirements of industry, whether this meant tracing patterns in a textile factory or reading drawings in a mine or at a construction site. The initiative to introduce such training came in this case not from the workers themselves, but from the bourgeoisie. Thus in 1833, for example, a poster addressed to "Maçons, Tailleurs de pierre, Charpentiers, Menuisiers, Ebénistes, Marbriers, Serruriers, Peintres en bâtiments" was tacked up around the city.[51] They were urged to attend a new course in geometry to be given by J.-B. Bernard, the municipal architect. (He took up his post at the Académie two years later.)

We do not know how many workers turned up to listen to Bernard at the first meeting one November night, but we *can* read what his audience heard. The architect explained, skillfully enough, why his course would be both useful to a worker, and desirable for an employer.[52] His starting point was a statement on which he said every observer would agree: while the buildings being raised daily around the city showed the "innate" talent of workers, what was lacking was, first, formal instruction and, second, a worker well enough trained to supervise construction in progress. For these reasons, local buildings were not perfect, but they could be (Bernard assured his listeners), if workers would study geometry and drawing. Thus

> you will find the means simultaneously to become more skillful and better able to command your salary. Until now, since your instruction has been left entirely in your own hands, you have not been able to recognize this truth. It's a great misfortune for you, because your future always stays null, you must stay ordinary workers all your lives, no matter what talents nature has blessed you with.[53]

The end product of the course was to be no less than a "superior man, a skilled artist," in Bernard's terms, and, evidently, a more committed participant in society, whose involvement was secured with the promise of escape from the nullity of an ordinary worker's existence.

What has all this to do with drawing instruction? Everything, in fact. It testifies not just to one means chosen to implement drawing instruction in Valenciennes but also to the ideology behind it. By 1841 this attitude had become deeply rooted in the Académie itself. By municipal decision, the hours of the sculpture, ornamental drawing and architecture classes were changed to include evening sessions so as not to conflict with instruction at other municipal schools (the *école primaire* and *collège*) and to allow workers to participate.[54] The Académie had opened its doors; it did not intend to remain an institution for artists alone.[55] This previous function was not completely abandoned, of course; students' artistic achievements continued to be put forward as a source of civic pride. But that single goal was now supplanted by the need to produce an *ouvrier qualifié*. After 1841 the Valenciennes Académie had two distinct tasks.

The tension between those two purposes, and the growing importance of the latter one, is writ large in various other documents of the time.[56] There is, for example, the correspondence between the mayors of Valenciennes and the Ministère de l'Intérieur, requesting supplies for the school. False claims are endemic in letters of this kind, since official requisitions were couched in terms which, it was hoped, would meet with approval. The mayor would necessarily present the school as a place worth encouraging, where teaching was being done that was consistent with the ministry's goals for the nation as a whole. But Mayor Carlier's assertions, in a letter of February 17, 1846, chime in with other evidence:

> Since the city of Valenciennes wishes to spread taste in the countryside of which it is the center and to offer young workers the means of distinguishing themselves in the professions they have embraced, it has opened in its drawing academy a school of sculpture which is very useful for those who are destined for woodworking, for the locksmith's trade, for the various kind of construction work, cast decoration, founders, chasers, etc. At the same time it wishes that those who have a disposition for the fine arts be able to present themselves advantageously at the Paris schools. This double aim happily has been obtained until now, and our young students have called attention to themselves in factories, workshops, and in the contests of the Ecole des Beaux-Arts.[57]

All of this preceded a request for casts to be sent the school; the request was granted. But along the way the document spells out the role the school was playing. It trained both workers and artists, and in his dealings with Paris, Carlier listed the workers first, perhaps because their education placed the greatest pressure on the school's facilities. Another mayoral petition to the ministry, this one from 1850, tells why: "The drawing academy of Valenciennes each year develops further because of the numerous factories which are being formed in the countryside and which demand workers who know drawing and the plastic arts."[58]

<center>∗ ∗ ∗</center>

Concerned and conscientious as Valenciennes's teachers and mayors seem to have been, it would be a mistake to credit them with *inventing* new teaching programs out of whole cloth in response to local needs. Such needs were not purely local. This is clear not just from mayoral letters to Paris, which hint at a relationship to a larger whole, but from other, more substantial sources. For example, take the testimony of a contemporary English observer, the painter William Dyce, who in 1838 was sent to the continent on a fact-finding mission by Parliament's select committee on the Schools of Design. He made a study of the day-to-day workings of Lyons's Ecole des Beaux-Arts, and felt able to generalize, on this basis, that "other provincial academies are in the same way meant to serve the double purpose of rearing artists and designers for the industry of their several localities."[59] From my investigation of the Académie in Valenciennes, I can second his assertion. It can be bolstered, moreover, by bits and pieces of other data, like the boast of the director of the Ecole de Dessin of Rouen in 1858: over a period of twenty years, he claimed, his school had taught 5,045 students—and no more than fifty of them had gone on to careers in the fine arts.[60] This situation prevailed outside of France. The Académie Royale d'Anvers, for example, though founded for the fine arts, gives equally telling statistics for a slightly later period. Of the 13,176 students inscribed during the ten years 1854–63, only one-fifth aimed to become artists—painters, sculptors, or architects—with that proportion diminishing every year.[61]

A transformation was overtaking art education as the nineteenth century approached its mid-point. It was partly a matter of government planning, partly the result of provincial progressivism; in both cases the need to respond to the simple pressure of demand played a considerable role. The result was changes which took place country-wide: they reached as far as Lyons and Valenciennes, to alter the way obscure provincials like Carpeaux were introduced to the first bare facts of art-making. From drawing instruction it was a short step for a school like the Valenciennes Académie to modify the teaching of sculpture so as to meet an even wider set of needs at forge or foundry. But, as so often in France in the nineteenth century, the essential initiatives were taken in Paris. It was there that the *pattern* of change was established; it was from there that teachers and guidance went out, letting it be known what art and education would now aim to achieve.

If there was any one institution that acted as a model for the transformation we have been looking at, it was the Parisian Ecole Gratuite de Dessin—the school which Carpeaux attended in the years around 1840. City fathers in Vitry-le-François, Corrèze, or Châlons wrote direct to the Petite Ecole, as the place was familarly known, for advice on the art schools they planned to open.[62] In 1843 the school's statutes were published in the *Revue Générale d'Architecture* so that provincial schools could copy them the more easily.[63] Nonetheless enquiries continued to come in from further afield: William Dyce paid a visit as a matter of course, and by the late 1840s an international cast of students—Poles, Italians,

Germans, Greeks, and more—was enrolled.[64] A decade later, word of the school had reached Cincinnati, Ohio: the Mechanics Institute sent a request for full particulars on everything from the "materials" given students to study, to the shape of the benches they sat on.[65] Valenciennes itself had landed a sculpture teacher from the Petite Ecole, at a rather early date. Laurent Séverin Grandfils arrived in 1840 and straightaway began introducing more of the new ways. When he left in 1856, the mayor wrote at once for a replacement from the same source.[66]

The Ecole Gratuite de Dessin had been founded in 1766 as a school for industrial workers. Its first director was Jean-Jacques Bachelier, one of the chief artists in the royal porcelain factory at Sèvres. Right from the start, in a memoir designed to "show the usefulness of this establishment," he put his stress on the special role of *dessin* in the new school. Drawing was no mere "*art d'agrément*"; it was the "soul" not simply of the three fine arts but of the "several branches of commerce"; it would prove in the end able to foster trade, and thus to be "infinitely precious to the state."[67] This is the principle, need it be said, on which most nineteenth-century drawing instruction was to be based.

To emphasize the economic utility of drawing, Bachelier reeled off the list of the various trades to which it would be valuable: *argenteurs, arquebusiers, artificiers, blondiers, bourliers (sic), brodeurs, charpentiers, charrons, chaudroniers, ciseleurs, couteliers, doreurs, ébénistes, émailleurs, éventaillistes, fabricants d'étoffes, fabricants de galons, fabricants de rubans, fondeurs, fourbisseurs, gainiers, gaziers, graveurs sur métaux, horlogers, lapidaires, luthiers, maçons, menuisiers, metteurs en oeuvre, opticiens, orfèvres, potiers d'étain, selliers, serruriers, tabletiers, tourneurs, treillageurs.* Most of the skilled métiers are named; the list reads like an alphabetical roll call summoning Parisian artisans to school—which is exactly what it was. The three sections of the school— "Géométrie et Architecture," "Figures et Animaux," and "Fleurs et Ornement"—were geared to serve fifteen hundred students on a tight schedule of classes and shifts, rotations reminiscent of factories in full production; on leaving this beehive, students were given a colored chit to remind them to come back on the right rotation—admission depended on having the proper color in hand.[68]

It may seem extreme to claim that the "industrialization" of drawing and drawing instruction began at the Petite Ecole, but to a certain extent this is the case. The school was intended to teach workers and their sons, to produce handier hands, "des mains parisiennes," as Henry James described the city's artisans, capable of crafting a finer and more competitive product. Moreover, in the process the worker himself was to be transformed into a new, more valuable asset. Bachelier wrote:

> The best of kings has deigned to cast his eyes on a class of citizens which his predecessors have left more or less in shadow. What a resource to make our commerce flourish and attract foreign money! Industry for us is preferable to work in a mine. Commerce has so much influence on individual states that it has become the basis of European politics. It is in merchants' cashboxes that dominion over the sea and the battlefields is decided.[69]

If the *raison d'être* of the Ecole Gratuite was to tap a forgotten, fertile resource which would fuel the engines of economic warfare in Europe (these are clichés in the making), the school would achieve that goal by teaching drawing and, with it, geometry. They were the tools which a young draughtsman could use to break from the "tastelessness" of the baroque (Bachelier's phrase) to a style suited to contemporary mores and markets. The method he advocated was, not surprisingly, the *modèle estampe*; at a school which aimed to teach fifteen hundred students every week, prints were a necessity, since they could be used and reused, and did not tire between sessions.

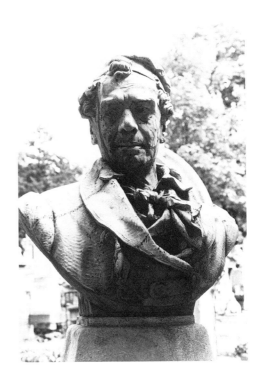

29. Adolphe Itasse, *Jean-Hilaire Belloc, 1783–1866*, 1868,
bronze (h. 58). Cimetière Père Lachaise, Paris.

The Petite Ecole was Bachelier's creation, so much so that, long after his death in 1806,
his son was summoned as an advisor in times of difficulty.[70] But the policies which
determined the school's direction during much of the nineteenth century are those of Hilaire
Belloc (1787–1866; fig. 29). Belloc was installed as director on October 4, 1831. He had
previously made his reputation as a history painter, and he went on painting and exhibiting
at the Salon until 1850; but his primary occupation became the Petite Ecole. He ran it
for thirty-five years.

In many ways Belloc seems a shadowy figure. He certainly appears less vivid than his
wife, Louise Swanton (1796–1881). The daughter of an Irish army officer, she was a trans-
lator of Byron and Dickens, and the author of original works in a moralizing vein (*Biblio-
thèque de famille; ou, Choix d'instructions familières*, 1832; *Pierre et Pierrette; ou, Les Dangers
du vagabondage*, 1838).[71] Louise Belloc knew, it was said, "la plupart des hommes distingués
de son temps" and received them at home on the rue de l'Ecole de Médecine, in the apart-

30. Entry to the Rotonda, Ecole Gratuite de Dessin,
wood engraving. *L'Illustration*, 1848.

31. Beginners' class in the figure and ornament, Ecole Gratuite de Dessin,
wood engraving. *L'Illustration*, 1848.

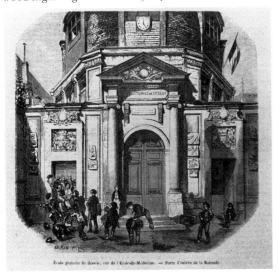

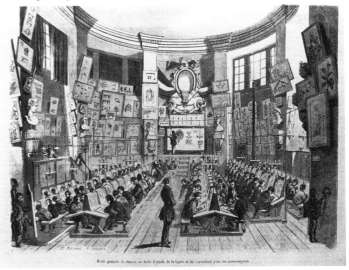

ments given the couple by the school. David d'Angers, Michelet, and Béranger were among her visitors. Belloc too was part of this liberal, literate world; he introduced Michelet to Béranger, and painted the historian's portrait in 1845.[72] It was with the Bellocs that Harriet Beecher Stowe stayed during a Paris visit of 1853 (Mme Belloc had translated *Uncle Tom's Cabin*). Stowe toured the Petite Ecole with her host. His devotion, "body and soul," to his duties impressed her forcibly. So did his school. From him she learned its function; it was, she wrote, "a prevision of the government to instruct the working class in the secrets of art," and she gave a careful account of how that instruction was accomplished.[73] Her description is enthusiastic, detailed, and, most important, accurate; at least it tallies with the engravings of classes at the school published about the same time in magazines like *L'Illustration* (figs. 30–33).[74] Classes were in session during the author's visit (as they are in the engravings), so Stowe could see students drawing from nature, after roses and thistles, and from a skeleton (to which a *gutta percha* musculature could be added) that they studied bone by bone, muscle by muscle, sequentially. She watched more advanced students draw from an elaborate frieze, dogs and hunters interspersed among "capricious" combinations of leaves and arabesques. She inspected their math notebooks and praised their penmanship.

The view Stowe constructs shows a worthy institution, a place for serious, if prosaic and elementary, studies. Yet she uses it as the impulse for a long-winded and enthusiastic discussion of the French natural talent and taste for beauty, a national proclivity shared, she said, by all classes. It was the sight of schoolrooms full of working-class boys busily drawing that led her to such contented generalizations, but her readers most likely would have thought her justified in her conclusions. We know that when a Swedish visitor to an American schoolroom, the novelist Frederika Bremer, saw boys drawing on their slates, the results—smoking steam engines and steamboats—were taken to be equally emblematic of national character.[75]

Journalists too were invariably favorable, though slower than Stowe to conflate art and industry. They too praised Belloc, the "bon et savant directeur," "homme excellent"; they too described the curriculum, "sincère, vivant et progressif"; they too cited the mission to instruct young workers. But, unlike the American, these French observers emphasized its role in the industrial and artistic economy of the nation. In the decade after 1848 a flock of articles, both specialized and popular, presented the school to the public, making

32. Class in drawing and modelling from casts, Ecole Gratuite de Dessin, wood engraving. *L'Illustration*, 1848.

33. Modelling from figures, ornaments and living plants, Ecole Gratuite de Dessin, wood engraving. *L'Illustration*, 1848.

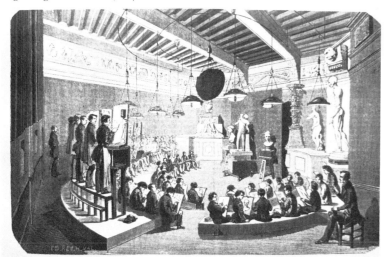

much of an institution whose aims were coincident with the policies of the governments on which it depended.[76]

The programs of the Petite Ecole were the product of development, innovation, and refinement undertaken by Belloc. In 1829, before he took over directorship, the school's curriculum still reflected the three main emphases which Bachelier had given to instruction. Prizes were offered in courses teaching architecture, stone cutting, basic structures, geometry, figures, animals, ornament, and flowers.[77] All of these apparently were taught from a huge library of *modèles estampes*, some 250,410 engravings and 2,380 plates.[78] In many cases these were multiple editions of motifs drawn by professors at the school (with the kind of self-sufficiency characteristic of the place) and run off in large numbers for the enormous classes. In 1831 the school possessed only twenty-nine plasters, a remarkably small number in comparison with other plaster collections (like those at the Ecole des Beaux-Arts or the Académie in Valenciennes, for example). They are remarkably consistent in character, too, with a uniformity reflecting their usefulness for ornamental design (e.g. "un taureau, une vache, une griffe de lion, écorché, 8 pieds de chevaux, 5 pieds de lion," etc.). In addition there was a skeleton, a few odd pieces of ornament, a few portfolios of engravings, five surveying instruments, and eighty-one geometric shapes—cubes, pyramids, spheres—which dated from a trade in 1808 with the Conservatoire des Arts et Métiers.[79]

On paper this seems a paltry inheritance. Evidently Belloc thought so too, since he devoted his directorship to augmenting it and to modifying the curriculum. By February, 1832, not six months after his nomination, he began to make changes. He hired a secretary to keep track of students and equipment, and a student helper, a *répétiteur*, who could take over some of the classes.[80] He contacted artists with new ideas for drawing courses, and considered their usefulness for his school.[81] He proposed a course in ornamental modelling, which turned the school from its traditional concentration on drawing towards the realm of sculpture. In his admirers' opinion and his own, this was one of the most important innovations he brought about. It was one among many, however. Instruction became more technical and more diverse. By 1847 students were being examined in architecture, stonecutting, basic structures, architectural drawing, architectural engraving, geometrical diagrams, stonecutting diagrams, structural diagrams, arithmetic, geometry, geometrical engraving, graphic design, ornamental composition, figure drawing, animal drawing, flower drawing, ornamental drawing, outline drawing, drawing of living plants, and drawing from casts.[82] There was a course in anatomy and another studying the history of ornament. Lecoq de Boisbaudran had perfected his system of memory drawing, and a wide range of models—including the plants and flowers Stowe saw—was used in drawing lessons.

Of course these changes were not accomplished singlehanded. By the early 1840s Belloc had assembled a teaching staff capable of assisting in the work. It included Eugène Viollet-le-Duc, first employed at the school in the mid-1830s as a *répétiteur*, in 1842 as an adjunct professor, and as full professor of ornamental composition in 1844. Horace Lecoq de Boisbaudran, like Viollet, was an adjunct in 1842 and made full professor in 1844, when the adjunct position was abolished. Sharing their rank was Gault de St. Germain who taught ornament and flowers. Above them in the hierarchy were Jäy, Herr, Peron, and Jacquot, respectively professors of construction, mathematics, figure drawing, and sculpture. Beneath them were the *répétiteurs*; in the 1840s there were four of these jobs awarded, usually to a member of the student body who had distinguished himself. Rank was clearly emphasized by wages: by the 1840s Belloc was paid 4,500 francs annually. The school secretary earned 1,200, and the full professors 1,500 francs, while adjuncts made 1,400

francs. *Répétiteurs* were paid 200 francs a year.[83] These are not high salaries, nor were the positions full-time; professors spent only one day a week at the school, and supplemented their income with commissions or other teaching jobs.

The discrepancy between Belloc's salary and that of his professors is one index of his greater responsibility for the school. In his case, responsibility meant accountability. The director was appointed by and answerable to the Ministère de l'Intérieur, and all his actions, including the hiring and firing of staff, had to go through that channel. From 1843, moreover, he was monitored by a *commission de surveillance* headed by Charles Texier, who had been appointed royal commissioner for fine arts establishments.[84] The date seems to mark a kind of focusing of ministerial attention on the school; Belloc was also instructed to keep close records of pupils, so that their impact on industry might be measured. But if Belloc was accountable to the ministry, his faculty was in turn accountable to him. They formed a *comité d'enseignement* whose function was stated in the 1843 statutes: "it governs the models and the methods of instruction, the time and length of classes, and deliberates on all questions relative to instruction."[85]

A simple enough statement, but an interesting one, because of the last duty that it mentions. Belloc conceived of his professors as a deliberating body; he assumed that they would have questions about instruction, and he institutionalized a means of addressing them. He also apparently proposed many questions himself. He asked for faculty opinion on a range of issues, from the necessity of competitions in the curriculum, to the pupils' rate of progress, and he had the answers entered in the school archives. The committee also heard reports from individual members on new methods they had tried. The names of students who participated in new courses (like Lecoq's drawing workshops, for example) were put on the record, so that their future progress could be measured.[86] The atmosphere apparently was one of openness and investigation (the difference from the Ecole des Beaux-Arts is striking), and a critical approach to teaching was valued and encouraged.

All Belloc's innovations, curricular and structural, had the same goal—or, perhaps better stated, shared the same conception of teaching. It was a conception which was anything but static, since the school acted on the principle that neither teaching nor learning could be done entirely by rote. Belloc and his colleagues evidently believed in *theory* as much as in practice, and their conviction appears in telling ways. For example, to help his students better memorize (and draw) a nose, Lecoq lectured them in its physiology and function.[87] The course in ornamental composition began with a presentation summarizing the general and particular characteristics of ornament through history.[88] Students learned to draw from roses and not from drawings of them. Figure drawing was augmented by anatomy. There is some evidence that these innovations were difficult for Belloc to secure. The obstacles were not just financial, although like any administrator the director did his share of wangling help from the government bureaucracy. Part of the problem was the school's policies: Belloc had to work hard to explain and justify them to the powers-that-be. This is suggested by an annotated copy of the statutes drawn up in 1843, at the moment when the school came under closer surveillance by the Ministère de l'Intérieur.[89] The new stipulations outraged Belloc. He covered one copy with emendations and arguments which readjust the balance of power in his favor. He was particularly testy about the way the new rules described his curriculum. Three drawing courses were defined using the word *copié*, e.g., "le dessin copié de la figure humaine" or "copié des animaux" or "copié des plantes," while sculpture was called "la sculpture copiée de la figure humaine et des ornements d'architecture." Four times Belloc drew a crisp little rectangle around the word *copié*, fencing it off from the rest of the phrase. In the margin he wrote, "This distinction removes from

the director and the Comité d'Enseignement one of their most important functions." That function was teaching as he thought it should be done, with a concern for more than exactitude.

Put alongside the details of Belloc's curriculum, evidence like this points to disagreement, not just about pedagogical principles, but about their practical application to teaching the working class. Belloc did not differ from the ministry about his school's basic purpose. One of the few stipulations in the 1843 statutes he did not propose to alter was its statement of intent: "Article 18. The sole object of instruction is the application of the fine arts to industry." But what kind of knowledge does properly prepare the way for that application? Belloc's instruction apparently encouraged a certain amount of autonomy on the part of the industrial worker in how that goal was ultimately accomplished. Belloc's curriculum left room for invention as much as copying: it placed its stress on theory as much as practice, on means as much as ends. Equally important, it did not include courses which would teach specifically *industrial* skills, like techniques for reworking a fabric pattern for a weaving machine, or translating it to stencils for printing wallpaper, even though his students would eventually need to know such things. The Ecole Gratuite was criticized on that account. Of the two most important institutions William Dyce visited in France, he much preferred the Ecole des Beaux-Arts in Lyons to Belloc's school, because he found that instruction at Lyons answered its industrial purpose in a more straightforward way. Most students at Lyons were destined for the silk industry; but the schoolroom, not the shop floor, taught them the workings of the Jacquard loom and the kind of patterns it required.[90] The Paris school was run according to a different philosophy. One of its teachers, Victor-Marie-Charles Ruprich-Robert, Viollet's successor at the head of the classes in ornamental composition, maintained that every school was forced to choose between teaching fundamentals and teaching trades. The Petite Ecole chose the former, so it taught drawing as its basic, linking discipline. Ruprich-Robert was proud of the choice.[91]

What kind of drawing did Belloc and his teachers foster? The question is by now familiar, but in this case it seems that the answer is genuinely new. The Petite Ecole did not stop with drawing by rote; it maintained figure drawing as part of the curriculum; it expanded the range of models students used rather than compressed them. Did not such a system promote drawing for artists rather than workers, even though that purpose is nowhere mentioned in the school's statutes? In his observations on the Petite Ecole William Dyce noted that on prize day it was Belloc's custom to "recount with pride" the names of students who had gone on to successes at the Ecole des Beaux-Arts (the surviving texts of Belloc's remarks confirm the habit).[92] More recently art historians have become accustomed to citing the same evidence in order to treat the Petite Ecole as a kind of "unofficial prep school" for its fine arts cousin.[93] Time and again the list of artists whose careers began there is totted up as a kind of proof: Carpeaux, Dalou and Rodin, Garnier, Davioud and Lhermitte.

The list could easily be extended, of course. We have, in fact, no means of knowing exactly how many students made the move that concerns us in Carpeaux's case. Perhaps ten, maybe twenty in any one year; that is, anywhere between a fortieth and a hundredth of the annual enrollment. Despite this minimal proportion, it is because of careers like Carpeaux's or Rodin's that the Petite Ecole has entered the art historical account, as if the school's contribution to the mix that makes a great artist alone justifies its mention. Dyce, however, had a rather different approach to the phenomenon of students graduating to the Ecole des Beaux-Arts: "I do not, I confess, see anything to fear on that ground."[94] He could put aside the *worry* that some designers became artists precisely because most

did not. Their education safeguarded them from the transformation, and they were better paid as designers than they would be as second-rate artists. Dyce made his point by way of comparison with English practice:

Take the case as it now stands in England—a young artisan of a better class, engaged in an occupation which requires some knowledge of art and possessing natural talent, is desirous of drawing the figure. Let us suppose him for this purpose at work at the British Museum, or, if he is able to afford it, at some private school: now who are his associates in study? Why young artists without exception. The result of this may easily be foreseen. Having no one to explain to him the bearing of the study he is engaged in on his industrial occupation, and being constantly associated with those whose purpose is the pursuit of fine art, he gradually falls into their habits of thought, becomes inoculated with their desire of fame, is disgusted with the humbler crafts, and in the end, perhaps overrating his talent, forsakes a certain subsistence for one always precarious, and to inferior ability most hopeless.[95]

This is a parable about class mobility. An artisan on the upper edge of the lower orders is "inoculated" with the ideas of artists (did Dyce really mean "infected"?—the suggestion of disease is there), so that he sees his former craft as they do, with disgust, and abandons life at the level of subsistence. All this through propinquity, because he could not study the figure among members of his own class. But in France . . . There, all manner of lessons are provided in drawing schools: class stability and security are not jeopardized.

Contemporary French treatments of this topic are rather more delicately phrased; perhaps Dyce's tone was set by the context of a parliamentary report, where plain speaking was just what was called for. When the subject was broached in France, the writer's reflections are couched in terms of self-improvement, rather than class mobility—along lines of Bernard's invitation to Valenciennes to leave the "nullity" of their ordinary existence. That vocabulary does not nullify Dyce's argument, however. Stability was promoted by schools like the Petite Ecole. It was the message on every prize day, just as much as the names of medallists in the annual *concours*. The press took notice of these ceremonies, often writing them up as a touching *fête populaire* which gathered proud fathers, "artisans with rough hands and sunburnt faces," and mothers "in simple bonnets" to see their offspring honored.[96] Year after year, these impeccable parents were treated to descriptions of what the book or medal given young Jean and Jules actually signified. According to the press and the Préfet in attendance, and even Belloc himself, the victories of these "younger people who every day in diligent study seek from work a position which fortune denied them from the cradle" are victories of the working class as a whole.[97]

Sometimes it was the students themselves who were addressed, along the lines of the speech given by the Comte de Rambuteau in 1836:

And so, young students, in deserving the esteem and friendship of your masters you can each week prepare for your future by mastering the means to continue to deserve them. A great many of the young people who attend drawing schools have owed to study there a significant increase in salary. Very often Sunday and Monday would devour the week's savings; today, Sunday is given over to drawing and those economies go into the savings bank. What benefits result! Once one has tasted the first pleasures of prosperity, the only source of independence, one wants to protect it and see it grow; one loves order, the basis of liberty; one becomes a good citizen; one gives an honourable example to one's children.[98]

These are the fundamental virtues of the bourgeois monarchy: it is no wonder they provided the refrain under Louis Philippe. Equally characteristic is the tone of prize-day speeches during the Second Empire. Then the catch phrase was *soldats du travail*; the idea of victory in international economic competition set the tone, not the more modest pleasures of a few francs squirreled away in the savings bank and Sundays at a drawing class.[99]

My point is this: drawing schools provided education, but they also provided their students with an image of what their lives ought to be like and the social role they were to play. Values and beliefs were disseminated alongside drawing skills; the highest prize awarded at the Petite Ecole, the Prix Percier, took into account good conduct as well as good drawing. Ideology appeared in broad outline when the prizes were conferred—though what parents and students actually made of the accompanying admonitions is another matter. But beliefs were also disseminated part and parcel with drawing skills—written small *within* them, if you will. The key values of *dessin* were precision and exactitude, reproduction and imitation, and, in the case of the Petite Ecole, the worth and interest of problem-solving. And built into the routine of art education was the assumption that art now had a necessary place in industry, that ornament was the essence of design, and that these matters were teachable.

Belloc called his instruction "visual and modern"—words to conjure with in the mid-nineteenth century. These phrases were meant as much for students as for journalists and ministers; it was students who would best understand that competitions at school led on to others in the marketplace. Pupils were asked to design fountains for Paris streets, and a bas-relief for the doorway of the school. (The latter was to include, as a sort of inspirational trophy, the head of Géricault, flanked by *écorchés* of man and horse, symbols of the great artist's contribution to their studies.) Sometimes the programs were more rarefied, less relevant to immediate personal experience, like that asking for "an entryway for the vestibule to the principal staircase in a ducal palace," or a coffer to be adorned with scenes from the adventures of Cupid. They were rarefied, but not necessarily archaic; they had as much chance of execution in a student's future working life as any self-consciously modern exercise, like the ornamental panels for a locomotive assigned in 1847.[100]

* * *

Let me begin to conclude this chapter by returning to Garnier's reminiscence of Carpeaux at the Petite Ecole. This is the recollection that begins, "At that time he was a real Paris *gamin*, almost a *faubourien*, rather undisciplined but still good at his work." It continues. "We did sculpture together and I'll always remember that in a competition on the subject 'The Attributes of Fishing,' I did better than he." "*Quel succès,*" the architect concluded with becoming glee.[101]

Yet the anecdote has more than the semi-comic interest which Garnier had in mind. Like all memories it is as much about the present as the past. The joke hinges entirely on Carpeaux the boy being Carpeaux the sculptor, even though it is obvious, reading Garnier, that the teller does not really believe that either he or his friend *was* the same person back then, more than thirty years before. Hindsight made him remember that he had witnessed Carpeaux emerging from his *gamin*'s identity. But the fact is that the Petite Ecole put future architects and sculptors in classes alongside masons, stonecutters, and gilders, and it taught them all at the same level. The school sometimes replaced, sometimes prepared for, further professional instruction, but in either case it offered skills useful to all.

34. Jean-Baptiste Carpeaux, *Page from a Notebook*, c. 1847–48, pencil on white wove paper (20.3 × 12.5). Ecole Nationale Supérieure des Beaux-Arts, Paris.

In so doing, however, it steeped its students in that special belief in drawing and decoration which was the ethos of the school. Whether or not an individual student actually competed in the school's contests in any one year is of less concern than the general purposes and atmosphere which he came to take for granted. It is true, of course, that the evidence does not often exist to say much more than this. In most cases it is only when a student later became an artist that his school record can be reconstructed at all. The archives are broken by gaps of a kind that make it infinitely easier to produce some quasi-sociological piece of information, like the fact that enrolled in 1843 were seventy-six sixteen year olds (Carpeaux was one) or twenty locksmiths and seventeen chasers, than to trace the career of any one of them.[102] Even if a student later did become an artist, his school program can be known only by dint of the diligence of an earlier biographer. In Carpeaux's case the careful efforts of the Valenciennes historian Edouard Fromentin at least silhouette his course, though they do no more.[103] The date of his enrollment, for example, is given variously as 1838, 1840, or 1842; he probably began by following courses in drawing, stonecutting, geometry, and architecture. By 1842 he was nonetheless advanced enough in sculpture to win three prizes in modelling from ornament, living plants, and casts. The second year saw six more prizes for a similar range of courses. In his final year, 1844, he took only one award, a second prize in the annual sculpture competition, before leaving for the Ecole des Beaux-Arts.

Such specific information makes pretty dull reading without any physical evidence to match it with. (There is a possibility that it would be dull in any case.) Carpeaux's Petite Ecole exercises do not survive; nor do Garnier's, for that matter. In fact only one of the sculptor's drawings, a page from a pocket notebook, might be said to preserve a trace of the school's instruction (fig. 34). It shows a woman's head in profile, crowned with

a flowering wreath—the type of head often silhouetted in contemporary architectural plaques. On the same sheet, though unrelated to the head, is a tall leafy plant.[104] This is not much evidence to go on. We can point to similar plants in engravings of the school and to their appearance in two competition drawings *à l'estompe* by Henri Chapu, first and second prizewinners in 1849–50, and genuinely products of the curriculum (figs. 35–36).[105] In Chapu's efforts the crinkled, spinachy surface of the curling leaves is described in detail, with a naturalist's attention to morphology more consciously scientific than not—and evidently, in view of the prizes Chapu won, in keeping with the reigning house style. Perhaps it is this observation which makes us realize that these earnest renderings are ultimately not very like Carpeaux's hasty effort.

Where does this get us? What is the point of studying an educational program whose results can be illustrated no more profusely than this? The answer is that Petite Ecole lessons allow of a different kind of demonstration. We should take as informative, for example, the fact that Carpeaux gained entrance to the Ecole des Beaux-Arts by proving that he could draw.[106] Equally instructive is the information that Carpeaux's first designs for commercial sculpture, two self-consciously charming boy and girl vases, were sold at about this time (fig. 37).[107] Just as illuminating about influence and affiliation, however, is Carpeaux's return to his old school years later, in 1850 and 1851, to fill the position of *répétiteur* for the anatomy course.[108] It is often claimed that he owed his friendships with artists and architects like Chapu, Rodin, Garnier, Davioud, Dalou, to one or other of his Petite Ecole sojourns. This is certainly true—but he also formed less remarked relationships with other men, like Charles Laurent-Daragon and Charles Capellaro, who both later worked as his *praticiens*, and with François-Louis Carpezat, an ornamental sculptor.

35. Henri Chapu, *Tige végétale*, c. 1850, black chalk and crayon on white paper (61.2 × 47.2). Musée, Melun.

36. Henri Chapu, *Tige florale*, c. 1850, black chalk and crayon on white paper (61.2 × 47.2). Musée, Melun.

37. Jean-Baptiste Carpeaux, *Vase statuettes*, c. 1845, porcelain. Location unknown; reproduced from A. Mabille de Poncheville, *Carpeaux inconnu, ou la tradition recueillie*, 1921.

Carpeaux did a medallion of Carpezat in 1855; a cast from it marks the sitter's tomb.[109] These friendships were as much the product of the Petite Ecole education as alliances with artists; they were certainly as significant.

The Petite Ecole taught a conception of skill and ambition, as much as anything else, and fostered the social relations to encourage them; it took the future accomplishments of its students as the best measure of its success. That is why, in the annual ceremonies, Belloc announced the names of Ecole prizewinners. He also read out other successes which to my mind are equally instructive. Take his speech in 1840; it concludes with this piece of news:

> You will learn with interest that the varied ornaments on the charming houses which are being raised as if by magic throughout Paris are the work, for the most part, of the students at the Ecole Royale et Gratuite de Dessin. The frieze of animals on the house at the rue Laffitte is by M. Rouillard; the foliage, for the most part by M. Aubin; two heads are by M. Laurent. Messieurs Fouquet, Dubourdier, and others as well worked on the ornament. All these young people were employed by the brothers Lachèvre, entrepreneurs in sculpture, also pupils of the Ecole, under the direction of the architect M. Lemaire.[110]

Belloc named these former students not least because their identities would mean something to his audience; a footnote added when the speech was published tells that those mentioned were all present that day. Remarkably enough, the building he credits to them still stands,

38. Frieze, Cité des Italiens, 1839. Rue Lafitte, Paris.

signed and dated 1839 by its architect, Lemaire, and recently restored (figs. 38–41). Without Belloc's speech the design would be allotted to Lemaire alone. Even with it the moot question of authorship is not entirely sorted out. But some sense of the economy of building practice nonetheless comes through when we realize that the animals in a frieze are the product of one hand, the foliage of another, the heads of a third—and that, even then, all the contributors have not yet been named.

All these devices are easy to recognize as forming part of the school's curriculum. The lessons show up in the deer romping through oak leaves, the classical moldings, the flowers

39. T. Lemaire et al., Cité des Italiens, 1839. Rue Lafitte, Paris.

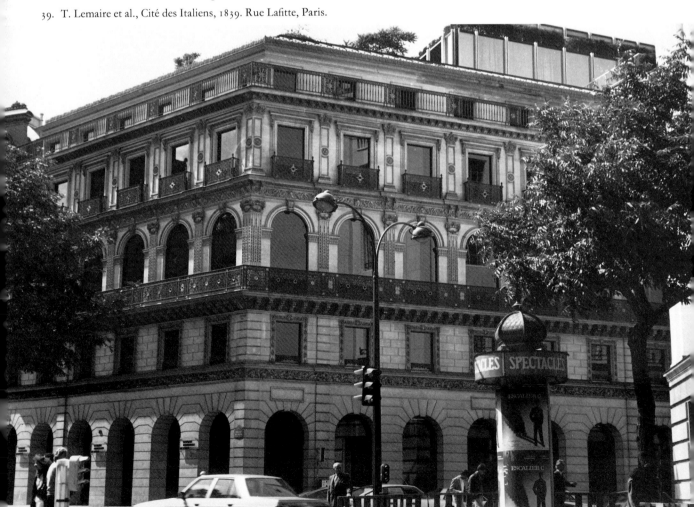

40. (left) Window, Cité des Italiens, 1839. Rue Lafitte, Paris.

41. Entrance doorway, detail, Cité des Italiens, 1839. Rue Lafitte, Paris.

and fruit. It is this language more than its gilt-lettered sign that makes the building legible. Its various components punctuate the facade and order its parts into a vertical and horizontal hierarchy whose emphases—at the entrance, on the *premier étage*, on the height and width of the windows—are unmistakable. They give familiar architectural elements the inflection of the *grand hôtel* with a single tenant—one that belies both the multiple occupants such structures accommodated and the speculative basis on which they were built. Decoration like this took the new education and made it visible; it made it an integral part of the luxury of mid-nineteenth-century Paris. It was applied to surfaces, to be sure, but not as a mere ornamental icing. On the contrary, it did a real task of definition: it articulated structures of a certain character, built for a certain market—for a bourgeoisie discovering its own existence in the Faubourg Poissonière or showing off that newfound identity in the arcades or along the boulevards, where caryatids bedeck the doorways, and *hôtel* windows—even *hôtels à loyer*—are lushly framed.

This last example may seem to take us far away from rudimentary drawing instruction, but the distance is not as great as it may look. After all, Belloc considered this building exemplary because his students' work on it showed their mastery of skills he had taught. The building offers further proof, if more is needed, of how drawing was taught in order to serve as the *lingua franca* of industry and the trades. There too it was a requisite of admission and a means of advancement, as well as the tool for internal communication and collaboration.

I have tried to argue, in particular, that this language assumed the advisability of orna-

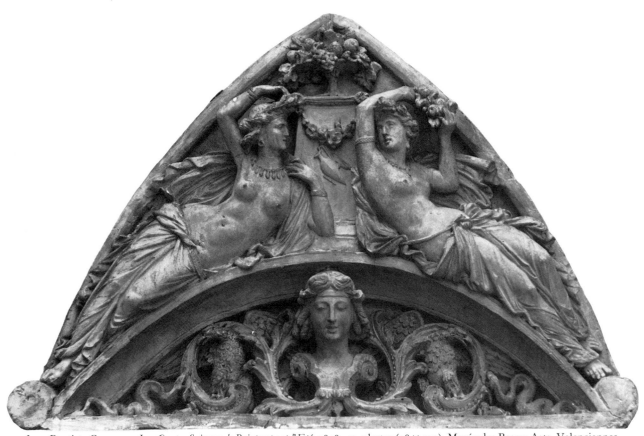

42. Jean-Baptiste Carpeaux, *Les Quatre Saisons: le Printemps et l'Eté*, 1848–49, plaster (98 × 130). Musée des Beaux-Arts, Valenciennes.

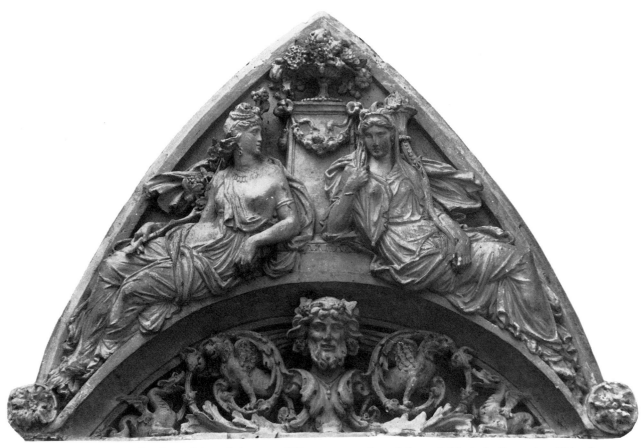

43. Jean-Baptiste Carpeaux, *Les Quatre Saisons: l'Automne et l'Hiver*, 1848–49, plaster (98 × 130). Musée des Beaux-Arts, Valenciennes.

44. Postcard showing *Les Quatre Saisons* in place,
Rue de Famars, Valenciennes, destroyed 1918.
Bibliothèque Municipale, Valenciennes.

ment and decoration. Carpeaux, for one, did not outdistance those assumptions. They ruled
his entire career; they are reflected in the commissions he accepted for fountains and archi-
tectural sculpture, and in his career as a sculptural entrepreneur marketing his own works.
But perhaps his first decorative commission is the most vivid illustration of Petite Ecole
lessons. It was awarded in 1848, in Valenciennes, where Carpeaux had taken shelter from
the revolution. One Louis Hollande, a prosperous cambric wholesaler, ordered an elaborate
overdoor for his house on the rue de Famars, one of the main streets running south from
the Place d'Armes to the ramparts. Tradition supplies what little is known about the com-
mission: that Carpeaux got the offer through the offices of J.-B. Bernard; that Hollande
paid him 100 francs for his design; that the oak panels carved from it were the work
of Charles Monseux and Florimond Godefroi, former students at the Valenciennes
Académie.[111] Only plasters now survive; the doors were destroyed in 1918 (figs. 42–44).
Old postcards show how Carpeaux's models, two ogive arches topping twin lunettes, were
planned to fit above wooden doors hung within a wide stone portal. The decoration is
plotted, albeit thinly, to a standard theme, the Four Seasons. In *Fall and Winter*, two draped
females lounge on the curving lunette, above a bearded herm flanked by battling griffons
and chimeras. In *Spring and Summer*, slight variations: more lightly clad loungers, a female
herm, warring birds and snakes. The doors are a gloss on the language of ornamental
sculpture fashionable in Paris; they must have seemed a trifle daring in Valenciennes, where
until mid-century architectural decor was still a rarity, reserved chiefly for public buildings
when it occurred at all. Carpeaux was already four years away from the Petite Ecole, but,
given the appropriate opportunity, he could rehearse its lessons with aplomb. We can
imagine the conversation between Louis Hollande and the young sculptor he had hired;
it must have followed the lines of Perdiguier's encounter with the *patron* of the shoe shop.

Had someone other than Carpeaux designed the overdoors—someone like Monseux
or Godefroi, for example—even the plasters would probably have been destroyed. They

were preserved because they are by Carpeaux and not because they are in any way superior to other anonymous bits of decorative sculpture. Anonymity was the expected condition of *ornemaniste* and draughtsman in the nineteenth century, and that view followed naturally from the concept of drawing as a normative skill. The means used to disseminate the skill were several, from the standardized drawing of the *cours de dessin*, which aimed to develop both imitative skills and an idea of drawing as an exact, verifiable means of communication, to the growth of schools of drawing. Chief among these in France, and in most Western eyes, was the Petite Ecole, where a more ambitious idea of drawing for workers was grafted onto the old stock of imitative instruction, with positive results. Somewhere between the two, the *cours* and the Petite Ecole, were schools like the Valenciennes Académie. They straddled the gap separating a fine arts tradition—the past—and an industrial present. In most cases, as in Valenciennes, they responded with some kind of mixture between the past, as represented by their own teaching tradition, and the example, as they read it, of the Petite Ecole. The particular proportions of that mix—the differences between schools in Lyons and Valenciennes, for example—were most often determined by the demands of the local industrial situation. By that yardstick, the Petite Ecole, with its emphasis on ornament and architecture, could be said to be most influenced by Parisian manufacturing and building trades, and therefore as much a local school as any other.

A bald recital like this robs these topics of the energy and emotion invested in them by the people who influenced their development. On the one side are the urgencies which reshaped the Valenciennes curriculum—above all the need for workers who could draw. On the other is Potier's yearning for the engravings after Raphael with which to prepare a student for the Prix de Rome. Or there is Belloc's vehement opposition to his lessons being characterized as copying; or Ingres's defense against the assault on art being waged by industry. In fact, threaded through all the strands of the story is the issue of art's relationship to industry, which reemerges at every juncture, around each issue I have cited. That relationship was debated, disclaimed, and encouraged, but all the while with the assumption that the two were somehow mutually relevant. It was art, however, that contributed to industry, not the other way around; industry eroded art. Their contrast can be reduced to more familiar terms, words like "elevated" and "base," "inventive" and "mechanical"; our various protagonists would have had no trouble in assigning them properly in the argument I have outlined—even if they disagreed.

Another way to state the opposition is identity versus anonymity; it is again easy to recognize the linkage of art with fame, and anonymity with work, even though it was clear to nineteenth-century observers—like the Goncourts, for example—that the ranks of artists were swelled with nameless, unsuccessful practitioners. Their lack of success was the index to their lack of a name; the two were in a fixed proportion. The students at Belloc's school, by contrast, were encouraged to accept namelessness as their lot, even their glory. Anonymity meant collectivity meant style: the worker would enter history through his contribution to period decor. Again these are the ceremonial clichés: "Unlike art, which is individual and which is met at its height only in one man within a vulgar generation, style is general and collective. It is the result of a succession of attempts and efforts; it is the work of every and each one, from the architect who conceives and erects a monument to the worker who undercuts a mold or carves a piece of furniture."[112] This sentiment is offered as a palliative to the concept of art as genius, as individuality. But it also teaches that identity means separating one's self from the collective mass, acquiring a name—Chapu, Carpeaux, Garnier—even while it sugars the pill of the worker's lot. When Carpeaux and Garnier become *patrons*, they will be well prepared.

62

CHAPTER THREE

LEARNING A LANGUAGE

"Qui dit école dit émulation."

Olivier Merson, "De la réorganisation de l'Ecole Impériale et Spéciale des
Beaux-Arts," Paris, 1864[1]

"Tell me first what is the subject," said she, "for I have sometimes incurred
great displeasure from members of your brotherhood by being too obtuse
to puzzle out the purport of their productions. It is so difficult, you know,
to compress and define a character or story, and make it patent at a glance,
within the narrow scope attainable by sculpture!"

Miriam to Kenyon, *The Marble Faun*, 1860[2]

In late August or early September, 1850, Carpeaux wrote to his friend Bruno Chérier des-
cribing that year's Prix de Rome competition, which had set students modelling a figure
of the wounded Achilles. Only a fragment of the letter survives, but it is illustrated by
a sketch which clarifies any possible doubts about its date or meaning (fig. 45). Characteriz-
ing the efforts of his fellow *valenciennois* Gustave Crauk, Carpeaux wrote, "The execution
of his figure isn't bad, but to be truthful—and according to the public—it expresses
nothing, says nothing; yet it does have some qualities, as I say, in execution. These are
our compositions. You can judge for yourself. I don't think I'm wrong."[3] And within
the body of the letter he pencilled the two figures, using the stilted abbreviated style charac-
teristic of his contemporary study drawings, and labelling them "me" and "Crauk" as
if the sketches were the two students themselves.

Carpeaux's comparison of his figure and Crauk's could not illustrate more clearly the
two principles which motivated study at the Ecole des Beaux-Arts. First there was rivalry,
émulation: each student was meant to build his stay there on the hope that *his* figure would
finally be judged the better one by less partial critics than friends at home. And second,
there was "expression", like some soft core of the curriculum, an indefinable essence separa-
ble from and superior to execution. In rehearsing these views, Carpeaux showed himself
not only a devoted student, but a calculating one as well. He was intent on winning the
Prix de Rome, and never missed the chance of showing off his work to good advantage.
Even in a sketch as small and casual as this one, he transcribed his own composition faith-
fully, so that Chérier could grasp its merits (fig. 47). He noted not just its awkward posture,
but its hard, choppy division of musculature, the molding of the truncated pier on which
it leans, even the faintly archaizing zigzag of drapery. There is no reason to believe that

he was not equally careful in rendering Crauk's version, though the sculpture does not now exist to give proof of the accuracy of such details as the short drapery hanging over the figure's shoulder, or more important, the springy swagger in its pose.

Neither figure won. The prize went instead to Charles Gumery, and his success was honored by reproduction in *L'Illustration* (fig. 46).[4] Why was his *Achilles* the winner? Perhaps because it was less agonized in its posture than Carpeaux's figure, or because unlike Crauk's it was poised and "heroically" wary rather than inexplicably triumphant. In any event "expression" was the key. Yet the Académie des Beaux-Arts explained its decision in slightly different, rather grudging terms: "The reasons for the judgement for figure no. 8 are that its lines are fairly successful, that parts of it are well modelled and of a fairly imposing character, and that the head is expressive."[5] Maybe—it is hard to tell about "successful lines" and "imposing character" on the basis of the evidence that survives. More striking is the desultory manner in which the Académie explained itself: it contrasts sharply with the sheer physical and mental energy which the Prix de Rome demanded of its annual crop of aspirants. The rivalry among men like Gumery, Carpeaux, and Crauk was real, a thing of efforts and emotions and exhaustion which bound them all to the same system and standard in the making of sculpture. Rivalry drilled the canon of expression and how to convey it through qualities of line and the character of modelling.

This system dominated French sculpture in the nineteenth century, though this is not

47. (facing page) Jean-Baptiste Carpeaux, *Achille blessé au talon*, 1850, painted plaster (h. 122.5). Musée des Beaux-Arts, Valenciennes.

45. Jean-Baptiste Carpeaux, *Sketches of Concours Sculptures*, 1850, pencil on writing paper. Bibliothèque Nationale, Paris.

46. Engraving after Charles Gumery, *Achille blessé au talon*, 1850, plaster. Reproduced from *L'Illustration*, 1850.

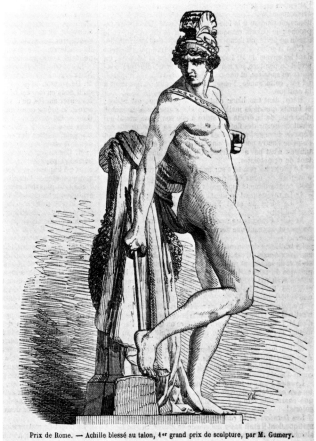

Prix de Rome. — Achille blessé au talon, 1er grand prix de sculpture, par M. Gumery.

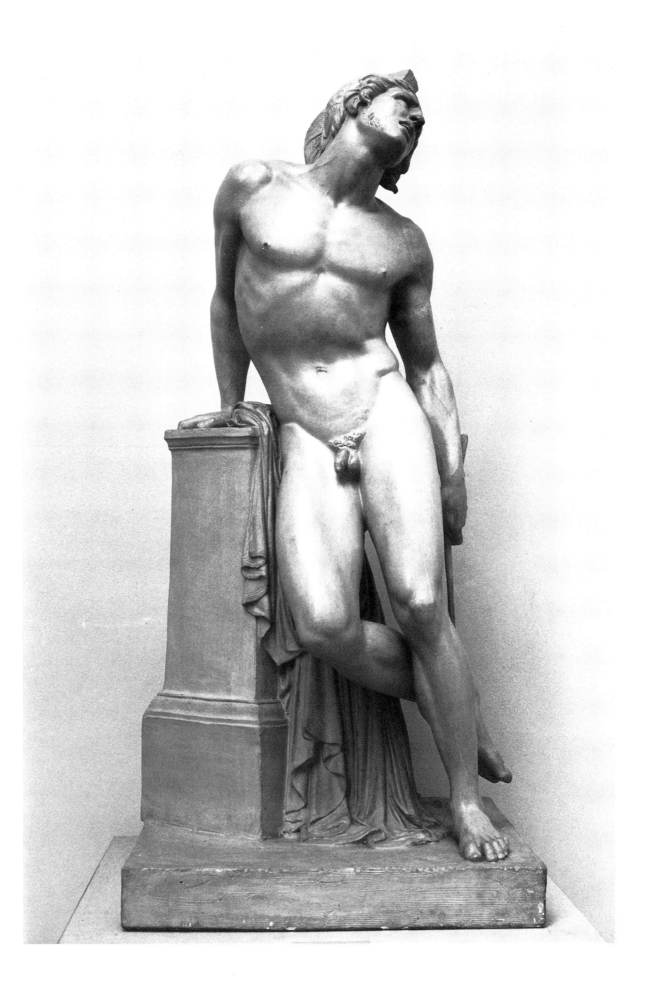

to say that it went unchallenged. On the contrary, one proof of the tenacity of the Ecole and its teachings is their resistance to criticism. It was not the idea of a national art school which came under attack, but the particular form it took at the Ecole. Twice, in 1831 and in 1848, the time seemed ripe to change that form. Twice the Ministère de l'Intérieur named the inevitable committee whose investigation was the preamble necessary for any reform.[6] Both committees failed, despite the apparent ripeness of the moment. In 1848 the reformers were deadlocked after only two meetings, unable to decide the question of whether to allow men who were not professors at the Ecole to sit on its admission jury. Such a curtailment of professorial power was unthinkable: the group disbanded.

The spoiling of such attempts meant that the Ecole continued essentially unchanged until its reorganization in 1863. So did criticism.[7] Discussion centered on the fact that the Ecole des Beaux-Arts was an art school funded by the French government and administered by its appointees and by artists whose professional identity had been institutionalized by their membership in the Académie des Beaux-Arts. This double affiliation opened the school to the criticisms levelled at both its parent institutions. The press accordingly relished treating its pupils as future academicians, or, at the least, as the next recipients of state commissions. Favorite metaphors made it a "cradle," a "nursery," a "gymnasium" in the old sense, where today journalists would say "boot camp" or "training ground." The metaphor itself is not important. What counts is the suggestion that the Ecole taught a preliminary version of the rules of art to students who would become artists. This assumption ostensibly ruled the place, even though it was certainly no secret that many students, like Salmson and Carrier-Belleuse, enrolled only to put some gloss on skills acquired elsewhere, and went away having accomplished that end. Even if only a gloss, it had the luster of Art.

What a difficult role for a school to play! Meant to groom sculptors, it was therefore held responsible for their shortcomings. When in 1868 Zola wrote about sculptors speaking art unnaturally, with a dictionary, a bad accent, and dreadful mistakes, it was no accident that his metaphors smacked of school. Sculptors with such poor skills, we gather, should never have been allowed to graduate—or been asked to do classics in the first place. But arguing on the school's side, however, was the fact that it had to work with such unpromising material, and transform it. It turned workers into sculptors—as best it could. Even Ecole professors seem to have believed explicitly in this mission. Take the testimony of David d'Angers, as he confided it to the pages of a notebook filled in 1848–49:

> Monday evenings, if you find yourself near the Ecole des Beaux-Arts, you see the young sculpture students bent and gasping under the weight of a batch of fresh clay which they'll use to shape a figure after the posing model. These children of the people descend from their poorly furnished attics—often they have barely enough to live on, yet they rejoice in a future which in their eyes seems wafted on golden clouds. And so clay takes on life, animation, under their fevered fingers. They don't yet understand the poem posing before them. This is the way a child forms the letters which will serve him to change men's lives, when he shows them the mysterious manifestations of humanity and the world our senses reveal.[8]

David continued in this vein for a while longer: "*Pauvres statuaires!* You are hard working men. *Sublimes ouvriers!* The gilded set does not appreciate you—but the future is yours." And so on. The irony is that when David called sculpture students *ouvriers* or *enfants du peuple*, he was speaking literally, as we have seen. An Ecole education was meant somehow

to accomplish a fairy-tale transformation, turning artistic illiterates into readers and creators of mankind's great epics.

David's enthusiasm here seems boundless, but so was the pedagogical problem the Ecole faced. Its solutions are one subject of this chapter; they are legible in the words and actions of professors and administrators, and in the works of sculpture students. In understanding this basic aspect of the place—its rules and traditions, the determinants of production at the school—we can begin to understand a second topic: how they were meant to shape the men who studied under them. No matter how much its purpose was couched in the elevated language of Art, the Ecole des Beaux-Arts trained all kinds of sculptors, professionals destined to work within the several branches of the trade. It fitted them for a future sanctioned by the fact of an Ecole training, even though, paradoxically, the career most students found was not that of government laureate or servant. Carpeaux became both, yet he did not consider himself a faithful follower of Ecole teachings. What, in the end, did adherence to the rules mean?

MASTERS AND STUDIOS

Carpeaux would have been the first to agree that the Ecole had its own system and rules of instruction. He even went so far as to spell them out when, in 1850, six years after enrolling, he finally made the decision to assimilate them completely. Then, to win the Prix de Rome, he found a new teacher, Francisque Duret, to replace his former master, François Rude. His analysis of the implications of that change takes the form of yet another of his letters to friends, this one to Louis Dutouquet, a young would-be architect who had returned to Valenciennes after a brief stay at the Ecole. The letter is an uncommon document, a student's candid assessment of two teaching methods and how they could affect his career.

> Since my return, my dear Louis, I'll tell you that my days have been spent on the run, with all of my errands aimed at changing studio and professor. You must understand that I left M. Rude with the greatest regret—it was from him that I learned the first elements of sculpture—but my interests were compromised there for a very simple reason, and I'll explain to you why! I think I've done the right thing. But back to the point.
>
> 1. M. Rude has a method (I must have spoken to you about it in my digressions about art) which adds up to a way of making sculpture entirely different from that of the Ecole. For example, he claims that sculpture—and to my mind, he's right—cannot be done competently except by mathematical rules, that is, by making use of compass, ruler, plumb line, etc. . . . In the end he makes his students *praticiens*, while at the Ecole, everything is done with the aid of the eye alone. And the Institut happily asserts that the arts in general exist more in sentiments than in measurements, which make us cold copyists grasping only the material aspect of what we do, while they . . . I think they are very pretentious in what they say, but I still must listen to them, say and do as they do. And because there is a great difference between these two methods, and because you cannot serve two masters at the same time, I say to myself, let's make a choice, the Ecole being a question of my future, my existence for me, I'm going to use every possible means to attain my goal; and to arrive at this goal, I must change professors. It's a decided, rational action, as you'll see, but I haven't succeeded quite as much as I had hoped. I'll tell you the outcome further on.

After much reflection, I didn't hesitate. I found old Abel de Pujol and told him what I've just explained to you, I begged and insisted that he speak to M. Duret of the Institut to receive me as his student. When he promised, it was a ray of hope; and to finish the job, I found Lemaire, whom I as much as forced to support my request along with M. Abel.

These gentlemen met last Saturday at the Institut, where it was agreed with M. Duret that he would give me the advice and lessons necessary to get me into the final competition. Since he wanted to see me, I went yesterday. He received me very well and even assured me that if I wanted to follow his opinion and advice, I would have the Grand Prix in two years. He would take over my artistic education, he told me, by making me study the style of the best Greek period, and setting me to learn anatomy from the bottom up, which for him is the alphabet of plastic art. Now, Louis, I can breathe again; unfortunately this gentleman cannot put me to work beside him, because he has no studio for students, but in the end I'm satisfied with this positive outcome.

As a result, I'm giving up M. Rude's studio, and I will work at home alone and in museums, and each of my studies will be submitted to these gentlemen, whom I'll see frequently.[9]

The tone of this letter is remarkable—how frankly, how matter-of-factly, Carpeaux describes his decision to get ahead! There are no pieties or false regrets softening his decision; he is perfectly clear about its implications. He believed that in quitting Rude and joining Duret he had launched himself on an entirely new program, one deliberately chosen because of the ways it differed from his earlier course: "you cannot serve two masters at the same time." The opposition is sharply drawn: technique and métier versus sentiments and ideas; science versus the eye; *praticien* versus artist; independent sculptor versus the Académie; failure versus success and a future within a system which Carpeaux thought necessary to his existence.

It is also remarkable that Carpeaux was sure a change of master would be efficacious, that he trusted Duret's promise of the Prix de Rome within two years (in reality it took twice as long). Such confidence is testimony to the fact that the identity of a student's teacher could be decisive for Ecole success, even though study in a master's atelier had no part in the institutional structure of the school. The adage "qui dit école dit émulation" had a hidden meaning: rivalry involved professors as much as their protégés, professors who played out their own games of enmity and alliance using students as pawns. How? Take the case suggested by Carpeaux's letter, that of Rude. Carpeaux was the only student taught by Rude to win the Prix de Rome, and his success, of course, came only after he had left Rude's tutelage. Even more remarkable is the fact that, while he was there, Rude's students advanced to the Prix semifinals only eight times out of a possible ninety-six—and half those successes were Carpeaux's.[10] On this basis it seems as if Carpeaux's assessment of his chances with Rude as his teacher was pretty accurate. But the students of Etex or Maindron or Elschoecht could complain with equal justification; between 1830 and 1863 only six ateliers—those run by David, Pradier, the partnership of Ramey and Dumont, Duret, Toussaint, and Jouffroy—produced prizewinners. Six masters taught thirty-four winners.[11] Statistically that works out to 5.66 students per master; actually it is five for David, eight for Pradier, ten for Ramey, Dumont, or the two in collaboration, six for Duret, four for Jouffroy, and one for Toussaint. Toussaint alone was not a teacher at the Ecole, though it should be added that Duret was named professor only in 1853. The conclusion is inescapable: Ecole teachers favored their own. They ran the largest ateliers, and their students were the most likely to advance in the educational system.

So the customary complaint stands up under investigation. Despite its national stature and the evenhandedness such responsibility should imply, the Ecole nonetheless served as a link in the chain of patronage and privilege which circumscribed success in Paris. Of course not all students jockeyed for positions with the masters who promised official rewards. Often the choice was in the hands of parents, not pupils, and teachers were selected by other criteria, like a common provincial background, or simply by word of mouth.[12] Rude, who was born in Dijon, always taught a contingent from the Côte d'Or, while David d'Angers enrolled students who shared his birthplace. The Genevan Pradier usually numbered several Swiss among his coterie—the pattern is clear. In cases like these, it was the pull of familiarity, belief, and custom which attracted students into a teacher's orbit more than any promise of success. Thus it comes as no surprise that tradition prefaces Carpeaux's work at Rude's with study in 1841 under Louis Auvray, a Valenciennes-born sculptor who soon turned art critic, and then in 1843 with his countryman, the painter Abel de Pujol.[13] And it is worth remembering that Duret's father, the sculptor Joseph, was born in Valenciennes.

Considerations like those Carpeaux outlined in his letter to Dutouquet entered the picture when success was a student's goal—and this in turn suggests that when Carpeaux joined Rude in 1844 he was motivated by factors other than the desire to get ahead. His sights may not yet have been set on success in its official sense, or he may simply have been poorly informed. Some such conclusion seems warranted if we compare his reasoning in 1850 with the thinking of another aspiring sculptor, J.-J. Perraud (1819–77), who won the Prix de Rome in 1847. Five years earlier Perraud mulled over a similar choice, and had few illusions about his chances with Rude: "David d'Angers, the only sculptor whom I knew by reputation in that period, and whom because I admired him I certainly would have preferred as a professor, had just left his students; Rude, who was neither a member of the Institut nor a professor at the Ecole, replaced him and recommended an entirely different system of training."[14] Against Rude's drawbacks Perraud weighed the advantages of the studio run by Ramey and Dumont. Not only was it frequented by Perraud's *lyonnais* compatriots, but three of its members had won prizes in the 1842 Rome competition. That news decided Perraud. All he had left to determine was which of his two new masters he would take for his special protector, and then settle down to earn the Prix de Rome himself.[15]

It is entirely possible that Perraud's story is colored by being written in retrospect, yet I doubt that he misrepresented his motivations. They are too circumstantial, too much in keeping with Carpeaux's testimony and what is known about Rude as a teacher. Perraud's facts can be tested: he gets his dates right, for example. For many years Rude had resisted teaching, despite friends' urgings, because he did not wish to involve himself in a system of privilege which students like Perraud took for granted. He gave in only in June, 1842 (the year Perraud made his choice), and then only reluctantly, at the insistence of a group of students left without a teacher when David d'Angers closed his studio.[16] To replace him, David first recommended an old pupil, Husson, then the academician Petitot. Rude was the third choice—he and David never saw eye to eye. And at first Rude too refused the job, on the grounds of his dislike for the institution teaching had become. In his eyes it had been corrupted into a kind of mockery of the dealings between patron and client in ancient Rome. Students were dependants, offering respect, loyalty, service; the master, like some lofty patrician, supplied his official influence to win them honors and commissions, and was repaid by more respect and adoration, mixed with not inconsiderable doses of flattery and imitation. The system was pernicious and unworthy, Rude wrote, and closed

to him at any rate because he had no influence to bargain with, and espoused an idea of teaching in which imitation played no part. His goal was the opposite: to impart "the means of artistic freedom and the habits of an independent spirit."[17] The program appealed to his petitioners. After "careful thought" they sent another letter, unfortunately couched in the fawning tones Rude feared, declaring their persistence "in wanting no other master but him" and "promising never to cease making new efforts to merit his precious counsel more and more."[18] Rude gave in (perhaps the barrage was too much for him) and opened a studio at 74, rue d'Enfer.

Two years later Carpeaux joined it; when he enrolled at the Ecole on October 2, 1844, he went backed by his new master's recommendation.[19] Why then *had* he turned to Rude, when someone like Perraud avoided him? It is not easy to be sure, but there are bits and pieces of evidence which point to Rude's having been chosen for Carpeaux *because* of the teaching he offered. Admittedly the clues are rather faint; deciphering them involves tracing the outline of a peculiar liberal network of support which saw Carpeaux through this stage of his career. Its chief members were Jean Baptiste Foucart and Victor Liet.[20] Like Carpeaux they were from Valenciennes. Close in age, some ten years senior to Carpeaux, the two formed a friendship as schoolboys and continued it in Paris in the early 1840s. Foucart was then a hopeful dramatist; Liet, a mere clerk for Lafitte and Caillard's parcels office, though apparently supportive of his friend's greater ambitions. The relationship survived Foucart's return home to become a lawyer. Liet's letters continued to discuss their common interests: Molière, mutual friends, a case Foucart had argued that was reported in *La Démocratie Pacifique*. And they exchanged news of Carpeaux—his drawings, his *concours*, his bas-reliefs. Clearly the young sculptor's education was something of a project with both men. It seems that Liet was responsible for introducing him to Rude and, moreover, that he sought out that particular teacher because of a real or imagined connection with a theory of education to which both he and Foucart subscribed. The theory was a kind of self-help system devised by Joseph Jacotot (the educator actually lived in Valenciennes in the 1830s, and Foucart, at least, had studied with him). Jacotot taught that art communicates through sentiment and that aspiring artists should ensure the clarity of their utterances by investing them with a unified, coherent expression of it—*l'unité de sentiment*, to use his term.[21] Liet professed to find this quality not only in Carpeaux's efforts of the mid-1840s, but also in Rude's works, when he visited the sculptor's studio with his young friend in tow. (Perhaps it is not entirely coincidental that Rude and Jacotot were neighbors in the rue d'Enfer until Jacotot died in 1840.)

Some version of Jacotot's method stuck with Carpeaux; years later, in Rome, the term *unité de sentiment* crops up in his notes and betrays Liet's lessons years before. But more important than individual teachings is the intellectual attitude Jacotot espoused. For him facts were the starting point for everything. At first they need not be understood, only repeated till understanding came. Intellectual emancipation followed: "I believe that God created the human soul capable of instructing itself alone, without a master."[22] Out of this creed, Jacotot devised a technique for learning. His beliefs came close to Rude's own emphasis on individualism, and to his method, as we shall see. They were also colored by the kind of explicit morality which seemed, to some observers, to tinge both Rude's life and art. By the time of his death Rude meant simplicity, moral habits, and republican politics, all of which, with the man himself, survived anachronistically into the Empire. Though it was the fashion to be clean shaven, he wore a beard to the waist, and did not blush to wash his arms at a public fountain after the day's work was done. The description comes from an essay by Théodore Silvestre, one of Rude's first biographers; his amused

tolerance for such backward habits is unconcealed.[23] Nonetheless I believe Carpeaux was sent to study with Rude exactly because of these personal qualities, and I want to cite one further shred of evidence for that hypothesis. It is a passage from Foucart's brief biography of his younger friend, an analysis of Carpeaux's shift from Rude to Duret.

> From Rude's atelier, where he made a start, Carpeaux went to that of Duret, perhaps a better artist in the grace and elegance of his forms, but who did not have, like his first master, that force of character, that energy of conception which are necessary to an artist, not just for himself but also for his students.
>
> On contact with the new milieu in which he found himself, Carpeaux straightaway lost his first theological beliefs (as was inevitable) and found himself like every artist nowadays with nothing to replace his lost faith and on that account given over to the sole motivation of artists of our generation: vanity![24]

This passage says as much about Foucart's view of Duret as it does about Carpeaux or Rude, but it also offers one more interpretation of the trade-off Carpeaux made in 1850, stating it boldly in moral terms: when Carpeaux entered the world of success, he left the healthful old ways behind.

It is difficult to tell whether Rude's character or the fact that he inherited his first crop of students from David had the greater influence on the size of his studio. In any event, it was larger than those run by most unaffiliated sculptors. The Académie's opposition therefore meant the exclusion of students of one of the most important outsiders. But Rude's distinctiveness as a teacher was not a matter of sheer numbers alone. More substantive issues were at stake, issues of practice and method, the visible signs of contradictory conceptions of making sculpture. Like the Ecole, Rude was credited with an educational system, the method which Carpeaux characterized in terms of measurements and métier. Other, more sophisticated writers agreed.[25] Charles Baudelaire, for example, believed that Rude's "practical and painstaking" instruction was special enough to have had its own profound, sometimes deleterious effect on contemporary sculpture. That influence was one of the themes of Baudelaire's 1859 *Salon*, where again and again he rated Rude's students in terms of their debt to the master.[26] (Thirty sculptors that year, Carpeaux among them, had listed themselves as Rude's pupils.) Yet Rude himself described his training in more metaphysical terms, claiming to offer "freedom" rather than any practical, measurable effect.

In the face of such divergent estimations, we are the more eager to know what this liberating and dangerous system was. It might be enough to say with Carpeaux that it was the opposite of what the Ecole taught, and proceed directly to our study of state instruction. But we can go further, since Rude figures as a teacher in several contemporary accounts. Silvestre, for example, boiled his method down to this dismissive prescription: "Rude's instruction can be more or less summed up as the collection of all the geometrical techniques used by every worker in sculpture asked to reproduce a given model in marble— in other words, the pointing system."[27] Rude did not give lessons in art because he believed it could not be taught. Instead he demonstrated métier, the essential prerequisite of art, as the *only* thing a sculptor could impart to a student. His "method," such as it was, demanded three steps: first, the general examination of proportions; second, the construction of the bony structure or armature; and then, finally, the addition of the musculature in clay, so that gradually the model was reproduced. Exact observation and mensuration with the aid of a rule, compass, and plumb line were Rude's "method," and his guarantee of success; they addressed the living model, "well posed and sure of the pose."[28]

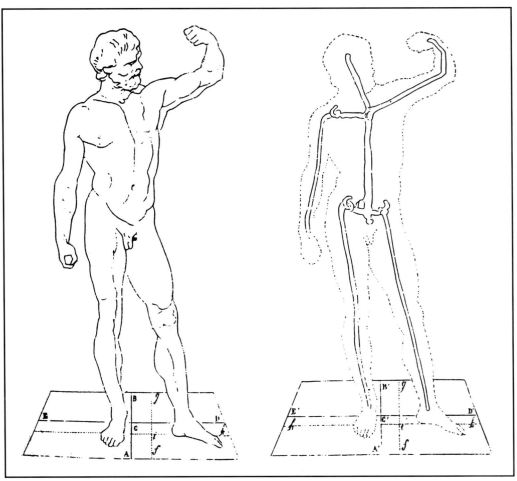

48. A model and an armature demonstrating Rude's sculptural system. From M. Legrand, *François Rude, sa vie, ses oeuvres, son enseignement*, 1856.

This is clear enough, as far as it goes. But it hardly suggests a method strict enough to have the impact Rude's was credited with. A more detailed account was published soon enough, however, a year after Rude's death. Its author, Rude's former student Maximin Legrand (b. 1819), undertook it not just as a pious duty but also to replace the lessons his master would no longer give. "Rude wrote nothing and it falls to those who heard his words to transmit them, since they form an education. They must be given entire."[29] So Legrand reported Rude's method in detail, like him beginning from three fixed points on the model's body; the first is found between the clavicles where the sternum forks; the second reference, also along the body's median, is marked by the pubic symphisis; the third corresponds to the inner projecting part of the tibia at the ankle, the malleolus, which carries the greatest amount of weight. These and succeeding points were marked on the armature with wooden pins which acted as reference points while the sculpture was being executed. Of these three points, the first, from which the others are measured, is most important. With the aid of a plumb line, a line AB, a point C along that line, and a perpendicular DE at C are constructed on the surface on which the model stands (fig. 48). This configuration is transferred to the plinth on which the statue is to be modelled, and using a large compass, the original mid-clavicle point is established on an armature already lightly covered in clay. The same process is carried out to transfer the

two remaining markers. Together these three points form the "firm tripod," the "solid base" of a sculpture, which would guarantee that it would be well grounded and stand erect.

At this point in the demonstration Rude is supposed to have told his listeners, "Now you are already in control of the general movement of your figure's skeleton and by extension, of the whole figure."[30] The process was not over, though, once these three principal points were established; by a similar method other bony projections of the model's body were located on the armature—on the front of the body, these were the shoulders, the two projecting pelvic bones, the kneecaps, and the malleolus of the second leg. (Zealous students, said Silvestre, would daub ink on the model's skin to pick out these spots.) On the posterior face, two references were established. The first, at the projecting vertebra marking the juncture of the head and neck, was determined from point C. The second, a point at the sacrum, was taken in three measures from the neck vertebra, the hip, and the pubis to determine, in this case, not length, but thickness.

Rude apparently practiced what he preached; it is not often that we can say so precisely how an artist proceeded. His dependence on this method meant that he began the whole process afresh for every figure he modelled. For each sculpture it had to be adopted *in toto* or not at all: each step is sequential and contingent. Only by sticking the course, following the procedure every step of the way, could its purpose—the reestablishment in inanimate matter of a posed living body—be fulfilled. Using descriptive geometry and an engineer's tools, the scheme transfers to clay and iron some of the particular physical properties, like weight and balance and interrelationship of parts, of the flesh it is meant to represent. And that, of course, was where the problem lay, at least according to the Institut—there, in the direct relationship between Rude's meticulous method and observable, reproducible fact. Could Art be made by a means that kept so close to Nature? Silvestre, for one, thought not: "Obedient and timid before external appearance, he respectfully called any five franc model Nature, and thus restrained the freedom of his own impressions. But in copying this or that man perfectly, he did not translate humanity."[31] Poor naive Rude, who fooled himself that any naked body could stand for Nature, or even Humanity—this was the Académie's objection precisely. By 1863 Rude was judged a founder of sculptural realism, because he could see Nature in nature, or perhaps nature as Nature, without submitting it to the corrections the Académie demanded to trim it to the predetermined shape of Art.

There is more to Rude's teaching than this method alone, however. Or, perhaps better stated, less, since the core of his educational philosophy was the axiom that art could not be taught. His instruction imparted a means—it was left to the student to achieve whatever end he could. Rude taught only a way of working; a worker's way, in fact. Such practical instruction did not sit well with either the century's myth of artist as genius or the confidence that art *was* teachable, if the teacher was the Ecole des Beaux-Arts. The threat was manifest at the level of both theory and practice. No wonder that an ambitious student like Carpeaux eventually negotiated a change. When he left Rude, he had been with him for six years—long enough to learn a method, but also to mull over just how seldom his fellow students advanced along the path to official success. During his stay, in fact, one glaring example of discrimination became something of a cause célèbre. In 1846 a contingent of Rude's pupils—"toute une école," wrote Thoré—was denied admission to the Salon.[32] They were not the only victims of the jury that year: of the 5,000 objects submitted more than half were turned away; 2,412 were accepted. But according to Thoré, the refusal *en masse* of a block of Rude's students (he numbered them at sixteen) was no

coincidence. They were not allowed to show because their works demonstrated independence of character and energetic talent—in short, because they were Rude's students. The men "without monuments" on the jury, artists who had never sculpted anything, must be jealous, Thoré reasoned. Not, evidently, of the achievements of a group of students, who after all had submitted rather commonplace work, a *Virgin*, a *Prodigal Son*, a *St. Peter*, a *Mourning Angel*. The jury must have been jealous of Rude, who despite his lack of institutional affiliation was in the process of creating a monumental, national art. In fact, Thoré devoted a long section of his 1846 *Salon* to Rude's *Napoleon Reawakening to Immortality*, which was not even part of the formal exhibition but which Thoré had seen at the studio. The *Napoleon* and the *Departure of the Volunteers*, Rude's great relief on the Arc de Triomphe de l'Etoile, were the kind of sculpture France needed, Thoré thought, even though France did not seem to know it, and insisted instead on commissioning its national monuments from men unable to do the job.

Thoré exaggerated a bit when he wrote about Rude's students in 1846. The Salon catalogue indicates that five did actually exhibit.[33] And the Salon registers, the administrative records of all works submitted, show that only eight others were refused.[34] But whether there were eight or sixteen refusals does not really matter. The point is that an idea of persecution and failure passed into the public conception of what "being Rude's student" amounted to, and, second, that his tutelage could clearly have a negative effect.

In all of this, the actual *meaning* of Rude's teaching for the works students produced tends to get submerged. We would like to be sure, for example, that Rude's students *were* badly treated, that there was no significant difference in idea and execution between the refused sculptures and the ones the jury let in—between the *St. Peter* that was turned down, say, and the *St. John* that was shown. And it is exactly this kind of knowledge which is the most elusive. Rude's students were not at all successful until the 1850s; the majority of their earlier works have disappeared. The most we can tell from titles is that together the refused and accepted works made up a fairly wide-ranging yet nonetheless standard collection of religious, republican, funerary, and historical subjects, with a generous sprinkling of portraits. A photograph of one of the excluded pieces, *Le Démon du jour*, does survive, however (fig. 49). Its author, Guy Lhomme de Mercey, had been a pupil at the Ecole de Dessin in Dijon, Rude's native city; he entered the atelier in 1842, one of the group of men who came from David d'Angers.[35]

Dated 1845, *Le Démon du jour* was evidently executed during its author's stay with Rude. At first glance, however, it looks more Romantic than like anything the master himself ever did. Its imagery is borrowed from the repertoire of the small-scale statuette; it is J. J. Feuchère's *Satan*, for example, done again life-size (fig. 50). But that impression is at once contradicted by the fully naturalistic, anatomically exact rendering, not just of the human form, but also of the bat's wings which enframe it. The figure is not so much demonic as skinny and old. Its gnarled, lumpy muscles and creased belly all strike us as specific things seen. Here we are confronted with Rude's method in action; it is easy enough—and surely legitimate—to make the link between the procedures just described and this particular sculpted anatomy. Its position is that of display: what is on show is mastery of the complications (the awkwardness) of the pose. The body is bifurcated along a line of action and relaxation; its left side is at rest, while the right arm and leg, by contrast, both project forcefully to carry the body forward. Yet the extension is properly counterweighted—we can almost feel those plumb lines in action—so that animation is achieved without the sacrifice of balance and a convincing posture.

All of this meticulous procedure is nonetheless used to render a subject which Rude

himself would never have treated, a modern-day allegorical hybrid of the type Thomas Couture was fond of painting. The sculpture, Lhomme's biographer tells us, is about a prevalent contemporary illness—the insatiable love of gold—and its power to destroy the arts. And for all the statue's physical exactitude—the signs of bodily decrepitude, the pointing finger, the book and pile of coin at the old man's feet—it is not clear that the viewer would grasp the work's meaning without some prompting. Naturalism in the end works against allegory, or puts itself in place of it. Such explicit physical particulars—the baldness of the head, the cut of the beard, the incongruity of those bat's wings—open, by virtue of their very particularity, the question of their appropriateness as vehicles for the sculpture's meaning. We end up wondering if they function as such vehicles at all.

Was this the reason for its refusal in 1846? Probably not: the sculpture was accepted in 1849 and awarded a third class medal. What had changed in three years was not the work itself, nor the public, but the jury and its openness to odd, discrepant realism of this kind.

It is tempting to see in this statue the two qualities most often cited as characteristic of Rude's teaching: his painstaking, scientific approach to construction, and the freedom he gave students to develop their individuality. Importantly enough, Lhomme de Mercey's sculpture, though consciously anti-academic, is not Rudian in theme. Self-improvement and self-liberation were the two talents the master aimed to give his students; he meant, to repeat his credo, "to place in their hands the means of freedom and to teach the habits of an independent spirit." This is the language of social reform, of contemporary utopian communities—it is no accident that the motto Rude chose for his studio promised "A chacun selon ses oeuvres" (To each according to his works).

49. Guy Lhomme de Mercey, *Le Démon du jour*, 1846, plaster. Destroyed.

50. Jean-Jacques Feuchère, *Satan*, 1850, bronze from a model of c. 1833. Los Angeles County Museum of Art.

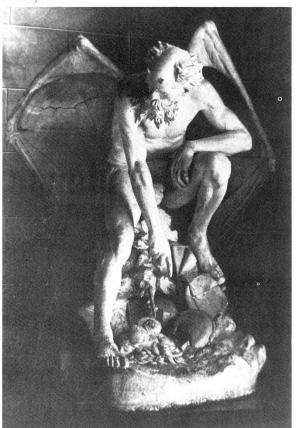

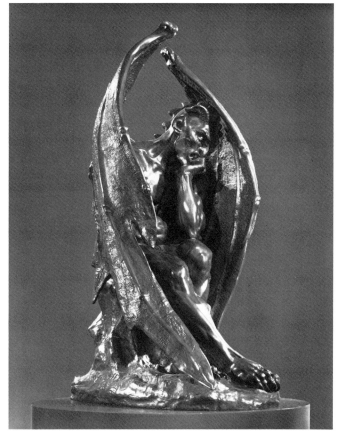

It is equally tempting to try to identify a work by one of Duret's students, one which looks appropriately imitative of the "best Greek style," and match it against *Le Démon du jour*. Tempting, but in the end insufficient, since the importance of the opposition between Duret and Rude is not so much a contrast between the methods of two individuals—the "Greek" and the "scientific," we might say—as between the approaches of a man and an institution. By this is meant simply that while Rude was credited with his own educational system, Duret must be considered, following Carpeaux's lead, a representative of the Ecole. Duret taught students as he himself had learned. He knew from experience how the Académie's brass ring could be seized, and Carpeaux caught his confidence. There is an intense seriousness to the tone in which Carpeaux described his plan of action in 1850: envoys and interviews, an evaluation made, and a program drawn up. And if Duret knew how to guide Carpeaux, it was because of his own fruitful involvement in the official art system.[36] After his return from Rome (he had won the Prix in 1823, at the age of nineteen), his career never faltered. He was soon caught up in competitions and commissions, the "thousands" of projects he described to his friend Dumont

51. Francisque Duret, *Mercure inventant la lyre*, 1828–31, plaster (h. 150). Musée des Beaux-Arts, Valenciennes.

52. Francisque Duret, *Jeune Pêcheur dansant la tarentelle*, 1832–33, bronze (h. 158). Musée du Louvre, Paris.

53. François Rude, *Mercure rattachant ses talonnières*, 1827, bronze. Musée du Louvre, Paris.

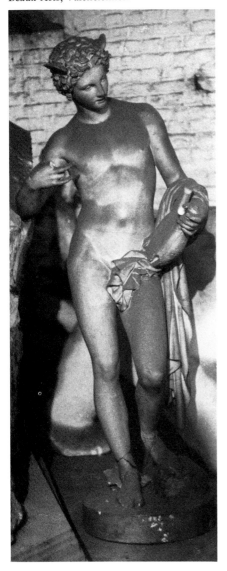
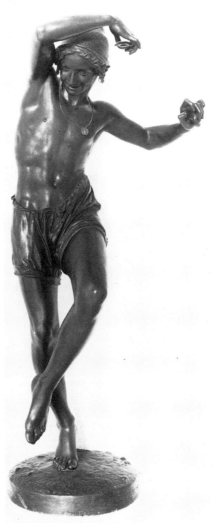
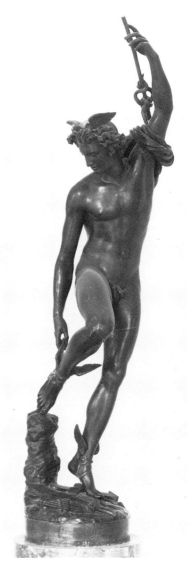

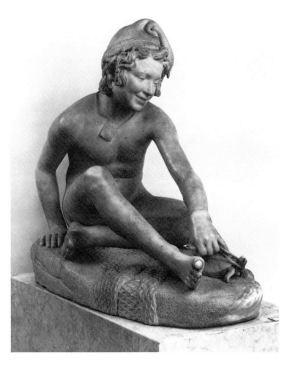

54. François Rude, *Petit Pêcheur napolitain*, 1833, marble (h. 77). Musée du Louvre, Paris.

back at the Villa Medici: "My *Mercury* advances, my *Head* is finished, I'm going to begin my *Saint* for the minister. And I intend to compete for the Madeleine. I've gotten a part of the frieze for the arch at the Etoile, but we're being paid so little—1,200 francs for 10 feet of modelling—that we've all refused this amount and are waiting for their reply."[37] The *Mercury Inventing the Lyre* (fig. 51) and the head, *Malice*, were both shown in the Salon of 1831; two years later the *Young Neapolitan Dancing the Tarantella* (fig. 52) confirmed his success.

It might seem simply coincidence that Carpeaux's two teachers chose similar subjects to launch their careers in the Parisian art world. Rude too exhibited a figure of the messenger god, *Mercury Reattaching his Wings* (fig. 53); it appeared at the Salon of 1827 on his return from twelve years of exile in Brussels. And in 1833 he showed a *Young Neapolitan Playing with a Tortoise* (fig. 54): his and Duret's *Neapolitan* were inevitably branded "sibling" sculptures by the press.[38] These overlapping subjects are more than coincidence, however. Despite the difference in their ages—Duret was not yet thirty, Rude over forty—each was making a debut before the public. In selecting these themes, both counted on the guarantee of acceptance attached to an antique subject and the exotic novelty of a romantic one.

Given this similarity, the works could hardly have made more different statements as to their authors' skills and aspirations. To elaborate: in the late 1820s, when two artists chose to represent a familiar subject like Mercury, they automatically accepted the constraints—primarily, those governing intelligibility—imposed by the subject. Yet within these confines there was a certain amount of latitude which lay mostly in what Mercury was shown *doing* and how that activity jibed, or did not, with what was normally prescribed. Rude's decision was the less conventional one, because in representing two actions simultaneously—movement and concentrated attention—it divided the work's energy and focus. His Mercury is action arrested, flight checked, a technical tour de force achieved by an understanding of the malleable tension of bronze. Duret, by contrast, rendered his subject in the calmer medium of marble and controlled it by *closing* both pose and gesture. The god's limbs curve inward like parentheses enclosing his body and its action, and our

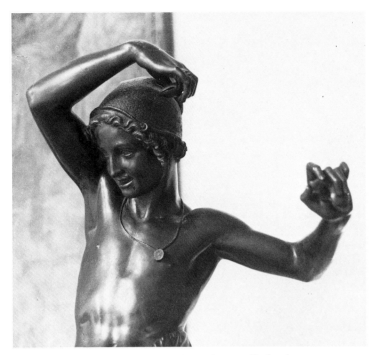

55. Francisque Duret, *Jeune Pêcheur dansant la tarentelle*, detail. 56. François Rude, *Petit Pêcheur napolitain*, detail.

perceptions. Mercury's attentive attitude, as he raises his hand to play the new-made lyre, holds *our* attention within the confines of the figure.

It is too simple to say that the relationship of the two Neapolitan fisherboys reverses that of the Mercuries, although now it is Duret's bronze that is active and movemented, and Rude's marble which is quiet and enclosed. Such a statement puts too little stress on the two works' shared subject matter, and the way each artist's decision about how to render it states an attitude towards sculpture and the meanings it makes available. The works *are* sibling sculptures, as the critics declared. Their relationship is evident in details like the knitted cap and medal each boy wears, which immediately transport him—and the viewer—to the sunny bay of Naples, and allow a linkage to whatever ideas about the place the viewer may hold. (In the early 1830s these ideas chiefly centered on its exotic primitivism.) Nonetheless the differences between the two sculptures erode this initial affiliation. They lie first in medium. Duret's figure is a bronze, and once again the metal seems to have been chosen as the material best suited to action and incompleteness. Now it is Duret's work which manifests movement. Its silhouette is broken by the angularity of lifted arms and raised leg, of bent wrist and cocked finger. Each angle clacks out a slightly tinny cadence, like the castanets the dancer holds—a sculpted rhythm in its way as unfamiliar to the Paris audience as the tarantella itself (fig. 55). The medium makes this movement possible, but both ensure that the sculpture remains "exotic," at a perceptual distance from its public; Duret traced the origins of his figure to a scene he had witnessed in Naples.

Rude's figure, by contrast, is purely Parisian, a combination of his observation of a model's easy studio pose, and the necessary learned vocabulary of attributes; without them his figure would have been trivial, just a boy and a turtle. When the artist finally visited Naples a decade later, he confessed his relief at finding that fisherboys really did wear those knitted caps. The relief, we may conclude, was all the greater since what the sculpture essentially claimed to offer in the first place was a kind of accuracy, the suggestion of

57. Francisque Duret,
Molière, c. 1834, marble
(h. 150). Comédie Française,
Paris.

58. Jean-Baptiste Carpeaux,
after Duret's *Molière*, c. 1851,
pencil on white paper
(12.8 × 7.5). Musée des
Beaux-Arts, Valenciennes.

59. Francisque Duret, *Venus
au milieu des roseaux*, 1840,
bronze (h. 250). Fontaine des
Ambassadeurs, Champs-
Elysées, Paris.

60. Jean-Baptiste Carpeaux,
after Duret's *Venus*, c. 1851,
pencil on white paper
(13 × 7.5). Musée des Beaux-
Arts, Valenciennes.

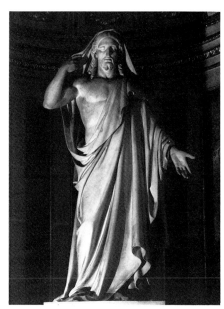

61. Francisque Duret, *Christ
se révélant au monde*, 1835–40,
marble (h. 250). Eglise de la
Madeleine, Paris.

62. Jean-Baptiste Carpeaux,
after Duret's *Christ*, c. 1860,
pencil on white paper
(15.4 × 8.7). Ecole Nationale
Supérieure des Beaux-Arts,
Paris.

63. Francisque Duret, ceiling of the Salle des Sept Cheminées, finished 1857, polychromed and gilded plaster. Musée du Louvre, Paris.

having seen and rendered directly—a claim made most effectively in the figure's soft matte marble surface, which has the force of flesh (fig. 56). Rude's figure is warm where Duret's is hot: they each establish a different dialogue between the real and the exotic, where that exchange defines an attitude towards sculpture's range of meaning. In the end it is unimportant whether Rude's boy is Neapolitan or not; it is the body that matters, not its being from somewhere far away. For Duret, the foreign flavor is essential.

Needless to say, the coincidence between Rude's and Duret's choice of subject matter did not last long. Yet Duret continued to define his identity as a sculptor in terms of his first successes, the works of the 1830s. In a letter of 1843, for example, written to David d'Angers to ask support for his candidacy to the Institut, he called himself not just the author of *Molière*, the full-size historical figure he sent to the Salon that year; he also cited the *Young Neapolitan, Malice,* and *Mercury*, successes then a decade old, and he drew up essentially the same list in another petition.[39] And since he seldom exhibited in the 1840s, these earlier pieces remained to a great extent the source of his reputation until the 1850s.

Duret's sculpture was also at the heart of his teaching. Among the hundreds of drawings in Carpeaux's notebooks there is evidence to suggest that the master, if he did not make copying his work a requirement, at least managed to suggest that such exercises might be useful. In the 1840s Carpeaux does not seem to have drawn after Rude, but after 1850 he studied the *Molière*, for example, and the *Venus*, the crowning element of the Fontaine des Ambassadeurs erected on the Champs Elysées in 1840 to Hittorff's designs (figs. 57–60).[40] In both, Carpeaux noted the essential of each figure rather than exploring any one of its aspects in depth, as he would do later in his career when copying other works by Duret. In a notebook drawing of Duret's Madeleine figure, *Christ Revealing Himself to the World*, sketched in the early 1860s (figs. 61–62), a blunt scratchy crayon dwells on the stiff folds of drapery which weight the figure and give it its imposing character.[41] In the earlier drawings, by contrast, quick light lines interlock to suggest flowing hair, a swathe of cloth, or the fussy details of period costume. In each case they note the signs that mark the figure's identity as Molière or Venus.

Dutiful consideration of the master's achievements was an old studio tradition. Duret

evidently ran his studio in the traditional way. This meant not just setting exercises; it also involved asking a student's collaboration to get work done. Even Rude used student assistants: one Gaston Guitton, for example, seconded him on the monument to Maréchal Ney, while his acknowledgement of the assistance of his "jeune élève Christophe" on the *gisant* of Godefroy Cavaignac was cast into the piece itself. Carpeaux often collaborated with Duret. There was a bust that he executed and Duret merely signed (which one, we do not know), and the decoration of the Salle des Sept Cheminées at the Louvre, and Duret's fine figure of Chateaubriand (figs. 63–64).[42] The master asked his pupil's help to finish the latter in a letter of about 1852; another letter asks for "un coup de main."[43] Given the absence in most ateliers of any formal curriculum, the experience gained from lending a hand, mounting a bust, polishing a marble, added up to a kind of *ad hoc* instruction, one of the principal benefits a private studio had to offer.

If, like Carpeaux, a student worked at his master's right hand on full-fledged commissioned sculpture, he necessarily gained at least some familiarity with the economy of studio practice—how a sculpture was taken through its many stages until final delivery to the client. When Carpeaux went round to help Duret finish the *Chateaubriand*, for example, he may well have known the kinds of studies which preceded it: labored schemes typical of Duret's tight, gritty little drawings, whose dark, heavily worked lines, like pictures by grade school boys, are the work of someone who holds his crayon tight and sets down an idea which is already fully realized in his mind (fig. 65). Duret's sketch for the *Chateaubriand* already maps the easy posture with which he will characterize his man of thought. The terra cotta maquette which followed (fig. 66) maintains that posture unchanged, simply translating it into three dimensions through a technique neither loose nor dry, elliptical, yet fully suggestive of the final appearance of the statue. The technique

64. Francisque Duret, *Chateaubriand*, 1849–54, marble (h. 155). Institut de France, Paris.

65. Francisque Duret, *Study for Chateaubriand*, c. 1850, pencil on white paper (10.5 × 6.4). Musée des Arts Décoratifs, Paris.

66. Francisque Duret, *Chateaubriand*, c. 1850–51, terra cotta. Location unknown.

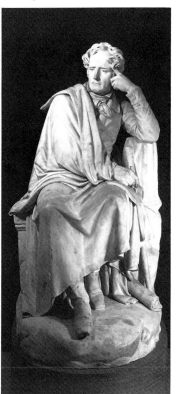

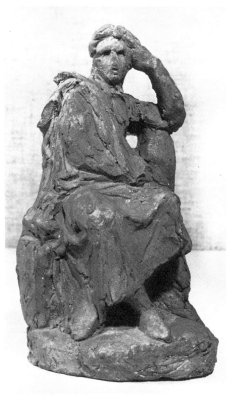

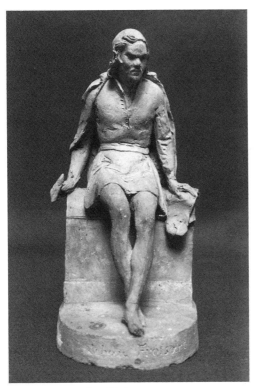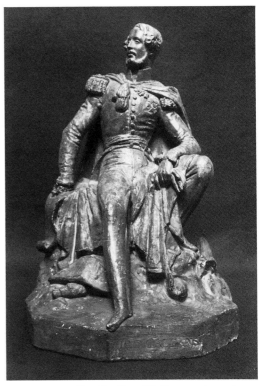

67. Henri Lemaire, *Froissart*, c. 1852, terra cotta (h. 28). Musée des Beaux-Arts, Valenciennes.

68. James Pradier, *Le Duc d'Orléans*, c. 1842, plaster with terra cotta colored patination (h. 42.5). Musée des Beaux-Arts, Valenciennes.

is Duret's own; it contrasts strongly with contemporary sketches like Lemaire's clay study for his monument to Froissart (c. 1852; fig. 67) or Pradier's earlier model for the memorial to the Duc d'Orléans (*c.* 1842; fig. 68). Both are smoother, more finished, subordinating the individualized *facture* possible in a sketch to a concept of completeness meant to evoke the presence of the final work. Carpeaux evidently absorbed his master's technique of manipulating clay. His study of *Philoctetes*, modelled for the Prix de Rome competition of 1852 (figs. 69–70), imitates many of Duret's characteristic sketch mannerisms: the indentations of a stylus to indicate facial features, a willingness to leave lumps unsmoothed into a uniform surface. These are qualities which all mid-century sketches do not share.

Of the several aspects of Carpeaux's study with Duret, the most difficult to document, oddly enough, are those he described in his letter to Dutouquet: the work in museums and at home, learning the best Greek style and anatomy. This is not because an interest in both is not discernible in his work. Anatomy, for example, clearly occupied his mind throughout his career. He purchased a set of anatomical drawings by Delacroix which was still in his possession when he died, and he conserved a whole group, some fifty, of his own anatomical studies which may well date from the early 1850s.[44] It is just at this time, moreover, that he was hired as *répétiteur* in the anatomy class at the Petite Ecole. It seems important in this context that anatomy was Duret's specialty, even his passion. Though nowhere is this particularly evident in his sculpture, it apparently came out in his teaching. The most extensive account we have of Duret at work in the Ecole des Beaux-Arts makes that interest its theme:

The amphitheatre was full when it was known that Duret was posing the model. Upright, penetrating, pitiless, he arrived and gave his review quickly, like a military surgeon going over the ranks of the wounded. Brusquely but precisely he criticized first move-

ment, then proportions, then contours. He stressed the proper value of the muscular mass from the point of view of exertion as well as of beauty; he had an absolutely accurate perception of false alignments and of equilibrium. For him, balance, veiled by living forms and by an intelligent construction, was the fulfillment of art.[45]

The description comes from the eulogy of Duret written by Charles Beulé, secrétaire perpetuel of the Académie; its imagery is telling. Duret had the manner of a military surgeon, brusque and probing, as he arranged the model's body to best advantage or rooted out the mistakes in students' efforts to render it. The emphasis on his innate sense of accurate proportion, of course, is reminiscent of Rude's teaching—and brings home again the basic difference Carpeaux drew between them. Duret's passion for accuracy was a thing of perceptions, whereas with Rude it was a matter of science. Duret verified with his eye according to an instinctive standard, while Rude used tools to true his figure to the living form. That contrast is implicit in this passage, just as the suggestion of "proper values" and false alignments invokes their opposite. If there are proper values then improper ones must exist as well; a notion of false alignments demands true ones.

For the thirteen years of Duret's tenure at the Ecole, the true and proper values he professed merged perforce with Ecole teachings; they *were* those teachings, at least while Duret was in the amphitheater. Yet they do not define the Ecole curriculum. Despite all the help a student might get from an individual professor, success at the Ecole meant

69–70. Jean-Baptiste Carpeaux, *Philoctète à Lemnos*, sketch 1852, patinated plaster (h. 38). Musée des Beaux-Arts, Valenciennes.

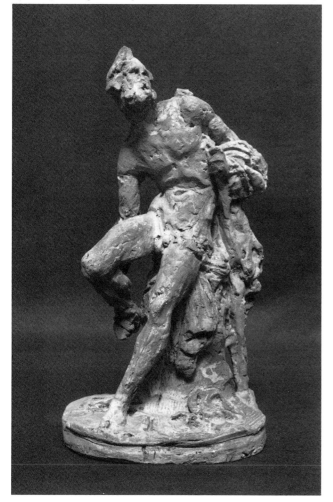

mastery on its terms, within its structure. Success demanded an entry into a self-defining sculptural system that working with an individual master did not quite ask. It is significant that in his letter to Dutouquet, Carpeaux wrote both that he had learned "the first elements of the sculptor's art" from Rude, and that he was about to learn anatomy, "the alphabet of the sculptor's art," from Duret. Common enough analogies in writing about art, but nonetheless apposite. The Ecole believed that it taught more than alphabets or rudiments: it taught an artistic language.

COMPETITIONS AND CURRICULUM

The adage which opens this chapter could easily read: "qui dit école dit concours." It would not scan so well, but its meaning would not be significantly altered, since the complicated fabric of competitions was the essence of the Ecole curriculum. The annual calendar, painstakingly transcribed by the school secretary after the November meeting of the Conseil d'Administration, shows the frequency with which they marked the passage of time: *concours antique, de composition, de la figure peinte, de place, d'arbres, d'après nature, de la tête d'expression*. Competitions were followed by judgements and spaced out by free study until the cycle started again the following year. But simply examining a calendar does not give a clear enough idea of this ritualized progress to make the ritual live. Even the notebooks of a determined student like Carpeaux, in which he faithfully listed the dates of coming competitions, and later, their results, are not sufficient.[46] His letters alone suggest the emotional pitch of his involvement in the school. He hastily, angrily, reported failure: "not much time to let you know the outcome of the competition for the *tête d'expression*, which has just been judged, and in which I wasn't as well rewarded as I could have hoped, at least according to the praise which the artists gave me during the public exhibition which took place this morning. I'm furious and disappointed at the outcome."[47] He recorded determination: "You know how busy one is during a competition, especially when you want to end up among the front runners. I've been ill for a long time, but I'm blocking it out and working with the intention of doing better in this year's contest than ever before."[48] Carpeaux poured out letters like this every year he was a student; they can stand for the hundreds of such epistles posted home to the provinces by fledgling artists. But even this evidence, revealing as is its emotional tone, is not enough to inform us completely about the Ecole system. The key to the *concours* is the regulations which governed them, a detailed, extensive set of stipulations distinct in several important points from the rules governing painting.[49] They decided students' admission to the school, controlled their production there, and dictated the conditions under which they left the place. The Ecole *règlements* are exhaustive in their presentation and careful in their wording; as determinants of production, they are as significant as the actual works executed there. Between their dull lines we can read how a student dealt with the school, and how the school dealt with a student.

The first stage in entering the Ecole was *inscription*, simply a demonstration of eligibility for the second step of admission. It brought the aspirant the right to attend all the school's courses and to present himself at the *concours d'admission*. The rolls of inscription were open in the secretariat for a month before the admission competition, and Frenchmen and foreigners less than thirty years old could sign up there. Parisians had to bring with them both legal proof of age and testimony from a known professor of their good conduct and knowledge of one of the *arts du dessin*. That is, they had to prove previous study.

A student from the provinces had to produce additional evidence of his character from the local mayor. For painting students, this sufficed. Aspiring sculptors and architects, however, had to join to these documents further proof of their skill at drawing. They were required to demonstrate their competence by taking a test administered at the school "*consisting of a drawing of an antique figure* made in three sittings of two hours each." The emphasis is that of the rulebook; from the outset the school insisted on skill at drawing that it could measure in its own terms. The nature of the test assumes experience at a drawing school, while the requirement demonstrates that sculpture students at the Ecole des Beaux-Arts entered with the experience of learning to draw, as we have described it, behind them.

All this preceded admission, which alone allowed the student to compete at the school. Admission proper hinged on execution of a figure drawn or modelled from nature, in the course of six two-hour sittings stretched out over a week in March or September (each sitting was broken down into several distinct sessions because of the large number of men competing). The *concours d'admission* also served as the *concours des places*, so that not only new students but also those previously admitted who had not yet received prizes in other school contests vied for the ranking the competition would award. The old hands had precedence over the first time aspirants in admission to the trial. On the day of judgement, all drawn and modelled figures were ranked together, regardless of the session in which they had been executed. The professors assigned them numbers equivalent to the number of seats in the Salle d'Etudes, a ranking which would determine seating order—and thus a student's view of the model—both on study days and in the various *concours*. Any student whose work did not receive a number was excluded. The system thus ensured a fairly constant enrollment from year to year. Admission of new pupils—at a rate which varied from forty-five to seventy-eight annually over twenty-five years—was governed not by the numbers of aspirants presenting themselves every year, but by the total of those already admitted who remained active.[50]

Once admitted to the school, the student settled into its regimented course of study, though attendance was not obligatory. The year was divided into two semesters, October 1 to April 1, when the rules stipulated that "study is done by lamplight," and April 1 to October 1. Then sessions were lit by natural light and the height and passage of the sun determined the time when each two-hour sitting began. (In winter attention was paid lest the sun mount too high in the sky and weaken the intensity of the lamp after work had begun.) Students were divided into odd and even groups. For the first week one group studied after the antique, while the other worked from nature; then the subjects were reversed. The model, whether antique or human, stayed the same for a fortnight so that every student studied both problems. It was the job of the *professeur d'exercice*, the artist on duty, to choose the assignments. As the sole supervisor of classes, at least for his monthly stint, what the professor did and said was totally up to him. It may have varied as little as did the teaching schedule itself; professors usually ended up working exactly when they had the year before. David d'Angers, for example, taught every January from 1844 until his death in 1856, with only one exception. Drolling usually took July, Ingres February, Ramey December, Heim November.[51] Substitutions did occur, which meant that sculptors could be teaching as many as six months of the year instead of the more usual four or five. Not until after the reforms of 1863 did professors run ateliers within the school, or supervise a consistent group of students. Only then were they held accountable for their pupils' performance and asked to file reports on it.[52] Before 1863 painting students were taught by sculptors and sculpture students by painters with a happy disregard for

both continuity and the technical boundaries of each medium. It was assumed that the matter of Ecole instruction, a philosophy of art (not, once again, technique or métier), could be imparted by any real artist. In practice, though, it seems that technical partisanship ruled: critics charged that the modellers automatically got a sculptor's attention during his month, while painters got the painter's help.[53]

Criticisms of this kind flourished, particularly in 1863 when the school was reorganized. Take for example this scathing estimation of the old way that professors operated:

> During the month he is on duty, the professor enters the room where the students are drawing or modelling from casts or from nature, and going from place to place, he makes this one lengthen a too-short leg, or that one shorten a too-long arm. I knew a professor—he was a sculptor—who during the sitting stayed seated in the corner of the study room; there he waited for students to bring him their studies and although from his armchair he could see at most the model's back, he mercilessly corrected figures done in profile, three-quarters, or straight on, as if they were all the same thing.[54]

According to this bitter judge (he is Olivier Merson, the author of our opening adage and an Ecole student turned critic), the more zealous professors visited the study rooms three times a week; some, though, managed to appear for only one of the four or five sessions usually held. Such "teaching by twelfths," Merson said, was both capricious and unequal; it was exactly this system that the 1863 reform replaced.

Since seating in the study rooms was governed by rank in the competitions, prizewinners took precedence according to the level of success they had achieved in the *concours d'émulation* (the collective name given the various competitions)—thus affirming in a basic and highly visible way the principles that competitions were meant to foster. Like daily studies, tests were under the supervision of the professor, and a modification of the rules in 1843 indicates that here, at least, he could be *too* active in his attentions to students.[55] The new provision restrained him from entering the room and talking to the contestants, so that the test might be a better demonstration of their talent, not his.

The calendar of contests was likewise governed by numerous regulations designed to make tests fair. Contestants were supposedly anonymous, their works designated only by number. Judging alternated, so that if one time the drawn or painted figures were reviewed first, then the next week the modelled figures were given priority. Such stipulations guaranteed that even the tension of waiting for the decision was shared. Other regulations which specified the size of canvases, the dimensions of bas-reliefs, and the heights of figures equalized rivals in a different way. All the sculptors had to use the common studio clay, rather than importing more malleable stuff. And, finally, a student who had received a first place in a *concours d'émulation* could not compete for the same prize again. A first medallist in the antique, however, was allowed to seek distinction in "the opposite genre," that is, the contest from the living figure, had he never won that prize. But if a first medallist did compete, he worked with the handicap of choosing his place after the second medallists.

Such administrative provisions are in part the simple, practical necessities which allowed the school to function. But the degree to which the competitions were regulated is also a clear indication not just of their importance in the life of the school and the seriousness with which they were approached, but also of the view, common enough among art educators, that student exercises need to conform to clear standards of size, material and subject matter. These criteria were meant to circumscribe a problem—to give participants some shared points of reference, to guarantee a family resemblance among the solutions they proposed—in much the same way as a present-day art teacher might ask students to paint

from a snapshot or to work after a set passage from Wittgenstein. The Ecole's limitations are only superficially more proscriptive. What they ensure is that the range of variation among students' work would be closely controlled and that fewer factors of performance would be at issue.

If the physical conditions regulating the competitions regulated performance as well, so did the competition subjects and the wording of the programs which communicated them. In a contest like the *tête d'expression*, for example, the subjects assigned cover an extraordinarily small range of emotions—Sorrow, Fear, Scorn, Attention (the most frequent), or sometimes a hybrid, like Attention Mixed with Fear.[56] Both painters and sculptors treated these themes, though not necessarily in the same year. As important as the subject, however, was how it was described. Take for example the program for the sculpted *tête d'expression* of 1841, Celestial Contemplation:

> In this expression full of innocence and candor, one must depict the love of God! The head should be raised, the neck extended and the eyes lifted sweetly towards heaven. The mouth and nostrils should be half opened, and finally, there should be a great calm in all the features. The modelling and coloration should be suave and pure.[57]

Although the text starts out by calling for insubstantial qualities like innocence and candor, it soon enough presents concrete demands: a raised head and extended neck, uplifted eyes, mouth half-open, nostrils half-dilated, features at rest. And if accident has made dilated nostrils invisible in Jules Cavelier's winning sculpture (figs. 71–72), the bust obviously translated the other requirements verbatim. (Why such vapidity should have been equated with the "love of God" is another problem.) What we cannot say is how much more successful (literal?) this solution was than the other entrants; only Cavelier's work survives. Once we know how scrupulously programs had to be followed, however, it is difficult to see different emotions as anything more than different sets of stipulations. If eyes are downcast, does a head show modesty rather than maternal love, or even a religious emotion located *internally* rather than in the heavens? Novices as we now are in the expressive sciences, we can be sure that François Alfred Grevenich's head represents Modesty and not some other expression mostly because it is labelled 1826, and Modesty was the subject assigned that year (fig. 73). Similarly, there is no apparent reason why Henri Lemaire's *Suffering of the Soul* (1820; fig. 74) or Jean-Antoine Idrac's *Mater Dolorosa* (1869; fig. 75) might not instead be *Celestial Contemplation*, since they exhibit many of the specific qualities called for by the 1841 program. And it is bewildering to inquire how Guillaume Bonnet's straightforward and straightfaced representation, in 1849, of *Attention* (fig. 76) might have differed from Louis Roguet's lost rendering of the subject assigned in 1848, "Expressionless."

The programs of the *concours de composition* adopt a similar approach, even though as narrative they have their own character. Each reads like a synopsis, the bare bones of a subject drawn from antique or Christian myth or ancient history.[58] Within the scheme was emphasized one crucial section, the moment to be represented. For example, when the subject was the Death of Lucretia, the moment was to be the Oath of Brutus (October 24, 1833). Or when it was the Sacrifice of Abraham (October 9, 1834), "the designated moment is that when Abraham hauls the ram to the altar and there takes its life." Sometimes instructions of a slightly different kind were given. When students had to represent Hercules carrying off Alcestis from Hades, they were advised that "the dog Cerberus should be shown the better to explain the subject" (October 15, 1835). Or a dry reminder could accompany the assignment, as in June, 1855, when the theme was "Theseus triumphs over

the minotaur, whom he has just fought": "the minotaur, as is well known, had the body of a man with the head and neck of a bull." The added prescription is quite specific: not just a bull's head, but his head *and* neck were called for, lest some ignoramus try to effect the linkage with a skinny human neck, or still worse, completely forget the minotaur's bestiality.

How did students respond to such instructions? Evidence is scarce because of damage done to prizewinning works in recent years. But even with limited information, the extent to which the conditions of the contest dictated results is apparent. Unlike the *concours de la tête d'expression*, say, which took three six-hour sittings, the composition test lasted only one day, with that relatively short duration indicating the limited degree of finish expected—as is borne out by works of which there is some record. For example: the program of the contest on October 26, 1850, which Carpeaux won, has not surfaced, and his small relief does not survive, but a photograph does exist (fig. 77). Plutarch is the primary source for the story in question, the tragedy of the exiled general Coriolanus, who took shelter with his sworn enemy, the Volscian leader Tullus Amphidius, and conspired with him for Rome's defeat. Carpeaux's rendering is simple and direct—but also amazingly sketchy. There are only the briefest allusions to an ancient setting: a flaming altar, a barely Ionic column, the leg of a curule chair. Physiognomy too stays equally suggestive. Carpeaux simply worked a few quick lines in the clay to cover Tullus's jaw with a beard; brows are stroked smooth for the leaders' classical profiles, while a quick triangular excision gives the Volscian soldier his only claim to animation. The marks of a stylus, rapid and repeated at various scales, cut the surface into a toga's folds. Some of these ellipses are remarkably effective, others simply awkward. Yet they cannot obscure or overshadow the work's effectiveness as a simple, legible arrangement of shapes, and it was precisely this matter of *composition* that the competition meant to test. Carpeaux concentrated on establishing a

71. Pierre-Jules Cavelier, *La Contemplation céleste*, 1841, plaster. Ecole Nationale Supérieure des Beaux-Arts, Paris.

72. Pierre-Jules Cavelier, *La Contemplation céleste*, 1841, plaster. Ecole Nationale Supérieure des Beaux-Arts, Paris.

73. François-Alfred Grevenich, *La Pudeur*, 1826, plaster. Ecole Nationale Supérieure des Beaux-Arts, Paris.

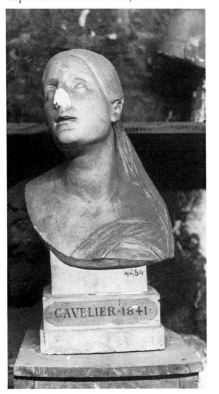

figural arrangement to tell his story. Coriolanus's massive dignity as he reveals himself, Tullus's surprise—these are carried by a restrained solution that works from the active imbalance of a weighty seated figure and two standing shapes across a central fulcrum.

Though no program survives for Carpeaux's relief, we can be fairly sure how it would have read because the same theme was assigned in the first round of the Prix de Rome the following year.

> Banished from Rome, Coriolanus was seated at the hearth of the king of the Volscians, with whom he had sought refuge. The latter, warned that a stranger had asked hospitality, arrived with his warriors. At this moment Coriolanus, who had been enveloped in his cloak, revealed himself to the king and told him that he had sought out his former enemy to avenge himself on the Romans.[59]

When this text was read to the assembled students, they protested "in a single voice" (according to the contest records) that it had been given only the year before. It was straightaway replaced by "Shepherds finding the head and lyre of Orpheus on the banks of the Hebrus," and the students got down to work. The rejected program describes Carpeaux's relief precisely, and the appearance of the same theme in two different types of contests is no coincidence. The four annual *concours de composition* were like practice rounds for the Prix de Rome, even if usually some care was taken to see that subjects did not overlap too closely.

Most of the school's activities served to gear students for the gruelling Prix, which lasted from the first round held in April or early May, until the final award ceremony on the first Saturday in October.[60] In January the *Moniteur Officiel* ran a notice of the dates of the first contests; sculpture was always held on the second Thursday in May. Foreigners could compete, but could take no prize, since the winner had to be an unmarried Frenchman

74. Henri Lemaire, *La Douleur de l'âme*, 1820, plaster. Ecole Nationale Supérieure des Beaux-Arts, Paris.

75. Jean-Antoine Idrac, *Mater Dolorosa*, 1868, plaster. Ecole Nationale Supérieure des Beaux-Arts, Paris.

76. Guillaume Bonnet, *L'Attention*, 1849, plaster. Ecole Nationale Supérieure des Beaux-Arts, Paris.

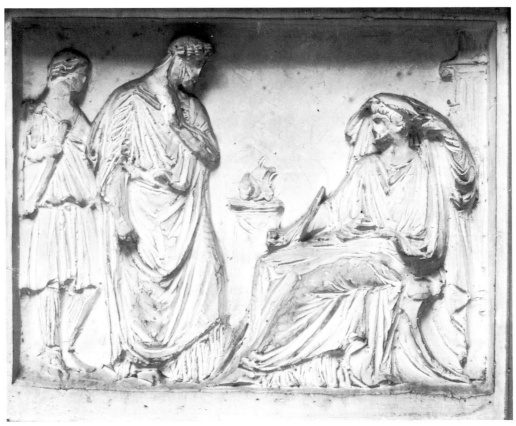

77. Jean-Baptiste Carpeaux, *Coriolan chez Tullus*, 1850, clay. Destroyed.

under thirty—though not necessarily an Ecole student. For the sculpture contest there were anywhere between forty-five and seventy-five entrants. In the first round, a day was given over to the execution of a sketch representing a mythological or historical subject; this was the phase that paralelled the *concours de composition*. A judgement weeded the original crop of contestants to sixteen, and their names were posted immediately. Within a fortnight, this sixteen returned to sit for the second round, taking places in the order that the sketches had been rated. The second test asked them to mount a figure after a nude model posed by the sculpture professors. The pose was only announced at the beginning of the contest, but the identity of the model who would be used was made known eight days previously. Perhaps this custom gave rise to unofficial posing sessions staged by students trying to gain some slight margin of familiarity. This was the more likely since the test itself consisted of only three six-hour sessions to mount and model an entry. Both the resulting figure and the sketch from the first contest were considered in the selection of the eight men who reached the final contest, so that skill both in composing and in anatomy had to be demonstrated.

In the final competition, the formats of bas-relief and figure in the round were selected in alternating years. In the first day's trial, the students established their sketches from a subject the sculpture professors read to them before they mounted *en loge*. At day's end these sketches were stamped, cast in plaster, and sealed away, to be brought out again seventy-two days later at the moment of the public viewing and judgement. In the meantime, the student's task was to render that initial sketch, remaining exactly faithful to it

while enlarging its scale to 1m55 by 1m15 for a relief, or to a height of 1m15 if the exercise was in the round. As they worked in the little cubicles, students could have only plasters cast from nature to aid them: this meant no engravings, no drawings, no tracings, no mannequins (both the jointed and stiff varieties were specifically proscribed), and no living female models. Nothing was left unsupervised; the rules even dictated that the casts of body parts had to be at a scale different from that of the contest sculpture. Similar constraints applied to painters: they were denied mannequins, engravings, paintings, or sketches, though they could have painted and drawn studies of the female body. Both sets of rules were meant to ensure that information which could be communicated graphically—for example, a compositional format or archeological details like a helmet shape or a toga border—would already be part of the young artist's mental baggage. Painted and cast studies of the female anatomy were permitted in recognition of the difficulty of fabricating natural forms from one's head. (That recognition had its limits, since nature itself was not allowed *en loge*. But perhaps this was a moral stipulation.) It was futile to regulate the use of male models or studies from them, since students always had their own bodies and those of friends from which to draw.

When the two months allotted for execution finally came to a close, the completed sculptures were placed on public view, though not before students had repaired any damage their work had suffered during transport. The two hours they were allowed were not a superfluous provision, since more than once on the trip from the *loges* the fragile clays were dropped and broken. Retouching was done under strictest security; no one, especially models, was allowed to be present. Further rules carefully spelled out how all works were to be exhibited: in a single row, at the height of one meter, on turning bases if they were in the round, with the backs of reliefs exposed, and under equal lighting. All these measures prepared for intense scrutiny under meticulously fair conditions, because the outcome of that scrutiny was potentially so important to a student's career.

At every stage of the contest, precautions were taken against infractions of these rules, precisely because infractions did occur. Guardians patrolled the long narrow corridor while the students sculpted. They noted anything out of the ordinary and reported it to the secretary of the Ecole. He in turn informed the Académie. The tone of one such report, Ludovic Vinet's letter of May 15, 1846, turns the rules into real events:

> On May 14, during the first round of the sculpture competition, Stock, the Ecole guardian, thought he heard the noise of paper rustling in the *loge* of one of the contestants. Since it is not normal for sculpture students to have paper in their cubicles, the guard assumed that this noise came from tracings that someone had managed to conceal during the search that had been made that morning; he entered the cubicle and took from the student's hand the tracings which I have the honor to bring to the attention of M. the President of the Académie des Beaux-Arts.[61]

This is the stuff of which drama is made: an alert guard, a suspicious noise, a contraband substance, a seizure *in flagrante*. The offending student had somehow managed to outwit the morning search and hide a set of tracings. The evidence was turned over to the Académie and the following day the student was expelled from the contest. In the official decision, the culprit remained anonymous; he is referred to only as "the author of the bas-relief no. 39 in the first contest." But the cheater was Carpeaux, as is easy to verify from the contest records, and from his own account of the event, written in a letter of June 10, 1846: "As for me, it's not going so well; I was in the May contest (where I expected you to be too); as luck would have it I was surprised by a guard while at work with

some tracings. He filed his report, and the decision was taken to eliminate me. I was really annoyed."[62] Carpeaux's letter contains the elements of Vinet's report and confirms it. What is striking, though, is the healthy mental state the letter reflects—not guilt or embarrassment but frustration at a bit of bad luck which foiled a maneuver he might otherwise have brought off.

Surveillance continued as the contest came to a close. The sketches were retrieved from storage, and the finished reliefs and figures carefully compared with them. Measurements were verified. With two months to mull over an idea conceived in a day, the temptation to adjust the placement of a leg or the turn of a shoulder was strong. Students often yielded, and nearly every year the Académie saw significant modifications in the work of two or three contestants. Their findings were sometimes stated quite simply, when they noted a change in the position of a head, for example. Or they might discern more subtle but more significant changes, like those perceived in the work of one contestant in 1852 "in point of composition and moral idea." And often the Académie played accomplice to students' attempts to slip a change by them. Once noted, an adjustment (the Académie termed them "rectifications") was often allowed; students banked on that permissiveness.

There is a kind of game going on here, in this cheating and rule-stretching and collaboration: it is not a meaningless one, since it is basic to the operation of the school. Another example can bring us closer to understanding it. This time the year is 1854, the subject Hector and his Son Astyanax. At their meeting for the preparatory judgement on September 9, the full sculpture section of the Académie—eight members, the elder Seurre, David d'Angers, Nanteuil, Duret, Petitot, Lemaire, Simart, and Augustin Dumont—was assembled.[63] They went straight to the verification, with Nanteuil and Seurre acting as the commissioners in charge of proceedings. That year, two infractions were noted. In sculpture no. 3 (by Moreau, a pupil of Pradier and Simart), they found that "while the right leg is forward in the sketch, as executed it is behind"—not a serious enough change to demand any action. In no. 5, modifications were more extensive: "The movement of the right leg is likewise changed; the head, which is turned to the right in the finished version is turned to the left in the sketch. The child, held away from his father's body in the sketch, is now pressed against his chest." This time the infraction was grave enough to "oblige" the commissioners to propose expulsion. The minutes record drily that, "after a discussion in which the proposal for expulsion was seconded, a vote was taken," a sentence which stands, I think, for some heated words among the eight artists present, since the motion was defeated only five to three.

All this would have little interest if later in the session the sculpture section had not awarded the Grand Prix de Rome to no. 5 on the first ballot. Rather an odd turn of events, this granting of the highest prize to a work which only minutes before had been threatened with elimination for infractions of the rules! These infractions were so glaring that the whole question of disqualification was raised again at the full meeting of the Académie, put to a vote, and defeated eighteen to eight. A figure *could* win the Grand Prix despite blatant changes if the majority of the Académie decided to disregard them because of the superiority of the work. In this case their explanation of the judgement is succinct: "For no. 5, remarkable execution, above all in the upper part of the figure."

The author of no. 5 was Carpeaux. He was competing for the ninth time in the Prix de Rome contest, for the sixth as a finalist. On three different occasions (in 1848, 1851, and 1854), changes of varying degrees were noted in his work; on a fourth he was expelled. These events are not as petty as they seem; they allow us to reestablish the attitude with which Carpeaux went at this manically competitive schedule. Clearly he had a sense—how

shall we say it?—of *expediency*, which allowed him to disregard the protocol he was meant to observe. If in 1854 he considerably modified his *Hector and his Son Astyanax*, he did so both knowing the risk he took and trusting that the qualities of his work would outweigh his offense against the rules. And he was right.

THE ECOLE LANGUAGE

To understand why Carpeaux was right, why his *Hector* won the Prix, we must return to our initial point of departure: to Carpeaux analyzing expression in his and Crauk's *Achilles* and to the Ecole as competition and rivalry. The school was the institutionalization of that concept; the curriculum implemented it in a strict, methodical way. But what has not yet been said is that, if the school meant rivalry, it also meant the execution of sculpture as a daily activity. Sculpting went on at a virtually ceaseless rate, even though the Académie's opposition to teaching its technical aspects was recorded by students and teachers alike. This is the attitude that Carpeaux summed up in his letter to Dutouquet: "at the Ecole, everything is done with the aid of the eye alone. And the Institut happily asserts that the arts in general exist more in sentiments than in measurements."

Yet, despite the Académie's adamant insistence on teaching sentiment above science, the school's curriculum did encourage technical skill. It stands to reason that in sculpting, you learn to sculpt. If a student followed the schedule of competitions at the Ecole, he learned his craft simply by practicing it. He might absorb the secrets of stable armatures in a backhanded fashion, from the advice of other students or a professor's casual suggestion, rather than from a more straightforward presentation in a lecture, but he learned the secrets all the same. They made up métier, the craft of sculpting. And if the Académie openly disavowed any interest in imparting such technicalities, the denial did not prevent accusations that in practice it taught them all too well. Observers of the sculpture competitions deplored a system which they saw as emphasizing technique alone. A critic writing for *L'Artiste* judged the school harshly on this account, seeing its effect as the opposite of its intention: "It manufactures workers and does not create artists." In this case the anonymous writer was not speaking literally so much as insisting that sculpture demanded a different kind of teaching, one consistent with its elevated character:

> If the art of sculpture consisted in more or less skill in tailoring arms, legs and heads, and in linking them willy-nilly one to the other, this art would not be heading straight for a deplorable decadence; we do not lack for stonecutters or marble carvers, but *art*, and sculpture most of all, demands greatness of thought, an elevated style, a purity of form which are nowhere evident in this year's crop of exercises.[64]

Most critics echoed this call for meaning in student work, even though a practiced observer like Théophile Gautier was realistic enough to accept that, at the level of the Ecole contests, just attaching arms and legs properly and making a figure stand erect *was* the point. He was willing to let exercises be just that, and judge them accordingly.[65] Other critics, however, like Arthur Guillot in *La Revue Indépendante* or Pierre Malitourne in *L'Artiste*, felt the weight of sculpture's moral tasks heavily enough to take the competitions very seriously indeed. They did not question the subjects and format of the competitions, securely rooted in tradition as they were, so much as the academicians' ability to fulfill the requirements of the programs they blithely handed out to students.

If the Ecole curriculum demanded the ceaseless production of sculpture, it also required

execution according to its own standard. Student exercises aimed to approach that standard, since it was the yardstick by which their work was judged. In performing the tasks that the Ecole set, said David d'Angers, workers were transformed into artists. He likened them to children learning their letters, the first elements of a language in which to speak to humanity. And Zola, remember, saw sculptors "speaking" Greek art, expressing themselves painfully and unnaturally in a half-learned language. Both used a concept of expression in sculpture, David supporting and Zola condemning it. For both, it hinged on language learned at school, the same language Carpeaux termed *sentiments*. When he said that Crauk's *Achilles* expressed nothing, the force of his accusation would have been completely intelligible to both Zola and David, even though each would have had his own view about the sculpture's emptiness.

Carpeaux's letter to Dutouquet suggests that the Académie had an idea of how the artistic communication they sanctioned could be achieved. Nonetheless, they kept the actual characteristics of the language a tacit, rather than explicit, side of their teaching. Although they judged student work in every contest and even wrote an explanation of their decision, their opinion was an assessment for insiders, recorded in the methodically maintained minutes of their meetings and not released for public consumption. For example, to explain the decision in 1843, they noted down this judgement: "because the chief figure is well rendered, because the composition is well understood, because each figure is well felt from the point of view of placement, and because there are some heads either well done or remarkable in terms of expression."[66] Well rendered, well made, well felt, well placed, well understood—these generalities did not have to be explained since they were the private parlance of a group which agreed in principle about the standards at issue, about what good meant. Yet this language could not be more opaque to us now, nor could it contrast more strongly with the Académie's public statements about style. It is convenient to call the language the Ecole taught *academic style*; the Académie itself did so. Here is how they defined it:

> The true academic style—and more than one example could be cited—is characterized neither by constraint nor by emphasis, but by a marked tendency towards the noble and the delicate. It is the protest of the disciplined imagination against its unbridled counterpart, of an inspired yet convinced and scrupulous art against a careless and negligent one; a return to antiquity which sees in physical beauty the image of moral beauty; a means of transporting souls to the higher sphere of greatness, purity, and the ideal.[67]

No more emphatic statement of academic doctrine could be hoped; all that is missing are the examples the authors forebore to give. Instead they declared both what it is and what it is not, and we understand that such clarification was necessary because of the existence of its negation. Academic style is disciplined creativity, not the negligent exercise of the imagination. Its purpose is the elevation of the soul, not towards heightened sensation or new awareness, but to the perception of a pre-existing metaphysical ideal. Antiquity is essential to the academic because it provides a proven model, the age-old site for a kind of mental transposition through analogy, from physical beauty to moral beauty.

There is, evidently, a great gulf between the higher spheres of academic style and the young sculptor learning good composition. Ecole instruction aimed to close that gap. We might assume, following the Académie's definition, that it believed a knowledge of antique sculpture and its physical perfections should be basic to the Ecole curriculum. Perhaps "fairly good rendering" or "expressive lines" translates as resemblance to ancient prototype.

Our discussion of works like *Coriolanus before Tullus* or *Hector and his Son Astyanax* might indicate that an attention to antique subject matter *was* one way that academic style was taught. And in fact, in the two phases of the forty-four competitions held for the sculpture Prix de Rome between 1820 and 1864 (that is, eighty-eight competitions in all), religious subjects were assigned only five times. They were chosen much less frequently than in the painting competition, where the total for the same period is thirty-seven.[68] A list of subjects from which the theme of the Grand Prix bas-relief was chosen (here it is given for 1851; it could be taken at random),[69] shows that only two religious subjects were even suggested: the Delivery of Saint Peter, the Death of Patroclus, the Anger of Achilles, Ulysses Returning Chryseis to her Father, the Death of Sophocles, Tyrtaeus Singing his Poems, the Wounded Menelaus, Patroclus and Achilles, Lausus Defending his Father, the Punishment of Dirce, Cain Contemplating Death, Sophocles at the Aeropagus, the Battle over the Body of Patroclus. Add to these for comparison the subjects mulled over for the figure in the round the following year: Orpheus Mourning Eurydice, David Conqueror of Goliath, Philoctetes at Lemnos, Cadmus Fighting the Serpent, Paris Launching an Arrow at Achilles, Achilles Taking Arms, Acontius, Alexander at Achilles' Tomb, Hector Holding Astyanax, the Victorious Meleager, Oedipus Receiving the Oracle, Hercules Binding Cerberus. Here only one in twelve is Biblical. But even more important, when a Christian story does appear, it goes against the grain of subjects and heroes which recur year after year; battles are fought, deaths met, arms taken and put down, by Achilles, Patroclus, Hector, and other heroes. As a general rule, the more important the contest in the succession of trials leading towards the Grand Prix, the more familiar the theme.

What is striking about these repetitive lists of subjects is that they refer to an antiquity of texts, not art objects. Most invoke the authority of an ancient author or myth, not a sculpture, and the initial knowledge their interpretation demands is literary, not artistic: the student has to remember the *story*, not ancient treatments of it. This might be less surprising in the painting contests, simply because ancient painting does not survive extensively to serve as models. But should not the sculpture competitions establish a direct relationship to antiquity by requiring close imitation of actual works? So we might think — yet the ancient subjects used in the *concours* do not ask for such replication. Though based on ancient sources, they are frequently subjects not known to be treated by ancient sculptors. Instead they first require textual knowledge, even though the program usually supplied some information for students shaky on ancient authorities. Simply knowing a text was not enough, however. Each student was expected to understand that the way to render it already existed. Recognizing a text was tantamount to translating it into the appropriate representation.

Students had to know what forms were good, what compositions expressed a subject. Where did they get that awareness? Or better, how was it provided? These questions are crucial, since this, finally, is what the Ecole thought it taught—those "sentiments," the sculptural decorum. We might say that these values *were* the Ecole, and we would think ourselves justified in our assertion by the way they were meant quite literally to be incorporated into it. As a result of policies implemented during the construction and arrangement of the school's quarters, principles of study became part of the physical layout of the place. In 1816 the buildings of the Couvent des Petits Augustins (most recently the location of the Musée des Monuments Français) were turned over to the Ecole, and in 1832 Félix Duban took over their renovation from his brother-in-law, François Debret. Working with foundations already partly completed under Debret's plans, Duban quickly drew up his own design for a school building to be called a Palais des Etudes, or Musée

des Etudes. The scaffolding came down in 1839, and Théophile Thoré, for one, supported the transformation of the "poor plan" Duban had inherited into a building which, he wrote, could house both the past and the present, both theory and practice. In short, said Thoré, in a dig at the professors who had opposed Duban's plans, "only good teachers are lacking."[70]

It was not Duban's job to provide professors. But in the Palais des Etudes he did design a structure which was to be the architectural embodiment of the school's policies. As a "museum" or "palace" for study (it was even called a *musée des modèles*) its purpose was the incorporation of the history of art within the Ecole itself. This intention was as much a part of Duban's designs as their clear, symmetrical *parti*. The actual arrangement of the museum, however, fell mostly to a curator, Louis Peisse (1803–1888). In March, 1836, Peisse sent an ambitious plan for the sculpture collections to Montalivet, Ministre de l'Intérieur.[71] In it, Peisse enumerated the collection the school had already acquired—the casts of ornament given by a former professor, for example, or the seventy-six fragments of Egyptian, Greek, Etruscan, Roman, *and* Asiatic ornament donated by an antiquarian— listing them as much to demonstrate their haphazard, motley character as to inform the minister, who was new to his job, of the school's assets. To replace these plaster bits and pieces, he proposed a systematic, orderly presentation of casts "methodically chosen and chronologically arranged," and including "modern" art—the kind of grand plan of which any new minister would be proud: "The concept of this new museum of models is thus historical above all. The plan is to do for the works of architects and sculptors what engraving has done for the painter's art; that is, to assemble the scattered masterpieces of the chisel just as one brings together the great works of the brush in a collection of prints." And the result would be even better for sculpture, Peisse wrote, since casts are exact reproductions while prints are only imperfect renderings which barely approximate their models.

Peisse thought himself an innovator, and to some extent he was. To his credit, he did not end the "modern" at Michelangelo, but continued from Goujon through Bernini, Puget, Girardon, and Canova; even Thorwaldsen was to be included (these last, though, he considered historical rather than aesthetic examples). But he also prided himself that his innovations were sensible, and selective, a kind of sculpted "Great Books":

> To aspire to collect within the walls of one building all sculpture, both ancient and modern, would certainly be an extravagant idea. But there is no question that the idea is not to form a *universal* glyptothek, but rather a glyptothek of masterpieces selected from every country and from every age—which is entirely different. This collection will have the aim and the usefulness of those libraries of Greek, Latin, German, English, and Italian authors which the publishers never tire of reprinting.[73]

Peisse was urgent and convinced, but he was no match for the ministry. Four years later he was still writing about his Musée des Etudes as a thing of the future. In 1847, when he again reported to the minister, the situation was not much improved. The building was long since ready to receive its plaster contents, but money was lacking. The situation was serious, and he described it vividly:

> For years, Messieurs the professors, the students and the public have been both surprised and painfully affected by the state of disorder, deterioration, and apparent abandon in which so many precious pieces are found: covered by dust, sometimes smashed or mutilated, confusedly arranged around great wooden cases that obstruct the passage of visitors. They return after years have gone by only to express their surprise at seeing

78. Central courtyard, Palais des Etudes, Ecole Nationale Supérieure des Beaux-Arts, Paris.

that nothing has changed, and they cannot understand why the provisional is lasting forever.[73]

Peisse himself may have been beginning to fear that the confusion would never be set to rights: nothing was getting done. In 1847 the Ecole was far from the orderly museum it later became (fig. 78). Instead of neat rows of casts we should visualize clogged passage-ways, dust and packing crates, and fingers chipped off plasters in the confusion. Even as late as 1855 the situation was still desperate; a report from the Committee on Casts is the cry of men being buried alive by plasters: "Casts are everywhere in the Ecole; cellars, attics, exhibition halls, all are invaded."[74,]

It is easy to be amused by this tale of a school slowly drowning under a flood of reproductions, but the story has something serious to say about Ecole study in theory and practice. Behind the ill-starred history of Peisse's collection is an understanding of the building as the container of an instructional text, an illustrated history of sculpture. The rules of art could thus be read in the very building where art was taught. To be sure, the text had a limited audience: architects and sculptors, not painters, were to read it. And casts, not originals, were to fill its pages. The school (theoretically) becomes a self-contained and self-sufficient entity, confident of its ability to present appropriate models. The concept which Duban tried to build into the Ecole, and which Peisse meant to carry to a conclusion, is peculiar to the nineteenth century. It shows a positive managerial assurance about the role of institutions: they were to offer, quite literally, a version of the past to their inmates; make that version not just accessible but unavoidable; make the past the present. This is how students were *meant* to learn. Yet, and here's the rub, for half—the most vital half—of the school's nineteenth-century history, this ambition was not fully realized. It remained an unfinished ideal: "Art" was less accessible to students than the concept of "academic style" assumes. Only gradually, later in the century, was history really made manifest, neatly arranged for students to use.

Some sculpture was on view at the Ecole, however, and you could doubtless sketch among the packing cases if you could find a perch. Duret once sent Carpeaux to make him copies of Michelangelo's *Night* and *Day*,[75] and if the Goujon plasters had not yet been uncrated, there *were* the works which had won prizes in the various Ecole *concours*—not only the Prix de Rome but also the *tête d'expression*, the *concours de composition*, and the rest. There is evidence to suggest that drawing after them was more to the point than making sketches of white plaster masterpieces. Prizewinning sculptures were displayed in accordance with a resolve expressed early in the century, at the moment when it was decided that the buildings on the rue Bonaparte should be turned over to the Ecole. The Comte de Forbin, then director of the Musées Royaux, described how they were to be used: "The sight of these works should provide students with a continual lesson, and so that it can be as effective as possible, the school grounds should offer a spacious, well lighted location where these works can be seen by students and public alike."[76] The Comte did not mean that medallists' works should be displayed merely as inspiring reminders of success. When he wrote "continual lesson," he meant that they should serve the same purpose as the drawings sent to provincial schools: they should be models which students were to copy. Carpeaux, at least, studied them diligently. He treated them as a repertoire of compositions, a sculpted manual that gave lessons in how to render specific subjects in a way which had already won success. Just as architecture students noted a previous year's *parti* or elevation, he made tiny sketches of most of the bas-reliefs from 1823 on.[77] A mere one and a half by three inches in size, these are pencil jottings, sometimes strengthened in ink, which set down only the main aspects of the rendering of a subject: the placement and number of figures, for example, or the presence of drapery, spears, or a chariot. Compared to their sources, Carpeaux's renderings of Duret's and Dumont's bas-reliefs of *Evandre Mourning* (1823; figs. 79–82), or his sketch of Théodore Gruyère's winning *Seven against Thebes* (1839; figs. 83–84) are small triumphs of ellipsis, which set down essentials laconically but without mistake. He did not limit his sketches to Grand Prix reliefs; there is one recording of Chapu's *Departure of Ulysses*, sculpted in the *concours de composition* of February, 1854—just seven months before Carpeaux took the Prix (figs. 85–86). In order further to solidify his mastery, Carpeaux usually traced these sketches in ink, and pasted both sets, copies and originals, into two pocket-sized notebooks. They were easily portable;

79. Francisque Duret, *La Douleur d'Evandre sur le corps de Pallas*, 1823, plaster (122 × 155). Ecole Nationale Supérieure des Beaux-Arts, Paris.

80. Jean-Baptiste Carpeaux, after Duret's *La Douleur d'Evandre*, 1847–50, pen, ink, and pencil on white paper (5.1 × 9.2). Musée des Beaux-Arts, Valenciennes.

81. Augustin Dumont, *La Douleur d'Evandre sur le corps de Pallas*, 1823, plaster (122 × 155). Ecole Nationale Supérieure des Beaux-Arts, Paris.

82. Jean-Baptiste Carpeaux, after Dumont's *La Douleur d'Evandre*, 1847–50, pen, ink, and pencil on white paper (5.1 × 9.2). Musée des Beaux-Arts, Valenciennes.

83. Théodore Gruyère, *Serment des sept chefs devant Thèbes*, 1839, plaster (123 × 154). Ecole Nationale Supérieure des Beaux-Arts, Paris.

84. Jean-Baptiste Carpeaux, after Gruyère's *Serment des sept chefs*, 1847–50, pen, ink, and pencil on white paper (5.1 × 9.2). Musée des Beaux-Arts, Valenciennes.

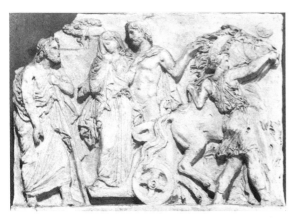

85. Henri Chapu, *Le Départ d'Ulysse et Pénélope*, 1853, clay. Musée Chapu, Le Mée.

86. Jean-Baptiste Carpeaux, after Chapu's *Le Départ d'Ulysse*, c. 1853, pen, ink, and pencil on white paper (5.1 × 9.2). Musée des Beaux-Arts, Valenciennes.

Carpeaux would have been able to study them anywhere—even (and very probably) *en loge*.

These little drawings give visual evidence not of the dominance of the antique, but of the existence of another concept of the "right way" to render a subject—a concept which dominated the Ecole. Paul Mantz made much of it in his review of the 1859 Grand Prix competition. He started off explosively:

And yet! What a strange outcome! What an assault against nature! What's this? Ten young men are born at different times in a France where the irregularities of local temperaments are still so vivid; they are unequal in intelligence, as well as in emotions; but they enter the same school, and thanks to the mechanism of an identical education, they are transformed. They polish smooth the roughness of their individual characters, and in the end they succeed in producing absolutely identical work, for all the world like young conscripts who learn to keep step and drill in perfect unison.[78]

Learning to sculpt, said Mantz, is suppressing individuality: it is getting the drill right and keeping time to a set tempo. In 1859, the year Mantz wrote, the exercise was the Wounded Mezentius. The program came from Virgil: "Mezentius has just been wounded by Aeneas; at once Lausus throws himself between the two opponents and protects his father against the fury of the Trojan hero."[79] Two prizes were awarded, the Premier Grand Prix to Alexandre Falguière and the Second Premier Grand Prix to Léon Cugnot (figs. 87–88; the two were rated nearly equal, and both won years in Rome). From their reliefs it is evident that getting the drill right in this case meant recognizing the subject as a battle scene, then devising a composition in which the opposing lines established by the

87. Engraving after Alexandre Falguière, *Mézence blessé*, 1859. Reproduced from *Gazette des Beaux-Arts*, 1859.

88. Engraving after Léon Cugnot, *Mézence blessé*, 1859. Reproduced from *L'Illustration*, 1859.

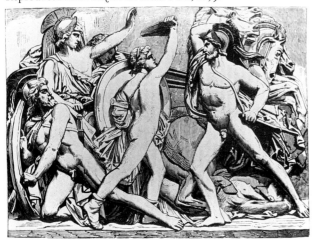

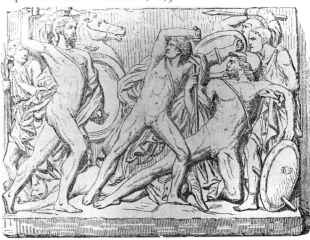

naked male bodies express the basic terms of the conflict. Mantz commented on the drama and movement of Falguière's solution, yet claimed that Cugnot's was enough like its fellow to have won the prize "had he stayed more strictly within the conditions of the program." If we compare the two, Falguière's does seem the better version, since he is able to make clear Lausus's youth and the various relationships among the three protagonists. And straightaway, in agreeing with the Académie, we too begin to weigh fine degrees of difference. Our agreement means that we accept the ruling formula for *battle*, just as victory in the competition hinged on the same acceptance. Neither student questioned, or was meant to question, the premises behind making a battle scene, and thus their solutions resemble every other combat sculpted there.

So the first rule for making good Ecole sculpture was to adopt a generic formula, the formula at the root of the uncanny resemblance Mantz saw among the 1859 reliefs. Yet surely sometimes resemblance was unavoidable. Surely the parallels between Ambroise René Maréchal's winning relief of 1843, *The Death of Epaminondas*, and the composition by Hubert Lavigne which took second place (figs. 89–90) are simply those dictated by the program, as by now we should expect:

> Mortally wounded at the battle of Mantinea, Epaminondas was brought back to camp. Before expiring he wanted to assure himself that his arms had been saved. He was shown his shield. He asked which side was victorious, and was told it was the Thebans. At these words he himself took the weapon from his wound and drew his last breath in the midst of the warriors who surrounded him.[80]

In the text, emphasis falls on a dramatic moment comprised of two interrelated actions, the showing of the shield and the death of the hero. Both had to be represented, one by the gesture of the nude warrior, the other by the action of an attendant. At this point, the difference between the two reliefs becomes revealing. Lavigne placed both shield and dying man at the compositional center; the subsidiary figures thus stand static and unnecessary to the action. Worse still, the movement with which Epaminondas greets death and victory clogs and obscures meaning, rather than clarifying it. Maréchal activates more of his surface by separating the two significant elements, yet locking them into an internal geometry; the arm of Epaminondas, as it removes the weapon lodged within his vitals, falls within that active triangle, and the secondary figures too are controlled by it. This is good relief, is it not? The composition offers the viewer clarity and movement simultaneously; it is able to show how it should be looked at and to make the looking tell a story. And so, no surprise, when Carpeaux came to learn how to render the death of Epaminondas, Maréchal was his guide (fig. 91). His succinct outline omits none of the points Maréchal had established.

The Death of Epaminondas was not a new subject in 1843. One critic called it hackneyed;[81] others, less impatient with the old themes, issued the perennial challenge to the professors to do it right themselves. Properly handled, wrote the critic for *L'Artiste*, it *was* meaningful; its lesson was the triumph of patriotism over physical agony.[82] He knew what a sculptor needed to render it: an elevated style, heartfelt study, and a profound knowledge of history and Greek art—in short, everything he thought lacking from Ecole classrooms (and everything the Académie professed to teach). In a long discussion, the writer in *L'Artiste* laid out what representing this theme demanded: a clear hierarchical arrangement won through focus, gradual diminution of planes, and subordination of secondary elements. He found none of these, needless to say, in the generel mêlée the eight contestants presented. (We might protest that Maréchal *was* making a stab at them.)

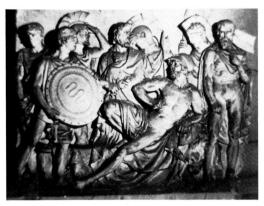 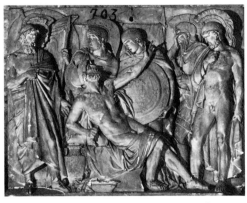

89. Ambroise René Maréchal, *La Mort d'Epaminondas*, 1843, plaster. Reproduced from a photograph in the Ecole Nationale Supérieure des Beaux-Arts, Paris.

90. Hubert Lavigne, *La Mort d'Epaminondas*, 1843, plaster (120 × 147). Musée des Beaux-Arts, Nancy.

The rules reviewers wanted observed were the old ones for neoclassical relief, the same rules which had guided David d'Angers in his own prizewinning *Death of Epaminondas* of 1811 (fig. 92). The contrast between David's subdued composition and the strong patterning, high relief, and packed surface of the later versions reflects gradual stylistic changes in French sculpture over thirty years towards what some critics termed a harmful pictorialism. At the same time the similarities uniting the reliefs of 1811 and 1843 confirm the tenacity of tested solutions and the continuity of the visual relationships which presented them: symmetry, caesura and rhythm, direction and hierarchy; even top and bottom, rough and smooth; these are the terms which young sculptors had to make balance out.

If the Académie encouraged continuity, this does not mean that only one representation of a subject was ever possible. Weighing variations was sometimes part of the game. A real enthusiast like E. J. Delécluze believed that even the most often repeated theme offered the chance to present it in a "new" guise when it was approached with imagination.[83] Like Thoré in the 1840s, he assessed student work with an unflagging interest in its finest nuances, and analyzed meanings and variations with the mastery of a scholastic. His reasoning is revealing. In 1854, for example, he could readily admit that the subject, Hector and his Son Astyanax, allowed two interpretations, both of which students had in fact proposed.[84] Six presented the hero with his arm outstretched, imploring the gods. Two showed him with his child held securely in his arms. The first was permissible, Delécluze wrote, since a raised arm may well have been allowable in the rituals of Trojan religion. The verdict sounds fussily—perhaps even falsely—archeological; it is the self-confident judgement of a painter whose own *Hector et son fils Astyanax* had taken a Salon medal years before. Delécluze could claim to know his subject's limits inside out. But what custom licensed, practicality forbade: an outstretched arm, he pointed out, is impossibly difficult to render in marble. (How odd it is to read about appropriateness and practicality in nearly the same breath; in Ecole matters, the former usually prevailed.) Carpeaux's *Hector* (figs. 93–94) would make a splendid marble; the sentiment found echoes elsewhere.

Delécluze made his critic's progress through the eight contestants, rating the one "perhaps too humble, perhaps too stiff," but with "true expression"; finding another too solemn, the next too Christian, its neighbor too old. It would be fascinating to be able to match sculptures to each description, but only one other besides Carpeaux's is now known. A.-D. Doublemard's *Hector* (fig. 95)—the one Delécluze called too Christian—won him a second prize. The Académie signalled its "good conception of the subject, which is well understood, and its nicely felt movement."[85] The movement *is* well felt and expressed; the figure has an open, confident swing as it strides forwards, mouth half open,

91. Jean-Baptiste Carpeaux, after Maréchal's *La Mort d'Epaminondas*, 1847–50, pencil on white paper (5.5 × 9.2). Musée des Beaux-Arts, Valenciennes.

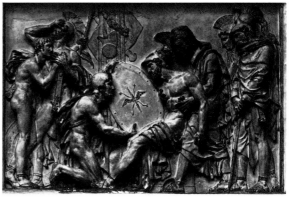

92. Pierre-Jean David d'Angers, *La Mort d'Epaminondas*, 1811, plaster. Ecole Nationale Supérieure des Beaux-Arts, Paris.

"imploring." Carpeaux too toyed with that solution, the obvious one (if a figure implores, then . . .). He tried it out in a notebook; in his sketch the raised arm reads as a pentimento (fig. 96).[86] His final solution avoids oratory in favor of a calm stable confidence of pose, partly achieved by the very modifications for which he risked disqualification. By tempering his work he arrived at the clarity and legibility necessary to Ecole sculpture. Playing his hand close, he restricted the impact of his work to the "remarkable execution" which won him the prize.

Delécluze interpreted the figure's qualities at some length:

> Here we are at M. Carpeaux's group, realistically calculated for execution in marble. Hector, whose weight all rests on his right leg, also holds his son in his arms to this side. Without boastfulness, but with a noble confidence founded in his moral and martial virtues, the father of Astyanax, moved by tenderness and making burning vows, looks to the heavens with a respectful confidence evident in his eyes and in the entire stance of his body. The drapery and helmet accompany the figure effectively, clearly proving that M. Carpeaux really knows how to render a figure in the round. The sole fault with which we can reproach this figure of Hector is the too pronounced projection of the right shoulder. His clavicle is evidently too long.[87]

It is clear that Delécluze was applauding more than Carpeaux's intelligence in designing a work that could be rendered in marble. This seemed only one mark of maturity in a figure whose execution another critic called "almost masterly."[88] The Académie reserved its praise for execution, but journalists went on to suggest that Carpeaux's *Hector* approached another level: it was almost real sculpture. Delécluze read the figure as he would any Salon piece he appreciated, assigning it an interpretation based on "toute l'habitude du corps," but evidently using physical form to derive emotional characteristics like nobility and confidence. Such a reaction gives the measure of the figure's worth to contemporary eyes; its form was able to touch off a moralized reading.

Simply by comparing the figure to Carpeaux's earlier competition pieces, the *Achilles* and *Philoctetes* (figs. 47, 97), we can see the basis of such reactions, and we notice too how far Carpeaux has pushed in the naturalistic rendering of anatomy. Where musculature earlier seemed to raise itself under the skin in hard, sometimes lumpy patterns, here careful modelling is evidently meant to show how surface and substance belong together. Muscles ripple because they are linked by transitions which convey continuous volume. The solid, sure stance of the figure is clear from every aspect. The Académie's approbation of this degree of naturalism—which despite plumed helmet and drapery is inescapable—should not be

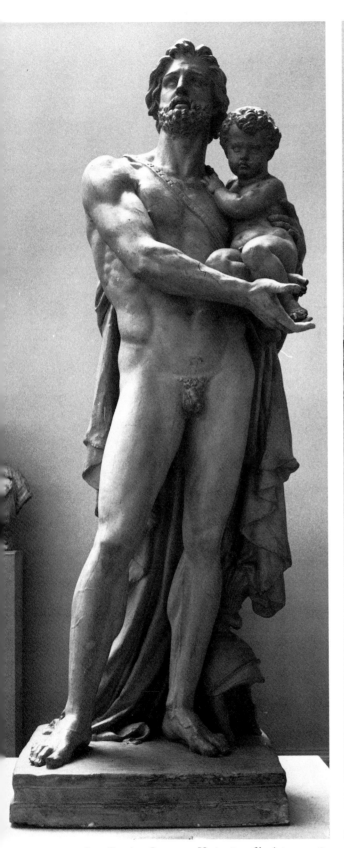
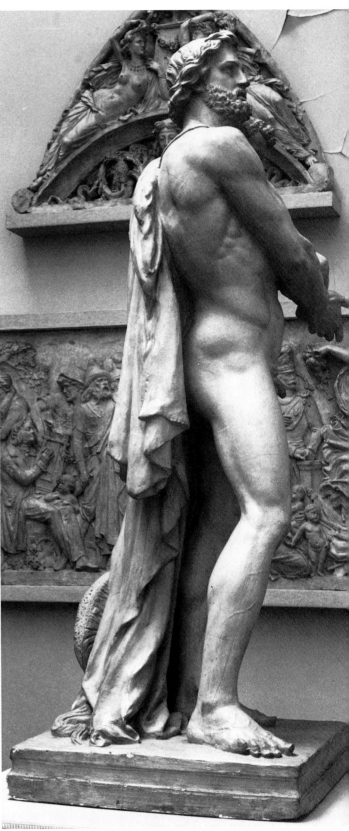

93-94. Jean-Baptiste Carpeaux, *Hector et son fils Astyanax*, 1854, painted plaster (h. 132.5). Musée des Beaux-Arts, Valenciennes.

surprising. Carpeaux's choice of physical type was impeccable. The male body, as he rendered it here, fulfilled an ideal of heroic nobility appropriate to Hector, whereas an equally meticulous rendering of a less splendid physical specimen would have been immediately condemned. In the eyes of the Académie, we remember, bodily beauty was the locus of moral beauty; to the hypothesis "if something is beautiful," academic doctrine allowed the illogical conclusion "then it is good." It seems never to have occurred to the Académie that beauty may be evil or ugliness good, or that such formulations do not alone circumscribe artistic expression.

Carpeaux trusted in his knowledge of anatomy, and he did so in his customary, calculated way. During the summer the competition was in progress, he did not report every day to his *loge* as he should have, to spend hours laboring over his entry. Instead he acted the part of professional sculptor that the critics were to assign him, and gave his time to the two commissions he had in hand: the bas-relief *Napoléon III Receiving Abd el-Kader at the Palace of Saint Cloud*, and the *Génie de la Marine*, a decorative group for the Louvre renovation. In the end he petitioned the Académie for an extension of the time allotted on the grounds of an injury to his hand.[89] Finally he finished his figure in just a few days, working with a speed which demonstrates that he knew exactly what he was about. To put real and ideal together so satisfactorily—to conjure up physical substance so intensely, yet still to observe one's teacher's dictum that this substance should be subservient to *theme*—these were matters which took some thought. The result, in the *Hector*, is a sculptural language at once ostentatiously bold and massively orthodox, a sculpture insistent on displaying its grasp of bodily particulars, yet equally adamant about observing the boundaries of the Ecole's view of art. In so doing, Carpeaux was learning his own language of sculpture, ironically basing it on a science of physical form, yet using it within the confines of the Ecole des Beaux-Arts and in compliance with its regulations. In awarding him the prize, the Académie was recognizing this uncommon skill in execution, which like it or not was one unmistakable mark of aptitude for sculpture. The hurdles of the Prix de Rome were meant to screen out lesser talents. For the winner, education was just beginning. For the loser, when time, money, talent, or will ran out, any further learning would be done outside the school.

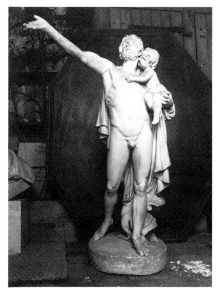

95. Amédée-Donatien Doublemard, *Hector et son fils Astyanax*, 1854, plaster. Musée des Beaux-Arts, Laon.

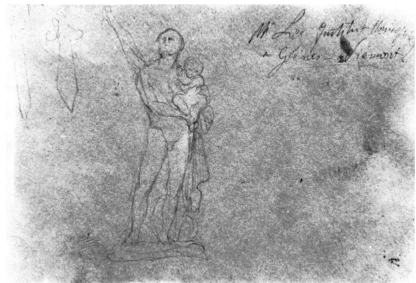

96. Jean-Baptiste Carpeaux, *Study for "Hector et son fils Astyanax,"* 1854, pencil on white paper (8.8 × 15.5). Musée des Beaux-Arts, Valenciennes.

Whether or not he won the prize, a student left the Ecole having been exposed to the approach to sculpture dominant in mid-nineteenth-century France. And for some students exposure, not prizes, was the goal. To quote Salmson once again: "Like me, Carrier did not enroll there to pursue a sculptor's profound studies, but only to acquire some general knowledge and the knack necessary for his profession of chaser, as I did for mine of engraver."[90] "Knack" (*tour de main*, Salmson wrote) was clearly one inevitable product of the packed competition schedule. As for "some general knowledge," that meant learning who or what the minotaur was.

In the 1850s an awareness of the dual function the school was serving surfaced in suggestions for modifications of its curriculum. They pointed to the need to reassess the role of art education as professional training. The administrator Léon deLaborde, for example, urged instruction which would mate the "progressive development" fostered by the Ecole *concours* to a "practical education equivalent to apprenticeship."[91] He proposed the plan in the belief that the study of art should, in his words, "prepare for the moment when the artist, feeling himself incapable of raising his thoughts above a certain level and of creating in the elevated sphere of art, resets his sights on goldsmithery or on sculpture destined for furniture or ceramics or interior decoration." In short, the school should openly avow the commercial destination of its skills. Even curricular changes proposed within the Ecole itself were motivated by similar reasoning. The recommendation of a committee named in May, 1860, to investigate ways of encouraging broader study instead of concentration on one medium, states this clearly.[92] The committee was proposing not some liberal concept of learning, but a more practical kind of instruction which would set sculptors composing pediments and friezes to "accustom them to decorating architecture and to familiarize them with its sentiments and needs." By the same token sculptors and architects were to collaborate in designing objects like candelabra, pulpits, thrones, and vases, as well as fountains and mausolea, while similar plans would have linked painters and architects. As outlined in the proposal, these might be exercises set at the Petite Ecole. And in spirit, if not in specifics, they are early ancestors of the professionally directed program of "Simultaneous Instruction in the Three Arts," finally inaugurated at the Ecole in 1883.

Such modifications and proposals point to the growing consciousness among art educators and administrators in mid-nineteenth-century France of the actual purposes of the instruction in sculpture that they offered. This awareness existed simultaneously with vain attempts to ignore that reality, to keep it shrouded in the mystification of Art dished up in official speeches: "Let us hope, therefore, that the imperial era which we have just entered will be rich in prompt and magnificent vocations. But I should warn you, all too soon you will have to leave that easy path where young artists find themselves. The arts promise not bread, but glory; whoever asks anything else of them will scarcely find bread."[93] Sculpture had to be acknowledged as a livelihood rather than an art, before it could be admitted that students needed to earn their bread. Their ultimate goal was *not* a noble career. Rather most would use their training in daily commercial practice—an admission which parallels the recognition that drawing was useful not just for art, but as a means of communication essential to industry. Importantly enough, the Petite Ecole, traditionally the training school for sculpture as a decorative art, lost enrollment immediately following the 1863 reform of the Ecole, as if some of its function had indeed been ceded to its Beaux-Arts sister.[94]

But long before administrative changes began to orient the Ecole des Beaux-Arts towards a more openly "professional" training, the curriculum in fact had offered preparation for

106

97. Jean-Baptiste Carpeaux, *Philoctète à Lemnos*, 1852, painted plaster (h. 127.5). Musée des Beaux-Arts, Valenciennes.

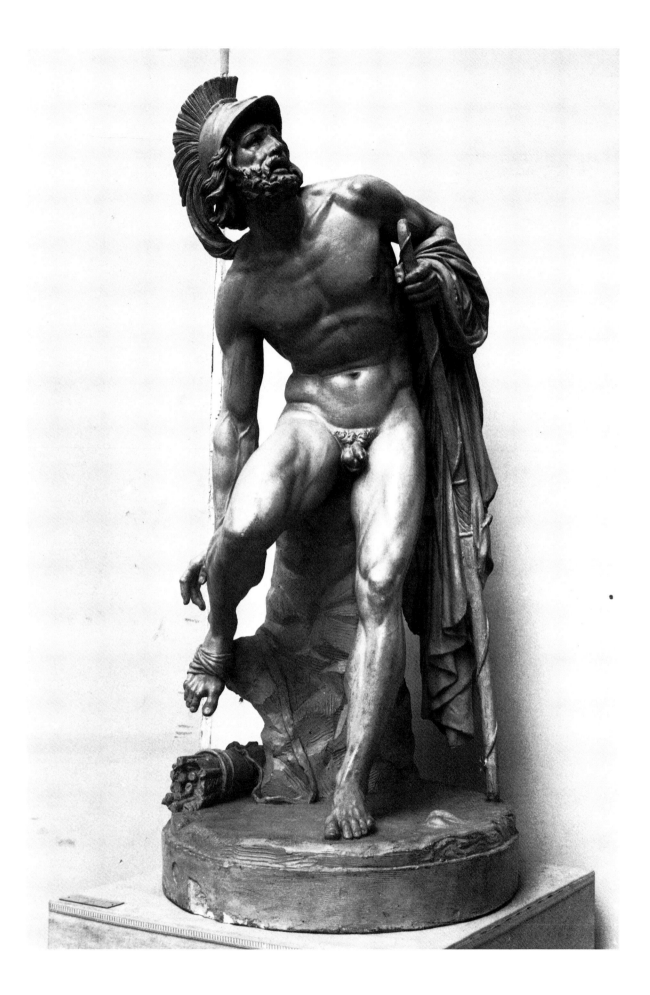

the mundane tasks of sculpture, as well as for its more sublime efforts. These tasks can be clearly stated, just as they were ticked off in that 1860 committee report: pediments, candelabra, fountains, caryatids, lampposts, and drinking fountains—an urban decor with both public and private, civic and domestic, manifestations, whose function in its broadest interpretation is to confirm prosperity and culture by its very presence. Despite individual variations and stylistic modifications—the differences between a caryatid on a theater and an image of Strasbourg on a railroad station—this nineteenth-century brand of sculpture functioned as a sign to be read independently of its ostensible content.

The Petite Ecole prepared its sculptors to produce that decor; ornament was the tool it offered. But the Ecole des Beaux-Arts also encouraged the same results, albeit in a rather different way. Its professors claimed to teach an artistic language, a special idiom based on the human body, disseminated as style or decorum, and couched as culture. Never mind that its uses were ultimately ornamental. Lessons at the Ecole used the great old myths and heroes; there was nothing to replace them, even if some students—the ones without "general knowledge"—had to be given some help in getting the stories straight. How better could a representational sculpture have been taught? The Académie still believed in the ancient tales, not recognizing what the later nineteenth century was to show, that their force could henceforth be tapped only when they were rendered as concepts or signs, and not as forms—to put it boldly, as the Oedipus of dream or fantasy or illness, not the tragic hero himself. Academic sculpture could not escape the literalness of its concept of embodiment. But the Ecole also taught a pattern of thought which itself hindered such recognition. Its formulations resisted change. If you sculpt a battle scene, then . . . Falguière's *Wounded Mezentius*, not Préault's *La Tuérie*. This linear construction of a simple thesis and an ordained conclusion is basic to academic instruction and essential to the decorum governing it. The course of study at the Ecole confirmed that habit of mind in all its aspects; the means for its effective inculcation was meant to be built into the very walls of the school. Its practicality is evident. Once its terms and patterns are absorbed, this way of teaching offers a formula for production, and can thus be effectively applied to a wide range of problems. It is equally adaptable as a device to go about designing a bust or a clock figure, equally serviceable for Salon sculpture and bridge decoration. Essentially conservative, the school's approach did not offer the tools to question basic procedures or to establish new criteria. Students there were bound into the Académie's understanding of "the narrow scope attainable by sculpture," to use Miriam's honest phrase, and their battles with fellow students and exemplary works were fought within those limits. A particular model might be put aside, but harder to avoid was an approach to sculpture which begins by saying, in Miriam's words, "tell me first what is the subject . . ." The Ecole assumed the existence of a closed set of well-known themes which were inseparable from their solutions. Given an assignment, the Ecole student could come back with a figure or relief which filled demands that the subject itself seemed to carry. If the theme was patriotic self-sacrifice, it was shown as *The Death of Epaminondas*, which in turn meant a certain combination of naked men in standing and seated postures, and one shield. The formula was meant to hold again and again. An assigned problem yields an automatic solution. But the Ecole's formulae do not operate in reverse. Students' solutions, sculptures, are not automatically legible. Although called a language, they are often indecipherable without texts in another tongue. We have to know their subjects from an external source simply to be able to understand them; again we are like Miriam. The Ecole trained sculptors to place themselves within sculpture's narrow scope; its expansion would come only through other means.

CHAPTER FOUR

"UN DÉFI À LA SCULPTURE"

> I am in Rome! Oft as the morning ray
> Visits these eyes, waking at once I cry,
> Whence this excess of joy? What has befallen me?
> And from within a thrilling voice replies,
> Thou art in Rome! A thousand busy thoughts
> Rush on my mind, a thousand images;
> And I spring up as girt to run a race!
>
> from "Rome," by Samuel Rogers, 1830[1]

> M. Carpeaux has finally arrived in Rome, along with four other *pensionnaires*.
> . . . These new boarders seem to me well disposed to work, and from the
> little chats I've had with each of them I have a good opinion of their intelli-
> gence; the most uncouth, as you told me, is M. Carpeaux, but I think he
> too will shape up in the end.
>
> Victor Schnetz to Ferdinand de Mercey, January 31, 1856[2]

> Find me another thirty-three year old who with no other recommendation
> than his work takes on the greats of this world, and this after three years
> of concentrated study. . . . I'll get the first medal, I'll be a Knight (of the
> Legion of Honor), I'll be swept on to the Institut; all this Rome is saying,
> and its echo goes straight to Paris.
>
> Carpeaux to his father, October 27, 1860[3]

The rules of the Académie de France required September's winners of the Prix de Rome
to take up residence at the Villa Medici, their Roman quarters, before the end of the follow-
ing January or to forfeit their stipends. So when on January 31, 1856, the Director of
the Villa, Victor Schnetz, reported the presence of a new crop of students to his ministerial
superior, his announcement and their arrival fell just inside the deadline. Except in Car-
peaux's case—he was a year behind schedule. January, 1855, had come and gone to no
avail. His truancy had given rise to a stream of letters: demands and excuses, requests
and allowances, were traded between Schnetz and the minister, the Académie and Carpeaux,
in an effort to square this aberrant behaviour with conduct expected from an eager winner
of the Prix de Rome. Carpeaux had explained his tardiness by pleading ignorance: "About
these rules—I absolutely did not know they existed, and there, Messieurs, I beg you to
believe, is the only reason for the irregularity of my position."[4] And in any case, he reminded

the Académie, he had had the best of excuses for his delay. Had not the Ministère d'Etat granted him a stay in departure so he could complete a commission granted by the Emperor himself? Schnetz was prepared to accept Carpeaux's story, though he could not agree with its implications; he even drew a lesson from it in one of his frequent letters to Paris. The administration was too lenient, he charged, too ready to set the rules aside; it was incidents like this one which threatened to tip the uneasy balance of student feeling at the Villa. "This lack of eagerness to come here to profit from the advantages that study offers our young artists has the worst possible effect on students already in residence, since the love of gain is already at work in them too and only increases when confronted with examples."[5]

The records of the Emperor's Household offer only limited confirmation of Carpeaux's official excuse. He did receive a total of 5,000 francs for a marble of his bas-relief *The Emperor Napoléon III Receiving Abd el-Kader at the Palace of Saint Cloud*, but the final payment was made in December, 1854—a few months after Carpeaux had taken the Prix, and a month before he was expected in Rome.[6] So a year was devoted to putting the finishing touches to a work on which no more money was due—a work which in the end he never finished. He supported himself on part of his Rome stipend, which the minister had decided to allow him—this unaccustomed leniency evidently intended to ensure delivery of goods that had been bought and paid for.[7] The action suggests a confidence in Carpeaux which Schnetz, for one, did not share. He had already decided on his attitude towards a man of Carpeaux's stamp: "I believe it is right to be a bit severe in this case, to cut short these impulses to stay on in Paris when a student has had the good fortune to obtain the Prix de Rome."[8]

All the signs nonetheless suggest that Carpeaux had looked forward to his Roman sojourn with as much eagerness as even Schnetz could have hoped. His relentless attempts to win passage there in the annual contest for the Prix de Rome are the most obvious witness to that desire. More mundane, though no less clear, is evidence like the anticipatory jottings in a notebook dated 1853–54, which transcribe a printed notice of the departures every five days of packetboats run by the Agence Maritime des Messagers and calling at Marseilles, Civitavecchia, and Naples.[9] A year before, he had been making lists of works and places to be seen in Italy, like the *"musée capitilino"* or *"l'oeuvre de Torwaldsen"*—he was as certain of his goals as he was hesitant about their spelling.[10] And soon after he arrived, he commemorated his safe crossing to the artist's promised land, labelling a note-book sketch of a careworn peasant woman "Premier Croquis fait à Rome au Trastevere."[11]

Dreaming of Rome was one thing; departing for it was another. It meant leaving behind commissions and friendships; it meant resigning a newly won professional status and starting again at the bottom. When Carpeaux finally arrived in Italy after his year's procrastination, Paris prizes and commissions were of little account. They could not save him from being singled out as the roughest in the new lot of beginners, even though Schnetz was sure Rome would work its usual magic once again. In a sense it did, though not as Schnetz would have predicted. Carpeaux's ambitions in Rome were not directed to "shaping up," if the term meant styling one's self or art to fit comfortably into polite drawing rooms and other predetermined patterns. Not that honors did not attract him: on the contrary, he expected his art to carry him to the doors of the Institut and swelled with pride at any Marquis's praise. But his own means of shaping up, the "three years of concentrated study" of which he boasted to his father, was a program of work of his own devising. It was undertaken from within the Académie de France at Rome, yet at times in conscious opposition to academic precepts. What resulted from that program was, above all, the great plaster group, *Ugolin et ses fils*. That work alone is enough to show how little—or

how eccentrically—Carpeaux had "shaped up" under Schnetz's care. Even fifteen years later, the sculpture was still notorious. At the artist's death in 1875, one obituary could still rate it "a challenge to sculpture";[12] another could still condemn it as "a ghastly composition, all of unmixed horrors."[13]

Both phrases are telling. The *Ugolin* could seem excessive and defiant to its first audience, and these qualities were all the more striking because the group had been sent from Rome; it had been conceived within the bosom of the very "sculpture" it seemed to defy. Yet paradoxically—inevitably—the Roman context shaped the group. Accordingly the measure of *Ugolin et ses fils* can be taken accurately only with the support of a knowledge of the French Académie at Rome. We need to rough out some of the patterns and standards which controlled experience there, and to try to weigh their impact on artistic production. We need to answer both simple and complex questions: What kinds of sculpture did students produce under the rules? What audience did they address? What aspects of their work did viewers count as meaningful? It is not enough to pose questions like these for Carpeaux alone. We need to have special instruments to understand individual reactions, and they can be forged only from a wider knowledge of institutional expectations and a variety of experiences. We want to put ourselves on a familiar footing with the ways students reacted to Rome—to have the familiarity of a Schnetz, for example, which can take an individual action or sculpture as a sign, as evidence of attitudes and intentions. Only with such equipment will it be possible to comprehend what it means to say that Carpeaux challenged sculpture.

From this statement of intention both a plan and problems arise. Problems first: patterns are determined by sifting masses of evidence—in this case, the sojourns and sculptures of the artists who won fellowships to Rome. This evidence is, at best, cumbersome; at worst, destroyed. Carpeaux's own stay, by contrast, is well documented. We cannot expect, therefore, that this sometimes scattered knowledge and the more detailed picture of Carpeaux in Rome will add up to some tidy whole—to a neat opposition, say, between the rule and its exception. If anything, we will find that there was no rule, even though Carpeaux himself believed one existed. Yet even in the few brief citations which open this chapter, some themes which characterize the shared experience of young sculptors in Rome have been suggested—Rome as an artistic mecca; the Villa Medici as an isolated, privileged environment where talents were nurtured and careers decided; a ruling notion of sculpture. Our first concern will be to see these themes as myth and fact, and to ground them in accounts constructed by observers, *pensionnaires*, the Académie, and actual sculptures. New criteria will emerge, less elusive than the "Roman ethos": the demands made of students; a sampling of *envois*; the Académie's judgements of them. Carpeaux's stay at the Villa must be seen against these preliminaries; they certainly shaped *his* knowledge of the place and formed the standard to which he reacted. Only by mapping these boundaries can we see how they were transgressed.

* * *

The dangers Schnetz saw in the example Carpeaux set his fellow students—above all, the rumors that his stay in Paris was proving a profitable one—echo an all-too-familiar refrain. As a student travelled the academic course he was meant to operate at an ever-increasing distance from money and the marketplace. The handful of men who managed at last to reach the Villa Medici had entered an ideal environment, a Roman cloister, there to begin the study of sculpture all over again. Or so the Académie declared; its descriptions of

the school's mission are revealingly vehement statements of the academic ideal. That ideal was perhaps most clearly phrased in this passage published in 1842:

> In striving to maintain in its school at Rome a strict observation of the rules and a respect for tradition, the Académie satisfies an obligation which it views as its highest mission and sacred duty, because it believes that the destiny of art in our country hinges on the fulfillment of that task. In our present society, in fact, too many causes combine to turn art from its rightful destination, which is to show forth, in all of its branches and with all of its resources, everything that is great, noble, and elevated. For this reason the Roman school, placed as it is within the heart of the Eternal City and far from our modern system, is, in the Académie's eyes, a kind of sanctuary where those with a serious vocation should fortify themselves by solid study, and real talents develop through worthy application.[14]

The Académie's view of its Roman branch is entirely consistent with its conception of embattled academic style: by that token the Villa Medici is transformed from a handsome sixteenth century palazzo into a bravely defended sanctuary conserving the heritage of art against the assaults of a new dark age, the present. In Rome a handful of students began a novitiate, following a way prepared by study at the Ecole des Beaux-Arts. They entered a pure, cloistered life far from worldly Parisian temptations—read the marketplace. Again and again *pensionnaires* were urged to leave the falsity of commerce alone, and Article 7 of the rules, which forbade "any work for the open market," was written to see that they did.[15] Industry and métier were proscribed in the Villa because there the true and tested gods, nature and antiquity, were meant to rule unrivalled.[16] Predictable deities, no doubt, but the Académie urged their worship with a vigor that edges into shrillness.

The Académie held firm to its argument that this quasi-religious existence overflowed with rewards: a life with easy access to Rome's masterpieces, devoted to study, open to inspiration, rid of familial cares—a life which, so the Académie reported gratefully in 1848, could remain undisturbed by the violence shaking the world at large.[17] And if critics were sometimes insensitive to these benefits, just as much as admirers they registered its ideal divorce from life in Paris. Travellers were usually quick to feel the sway of such an enchanted existence, though they did not necessarily approve. Thus Henry James's description in a travel notebook sets down both the dream and its dangers:

> January 26 [1873].—With S. to the Villa Medici—perhaps on the whole the most enchanting place in Rome. . . . I should name for my own first wish that one didn't have to be a Frenchman to come and live and dream and work at the Académie de France. Can there be for a while a happier destiny that that of a young artist conscious of talent and of no errand but to educate, polish and perfect it, transplanted to these sacred shades? . . . What mornings and afternoons one might spend there, brush in hand, unpreoccupied, untormented, pensioned, satisfied—either persuading one's self that one would be "doing something" in consequence or not caring if one shouldn't be.[18]

The Villa's beauties are all here, in a few lines. Its shady paths and studios have Rome's own charm, refined to an essence and shut away in the privacy of a walled garden above the city. James's imagination runs away with the dream of "creating" amidst such luxuries—until he shows us its dangers. The Villa's heady atmosphere can be an opiate, dulling the senses even as it feeds them.

Other visitors saw the place in a similar light, even if they were not necessarily so subtle in their descriptions. Like James they reacted subjectively, measuring the place against

their own standards and knowledge, finding there what they meant to see. The English traveller James Whiteside compared the care the French government lavished on its young artists to the solitary neglect in which their British counterparts struggled. British to the core, of course he ended by declaring that talent is only improved by self-sacrifice: "All the modern schools and societies of France have not produced a painter worth a rush."[19] Or there is the reaction of the Catholic publicist Louis Veuillot. Deeply attracted to Rome's legendary power, he steeped himself in the aura accumulated through the centuries of her Christian history. But despite his intoxication with Rome, he was sober enough when it came to the Villa Medici and its inhabitants. Like James, he saw *pensionnaires* polishing their talents, but the view disgusted him. The whole process was less like education than the laborious manufacture of some useless luxury item. At the Ecole des Beaux-Arts, he declared, the Institut put its possible heirs to the test, and sent them to Rome if the results were good, or they were especially persistent. There they were "to perfect themselves": "les perfectionnements sont en petit nombre, et sont petits, petits, petits."[20]

The conclusion is clear: a stay at the Villa Medici could kill inspiration rather than foster it. Many causes were cited to explain this malign effect, from the lack of guidance available in Rome, to students' inability to resist the city's temptations, or, conversely, to their total isolation from them. The critic Gustave Planche, one of the most vocal adversaries of the school, espoused the last explanation. He saw the place as the home of a small closet sect of self-satisfied students endlessly exchanging and sustaining ignorance and prejudice. The cure was simple, and radical: abolish the school, and send students home again. As the capital of art in the nineteenth century, his argument ran, it was Paris that now dictated artistic production, and there the audience for art paid no mind to whether a student had studied in Rome. It was thus both unrealistic and impractical to ship budding professionals off to Italy to prepare for a future that would be lived out elsewhere.[21] This opposition between Rome and Paris pitted tradition against modernity, couching the argument in artistic terms, yet echoing the tension so often felt between the two cities in the nineteenth century. It was the opposition between old and new, north and south: Veuillot valued Rome's perfume the more in contrast to his distaste for the odors of Paris. He cherished the scent of churchly incense and reviled the stench of tobacco in the café-concert. Michelet made out a similar dichotomy between the two cities, though he revised Veuillot's terms to express it. For Michelet, Paris was the future and Rome the past, a huge abandoned garden in which the whole world had been buried.[22] Former heresies could now be uttered freely; it was possible to assert that Rome no longer mattered very much, even in cultural terms, even in terms of religion. And doubts like these gave force to questions about the necessity of French artists studying there.

Outside the walls of the Académie, then, opinions of the Villa Medici and its students were none too high. As in the case of the Ecole, the charges levelled against academicians were also brought against *pensionnaires*—only now the appearance of privilege and anachronism was all the more flagrant since these students were considered chosen heirs. If it was the fashion to dismiss the Académie yet secretly to hanker after membership— Flaubert tells us that—then castigating its products in print was apparently one way of keeping up the pretense. Art critics frequently made "winner of the Prix de Rome" a dismissive rather than honorific epithet, using it to suggest not an artist's merit, but his lack of same, and lumping him with other equally hopeless or irritating cases. In 1863 the stigma alone was enough to deter one hostile writer from discussing Carpeaux's *Ugolin* at all; or at least it was the reason he chose to give in print.[23]

While a student was at the Villa Medici, however, attacks like these could hardly have

seemed very important. He was at the heart of the academic system, out of earshot of its critics; his persistence in trying for the Prix de Rome had long since indicated his conscious tolerance—if not his espousal—of the ideas and standards of the profession he intended to enter. He wanted above all to say *yes* when asked if he had been to Rome. If he had criticisms of the Villa Medici, they were addressed to the detail of the place, to the particular ways it affected his life and work. Students sometimes chafed a little under harness, but by and large most began to participate in the little world of the Villa, fitting its pattern and filling its requirements.

Adjustment was crucial, and not always easy. As Carpeaux's story demonstrates, it did not depend simply on a student's desire for success. A certain amount of anxiety was thus inevitable. Even back in Paris anticipation ran high, and the details of life in Rome were traded around the Ecole, discussed, elaborated, and embroidered into myth. No source of information was left untapped. Thus while Cavelier was still a contestant for the Prix de Rome, he wrote to his friend Auguste Ottin, who had been established at the Villa since 1837, to ask for any scrap, any hint, to evoke the place: "But you can understand how much interest any details have for me—about the life one leads, or the manner of study, in short, about the actual position one occupies."[24]

Anticipation could stay at the same pitch for the whole journey from Paris, through Marseilles if the trip was made by steamboat, or even longer if one travelled overland. Naturally it reached its height on the edge of Rome, and the habitual sport of the old students played on just that agony of suspense. Every year the same joke was staged. Wearing scrupulously sober faces, the *anciens* rode out to greet the new arrivals, and broke some sorry news about life at the Villa, which eventually turned out not to be true. When the worst was over, the new students wrote home to describe the odd reception they had received. Take for example Georges Bizet's letter to his parents:

> We were wonderfully greeted by our comrades who deemed it necessary to pay a charming trick on us: short-sheeted beds, night-tables broken and held up by a sliver of wood, which made a frightful noise every time they were touched. . . . It's an old custom, but not an offensive one. Soumy, an engraver, covered his eye with a bandage and made out that he had gotten a knife wound. They painted us a grim picture of the city of Rome, which we passed through at seven in the evening—and all this is not finished yet.[25]

Bizet was a very young man when he wrote this—he won the Prix de Rome at nineteen—but, even so, he seems less than amused at his future comrades' little jokes. We can see him contemplating the idea of five years of "charming tricks."

The rites of passage traded, of course, on the new students' real anxieties about the dream of Rome. It was always possible that things would not work out well. A creaky night-table could be borne, but unsympathetic companions were less easy to tolerate. Each *pensionnaire*'s life in Rome was the story of the ease or malaise he felt in the new environment. Read separately, these stories might seem only an endless series of personal dramas or melodramas, but in sum they suggest some of the discomforts and real dangers of Italian life. It was a foreign country which spoke a different language; so much was obvious, but for Carpeaux, at least, it meant endless lists of conjugations and numbers (*uno, due, tre; esso, essi, esse*) as he tried to get the basics under his belt. The climate seemed equally foreign to many Frenchmen, and they fell victim to heat and malaria. A doctor was in constant attendance at the Villa. The financial records of his services reveal that most of the French inhabitants were constantly being dosed for one illness or another.[26] It was

not uncommon for a stay to be cut short for reasons of health, and illness could be mental as well as physical. Depression, even insanity, were causes the director frequently cited to explain a student's return to Paris (the sculptor Bonnardel died raving mad and the painter Chifflart had to be removed to a Paris asylum). Sometimes simple boredom was the problem. Edmond About called Rome the dullest city in Europe,[27] and Francisque Duret's description of his own ennui might be the illustration of About's opinion: "I wanted to send you some interesting news, but everything is as usual. The *Pensionnaire* rises at about eight o'clock and spends his day without exactly knowing how; evening comes, and he doesn't exactly know where to go for a bit of amusement: some go straight to bed, others go to a café, a few more yawn in polite society."[28]

Were students lucky or not? Duret is one of those who went home before time. Though he was called away by sickness in his family, illness and ennui could certainly take their toll. Their impact is the more remarkable because the physical setting of the Villa, as visitors agreed, could not have been more splendid. It sits on the Pincio, up above the Spanish Steps, floating free from the heat and dust of Rome. Designed for a Cardinal in 1544, the structure is grandiose and simple at the same time;[29] it clothes a strongly geometric volume in a decorated sheath (fig. 98). "The great facade on the garden," so James was to describe it, "is like an enormous rococo clock face all encrusted with images and arabesques and tablets."[30] (It was there, before the portico, that students posed for the annual group photograph.) Out from the garden, the prospect takes in the entire city; sunset from the terraces is a tour de force. The road up to the Villa, shaded by an avenue of oaks, ended at a huge door framed by enormous antique marble columns; inside was a world of marble and water and cool tile floors—a world in hiding from the Roman summer.

The Villa was really a palace, a fairy-tale. "We are like little princes," one student wrote. And why? Not on account of columns or fountains, in this case, but because of the "two meals a day, which is absolutely delightful."[31] It was also nice to have a private room; *pensionnaires* were housed either within the main body of the building, or on the second floor of the loggia which runs along one edge of the garden. The sketch which Henri Chapu sent home to his parents suggests the quarters (fig. 99): bed draped with mosquito netting, a few pieces of wooden furniture, sketches pinned to the walls, casts standing on shelves, and a window open to the Roman vista. The rest of the sculptor's apparatus—the modelling stands, armatures, mannequins, perhaps a cast of Houdon's exemplary *écorché*—was kept in the atelier assigned him in the shaded garden.

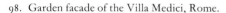

98. Garden facade of the Villa Medici, Rome.

99. Henri Chapu, *Study of the Artist's Bedroom at the Villa Medici*, c. 1859–60, pencil. Musée, Melun.

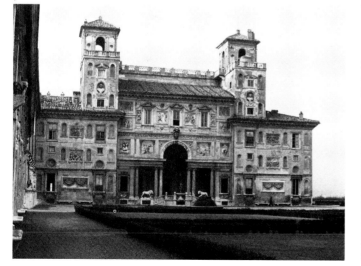

In addition to these private spaces, the Villa provided a series of public rooms: the *pensionnaires'* dining room, lined with dozens of portraits of previous students; the *salle des praticiens*; and the *salle du modèle*, with its rotating model stand and places for ten draughtsmen and five sculptors.[32] A model posed there for two hours every day, in sessions open to students from inside and outside the Académie. There was also a Galerie des Plâtres, which ran the whole lower length of the loggia wing, and a Galerie d'Architecture inaugurated under Ingres (of which more later).

The entire establishment had about thirty-five residents: that is, some twenty-two *pensionnaires*, the director and his family (if he had one), his secretary, a porter, his underlings, chambermaids, a cook, a gardener, and his assistants—these last all wore the Villa's green livery. Supervision of every aspect of the place was left to the director: all inhabitants, provisions, equipment, repairs, and construction were in his charge. He administered the rules which governed not just the students' work, but also the payments allotted them and the conditions under which they left the Villa, either for travel or to return to France. During his five-year term, he answered for all of his decisions to both the Académie and the Ministère des Beaux-Arts. In case of clashes between students and the rulebook, he acted as mediator or accuser before these two final bodies.

The director held power at the Villa, and it is a commonplace of descriptions like mine to say that the director gave it its tone:[33] the festive soirées staged while Horace Vernet was in charge are contrasted with the sedate evenings at which Ingres played the violin and Mme Ingres sewed. Of course there were more substantive differences. Ingres also played the role of a teacher, for example, though his position did not strictly require it. Under Schnetz the Villa seems to have been neither especially worldly nor particularly dull, and the same slight indistinctness clings to his impact on student thinking.[34] It is certain that with Schnetz as host the traditional weekly receptions were frequented by French and Romans alike. His long familiarity with Rome (his first directorship, from 1841 to 1846, was awarded after years of residence there) gave him a wide circle of acquaintance and helped to mix the Villa's residents more thoroughly with Roman society. In any event, Schnetz's conscientious conduct of affairs satisfied both Académie and administration alike; his second tenure lasted thirteen years, longer than that of any other nineteenth-century director.

The most critical aspect of the director's role was his approach to student work. His power extended even to the subjects they decided to treat. He could veto any proposal, either outright or, more subtly, by discouraging an inappropriate selection. (Ingres, for one, was sensible of the *limits* of this power; he distinguished between a "simple" veto, and the more delicate business of turning students' choices in a new direction.) He visited ateliers and commented on what he found, acting as guide and interpreter of the rules the Académie had decided, and keeping a running tally of how many of the required exercises a student had completed. Painters, sculptors, and architects all moved through progressively more difficult assignments during their five-year stay, but the different demands of the lessons assigned each group assumed that the skills of each discipline were learned at rather different rates. For example: for the first two years of a painter's stay—and the first *three* for an architect—he repeated exactly the same problems.[35] In the painter's case that meant a life-sized figure from nature, a finished drawing after an old master picture with at least two figures, and a drawing from the antique. As his annual submission the architect assembled four studies of details chosen at will (though with directorial approval) from the best antique monuments; in the third year he added a section of an ancient building, indicating proportions and construction. Of course there were aspects of these repeti-

tive *envois* which the requirements did not specify and which served to differentiate them: the painters' life-sized figures were most often fitted out with mythological or religious trappings, for example, and given some dramatic or pathetic story to enact. Yet these ostensible differences in subject matter cannot completely obscure either the similarity of each exercise or the fact that together they bespeak a specific understanding of artistic language and the progressive order in which each medium is learned. Initially a painter painted a figure and drew from older art: he was repeating his alphabet in full and finished form. He kept on saying it, composing a sketch only in the third year and painting a copy only in his fourth. Finally, in his last year at Rome, he arrived at the *tableau*, a full-scale, complicated invention. Likewise the architect designed only in his last year, when his project was a "public monument in keeping with French custom." The year before, his studies had still been focused on the antique: the fragmented drawings of the earlier *envois* were replaced by studies which allowed the presentation of an ancient monument in its entirety, even restored to its original state.

So painters and architects worked step by step, accumulating skills progressively: drawing before painting, part before whole. Never mind any backlog of experience already accumulated. For sculptors, however, the sequence was less progressive, and began from an entirely different point. They started the first year with a marble copy of an antique statue: the finished product would be added to the government's store of such items. In this task they were aided by a *praticien*, in a relationship which replicated the arrangements they would use as full-fledged sculptors. The Italian worker blocked out the model on the marble and worked it to the stage of finish "à la grosse gradine"[36]—that is, roughing it out with a large-toothed chisel. The copy seems to have been less-than-inspiring exercise; so many students neglected it that after 1845 it was held over to the second year to allow extra time, and an original composition for a bas-relief of one or two life-sized figures (one nude) was substituted for the first year problem. Under the new rule the copy was to be accompanied by a *tête d'expression*, which, as students were often reminded, was to be not just a simple portrait, but a "true representation" of moral qualities or sentiments. In the third year two more works were due, a life-sized figure in the round and a bas-relief of at least eight figures, meant to be an exercise in "large sculptural conceptions, the relationship of planes, and the monumental effect which a bas-relief should produce" (this although it was only forty centimeters high!).[37] The fourth year tribute was also comprised of two works: the model of a second life-sized figure and the sketch of a group of not more than three figures. The last year was spent finishing a marble of the figure composed the year before.

As always, it is hard to translate rules into people and sculpture; we shall make the effort before too long. But first it is important to notice that the labor of sculpture meant that the sculptor's work load was heavy. The course was demanding and it did not move through quite the same pattern of progressive complexity as the studies asked of painters and architects. From the third year onwards a sculptor worked at the level of difficulty of the final *envoi*; moreover, he was never asked to resolve at full scale the complications of multifigural groups or reliefs. The rule held him to the full-sized figure because the sculptor's achievement was considered to be concentrated in his mastery of the figure, alone, isolated, and self-sufficient. The only study of its parts which might prove useful was the *tête d'expression*. Neither a new nor a strenuous exercise, it was done only once.

In executing the works required of them, *pensionnaires* were becoming sculptors. *Real* sculptors this time—sculptors' sculptors—not working in contests on set subjects, as they had done at the Ecole, but choosing and completing their own themes, even if in accordance

with academic prescriptions. This process of maturation is certainly one aspect of what Schnetz had in mind when he wrote that the new arrivals—Carpeaux among them—would shape up. And though a student might worry about Rome before he arrived, he could be reasonably sure that this process would structure his stay. In the end it was what made the risk and discomfort worthwhile, even if the rewards sometimes seemed impossibly far off. Most students must have needed doses of encouragement from time to time, perhaps along the lines of the urgings young Cavelier sent his friend Ottin: "Have courage, remember that you are in Rome, and that you must become a sculptor."[38] "Tu dois devenir *statuaire*," he wrote, underlining the key word to make his point. Even the still inexperienced Cavelier was learning to weigh benefits against drawbacks and, from Paris, to understand Rome's problems: "It's painful," he agreed, "to be hindered . . ." Another of Ottin's correspondents, the writer Loubens, who was a member of a self-styled *cénacle* which included Petrus Borel and Célestin Nanteuil, offered his own advice: "These academic tribulations do not surprise me; be unctuous because you must for three years, then come back home and take it out on us in big blows, and while waiting, if they make you work for niches, then make them statues too big to fit."[39]

The frustrations of Ottin's Roman career are only hinted at by quotations like these, but the hints point to the chief artistic problem of a student's stay: hindrances, limitations, "academic tribulations"—in short, the difficulty of becoming a sculptor under supervision. The task entailed not self-definition or self-expression, but staking out an individual territory within the academic compound. In Ottin's case, his own account is the best description of what that entailed; the headlong rush of words in a letter home captures something of his eagerness to succeed in a difficult milieu and medium. He set up his tale carefully, first reminding his family of the good impression that his copy of the Belvedere torso had made on M. Ingres and his determination not to surrender the advantage. Wasting no time, he went straight to work modelling a figure he hoped would serve as his final *envoi*, and submitted it to the master's approval. "M. Ingres recommended that I not make my figure more than five or five-and-a-half feet tall; since I disagreed and thought it should be at least six feet tall, I began it at that height without warning him, and when it was massed, I looked for him to show him, really fearful that he would make me reduce it to the height he had allowed me."[40] To Ottin's relief, Ingres did not ask him to shrink the scale. All his hopes rested on the impact that extra half foot would make. (Size and his chosen subject—a *Hercules*—evidently went hand in hand.) "After all this, I can flatter myself that I'll make quite an impact on my return; this will be the largest figure ever made at the Académie; larger by several inches than even Jouffroy's figure, and I really think that I'll study mine every bit as well as he has his—if not better."

Ottin's eager calculations, his idea of winning over Ingres in order to overwhelm Paris, help us begin to understand the several audiences to which a sculptor's work was to be presented. It had to earn, if not the director's enthusiasm, then at least his passive sanction; otherwise it might never be sent home. In Paris, its first audience was the Académie. But *envois* were also meant to be seen in public. They were put on show each September, in the exhibition of *concours* sculpture at the Ecole. Critics and public attended in force; the display was their initial contact with pieces they often saw again at the Salon, months or even years later. When Ottin flattered himself that he would make "quite an impact" with his *Hercules*, it is difficult to know which audience he had in mind. Critics and Académie were separate quantities; the same work would not necessarily appeal to both. Some sculptors must have produced for official viewers while others aimed at a wider public; still others tried for a judicious mix of the two.

The case of Ottin brings us in contact straight away with the difficulties of studying nineteenth century sculpture. His tactic, it seems, was to impress by overwhelming, to make a statue bigger than any real or mental niche. But all that remains of his *Hercules*, ambitious though it may have been, are verbal accounts: the texts just cited, the Académie's thoroughgoing attack when the figure reached Paris, and Ottin's own chagrined apologia, written as a kind of explanation to his patron François Sabatier. And yet, even without the statue, these last are useful documents, especially when read in the light of Ottin's first letter home. The Académie catalogued the figure's faults succinctly: it was hackneyed, mannered, ill-studied, and modelled from a common physical type lacking the elevated character and nobility necessary to represent the god. All the work possessed was— horrors!—"l'exagération des formes."[41] Against this Ottin asserted simply that he had wanted to represent "a man in the fullness of his force and beauty"[42]—*not* Hercules the god, but "the strapping young man whom nothing resists, who makes everything bend under his powerful arm." Strapping did not mean musclebound; Ottin claimed to have carefully avoided the weighty, overburdened bodies of familiar models like the Farnese or Commodus *Hercules*.

We need the *Hercules* to prove or deny Ottin's claims and the Académie's accusations, and to measure what they mean in representational terms. But even without it, the two texts combine to suggest some matters which the Académie and a sculptor might dispute. The central issue concerns the limits of representation: is there one Hercules whose particular characteristics can only be conveyed by a certain anatomy, or are there several Herculeses with various bodies among which a sculptor can choose? Can he invent a Hercules? These questions do not broach matters of identity so much as they aim to define, to delimit, the selection of appropriate forms. How closed is the sculptural code? The academic assessment of student work repeatedly insists on the fixity of meanings which sculpture can be allowed to convey and on an equally finite set of forms able to communicate them. Examples can be chosen almost at random. In 1842, passing judgement on Jean-Marie Bonnassieux's fifth year *envoi* (fig. 100), the Académie was clear that "M. Bonnassieux's *David* does not show the style which the subject demands"—this even though they recognized a good compositional order to the figure itself. The reprimand meant that the body assigned the young Biblical hero, "short" and "round" in their eyes, could not convey the qualities of courageous temerity and patriotic fidelity that rightly belonged to him.[43] In 1851, in an account of Eugène Guillaume's final exercise, *Anacréon* (fig. 101), the Académie's judgement, though more approving, still rested on the same kinds of assumptions. Appropriateness of rendering was weighed in some detail, with suggestions about how it might be improved:

> The subject of this statue is well chosen; the abandon of the pose is well suited to the personage, but what does not accord so well with Anacreon is the head, which lacks style and elevation, and the short and too-accented forms of the torso and arms. In putting more softness into the flesh, the artist will get more suavity in the contours. He could also study the folds more carefully on the right side, where nonetheless the drapery is well adjusted and in good taste. On the left, where it is too abundant, he could diminish its mass and make the contour more evident.[44]

Here finally the Académie was getting down to cases. Here enthusiasm for Guillaume's figure provoked some amplification of the usual cryptic criticism to include a precise description of the fine adjustments which could actually make a difference. It is not that the recommendations—easier contours and well-studied drapery and clearer

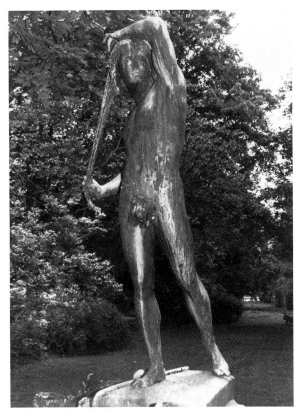

100. Jean-Marie-Bienaimé Bonnassieux, *David tendant la fronde*, 1840–43, bronze (h. 200). Jardins de Chevreuse, Troyes.

101. Eugène Guillaume, *Anacréon*, 1852, marble (h. 185). Musée d'Orsay, Paris.

definition—are in any way unusual. Yet for once they are given, and given in specifically visual terms. The statement is thus an analysis of decorum, of the suitability of the various decisions the artist took. The initial choice—here as in any work—is subject matter. Representation of the Greek love poet is sanctioned because contemporary French painting and sculpture contain endless precedents for the choice. The Académie might have even remembered fondly that Guillaume's own master, Pradier, had sent an *Anacréon* as his *envoi*. The subject carried with it license to give the figure soft muscles and an abandoned pose—usually proscribed for sculpture—though any hint of a similar sensuality in the poet's face was to be strictly avoided.

Decorum was not the only standard the Académie used to judge student works. It censured other faults, like lack of study, or lack of finish, or a poor choice of subject. But all of these are tied back to the ruling concept of the appropriate. In 1843, for example, Louis Chambard sent as his last *envoi* a marble *Orestes Pursued by the Furies* (fig. 103).[45] In its report, the Académie leapt to the attack: "The choice of subject seems unhappy, seeing that an Orestes, in this particular situation, cannot easily be conceived isolated from the Furies which chase him."[46] Even if we grant this point, should we not fault a logic which goes on to rebuke a figure for the movement and expression it uses to represent a subject just declared taboo? The Académie nonetheless was undeterred by its own dictum. It continued: "Its attitude is almost all reminiscence, without that reminiscence having the merit of referring to a type appropriate to the subject." And to conclude, the report measured the execution of the *Orestes* against a proper treatment of the theme, even though the ban on representing it was still in force: "The rendering is too conventional, it does not indicate enough study from nature, nothing lives or palpitates in this figure, where all the passions of the soul and all the fibres of the body ought to be in play." The exact meaning of

120

this call for a vital rendering of a tense, energized form is of course not as clear as it first seems; unlike the advice to Guillaume, which suggested smoothing swathes of drapery and softening some contours, this critique includes no hint of how to create the illusion of life it demands; perhaps we have struck the real taboo.

A certain sophistry rules commentary like this, which describes a subject as forbidden, then issues instructions on how best to treat it. What kind of lesson is being taught? Even for insiders, it must have often been difficult to be sure. How elusive such reasoning could be—how difficult to anticipate—is clear if we compare the Académie's judgement in Chambard's case with its reaction, four years earlier, to another *Orestes*. The work in question was Pierre Charles Simart's fifth year *envoi* (fig. 102; 1839). As it happened, the work marked Simart's first real public success: its appearance in the Salon of 1840, wrote his biographer guilelessly, was one of the epoch-making events of art history.[47] If Simart's own words are to be trusted, it also marked a real acceptance of academic precepts on his part. The subject was a second choice, replacing his original intention to carve David in the Grip of a Lion—to his mind "a group which could produce a great effect, because of the extraordinary energy to be expressed."[48] Discouraged by Ingres's disapproval and the difficulty of finding a lion to study—the nearest was in Naples—he chose a new theme, from Aeschylus this time: "Orestes, pursued by the Furies and exhausted by fatigue, falls at the feet of Minerva's altar while imploring her." Already, on the basis of Chambard's experience, problems can be anticipated. But Simart was as serious a student as ever studied in Rome; he weighed the merits of this new theme as clearly as he had reckoned the advantages of the David, and sounds very much the academic in the process: "Although it is not in fashion, there is something here of real interest from two points of view; first of all, form, which must be selected from the most noble, because Orestes derives his origins from the gods; second, concerning expression, it is impossible to have more ways to move, interest, and touch the spectator."[49] Despite his confidence, however, Simart nonetheless wrote this analysis in the bitter assurance that his work's merits would never be appreciated by the contemporary public: "The majority of the public looks at a statue or a group exactly as a *grisette* reads a novel. . . . This public must be amused, otherwise it pays no attention—that's why we have the romantics!"[50]

His statue's success in Paris forced this wise young man to reassess his attitude towards the public, "whose opinion I thought I had the right to scorn, oh human weakness!"[51] The Académie's reaction, however, could not have been equally gratifying. In 1839 it discussed the plaster of his figure, along with the other Roman *envois*, since the marble was not yet finished. Simart's *Orestes* was not condemned outright, since, unlike Chambard, he had had the sense to show the hero seeking refuge rather than pursued—a more finite, less open conception. The two subjects in fact demand a very different orchestration of the body: desperate tension is needed on the one hand, relaxation on the other; one demands the wariness of hunted prey, the other the exhausted relief of a man who has found the god's protection. But the criticisms the Académie offered—though it basically approved of Simart's solution—suggest even further the narrow territory within which a sculptor was asked to work.

> Considered from the point of view of composition, this figure does not render the subject in a satisfactory manner. The abandon of the pose indicates only the heavy weight of fatigue, without completely showing the moral character of an Orestes represented in this particular circumstance. The figure is too much conceived in the manner of bas-relief, above all in the placement of the head, which falls back onto the right shoulder instead of inclining on the chest, which certainly would have produced a better effect. The move-

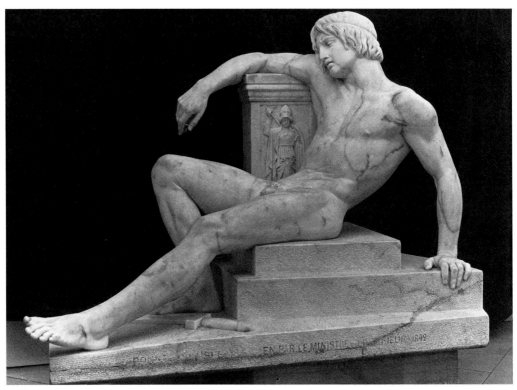

102. Pierre-Charles Simart, *Oreste réfugié à l'autel de Pallas*, 1839–40, marble (h. 128). Musée des Beaux-Arts, Rouen.

ment of the shoulder is not right, but above all it is the character of the head which leaves much to be desired. In it Orestes the parricide cannot be seen. The hair—soaked in sweat as it ought to be—is too systematically arranged; more disorder would have been preferable.[52]

This negative assessment, which found both pose and head lacking in proper character, was countered, to be sure, by appreciation for the strengths of Simart's just, noble handling of the body. But the initial reproach nonetheless remains. The relaxed, exhausted pose (let alone a too-tidy coiffure) did not completely suggest Orestes, even though Simart was entirely conscious of the central issue, Orestes' "origin from the gods," which Chambard had neglected. Once again we find the Académie measuring a work against an unknown ideal which, we imagine, would somehow embody the demands they made of Chambard's and Simart's efforts. As if in confirmation of the hypothesis, the next academic rendition of the theme, modelled by Raymond Berthélémy in the Prix de Rome competition of 1860, advanced a sorry compromise, crossing a more energetic conception of the outlaw Orestes with the necessary depiction of him "seeking refuge" (fig. 104).

From critiques like these it might seem that the Académie was insatiable, that no amount of careful effort could ever fulfill its demands. It approached student sculpture in a rhadamanthine guise, armed with worries, reservations, and a battery of constraints which it used to enforce its unspoken working code. A limited student like Chambard could have little hope before such artillery, and even the most dutiful—someone like Simart—was made to understand that he could not yet be considered a rival, or even an initiate in full possession of the Académie's secrets; nor could he ever be, we suspect, while still a student.

103. Wood engraving after Louis Chambard, *Oreste poursuivi par les Furies*, 1843, marble. Reproduced from *L'Illustration*, 1843.

104. Raymond Berthélémy, *Oreste se réfugiant à l'autel de Minerve*, 1860, plaster. Ecole Nationale Supérieure des Beaux-Arts, Paris.

Academic opinions cannot simply be passed off as a specially querulous branch of art criticism; they were weapons and tools in influencing young sculptors, though their effect depended on the skills and temperament of the individual artist addressed. In some cases, demands were repeated year after year, *envoi* after *envoi*, until they provoked satisfactory results. That certainly was the case in the Académie's dealings with Henri Chapu (1833–1891). The winner of a Prix de Rome in 1855, Chapu's first success had mostly been testimony to his teachers' confidence and sympathy and the vivid impression he had already made at the Ecole; his bas-relief *Cleobis and Biton* had been dropped and damaged before the judging, and its superiority had to be taken on faith. In the end Chapu shared the prize with Doublemard. Yet the Académie's first assessment of his Roman work recalled this beclouded start as a triumph, the better to contrast it with the abject failure—*The Dead Christ with Angels* (fig. 105)—which he had offered as his *envoi*. The task was undertaken rather gingerly, but the rhetorical disclaimers which prefaced the reproach in the end do not soften it.

> If [the Académie] heeded the severe voice which after all is only the expression of the concern it harbors for its laureates, it would have more than one reproach to address to M. Chapu. It would tell him that his bas-relief of the *Adoration of the Angels* [*sic*] does not have the calm, the unction, befitting the subject; that nothing justifies the disordered movement of the angels' drapery; that he ought to have avoided the disparities in planes which spoil the harmony of the whole.[53]

This opinion, like those cited above, is written from a basic certainty about what the subject demands: calm, unction, and uniform planes. It happens to concern one of the loveliest

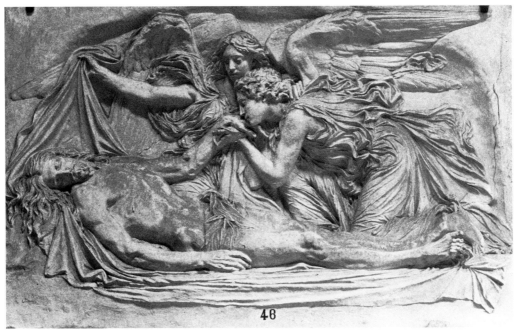

105. Henri Chapu, *Le Christ mort aux anges*, 1856, plaster. Musée Chapu, Le Mée.

works sculpted at the Villa Medici. But it is out of the question, for these judges, that beauty be achieved as Chapu does it. They are not capable of asking if the crisp flowing lines of Christ's winding sheet and the angels' robes do not in fact combine to form a focused whole. We might argue against the judges that Chapu studied the poses of each figure separately just so the composition *would* resolve "harmoniously" around the cherishing gestures of the angels, whose widespread wings enfold the flaccid corpse (fig. 106).[54] The final resolution did not seem to matter: its separate emphases were too disorderly. It is no wonder that this opinion recalls the similar dismissal—by the salon critics as opposed to the Académie—of Edouard Manet's *The Dead Christ with Angels* (fig. 107). The com-

106. Henri Chapu, *Etude pour la pose de l'ange*, pen, pencil, and brown ink with brown wash (44 × 57.7). Musée, Melun.

107. Edouard Manet, *The Dead Christ with Angels*, 1864, oil on canvas (179.4 × 149.9). Metropolitan Museum of Art, New York.

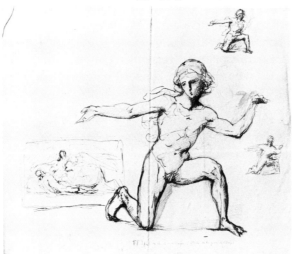

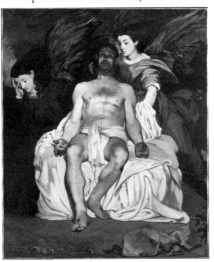

parison might be unexpected, but it is not far-fetched. Manet too was asked to idealize and conventionalize Christ's corpse rather than show it dead. And *his* critics went even further, pinning down his work's defects by naming the stylistic precedents on which it relied.[55] Chapu's critics stopped short of such specifics, as if they could not bear to discuss Chapu's disgraceful debts. It was left to Chapu's teacher, Francisque Duret, to put a name to the problems. And, despite his paternal tone, his remarks were not calculated to encourage; his attitude was more frustrated than anything else. He began with a verbal wring of his hands:

> My poor Chapu,
> Have you really completely forgotten the good sculptural principles you demonstrated in your Prix? Everyone built great hopes on you, and you make the most frightful *envoi* I've ever seen! Why the devil do a Christ, the most beautiful of men, when you're not even capable of making an ordinary man of the kind Rome abounds in? At least they have character and that fits perfectly with sculpture. Your bas-relief is misunderstood in its planes, the nude frightfully drawn, its taste does not belong to any artistic epoch [le goût n'appartient à aucune époque de l'art], and I'm very distressed to see such a thing.[56]

In the end Duret assumed a slightly more constructive tone: "Look a bit at the best Greek sculpture and at Michelangelo, and not at rococo painting, which has only the dubious merit of color. Sculpture wants nobility and handsome forms, and not little touches, hollows and bumps like those you put in your Christ, which convey exactly nothing." And then, if this was not enough, the teacher closed with a loaded exhortation: "Try then, my dear child, to look a little at the antique, and count on my devotion and friendship if you make yourself worthy of it."

The hollows and bumps which set Duret complaining—along the arm, perhaps, or around the knee, or where the muscle falls slackly away from the shinbone—articulate the fact of Christ's body as corpse. Chapu did not invent these devices; they are probably inspired by study of medieval and Renaissance *gisants*, though they may owe something as well to Rude's *Godefroy Cavaignac* and Préault's *Ophelia*. These suggestions are enough to indicate what the controversy around the work really entailed. Chapu's treatment of sacred flesh arose from a personal understanding of his subject: he avoided antique convention for a Christian subject and tried to unite intense sentiment with a treatment of the body meant to convey it. But Duret's letter told him that the attempt was foolhardy and instead offered a program of study which might return him to the fold.

Conscientious student that he was, Chapu endeavored to place his third year *envoi* more firmly within the academic domain. He sent in a more appropriate subject, a figure "which he calls Triptolemus" (fig. 108; the plate reproduces the bronze version of the work exhibited at the Salon of 1865). This slighting reference is the Académie's. It did not accept that nomenclature, and explained why. "If one wanted to see in this statue only a study figure, a *Sower*, for example, one could praise in it a certain sculptural character and a good movement. But it is impossible to see it as the demigod Triptolemus, the pupil and minister of Ceres. It seems that M. Chapu gave it this name after the fact, thinking to elevate his work. He was mistaken, since his statue has neither the beauty nor nobility which the subject requires."[57]

Frustration sets in at this point; how could the Académie be so sure *it* knew what Triptolemus looked like? As if aware that more than naysaying was in order, this time it deigned to offer Chapu some advice. It told him how artists should proceed: "Before executing

a work, an artist must above all take inspiration from the character of the subject he wishes to treat and look for the true expression of it." Chapu might have protested that this is exactly what he did. He wanted to show Triptolemus, so he found a very simple movement and a Roman "from the good old days"—perhaps the model with "the very handsome air" which Degas had sent him.[58] The difference centers on the question of true expression. In Chapu's eyes, a handsome man in the act of sowing was Triptolemus. This direct uncomplicated relationship between representation and subject matter was at the root of his own conception of the artist's task. "A sculptor or painter has been sincere," he wrote, "when working either from nature or the imagination, he arrives at a single image or group of images; he must push himself to reproduce them as he saw them, without substituting for those truthful forms other shapes derived externally, from works of art."[59]

At this stage of his development, three years into his Roman stay, Chapu was still not yet totally indoctrinated. He was a skilled sculptor, but his intentions were still at odds with academic procedure. The result was a work like the *Triptolemus*, which the Académie wholeheartedly condemned and art critics warmly approved. When Théophile Gautier, for example, saw the plaster version at the Salon of 1865, he had no trouble deciphering Chapu's intentions. God and worker stood united, and Gautier saw nothing inappropriate in their union. For him, the statue's clear resolution of pose and gesture implied steady rhythmic toil. He saw seeds scattered in a furrow; the figure summoned with it the living world. This is not to say that Gautier was blind to the statue's overtly triptolemaic characteristics—these he summarized vaguely as "a certain rustic majesty."[60] His vagueness is the clue to his procedure here: majesty and godlikeness were no longer necessarily the

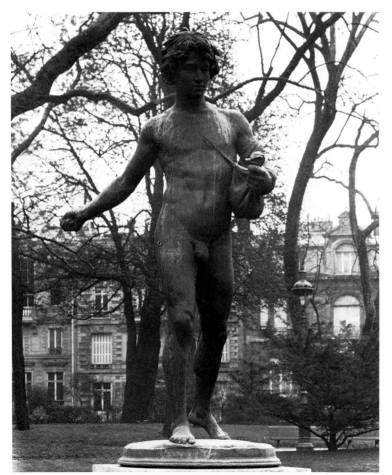

108. (*left*) Henri Chapu, *Triptolème* or *Le Semeur*, 1859, plaster; 1865, bronze (h. 170). Destroyed; formerly Park Monceau, Paris.

109. Henri Chapu, *Mercure inventant le caducée*, 1859, plaster model; 1860–61, marble (h. 110). Musée d'Orsay, Paris.

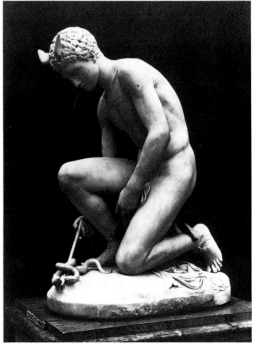

main matter of *Triptolemus*; for Gautier there was no single guise in which the god of agriculture could be embodied. The grounds of criticism are shifting: the concept of "true expression" is giving way to other formulae. (It might even be possible—this is the drift of such commentary—that sculpture could be effective without being precisely "expressive" at all.)

Chapu, however, took the Académie seriously. His last *envoi* made one final attempt to align his work with their requirements. This time he aimed at safety on all counts. His choice of theme was orthodox, not to say unassailable. He showed a *Mercury* (fig. 109), and so interpreted a subject nearly identical to his teacher Duret's *envoi* some thirty years before (fig. 51). The reference would not have been lost on the Académie, or on the older sculptor. (Duret's *Mercury* was inventing the lyre, it is true, and Chapu's discovers the caduceus.) But while Duret had been praised for his ingenious sentiment and delicate expression, and refined rendering of both qualities, Chapu was dismissed in a single brief, bored sentence: "The execution lacks neither grace nor truth," followed by the automatic exhortation to careful finishing of the marble.[61] Chapu's figure *is* somewhat graceful, and worked from a thorough anatomical understanding of its pose. But because it so carefully observes the rules, it is also rather dull. This is the sad tale of the good student who goes wrong trying to do better: his career was to languish for several years after his less-than-triumphant return from Rome.

One of the things a diligent student was to do in Rome—the reader will have noticed that it looms large in Duret's *rappel à l'ordre* to his pupil—was to go out and soak himself in the city's artistic treasures.[62] The Villa Medici came to be organized and administered, however, in a way which fostered more cloistered, less energetic lessons. For years it had maintained a library and kept a small collection of plasters. Under the direction of Ingres these facilities were greatly expanded. The painter sank his energies into the maintenance and improvement of the Villa, its gardens, and its equipment—all part of his rights as director. There were many changes, enough to provoke eyewitness accounts. This is one *pensionnaire*'s description: "The Villa Medici is being embellished under M. Ingres. The old fragments are being carefully put back into place. The fountains are being restored; in the end a thousand little things that were hidden before now add to the richness of our elegant sojourn." The writer's tone—he is the sculpture student Bonnassieux—becomes rather quickly half-ironic, and the letter continues in more or less the same vein:

> But inside the Villa, M. Ingres has just committed a profanation which I find difficult to forgive him. At his order, all the plaster statues which decorated the grand salon have been removed—to be put where? In filthy corridors or miserable corners which never see a broom. So these handsome souvenirs of *pensionnaires* are already dispersed, and some half-mutilated. It seems to me that M. Ingres has not acted much like a conservator of the arts. My comrades too have looked unhappily at the denuded salon, which used to produce the most brilliant effect. But M. Ingres is director, and he brooks no contradictions. He venerates everything antique, but outside of that, he sees nothing.[63]

Had he been less irritated by the state of affairs, Bonnassieux might have gone on to describe the constructive form Ingres's passion for antiquity was taking. Not only were student works turned out-of-doors (they were not sufficiently antique), but a massive renovation of the Galerie des Plâtres was also begun, and a smaller Galerie d'Architecture constructed next to it. Both were to be furnished with plasters—fruits of the massive casting program Ingres was supervising for the Ecole des Beaux-Arts. The two projects had much in common, and it made practical sense to undertake them simultaneously. Each would

result, so it was hoped, in a study collection of plasters reproducing ancient sculpture and ornament housed within school walls.

It is not difficult to sympathize with Bonnassieux's impatience. No doubt it made sense to assemble the riches of Rome for students far away in Paris; but that hardly explains why it was deemed necessary to assemble the same collection in Rome itself, when the originals were only a few miles away. The majority of the hundred and fifty-nine casts installed by 1851 reproduced originals then located in Rome—the *Dancing Faun* from the Capitoline Museum, for example, or the *Marsyas* from the Villa Albani.[64] Despite a few casts from other places (Naples, Paris, the Parthenon), the Galerie des Plâtres was essentially a collection of Rome's antiquities interspersed with twenty-five chairs. The display was open to students and public alike, and it was meant to be used. Even so, we cannot say how many students actually drew there. How would it be possible to tell if a sketch of *Marsyas* were done at home or in the field? In any case the Académie's precious belief in its Roman establishment becomes just slightly tarnished by the discovery that the school allowed a student to work from treasured monuments as if he had never left Paris. The sensibility which fitted out the Villa with its own cast collection is not simply an approach to past art as a compendium of motifs to be consulted; artists have thought that way for centuries. The Villa was made to look like a *school*, that is the point, using the budget of the Ministère des Beaux-Arts to reproduce the regulation motifs and to present them conveniently, all of a piece—even when the original was only minutes away.

Now this is not to say that the Villa or its director forbade direct encounters with art in Rome, or tried actively to restrain students from experiences of Roman life. Even Ingres allowed them, or so his biographer was at pains to tell us. To substantiate a picture of his liberality, Lapauze rehearsed the tale of the master's visit to Ernest Hébert's studio to inspect his first year *envoi*.[65] The younger painter had carefully set out his "studies"— Ingriste pastiches of the classical repertoire—and stashed away his drawings of Roman peasants like so much dangerous contraband. It was of course these watercolors of beauties and bandits which Ingres's hooded eagle eyes sought out, and the pastiches which he rejected. In the end, however, the interest of the story is not Ingres's liberality, but that a proof of it was thought necessary. In fact the Villa, with Ingres at its head, gave students the means never to leave its walls even while it encouraged them to study the antique.

Rome and the Villa were two different things, or so it seemed, and Schnetz for one urged *pensionnaires* to keep the differences straight: "The Ecole at Rome is the Rule, Rome is Liberty. Your wings have sprouted; try them out; launch yourself outside the nest. Go as far and as high as your strength permits, but remember the rules; never forget them. Obey the thin thread I hold in my hand and which calls you back."[66] Sporting imagery aside, this little homily operates in rather the same way as the Académie's attitude to the antique and student sculpture. Experience the glories of the past, it urges, but never mind if you do it from casts. Make full-fledged sculpture, it says, but be sure you conform to our rules. Range as far as you like, offers Schnetz, but never forget that you are not free. It takes only the briefest recollection of Chapu's experience under the rules to weigh Schnetz's statement properly. The painter was probably unaware of any discrepancy between a liberty extended with one hand and restrained with the other. His offer and its built-in limitations can stand to define the Académie's understanding of how students were to learn.

Young artists reacted with varying success to this program, and in many cases the Académie's assessment of those reactions (at least, the sculpted ones) determined their reception in the Paris art world. The eager Ottin, for example, whose effort to make an

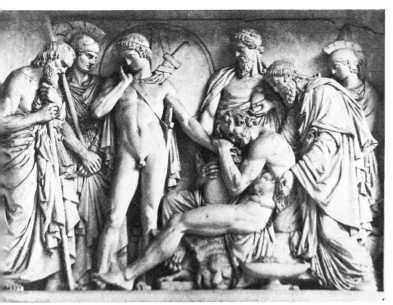

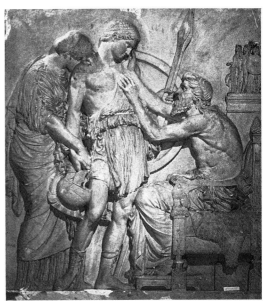

110. Jean-Joseph Perraud, *Télémaque apportant à Phalante les cendres d'Hippias*, 1847, plaster.

111. Jean-Joseph Perraud, *Les Adieux*, 1848–49, plaster (c. 221 × 214). Musée des Beaux-Arts, Lons-le-Saunier. Lons-le-Saunier.

impression led him outside the Académie's constraints, always remained somewhat detached from the official structure. In 1855 Maxime Du Camp described his career as a slow process of self-liberation from the tyranny of his training: "he struggles against a tradition which can no longer today satisfy his generous instincts."[67] Ottin certainly reflected long and hard about the educational process and the demands of sculpture; he published a treatise on the subject in 1864.[68] He felt distant enough from the established art world and its institutions to show with the Impressionists in their first exhibition in 1874—when he was sixty-three years old.[69]

We might call Ottin the bad student who stayed bad; just as Chapu was the good student who went wrong trying to be better. But there were good students who stayed good all the way through their *pensions*—students whose work, in other words, exemplified the Académie's aims. Jean-Joseph Perraud is an example. Prix de Rome in 1847, his success with the subject *Telemachus Carrying the Ashes of Hippias to Phalante* (fig. 110) was enormous, so great that even fourteen years later it was described as "a classic work before which the young people stop, nodding their heads with a meaningful air."[70] This grave admiration of an illustrious forebear was just the sort of appreciation the Ecole meant to foster. And the Académie too remembered Perraud's first success with pleasure. They recalled it, for example, when they reviewed his *envoi*, *Les Adieux* (fig. 111), which represents a young warrior receiving the farewell embrace of his blind father, while his weeping sister hides her head. The reputation of the old work enhanced the reception of the new, but the reference to the earlier relief was appropriate for more than sentimental reasons. In composition and feeling the later relief derives directly from the premises set out in its predecessor. Perraud was playing safe, relying on a tested format, while paying considerable attention to the refinement of details and drapery. The Académie's judgement breathes its contentment: "The appearance of this work has a good character: the style is elevated, the planes well adjusted, and the drapery well executed in many places. In the presence of this work, in which the Académie can regret only a few details harming the simplicity of its lines, which is so necessary in monumental sculpture, the Académie can only congratulate itself for requiring from its young sculptors such large-scale studies."[71]

112–13. Jean-Joseph Perraud, *Adam*, 1853, marble. Dépôt des Musées Nationaux, Château de Fontainebleau.

This is contentment indeed, where appreciation ends up as self-congratulation. And the extent of academic enthusiasm for *Les Adieux* is measured less in this assessment than in the sculpture's inclusion on a list of four key works drawn up in 1854.[72] The four were nominations for the Prix Leprince, to be awarded to the best sculpted *envoi* of the last five years. Guillaume's *Anacréon* was a second candidate; Maillet's *Agrippina and Caligula* another. Significantly enough the fourth was also by Perraud—the *Adam* (figs. 112–13), designed as his fifth year exercise. It was the judges' unanimous choice.

The *Adam* won out over stiff competition: all four nominees satisfied the Académie's difficult appetite for the proper blend of subject, decorum, and execution. The decision in favor of *Adam* thus gives added weight to the opinion offered by the Académie in 1853, when they first examined it. Although even that verdict began with the usual reservations about the suitability of the author's interpretation of his subject, for once disquiet gave way to enthusiasm—or something quite like it.

A marble statue of *Adam*, about seven feet tall, is the work which crowns the fellowship of this artist.

At first look, one is struck by the forceful character which the work presents, but this impression is perhaps not that which best accords with the subject. The proud attitude which M. Perraud has given his *Adam* is not that which befits the father of mankind as he is humiliated by divine anger, and the athletic character of his figure

130

is also not the form appropriate to this personage. It is certain as well that the placement (between the figure's legs) of the knotty tree trunk used for the ploughshare causes a certain amount of embarrassment in the figure's composition. But after these observations, which the very importance of the work suggests we make, we state with pleasure that this statue is stamped with a remarkable distinction and that it offers an amount of originality worthy of praise. We can furthermore mention fine parts in its execution and note the force of life and modelling that the artist has been able to lavish on it. In the face of these qualities, and bearing in mind a marble executed with this vigor and warmth, we think it possible to express the hope that the government acquire this statue, which is such a worthy completion to the varied series of M. Perraud's studies.[73]

This analysis seems to me a model text, a summary of the academic attitude. It is exemplary in its omissions as well as its conclusions, and comparing either to the work in question gives the whole incident the flavor of a cautionary tale. Can this really be the sculpture which marked the utmost of student achievement in the years round 1850? The Académie thought so, for all its worries over inappropriate expression and possible "embarrassment" of props. The worries fell away in comparison to the work's "force of life and modelling," its "vigor and warmth," its right amount of originality.

To be fair to poor Perraud, it is hard for us to gauge what was meant by the comments on his execution, since the *Adam* is now so weathered. Nonetheless the judgement is exemplary, not because it so openly relishes technical qualities (which were supposed to offer pleasures of a secondary kind), but because of the way certain habits of mind survive, even in the face of genuine admiration. The qualities of energy or rendering are undeniably seductive; in the end they are prizewinning, they are the best the Académie can do. But all the same the sculptor has a higher duty: he has to define his subject's proper character; he should not let life or modelling get in the way. Adam can be forceful, but not proud or athletic. The Académie was not prepared to set those literal standards aside and interpret the work in a freer, more allegorical fashion. Adam was Adam, not Labor or Agriculture. What mattered most of all was this fixed, secure relationship between subject and rendering.[74]

But did not the Académie make out Perraud to be "original"? Were their standards really as rigid as I am implying? Well, yes and no. "We state with pleasure that [*Adam*] offers an amount of originality worthy of praise." The phrase is equivocal; and looking

114. Antoine Etex, *La Résistance*, 1833–36, stone (h. 11m60). Arc de Triomphe de l'Etoile, Paris.

115. Auguste Préault, *Guerrier Gaulois*, 1850–53, stone. Pont d'Iéna, Paris.

116. Jean-Joseph Perraud, *Soldat gaulois avant la domination romaine*, c. 1850–53, pen and ink on white paper. Musée des Beaux-Arts, Lons-le-Saunier.

at the *Adam*—taking note of its stilted quotation from the Belvedere torso, paying due heed to the havoc it plays with bodily proportions—it is hard not to wonder what the Académie would have found hackneyed. Clearly originality was best administered in very small doses. And detecting it, at least in this student's work, was one way of avoiding obvious comparisons: the Belvedere torso was one thing; the *Adam's* relationship to more recent, and infamous, sculpture was another. Did not the work betray an interest in Etex's *La Résistance* on the Arc de Triomphe—in particular a debt to Etex's Gauls—and a fascination with Préault's *Guerrier Gaulois*, unveiled on the Pont d'Iéna in 1853 (figs. 114–15)? These sculptures are *Adam's* "context," so to speak, one neither Biblical nor antique. They are what lies behind Perraud's conception of Adam's masculinity: an overwrought conception, we may think it, right down to the obvious parapraxis of the plow between the legs. Adam must above all be authentically *French*; he must be as Gallic as the proverbial cock. (Compare the drawing Perraud made in Rome of a *Soldat gaulois avant la domination romaine,* fig. 116: the soldier and Adam are from the same mold.)

Although the Académie could never have written the analysis I have just given, it does not seem to me to be outside the range of some viewers in the 1850s. After all, the Gallic flavor of the *Adam* is not subtle, nor the relationship to contemporary sculpture obscure. Yet nonetheless the Académie gave its seal of approval. The reason, I hazard, was because in the *Adam* it could see itself speaking. It could see a work such as might have been produced by an academician, in which a requisite distance from a variety of poles—nature, the past, the present—has been carefully measured, and called originality. Hence the accolade with which the text closes, the all-important recommendation for state purchase. The good student was launched—or so it seemed.

Yet three years later the Académie secretary Halévy was still urging the acquisition.[75] And in 1861 Halévy's successor, Charles Beulé, saw Perraud as a copybook example of the official sculptor's predicament.[76] Perraud, Beulé said, had done everything right; he had earned the approval of his colleagues with his Prix de Rome and never relinquished it. But public appreciation and recompense had not followed. Perraud himself was embittered by his failure, the more so because success had seemed assured. To quote him directly:

> Glory is not offered him who pursues beauty sincerely and loyally, without charlatanism. Artists are a generous breed and do not covet what is honestly acquired. Despite what is said, if there are hatreds among them, it is a rare thing, one which deceives and perverts public taste. I have savored, though not without reservations, the praise addressed me; I have had as much of the smoke of incense as I deserved, and from the best fires. But the smoke dispersed, and it was time to return my plasters to the studio. I did not have the means to exhibit my efforts in marble. I've been given first medals, and medals of honor, and the Legion's cross, and consideration—that's all.[77]

Perraud's return to Paris (Capharnaum, he called it) brought him in touch with the reality of public taste and the necessity of pursuing his art as his livelihood. Once praise had evaporated, even the best augured career could come to an abrupt end. Despite the Académie's efforts to gloss over the fact, the sculptor's career *was* lived out in Paris, with the Roman stay a five-year interregnum. The heady fumes from academic altars—you will notice that Perraud won the very same honors Carpeaux coveted in 1860—were quickly dispersed, and the sculptor was left to replace them with something more concrete. His reaction was determined by his adherence to the academic definition of how his profession should be practised, and the answers it suggested to questions of patronage and production.

In many ways the stay at the Villa Medici was meant to teach the young sculptor a

professional code. It groomed him to practise a public art and to enjoy public favors, even if these opportunities were actually never forthcoming. Both were further aspects of "shaping up"—although for some students formation started with getting used to square meals. While a student at the Ecole des Beaux-Arts came away with a straightforward approach to sculpture-making applicable to the range of commissions he might be expected to fulfill, the hand-picked product of the Villa Medici was being prepared for a higher task. "Tu dois devenir *statuaire*," Cavelier wrote to Ottin; here, in this conception of the goals of study undertaken in Rome, the distinction between the words *sculpteur* and *statuaire* can best be seen. At the Villa, the young artist was meant to learn an approved language for official, public communication: he became a *statuaire*. It is too simple to say that he learned to imitate antique sculpture. The academic language was not *copying*; it could be found or found lacking in subjects like Adam or David or Orestes. Though the Académie never tired of asking students to study Greek sculpture, it also warned against too slavish imitation. Instead, academic style meant limitation, not imitation, not erring into physical extremes. Good sculpture showed man and woman as neither too young nor too old, too fat nor too thin, too contorted nor too relaxed, too tired nor too eager, and so on. In following this median path academic sculpture perhaps took the route of an eroded idealism, but that term is enlightening only when it is joined to a recognition of how anxiously and literally it was asserted to shore up failing truths. Academic sculpture was locked into the literal, not the metaphoric. It was based on a system of correspondences between the physical and the metaphysical which took such linkages to be natural and inevitable. In such a system, where nobility is a quality of character dependent on a straight brow and a high forehead, analogy or likeness provide the only account of cause. The transformation from resemblance into metaphor therefore required the impetus of exaggeration to jar perception, to turn it aside from the solid materiality and presence of the sculpted object. And this, briefly stated, is how Carpeaux challenged sculpture.

* * *

Who was the Carpeaux who finally arrived in Rome? Much has been written in answer to this question, most of it in as extreme and romantic a vein as the subject would bear.[78] Even without embroidery, the story of Carpeaux's Roman years is strong enough stuff to earn frequent retelling. It has everything: illness, romance, conflict, rebellion, even a happy ending of sorts in the form of *Ugolin et ses fils*. No doubt I will not be able to steer entirely clear of these tropes in my effort to present a version of the tale. The effect I aim at, however, is not romantic. Rather, I shall try to show the complex ways Carpeaux cobbled together, from likely and unlikely sources and with patchy preparation, his own view of the Eternal City and her artistic treasures. The chief problem he faced was how to appropriate the art of the past. This was the great dilemma for many nineteenth-century artists; for some of the best of them, being in Rome only exacerbated matters. I shall argue that Carpeaux made a kind of peace with the difficulty which so tormented others; that he devised a special solution to it, with distinctive safeguards and guarantees; I shall try to define its main terms.

The process must begin hesitantly enough, since for several months there is little information about Carpeaux in Rome. He was present at the Villa: we can be sure because he signed for his seventy-five franc stipend each month from January, 1856, until the following July, when he left for Naples.[79] But if he wrote letters during that period, none now remains. The first letter we have dates from July, 1857, eighteen months after his arrival.

The only exactly contemporary evidence about this first phase of his career at the Villa, Schnetz's letters to de Mercey, indicates that the sculptor's incorporation into daily life was less smooth than the director had predicted. The disputes between Schnetz and his new, recalcitrant student, which began with Carpeaux's refusal to undertake the prescribed antique copy for fear of damaging his eyes, are among the familiar, often-repeated refrains in the saga of Carpeaux, "mauvais élève à Rome." It is an epic with long and pathetic choruses of directorial irritation: "You were certainly right in telling me that M. Carpeaux would give me more trouble than pleasure. Since he's been at Rome, he's been able to do nothing in the usual manner."[80] Carpeaux was stubborn and clumsy, Schnetz maintained, profligate with money, and unabashed about asking for more.

All this is true enough, it seems. But once Carpeaux broke his silence, his letters make clear that he too had plenty to complain of. In July, 1857, he finally wrote to his parents. His letter brought them up to date; it is also the first expression of his attitudes to Rome. Eighteen months of illness, irritation, and confusion had helped to make the characteristic mix of egotism, aggression, and resentment which were to mark the next four years of his stay. The letter gives a good picture of the man and his reactions to Rome, though it begins by disclaiming any such purpose: "If I were obliged to write you the history of the two years I have just spent, I would give up before I began." He did tell some of the story, of course, in a letter whose form and message are both significant.

I don't know if it was luck or mischance that brought you news of me. You should understand that I am more sinned against than sinning. Today the clouds have lifted, hope has helped me brave the storm, and I've come back safe to the harbor of life. I'm using that figure of speech to tell you that I touched Charon's barque; but fate brought me out of danger and back to life.

At the most glorious moment for a young man, that is to say, having attained an important point in life (my Grand Prix de Rome), I was stricken with a disease of the eyes. What horrible suffering!... and I lost my sight! Two months passed in the most frightful torments. Ah! If I had had a pistol you would not be reading this letter. And all alone in such a state!... A lucky chance brought me a man with whom I had eaten misery's crust when we were students, he in medicine, I in sculpture. I had been given up by the most famous doctors, I had sacrificed everything with no result when he offered to help. My eyelids were opened and two candles placed before them; I could not see the light. I was blind! How many times I called you through my tears! This man would kill or save me—what genius!... He opened my veins three times daily and his leeches drew from me all the blood I could have had; the inflammation diminished through want of blood and a fortnight later I saw light return once again.

I was taken to a wood, so that green alone would present itself to my sight. Seven months passed and the following year I was sent to Italy; hardly had I arrived than the climate forced me to the seaside and I left for Naples. There a fever reigned which might as well have been cholera since it was incurable. I was alone in a hotel two days after my arrival when I was overcome by vomiting which lasted fourteen hours. I asked and begged in vain for a doctor to be called; my prayers were useless—I wanted to go down to ask for assistance, but hardly was I in the street than I lost consciousness and fell—I was picked up in a carriage by two men who offered to accompany me, but on the way they stole my watch and ring.

Finally, I found myself in a bedroom and the symptoms with which I had been stricken redoubled themselves. The attack increased, with no help available. But a secret force

made me resist and I begged the servant as an act of charity to get from a pharmacy the medicine prescribed in Raspail. In this treatment there is calomel, but in a very small dose, 10 centigrams. Presence of mind had left me, and I ordered thirty grams. Poor me—I didn't know I would place my life in danger, but my ignorance saved me. Calomel is a mercury salt, which taken in small doses acts as a purgative. I had swallowed 120 times the dose [*sic*], two minutes later my chest heaved, I tried to cry out, I had no voice left, I looked at the book and I saw I had poisoned myself . . . then I broke everything, carafe, chandelier, washbasin, all to make noise. I declared I had poisoned myself, and only then was an emetic fetched and thank God I brought up a foamy liquid white as milk. A doctor was called, who prescribed noodle soup and ice cream. It was a Neapolitan doctor. Had I taken the least morsel, I would have choked. He also said, "I don't need to come back, pay me . . ."

In spite of all this, luck did not abandon me. I found a friendly figure, after my long attack. It was a *pensionnaire*, an architect making the trip to Sicily. He found me unconscious at the moment that the people at the hotel were about to force me to swallow the prescribed macaroni.

He stopped it and went to look for a German doctor; he more prudently forbade me all nourishment and saved me after thirty fearful days. He prescribed a rest at the seaside. I was taken to the Sicilian coast and when I was strong enough to withstand the trip I left for Rome. The air stifled me and the pains in my gut increased. The doctors declared that only native air could be good for me, so I was sent back to France, where my convalescence lasted for months; and I have just returned to Rome, hoping in the future.

These few lines can give you, my dear parents, an idea of what I suffered. From this real crisis came a human experience for a man who learns to understand himself only in extreme situations.[81]

In these "few lines" Carpeaux shows himself a good letter writer: which is to say, a master of cliché, an adept at rhetoric, and totally absorbed in every detail of the story he unfolds. It is not that the letter lacks a basic core of truth: he apparently did suffer from eye trouble in 1855, but the desperate blood letting and the green wood are no doubt exaggerated in the telling.[82] As for the poisoning in Naples, he seems almost to relive its drama as he wrote: "I broke everything; then . . . I brought up a foamy liquid white as milk." The letter would be funny were it not so seriously meant. The experience gave him a new knowledge of himself, he believed, and it brings us a sense of the intensity with which events grasped and shook him which is a clearer portrait than any likeness I know.

The letter continues with a description of life at the Villa which is even more revealing. At least initially, Carpeaux's Rome was no ideal—it was enemies, constraints, poverty, enforced idleness, loneliness, and, above all, ambition:

Here my affairs aren't brilliant; the stipend is a ridiculous amount; my first year's payment of 2,400 francs was stolen from me by the director, a friend of Lemaire. My protests have been useless and since my complaints, I get on very badly with him. And finally, Italy pleases me not at all. We are barracked like privates, forced to come in at a set hour for lunch and dinner; in short, the liberty which makes a man is taken away. My studies have not done me any good, since I've only looked. My illnesses have kept me from producing anything; in sum, here are two and a half years lost, everything but life.

175 francs is allotted us as pay per month. One hundred of that is held out for food, so seventy-five is left for light, tools, clothes, coffee, and the cigars which are indispensable in this country—so it's a happy event when something is left to smoke at the end of the month.

"There's nothing left for a young man's life."

"Non che niente per il ragazzo," as the Italians say.

Here I'm learning architecture because the antique monuments are admirable. I'm also cultivating painting along with sculpture; these three arts are related and I want to know them. My taste has been raised and strengthened at the sight of masterpieces. I am often told that I have a head like Michelangelo, that fertile genius of the Renaissance, whose works astound everyone who cultivates any one of the three arts he practiced so nobly. In fact I feel a vivid sympathy in my imagination for that great man, and all my works are marked with his gigantic stamp.

I want to straddle the currents and fashions of the century; I feel my forces strong enough to try. But my soul is too sensitive, my emotions are too large not to be emptied into friendly hearts. I need a family and have none. I often have the idea of marrying but reason stops me, and I tell myself, Wait, keep waiting. Reassure me, my dear parents, don't leave me to myself alone, come calm my bitterness and hold out your own loving hands. Then I will return to life, like a shrivelled plant that is given water.

On July 16, 1858, almost a year after this long letter, Carpeaux wrote a similar missive to the wife of his friend Foucart. Like its predecessor, the second letter served Carpeaux as the vehicle for an apology for extended silence, and a description of his situation in Rome. His contrition is typical, and his account of life at the Villa contains no surprises— unless they are to be found in his lack of adjustment after two and a half years to its hampering conditions. The most important section follows only after due railing against what he scornfully dubbed "a real cooking school."

For two years I've lived in Rome's streets, looking at nature for the distraction I cannot find in the studio. It's there that I've quarried my most extensive series of observations. I've done drawings based on movements, and I've achieved a certain merit in this genre which distinguishes me, it is said, from others. I'm even told that no one draws like me *at the Académie* [*sic*].[83]

This letter indicates one further aspect of Carpeaux in Rome: Carpeaux the draughtsman. His drawings were both a means of contact with the city and a tool in a personal process of learning which, as he stated with a mixture of pride and anxiety, separated him from other artists and from the Académie. Taken together, the two letters outline a view of what counted in his life. Strife with the director, financial worries, and a complicated ambition directed his conduct; Michelangelo influenced his art, and drawing was his main means of expression.

It might be argued that taking these letters seriously as statements of purpose does them too much credit. The fate of good intentions is proverbial, and Carpeaux habitually showered correspondents with vehement declarations without carrying them through. Yet, despite illness and conflicts, his Roman stay *was* characterized by a serious effort at self-instruction—by "applied study," as he put it, of the topics he listed. And these subjects were only a partial list. Another written document, this time self-addressed, gives further information on how his education was to be accomplished. It takes the form of a long list, drawn up on a notebook page and simply titled "projets d'étude—Roma." It continues:

types and curiosities to study
look at customs and beggars, brigands, etc.

anatomy of men
 women
 children

osteology of the male
battle of the skeletons

Michelangelesque painting
studies of various subjects
 the diversity of nature

open relations with the Galerie Dumas
to travel to oriental lands

At the very least, these three documents make some serious claims for Carpeaux's Roman study. They are worth examining. If we are to believe them, the first phase of Carpeaux's *pension* had little to do with sculpting, a lot to do with Michelangelo, and still more with drawing. Even the roughest reckoning of Carpeaux's production between 1856 and 1858 bears this out. Against only one sculpture which can with certainty be said to have been completed in these years we can weigh a handful of paintings and literally hundreds of drawings in a range of media, scales, and degrees of completeness—from *académies* to finished watercolors to quickly pencilled sketches. Should they not be evidence enough, we can cite the testimony of as non-partisan an observer as Schnetz himself. His opinion was given in the course of the director's annual report on the state of *pensionnaires'* studies; the context is his account of Carpeaux's work for 1858: "As was easily predicted, he did not find himself in a position to finish his model in time for the exhibition." But Schnetz continued: "To be fair to this *pensionnaire*, the Director must add that, despite the irregularity constantly noted in his termination of the obligatory exercises, it is enough to have seen in his studio the quantity of studies of every type that he has made from the masters to be able to reassure oneself that he is studying his art seriously and has profited from his Roman stay as much as the other students."[85] The note of the scrupulous fairness is unmistakable, but it is edged with admiration as well. So Carpeaux's disclaimer, "I've done nothing but look," needs plenty of qualification. Learning in Rome meant looking with a pencil in hand.

But if Carpeaux's disclaimers ask for modification, so do his assertions about his drawings, in particular the boast that he did not draw like other people—especially people at the Académie. The assertion will not stand up to much testing. There are actually strong links between some of his drawings and those of his fellow students. For example: take Chapu's volumetric black chalk study of a man's head (fig. 117) which aims at making clear distinctions through light and dark. It can be related, surely, to Carpeaux's large study of a Roman beauty (fig. 118), all crisp outline and carefully worked modelling, with the outline finally transforming into the hard edge of a sculpted bust. (Is the draughtsman playing with the idea of a model becoming sculpture under his hands? Or *is* this a bust? We are presumably not meant to be certain.) And Carpeaux's drawing in turn leads to a page in Chapu's sketchbook where another handsome Italian woman is seen in profile

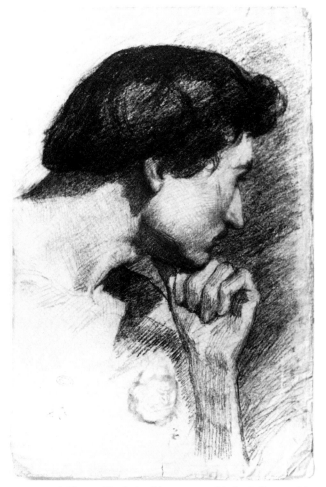

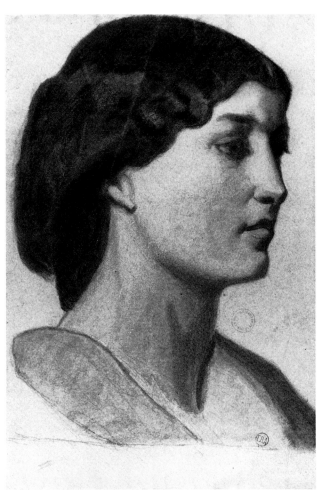

117. Henri Chapu, *Head of a Man*, c. 1858, black chalk on white paper. Musée, Melun.

118. Jean-Baptiste Carpeaux, *Head of a Woman*, 1857–59, black chalk, stomped, on blue wove paper (43.3 × 29). Ecole Nationale Supérieure des Beaux-Arts, Paris.

and full face (fig. 119). She may be the model who posed for Soumy's oil *La Carolina* (fig. 120); even Perraud tried his hand at the genre (fig. 121). Or to take another example: Chapu's study of a model's arm, head, and shoulders (fig. 122), which translates the fore-shortened, awkward pose through closely controlled rendering of light and shadow, invites comparison with Carpeaux's drawing of a pensive young model (fig. 123). Unlike Chapu, Carpeaux worked on a full folio sheet; his figure is built up of small crayon strokes. The texture of the paper lends each stroke a certain burr whose softness suggests diffuse lights. Chapu's handling conveys the impression of stronger, harsher illumination. But both students here exhibit a similar desire to describe the human form in detail, rather than abstracting from it. They probably worked from the models who posed regularly at the Villa in sessions which attracted draughtsmen from the wider artistic community—Gustave Moreau and Edgar Degas among them.[86] Despite his claims, Carpeaux is no more ambitious than Chapu, though perhaps more talented; in studies like these neither shows himself outdistancing his contemporaries in or outside the Villa.

That Rome had a peculiar attraction for artists is certainly not a new idea. In 1860 it was as much a truism as in 1760 or 1660. The difference in the mid-nineteenth century lay first in degree: the city's international cast of artists had by then reached "pandemonium" proportions. That word belongs to a contemporary French journalist trying to describe Rome's babel of eminent masters to a Parisian readership with an appetite

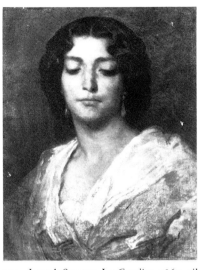

119. Henri Chapu, *Two Studies of an Italian Woman*, late 1850s, black chalk on white paper. Cabinet des Dessins, Musée du Louvre.

120. Joseph Soumy, *La Carolina*, 1860, oil on canvas (49 × 39). Musée des Beaux-Arts, Marseilles.

121. Jean-Joseph Perraud, *Head of an Italian Woman*, c. 1850, black chalk. Musée des Beaux-Arts, Lons-le-Saunier.

for cultural bulletins.[87] His dispatch ran through a random list of some of the more famous residents of Rome's studios—the German Peter Overbeck, the American William Wetmore Story, Léon Benouville, Jerichau the Dane—and various other, equally deserving names would have been available in 1859, to make the roll call even grander.

But if in the mid-nineteenth century Rome lured a larger quotient of artists than ever before, that fact is interesting particularly because there was such unanimity in the images

122. Henri Chapu, *Etude de modèle*, late 1850s, pencil (33.6 × 25.7). Musée, Melun.

123. Jean-Baptiste Carpeaux, *Study of a Seated Boy*, c. 1858, pencil on white paper (46.3 × 32). École Nationale Supérieure des Beaux-Arts, Paris.

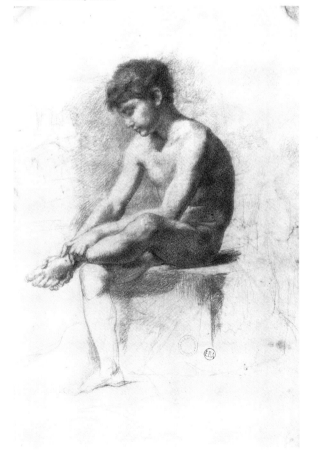

they produced. In this first heyday of travel photography, representations of place gave ground to images of people. A Rome which once had been all moonlit ruins and imposing palazzi ceded its place as a subject to its exotic inhabitants—a pre-industrial urban peasantry of crooked *vecchie*, brigands, and banditti. We are back to the first item on Carpeaux's list of reminders, "Types and curiosities to study: Look at customs and beggars, brigands, etc." These notes are informal, entirely personal—but they might have been set down by scores of other artists.

So Carpeaux's claims for the originality of his Roman studies are not entirely borne out by the subjects that attracted him, or by the way he rendered them. Nor could they have been—his vision had been formed, doubtless years before his arrival, by an idea of the city as a place with themes and studies as fixed as the cast of the *commedia dell'arte*. It was inevitable that he made the choices he did. His two large-scale drawings of *pifferari* are cases in point. Folkloric in the extreme, *pifferari* were Abruzzi shepherds who periodically became wandering beggars, playing pipes and fifes to earn their alms. Walking down from the hills near Rome, they spent two weeks in the city staging their small devotional concerts before every shrine of the Madonna and posing for artists between times.[88] When in 1852 the American illustrator J. G. Chapman took on the subject, he was careful to suggest both setting and custom (fig. 124): he included a dome, the Castel St. Angelo, a flower-bedecked niche for the Virgin's image, and in the foreground, father and son piping away. The man's devotion is matched by his son's innocence; we can tell by the soulful way Chapman has drawn their eyes. But their native costumes are described just as diligently: leggings, round-brimmed hats, and knee-length capes—odd local trappings Chapman's American audience could pore over with curiosity. These costumes said *pif-*

124. John G. Chapman, *Pifferari playing before a Shrine of the Virgin*, 1852, etching (22.2 × 17.2). Print Collection, New York Public Library. Astor, Lenox and Tilden Foundations.

125. Jean-Baptiste Carpeaux, *Pifferari*, late 1850s, black crayon on blue paper (27 × 19). Ecole Nationale Supérieure des Beaux-Arts, Paris.

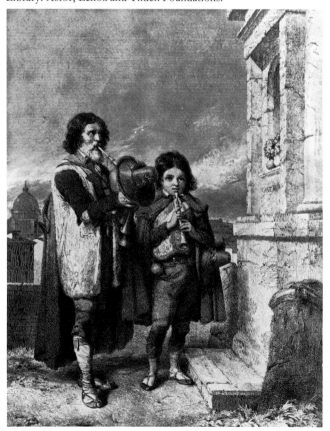

126. Jean-Baptiste Carpeaux, *Studies of Italian Peasants*, late 1850s, pencil on blue paper (9.1 × 15.5).

ferari: when Pradier or Gérôme showed the shepherd players, they perforce gave the same attention to the curious details of their dress.[89]

Carpeaux's *pifferari* sacrificed most of this narrative bric-a-brac (fig. 125). Enough remains, in the way of capes and hats and so forth, for any foreign viewer to be sure of the figure's exotic identity, but setting and idiosyncracies of costume yield to broad strokes of a crayon putting down stance, mass, and volume. This is a way of drawing which works through generalities rather than particulars, but does not end up as a result with something indistinct or approximate. On the contrary, it takes its stock properties and makes them real: it lays hold of individual figures and separates them from their tourist backdrop. Effective representation, in a case like this, seems to depend on the suppression of surface characteristics, the better to register each body's identity.

From a consideration of what is ordinary about Carpeaux's drawing a sense of what is original is emerging. Evidently the matter hinges not on *what* they show, but *how*. And other drawings—this time the abbreviated pencil jottings in his omnipresent *carnets*—make the difference that much clearer. Traced on page after notebook page, Carpeaux's studies of peasants manage to transform their oblivious sitters into shapes most often suggesting figures huddling together conspiratorially.[90] Even in a study of an individual head, Carpeaux's quick, nervous strokes turn chin, nose, and mouth into sharp menacing angles which answer the jutting brim of a hat (fig. 126). From a group of men wrestling pigs to the slaughter, he takes a rhythmic pattern of quick comma-like strokes (fig. 127). The suggestion? Latent energy, not aching toil. Yet despite their peculiar lack of specificity, there can be no doubt that these are drawings done from observations *en plein air*. Carpeaux boasted that Rome was his studio—we must imagine him, notebook at the ready, stopping dead in some *vicolo* to survey a crew of workers on the job. In a few cases, evidence bolsters imagination, and we can be sure of a drawing's circumstantial origins. This is the case with the sheet called *Scene in a Tavern* (fig. 128), which bears a long inscription by one of Carpeaux's extracurricular friends, Louis Barnet, a French army officer stationed at

127. Jean-Baptiste Carpeaux,
Tuérie des Porcs, c. 1860, red
chalk on white paper
(16.5 × 22.5). Musée des
Beaux-Arts, Valenciennes.

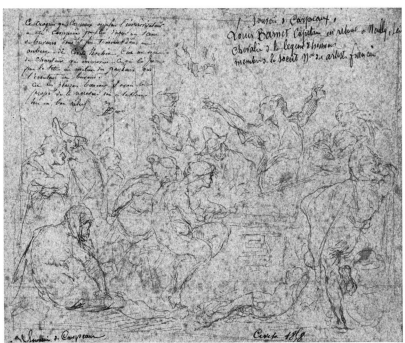

128. Jean-Baptiste Carpeaux,
Scene in a Tavern, c. 1858, pen
and ink (17.6 × 22.2).
Metropolitan Museum of Art,
New York.

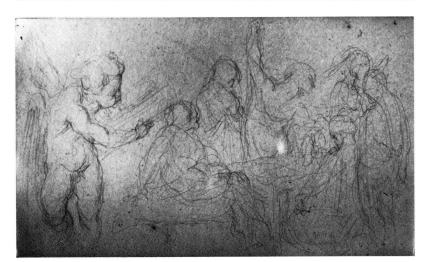

129. Jean-Baptiste Carpeaux,
Study of a Singer, c. 1858,
pencil on white paper
(9.1 × 15.6). Musée des
Beaux-Arts, Valenciennes.

Civitavecchia. "This sketch," Barnet wrote, "which Carpeaux called 'The Improvisor,' was composed after a scene of drinkers which he witnessed in a tavern in Civitavecchia. It's a kind of singer who improvises whatever comes into his head in the midst of peasants as they drink." A rather awkward description, this, which leaves room for doubt about Barnet's inwardness with local custom. But, doubts aside, the key phrase is "composed after a scene which he witnessed." The assertion is certainly true. It may well be that one of the faces in the drunken crowd belongs to Barnet himself; perhaps his presence there explains why Carpeaux gave him the drawing; in any case Barnet was in a position to know its origins. Yet his description leaves out one step in the process—the first one— Carpeaux's notebook record of the singer's ecstatic posture, which survives, though in reverse, within the full-dress version it inspired (fig. 129).[91]

It is important, I think, that in his letter to Mme Foucart, Carpeaux insisted on both the originality of his kind of drawing and its reliance on nature. Even a glance at the contents of his pre-Roman notebooks, with their predilection for the neat and finite, bears out the first of his assertions, at least in its relationship to his earlier practice. Carpeaux had been carrying sketchbooks for a decade, looking at people moving and at rest, at home and in the street, and recording them in tight, cramped little vignettes which encapsulate one sentimental idea, a kiss on a dog's nose or mother leading baby along (figs. 130– 31).[92] In Rome Carpeaux relaxes as a draughtsman. He achieves fluidity and the power to suggest and to generalize. And if his notion of Roman street life as a kind of "nature" is slightly problematic, it is at least partly justified by the movement which Carpeaux's new talents allow him to convey.

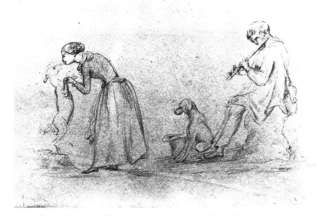

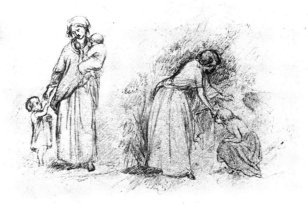

130. Jean-Baptiste Carpeaux, *Study of a Man, Woman, and Dogs*, c. 1850–51, pencil on white paper. Musée des Beaux-Arts, Valenciennes.

131. Jean-Baptiste Carpeaux, *Study of Women and Children*, c. 1850–51, pencil on white paper. Musée des Beaux-Arts, Valenciennes.

But as striking as these new qualities in Carpeaux's work, and the weight he gave them in his letter, is the way his enthusiasm was followed straightaway by its negation, by dissatisfaction with these very achievements. No sooner had he finished assuring his correspondent of the compliments he himself had been offered by all and sundry ("personne ne dessine comme moi *à l'académie*"), than Carpeaux rejected them outright: "Tired of always making studies while producing nothing, I said so to my parents. At once they sent me 100 francs a month and I owe to their aid the happiness of having made a statue which will win me felicitations and money."[93] A new subject was launched and the usual string of boasts followed: "Everyone tells me that I've made a remarkable work. The Minister should give me a marble so I can carve it here [in Rome]. And right in the middle

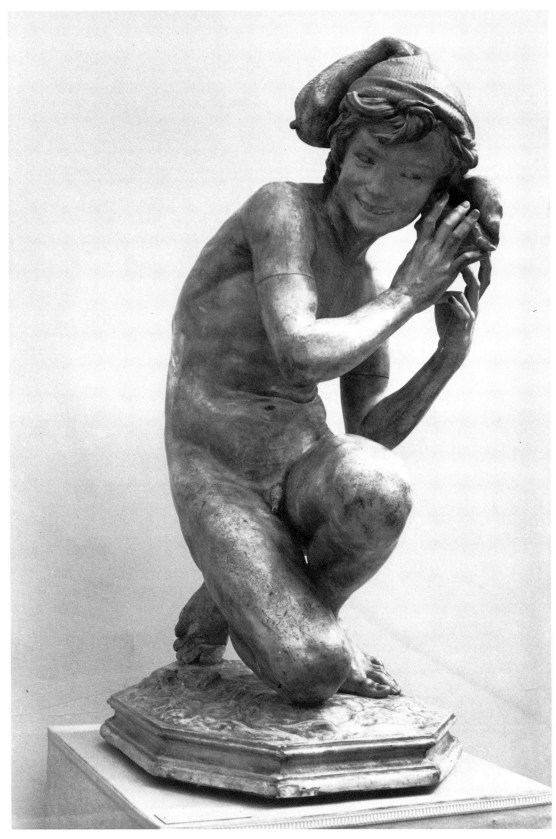

132–33. Jean-Baptiste Carpeaux, *Jeune Pêcheur à la coquille*, 1859, plaster (h. 92). Musée des Beaux-Arts, Valenciennes.

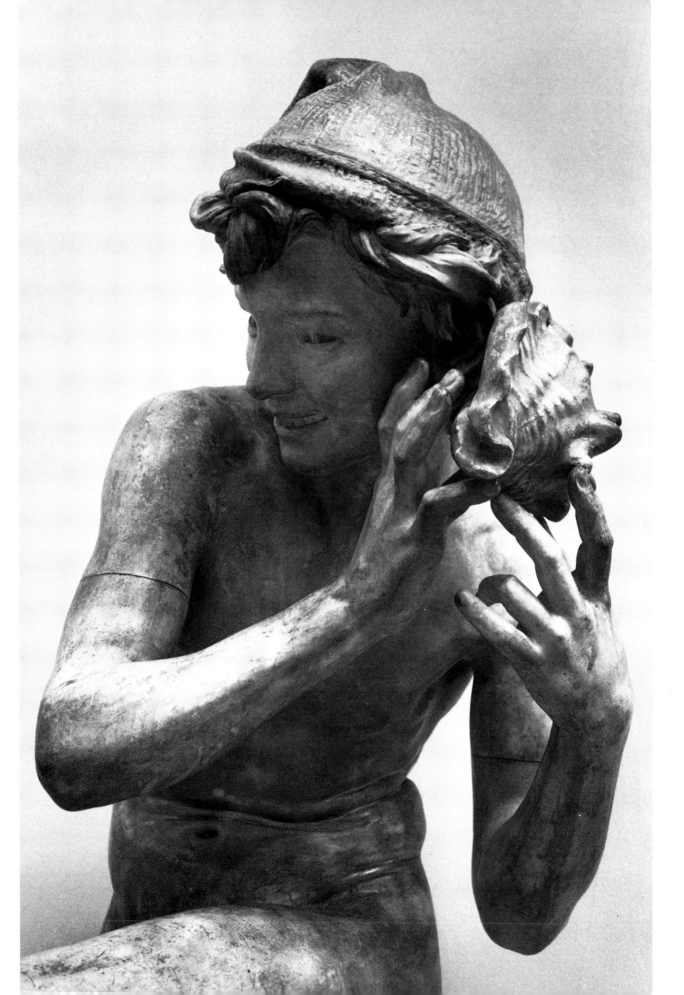

of the director's reception, About, critic of the Salon of 1857, said, 'Carpeaux has made one of the most remarkable works of modern times—his figure can be compared to that of his master Rude.' " And so on—Carpeaux rattled away for a few more lines until the happy recital was broken off by other topics. In fact he was so involved in these pleasurable details that he never named the "remarkable" work in question, the *Jeune Pêcheur à la coquille* (figs. 132–33). (He would submit it as his third year *envoi* in 1858, and again—by dint of a rather elastic interpretation of the rules—in marble as his fifth year offering.)

Despite the novelty of his drawings and his running battles with Schnetz, Carpeaux was still a sculptor and still a sculpture student at the Villa Medici. Reams of sketches only raised the pressure to produce, to sculpt. While Rome's streets might well be his studio, his audience was taking tea in the director's parlor. But what kind of relationship was there to be between drawing and sculpture? Surely their conjunction in Carpeaux's letter is not fortuitous—surely Carpeaux's venturesome course of training can be read in its first full-scale result? Carpeaux certainly claimed that his figure derived from "nature"; he traced the composition to a real *lazzarone*'s unstudied movements, a gesture spotted in the field on that ill-fated trip to Naples.[94] No doubt. About's first response is nonetheless more revealing. As a Salon critic, he was trained not to see nature but works of art, and the *Jeune Pêcheur* wore its artistic credentials on its sleeve. The critic compared it to Rude.

He was right to do so. The sculpture derives from Rude's *Jeune Pêcheur à la tortue* and from Duret's *Pêcheur napolitain dansant la tarentelle* (figs. 52, 54). But it might equally well have been likened to J. Klagmann's *Enfant jouant avec des coquillages* (fig. 134; Salon of 1847) or P. Hébert's *Enfant jouant avec une tortue* (fig. 135; Salon of 1849) or B. Frison's *Le Pêcheur des coquillages* (fig. 136; Salon of 1852) or G.-L. Nast's *Pêcheur napolitain et son chien* (fig. 137; Salon of 1857) or, for that matter, to any of the four other statues of young fisherboys on view at the Salon of 1859, where Carpeaux first showed his effort.[95] Other versions of the same theme, like A. Sopers's *Jeune napolitain jouant à la rauglia* (fig. 138; 1859) or H. C. Maniglier's *Pêcheur ajustant ses filets* (fig. 139; fifth year envoi, 1860), could easily claim the same honorific ancestry.[96] So the apparently flattering comparison to Carpeaux's teachers circumvents the work's filiation to a crowd of contemporary fisherboys. It was no doubt an amnesia the artist wished to encourage. In the spring of 1858, as he brought his figure to completion, Rude's marble was on his mind. Several letters to his friend Charles Laurent-Daragon beg for a plaster of the head of Rude's boy—not to copy, Carpeaux protested, but just as a reminder. And when Carpeaux's statue was being cast, Laurent was instructed to make sure the patina repeated the color of Duret's *Pêcheur*.[97]

It is not difficult to understand why Carpeaux invoked a comparison with his teachers. For one thing, it was a time-honored strategy, which other *pensionnaires* had used to good advantage. In Carpeaux's case, however, the comparison obscures as many of the implications of his choice of theme as it reveals. When, in 1833, Rude and Duret first showed their Fisherboys, the subject could still fascinate a Salon-going audience. Both artists evoked facets of the myth of an exotic Italy, whose unspoiled inhabitants lived in unfettered, intuitive harmony with their world.[98] "The fishers by the water have no boast save of their freedom." By the late 1850s, however, that dream had begun to lose its allure. In those years Italy meant principally the diplomatic negotiations of Count Cavour to secure French support in expelling Austria from the Italian peninsula. A different kind of freedom was now at stake, or so the partisans of nationalism argued.

We might expect some enterprising artist to activate this new set of associations. The Italian sculptor Vincenzo Vela, who sent a group titled *Italy Thanking France* to the Salon of 1861, certainly tried to do so. But should not the active trade in fisherfolk have been

134. Engraving after Jules Klagmann, *Enfant jouant avec des coquillages*, 1847, marble. Reproduced from *L'Illustration*, 1847.

135. Engraving after Pierre Hébert, *Enfant jouant avec une tortue*, 1849, plaster. Reproduced from *L'Illustration*, 1849.

Salon de 1847. — Enfant jouant avec des coquillages, statue en marbre, par M. Klagmann.

Salon de 1849 — Enfant jouant avec une tortue, statue en plâtre, par M. Hebert.

136. (right) Engraving after Barthélémy Frison, *Le Pêcheur des coquillages*, 1852, plaster. Reproduced from *L'Illustration*, 1852.

Le pêcheur de coquilles. — Statue, par Frison. — Dessin de Marc ; gravure de Best, Hotelin et Cie.

137. (far right) Engraving after Gustave Nast, *Pêcheur et son chien*, 1857, plaster. Reproduced from *L'Illustration*, 1857.

Nº 3035. Pêcheur et son chien, groupe en plâtre par M. Nast.

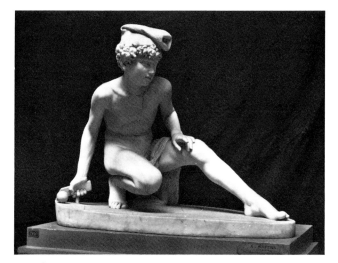

138. Antoine Sopers, *Jeune Napolitain jouant à la rauglia*, 1859, marble. Institut Royal du Patrimoine Artistique, Brussels.

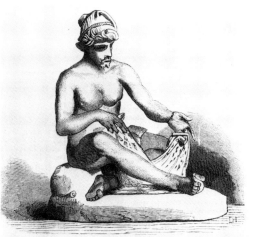

Pêcheur ajustant ses filets ; envoi de M. Maniglier.

139. Engraving after Charles-Henri Maniglier, *Pêcheur ajustant ses filets*, 1860. Reproduced from *L'Illustration*, 1860.

147

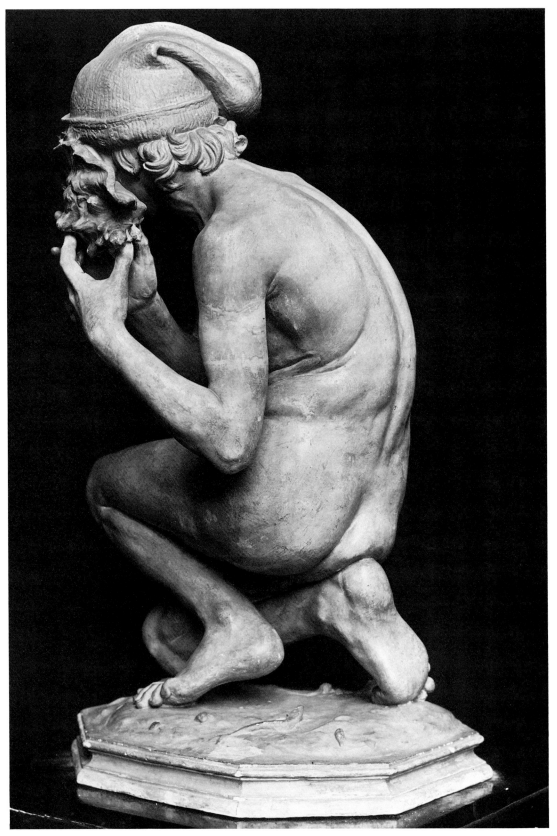

140. Jean-Baptiste Carpeaux, *Jeune Pêcheur à la coquille*, rear view, 1857–58, plaster (h. 92). Musée du Louvre, Paris.

tied to just this escalating market? At the very least, might not some critic have mined the resemblance between the fisherboy's customary cap and the Phrygian variety? This was not the case. The genre did not seem to lend itself to such updating. Slowly but surely emptied of its first powers of evocation, it became what it always had been at heart: an excuse to model a nude figure, one not modern, yet nonetheless not ancient. What it meant in terms of actual workmanship had been established, once and for all, by Rude and Duret.

In the 1850s a Fisherboy signalled its status as an exercise—hence its apparent suitability as an *envoi* theme.[99] Like any exercise, the category provided its own context and criteria, and About, for one, measured both with the ease and approbation Carpeaux had bargained for. Such approval—and its more tangible manifestations, like the second class medal awarded the bronze in 1859, and its subsequent purchase by James de Rothschild—must have gone far to mitigate the Académie's somewhat stilted approval of Carpeaux's figure, and its exhortation "to exercise his talent on noble subjects."[100] These objections were slightly formulaic, it is true; on their heels came the offer, relayed via Schnetz from de Mercey, to purchase the figure for 2,000 francs.[101] Carpeaux refused the bid; the bronze cast *à la Duret* was by then already mooted, and the new material doubled the asking price. Carpeaux originally planned to charge 5,000, but the sacrifice of 1,000 francs allowed him to retain reproduction rights. From the start he envisioned mantlepiece versions. It is no wonder that the *Fisherboy* eventually ended up atop an inkwell.[102]

These bronze Fisherboys—let alone inkwells—seem worlds away from Carpeaux's desire to be original and his serious plans for self-instruction. So they are, and not just because of Article 7, the Académie's proscription of commercial work. Carpeaux's conduct is contradictory, his aspirations unrelated and sometimes mutually exclusive for more basic reasons: because there was no coherent stance on offer, for him or any other *pensionnaire*, from which to manage the complex and unrewarding business of launching a sculptor's career. The *Jeune Pêcheur à la coquille* was Carpeaux's first real stab at the task. Only his second salon entry; submitted after a six-year silence; sent this time from the stronger base won by his Prix de Rome; aimed at a wider market—all these factors determined the work's form and range of reference, without Carpeaux being aware of their decisive character, or of any discrepancy with his other actions. After all, had not this subject, like his drawings, been found in nature? Was it not posed by a native Roman, a boy from the Borgo whose grandmother also sat to Carpeaux? Maybe in the end originality in sculpture could only amount to varying the theme, quickening the tempo, transposing the key. Perhaps there were no other options; or perhaps, in a climate where the academic was well rewarded, none was viable.

Within such a context, Carpeaux's sculpture could even seem original, alarmingly so. In his *Gazette des Beaux-Arts* column Paul Mantz wrote, "Carpeaux has given us a more personal production, a plaster model in which any investigation into style has been systematically avoided." For Mantz, these are damning words. He continued, "[the child] smiles, and unfortunately his smile stretches into a grimace. This little character, who is not so naive as he pretends to be, twists and turns like a monkey with a stolen nut."[103] Mantz never came to appreciate the statue, despite several chances to change his opinion (Carpeaux showed versions in the Salons of 1861 and 1863). "Once this figure appeared violent and exaggerated, as if the little fisherboy were expending an awful lot of energy to lift a light seashell to his ear. Before the final version of this work, the impression stays the same."[104] It is hard not to sympathize with Mantz's worries: there *is* something simian and exaggerated here. But that something is also what makes the figure "personal." Its listening pose generates an active imbalance which breaks the customary internal calm

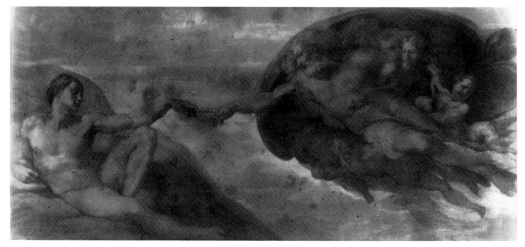

141. Joseph Soumy, *The Creation of Adam*, after Michelangelo, c. 1857, exh. 1861, drawing (54 × 118). Musée des Beaux-Arts, Lyons.

of the figural type. The angles of raised knee and bent elbow oppose one another; weight swings out from the pelvis; the turning shoulders must be countered by the hips. All this is well-managed, albeit with a few lapses in the folds of flesh along the figure's left side (fig. 140). Yet, regardless of their success, such minor modifications of the type could be read as *innovations* only within this specially limited figural context.

Perhaps the contradictions inherent in Carpeaux's practice in Rome will be clearer if we return to his concept of self-education—in particular, as it was manifested in his attitude towards Michelangelo. He wrote at the time: "I feel a vivid sympathy in my imagination with that great man, and all my works are marked by his gigantic stamp." Except the *Jeune Pêcheur*, we might add *sotto voce*: remember that these lines were penned in 1857, just as the Fisherboy was being completed. Nonetheless Carpeaux did make an emotional and artistic commitment to Michelangelo. In fact he adopted the great Italian as an ally in a struggle to define the ways his own art could relate to the past. But this commitment could overlap with other endeavors without interrupting them, and the time-consuming nature of sculpture often made such multiple, simultaneous involvements necessary.

For Carpeaux, the problem was not how to know Michelangelo, but how to *learn* from him; how to impress his art with that "gigantic stamp." He used at least two methods to direct his looking, and in each, another artist acted as guide. The first is the most expectable: copying. Yet understanding how Carpeaux's copies were undertaken involves us in explicating Carpeaux's friendship with a far from straightforward personality: Joseph Soumy, winner of the Prix de Rome for engraving in 1854. We have encountered his name before in this narrative, at Burty's house. There he was termed "a certain Soumy, one of their dead friends." After Soumy's suicide in 1863, Burty undertook a belated eulogy, gathering his evidence from the dead man's comrades, though in the end placing as much emphasis on the harshness of fate and his subject's too-nervous constitution as the topic seemed to demand.[105] From the records of Soumy's stay in Rome, however, a more definite picture of the engraver's character emerges; it is manifested most of all in his mixed feelings about the Villa Medici. His is one of the more eloquent variations on the theme:

Here I am, not knowing what to do: stay in Italy, have passable meals and a fairly good bed, but make bad engravings and go back to Paris a cretin. Or return to France, pick up odd jobs again, live more or less like the birds of the field, make a little art

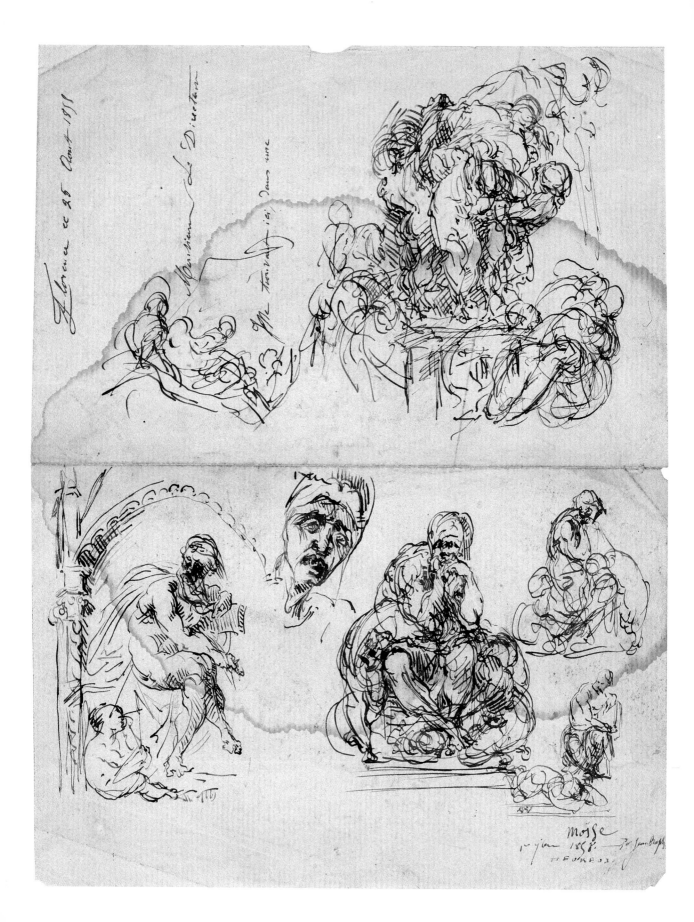

and more love. Have a less varied table than here and no servants either—perhaps hunger too, which I already know. But at least no more subjection.[106]

The passage has the ring of truth about it. Soumy returned to Paris by late 1857, and apparently things went more or less as he predicted. But he did not leave Rome without introducing Carpeaux to Michelangelo, and to the techniques of painting (doubtless also to his opinion of academic life). The epitaph Soumy's biographers propose—"He understood Michelangelo and was admired by Carpeaux"—links the three names unhesitatingly.[107] It is true that Soumy's paintings and engravings after motifs like the Libyan Sibyl, the Creation of Adam, and the Last Judgement are loving, meticulous work (fig. 141). Their careful fidelity may have prompted Carpeaux to turn from his customary casual sketches to a more literal approach to the same works. His efforts resulted in studious transcriptions of bits and pieces of the Sistine decor copied out on folio sheets of drawing stock.

More about the intellectual tenor of this friendship it is impossible to say. Both men were then borrowing books from the Villa library; perhaps their discussions made use of the *Vie de Michelange* by Quatremère de Quincy that Soumy checked out, or perhaps emulating their idol's taste in poetry, they pored over a borrowed copy of Flaxman's *Dante*.[108] This of course is the second method Carpeaux used to master Michelangelo: distilling a version of him from printed sources. Here the aid of another artist, Alphonse Roussel, was apparently most valuable. Roussel was a painter. His friendship with Carpeaux may have preceded his two-year stay in Rome, from April 1858 to 1860; it certainly survived it. After that date Carpeaux's scribbled lists of reminders most often include an *à écrire-Roussel*. And his letters to other correspondents are peppered with references to the man.[109] After Roussel's death in 1869 it was Carpeaux who paid the expenses of exhibiting one last canvas at the Salon (appropriately enough, the picture was titled *Young Girl at a Fountain. Studied at Rome*).[110]

In Rome, Carpeaux modelled a medallion portrait of his friend's slightly sharp, nervous features, his jutting chin and short wavy hair. The result is a quick, light-filled image, one which edges away from portraiture to echo another head, Michelangelo's *Tête de faune*, which Carpeaux had copied, probably in 1857 (figs. 142–43). Perhaps only half-consciously, an equation is made between the one head and the other—appropriately, it seems to me, given the role Roussel played in the sculptor's coming to terms with Michelangelo. Part of that process apparently was a manuscript biography of the master which Roussel wrote out on paper dated October, 1859, and marked with an ornately monogrammed *AR*.[111] Needless to say, the text is not testimony to scholarly research. Instead it is a tool towards a peculiar, selective appropriation of Michelangelo. He is labelled "The Powerful, The Energetic, and The Great," and his aims clearly stated: "To Speak, to Strike, to Convince, that is his purpose." Roussel drafted three other descriptions for his friend. For example, Phidias meant "Emotion and Pleasure," and a clear moral: "The important point is to have a wise purpose and to accomplish it valiantly, frankly. Triple unity of conception, composition and style." Raphael was "The Divine" (as always); Homer, "The Prince of Poets." Roussel did not stop with these slogans. All four are further described through both personal characteristics and works of art. In the process, each becomes an exemplar of either a particular stance towards the difficulties of being an artist, or the essential qualities of art—or in Michelangelo's case, of both.

Citing these fragments of long-dead friendships between Carpeaux and little-known artists like Soumy and Roussel, I am conscious of how odd and insubstantial they must

I. Jean-Baptiste Carpeaux, *Studies after Michelangelo and for Ugolino*, 1858, pen and brown ink on folded blue-grey stationery paper (27 × 20.5). Art Institute of Chicago.

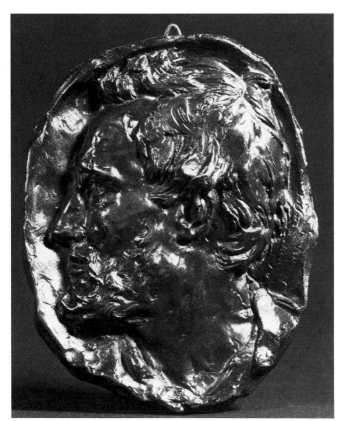

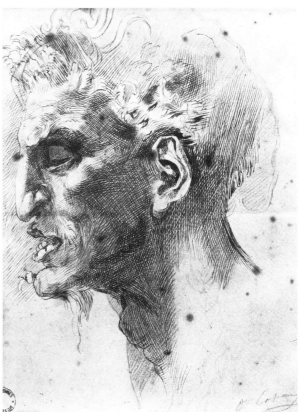

142. Jean-Baptiste Carpeaux, *Portrait of Alphonse Roussel*, 1859–60, lead or zinc with bronze patination (18.4 × 14.8 × 4). Private collection, Los Angeles.

143. Jean-Baptiste Carpeaux, *Tête de faune, d'après Michelange*, 1858–60, pen, ink, and red chalk on white paper (35 × 28). Musée des Beaux-Arts, Valenciennes.

seem. Of what possible interest is the guidance of these anonymous men—"of whom there are so many in art," to borrow the Goncourts' phrase? Their anonymity is once again the point. It is significant that Carpeaux improvised from such unlikely sources the knowledge and understanding of Michelangelo which would prove crucial to his art. This is not scholarly learning, but enthusiasm tenuously tied together by pieces of myth, tidbits like the tale of the boy Michelangelo precociously advising his master, or the old story that identifies his nurse's husband as a sculptor (in this version, at least). Should not our understanding of Carpeaux's grasp of Michelangelo include some idea of just how idiosyncratic, how fragmentary, it was?

In this light it is no surprise that Carpeaux tailored an image of Michelangelo to suit his own ambitions and needs. The great Italian—and other Renaissance artists—became paradigms of the struggle for freedom from academic slavery, pioneers whose trail could be followed, albeit with difficulty. These are notions Carpeaux himself articulated in an ambitious though fragmentary essay; the central question, once again, is how best to make use of the past:

> Antique execution. That is slavery, and my spirit refuses this heritage. But in the epoch of the Renaissance fearless geniuses broke the bonds of slavery. Under their chisels marble and bronze began to palpitate with movement and with passion, without having lost anything of antique science. They understood how to introduce new elements into art; their works were epoch-making and still today when an artist feels himself pale and cold, quick he runs to Michelangelo's works to warm himself as in the rays of the sun.

152

In reacting to the chill of the antique Michelangelo was carried past truth by his vigor and genius, but also what grandeur, what life, what energetic expression of nature—he makes it all energy.

Renaissance sculpture, which is a reaction like all reactions, overshot its goal. Also the artist who would take these works as a model will inevitably be condemned should he imitate them faithfully. This would be unpardonable since he would be crushed by the name of Michelangelo who will always have the label of master and creator. Or perhaps not wishing to imitate his model faithfully but only to take inspiration from it, an artist can fall into exaggeration of the kind of which unfortunately we have many examples.[112]

This is a powerful piece of writing, I believe: the prose may be clumsy, but the effort to assess Michelangelo—to form a notion of what working from him might involve—is serious and sustained. Not that an answer is offered, exactly; but at least the dangers are clearly stated. Imitation, even influence—both threaten to obliterate an artist's individuality, even though Michelangelo's example is as vital, as necessary, as the sun itself. So any alliance with Renaissance precedent will have to be carefully negotiated. "Of course," you say. But the fact remains that around 1860 making some kind of peace with the past was still a major issue, and for many artists influence, if not direct imitation, was the terms of the settlement. Carpeaux's caution about both suggests that he suspected there might be another way to proceed, and a notebookful of drawings from 1858 indicates he found it.[113]

It is difficult to demonstrate the truth of that last statement without the actual notebook in hand, since the faint evidence it contains is barely legible after a century. Yet the effort of decipherment is worth making. The notebook is one of the Henry Penney brand of sketchbooks which Carpeaux carried in the 1850s; its green leather binding bears a label affixed years later, "Rome et Florence"—a span of usage clearly reflected in the book's contents. They range from small sketches of seated youths, all indirectly related to the *Jeune Pêcheur* and one apparently a gloss on Maniglier's version of the subject, to notations directly linked to *Ugolin et ses fils*. The pages in between are filled with quick studies done in the street and after works of art (figs. 144–56). As he often did, Carpeaux worked from both ends towards the center of the book, so there is no clear temporal progression. Both endpapers are given over to written reminders, like names and prices, and deeper in the book there is a list of things to see in Florence: "St. Spirito, Casa Buonarotti, Vierge à la chaise, Vierge au baldacchin, Vision d'Ezékiel, bronzes, dessins, chapelle des médicis, Andrea del Sarto, St. Maria Annunciata." The list is a good index both of Carpeaux's itinerary in Florence and of drawings contained in the *carnet*.

On the last page of the sketchbook Carpeaux jotted down the name and address of a Florence photographer.[114] The note suggests straightaway what the book was for—the purposes it would serve and those it could safely ignore. If Carpeaux had need of faithful reproductions of the city's treasures, he could buy casts and photographs; other scribbled lists of titles and prices indicate he did so.[115] The sketches he made as he toured Florence were not strict records of form. They were not meant to capture detail precisely. Rather they fixed on a few aspects of their models—the swell of a hip, the stretch of an arm, perhaps a hint of surface texture. They picked out particular monuments of the Renaissance city for future study—took note of Giovanni Bologna's *La Fiorentina* on the Tribolo fountain at the Villa Petraia, or his small bather at the Uffizi. Carpeaux looked hard at Donatello's *St. George* at Or San Michele, taking from it perhaps the most finished of any of the notebook

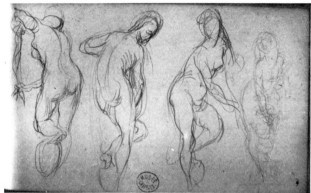
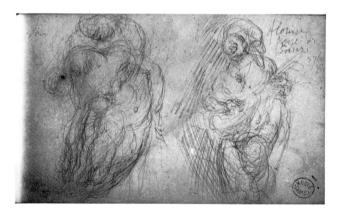

144-56. Jean-Baptiste Carpeaux, studies in a notebook used in Rome and Florence, 1858, pencil (9.1 × 15.8). Musée des Beaux-Arts, Valenciennes.

drawings he did in Florence—a two-page sketch which places the dragon killer firmly in his niche, and then invents its own flourishes for a Gothic frame. As he drew, Carpeaux was able to see and simultaneously to invent, so that his copies in the Loggia dei Lanzi, for example, though clearly identified by an inscription, lose hold of their identities as Hercules and the Centaur, and become any two figures merged in desperate liaison. Yet his research was thorough, as the list suggests: he was building a formal repertoire, choosing his angle of vision with care. Looking at *La Fiorentina*, for instance, he set down its voluptuous movement from just the point where the curves seem fullest and the tensions of its posture the most active. He consulted drawings too, perhaps through the offices of the director of the Pitti Gallery, whose name he noted in the *carnet*.[116] Other sheets were on view at the Uffizi, including designs which then passed as Michelangelo's plans

155

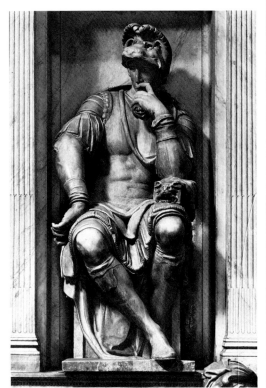
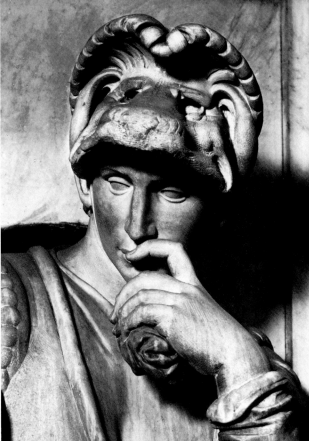

157–58. Michelangelo, *Lorenzo de' Medici*, 1524–34, marble (h. 178). Medici Chapel, S. Lorenzo, Florence.

for the Medici Chapel and the tomb of Julius II. In both cases it was the figures wedged within the architectural surround which fascinated him. His notebook versions trap similar figures in cramped, claustrophobic niches; even when no niche is indicated, still other figures are shown intertwined in constricted reclining postures.

Interspersed among these pages are drawings which explore for the first time the conception which would finally be resolved as the Ugolino group. In a sense, the entire *carnet* performed that exploratory function, because it served to rehearse the various ways—all of them restless and contorted—in which bodies can be made to overlap and intertwine in space. But some sketches are more directly preliminary: for instance, a version of the Laocoön legend, or an agonized male head, cradled in a hand, or another with deeply sunken eyes, or a page of adolescent male forms laid out in dejection or death. And included among them are two faint studies, almost breathed onto the page, in which these tortured bodies coalesce into a pyramidal pile of curving strokes: they are first, tentative renderings of the monumental body of Ugolino and the clinging shapes of his sons.

These studies are most legibly elaborated outside the notebook in the strongly inked sketches on a sheet of writing paper dated "Florence, August 25, 1858" (col. pl. I).[117] Carpeaux had evidently meant to use the paper for a letter to Schnetz, which, judging from the way it begins—"Finding myself here in a . . ."—was to have been yet another request for emergency funding. When the page was spoiled, however, he reused it, recapitulating several of the compositions he had tried out in the notebook, including the Ugolino grouping. But the sheet is more than just one fixed point in a chronology. It demonstrates the way Carpeaux was moving from a confrontation with Michelangelo's art to a transformation of it. Three of the studies on the page show that Carpeaux developed the pose he gave Ugolino directly from Michelangelo's figure of Lorenzo de' Medici in the Medici

156

Chapel, embedding it at the heart of his own work (figs. 157–58). The hollow-cheeked, sunken-eyed head in the center of the sheet's lower half is Lorenzo, made ghoulish and horrible, yet unmistakable because of the indications, in a few curved and parallel lines, of the visor and crest of the duke's helmet. Next to the head Carpeaux drew a full figure of Lorenzo, capturing the odd opposition of limbs which Michelangelo had used to convey poised contemplation: knees at slightly different levels, left arm resting above the left knee, left hand raised to support the chin, left forefinger crooked across the mouth—all this is clearly though elliptically conveyed. A few lines lead down from the shoulder to render the awkward, thwarted turn of the passive right arm, while in the lap and on top of the head brisk parallel strokes describe the pleated toga and crested helmet of the military costume. The essence of Lorenzo is thus captured in a few lines, but Carpeaux did not stop once he had recorded the statue. Instead he drew directly over this first transcription, tightening its center by adding a new right arm which supports the head, and clothing this central core in a sheath of curves suggesting dependent figures. Stripped away, they would leave the *Lorenzo* intact. But it was the new conception Carpeaux wanted to retain; he quickly repeated it, in the version just to the right.

Looking at these small sketches and the notebook studies which accompanied them, we can see some of the complexity of this way of studying past art. For Carpeaux, at least, it meant not "copying" but devising a way of seeing and rendering which quickens and transforms a model, as if to grant it a new state of being. This meant many things: approaching a sculpture from several directions, making it move by moving around it and finding its most active contours; or if the object was fixed in one plane, recasting it graphically with a flurry of lines which carry their own suggestion of motion. If this is copying, it is copying of a specially active kind: it conflates and interprets its material, investing it with a physical or emotional tone perhaps suggested by the source, though not necessarily contained there. This process of transformation is nowhere more evident than on the sheet once intended for Schnetz. Studying Michelangelo, it tells us, was as much metamorphosis as close reading, and as much memory as confrontation. This is apparent from two other notations on the same page. The personage at left with pen and tablet might well be a Moses; it could equally well represent a prophet along the lines of those on the Sistine ceiling.[118] The smallest figure, the one with a reclining slave beneath him, is certainly a Moses, a memory of Michelangelo's marble in S. Pietro in Vincoli. Carpeaux specified its identity as *Moïse*; he coupled that message to the word *Heureux*, and linked them with the date, September 1, 1858, and his own name, Jean-Baptiste, so that the whole becomes a kind of index to his mental state.

It is tempting to ask why Carpeaux was happy that September day (if we are to believe the bulk of his letters, happiness was not his customary state) and to tie the answer to his discovery of the Ugolino composition. The explanation is probably not far wrong. It is evident from inscriptions on other drawings that Carpeaux frequently put words to his emotions when he drew from Michelangelo, in a way that suggests a direct relation between ego and artistic process.[119] Most often the relation was an anxious one; but here, for once, the label expresses satisfaction, and the viewer is tempted to attribute that state of mind directly to the resolution of a formal problem—the more so because Carpeaux had been considering ways to treat the subject since at least the previous December. "But what is even nicer, I've just found my composition for the final year. It's a group of four [*sic*] figures. The praise I've received for this composition is a proof that I need only continue in the same direction. The subject is dramatic to the nth degree. There is a great analogy to the Laocoön."[120] The reference is not as vague as it might seem. Carpeaux can only

mean the *Ugolin*, and, sure enough, his letters soon after cite his subject chapter and verse: "Chant XXXIII, Enfer du Dante."[121]

The crucial elements are thus in place: a subject from Dante and the influence of Michelangelo—a not untypical mix for sculpture in the later nineteenth century. But—and this is the remarkable aspect of the sculpture's history—the mix did not jell into an exhibitable sculpture for nearly four years, until fall 1861. From conception to completion was a period plagued by every imaginable worry and delay: from Carpeaux's first wrestlings with a recalcitrant armature that just would not come right (what had become of Rude's rigorous lessons in constructing the infallible "firm tripod," we wonder?); to still further strife with Monsieur Schnetz, who pointed out with proper directorial compunction that the rules forbade subjects from Dante and that anyway this one had too many figures; to a strapping model for Ugolino who drank when he got paid; to illness; to a trip to Paris to win prolongation of a *pension* that finally had run out. And so on. In such tedious circumstances the *Ugolin* was brought to term.[122] In fact, they provide the subtext to a contemporary caricature of Carpeaux at work in his Villa studio (fig. 159): the great, glowing, heroic pile of a statue towers above emaciated Italian models and above the artist himself, and art transcends human foibles once again.[123] Yet despite the colorful particulars of the case—the tragicomic note all too typical of Carpeaux's doings—the story should have a familiar ring for other reasons. These are the conditions of production typical of sculpture in the nineteenth century: the institutional context; the worries about money and models; the uncertain task of fashioning the work itself.

In Carpeaux's case these conditions make for fat dossiers, clutches of drawings, and clay sketches—artifacts which circle round the monumental group like so many satellites fixed in their dependence on a dominant center. Or perhaps another, equally hackneyed natural image better suggests the relationship which this "subsidiary" material has been

159. Caricature of Carpeaux at work in his Villa Medici studio, 1860–61, black crayon heightened with white. Bibliothèque Nationale, Paris.

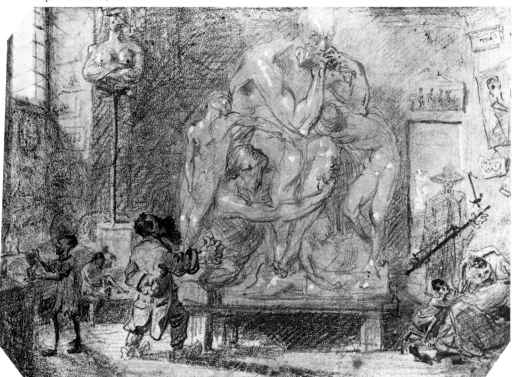

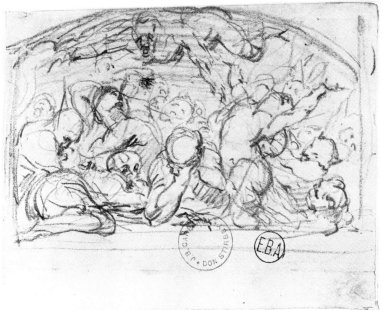

160. Jean-Baptiste Carpeaux, *Projet du bas-relief cintré*, 1858, pencil on white paper (11.7 × 14.6). Ecole Nationale Supérieure des Beaux-Arts, Paris.

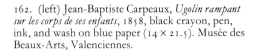

161. (above) Jean-Baptiste Carpeaux, *Reclining Figures in Lunettes*, 1858, black ink on wove paper (29.1 × 22). Art Institute of Chicago.

162. (left) Jean-Baptiste Carpeaux, *Ugolin rampant sur les corps de ses enfants*, 1858, black crayon, pen, ink, and wash on blue paper (14 × 21.5). Musée des Beaux-Arts, Valenciennes.

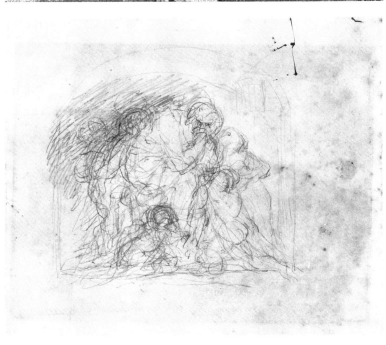

163. Jean-Baptiste Carpeaux, *Study for Ugolino*, 1858, pencil and ink on white paper (9.2 × 12.4). Metropolitan Museum of Art, New York.

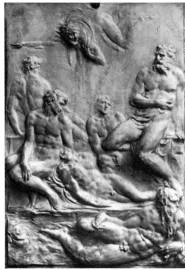

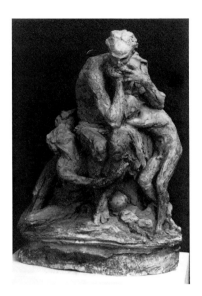

164. John Flaxman, *Ugolino and his Sons*, 1793, engraving. Fine Arts Library, Harvard University.

165. Pierino da Vinci, *La Morte del Conte Ugolino*, terra cotta. Museo Nazionale, Florence.

166. Jean-Baptiste Carpeaux, *Ugolin et ses fils*, 1860, terra cotta (h. 56). Musée du Louvre, Paris.

thought to have to the final work. From a seed of an idea stems its first offshoots as drawing, and then its final masterly efflorescence, with those dossiers providing information about the nutritive composition of the soil in which germination took place. The chronological distribution of Carpeaux's studies for Ugolino feeds this conception, since they seem to reveal decisions taken without waffling or backsliding. They form a series which can easily, if mistakenly, be read as progress towards an inevitable goal.

Before August, 1858, Carpeaux considered modelling Ugolino as a bas-relief. At least four drawings accordingly contain the theme within an arched framework. One shows the desolate Ugolino, surrounded by his sons and the fainter gibbering features of ghosts and devils; above them flies a screaming figure personifying hunger (fig. 160).[124] Another is more literal in its rendering of place: a cramped prison cell lit by a barred window is filled by the fallen bodies of Ugolino's sons (fig. 161).[125] He crawls above their prostrate forms, reaching out in an attitude based on the Sistine *Adam*, an ironic reference which transforms a gesture towards life into a movement to ward off death. On another sheet the prison confines are shown only by shadows (fig. 162).[126] In this gloomy space Ugolino digs clawlike hands into dead flesh, while the stain of ink beneath his grimacing face reads like blood. Even as late as the Rome and Florence sketchbook, there is a drawing which still suggests a bas-relief. And a larger version of that same idea likewise shows Carpeaux poised between two worlds: the group itself becomes more and more a substantial pyramid of forms, freestanding and demanding room; but the framework stays compressed and two-dimensional (fig. 163).[127]

The conclusions to be drawn from this cluster of drawings, however, have nothing to do with the inevitable ripening of artistic fruit. The change from relief to statue was radical and discontinuous; it marked Carpeaux's steering of his idea towards a notion of what might be called "artistic intelligibility." Think of a bas-relief along the lines of any of these drawings. It would be gruesome, yes, but also unstable and unconventional, more like Préault than anything else in art. This is true even though Carpeaux evidently had let the Ugolinos of both Flaxman and Pierino da Vinci—the latter then thought to be by Michelangelo—influence his first ideas (figs. 164–65).[128] The arched format and the flying Hunger both come from these sources, but not the oppressive spatiality or the brutal juxtaposition of bodies. Building the new Ugolino around a Michelangelesque core meant negating this unstable concept, assimilating it to another idea of statuary, of composition. And that idea guided the piece to completion.

Calling this concept "artistic intelligibility" is one way of naming the decisions which the final group bespeaks. Yet several kinds of choices were involved, from fixing on a way to mass the pyramid of bodies and deploy the subordinate shapes of Ugolino's doomed offspring, to deciding how the nature of Ugolino's dilemma could come to a kind of crux in the positions of his hands and feet and in the great corded musculature of his body. These are decisions made not in drawing but in modelling, en route from the fragile clay sketch (fig. 166) to the enormous final physicality of the thing. The decisions are complex, but nonetheless they may be said especially to effect *artistic* intelligibility, because they align the group so firmly with precedent and pattern. They allow, even encourage, a reading in terms of likenesses and prototypes—other Ugolinos, other muscular masculine figures, other powerful torsos, other pyramidal compositions—even while simultaneously the results of these same decisions serve to distinguish the group. They make it possible to see just how brilliantly, how intensely, Carpeaux had internalized his chosen archetypes— not just Michelangelo, but the *Laocoön*, even the Belvedere torso. But at the same time they are the evidence of his conventionalizing the group, returning it to the language of western sculpture.

What happens to *textual* legibility in the process? Carpeaux, after all, had a subject to represent, a passage from Dante which remained a fixed point of reference no matter how or if he chose to respond to sculptural tradition. In bas-relief, that subject would have been well served.

> He raised his mouth from his ferocious meal,
> That sinner, wiping it upon the hair
> Of that head, the back of which he had spoiled.
>
> Then he began: "You are asking me to renew
> A desperate grief, which presses on my heart,
> Even to think of, and before I speak.
>
> But if my words are to be a seed
> Which may grow to infamy for the traitor I gnaw,
> You shall see me speak and weep at the same time.
>
> I do not know who you may be, nor how
> You have come down here; but, when I listen,
> It seems to me that you are a Florentine.
>
> You should know that I was Count Ugolino,
> And this is the Archbishop Ruggieri:
> Now I will tell you why I am so close to him.
>
> That, as a consequence of his ill thoughts,
> Trusting myself to him, I was taken
> And thereafter killed, no need to tell you;
>
> But what you cannot have understood,
> Is how cruel my death was; that you shall hear,
> And you will know whether he offended me.
>
> A narrow outlet in the close lock-up
> Which, because of me, is called the Tower of Hunger,
> And in which others must be shut up still,

Had shown me several moons through the slit,
When one evil night I had a dream
Which rent the veil of the future in two for me.

This man appeared as lord and master,
Hunting the wolf and the wolf-cubs on the mountain
Because of which the Pisans are unable to see Lucca.

With hounds that were hungry, eager, skillful,
He had put ahead of him, Gualandi,
With Sismondi and with Lanfranchi.

After a short run, so it seemed to me,
Father and sons were tired, and, with sharp teeth,
It seemed to me their sides were split open.

When I awoke, before the next day came,
I heard my little sons cry in their sleep,
Asking for bread, for they were with me there.

You must be cruel, if it does not hurt you
To think of the apprehension in my heart;
And if you do not weep, what do you weep for?

They were awake, and then the hour approached
When, ordinarily, food had been brought in,
And, on account of our dream, we were all anxious;

And I heard below the way out of the tower
Locked up; and then I looked into the faces
Of my sons without saying a word.

I did not weep, but turned to stone within:
They began weeping; and my Anselm said:
'Why do you stare so, father, what is the matter?'

But I neither wept nor could reply
All that day, nor the night that followed it,
Until the sun once more rose in the sky.

When a small ray of sunlight found its way
Into that grim prison, and I saw
On four faces the look that was in my own,

I bit into both my hands for grief;
And they, thinking I did it because I wanted
To eat, without any hesitation rose

And said: 'Father, it would hurt us far less
If you ate us; it was you who made us put on
This miserable flesh, now you can strip it off.'

I calmed myself, not to make them more unhappy;
That day and the next we all stayed silent:
Alas, hard earth, why did you not open?

167. Jean-Baptiste Carpeaux, *Ugolin et ses fils*, 1857–61, bronze (h. 194). Musée d'Orsay, Paris.

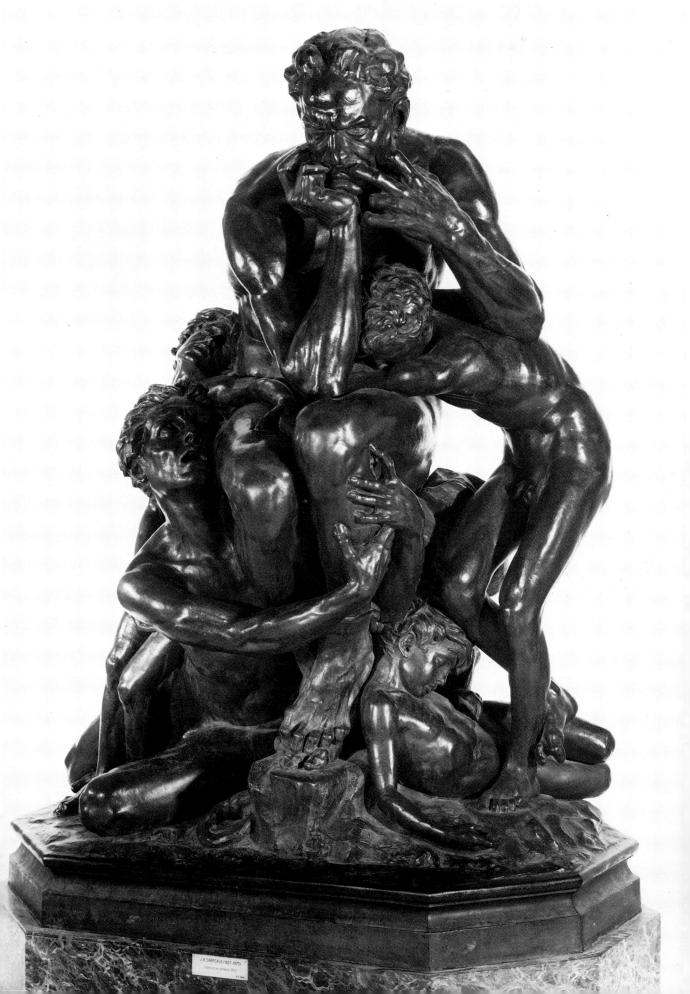

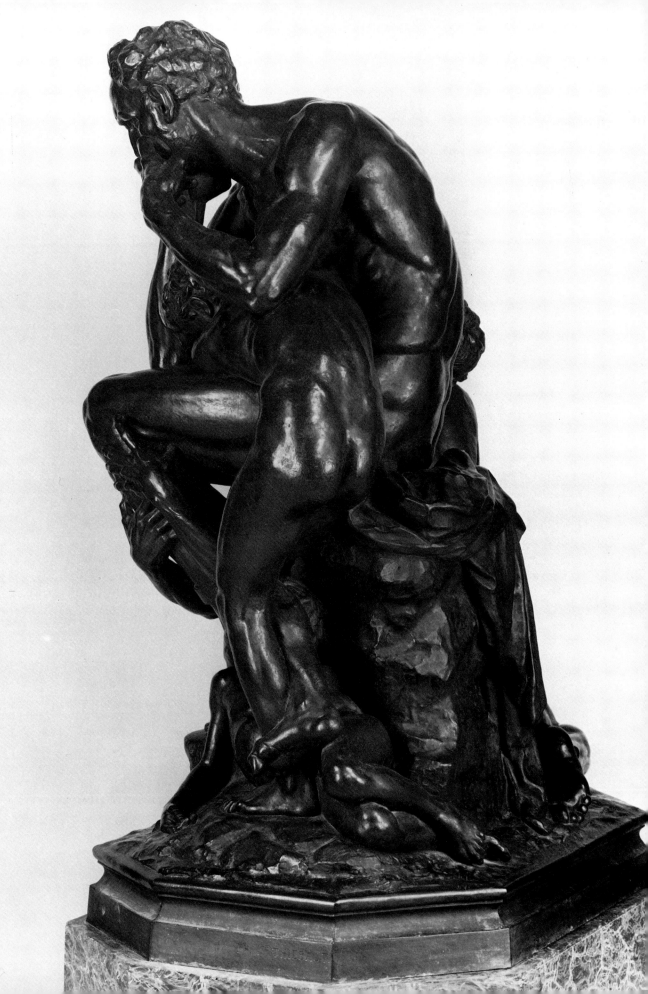

When we had arrived at the fourth day,
Gaddo threw himself full length at my feet,
Saying : 'My father, why do you not help us ?'

Then he died : and, as you see me now,
I saw the three of them fall one by one,
Between the fifth day and the sixth ; then I started,

Already blind, to grope over their bodies,
Calling them for two days, after they were dead :
And, after that, grief was less strong than hunger."

When he had said that, with his eyes bulging,
He again seized the miserable skull with his teeth,
Which, on the bone, were as strong as a dog's.[129]

It is not just the pictorial qualities of relief that make it an appropriate means to render this passage visible, although certainly the possibility of indicating setting—the "narrow outlet in the close lock-up," or prison grimness—are powerful arguments for its use. What better way of rendering a text than by staging it, responding to its verbal cues with a set of signs which likewise make time and space specific? But more important, the physical limitations of relief, the restraints on the relationship of figural scale to rectangular format, offer a metaphoric means to allude to this fatal confinement. A freestanding figure, by contrast, sacrifices pictorial possibilities. Context can be only minimally evoked : Carpeaux did all he could with the huge ring and chain he placed on his sculpture's base. But with no context, what constraints can the figures struggle against? What restrains them? In ridding himself of any pictorial means for narration, Carpeaux had to fall back on the body alone as his communicative vehicle. And he gave the body a coherence, a solid whole vigor and clarity, which inverts the partial, exaggerated, and brutally illogical treatment that the bas-relief drawings consider. Those first responses seize the violence collected in Dante's imagery of hunger and of eating and release it in explicit form. It might seem, in other words, that artistic legibility jeopardized the kind of textual legibility which such aberrant relief structures allowed. How could a freestanding figural group, especially one so confident of its relationship to western sculpture, secure the same meanings?

The answer, I think, is that it could not. The two kinds of fidelity, to tradition and to Dante, are not completely compatible. The group's final format inevitably brought with it some degree of diminution in the statue's response to the horror of its textual source. Paris critics, particularly the Académie, saw this diminution solely as a matter of setting and historical legitimacy : these necessarily made the subject pictorial, they argued, and better left to painting.[130] This line of reasoning seems to me to miss the point, however ; surely Carpeaux *did* manage to realize Dante's theme as a freestanding sculpture. It is more appropriate to ask how the subject—which Carpeaux evidently understood well—was made legible once the means of relief were rejected.

The question sends us back to the group : to its three-dimensionality and to the ways this condition could be mined for its own kind of legibility (figs. 167–71 and col. pls. II–III). In the sculpture's final state, the narrative could be secured only by the juxtaposition and interweaving of five bodies, and by the treatment of the bodies themselves. The result is a composition where, from frontal views at least, disjunction is the rule. Backs arch ; arms reach, bend and fall ; knees jut and fold in ways which refuse to form visual patterns. There is a kind of formal echoing, it is true, in the bodies' repeated extensions and flexures,

165

168. Jean-Baptiste Carpeaux, *Ugolin et ses fils*, side view.

but these echoes are not rhymed or made mutually responsive. The aligned legs, arm, and head of the seated count do construct a central pole, but they also compress the body unnaturally, doubling it over so its parts fight against themselves. Foot grinds into foot, knee presses against elbow, one hand props up a massive head while the other digs at the cheek and widens the mouth to a grimace. Against this self-consuming center, the sons reach or flaccidly fall, each infused with a different measure of vitality whose very variety comments on the hyperactivity of the figure they depend on. The sculpture demands such comparisons, because disjunction is its rule. Formal variety is exaggerated; actions only lead deeper into the thing itself. Yet these effects hinge in turn on Carpeaux's stagger- ing effort at physical veracity, from which results a sculpted ages of man. The artist believed this aspect of the work was crucial: "I feel myself that my work is above the ordinary. The series of different ages, the varieties of expression, the individual exactitude of each figure give the whole something inexpressibly pathetic which strikes every viewer who has seen the sketch."[131] For this particular viewer, however, the veracity of each son's figure is less important than the final *excess* of reality in Ugolino. Anatomy makes a point of its fidelity to nature, except within this central figure. Its physiology is not human but superhuman: each muscle is caught in flex, and bones stand out with equal hardness. The back is sheer exaggeration. A vast, humped, craggy terrain of flesh in which every muscle is mapped in relentless relief, it seems from some views to burden Ugolino like his own albatross. And so we come to see how this pursuit of physicality—this insistence on sculp- ture's three dimensions—does after all make Dante's tale legible: it throws meaning back into the body, makes the body the bearer of signification. By this very emphasis on flesh— not movement, or action, but flesh; knotted, slack, or urgent, self-consuming, burdening itself—Ugolino's anxiety, his temptation, and his sin are all made visible.

And yet the realization of Dante's text, satisfying as it may be, is limited by the same three-dimensionality which is the source of its power. To put it simply: a satisfactory read- ing is here contingent on point of view. From several positions—at the sides or in the rear—dissonance and lack of rhythm disappear. Dynamism resolves into pattern. It is almost as if the work were *not* three-dimensional, as if somehow it remained a relief in Carpeaux's mind, so that the solutions he found for the other views appear perfunctory: a bit of drapery, some neat containing angles. No wonder that in the later drawings of the group, after 1859, he always saw it from the front, as if only that preferred view existed in his mind.[132] This is not to say that the other profiles were not carefully worked out, but that the decisions about how to solve them were essentially different from those govern- ing the chief aspect. Back and sides are marked by a flat geometry which may be another odd legacy of drawing's role in this project—traces of an incomplete transformation from a pictorial to a sculptural conception. Or it may be the result of a certain discomfort, on Carpeaux's part, with sculpture in the round: his partial adherence, in the words of von Hildebrand, to the idea that "the sculptor forms something three-dimensional for the pur- pose of affording a plane visual conception."[133] Carpeaux's *Ugolin* seems to be caught between two contradictory conceptions of sculpture. Its principal frontal views pointedly avoid any planar conception, and on this avoidance meaning hinges. In the three other quadrants planarity rules, and the viewer's investigation of freestanding form is only partially rewarded.

It was inevitable that *Ugolin et ses fils* should have caused some small commotion when it was made public. In a climate where the extra inch added to a sculpture's height spelled ambition, Carpeaux's aspirations were written in majuscules. In Rome they had their first rewards. Late in the spring and on through the summer of 1861, Carpeaux's Villa atelier

II. Jean-Baptiste Carpeaux, *Ugolin et ses fils*, 1857–61, bronze (h. 194). Musée d'Orsay, Paris.

169. (following page) Jean-Baptiste Carpeaux, *Ugolin et ses fils*, rear view.

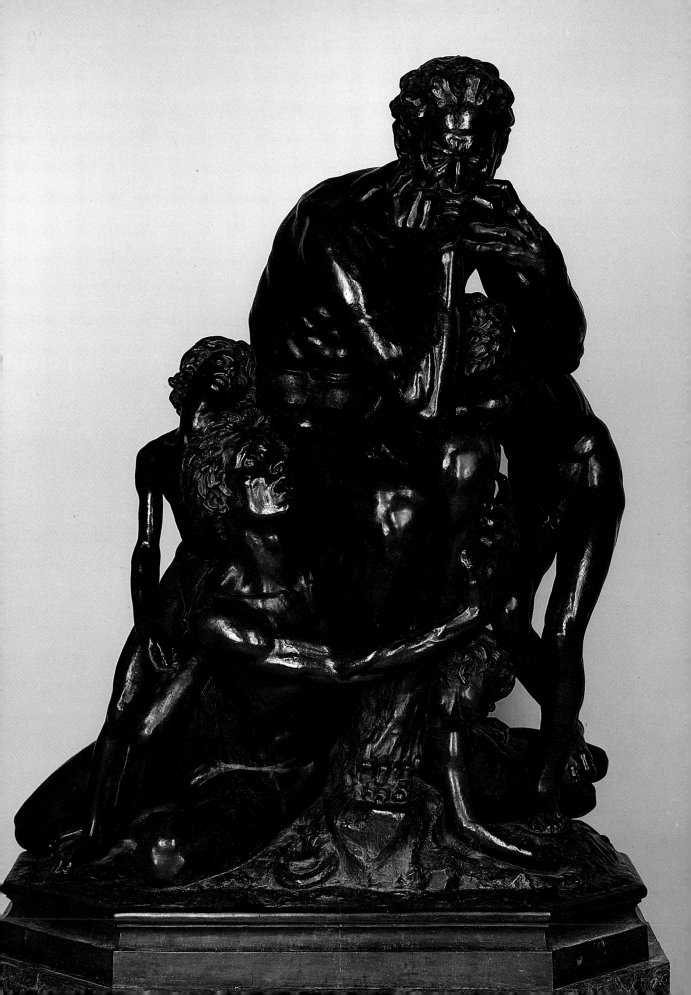

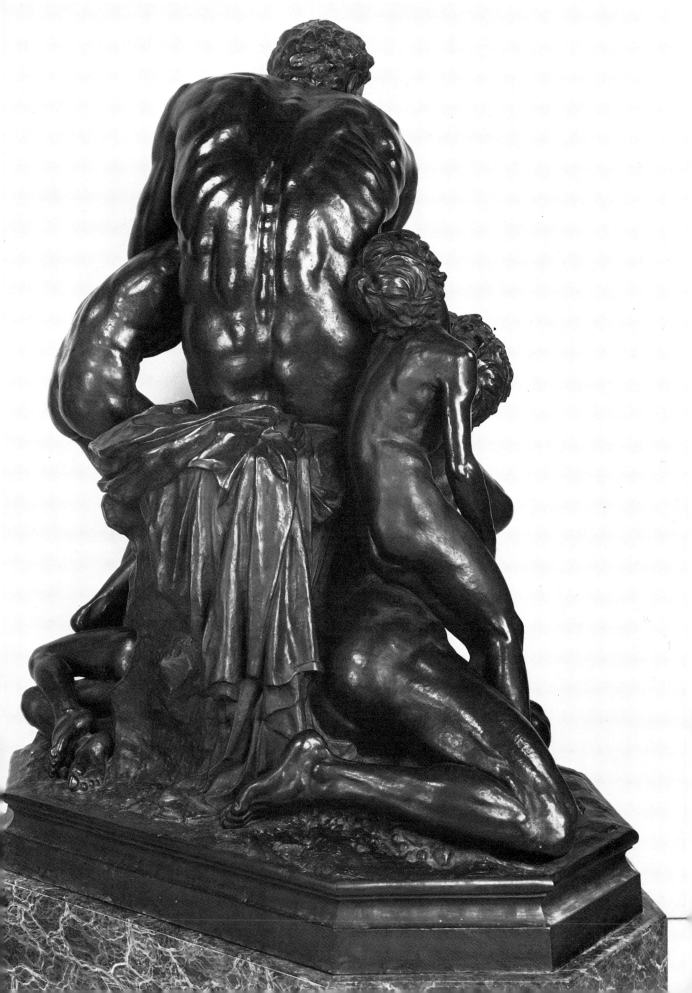

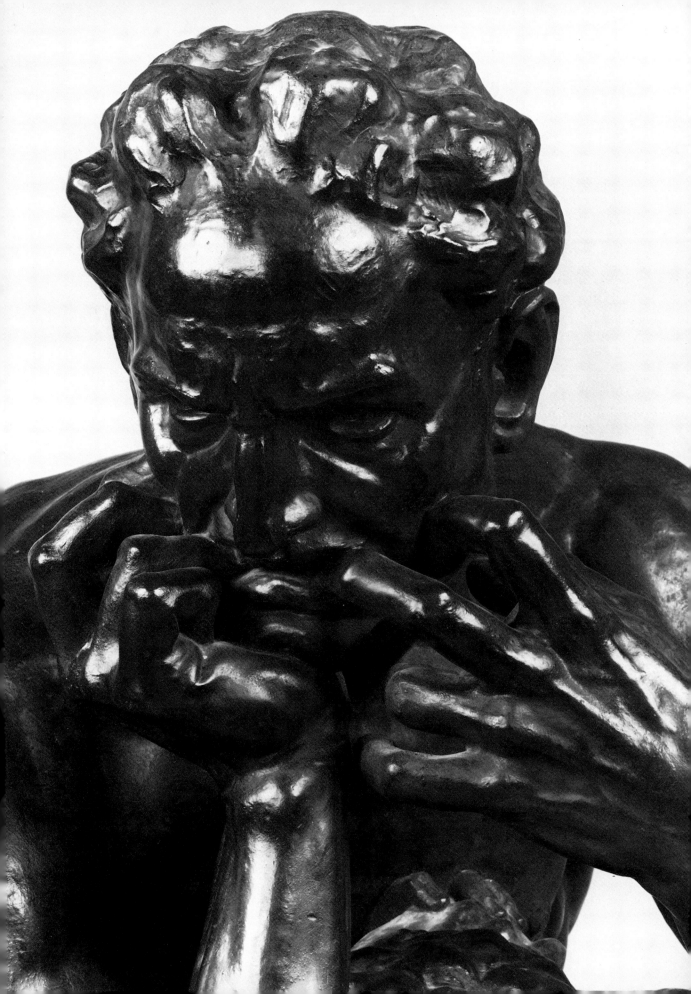

became a stop on Rome's "artistic promenade." He was visited and congratulated, and this success promised honors on a far grander scale. The Roman triumph was particularly sweet, of course, because it meant personal vindication as well as artistic success. In the fall of 1858 Carpeaux had tried to wean himself from a subject which the rules forbade and time made impracticable. He even nibbled at new themes: Ugolino could be decked out as St. Jerome, or failing that, a whole new project begun. For a while he considered working in a pastoral mode, borrowed Longus from the Villa library, then hit on *Paul and Virginia* instead.[134] These efforts proved fruitless, but they had their own importance for the Ugolino group. Here is Schnetz's account:

> The other day he told me that he is haunted by the idea of his group, has been unable to think of anything else, and has returned to it despite himself. This disobedience to the rules sets a bad example, and that was the reason I persisted in telling him to give in, but with a debtor you take what you can get. So I'm letting him proceed at his own risk. He will have to make almost a masterpiece to win amnesty. I hope for his sake and ours it's not a fiasco. In any case he will be able to finish no more than the plaster model here in Rome.[135]

Carpeaux's recalcitrance had raised the stakes almost intolerably high, and his pride and relief at his eventual success are to be measured on that heightened scale. As for Schnetz, once it was clear he had a masterpiece, not a fiasco, on his hands, he was entirely supportive, ready with recommendations and encomia to help the group over the hurdles of exhibition and sale.

Reentry into artistic Paris was the next step; negotiations for transportation, display, and purchase were opened straightaway. Never mind that the ethic of the Villa Medici implied that these rewards came automatically. Events belied the claim. Carpeaux's case was particularly questionable since he had so long outlasted his Roman stipend. Could the *Ugolin* be crated and shipped at government expense? Would the Académie write an official opinion? What about purchase? Ministries exist to answer questions like these, and to take pains over the process. Each condition had to be separately bargained, each privilege individually won, even though the answer was yes in every instance. The government paid the freight charges, the Académie sanctioned a week-long exhibition in the Ecole chapel, then extended it for months. The sculpture section duly read and recorded its formal report to the body of Beaux-Arts academicians, though they had to be begged by Carpeaux and urged by the ministry to do so. Purchase was approved and 30,000 francs paid out. By December, 1863, the Louvre architects had been notified that a bronze cast was en route to a position in the Tuileries that made it a pendant to the Laocoön.[136]

What could be more appropriate, more satisfactory? Surely here is the happy ending this chapter promised from the start. No matter that these honors are something less than the hero's welcome Carpeaux predicted: there was no first medal, no knighthood, no election to the Académie. The year 1863 nonetheless saw Carpeaux's reputation finally and firmly launched. The *homme d'Ugolin* was born. But the epithet should alert us to the notoriety which edged this reputation, and send us back to *Ugolin*'s Paris reception armed with some questions about the nature of this success.

Take the Académie's official report: it concluded that the future augured favorably for this young sculptor. But look at the path by which they reached that conclusion:

Gentlemen:

In this important work inspired by Dante, it must first of all be regretted from the point of view of conception that the figure of Ugolino is not chiefly animated by that

169

paternal sentiment which the poet traces so strongly and which is the essence of the subject. Because of the nudity of the figures it might also be judged that the work departs from the character of the epoch in which the drama was played out, but we do not attach importance to this observation since we believe the author justified in this liberty by respectable examples.

The conception of this group leaves something to be desired from a sculptural point of view, as much from a kind of confusion in the grouping of figures as from a lack of clarity in the disposition of the lines of the subject, which in view of the number of obligatory figures, lends itself with difficulty to the demands of sculpture in the round and seems more to belong to the domain of painting. On other counts, M. Carpeaux's work attains a high degree of merit. His figure of Ugolino is rendered with great energy.

The two youngest children, which demand recognition most of all, demonstrate a beautifully integrated expression, really touching, to which a remarkably truthful execution contributes.

The two eldest share these merits to some degree. Yet the one who embraces his father's knees—above all, his arms and hands—shows a muscular contraction much too pronounced for the age and purpose of the figure.

The author's excessive desire to display his anatomical studies in some respects harms the truthful feeling of the form, gives a kind of uniformity to the character of several of the figures, and seems, moreover, ill-motivated in figures exhausted by hunger.

Despite the critical observations indicated in this report, we are happy to recognize, in sum, that M. Carpeaux's group is from more than one point of view, but above all, in execution, a remarkable work. We firmly believe, therefore, by reason of the talent which this young sculptor has demonstrated in the past and which he today displays in an entirely different genre, that his future augurs favorably.[137]

Imagine Carpeaux reading this text—or any partisan of his sculpture, for that matter. Think of the hurried search through six paragraphs for the "good bits"—unqualified praise—sandwiched between worries and regrets. The praise is there, it is true; this is *almost* a favorable report. But not quite. In the end the balance between objections and approval is unsatisfactory. The negative tone is not just a matter of phrases like *trop peu modérée* or *défaut de clarté* outweighing references to *une oeuvre remarquable*, but the way the whole report is laced with qualifications without being salvaged in the end by anything more concrete than a bright prediction for Carpeaux's future. What is lacking is the recommendation for purchase that was invariably attached to the Académie's favorite works. The problem was not one of skill or effort; it had nothing to do with the manual side of making sculpture. As usual, Carpeaux gets high marks for execution. The problem is all about meaning: what might be said and read in a sculpture representing Ugolino and his sons, once it becomes apparent that such an anomalous object actually does exist. The Académie expected to read in this group a representation of paternal sentiment. Instead they found a confused composition and an exaggerated, rhetorical anatomy. It is odd to read that the work looked like an "immoderate" demonstration of anatomical study, yet was not realistic enough; and odder still to confront these opinions as official academic judgements. It is precisely these devices, of course—Carpeaux's treatment of anatomy and composition—which keep the work from communicating "paternal sentiment". But once it is granted that the group represents the taboo and temptation of cannibalism, with Ugolino's unclean sin shown as *self*-consumption, the Académie's objections seem like willful or ignorant misreading.

170

171. Jean-Baptiste Carpeaux, *Ugolin et ses fils*, detail, feet and chains.

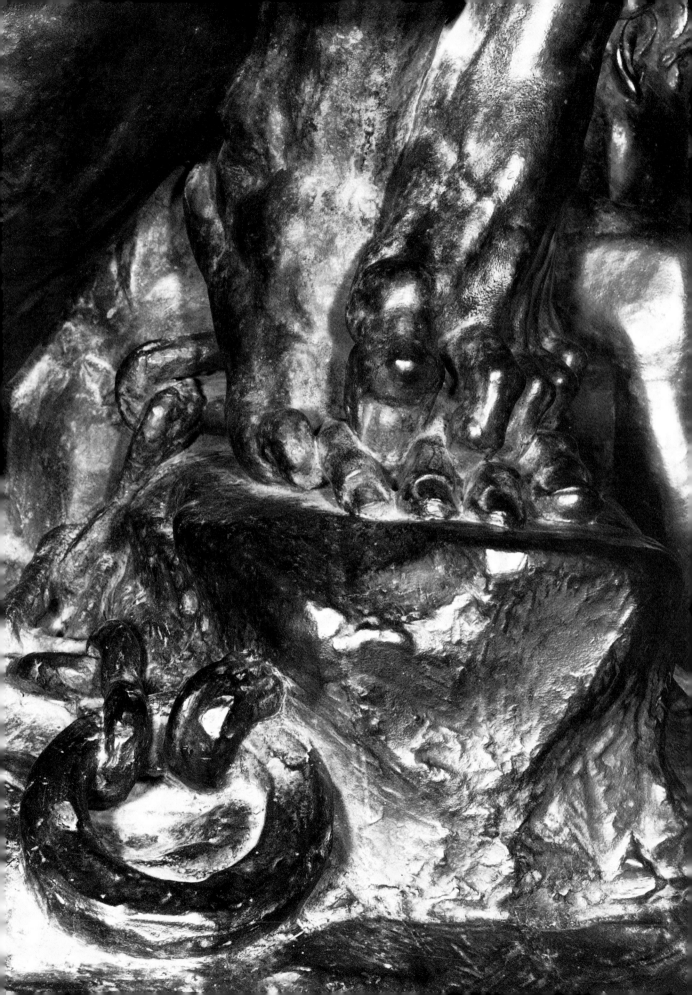

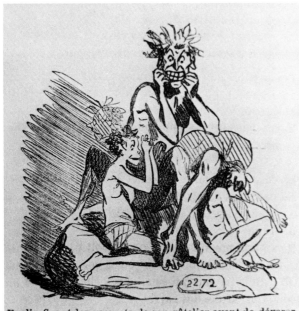

Ugolin fixant les ressorts de son râtelier avant de dévorer
ses enfans.

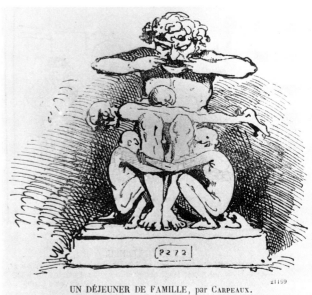

UN DÉJEUNER DE FAMILLE, par CARPEAUX.

L'asile le plus sûr est le sein de son père.

Voyez comme ce père est de bronze! Le moment choisi par le sculpteur est
celui où Ugolin se dispose à avaler le premier de ses fils. Pour un père ce
sera bien dur!

This was the real difficulty Carpeaux's work presented: reading its forms, its treatment of the body, as a vehicle of Dante's final unspeakable meaning. The difficulty was widespread. When the group went on show at the Salon of 1863, the professional critics faced the same problem. Carpeaux apparently anticipated it; he showed the group buffered by marble versions of the *Jeune Pêcheur* and his bust of Princess Mathilde. Some critics took refuge in the grace of the one and the dignity of the other in order to allot a measure of the praise Carpeaux seemed to demand. When the *Ugolin* was discussed—and it was sensational enough to warrant an extensive treatment—critics seemed to shy away from naming what it showed.[138] Georges Dumesnil came closest to citing Dante's text, but even he backed away from reproducing the key section. He gives only the narrator's words verbatim: for Ugolino's speech he substitutes, "Et la tête se met à raconter on sait quelle agonie! et avec quelles couleurs!" He assumes that Dante's passage is too familiar, too horrific, to warrant retelling. And other critics tacitly agree. This is not to say they cannot praise the work, as do Chesneau and Castagnary; both recognize in it a new hope, a new epoch for sculpture.

The striking thing about most critiques of *Ugolin et ses fils* is the way they avoid naming what the work represents, yet nonetheless cannot avoid expressing anxieties about the body, about the way this unnameable expression is achieved. In the *Gazette des Beaux-Arts* Paul Mantz worried openly that the work was "inexpressive, or at least not as expressive as it should be for those who know the sinister story Dante recounted. The gesture of the starving man who lifts his fingers to his dry lips is hardly admissible in sculpture. It is more bizarre than rational." In *Le Correspondant* Claude Vignon fixed on the "thin" and "starving" figures as the focus of her remarks; for her they added up to an impoverished anatomy. For Georges Lafenestre, what was remarkable was the strange, anti-sculptural clenching of Ugolino's head, hands, feet, and mouth. It was the *extremity* of all these forms that seemed so striking: words like *stiff* or *mechanical* or *tortured* asserted themselves almost automatically. Their use seems entirely appropriate to the sculpture—until we remember just how damning these criteria were for an art usually measured by the index of the noble and the elevated.

172

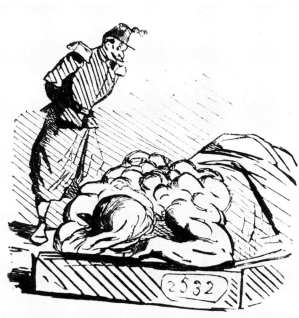

La bataille des omoplates gagnée par M. Préault.

172. Cham, caricature of *Ugolin et ses fils*, 1863, wood engraving. *Le Charivari*, 1863.

173. Bertall, caricature of *Ugolin et ses fils*, 1863, wood engraving. *Le Journal Amusant*, 1863.

174. Cham, caricature of Préault's *Hecuba*, 1863, wood engraving. *Le Charivari*, 1863.

In the light of those standards, it is perhaps less surprising that no critic asserted that Carpeaux had found a way to convey the violence and horror of Dante's text. Doing so would have meant discussing the implications of the various kinds of violence Carpeaux does to the male form. It would have demanded pinning down, in relation to the text, the connotations of a musculature identified as "thin" or "clenching," or hands which "clutch" or a mouth that "gapes." It would have meant taking them as signs, not errors, and this no critic, even an admiring one, was prepared to do.

Except the caricaturists, that is. As usual, Bertall and Cham stood ready to pronounce the unspeakable in terms as clear as their medium would allow. They had to be sparked by some hint of notoriety, it is true, but the *Ugolin* offered more than a hint. (When Vignon wrote that she was "neither surprised, nor moved, nor conquered" by the group, it was because others declared they were all three.) Both cartoonists fixed on the key aspect of Ugolino, his cannibalism, and found different ways to show how Carpeaux's group conveyed it. Cham's Ugolino has a gaping mouth because he is inserting his false teeth before tucking in; his expression is the mechanical grimace of dentures too big to fit (fig. 172). Cham took the point of Ugolino's gesture, and he noticed the unnatural profusion of limbs in the rest of the sculpture. Yet some of his jabs seem, in retrospect, almost like concessions to the Académie. His prisoners are properly skinny, after all, appropriately starved, and decently clad in modest trunks. He turns them back into people begging to be spared, while Bertall takes the opposite route (fig. 173). His figures are mostly stiff geometry, a frozen representation of Carpeaux's angular composition. The grimace is equally mechanical, but it is there to show that Ugolino is a cannibal, presiding at a "family meal" he will swallow whole.[139]

The apparent preoccupation with anatomy in *Ugolin et ses fils* is the place to begin to conclude this chapter. Anatomy—the body—was the vehicle for Carpeaux's challenge to sculpture, and it was the choice of that vehicle that made his challenge impossible to ignore. It came from *within* sculpture itself, from within the skills and talents of sculptural representation which the Académie acknowledged as its own. Correctness in the academic sense— the representation of nobility or truth—was contingent on the proper degree of resem-

blance to a corrected nature. Carpeaux's work was inescapably, evidently, studied from nature, though it did not end with such study alone. It was exaggerated *out* of that beginning, away from nature, and on such exaggeration communication hinged. Carpeaux no longer treated the body as an *index* to characterological equivalents; instead it became a compendium of attitudes, suggestions, and metaphors.

But because the metaphors were couched in such recognizable terms—in terms of the body—they stayed admissible, if not entirely discussable. They could provoke the worried, anxious reactions I have cited. It was important that such discussion stayed fluid, so to speak; that is, it flowed around Carpeaux, rather than backing up into the pools of ridicule which greeted Préault the same year. In 1863 Préault sent a *Hecuba* to the Salon. Once again this strange, great artist provided an example of what not to do in sculpture, and how not to do it; and it is important for my purposes that his example points to the limits placed on the liberties that could be taken with anatomy. The statue does not survive, alas, but we have the evidence of Paul Mantz, if we wish to reconstruct it: "Préault . . . is outside the eternal conditions of sculpture, an art with all the rights in the world except, however, to make an abstraction from humanity. Hecuba can roll on the ground and double up in convulsions, but she must still remain a woman. . . . Préault has tortured his lines, exaggerated proportions, dug deep holes, lengthened and shortened limbs for a certain effect of decoration and color—in short, he has treated the human form like an arabesque, sculpted a thing and not a person, and in so removing himself from reality and life, he has bypassed drama, which can never exist where man is not."[140]

In 1863 *Hecuba* appeared to do such violence to the body that communication ceased: it is no wonder the work was caricatured as a pile of lumps (fig. 174). Against such extremism, Carpeaux's group looked "challenging"—something to take sides over but not to reject completely. It is one thing to say that a work represents a non-sculptural subject, and another to declare it is not sculpture at all. *Ugolin et ses fils* is proudly, insistently sculpture, in a way which proposes its own definition of the term. The validity of Carpeaux's conception was debated, not its very existence. The point is a delicate one. Carpeaux's new conception *was* attacked, after all, and the sculptor almost did not survive the formal transition from student to artist. Unlike Perraud, he could rejoice in a state commission, but that award was initially granted with the proviso that the composition be modified before casting, apparently to return it to a more familiar conception.[141] At the insistence of Carpeaux's supporters, the stipulation was soon enough relaxed, though not before one critic reported approvingly that the government had refused the work point blank.[142]

For Carpeaux's career, it was initially more important that censorship was defeated than that it was attempted. The *homme d'Ugolin* was finally launched, and the honors and successes of the next several years can be charged up as profit to his impact in 1863. Notoriety at first helped to muffle Carpeaux's challenge to sculpture, but it would not stay quiet for long.

174

III. Jean-Baptiste Carpeaux, *Ugolin et ses fils*, detail of Ugolino's back.

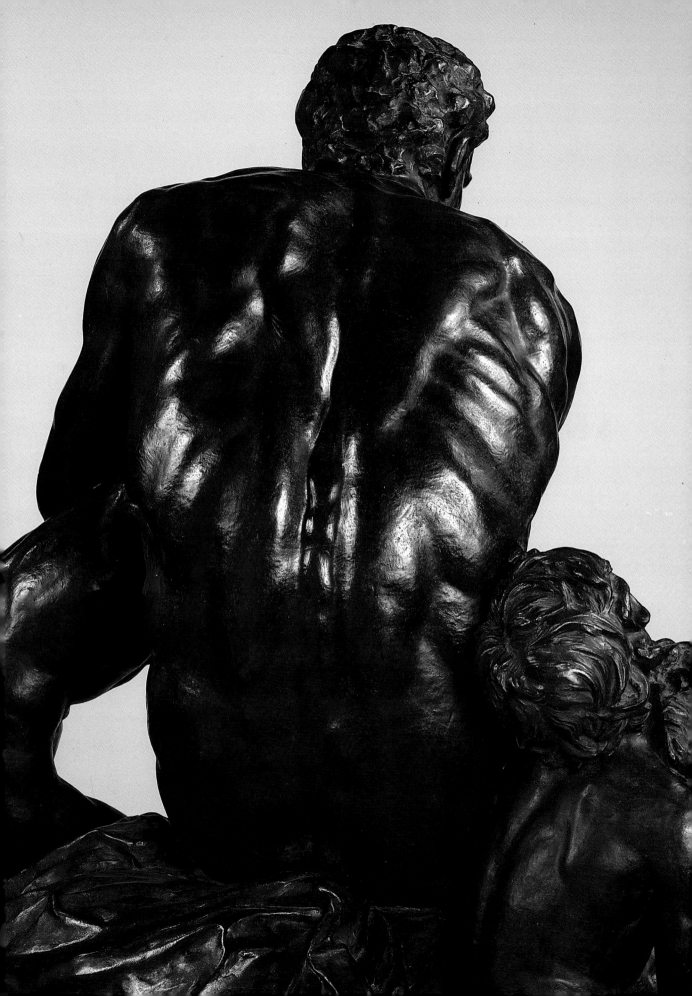

CHAPTER FIVE

ART AND PROPERTY

In November 1864, Carpeaux was a guest at the château of Compiègne. To his delight and trepidation, he had landed an invitation to an imperial *série*, one of the grand, fortnight-long house parties periodically staged at the residence appropriate to the season. By all accounts this gathering, the annual celebration of Eugénie's birthday, was particularly festive, but the artist was the first to admit his discomfort in that glittering, still unfamiliar courtly milieu.[1] A few words from the Empress were enough to touch off waves of vertigo, and worse, he didn't hunt. While the other guests seemed totally absorbed in the pleasures of the *fête impériale*, Carpeaux was intent on business. He was after the chance to model Eugénie's portrait. A stream of letters to relatives and friends recorded the fluctuations of his spirits as he maneuvered to secure his goal: "What joy and good fortune, my friend!"[2] when he managed, despite his dizziness and the stares of "thousands" of curious eyes, to express his hopes to the sovereign; "I feel the blow terribly," when she was too tired to pose.[3] And when finally she rejected the idea completely, a new plan substituted itself: "I am going to ask the Empress to let me make the bust of the little Prince Impérial, I think he has the time; he who asks nothing, has nothing; I will try."[4] The imperial couple both accepted the idea of a portrait of their son, and the Emperor even suggested that a likeness "en pied" be executed simultaneously. Carpeaux, not surprisingly, was elated at the reward his persistence had won. The commission was "an entrée to their majesties,"[5] he wrote, whose prestige promised to bring the thirty-seven year old artist the portrait busts and state commands which would solidify his growing reputation.

Work proceeded smoothly. By early May, 1865, the statue was well advanced and the bust completed. Eugénie viewed and approved them in the atelier installed for the artist in the Orangérie of the Tuileries gardens, and the Emperor gave his sanction after his return from Ajaccio in June. By mid-August the life-size portrait, for which the bust had served as a preparatory study, was finished.[6] That fall, preparations were begun for its execution in marble (figs. 175–79).

So far, these events seem perfectly predictable, a familiar chapter in the annals of official portraiture. According to pattern, the saga should end here, with the marble completed, the sculptor paid off, perhaps a few copies commissioned for provincial *mairies*. Not so. With the termination of the first plaster models of bust and statue, the commercial life of Carpeaux's portraits of the Prince Impérial was just beginning. In the eyes of both artist and patron, the sculptures seemed ripe for exploitation as art, as property, and as propaganda. This chapter gives an account of that exploitation; it tells a story of speculation, miscalculation, and misreading, of risk and failure in several markets—a story which, because of the image and objects involved, portraits of the Emperor's son, must be read

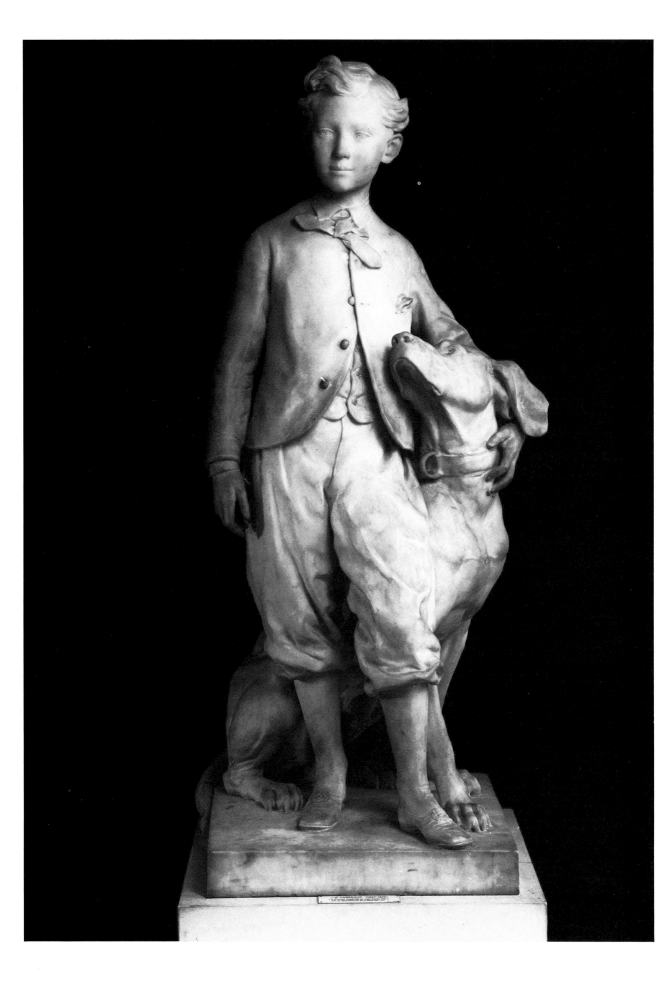

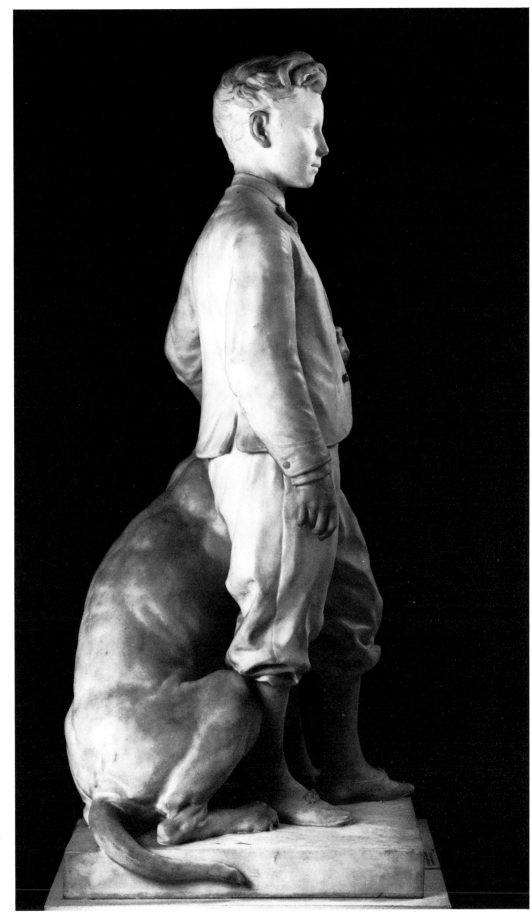

175–76. Jean-Baptiste Carpeaux, *Le Prince Impérial et son chien Néro*, 1867, marble; from model of 1866 (h. 140.2). Musée d'Orsay, Paris.

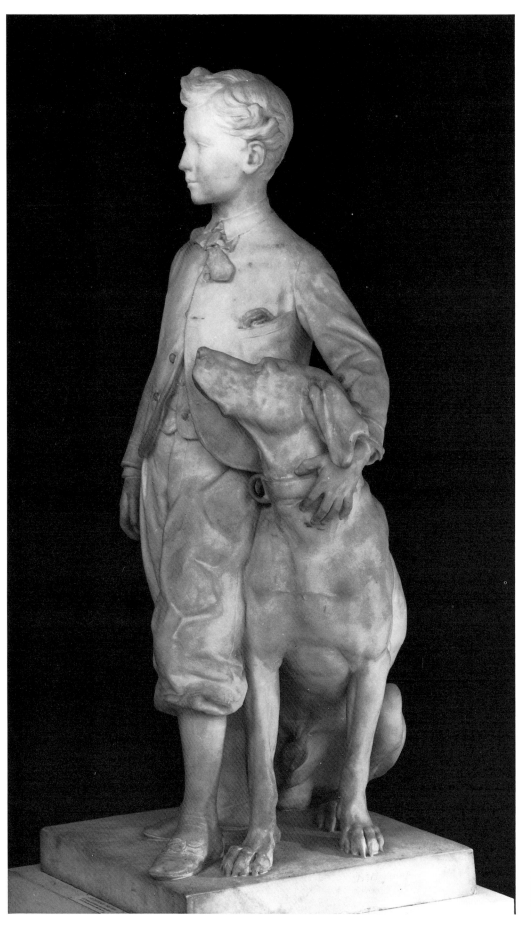

177–78. Jean-Baptiste
Carpeaux, *Le Prince
Impérial et son chien
Néro.*

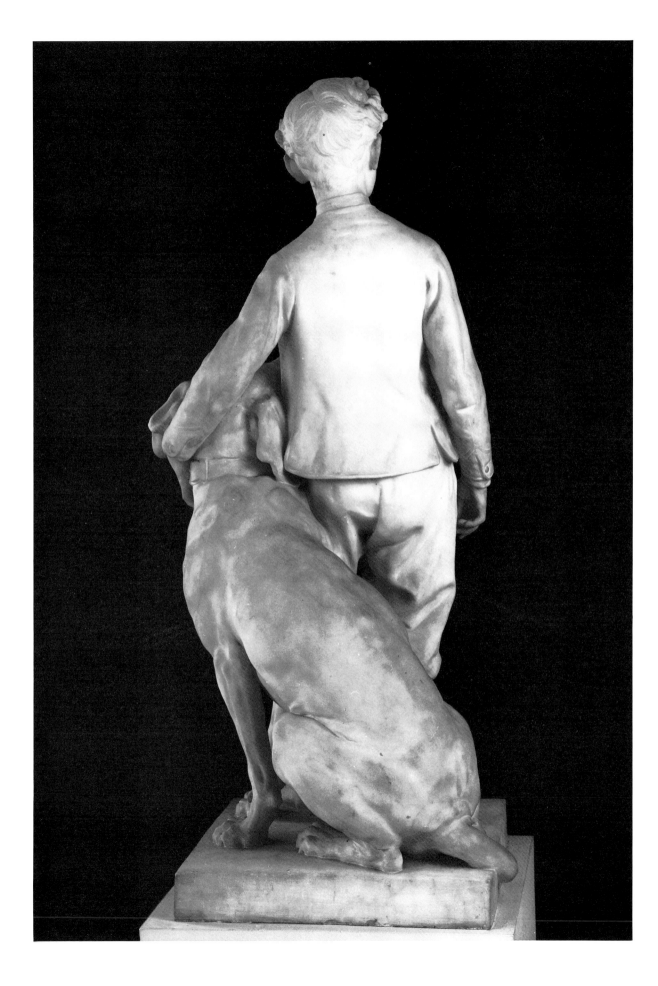

in terms of the dynastic ambitions and failing fortunes of Napoléon III. But it presents another subject as well, an account of the sculptor as tactician and entrepreneur, who tries to adopt the strategies for success which an imperial government and a capitalist economy seem to demand. To some contemporary critics, Carpeaux's intentions were transparent: by 1866 they placed the sculptor at the head of the "partie officielle", where membership meant a kind of compliance. Its symptoms were success in the state art education system and alliance with the imperial family.[7] The label fits the facts of Carpeaux's career, yet it does not adequately describe his sculpture. One of his portraits of the Prince Impérial, the statue *en pied* known as the *Prince Impérial et son chien Néro*, could not easily be read within the terms of "standard official" portraiture, and for that reason many critics avoided discussing it. Their refusal signalled their rejection of the work and that rejection in turn is symptomatic of the peculiar ambiguities and complexities — we might say "originality" — of the image itself.

I have sorted this account into two separate parts; their interrelationship will be obvious. For the sake of clarity I have found it convenient first to discuss Carpeaux's conception of imperial imagery, the modifications that concept undergoes in his portraits of the Prince Impérial, and the significance of critics' reactions to the works. The second section treats the portraits as property, spelling out in necessary detail the financial history of the works in order to define both this aspect of Carpeaux's uneasy exploitation of his art as a marketable commodity, and the mutually manipulatory relationship between artist and government which that exploitation produced.

It should be clear from the outset, however, that these topics are only artificially separable, as Carpeaux well knew. For him art was property: he saw not only their equivalence in an intellectual sense but also the commercial potential of that relationship, and set about exploiting it by means of an evolving business operation which culminated, in the words of Jacques de Caso, in "a unique example of undisguised commercialization."[8] The marketing of the Prince Impérial portraits is a crucial stage in that development, but it is only one aspect of a larger phenomenon. Carpeaux's entire career is characterized as much by his attempts to capitalize on his art as by any developing sculptural style. Those efforts went towards transforming the finite conception of artistic production within which he first operated, whereby the artist transfers ownership of an object or model to a purchaser on receipt of a flat fee, to a notion of artist as *rentier*, periodically collecting returns over time from a model in which he retains a partial interest or owns outright.

Specific transactions and commissions give the evidence of this transformation. Its end point was the studio Carpeaux had built on a plot of land in the expanding suburb of Auteuil, a property he purchased from the city of Paris. By 1875 it housed an established business, with at least twenty-five employees, its own workshop rules and business cards, identifying stamps and international sales.[9] It was well enough rooted, moreover, to survive the artist's death and the ensuing disputes over his legacy.[10] By 1878 a new price sheet had been prepared and, though no longer strictly classed as art, its products were making a brave enough show in the Salle des Céramiques at the Exposition Universelle, under the banner of the sculptor and the direction of his widow (fig. 180).[11]

Yet the Auteuil studio can be said to have been years in the making. From the models sold to the porcelain manufacturer Michel Aaron some thirty years before, Carpeaux progressed (in a manner of speaking) to a contract, in 1855, with the founder Victor Paillard, to share profits from a commercial edition of a model the sculptor would provide.[12] The contract had no issue, but its abortion did not deaden Carpeaux's interest in business. French law secured a sculptor's exclusive right to reproduce his work as he saw fit.[13] When

180

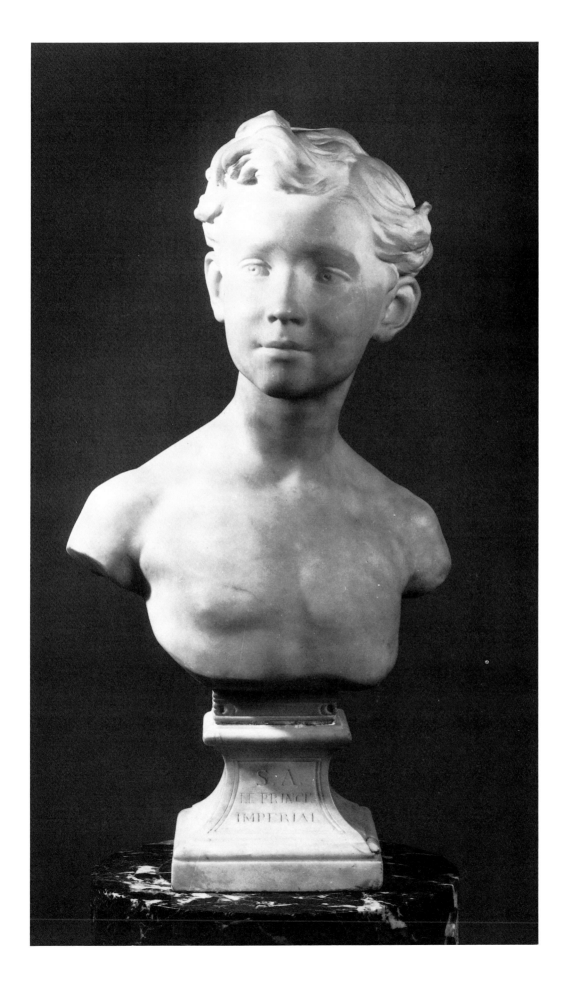

in 1859 Carpeaux lowered his price for the *Jeune Pêcheur* in order to retain that right, he showed himself fully conversant with the law and ready to gamble in order to take advantage of its provisions.[14] And in 1863 he began to try to make the risk pay off. He ordered a model for a reduced version of the *Pêcheur* from the firm of F. Barbedienne, which specialized in small-scale editions, and then had five examples cast at the foundry owned by Victor Thiébaut, where, through no coincidence, the huge bronze *Ugolin* destined for the Tuileries had been produced that same year.[15]

Admittedly these few small bronzes make for a rather tentative beginning to the business of commercialization; at this stage in his operation Carpeaux relied on the capital of the individual founders he used, purchasing bronzes for resale rather than setting up to produce them himself, as he would a few years later. In fact at this moment Carpeaux was effectively subsidized by Thiébaut. Before 1863 the sculptor did not maintain a running account with the foundry. Their infrequent dealings were regulated on a cash-and-carry basis, with each individual cast produced and paid for soon after. From 1863, however, business was on a different footing. With the *Ugolin* Carpeaux had handed the foundry a major piece of business, a 15,000 franc commission. But Thiébaut's records for 1863 show a payment of only 6,000 francs, some 10,000 less than the year's total charges. Carpeaux had credit, in other words, and he used it. The new arrangement was not entirely beneficial to either party: Carpeaux's bill climbed as interest was added to the total, while Thiébaut, needless to say, went unpaid. (The bill had still not been settled six years after the sculptor's death.)[16]

Carpeaux's dealings with Thiébaut provide more than a context for the *Prince Impérial* editions. They open a set of problems common to all aspects and stages of Carpeaux's

180. Photograph of the display of the Carpeaux atelier, Salle des Céramiques, Exposition Universelle, 1878.

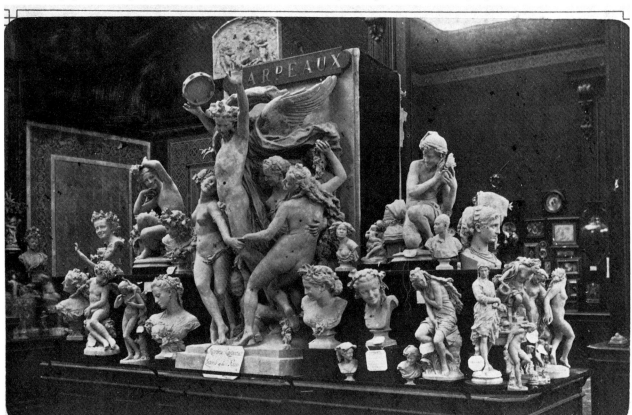

SALLE DE CÉRAMIQUE (FRANCE)

commercial operation. These questions are treated at length in the pages that follow, yet the same points might be made using other examples. There is first of all the problem of *how* to constitute one's art as property: what makes a work marketable? Carpeaux's decision about the *Jeune Pêcheur* in 1863 must have rested as much on his sense of the currency of his name as on his confidence in his imagery. Yet opinions on such a crucial matter as marketability were often sharply divided. In 1869, for example, the artist received entirely contradictory advice concerning the saleability of the crouching *Flore*, were it to be extracted from its context—Carpeaux's decorative ensemble for the Pavillon de Flore— and presented at smaller scale. The usually astute Barbedienne maintained that it was entirely unsuitable as an independent work since it was designed for a radically different purpose.[17] At virtually the same moment a bookkeeper was assessing Carpeaux's accounts and urging greater commitment to commercial versions, including "even the *Flore*."[18] Carpeaux may have been seduced by the returns his advisor promised from expansion; in any event the sculptor followed his advice, and devised ways to turn this and other public architectural ensembles into private, decorative, potentially profitable sculptures. Proprietorship meant weighing public appeal. In the end the sculptor produced a remarkably homogenous collection of busts and figures, "always smiling that fixed smile of hilarious statues," in James's phrase.[19] Rightly or wrongly these works have been taken to represent Carpeaux, to characterize his art as a whole: "The smile in marble was Carpeaux's speciality."[20] They certainly demonstrate his conception of public taste.

Proprietorship meant other things as well, chief among them overseeing the physical work of the studio: planning its economy, foreseeing its arrangements. These tasks combined artistic and administrative concerns; for Carpeaux they were both a preoccupation and a burden. In the 1860s, for example, his lists (not quite automatic writing, but at least as revealing) become increasingly weighted with reminders having to do with the business of art: "send cards to Barbedienne for the sale at the Hôtel Drouot—summon the *metteur aux points*—begin marble negress—reduction in two proportions—consider the busts, have them reduced by half—cast: *Palombella, Modestie, L'Espérance*—reduce *L'Espiègle* . . ."[21] And so on.

Carpeaux appointed a series of atelier supervisors to absorb at least some of these responsibilities. His brother Emile worked for him first in the mid–1860s, and then again briefly in 1873. He was succeeded by M. Meynier, who was followed in turn by Cyrille Lamy. Carpeaux's second contract with Emile survives; its terms are revealing in the careful way they distribute duties between supervisor and sculptor. In accepting direction of the studio, Emile undertook, in Carpeaux's absence, "to supervise fabrication, to receive commissions, to take charge of deliveries and receive payments, to organize and stock warehouses and exhibitions in the French *départements* and abroad." Carpeaux reserved for himself exclusively "the designation of works to be reproduced, their number, and the location of exhibitions and warehouses."[22] The contract with Lamy lists the same kinds of tasks, while Meynier, who had developed a machine for reproducing works in marble, had more expertise to offer and consequently assumed more responsibility.[23] But whatever the stipulations governing these individual relationships, Carpeaux was still the *patron*, still the owner of an operation which he struggled to control even in the last years of his life, when illness and equally debilitating family troubles kept him away from Auteuil. His letters to supervisors and *praticiens* alike are liberally laced with technical instructions: Carpeaux gave advice about how to conceal mold lines and directions for cutting free the marble supports on *Napoléon III*'s mustaches.[24] Occasionally there was an abrupt "Finish it as you see fit."[25] An 1874 letter to Meynier is even sharper in tone.[26] Carpeaux had discovered that

unauthorized examples of his portrait of the ballerina Eugénie Fiocre were being produced behind his back. A brief lecture on property rights ensued: permission for reproduction, such as that ceded by Gérôme, Dumas, and Gounod (whose busts Carpeaux had modelled), had to be granted before an edition could be sold. But sometimes it was Meynier who pointed out that Carpeaux's rights had been violated: in 1874 he announced that a pirated bronze version of the *Jeune Pêcheur*, with no studio marks, was on sale at Bon Marché.[27]

These are the themes which must dominate any study of art and property. How does an artist construe the relationship between the two categories? What boundaries does he place between them? What makes a work of art marketable? How does the producer attempt to guarantee a work's continued viability as a commodity? These questions are the more pressing in Carpeaux's case because of his credentials as an artist and the relative anomaly of his commercial enterprise. For years the Académie had been intoning its anti-commercial credo at artists of equivalent stature. If some bent the rules, occasionally selling the model of a Salon success for reproduction by a foundry, none distorted them as violently as did Carpeaux. His artistic credentials distinguished his business activity from that of contemporaries like Clésinger or Carrier-Belleuse, from whom less was expected. Clésinger's legal quarrels with Barbedienne about the authorship of his many edited works only continued his longstanding notoriety, but his years of residence in Italy meant that official works were automatically precluded.[28] Carrier-Belleuse, despite his obvious artistic brilliance, for many years remained in some critics' eyes a cut below the greatest sculptors just because of his commercial involvement.[29] Carpeaux won public commissions of a magnitude to which neither Clésinger nor Carrier-Belleuse apparently aspired, yet, paradoxically, commissions accumulated while his commercial enterprise was expanding. By the early 1870s, which saw his sculpture exhibited and auctioned in Europe's major cities, something like one-quarter of the objects offered had been reworked from architectural ensembles, and this in a context where the total number of pieces for sale was grossly expanded by the inclusion of multiple versions, in different sizes and media, of the same composition.[30]

In any case, whether a commercial sculpture was salvaged from a commission or designed expressly for replication and sale, Carpeaux was willfully eroding the uniqueness of his art and propelling it towards another concept of authenticity, one whose guarantees were the stamps, seals, numbers, and signatures pressed or chased into the surface of every piece taken from the mold (figs. 181–82). These emblems were aimed at the collector, of course, but there are ways in which Carpeaux's use of the market had less to do with the consumer than with his own view of art *as property*. Reproducing his works meant recuperating them for himself: removing them from the private or official spaces of the patronage relation

181. Atelier stamp: PROPRIÉTÉ CARPEAUX.

182. Atelier stamp: ATELIER DEPOT 77 RUE BOILEAU AUTEUIL PARIS.

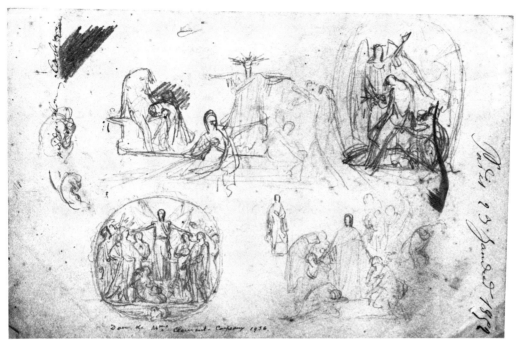

183. Jean-Baptiste Carpeaux, *Studies for Bas-reliefs*, 1852, pencil on paper. Musée des Beaux-Arts, Valenciennes.

and entering them into a new context, the market, a territory which he thereby claimed as his own milieu. This is a process which seems to demand a variation on Walter Benjamin's axiom: "The technique of reproduction detaches the reproduced object from the domain of tradition."[31] The first effect of reproduction is certainly more immediate, less global: the work of art is detached from the sphere of ownership and control and entered into an arena where other rules—we might say use values—apply.

Yet the detachment could never be entirely clean, absolutely surgical. Shreds of the old "artistic" identity of an object always clung to the new version, staining it with the old connotations. This was certainly the case with Carpeaux's portraits of the Prince Impérial. In the end the two conditions exist in a causative and uncontrollable relationship, as I hope to prove.

ART

Carpeaux knew the rules of imperial portraiture. His bust and statue of young Eugène-Louis-Jean-Joseph Napoléon (1856–1879) were neither his first imperial portraits nor his first attempt to profit from the physiognomy and public identity of France's ruling family. Early in his career the artist, convinced that success could best be won with imagery supporting the authority of Louis Napoléon, began to work out what form that imagery might take. A first idea, a drawing for a medallion (fig. 183),[32] presented the ruler as the agent of peace and restorer of order—although the coup d'état of December 2, 1851, met with armed resistance in Paris and the provinces, and although some 26,000 people suffered government reprisal for their opposition to the overthrow of the existing republican constitution.[33] Carpeaux's image, roughed out in the lower left corner of a piece of writing paper dated "le 23 janvier 1852," would have made good publicity for a regime trying to ride out the rebellion it had sparked; the sketch is a visual formulation of the Prince

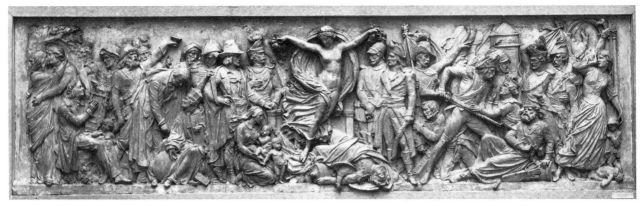

184. Jean-Baptiste Carpeaux, *La Sainte Alliance des Peuples*, 1848–49, plaster (99 × 360). Musée des Beaux-Arts, Valenciennes.

President's message as he toured France on his ritual pacificatory travels of 1852: "L'Empire, c'est la Paix." If the sentiment is simplistic, so is Carpeaux's drawing, both in its stock emblematic legibility and in the mental process which produced it. The artist simply adopted the scheme of the central portion of the republican relief *La Sainte Alliance des peuples* (fig. 184), which he had modelled in 1848–49 for a friend, the Valenciennes lawyer Foucart.[34] In plugging in the new president in place of Peace, Carpeaux transformed the composition from a representation of international brotherhood—his imagery is outlined by one of Béranger's songs—to an emblem of the civic order the new regime had promised. The equation, needless to say, is facile, a handy expedient for a young artist casting around for a pro-Bonaparte motif.

When, less than a year later, Carpeaux actually sculpted an imperial theme, his choice of subject and means of representation were more sophisticated, if no less propagandizing, than this first idea. Rather than allegory, his genre was history. He chose to commemorate Napoléon III's reception of the valiant Arab chieftain Abd el-Kader at the palace in Saint Cloud, which took place on October 30, 1852. Two weeks earlier the Emperor had visited the emir at Amboise to free him from the confinement in which he had been held for five years. Abd el-Kader paid a formal visit of thanks to his liberator, which Carpeaux

185. Jean Baptiste Carpeaux, *L'Empereur reçoit Abd el-Kader au palais de Saint Cloud*, model, 1852–53, marble (155 × 298). Musée des Beaux-Arts, Valenciennes.

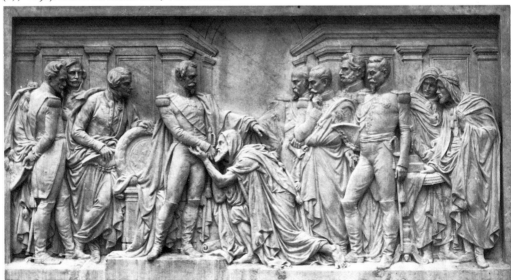

186

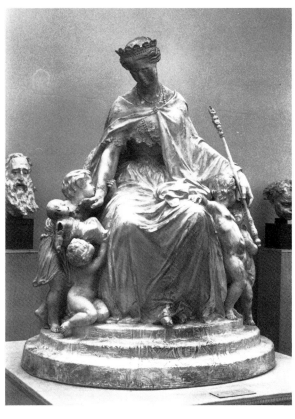

represented with all the measured magnitude that had become the formula of nineteenth-century historical relief (fig. 185). The composition is meant to communicate the magnanimity of a ruler who, in contrast to his Orléans predecessor, used his power to liberate rather than to imprison—exactly the message Napoléon III intended when he set the heroic Arab free.[35] The Emperor's gesture as he receives the kneeling Abd el-Kader (who stands as an equal in other representations of the scene) translates easily for the viewer into the qualities of character, like generosity and nobility, we are meant to assign him. The two figures recall the central group of Gros's canvas *Napoleon at the Pest House of Jaffa* (Carpeaux copied sections of the canvas several times from the beginning of his career).[36] The reference is a direct, apposite invocation of another "royal touch," which summons with it the powerful Bonapartist sentiments whose force Napoléon III wished to tap.

Despite its subject—or perhaps because of it—the relief attracted little attention in the Salon of 1853. There is Nadar's stinging exhortation, "Plus fort, M. Carpeaux!"[37] But, as in the following decade, Carpeaux chose his subjects to attract imperial patronage rather than critical recognition, and it too was not immediately forthcoming. Only after desperate, half-comic machinations did Carpeaux succeed, quite literally, in putting himself and a version of the sculpture in the Emperor's path and finally landing a commission.[38]

But even while working on the Abd el-Kader relief, Carpeaux had begun a group, *L'Impératrice Eugénie protégeant les orphelins et les arts* (fig. 186), meant to capitalize on Eugénie's image as the benefactress of the poor. Official propaganda had cultivated that identity for the young woman from the moment printed broadsides presented her to the nation as Napoléon III's intended bride. The population was promised: "In her the unfortunate will find a mother, the talented and enlightened a protectress. In the history of the Bonapartes, moreover, women have been specially marked by a goodness and charity which distinguishes them."[39] Carpeaux's group takes its program from exactly such a manu-

factured image, because he evidently trusted that there was a market for a sculpted representation of Eugénie the philanthropist. This is the work he hoped to edit commercially in collaboration with the founder Victor Paillard; in 1855 the two men contracted to split any profits from its sale.[40]

Carpeaux's determined pursuit in 1864 of another imperial portrait commission was motivated by the same confidence which had dictated his actions and directed his art a decade before: the sculptor trusted that success depended on imperial patronage and that a sculpted imperial imagery was a commodity saleable in several markets. The portraits of the Prince Impérial combined the possibilities individually presented by the Abd el-Kader relief and the Eugénie group, with one important difference. The Prince's portraits were made to order, not executed on speculation and offered for sale as finished products. The two early works, by contrast, were calculated to appeal to the taste of a market as Carpeaux conceived it. In both cases that conception decided sculpted form, and the stylistic differences between the works reveal his separate understanding of each market. The *Abd el-Kader* is based on ideas learned at school, in the competitions which made up the curriculum of the Ecole des Beaux-Arts. As historical relief, Salon sculpture, and a potential government purchase, it concedes to the dominant rule of the hierarchy of genres which governed stylistic modes. Carpeaux geared himself for the "elevated" inflection this market demanded with a series of quick pencil sketches after antique statues, notebook jottings which seize poses and proportions of figures with one arm outstretched or joining hands. The series culminated in a first attempt to describe the two interrelated figures of Emperor and chieftain in terms set out by the statuary the artist had been examining (figs. 187–88).[41] This kind of study of relevant models contrasts with surviving drawings related to the Eugénie group. Small in scale, somewhat hesitant, these make careful notes of details of imperial regalia, like the bees decorating the Empress's throne or the intricate ornament of the scepter she holds.[42] The trappings of rule rather than the features of the ruler dominate the work, because it is the fact of rule which is most important. Eugénie is not presented as an individual personality but as an imperial emblem generalized into an easily identifiable image of munificence, whose meaning is clarified through its relationship to traditional representations of Charity. The figural vocabulary, however—a mannered anatomy of boneless tapering forms for the Empress and exaggerated curves and rolls of flesh for the putti—is that of other commercially produced images, like romantic lithographs and small-scale bronzes of the two previous decades.

But as portraits commissioned directly by the client, Carpeaux's sculptures of the Prince Impérial did not depend on the artist's isolated conception of his market, but on direct contact with the purchaser. The client could specify the qualities he wished his purchase

187. Jean-Baptiste Carpeaux, *Study of Classical Statuary*, c. 1853, pencil on white paper (6.5 × 11.5). Musée des Beaux-Arts, Valenciennes.

188. Jean-Baptiste Carpeaux, *Study of the central group for the Abd el-Kader relief*, 1853, pencil on paper (6.5 × 11.5). Musée des Beaux-Arts, Valenciennes.

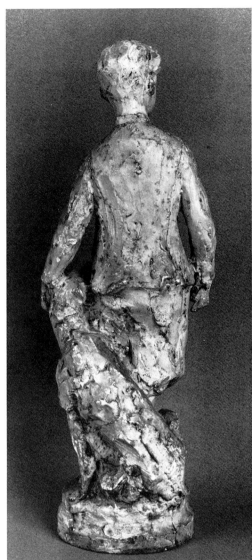

189-90. Jean-Baptiste Carpeaux, *Le Prince Impérial et son chien Néro*, sketch model, 1865, plaster (h. 43.8). Musée d'Orsay, Paris.

to have and reserve payment on condition of satisfactory delivery. The nervous tone of Carpeaux's letters during the spring of 1865, as he waited for Eugénie's visit to his Tuileries atelier, indicates that such a possibility was not far from his mind.[43] Unlike his earlier representations of the imperial family, these were portraits executed from a posed model (either the prince or the boy who sometimes filled in for him). As such, both bust and statue were expected to provide a vivid resemblance to their subject. In keeping with Carpeaux's customary portrait technique, the likeness was worked up at full scale, the artist modelling directly from the sitter, rather than in preliminary clay studies. Thus the only known sketch model for the piece (figs. 189-90) simply aims to suggest the general massing and interrelationships of the pose, but does not define the final solution. Similarly, the drawings which Carpeaux made at this time do not examine the subject's physiognomy. Rather they see the prince in silhouette, his features hidden, as an awkward little shape clad in the simple suit of short jacket and knee pants in which Carpeaux would sculpt him.[44] What the artist was after in these quick jottings was characteristic outline and action, evident in the contour and volume of the final piece. Both were as essential to the portrait

he was to produce as the poses and proportions of his museum studies were to the Abd el-Kader relief. The clients wanted a portrait which looked like their son. Carpeaux provided it (fig. 191).

At the same time, evidence suggests that a portrait which looked like a prince as well as a boy was specified at the outset, though whether by Carpeaux or the client or by both is hard to tell. Later in 1864 or early the next year Carpeaux wrote to a friend, "As you know, I have been entrusted by the Emperor with making not the bust of the Prince Impérial, which I told him I hoped to do, but a full-length statue to be cast in silver like the little Henri IV at the Louvre."[45] The standing portrait *was* eventually cast in silver patinated bronze and shown in the Salon of 1868, though not before plaster and marble versions had both been exhibited (in 1866 and 1867, respectively).[46] Inevitably, critics compared even those earlier, stark white examples of the work to Bosio's "petit Henri IV" (1824; Fig. 192) and to François Rude's portrait of the adolescent Louis XIII, cast in silver for the Duc de Luynes (payment completed 1843; fig. 193), as the two obvious nineteenth century prototypes for images of royal youth. Carpeaux certainly knew both precedents: his study with Rude had begun soon after the *Louis XIII* was finished; in the mid 1860s his interest in the *Henri IV* was serious enough to prompt him to sketch a copy in a pocket notebook.[47] But more important is the fact that before Carpeaux's statue was begun an image of royal childhood and royal destiny was being invoked as one possible pattern—a pattern to which the portrait would only partially conform.

Not that the communication of royal destiny was less important to the meaning of Carpeaux's statue than it was to these two precedents. But both Rude's and Bosio's statues are versions of ancestor portraits, commissioned to embody and emphasize the glorious lineage of their nineteenth-century owners, the Duc de Luynes and Charles X. The reigns of Henri IV and Louis XIII were historical fact. Rude and Bosio each had to invent an appropriate fictional childhood to match that fact and assign it a young body in which future greatness would be immanent. For Carpeaux, the problem was reversed. He was presented with the fact of a nine-year-old boy—the Emperor's son—a child whose right to the throne was contested and whose destiny, even without the advantages of hindsight, was in 1865 far from sure.

Exactly who he was, this nine-year-old, was in a way equally uncertain. His paternity was the issue, though not in the usual sense. The boy was the son of Napoléon III, and

191. Levitsky, photograph of the Imperial family, c. 1865. Bibliothèque Nationale, Paris.

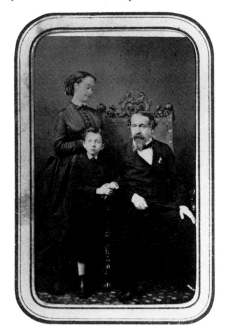

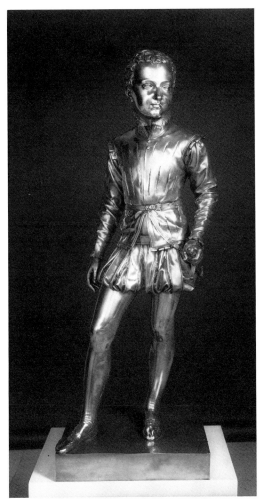

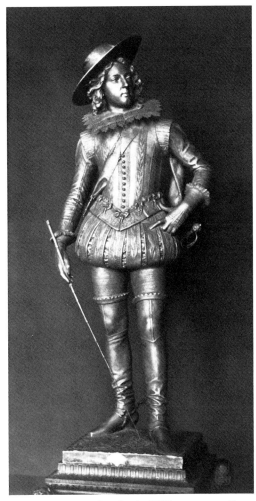

192. François-Joseph Bosio, *Henri IV enfant*, 1822–24, silver (h. 125). Musée du Louvre, Paris.

193. François Rude, *Louis XIII*, c. 1843, silver. Château de Dampierre.

his dual status as child and heir made him doubly dependent on his parent, and doubly valuable to him. If he was to inherit his father's name and throne, they would come entailed with the conflicts and confusions of the various contradictory roles—dictator, liberator, humanitarian, caesar, censor, bourgeois—its previous occupant had tried to play. Napoléon III had seized power under the aegis of a dynasty he intended to continue: the son would succeed the father, just as the nephew had replaced the uncle. It was the Emperor's name that announced his lineage, and argued his claim to rule:

> Louis Napoléon will take the name of Napoléon III. It is the name which resounded in the popular protests. . . . We did not choose it. We accept it as the product of an entirely naive and spontaneous choice. . . . It resolves the question of heredity for future years and signifies that the Empire will be hereditary after Louis Napoléon as it was for him."[48]

The new Emperor did not allow his family ambitions to rest on a name alone. The dynasty was made law by a senatorial decision of November 7, 1852, and the constitution modified accordingly. *La dignité impériale* was to pass patrilineally, by primogeniture, according to traditional French adherence to salic law.[49]

When less than three years later a boy was born, the celebrations were fit for a prince. A cannonade of 101 shots, the royal salute for a male heir, announced the birth and the

senate responded with a chorus of *Vive l'Empereur*.[50] Hundreds of thousands of francs were spent to mark the event. There were diamond medals and free shows; the imperial cradle alone cost more than 161,000 francs.[51] A machine was set in motion to create a Prince Impérial and present him to the populace. The child was the future, the assurance of continuity, and his public display as a living reminder of dynastic hopes began early. At six months he was dressed in military costume, strapped to a shetland pony, and led around the Tuileries courtyard. Later, on his daily rides to the Bois de Boulogne, he saluted the crowds that gathered along his route "with a gracious, though somewhat mechanical gesture."[52] While other future rulers, like the Prince of Wales, Victoria and Albert's Bertie, could barely escape a rigid schoolroom regimen packed tight with the hours of lessons his parents thought necessary to prepare a king,[53] young Louis—"Loulou"—was already being made useful awarding prizes and opening exhibitions. A personality was gradually built for the child. The military uniforms he was asked to wear emphasized (his father thought) his dependency on the army and his eventual place at its head. Called the "Enfant de France," he was given this name to "teach him what his duties are" (his father again). Since childish sayings were in fashion, "it was to be expected that the Prince should make speeches, or rather that they should be invented for him."[54] Popular journalists like Timothée Trimm of the *Petit Journal* visited the palace to scoop the latest bit of wit or wisdom from the boy's mouth. And in keeping with his public image, the witticisms which survive reveal the Prince's precocious knowledge of his Bonaparte heritage.[55]

How does this picture of packaged official childhood fit with Carpeaux's relaxed, informal portrait of a boy with a dog? Why is Louis not shown in the uniform of a pint-size grenadier, or, at the very least, with his simple suit embellished with some of the dozens of decorations awarded him by the governments of Europe and the Americas?[56] The question is the more pointed in view of the immediate precedents, Bosio's and Rude's statues, which Carpeaux knew. The answer, I think, is that the portrait responds to another aspect of the public image of the Prince Impérial, the side that let him be a boy, which repeated his sayings *as those of a child*, which allowed him playmates and games, which wanted to send him to *lycée* like other boys, but instead, because he was the Prince Impérial, had the *lycée* professors come to him. It is worth remembering here the terms in which the Emperor announced his impending marriage to Eugénie de Montijo. He was making a love match, the proclamation read, which was contracted outside the rules of aristocratic political alliances in order to satisfy personal desires.[57] The Bonapartes publicly espoused bourgeois values: the advantageous love match and the raising of children who are granted the pleasures of their particular estate even while a full measure of filial duty is exacted from them.

Winterhalter's portrait of the Prince of Wales as a sailor boy (fig. 194) responds to a similar conception of royal childhood—with one important difference. Albert Edward is given youthful bravado and directness, a rumpled, childish carelessness, but the picture remains a costume portrait. Bertie is dressing up, delighting his audience with his confidence in the charade. Carpeaux's portrait is a masquerade as well, but a more convincing one. It shows us a prince in mufti, whose costume is successful because it transforms his identity completely, yet plausibly. We can easily accept him in this new guise as a bourgeois boy with his pet, while we don't "believe" Bertie as a real sailor for a moment—nor are we meant to. The effect of the sculpture is likewise precisely calculated, but with calculation aimed to secure a subtle yet identifiable "naturalness" of pose. Critics found phrases like "boyish grace" and "youthful swagger" to describe it, and any period photographer would have tried desperately to get his sitters to strike such a nice balance between childish affec-

194. Franz-Xaver Winterhalter, *Albert, Prince of Wales*, oil on canvas. Royal Collection.

tion and canine devotion. The group is believable, as Carpeaux rendered it, because of the curious anonymity and restraint of his attention to the play of volume and surface and because of his articulation of differences in substance and weight. The only regularities he allowed are anatomical, in the full softness of the Prince's face, for example, or the twin whorls of the pelt on the dog's chest. The sculptor (and his *praticien*) avoided deep undercutting, rounded edges, and straight lines to render folds and volume. They pared and sliced and scraped the marble, shearing it away to leave a tissue of individual accident. Each feature tries to convince us that it is a specific, rather than a generalized incident. Each marble object stands in easily for its leather or cloth or living model, because the means and material which describe it do not carry a collection of associative meanings. There is detail in both Rude's and Bosio's figures, in folds of cloth or tight-drawn hose or miniature weaponry, for example, but such details are rendered with the precision of a fine piece of jewelry. Carefully modelled, cast, and chased, each statue is obviously an *objet de vertu*, the product of skilled work with precious stuff. Form asserts the worth of both object and subject in a way which the conscious neutrality of Carpeaux's handling avoids completely.

Although seemingly so simple, Carpeaux's portrait manages to embody an identity available in the public image of the Prince Impérial. Yet it does so not by presenting him in the obvious guise of dynastic heir and future Emperor, but by assigning him a secondary role, the child's part, which because of its basis in physical fact could seemingly not be challenged. An inadvertent status, childhood, becomes a privileged identity, and, intentionally or not, the work apparently could circumvent the opposition that a more straightforwardly "official" representation might have provoked. Potential criticism is deflected, replaced by a play for whatever sympathies and sentiments an image of a well brought up boy and his dog might stir in the adult bourgeois breast. Yet Louis's identity as Prince *is* still present, subordinated within the group even though it is no longer lodged in his person. His public status is displaced to an attribute, the faithful dog Néro. The animal's muscular body curves protectively around his young master—or, more properly speaking,

around his master's young son, since Néro was the Emperor's dog, the gift of the Russian ambassador. Néro stands in for the absent father, in a sense becomes him by analogy. His powerful scale defines the boy's bodily status, the small stature of his nine-year-old frame, and the dog's anxious devotion only emphasizes the worth of the child he worships.

It is easy to be convinced by Carpeaux's portrayal of childhood, by the unaggressive ease and sobriety he attributes to that state, and thus to overlook the fact that this message replaced the standard freight of symbol such statues were meant to carry. Carpeaux's portrait should say *more* about its subject; it should make its message obvious and easily legible, the way Auguste Clésinger did in his representation of the infant Prince (fig. 195). Like Carpeaux's Abd el-Kader relief, Clésinger's effort was work done on speculation, and sent from Italy to the Emperor in 1857, the year after the Prince's birth. The gamble paid off. The piece was placed on an upper landing in the Tuileries where Courbet, on trial for his part in the Commune, swore he had tried vainly to find it in 1871, "pour le mettre en lieu sûr."[58] The marble was a cliché of mythological portraiture. Nominally it represented the young Hercules, his body an incongruous mix of baby fat and manly muscle, in the act of strangling the two serpents which had threatened him and his mortal brother as they slept. But Courbet—and presumably Napoléon III—had no trouble in recognizing it as "the Prince Impérial slaying the hydra of anarchy." Mythology and classical nudity easily convey a message no conventional portrait could get across so economically, and Clésinger used them equally fruitfully in portraits of aristocratic children (fig. 196).

Works like these maintain a basic convention of the sculpted portrait, which commemorates people "for the ages" by presenting them in ageless guise. Carpeaux's portrait circumvents that convention to replace it with a different etiquette, one which defines a contemporary image of childhood as an equally valid field of reference. It is possible to

195. Auguste Clésinger, *Hercule enfant*, 1856–57, marble. Believed destroyed; reproduced from a photograph in the Musée des Arts Decoratifs, Paris.

196. Wood engraving after Auguste Clésinger, *Les Enfants de M. le Marquis de Las Marismas*, 1847, marble. Reproduced from *L'Illustration*, 1847.

197. Jules Franceschi, *Jeune Garçon*, 1868, marble. Musée National du Château de Compiègne.

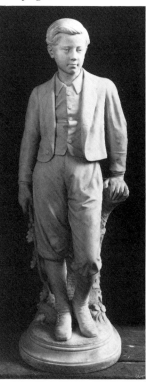

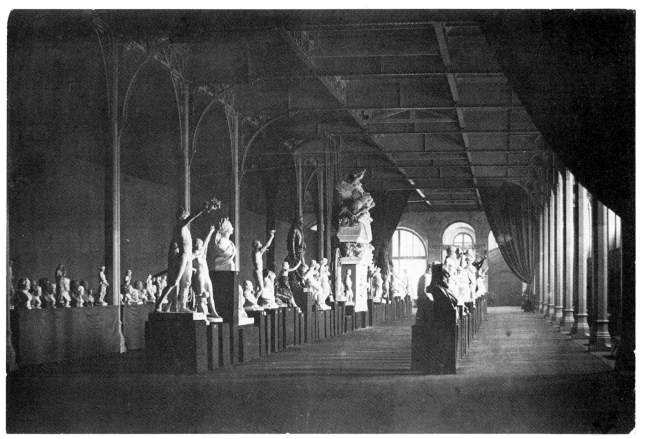

198. C. Micheloz, photograph of the sculpture installation in the Palais d'Industrie, Salon of 1866. Archives Nationales, Paris.

overlook that circumvention, I think, because the terms which it substitutes are today so familiar. The sculpted mythological portrait almost immediately gave way to the model Carpeaux's *Prince Impérial* established. He had portrayed a prince as a bourgeois boy. By 1868 two of his contemporaries, Jules Franceschi and Henri Chapu, had completed portraits which followed Carpeaux's lead to show bourgeois boys as princes (without the dog) (fig. 197). At a time when the conventions of mythological portraiture were finally exhausted, their use of Carpeaux's statue as a model was unexceptionable.

But what was possible in the portrait of a boy was not so easily acceptable in a representation of the Prince Impérial. In 1866, when Carpeaux exhibited the plaster model of his statue, it was hard to ignore the work. By then most critics agreed, some grudgingly, that despite his official connections the sculptor was the hope of a waning French school. His two Salon entries occupied a central place in that year's controversial indoor exhibition at the Palais de l'Industrie (fig. 198). The *Prince Impérial* stood almost on one axis of the installation, in the shadow of the colossal half-size model of Carpeaux's sculpted decoration for the exterior of the Pavillon de Flore—certainly the largest and one of the most notorious pieces exhibited that year. By rights, the portrait's placement, its subject, and its author's growing reputation should have won the usual buzz of popular attention and critical approval. But on the evidence of two different writers such attention—or at least approval—was denied. One passed the work off contemptuously: "The statue of the Prince Impérial, a plaster by M. Carpeaux, is more looked at than admired. It is a very empty work."[59] According to the other, Louis Auvray (like Carpeaux a native of Valenciennes and a trained sculptor), the public did not even bother to look at the work, and he took the critics' silence as one further symptom of the general indifference:

M. Carpeaux is of the modern school; he loves truth; he neither embellishes nor idealizes nature, he copies it; he is a realist in the good sense of the word. He wished to make a portrait that would be a naive likeness without worrying about the rank of the sitter, without caring for the prestige attached to the name he carries and the throne he is called to occupy. In fact nothing in his posture, in his expression, reveals the heir of Napoléon III, as Bosio and Rude certainly would have done. . . . Let us then not seek in this statue what is called an official portrait, but instead a portrait which is a really good likeness with an uncomplicated sentiment.[60]

It will be obvious that Auvray's thesis agrees in general terms with what I have described as the primary quality of the statue: he too suggests that Carpeaux's portrait substitutes naive realistic resemblance for official convention. The work therefore cannot be read in a traditional way by those who approach it with traditional preconceptions. The result is the refusal by many critics to discuss it at all, a refusal which Auvray implies is deliberate neglect of a work which should have received attention. And it does get left out of the *Salons* of important as well as incidental critics, writers like Charles Blanc, Théophile Thoré, and Maxime Du Camp. For Auvray, rightly enough, these omissions were as significant and irritating as any critical discussion would have been.

What Auvray did not mention was another tactic critics used, that of reading the work in terms of their preconceptions about imperial portraiture or the dynastic question, as if the customary conventions were still in force. Take this passage from a Salon pamphlet written by another native of northern France:

The statue of the Prince Impérial is modelled with the boldness and vigor which characterize the talent of M. Carpeaux; nonetheless beneath the apparent roughness of his chisel one sees exposed the distinction and finesse so manifestly diffused over the visage of France's Child. There is in this pose a slightly swaggering air redolent of a corporal in the grenadiers guards; yet at the same time there is that infinite sweetness and that supreme goodness which suggest the son of the Empress Eugénie.[61]

The text demonstrates a standard feature of criticism, expressed here in a commonplace enough way: rather than study a work or discuss it, the author locates it by applying a set of assumptions. They are clear in this passage: (1) the facial features of the Prince are distinguished and refined; (2) his bearing is that of a corporal in the grenadiers; (3) he possesses the sweetness and goodness of his mother. The passage strings together statements which are related, almost accidentally, to Carpeaux's work. They are legible there despite the "boldness," "vigor," or "roughness" which might well have obscured them to a less eager reader.

Assumptions can be presented more subtly, hidden in passages of description which work to pass them off as observations about form. That is the movement of this analysis by the little-known C. Beauvin which, though brief, is nonetheless representative:

The statue of the Prince Impérial resting one hand on his dog's neck breathes, through a play of fine, supple, elegant, svelte lines, a nobility and distinction such that, despite the familiar simplicity of the attitude, one would recognize in him the child destined to rule.[62]

The pattern is standard—entirely unmindful of the contradiction at its core—and the eminent Théophile Gautier's observations on the sculpture unroll in exactly the same order: from an approving description, first of pose and then of Carpeaux's treatment of modern

costume, he moves smoothly to comments on the child's future and masks them behind description, just as the phrase "the child destined to rule" was screened in the passage above. In fact the two begin in strikingly similar ways. Compare Gautier's version:

> The young prince rests one hand on a large dog who lifts his head towards him in a friendly way. He lets the other fall down along his body with the most natural gesture in the world. M. Carpeaux has attempted modern costume in a straightforward way: a light jacket, short pants descending just below the knee, a soft tie, carelessly knotted.

And the transition flows equally imperceptibly, as Gautier's account continues:

> All the while conserving the unstudied grace of childhood, the head, which is a very good likeness, moreover, already shows resolution and thought. The almost manly firmness of the glance signals that large destinies rest on that young forehead.[63]

Gautier reads the statue as he might interpret Bosio's *Henri IV*, as if the future were guaranteed and Carpeaux's likeness simply a confirmation of it. A state pensioner, librarian to the Princess Mathilde, and critic of the arts for the *Moniteur Officiel*, the newspaper of government record, Gautier had plenty of reason for his view. But what is most important is the way he asserts it, as if modernity and naturalism only confirm the Prince's heritage and with the excellence of the likeness simply an aside slipped into the discussion of imperial destiny on which he prefers to concentrate.

The evidence points to the accuracy of Auvray's claims about critics' reactions to Carpeaux's portrait. Many preferred not to discuss it; those who did tended to impose their own view of the imperial dynasty on the statue; and its form, while not demanding such analysis, did not limit response with the rigidity that a bust of the Prince in military costume, say, would have done.

One critic, Edmond About, did allow Carpeaux's portraits to provoke questions about the possibilities presented by imperial representation, rather than automatic assurances of the young Prince's destiny to rule. A few sentences from this discussion, published in *Le Temps*, can convey his view:

> There are two ways of interpreting likenesses of young princes. The artist is free to impose them on us as future dominators, arrogant before their time, and taking possession of the world from their first step. The other interpretation, one more consistent with the ideas and sentiments of our age, is to accentuate the weakness and grace of these little creatures, who are destined to the cares of power, to the weight of crippling responsibilities and perhaps to reversals of fortune. One presents them to the public in a guise which recommends them.[64]

Here the writer distinguishes a particularly "modern" way to portray an heir to a contemporary throne, a way which will suggest weakness as well as grace. A future emperor does not dominate, he is dominated; his master is The People. Thus the passage continues:

> and they are placed under the protection of the one inevitable sovereign: "People: look at this little being, so smiling, tender, and good. Surround him, protect him, adopt him, because he asks only to love and serve you, and he knows from childhood that he is nothing and can do nothing except through you!"

For About, the modernity of Carpeaux's likeness was its presentation of its subject in a guise analogous to and evocative of his relationship to *le peuple* and their control of his future. Sovereignty is in the hands of the populace—that is the message About reads in

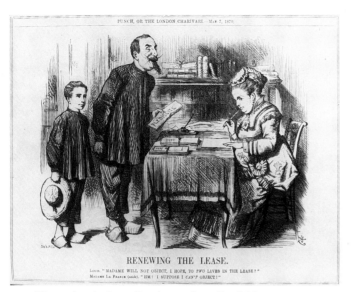

199. "Renewing the Lease," caricature from *Punch*, May, 1870.

200. Photograph of *Le Prince Impérial et son chien Néro*, installed in the Tuileries, 1867–70. Bibliothèque Nationale, Paris.

Carpeaux's portrait. The Prince really *is* the Enfant de France and France must give assent to his rule. The sentiment recalls the Emperor's continued assertion that he headed a plebiscitary empire, though the plebiscite was a form of popular sanction employed only three times during his rule and only once, in May, 1870, under the Empire. On this last occasion, however, the Emperor's increasing ill health made it apparent to observers in and outside France that the question put to enfranchised Frenchmen had heightened dynastic implications (fig. 199). The proposition read: "The People approves of the Liberal reforms brought about in the Constitution since 1860 by the Emperor in agreement with the great *corps de l'état*, and ratifies the *sénatus-consùlte* of April 20, 1870." Its resounding endorsement meant, proclaimed the ruler, that "we can face the future without fear": he was speaking about familial, as well as personal hopes.[65]

Three years before, as the tempo of liberalization quickened, About managed to derive from a portrait the argument used to justify the existence of the Second Empire. But—and this is the point—his judgement was not formed about the statue *Le Prince Impérial et son chien Néro*, but about the marble bust of the Prince that Carpeaux exhibited a year later in the Salon of 1867. The distinction is crucial. About did not even mention the statue in 1866.[66] The next year he referred to it only to emphasize the superiority of the bust. The latter was, he wrote, "a great and praiseworthy *progress* [my italics] over a certain group, which expressed neither the will to dominate, nor the desire to please and which, despite perfect execution, said absolutely nothing."[67] The "certain group" was of course the full-length statue, then on view at the Exposition Universelle, for which the bust, we remember, had been a preparatory study. Its perfect execution could not hide its emptiness, in About's eyes. It was meaningless because he could not apply either of the two meanings he allowed "les ressemblances des jeunes princes" to express. Simple resemblance alone was not the issue, since a change in format, not features, could completely alter a message. The truncated form of the marble bust, with its suggestion of thin little shoulders evoking "heroic" nudity, could sustain a valuation that the image of boyhood could not.

Several patterns of response begin to sort themselves out from the yearly crop of Salon criticism: silence; admiration for successful resemblance without discussion of political content; admiration for successful resemblance actively preferred to overt political content;

198

admiration for successful resemblance read as affirmation of a destiny to rule; outright condemnation. All of them, overtly or not, circle around one issue, the political identity of the Prince Impérial and the possibility of accepting Carpeaux's image of him as an adequate representation of it. Once defined in this way, both the silence of some critics and the opposition of others can be better interpreted as a refusal to acknowledge an ostensibly de-politicized image of a child whose actual identity was so clearly political.

Property

In the fall of 1865, Carpeaux received 15,000 francs for his statue, and in January, 1866, 4,000 for the bust, payments which mark the terminus in the first stage of the portraits' financial history.[68] The money bought Carpeaux's work in the creation of the models, their execution in marble, and the marbles themselves, while the sculptor retained rights to their reproduction by photography as well as by other means. Both sums were paid from the Emperor's private purse rather than from the public budget, allocations which emphasize the "personal" nature of the commissions and the imperial role as a "private" client in this first stage of their history. In keeping with that rather artificial status, the marble statue was soon set up in the *terrain vague*—neither private nor public—of the Tuileries (fig. 200).

Once a model was established, Carpeaux's role as a sculptor and a supplier of goods demanded the organization and coordination of the efforts of the men in his employ. In nineteenth-century France, the profession of sculptor meant, almost by definition, a division of labor, as we have seen, with the various processes required to execute a model in more permanent form left to men hired for that purpose. As was his usual practice, Carpeaux probably used professional casters to establish the original mold and plaster;[69] he certainly paid *praticiens* to execute the marble version of the work. A suitable stone block had to be chosen at the government Dépôt des Marbres and delivered to the artist's studio. Verseron, the stonecutter hired to prepare the block, spent twenty days simply constructing a firm bed for it and tracing an outline drawing on its surface to serve as a preliminary guide for the cutting. After a flaw was found in this block, a new one was chosen (fig. 201),[70] and twenty more days in November, 1865, were spent readying it to be carved. For both stints, Verseron was paid at a daily rate of eight francs, then the standard wage for a stonecutter. For the *mise au point*, the transferral of the design from the plaster to the stone, performed with the aid of a pointing machine, Verseron was paid 1,700 francs, the price agreed before the work was begun.[71] A second, more skilled worker, the *praticien* B. Bernaërts, took over execution of the group as it advanced towards completion. In May, 1866, he received the previously agreed sum of 1,400 francs for his labor.[72]

This first chain of payments, which might be written client→sculptor→*praticien*, is the kind of financial arrangement typical of most of the commissions which Carpeaux undertook, and typical as well of arrangements between sculptors and clients where one or at most several examples (marbles or plasters) of a sculpture are supplied. Once a sculpture is edited, however, the pattern of exchange becomes considerably more complicated. In this case that decision can be dated to the fall of 1866, not by means of a frequently cited but undated letter in which Carpeaux announced this intention to a friend,[73] but through the records of the artist's dealings with the firm of F. Barbedienne, which Carpeaux employed to establish reductions of the portraits to serve as models for a commercial edition.[74] Small-scale versions of the bust had been made in September, 1865, but it is most

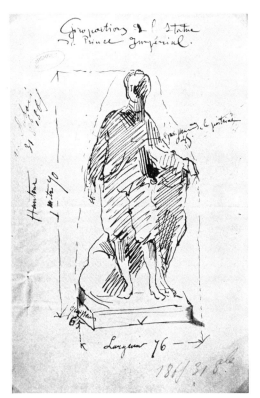

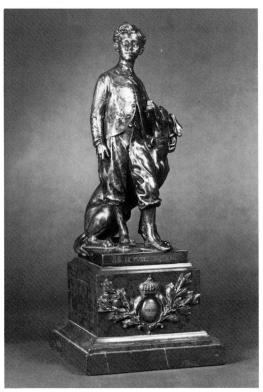

201. Jean-Baptiste Carpeaux, *Proportions de la statue du Prince Impérial*, 1865, pen on blue writing paper (21 × 13). Archives Nationales, Paris.

202. Jean-Baptiste Carpeaux, *Le Prince Impérial et son chien Néro*, late 1860s, silvered bronze on red marble base (h. 66). Collection of Mr. and Mrs. Christopher Forbes.

likely that these were not meant as the basis of an edition for sale, but rather to produce examples as gifts to friends, family, political associates, etc. (Carpeaux had ordered similar reductions from Barbedienne in 1863 and 1864, on behalf of other clients whose busts he had sculpted.)[75] Reductions of the statue had been established in three sizes—eighty-four, seventy, and forty-eight centimeters—by November 9, 1866, when Carpeaux was billed for the work, and a fourth model at one-fifth original height—twenty-eight centimeters—was made in December. At the same time, existing casts of the busts were repaired and mounted and new bronzes made from the reductions. By the end of 1866, Carpeaux had paid Barbedienne 5,432 francs for services related to the Prince Impérial editions, of which 1,890 francs went to produce the original reductions. In 1867 outlay for the edition was equally high; in the course of the year Carpeaux paid the founder 13,230 francs for new bronze casts in all sizes of the bust and statuette. Some of these—perhaps four or five—were sold from the Barbedienne showroom at 30, boulevard Poissonnière, with the manufacturer taking his standard twenty per cent commission.

Despite such scattered sales through Barbedienne, it was nonetheless Carpeaux's brother Emile who, from October, 1866, undertook to manage the marketing of the works. Carpeaux, for his part, was aware of the risks and expenses involved in this joint venture; he was convinced that the enterprise would make their fortunes or ruin them. And while he was motivated by his longstanding belief in the profits to be realized from imperial imagery, his venture was soon actively encouraged by the imperial government, as the official dossier records.[76] In this second round of negotiations between artist and government, the Ministère de la Maison de l'Empereur et des Beaux-Arts, acting under the Emperor's direction, became the sculptor's client, while Carpeaux was the proprietor of

an image he hoped to exploit for gain. The various steps in these negotiations are complicated, but worth unravelling. The manipulations and maneuvers on both sides reveal clearly both the extent of the government's commitment to promoting art as propaganda, and the way an artist could use his understanding of that commitment as a lever in negotiations with his imperial customer.

Some four months after editing of the statues had begun, the government asked Carpeaux to describe the steps he had taken to promote sales. His reply, addressed to the Emperor on March 1, 1867, begins in a way which demonstrates the ruler's personal interest in the publication of the image: "Having been asked to submit to your Majesty the efforts I have expended to date on the publication of the statue of the Prince Impérial, and what would be necessary to accomplish it . . ."[77] Carpeaux did not explain in his letter what was necessary to bring off the job successfully. Instead, he requested an audience with Napoléon III—and was granted an interview with the Maréchal Vaillant, Ministre de la Maison de l'Empereur et des Beaux-Arts, within a few days. The result of their meeting was the appropriation of 10,010 francs from the budget of the Ouvrages d'art et décoration d'édifices publiques for the purchase of statuettes and busts of the Prince Impérial—a decision whose aim, as the ministerial notification stated clearly, was "to aid you to publish the portrait of S. A. Mgr. the Prince Impérial."[78] Carpeaux had known unofficially of the purchase from his meeting with Vaillant on March 5, 1867, and he was soon trying to parlay the administration's expressed interest in the portraits into further payments. His growing involvement in commercial production of his art had made him prey to the same problems that other *patrons* experienced. Although the scale of his operation was relatively small in comparison to its size later, after the opening of his Auteuil atelier, he nonetheless felt the impact of growing worker agitation in the bronze industry as a whole. The strike of bronze workers in the spring of 1867, and the subsequent lock-out with which their employers retaliated, shut down—among many manufacturers—Barbedienne, Paillard, and Thiébaut, all founders Carpeaux used.[79] To meet the contract the government had just given him he was forced, so he claimed, to set up a small-scale casting operation in his own atelier and undergo the expenses that entailed. His request to the government for 5,000 francs to offset this new outlay was not met, but it reveals both Carpeaux's awareness of the possibility of manipulating the government's interest in the merchandise he had on offer, and his willingness to do so.[80]

Carpeaux and his brother did deliver part of the government's order on April 8, 1867. A second consignment was made the following June and a third in September. That the administration should then be preparing to meet a demand for multiple images of the Emperor's son—more than a year after the portraits were completed—is perhaps due to the role the boy would play that spring. The Exposition Universelle opened belatedly in April, under his presidency. At age eleven, the Prince was a puppet president, his appearances limited by poor health to a few ceremonial occasions,[81] but his deployment in such a public spotlight exposed him in his official role as heir apparent, when the assurance of legitimate succession could help to shore up the Emperor's increasingly shaky position. In this context, the boy's image had a renewed relevance—and market value.[82]

Carpeaux meant to continue to profit from it as an artist as well as an entrepreneur; he included the marble version of the statue in the group of sculptures he showed in the Beaux-Arts section of the Exposition, and the bust in the Salon. Another life-size version of the piece was exhibited simultaneously in the display of Christofle et Cie. (fig. 203).[83] Founded in 1841 by Charles Christofle and by 1867 directed by his son Paul and a collaborator, Henri Bouilhet, the firm, with 12,000 workers, was one of the country's largest gold

and silversmiths. Its financial success was the result of the elder Christofle's discovery of electro-chemically produced gold and silver patinas, both faster and cheaper to produce than the time-consuming process traditionally executed by artisans. Producers of *objets de luxe*, Christofle's cachet was not just the high artistic level of their product, which they advertised proudly, but also their high-class clientele. Their 1867 display included a hundred-place *surtout* belonging to the Emperor, and another table service owned by the city of Paris which had been designed by the architect Victor Baltard to a program written by none other than the Baron Haussmann, Préfet de la Seine. The *Prince Impérial* stood among the table settings, looking rather like a lamp figurine who has wandered away from his post, but at the same time an attention-getting advertisement for *galvanoplastie* and the refinements of the process which the firm had recently developed. The technique, which results not in a cast properly speaking, but rather in a thin metal deposit left within a mold suspended in a chemical bath, was often criticized for its fragility and inability to produce pieces in the round. Christofle claimed innovations which conquered these difficulties.[84] What better way to demonstrate them than by a free-standing, life-size *galvanoplastie* of the exhibition's patron as seen by a famous sculptor—a simultaneous tribute to art, industry, and France? Christofle approached Carpeaux, as the owner of the right to reproduce the statue, in early 1867. By the terms of their contract, Carpeaux received a flat sum, the price of a cast, for furnishing Christofle with a plaster model to be used for the electrotype and then returned to the sculptor in its original condition.[85]

The contract between Christofle and Carpeaux, which also governs possibilities of sale and potential profits, makes it clear that this was a speculative venture for both parties. In 1868 Carpeaux continued to investigate ways to exploit the work. He received estimates from Christofle for a *galvanoplastie* edition of both bust and statue in the various versions and sizes then available.[86] The founder Thiébaut produced at least one silver-patinated bronze of the statue, and perhaps the version shown at the Salon of 1868 as well.[87] It is probable that he cast small silvered examples at the same time, like the sixty-six centimeter

203. Display of Christofle et Cie., Exposition Universelle, 1867, wood engraving. Reproduced from *L'Illustration*, 1867.

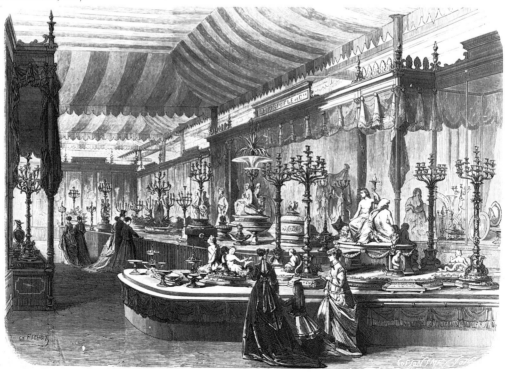

statuette Eugénie gave to her landlord at Chislehurst, Nathaniel Strode, in 1874 (fig. 202).[88] Models in the two smallest sizes of the statuette, nos. 3 and 4, were supplied to the porcelain manufacturer Michel Aaron, and molds made for an edition.[89] Carpeaux continued to have plaster and terra cotta proofs made, and two statues were cast in aluminum, then a rare metal whose industrial use had been supported by Napoléon III.[90] In January, 1869, Barbedienne made a reducion to one-fifth size of a new version of the full-length statue, the *Prince Impérial au chapeau*—probably the version shown at the Salon of 1868, which suppresses the dog, and gives the Prince the ribbon of the Legion of Honor. By the same date Carpeaux had reworked the bust of the prince into a portrait in a grenadier's uniform (fig. 204), although this version was never edited.[91] Both of these later portraits are more formal in costume and pose than the earlier versions and their very formality—perhaps a response to flagging sales and critics' silence—fills a gap in what was now a lengthy series of variants and scales.

A certain desperation marks this ceaseless multiplication of versions, sizes, and materials. The artist evidently believed that by ringing the changes on his designs he could finally capture his market, and that somehow, by producing a prince for every taste imaginable, the fortune he had sought with Emile (whose mismanagement of affairs had made Carpeaux dissolve their agreement early in the association) might in the end be earned. There is plenty of evidence to show he was mistaken. While the complete bookkeeping records of Carpeaux's atelier do not exist, his account with Barbedienne indicates that sales through that channel, at least, were slow. Moreover, what income they provided must be partially attributed to the success of bronze reductions of other works like the *Jeune Pêcheur à la coquille*, the *Rieur*, and the *Rieuse* (the first available since 1867, the last two since early 1868). The government, however, remained a faithful customer. In December, 1868, it ordered thirty-seven different examples of the portraits for 7,692 francs—their only documented sale that year.[92]

That same year, 1868, Carpeaux went to court to protect his right to reproduce the work, but only months later, by January, 1869, he had given up hope of making a profit from directing his own commercial sales of the portraits.[93] He nonetheless continued to believe that the work had not yet lost its value as a marketable commodity, given the right client. That client was the government, and Carpeaux again addressed the Emperor directly. When his first letter of January 24, 1869, went unanswered, he resubmitted it unaltered on February 11. The letter did not need changing; from the first it had been carefully constructed to apply pressure to the regime at several points. On second reading, it provoked the response it sought. What Carpeaux managed to say in a few paragraphs deserves examination:

Sire,

I do not know if your majesty remembers the moment when, pressed by your kindness, I resolved to make an edition of the statue of the Prince Impérial: that enterprise, which I pursued for three years, has not succeeded.

Moreover, the work I undertook at the Pavillon de Flore, for which I received thirty-two thousand francs for eighteen figures all twice life-size, left me a deficit of more than ten thousand francs; and soon the group being executed on the facade of the Nouvel Opéra will take me along the same route, one deplorable for an artist eager above all to leave to his age a name and a body of work fully commensurate with his talent.

Thus I see myself today, as a consequence of ceaseless, crippling sacrifices which I have undergone to keep afloat an industrial and commercial enterprise for which my previous experiences hardly prepared me, I see myself, as I say, forced to realize straight-

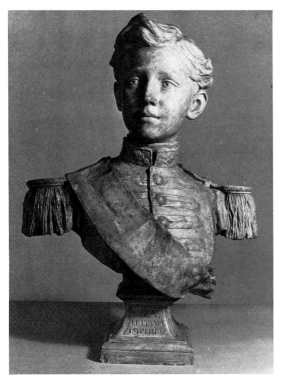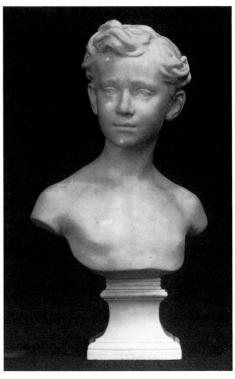

204. Jean-Baptiste Carpeaux, *Le Prince Impérial en uniforme des Grenadiers de la Garde*, c. 1868, plaster (h. 64). Tannenbaum Collection.

205. Jean-Baptiste Carpeaux, *Le Prince Impérial*, 1869–70, biscuit de Sèvres. Manufacture Nationale de Sèvres.

away whatever can return me some money, from the purely material part of the operation and from my rights to the statue of the Prince Impérial.

But before deciding to put up the matter at public auction, I think I ought not to decide anything without having previously obtained the formal authorization of Your Majesty.

It is this, then, which I solicit from your bounty, Sire, and I am, while awaiting your orders, your very humble and respectful subject,

Bte Carpeaux

Paris, January 14, 1869

71, rue Boileau (Auteuil-Paris)[94]

The sculptor first defined the government's responsibility for his difficulties: its encouragement had spurred his resolve to commercialize his portrait of the Prince Impérial, and that attempt had failed; its commissions had left him in "deplorable" penury, despite his sincere desire to devote his energies to an art which will have an impact on his age. A strategic opening, certainly, and one which intends from the outset to put the government, and specifically the Ministère des Beaux-Arts, and even the Emperor, in the sculptor's debt. Carpeaux is the wronged party, as he tells it, the patriotic selfless artist lost in the complications of industrial production, for which he is little prepared and ill-suited (even though Carpeaux had been involved in various aspects of industrialized art since the outset of his career). The solution he proposed was simple enough: the public auction of his right to reproduce the portraits of the Prince which he had been so unsuccessful in selling. The letter ostensibly sought official authorization for that sale. It did more than that, however; it presented a thinly disguised threat of an eventuality which the administration wished to avoid. Once registered, it provoked action, which left its trace in the official dossier as a rash of scrawled notes, reports, and letters, as plans to forestall the danger

were tried out. One such report, written by the Maréchal Vaillant on February 22, 1869, before Carpeaux had been interviewed about his claim, states flatly, "Reasons of great importance oppose the granting of such an authorization."[95] Of the solutions the Maréchal suggested, he preferred as the most practical the plan to purchase a work which Carpeaux had on hand rather than commission an entirely new sculpture, which Vaillant realized Carpeaux would execute late and at financial loss.

A bargain was eventually struck, and by April 4, 1869, the government had become the owner of the casts, molds, and reproduction rights of the various versions of the *Prince Impérial*, for the price of 16,000 francs. The sale was a rather ragged affair. Carpeaux repeatedly pressed for more than the 15,000 francs originally agreed on, by disclaiming the accuracy of his first estimates of his outlay in the project (a successful tactic), and by offering, even delivering, goods not included in the original agreement (which the administration refused to accept). The ministry, for its part, maintained careful surveillance over both the property it was acquiring and the supplier. The molds, models, and casts were inventoried, their condition noted, their possible usefulness weighed. As the new owner, the government quickly made plans to take over production and sales, since the acquisition of rights to the statues was not a charitable act but a business venture. Prices were established for bronze, plaster, and marble examples, usually at a twenty to fifty franc markup over the price paid to Carpeaux. By April 29, 1869, Desachey, *mouleur* for the Ecole des Beaux-Arts, had been instructed to supply the Manufacture Impériale de Porcelaine at Sèvres with models for an edition to be produced there. His casts were not crisp enough for the fine scale and detail needed in porcelain production, but by November, 1869, the Sèvres workshops had obtained adequate results from the original model and production and sale were begun (fig. 205).

The Sèvres edition represented an important commitment in the economy of the Manufacture, since at that time most of their commerce lay in less wholly decorative items, objects like table services and vases. Very few sculpture pieces were sold there during the 1860s, although they would play a greater part in late-century production. But the decision to market porcelain portraits of the Prince was not a move to "popularize" his image. The smallest, cheapest version of the bust, priced at twelve to eighteen francs depending on the detailing, cost about two days' wages for a man like the stonecutter Verseron. This is by no means an impossible outlay, but nonetheless the price is considerably higher than the few francs which could buy a photograph of the Emperor, or of his son.

The largest consumers of the first Sèvres edition were the Imperial household and the national lottery (which provided the funds for imperial charity to individual citizens). In ten months' time, fifty-nine busts and statuettes were charged to these accounts.[96] Precise records kept at the Manufacture give the names of all the portraits' private purchasers during the same period, as well as the price paid and the object selected. Before September, 1870, five different people spent a total of 241 francs 80 centimes for nine busts and one statuette of the Prince.[97] Behind those figures are a M. Pommerette's purchase of a bust for sixteen francs, M. Laureau's of a bust at twelve francs, M. Pardon's of a statuette at forty francs—three private citizens, evidently *bons bourgeois* and loyal Bonapartists, making modest purchases. The other two buyers, the Princess Mathilde, who took two busts at thirty francs each, and the Duc de Mouchy, who bought five at twenty-three francs apiece, were shopping for propagandizing presents which embodied the givers' close relationship to the imperial family. (It is worth noting that, even on this scale and in a different medium, the standing figure of the Prince was apparently considerably less popular than the bust.)

It cost the Sèvres manufacture 870 francs for molds and repairs of the models before production of its edition of the portraits could begin. Like Carpeaux, it never made a profit from the venture, since the overthrow of the government and exile of the imperial family in September 1870 made the image unsaleable. Sèvres resumed production of a version of the portrait fifteen years later, in 1885 (though some sources state, without documentation, that a statuette was sold in the interim under a more innocuous title, *L'Enfant au chien*).

Carpeaux himself contemplated resuming production of the works much sooner, even though he had surrendered that right in 1869. A police surveillance report dated January 21, 1875, records that Carpeaux had not only delivered a cast of the statuette to the ballerina Eugénie Fiocre, but had begun to have molds repaired as if in preparation for a new edition; showing some knowledge of the practicalities of sculpture, the operative concluded, "it is probable that he has orders which will pay the expenses of the initial outlay."[98] There is no evidence, however, that this clandestine edition was actually completed during the artist's lifetime; only after his death, when control of the Auteuil atelier had passed to his widow, Amélie, née Montfort, was a new series cast. By 1878 the business card of the atelier, printed especially for that year's Exposition Universelle, offered a forty-seven centimeter terra cotta of the statuette for 150 francs.[99] Sales of this work are undocumented, and the size of the edition equally unknown. However widely they were marketed, these new casts were based, as earlier, on the confidence that a public existed for them, whether that audience was motivated by nostalgic sentiment or the desire to demonstrate its Bonapartist sympathies at a time when the debate over the reinstitution of a monarchy made such sympathies seem far from idle. But the Prince was killed in 1879 and his death ended the active life of Carpeaux's portraits as imperial imagery.

<p style="text-align:center">*　　*　　*</p>

This chapter has discussed aspects of the history of Carpeaux's portraits of the Prince Impérial under the separate headings "Art" and "Property." I introduced those divisions with an acknowledgement of how arbitary they might seem, and what followed supports that admission. The two exist simultaneously. Carpeaux presented the portraits in the Salon, for example, both as property and as demonstrations of his art, and the modifications he made in the marketed and exhibited versions seem to respond to the reactions of art critics. The few clients who eventually purchased reductions of the works may well have wanted them as miniature reminders of the sculptor's skill rather than because of their sympathy for the sitter and his father's government. And certainly there is no doubt that the Salon was a marketplace for art. Prospective patrons shopped for a portraitist whose style suited them or for a figurine which took their fancy. Critics too were clients whose coin was words. They "bought" a work or ignored it, and their attention could itself be a valuable commodity. But if the boundaries between the status of sculpture as art or property shift, and if in fact a work has dual status at any one time, what seems to remain constant, at least in the particular history we have been examining, is the kind of failure these portraits met in each category, in each public market. As works for private clients, they were a success by every convenient standard: they were approved, paid for, set out on view, cherished until the clients' deaths. As works of art presented to the public, however, they won the usual rewards only slowly. Critical approval was for the most part withheld, and their greatest impact was to be seen in the imitations of contemporary sculptors—until, decades later, they entered a public collection, where they now stand as suave, uncontrover-

sial demonstrations of their author's skill. As propaganda, their failure was equally complete. They never sold widely, and Carpeaux's attempts to edit them commercially brought him close to financial ruin—or at least provoked that claim.

This study, then, has documented failure, within the critical and commercial contexts which formed the conditions of production for most nineteenth-century French sculpture. Yet it is important to emphasize that this is not the dismal story of some *Portrait de M. X* by sculptor Y, which after being ignored at the Salon sank into perfect obscurity (the typical case); it is rather the history of images of the imperial heir. The risks its author and owners were willing to take to sell the portraits commercially only dramatize their lack of success, and the collaboration of other entrepreneurs, like Christofle for example, heightens the effect.

Finally it is necessary to explain that failure as well as document it, to say why critics were inclined to ignore the work and purchasers to refuse it. Part of the answer is contained in what has gone before, in my characterization of the portrait as assigning its subject a secondary, unstable, bourgeois identity, and in my discussion of a critical discourse which refused, in various ways, to acknowledge that identity. Carpeaux's statue presented a possible public image of the Prince, yet one which its public was not completely ready to accept. It is as if two incompatible substances were being asked to join forces, an ingratiating image of the bourgeois Prince to align with more familiar, more clearly propagandizing representations of the imperial family, like "Eugénie the philanthropist" or the "liberating Emperor," for example. The link could not be made, at least in the minds of the sculpture's first audience. The late 1860s were not the early 1850s, and we can see the same kind of disjunction between the ethos of "liberal empire" then being tacked to the surface of an authoritarian regime, and the earlier propaganda which had argued for that regime since its inception. To accomplish the change, governmental gears had to be shifted and a different basis of strength won. The shift, broadly speaking, was from the attempt in the 1850s to secure rural and working-class support, to the effort in the 1860s to win the backing of the bourgeoisie. It was not successful. It is finally on this level that the portraits' failure—or at least that of the statue—must be explained. Carpeaux's sculpture, and the efforts to commercialize it, fall somewhere in the middle of this shift of tactics, between the posters pasted on walls outside factories in the 1850s and the full-blown splendor of the Opéra facade in the following decade. And the work falls as well into a kind of no-man's-land of speculation, provoking questions like those Carpeaux may have asked himself as he tried again and again to redesign the group. Would it have worked if the Prince had worn a uniform? Should the dog have been left out? Was there not a more judicious mix of faithful resemblance and historical style, like the impressive balance of the two worked out in his magnificent—and successful—portrait of the Princess Mathilde? Would that not have better answered public expectation? Questions like these, and in fact much of the history presented here, point once again to the existence of certain tacit codes or categories which governed public perception of a piece of sculpture and the work it had to do in the public realm. Similar expectations were had of painting, but they could be escaped, while sculpture seemed tightly bound by constraints which defined its expressive possibilities. The familiar axiom still held firm: as the more permanent of the two arts, sculpture was the art of order, of agreement. Its purpose was traditionally not the expression of secondary, unstable meaning, but of primary assumption. It is this general understanding which Carpeaux's portrait contradicted. It tried to redefine the qualities of imperial portraiture, only to find that they were fixed within an ideological framework the more rigid because of its lack of coincidence with political reality.

IV. Facade of the Opéra, Paris, detail.

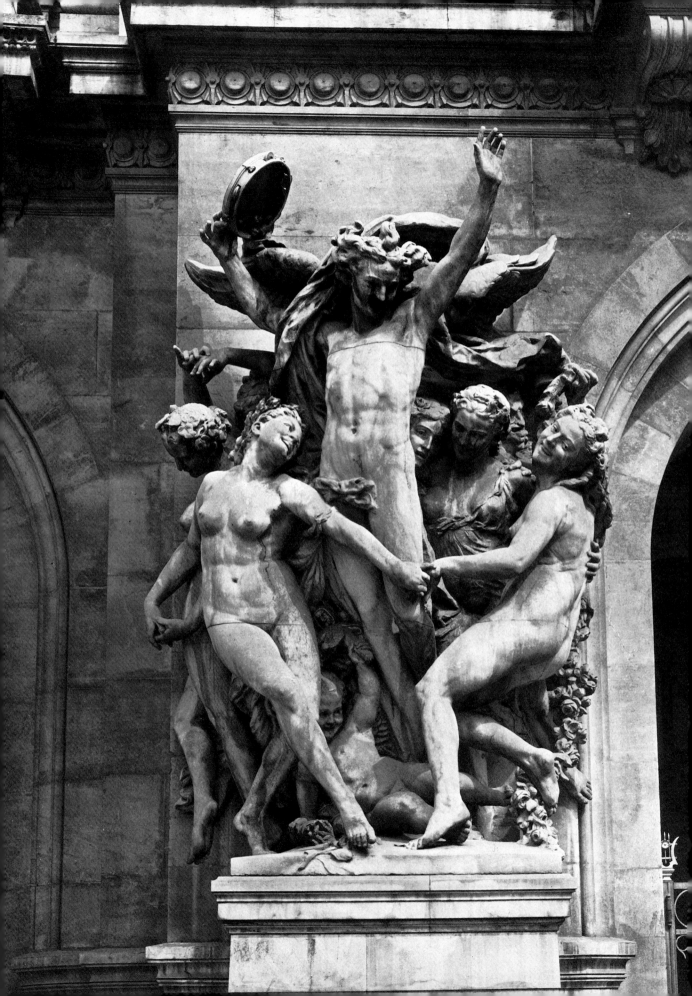

CHAPTER SIX

ART AND PROPRIETY

Art without rules is no longer art, it is like a woman who undresses completely.

E. Pinard, 1857[1]

A picture which represents a nude woman is only immoral by virtue of the stratagems which a painter invents to hide the things which the whole world knows.

E. Vermersch, 1867[2]

La Danse is an enormous sculpture, but its size was initially tempered by its placement within the facade of the Paris Opéra (figs. 206–07). There it was given scale by the tiers of cut stone which rose above it; seen up close or out of context it seems to spill over into the space it occupies. *Seems* is perhaps too weak a word, though, because one of its most noticeable aspects is the way clear boundaries between the statue's space and the viewer's space are overstepped. The geometric shape within which we ought to be able to inscribe the group is dented and poked out of shape by protruding hands and knees and feet and haunches (figs. 208–09). They kick and reach out towards us, with movements which open the sculpture up to space and shadow. We are invited to enter it, at least with our eyes, to read past the slim central figure, the *Génie de la danse*, to the heads of the dancers gathered beneath his outstretched arms (fig. 210). But if, in looking, we approach the group, size again becomes an issue. The closer we get, the more imminently it rises above us. The dancers' faces become invisible through the thicket of legs from which we, like the little *putto*, now look (fig. 211).

This is a reasonable description of what happens when we look at *La Danse*, I think, because it suggests the kinds of cues which direct that process, from whole to part, from shape to central figure, to a resting place beneath that figure's feet. What it does not convey is the number of diversions possible along the way, the points where choice or direction are not made clear or where a deeply cut garland or a smiling face detains us. Nor does it indicate the alternative, rhythmical progress which is possible around the irregularly linked chain of interlocking dancers' limbs. Once the *Génie*'s figure is understood as the group's axis—this happens almost immediately—how to proceed? There is no symmetry to make that question unimportant. The sculpture's parts are not measured and matched sequentially, the way they are in the clear, inevitable order of the other Opéra groups. Next to them, *La Danse* is disordered, almost illegible. Its parts are doubled, even tripled; for every one we get two or three.

209

206. Jean-Baptiste Carpeaux, *La Danse*, 1865–69, Echaillon stone (h. 330). Formerly Opéra, Paris; now Musée d'Orsay, Paris.

What to call this composition? How to rate it? There is certainly no absence of both epithets and assessments among the many views articulated since its unveiling. It is no exaggeration to say that Carpeaux's group was one of the most controversial sculptures of the nineteenth century, with the brouhaha that greeted it equalled only by the controversy touched off by Rodin's *Balzac* in 1898. Both were lampooned, defended, caricatured, and praised. But there are important differences in the tenor of the two disputes. The *Balzac* was a plaster model placed on view at the Salon (prominently, to be sure, since Rodin chaired the hanging committee). Commissioned and refused by the Société des Gens de Lettres, *Balzac* became part of Rodin's artistic identity, but not, until 1939, a public monument. When *La Danse* was unveiled on July 26, 1869, it became public property. The work was an accomplished fact, duly vetted and approved as a seemingly permanent monumental part of an even more monumental whole. And it was seen not in the relative privacy and obvious impermanence of the Salon, but from the street, as part of a building already being called as characteristic of its age as the cathedrals are of theirs. So when judgement was passed on *La Danse*—as it soon was—the verdict seemed to have special weight because the public weal was somehow at stake.

From the outset opinion was divided. That puts the case mildly—Paris was amazed at its own ability to keep talking about *La Danse*, and to give its talk the tone of scandal. The dispute overshadowed news of the grisly lingering death of the lion tamer Lucas, the victim of a mauling by his own huge beasts. And the press accounts ceded only to

208. (right) Jean-Baptiste Carpeaux, *La Danse*, side view.

207. Charles Garnier, Nouvel Opéra de Paris, 1861–75.

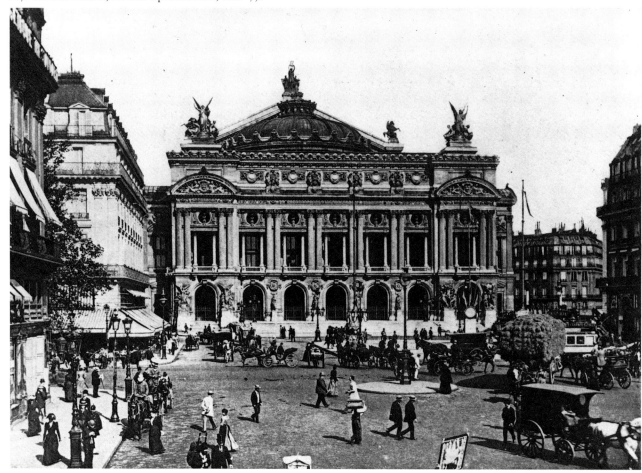

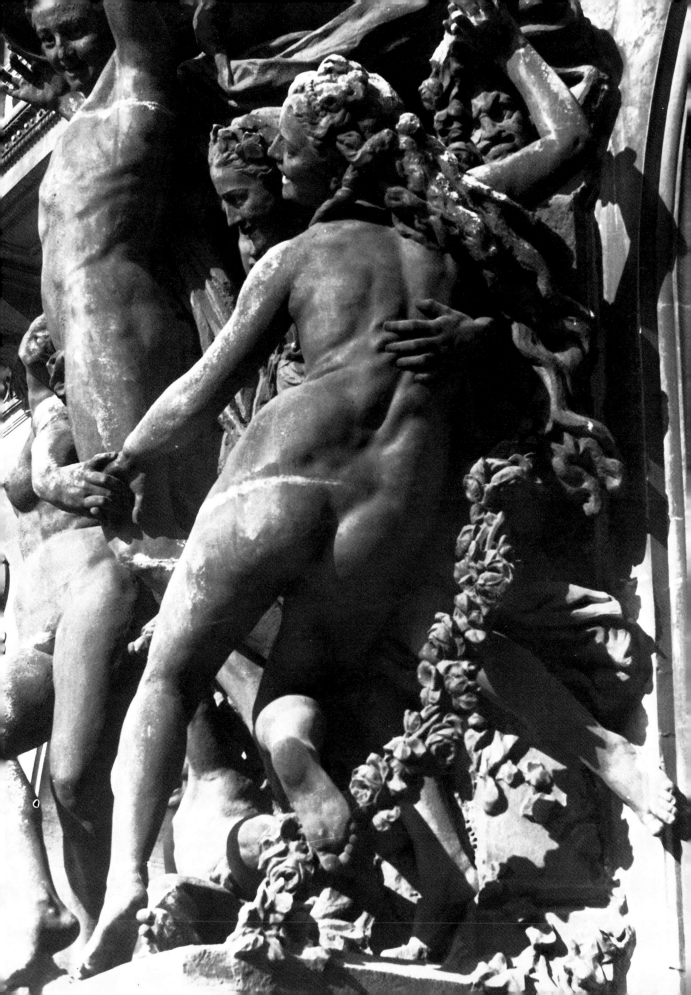

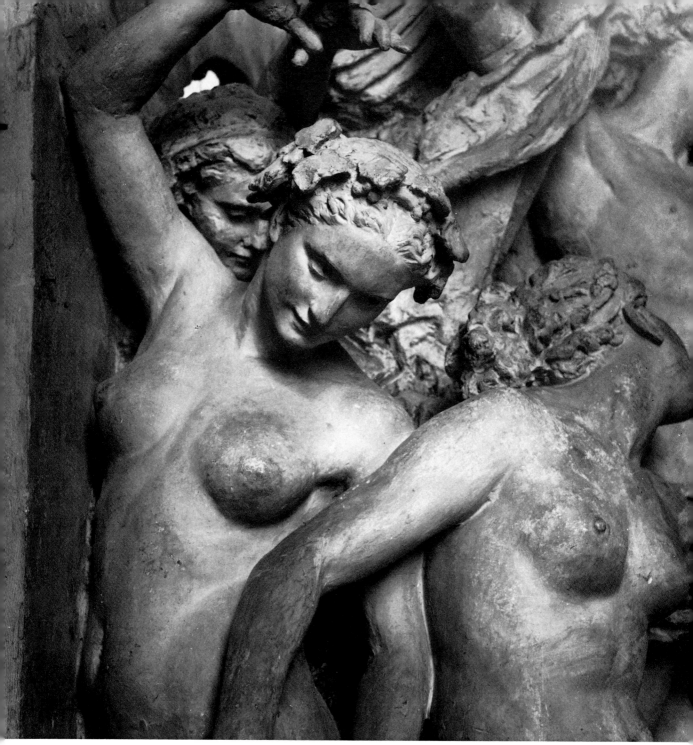

209. Jean-Baptiste Carpeaux, *La Danse*, detail.

the infinitely more grisly "Affaire de Pantin", the discovery of the brutally murdered bodies of a woman and her five children, hastily buried in a plowed field on the city's northeast edge. The notoriety of *La Danse* was part of this same spectacle. It was prolonged, even heightened (at Carpeaux's instigation, some charged), by an act of vandalism which shocked the city almost more than the sculpture itself. During the night of August 27, 1869, a bottle of ink was hurled at it. The then-bright white flank of the front dancer on the left was stained—journalists and caricaturists both rushed to describe the damage (figs. 212—

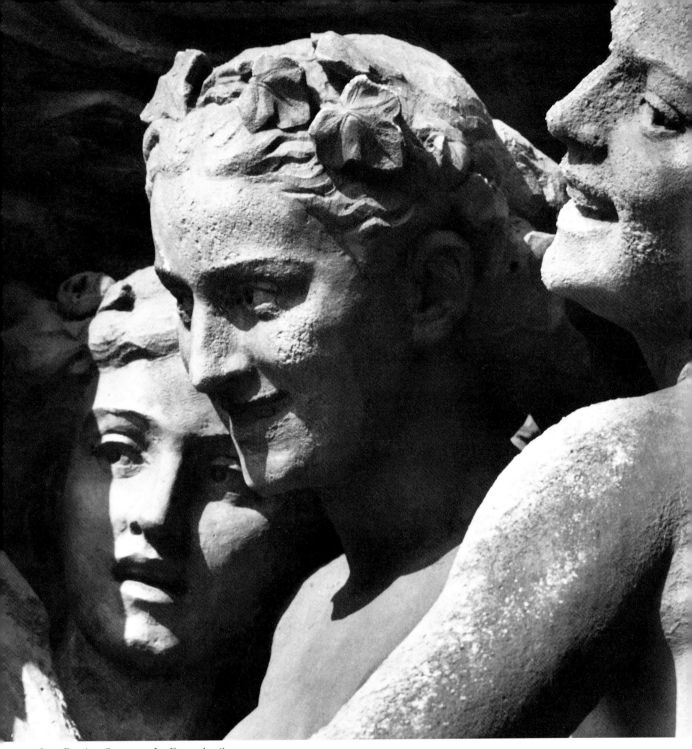

210. Jean-Baptiste Carpeaux, *La Danse*, detail.

13). With the spot, public opinion was again unstoppered, and disagreement grew even more bitter.

All this is part of our story. Criticism of *La Danse* will occupy us at length in the course of this chapter, as will the conditions under which such a group was conceived and executed. We need to spell out in some detail the peculiar history and controversy of *La Danse*. Why should one work be so controversial? Where did responsibility for its excesses lie, with the sculptor or the architect who hired him? How was its place in a decorative ensem-

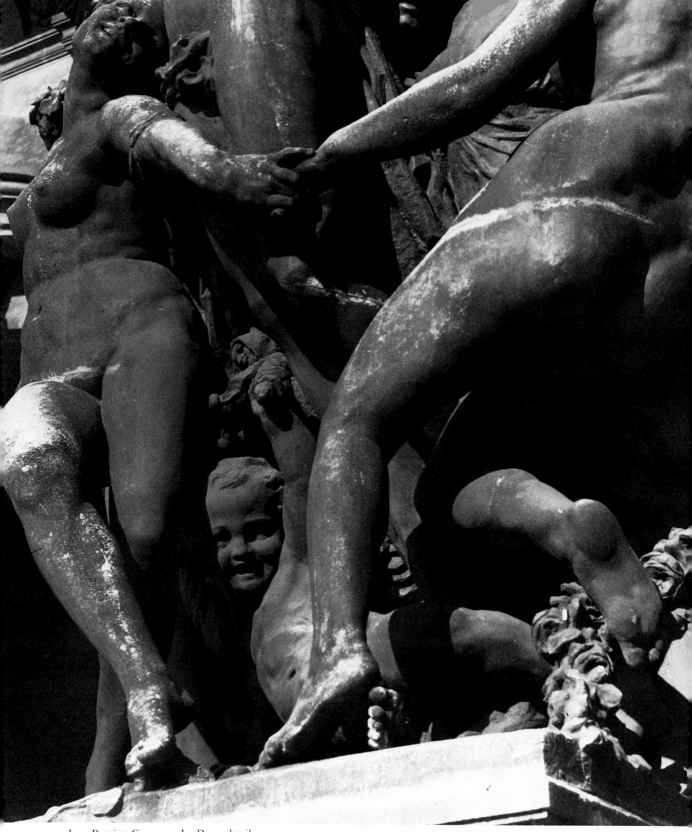

211. Jean-Baptiste Carpeaux, *La Danse*, detail.

214

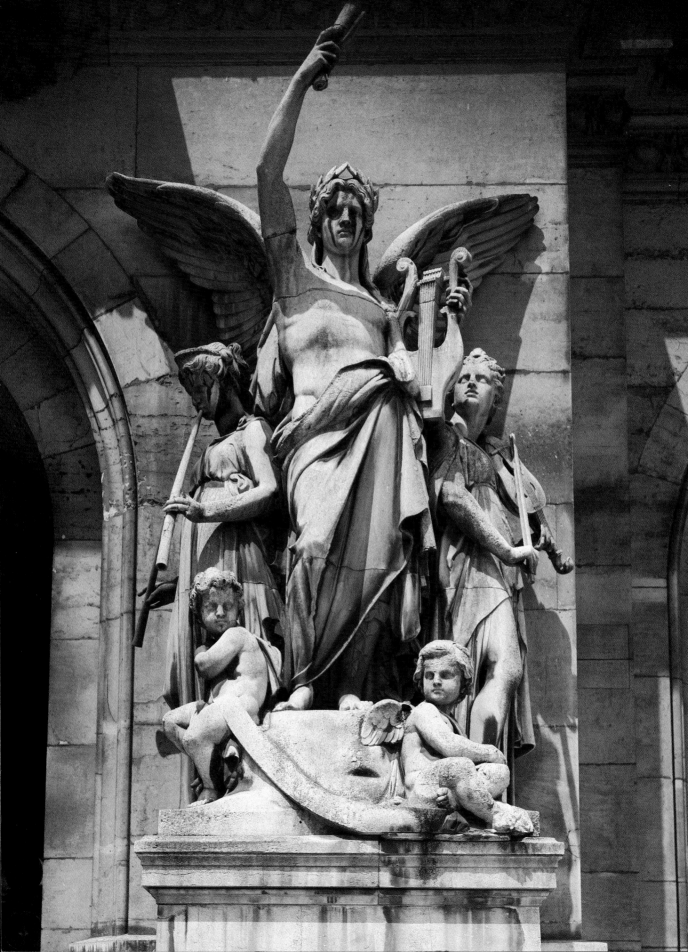

ble to be weighted against its qualities as an individual work? What was the controversy about? What kinds of dangers and promises did the group seem to present? We shall see that its critics and champions rallied under different banners, but that they took positions which are not self-evidently opposite. *La Danse* was alternately styled a threat to morality and a blow struck for modernity, with the expectable factions, right, left, and center, subscribing to these views. But why was this group thought immoral, when artistic nudity was a Salon commonplace? How could the "modern"—read subversive, avant-garde— appear on the facade of the one building which already stood for the Second Empire?

<div style="text-align:center">* * *</div>

La Danse is decoration. For many viewers, it is also Carpeaux's masterpiece. Its masterly qualities, however, have usually served somehow to countermand consideration of the group's role as decorative sculpture. When it is reproduced, it is most often shown severed from the context for which it was designed—only partly because such symbolic isolation was eventually carried out in 1964, when the group was sent indoors for protection.[3] The choice to save *La Danse*, and it alone, was not accidental; prophylactic measures had been suggested as early as 1889.[4] By that time its status as masterpiece was entirely secure; controversy had yielded to a reputation cemented by Carpeaux's death (fig. 214). Even Charles Garnier, writing for history in a *post facto* chronicle of his building's development, preferred to characterize *La Danse* in the customary way, not as decoration, but as a brilliant work whose energy he could not bear to stifle by forcing it to conform to his design.[5]

In the end, though—and *pace* Garnier—it is more illuminating to say that *La Danse* is decoration than to celebrate its wild individuality. Though Garnier forebore to call in the debt, the work owes its existence to his Opéra; it was commissioned and sculpted as part of that whole and determined by it in all kinds of ways. The fact that Carpeaux was chosen in the first place, for example, is at least partly due to his longstanding friendship with the architect. Virtually unknown, certainly unpracticed, Garnier won his commission in a competition that fielded nearly two hundred contestants. The controversial award

V. (left) Eugène Guillaume, *La Musique instrumentale*, 1865–69, Echaillon stone (h. 330). Paris, Opéra.

212. "Les Curieux devant le groupe de la Danse, de M. Carpeaux," 1869, wood engraving. *L'Illustration*, 1869. Bibliothèque Nationale, Paris.

213. "Potins du Jour," *Le Bouffon Politique*, 1869. Bibliothèque Nationale, Paris.

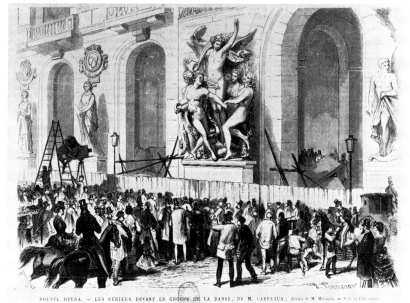

La tache du groupe de Carpeaux.
De l'encre d'une grande vertu pour la réputation de l'artiste.

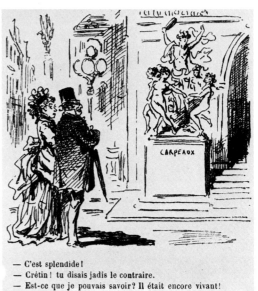

214. Cham, "C'est Splendide!" 1875, wood engraving.
Le Charivari, 1875.

— C'est splendide!
— Crétin! tu disais jadis le contraire.
— Est-ce que je pouvais savoir? Il était encore vivant!

was announced on May 29, 1861.[6] By Christmas, 1863, Garnier had begun to discuss his planned decor with Carpeaux and other sculptors, and Carpeaux was soon passing on his news to a friend: "I have just been chosen by Garnier to complete one of the handsomest tasks of the Opéra. I am asked to do one of the great bas-reliefs of the facade, in the spirit of the Arc de Triomphe. Or the group which will crown the monument. 40,000 is earmarked for the job."[7] Admittedly this first reference on Carpeaux's part is rather vague: his words have the air of someone who is repeating all he knows about a project, all Garnier has yet told him.

More information, in the form of an official commission, was not forthcoming for nearly two years, and this delay was likewise a function of the group's status as decoration. Constructing the Opéra was an exercise in organization which, as Garnier realized soon enough, demanded the careful orchestration of artistic commissions and cost-efficient building practices, all the while operating under the supervision of a ministry (in this case, the Ministère de la Maison de l'Empereur et des Beaux-Arts) which sometimes preferred its own plans. In 1863 Garnier intended to commission nine big groups: the five to be placed along the building's roofline, and four destined to frame the terrace.[8] Carpeaux was securely included on the second list; his name was assigned a *Génie couronnant la Danse amoureuse et la Danse bacchique*, beneath Guillaume's *Génie couronnant la Poésie lyrique et la Poésie légère*, and preceding the allotment to Cavelier of a *Génie couronnant la Comédie et le Drame*, and a *Génie couronnant le Chant et la Musique* to Jouffroy.

These commissions did not go out in 1863. By the time they were issued, in 1865, Perraud had stepped down from his first assignment—the figures capping the monument, *Apollon couronnant la Danse et la Musique*—and opted for a group on the terrace.[9] (From the start he must have been undecided about working on the *Apollon*; hence Carpeaux's brief mention in 1863 that he himself might be allotted the job.) Perraud's decision initially bumped Carpeaux from his place in the roster; he was shifted to responsibility for the two caryatids on the Pavillon Impérial left open when Aimé Millet took Perraud's place. Only when Cavelier withdrew his services was Carpeaux returned to a post comparable to his original assignment. Even then, Perraud was allowed to choose his subject first; Carpeaux had to content himself with whatever was left.

The story has the air of musical chairs for sculptors, with Carpeaux almost ending up odd man out. He was the youngest of the group and apparently the most appropriate

sacrifice, despite his friendship with Garnier. Yet the way these commissions were handled put all the sculptors at a disadvantage, since in two years' time the price they were to be paid sank steadily from 40,000 to 35,000, finally to 30,000 francs, even though Garnier believed from the start that his artists were already being asked to work at sacrificial rates:

> To my mind the question of price is more difficult to resolve; above all it is an administrative matter, one which demands justice, which you, alone, Excellency, can judge and for which I cannot take responsibility. I can only say that the prices I propose have been conscientiously discussed, that they are based on earlier amounts, and that all the artists have willingly sacrificed legitimate profit to attach their name to a monument which because of its great importance will be considered a manifestation of art in the reign of his majesty the Emperor Napoléon III.[10]

Already we are deep within a narrative which has the earmarks of any saga of public works: delays, curtailed allotments, commissions that all too easily could slip through one's hands. Setting out a view of *La Danse* as decoration means preoccupation with just such details; more will follow. But it also means linking them to an approach to architecture which insisted on a sculpted decor for buildings, for all the inevitable accompanying ennui. Garnier shared this view with his age; it prevailed at the Ecole des Beaux-Arts, where sculptors learned to maintain clear, tested ideas and architects were steeped in the assurance that communication in architecture hinged on the appropriateness of their building's representational—decorative—character.[11] It was institutionalized in Paris, which set up commissions to devise decorative schemes for public buildings and to deliberate about artists' renderings of them. In 1863 Carpeaux was interviewed by just such a commission as a result of his work for the decor of Théodore Ballu's church, La Trinité. The sculptor saw his maquette examined and suffered the negative, highly academic assessment which greeted it: "*La Tempérance*, by M. Carpeaux, lacks amplitude and character. The picturesque and relaxed manner in which the subject is treated does not fulfill the conditions of monumental sculpture. In executing his model the artist should try to align himself as much as possible with the style adopted by M. Maillet in his group *La Force*."[12]

In other words, Garnier was licensed by both current practice and cultural priorities to produce a sculpted building. He was left to devise the means of doing so. The Parisian predecessor of his structure, the opera building on the rue le Pelletier, was positively sparse—it offered little by way of guidance, either programmatically or structurally (fig. 215).[13] Moreover, the practicalities of the task were complex. Responsibility necessarily devolved on the shoulders of an office staff of architects whose capability was the cornerstone of the operation.[14] The sheer scale of the works demanded such delegation: after a terrain was chosen and its population of widows, shoemakers, and notaries paid and packed off, the building's foundations were rooted in a gaping excavation.[15] Hundreds of thousands of kilos of sand, iron, and cement were swallowed up there annually; four grades of brick were in use, and thirteen types of stone. The site was equally hungry for human fodder: by 1869, 1,107,632 workdays had gone into the building, with stonecutters and joiners contributing the largest slice of labor, 349,235 days.[16] (By the same date 311 workers had been injured and 10 killed.)

Sculptors were at work on the site from 1862. By 1869 they had logged 38,006 workdays, with the most intense activity concentrated in 1865 and 1866, as the facade was brought to completion. It is difficult to translate these figures into the labor and wages of real men; to be certain, for example, whether the Ecole-trained elite is included (probably not) or even how many individual men are meant. In any event, Garnier himself did not add

up these tallies, even though he returned them to the ministry over his signature. His contribution was in the area of policy, creating the conditions under which workdays were lived out. He hired and fired as a matter of course, and as a result exposed himself to the inevitable charge "of giving his old pals a slice of the huge stone cake."[17] He fielded recommendations from all kinds of people promoting particular interests: the bronzes of the Maison Languereau, the talents of the sculptor Dantan, the services of an out-of-work *marbrier*.[18] He defended his bailiwick—particularly the decoration—against threats of financial curtailment, arguing for its completion in terms which grant the project a kind of inevitability or autonomy, as if it were separate from the architect and sometimes contrary to his personal interests: "Your Excellency should be convinced that I am pestering in this way solely in the interest of the monument alone, and that if I were concerned only with my welfare, I would have yielded on this question long ago."[19] Evidently the Opéra was a matter that transcended questions of its author's best interests. Garnier continued, summarizing the problems which plagued him: "In fact it is a difficult job to superintend all the artists, and not to hinder their individual work, even while keeping them to some general guidelines. This one must be encouraged, that one scolded, and they all must be made to modify their work nearly every day. And all this while leaving them the liberty to achieve an individual appearance—a difficult task, and harder still since it must be done without wounding their self-respect."

Observations like these create an impression of Garnier's energy and devotion which, if slightly self-serving in the context of a report to the minister, was apparently not far

217. (right) Delmaet and Durandelle, photograph of ornamental sculptors at work on the Opéra, c. 1867. Bibliothèque Nationale, Paris.

215. Delmaet and Durandelle (?) photograph of the Opéra, rue le Pelletier, Paris, before 1873. Bibliothèque de l'Opéra, Paris.

216. Delmaet and Durandelle, photograph of the Opéra under construction, c. 1865. Bibliothèque Nationale, Paris.

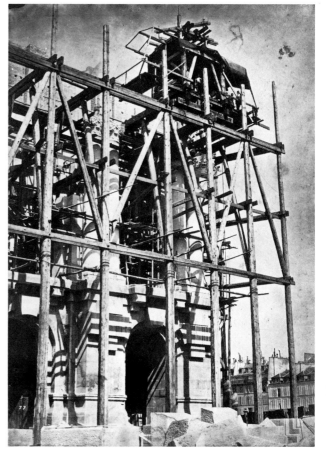

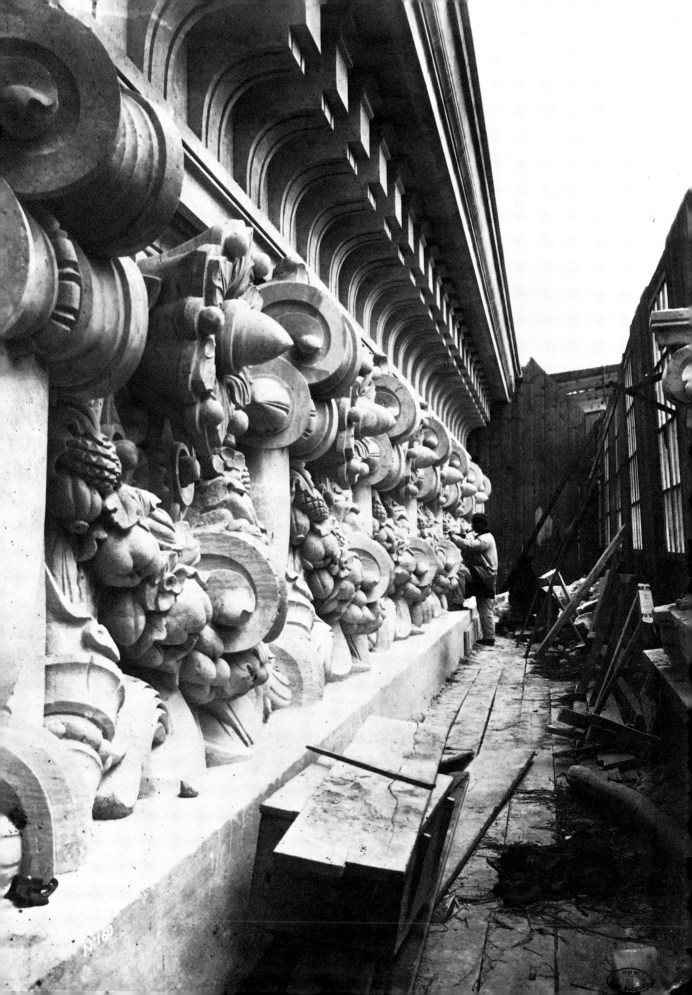

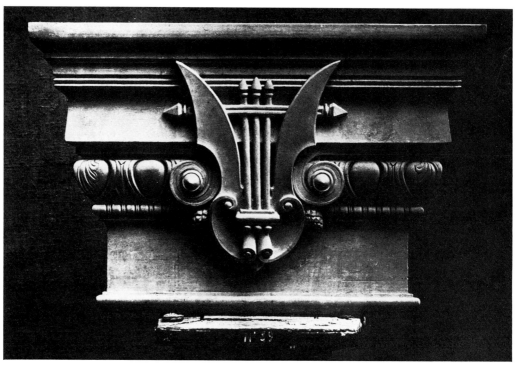

218. Delmaet and Durandelle, photograph of a capital for the Opéra, c. 1867. Bibliothèque Nationale, Paris.

from the mark. By all appearances Garnier was meticulous. The albums of photographs he commissioned from the firm of Delmaet and Durandelle document both his structure and his effort to record it from the ground up (figs 216–18). And he was a tactful, sympathetic supervisor—up to a point. His respect for artistic talent was not allowed to contradict his business sense. On Garnier's worksite a sculptor may have enjoyed constant encouragement, but that support carried with it only limited guarantees. It could not change the fact, for example, that once an artist conceived a figure or an ornamental motif he was not necessarily employed to execute it. Instead the labor of carving was most often farmed out to whomever promised delivery at the lowest price. The sculptors protested: Jules Corboz and a certain Houguenarde relayed their collective refusal to supply prices for any designs they had not made themselves. Here is Garnier's reply:

> I have to tell you that I will not accept this refusal, and that when I summon you, it is in order for you to respond to my request, and not for you to give me a lesson.
>
> I do not know if it is pride or financial interest which made you and your companions act this way. In either case you were wrong. Your pride should be in no way wounded by my manner of proceeding, and I believe that in the relations I have had with sculptors I have always treated them as artists. But the role of artist ceases when the model is finished, and in the matter of execution they become, quite simply, contractors. They ought not, therefore, to take offense in any way. If I make use of competition, it is not only my legal right but my duty as an employer, and your pride ought to suffer not at all.
>
> As for your financial interest, it would be harmed much more if you renounced competition, because not only could I not employ you to execute lots for which you did not make the model, but I would also be forced not to use you for the models which you did make.

Take good note of the difference; you make, under my direction, an ornamental model. You are an artist and must be treated as one; but once the model is finished and paid, it belongs to the administration, which can use it as it sees fit. In the matter of the execution, it chooses the best way and thus employs *praticiens*. You are, and become in this instance, sculpture contractors, because you no longer make sculpture yourself, and because you have your work executed by men whom you pay at a reduced rate, or by the day.

To summarize, I will continue as I have begun; that is to say, I will continue to make use of several executants for the lots, because I will offer the man who has made the model the job at the lowest possible price, and I will give work to whoever proposes the lowest price, whether it is a part of a large job, or another job entirely.

But be sure, Monsieur [*sic*], that I intend to direct my affairs as I see fit, and anyone who refuses for one reason or another to follow the path I indicate will be immediately considered as discharged both from execution and from the models.

As I am aware of a certain coalition among the sculptors, you would be well advised to communicate this letter to your fellows so that they know my intentions.[20]

The difference between sculptor and *praticien* has rarely been spelled out so brutally; Garnier is absolutely clear about where and how money draws the line between them: "Le rôle de l'artiste finit où le modèle se finit." The man himself survives unchanged, but if he wants to be paid for further work, he must surrender his artist's position and accept payment on the lower scale: sweated pay for sweated labor, even if the design is his own.

Perhaps the old phrase best characterizes Garnier's operation: he ran a tight ship, in order to put into practice a view of architecture which he came to symbolize. Not least by virtue of having won the Opéra commission, Garnier became a highly visible spokesman for a theory of decorated architecture. It is almost as if the role came with the job, since it was more or less assumed that the Opéra would be a decorated building. Its earliest programs called for luxury at a time when luxury in building translated as ornament.[21] Garnier's surviving competition drawings supply it (figs 219–20). So do most of the other entries—even when they supply little else (fig. 221).[22] (The motto this contestant, one Count G. Roussäy, chose is all too accurate: "No need to be an architect to have a mason's ideas." He meant *franc-maçon*, one imagines—but in this case a little more architecture would not have gone amiss.) Garnier's efforts are infinitely more skillful, but they too present a kind of generic decor, a set of graphic conventions for sculpture. In his drawings, the clearest aspect of the ornament is its omnipresence. Details and a program for the whole would be worked out at a later date, when and if they were required.

They were required soon enough, and there is some evidence to suggest that how they would be developed was a matter of concern in several quarters. The Emperor asked to see a mock-up of the principal facade, but was satisfied instead with inspecting the plaster model prepared by the sculptor Villeminot late in 1861.[23] The model in turn took account of changes already recommended by the venerable Félix Duban, in his capacity as Inspecteur Général des Bâtiments Civils. Reviewing Garnier's winning design in July, 1861, Duban had spelled out his worries and hopes concerning the "architectural character" of the proposed facade. He feared that Garnier had been too dependent on borrowings from the Louvre colonnade in order to achieve the requisite grandeur and monumentality, without realizing that this very grandeur could easily prove dreary. His conclusion? "Finally let me state the opinion that if a high degree of architectural splendor is suggested by the

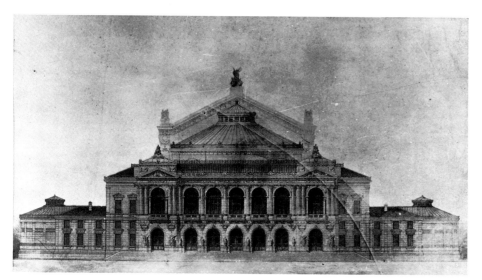

purpose of the building, its elements should not be borrowed from other structures having a different purpose; instead they should express the special function of the Opéra by a definite character—a character which, in my opinion, ought to be equally determined by the beauty of exterior forms and by the appearance of interior comfort which good society looks for in the places it frequents."[24] Serious demands— yet only a month later, on receipt of the modified design, Duban could declare himself satisfied: "Garnier has directed himself to tempering the rather cold majesty of the facade by introducing forms more at the human scale, so to speak, as well as materials calculated to animate its appearance."[25] The final hurdle was passed. Garnier could proceed more or less as he saw fit.

A collection of essays, *A travers les arts* (1869), eventually aired the architect's views in print, but it should have been obvious to most readers that the book simply gave written form to ideas already manifested in design. (The facade had been unveiled in 1867, and lithographed sets of drawings were available two years before.) For example, when in an essay called "La Décoration artistique" Garnier asked if a building should be the product of one intelligence or many, the question was rhetorical, its answer apparent even before he marshalled names like Michelangelo, Raphael, Scamozzi, Sansovino, even Giotto, to prove his point. Garnier held to the position he himself had already taken in practice; he urged the necessity of a single architect versed in all the arts as the sole means to guarantee a unified composition. Unity is the result of harmony, which in turn is secured when an architect studies the placement of individual decorative elements—painting and sculpture—so that they identify perfectly with their surroundings. Each has its own specific province, to be sure: painting contributes color, or *la tache*, as Garnier called it, using the term like a draughtsman applying washes to a design. "The principal, the only aim of decorative painting in architecture is to attract attention to parts of rooms which are more emphasized than the rest."[26] And sculpture? "It is form which must dominate in sculptural decoration, even when it has a polychrome trim; not the particular form of each muscle or each part, but rather the general form, the silhouette."[27] Painting adds emphasis to architecture, but sculpture in many ways becomes part of it. Like architecture it submits to laws which Garnier summed up as those of opposition, truth, firmness, and silhouette. The relationship means that in making sculpture, still further guidelines must be followed: "The artist must avoid indecisive contours, stiffen strong lines and boldly emphasize indentations and gaps as well as clear and decisive proportions."[28]

In the course of this essay, Garnier never once mentioned his own designs; theory should not sound like self-congratulation. But earlier writings—not theory, but ministerial

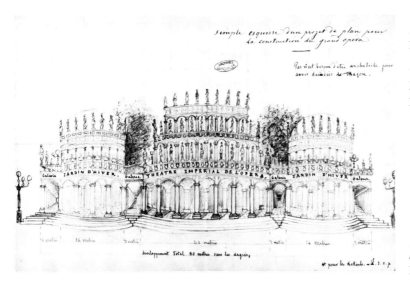

219. Charles Garnier, *Preliminary Project for the Façade of the Opéra*, 1861, pen, ink, wash, and pencil on paper. Bibliothèque Nationale, Paris.

220. Charles Garnier, *Preliminary Project for the Right Pavilion of the Opéra Façade*, 1861, pen, ink, wash, and pencil on paper. Bibliothèque Nationale, Paris.

221. Comte G. Roussäy, *Simple esquisse d'un projet de plan pour la construction du grand Opéra*. 1861, pencil, pen and ink. Archives Nationales, Paris.

reports—reveal how much his later decisive tone owed to a practice of architecture which had already begun to take shape under his direction. In 1863 he wrote, describing the role of the roof sculptures, "From the point of view of the monument's decoration these are the most useful; they will give it accent and movement, break up long lines and lighten large masses; finally, with their energetic profile, they will stand out against the sky and characterize the structure."[29]

These early ideas are as telling as their public, published versions. Heir to his training, Garnier believed in sculpture primarily as an element in the architect's vocabulary, an extension of architecture proper, used for its formal properties to articulate a building's lines and volumes. In the case of the Opéra, this meant symmetry, most of all: a façade and the planes behind it governed implacably by laws handed down by the lyre-holding Apollo; first to Musique and Poésie, on either side, and from there down to the four big groups on the terrace. Left reflects right, and vice versa; the mirrored sculptures raise opposite arms, so that the building is enframed, bracketed within their forms. It was a commonplace of mid-century design treatises to speak of the eye being led or restrained by lines which can control it.[30] This was Garnier's language, and he put his views into practice on the Opéra, using an insistent symmetry which makes his system replicate itself. As Ernst Gombrich would say, this is a scheme of decoration which maximizes redundancy, thus visual comprehensibility, since its whole logic is based on reiteration.[31] But, still following Gombrich, it is also a scheme which, because of this very repetition, discourages a viewer from reading further. Forms duplicate each other regardless of ostensible meaning as *musique* or *poésie*, say, so that meaning is inevitably eroded.

Garnier did not use the term redundancy, it is true. Instead he declared that works of art lose their individual character once in place on a building, to be reconstituted in the new context as real decoration, parts of a whole: "elles perdent leur caractère individuel pour constituer seulement une vraie décoration."[32] For Garnier this loss of individual character was an article of faith, just as is redundancy for Gombrich. Like many statements of belief, it was pronounced without proper testing; in 1866, when it was written, no monumental sculpture was yet in place on the Opéra. Garnier simply trusted that his symmetrical scheme would produce a visual order strong enough to outweigh individuality, to produce the "unity" that was his architectural goal.

He was mistaken. It proved—still proves—impossible to conflate *La Danse* with the other three groups on the Opéra façade: no one bothers to call *them* masterpieces (figs. 222–24). Within weeks of the unveiling, Garnier was being taken to task for the discrepancy;

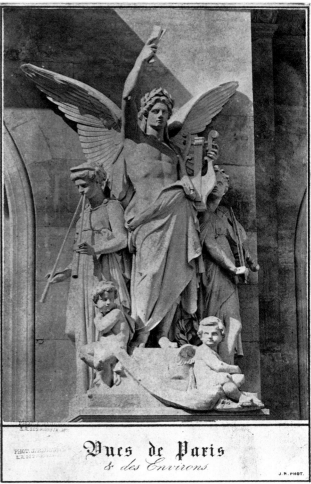

ironically his own essay, "La Décoration artistique," was cited chapter and verse to bring the charges home.[33] An explanation was thought in order. What needed explaining was why the work was ever allowed there at all. Why was Carpeaux not required in the end to make his sculpture look more like the others in its category? The question was the more pressing since, in keeping with his theory, Garnier tried to control the form of the groups from the outset. Each sculptor was issued both a plaster maquette of his site and two measured outline drawings defining the necessary silhouette in profile and full face (figs. 225–26). And Carpeaux, as a relatively late arrival, was urged to work from the example of the other artists: "I am sending you the plaster and the drawing for the facade group. Try to see Guillaume before beginning. He has already done some sketches and knows more or less what I want."[34] Or: "This morning I went to see M. Jouffroy's sketch with Perraud, and I established the outline of the whole. So before you get fully mixed up in yours go see it. . . . But it goes without saying that his sketch is only one chosen layout, and that it need not hold you to anything in the arrangement of your group."[35] There is no way to be sure if Carpeaux did visit Jouffroy's studio in the rue Notre-Dame-des-Champs. He does seem to have called on both Guillaume and Perraud, however, and even sketched the preliminary versions of *La Musique* and *Le Drame lyrique* which each had already begun (figs. 227–28).[36]

These instances are only a few examples of Garnier's concern for the form of Carpeaux's work; they can be multiplied at length. We have his words, for example, to show his

224

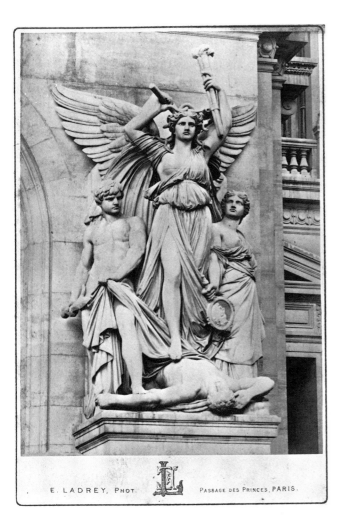

E. LADREY, PHOT. PASSAGE DES PRINCES, PARIS.

222. E. Ladrey, photograph of François Jouffroy,
L'Harmonie, c. 1869. Bibliothèque Nationale, Paris.

223. J. Raudnitz, photograph of Eugène Guillaume, *La
Musique instrumentale*, c. 1869. Bibliothèque Nationale, Paris.

224. E. Ladrey, photograph of Jean-Joseph Perraud, *Le
Drame lyrique*, c. 1869. Bibliothèque Nationale, Paris.

225. (below left) Charles Garnier, *Scheme for an Opéra Group,
full face*, 1865, pen and ink on graph paper (26 × 20.3).
Cabinet des Dessins, Musée du Louvre, Paris.

226. (below) Charles Garnier, *Scheme for an Opéra Group,
profile*, 1865, pen and ink on graph paper (29.3 × 20.9).
Cabinet des Dessins, Musée du Louvre, Paris.

belief that the group was to communicate movement: "The last thing we want," he wrote, "is three little stick-straight guys all in a row."[37] And the architect was confident that the statue ought to make some relationship to dance as it was then practiced at the Opéra: he helped Carpeaux to arrange visits to the Foyer de la Danse, where ballerinas received male callers (Petipa, the reigning dance master, was to accompany the artist, perhaps to lend the occasion a more businesslike air).[38] Garnier provided more routine services as well, fielding Carpeaux's questions, inspecting and approving Carpeaux's sketches, maintaining contact as the sculptor completed his half-size model and then, with a hand-picked group of *praticiens*, began to carve the group *in situ*.[39] Much of this business was carried out in hastily arranged meetings whose informality only slightly masks their administrative necessity. Once a year, however, Garnier openly assumed an official tone, in the annual reports he submitted to the Ministre des Beaux-Arts. These assess all the groups for the record, and estimate their progress towards completion. The year in which the groups were formally commissioned, 1865, marks their first mention in his report.[40] From it we learn that Guillaume and Jouffroy had both completed their small sketches and were about to begin half-size models. Illness had interrupted Perraud's work, but he needed only a few days more. Carpeaux had finished his sketch, in a manner of speaking. Garnier noted: "There will doubtless be some modifications necessary to harmonize it with those of his fellow sculptors."

Although these modifications are not again mentioned in the official dossier, Garnier must have considered them satisfactorily completed. The evidence is found in his 1866 report, where he compares the four works:

227. Jean-Baptiste Carpeaux, *Study of La Musique*, c. 1866, black pencil on graph paper (24 × 17.1). Cabinet des Dessins, Musée du Louvre, Paris.

228. Jean-Baptiste Carpeaux, *Study of Le Drame lyrique*, c. 1866, black pencil on cream paper (14 × 9). Musée des Beaux-Arts, Valenciennes.

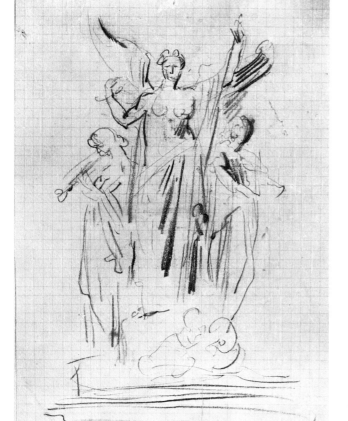

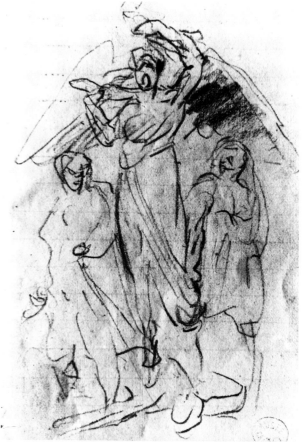

These groups are distinguished from each other by great qualities: that of M. Jouffroy is simply composed, with pure lines. That of M. Guillaume is arranged with great art and finesse. That of M. Perraud is impressive, and that of M. Carpeaux is vivid and coloristic. All the groups are marked by the various talents of their authors, even while they conserve general lines which harmonize among them.[41]

As criticism goes, this is rather prosaic stuff; what the passage really provides is the reason *La Danse* was allowed on the Opéra. It was there because of Garnier's theory, his belief in the power of lines to harmonize four individual works. And it is just about possible to see the requisite silhouette in *La Danse*, to claim that it suggests the necessary profile even though it suggests much else besides. The group does align along the key vertical, marking it with the *Génie*'s left arm to parallel or reflect the energies of the other groups and enforce the ruling symmetry. The wings trace their prescribed arc against the building proper; if one squints, the dancers can just about be compacted into the required number. Garnier apparently trusted that this reading of *La Danse* would dominate, and his faith was shored up by his conception of the architect as majordomo of the arts. He meant to equal his Renaissance heroes, who fostered a sculpture at once ornamental and masterly; he wanted a masterpiece for his building, yet he still believed that his decorative geometry would have the final say.

It is remarkable that in these letters and reports Carpeaux's subject was never mentioned; even the official commission left it unnamed.[42] The sculptor himself found the omission peculiar: to Garnier's suggestion to visit Guillaume he replied: "Thank you for the kind advice to consult with Guillaume about the sketch but I would like to know directly from you what subject you are giving me. Please let me know about this, because I would be terribly embarrassed if I didn't know the theme I was to treat."[43] The tone is polite enough, even though we sense Carpeaux finds it odd to be making such a request, and is anxious about not being fully informed. A full month later, he was still in the dark. By then embarrassment had evolved into irony: Carpeaux did not much like being the last to know. "I am writing to ask if my colleague Perraud has decided on his choice of subject so that I can get on with whichever one chance allows me."[44] Faced with *this* request, Garnier finally felt compelled to explain at some length:

My dear Carpeaux,

I haven't yet sent you the subject because I didn't want to do double work. I no longer remember exactly what was agreed with Perraud, and I'm afraid he has already begun his sketch. So I cannot tell you your subject exactly until after Perraud's return, which should be soon.

I am very upset at the delay, because we are going to be fairly pushed, and I don't want to hide from you that what you have to do seems to me very difficult.

The two subjects between which you float are Bacchic Dance and Amorous Dance, or some other kind of dance entirely, and Comedy and Drama.

You could already begin to think about the general arrangement, because we absolutely don't need three stick-straight little guys all in a row.

I hope to let you know what you have to do in a few days, and we'll try to make it come out for the best.[45]

In the end it was Carpeaux who did double work. He did not wait for Perraud's decision, but began drawing and modelling sketches on the theme of Comedy and Drama, which had first been Cavelier's assignment; Carpeaux apparently gambled on it falling to him and even submitted for Garnier's approval a maquette mounted on the mock-up of the

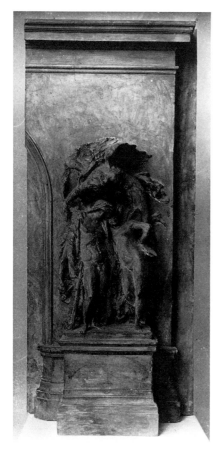

229. (above) Jean-Baptiste
Carpeaux, *Le Drame lyrique et la
Comédie légère*, c. 1865, plaster
(103.2 × 44.5 × 28.5). Musée du
Louvre, Paris.

230. (above right) Jean-Baptiste
Carpeaux, *Study of an Opéra
Group*, 1865, pencil heightened
with white (20.4 × 13.4). Musée
des Beaux-Arts, Valenciennes.

231. Delmaet and Durandelle,
photograph of a ceiling boss for
the Opéra, c. 1867. Bibliothèque
Nationale, Paris.

Opéra wall (fig. 229), as if that *fait accompli* could influence the outcome of events. The strategy failed. Garnier later called the sketch 'illegible," remembering its lowering, secret- ive winged genius, the male Drama, and female accompanying Comedy as a gloss on Adam and Eve bedevilled towards their fall.[46] But the group was really not illegible so much as inconsistent with the Opéra scheme. Carpeaux seems to have been urged back into formal correctness: a notebook sketch (fig. 230) shows him returning to the measured outline drawing and considering its provisions in terms of the site which he was ultimately assigned—even though he does not yet seem to know that his theme would be *La Danse*.[47]

Letters and drawings like these heap up circumstances around *La Danse*, so much so that it is worth noting how these circumstances boil down to a kind of opposition between subject and form. For Carpeaux, the subject was essential; for Garnier, forgettable. The architect's earliest drawings suggest that the carved decor was planned before its subjects were chosen, and for reasons we have seen, his attention was fixed on refining matters of form as he worked with his sculptors to translate graphic ideas into three dimensions. This way of proceeding meant that there was no real program for the Opéra; it developed ad hoc, with checks and changes of mind, and with awkward ideas like Jouffroy's *Génie couronnant le Chant et la Musique* eventually evolving into *L'Harmonie* and Guillaume's *Génie couronnant la Poésie lyrique et la Poésie légère* mutating into *La Musique instrumentale*. Though the ambiguity of Garnier's later statement "Everything I retained from Ovid's *Metamor- phoses* went into it"[48] is certainly unintentional, the presence of Apollo at the building's summit does not make the program mythological. Instead the building struggles to declare itself an opera house. The busts and medallions dotting the facade represent, not nymphs and satyrs, but composers whose identity is spelled out clearly in labels bearing names and dates. Huge mosaics announce the words *Choréographie* and *Poésie lyrique* without apply- ing them to individual sculptures (col. pl. IV). These and other inscriptions, inside and out, list more composers' names—Halévy, Rossini, Auber—and opera titles and ballets and dance masters, to give the building a specificity of meaning intended to work against the redundancy of ornament (fig. 231).[49] Texts are part of the building's public face, tying it down to a declaration of its function that sculpture alone could not secure. Or perhaps there is too much sculpture for the building to be legible without textual aid. In fact the only inscriptions which the prudent Garnier did not have written permanently into his structure were the Emperor's initials; instead, so the story goes, big bronze *N*'s were separately cast and affixed with a single, easily detachable bolt.[50]

On the Opéra facade two different yet complementary schemes—the formal and the textual, we might call them—are simultaneously at work. The architect's conception of a unified decor almost automatically rules out the possibility of sculpture which could perform any but the most restricted representational task. Hence the reliance on writing to circumscribe meanings otherwise left entirely too open. Both assume that a sculpture's subject, if not an afterthought, is somehow secondary to the main business at hand. But in *La Danse*, this is simply not the case. The subject is essential, because of Carpeaux's understanding of the way sculpture should communicate.

Perhaps the best way to make this case is through comparisons between *La Danse* and two other groups, Jouffroy's *L'Harmonie* and Guillaume's *La Musique instrumentale*. Garnier considered both exemplary, albeit of slightly different principles. *L'Harmonie* is the fulfill- ment of an architect's dream because, in Garnier's words, "it is willing to efface itself."[51] And Guillaume's effort is even more remarkable, Garnier decided, because "it functions as architectural sculpture while remaining sculptural sculpture."[52] Rather cryptic remarks, to be sure—yet it is possible to say why he distinguished between the two groups. The

difference is partly a matter of relative conformity to the outline: Jouffroy's work, strictly speaking, is more correct. But more than this, the difference is a matter of legibility. Jouffroy's solution so completely effaces itself as to be unintelligible. In 1869 it was variously called *La Déclamation* and *La Poésie lyrique* as well as *L'Harmonie*, with those identifications not involving misreadings so much as a lack of material on which a reading could be based.[53] There is a female figure with palms and crowns in her arms and at her feet; the two smaller characters, animate attributes carrying scroll and musical instruments, and thus perhaps Poetry and Music, should clinch the subject—but do not. A reading of Guillaume's group cannot help but be more conclusive (col. pl. V). It presents a standing man with lyre and scroll, two flanking females with a double pipe and violin, and a second scroll hung between two putti and covered, once upon a time, with the opening notes of the William Tell Overture. So the group, we decipher, represents Instrumental Music.

The claim here is not that this is a complex process of reading, or even an engrossing one. Nonetheless it is possible to agree with Garnier that this is "sculptural sculpture"—in other words, that it typifies sculptural communication in the 1860s. Works like Guillaume's group—or even Jouffroy's, for that matter—are meant to be read hierarchically, through a gradual process of association, of information gathered successively from subsidiary figures and read back onto the central form. The process adds up to a kind of sculpture by rote, if you will, where the interconnections between the parts of a work are either arbitrary or painfully obvious. The result is a way to keep ideas and meanings abstract despite their representational, material form.

La Danse demands a different process of reading (col. pl. VI). There is still a central figure, it is true, and his position means that he is a constant reference point. But any notion of decorum or hierarchical progress is useless here. Take the matter of proceeding to left or right to add in information carried by subsidiary figures. For *La Musique instrumentale* the process is uncomplicated. Either choice is valid, tenable until the requisite information has been gathered. In *La Danse* the opposite is true. Neither choice is stable or complete; neither can be maintained because the two dancers are connected by linked hands and are still further linked and interlaced. And the process of information gathering, of finding the attributes which might provide a meaning? Equally fruitless: initially there *are* no attributes, just bodies a-rhythmically rendered, all caught mid-step, mid-movement. The more we look, the more we are distracted by a shadowed, elusive face or legs that buckle and kick. The closer we approach, the more complete our distraction becomes— soon it is empty space or the feel of flesh that holds us. Only in the end, through the latticework of legs, do we spot anything at all that has the status of attribute. Happily waving his jester's wand, a putto hides beneath the dancers' feet. A faun's head is almost completely lost in darkness. Belatedly they signal the madness of the whole affair.

Because *La Danse* displaces or swallows its attributes, it does not follow that, as in *L'Harmonie*, no meaning is secured. Meaning is evident in Carpeaux's sculpture: this is dance, not because of a label or a scroll, or even the putto and faun, but because stone bodies take the poses of people caught in motion—because they are dancing. It is difficult to be not deceived by the quickness of surface here, and easy to slip into metaphors that make stone flesh quiver or dancers circle and sway (contemporary critics saw them sweating). We might call these effects realistic, but what we would really be saying is that this is a way of sculpting which locates meaning squarely in its rendering of the human body, and therefore goes to great lengths to achieve the necessary illusion of physicality and substance. This is the realism of *Ugolin et ses fils*, its exaggerations tamed but its disorders emphasized, so that the inward tensions of the earlier group here explode as movement.

230

VI. Jean-Baptiste Carpeaux, *La Danse*, 1865–69, Echaillon stone (h. 330). Musée d'Orsay, Paris.

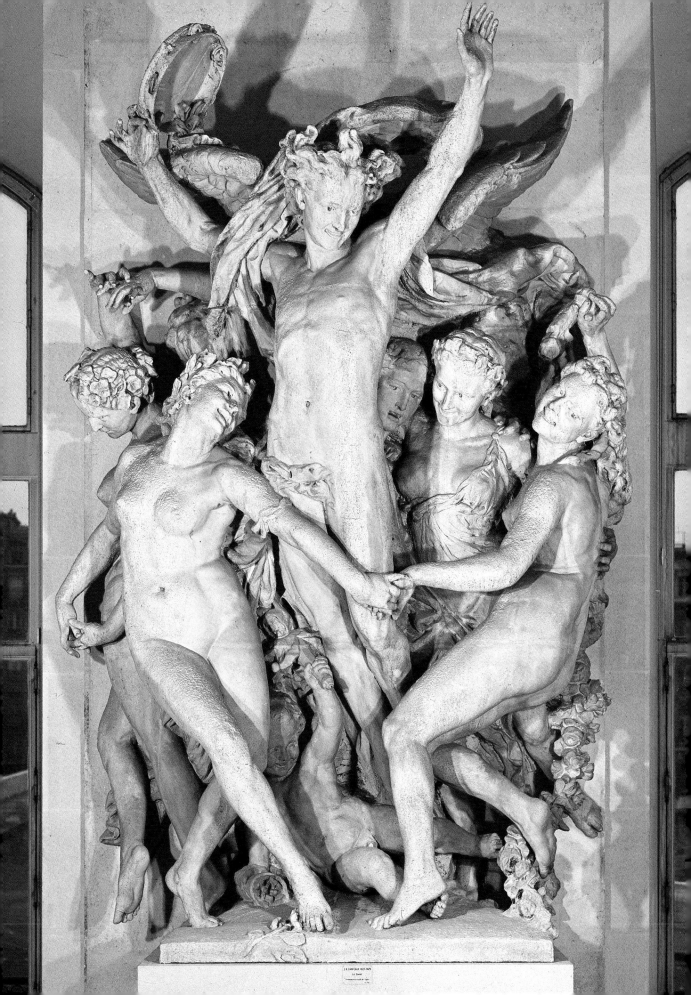

It might be objected at this juncture that such an analysis of *La Danse* has made my account jump its self-imposed boundaries. Surely I have presented reasons for considering *La Danse* a masterpiece, not a decoration. Surely Carpeaux was deliberately refusing the terms of the genre as they existed, and aiming to create a work *à part*, separable from the decent personifications of his colleagues. This was certainly the case: many of Carpeaux's drawings from 1866 and 1867, the period of his most intensely creative work on the group, reveal how much he was then preoccupied by great precedents—Raphael, Michelangelo, Rude— as if such study would infuse his design with their energy and mastery. His ambitions are characteristic; so are the delays which resulted: Carpeaux labored over the group for months after it should have been completed, buying himself the extra time with periodic announcements—in July, September, and October, 1867, and again in January, 1868—that he was *about* to finish.[54] These are the signs of an extraordinary investment on Carpeaux's part. Yet the fact remains that the context of creating a public decorative sculpture called that effort forth, and made it controversial.

That context also determined the way the public approached *La Danse*. They measured it, like its fellows, against the standard of public decorative sculpture, looking, with anticipation or misgiving, for what one critic called "the honest correctness of academic sculpture."[55] Such expectations were perfectly justified; three of the four sculptors in question were members of the Institut. Polite applause from gloved hands seemed in order.

It was not forthcoming, not least because the atmosphere into which the groups were released encouraged anything but polite assessment. Their presentation, for example, was stage managed like a piece of urban theater. For two long years the Opéra facade had been entirely hidden, housed behind a minimalist shell. Once that cladding came down, in 1867, smaller scaffoldings were left in place to keep the sculptures well screened from view (figs. 232–33). These were removed piecemeal throughout the summer of 1869, with the public dutifully gathering for each new revelation, and the press mocking the endless murmur of anticipation—"Sera-ce beau? Sera-ce laid?"—while contributing to it.[56] Even the usually loyal *Moniteur Universel* found the repeated ceremonies premature and rather unseemly: "The Nouvel Opéra shamelessly makes us witness all the crises of its growth."[57] Parisians did not seem to mind being offered this entertainment: some 6,000 turned out on July 26, 1869, when the four big groups were unveiled.

"Official" though they certainly were, these ceremonies played only a very minor part in governmental concerns that summer. The spring by-elections had seen republicans take seats in major cities like Paris, Lyons, and Marseilles. Twenty-five of these new representatives came from the far left wing of the party. The Assemblée Nationale took on a more intransigent tone. At the first meeting of the new session on July 6, it demanded that the government be confronted with "the necessity of satisfying the sentiment of the country."[58] A vote planned for early September would liberate the Senate from imperial supervision. Meanwhile orators at the newly legal public meetings had been urging an end to the Empire on a nearly nightly basis. (The meetings were attended by workers and leftists of various stamps; a journalist's worried report of their substance went through three editions between March and May 1869.)

No wonder the Bourse was panicky; it did not help that street skirmishes between police and workers were on the rise. The conservative papers, using standard diversionary tactics, gave extended coverage to imperial vacations and the imminent opening of the Suez Canal. Perhaps the endless Opéra ceremonies were meant to serve the same purpose. If so, the

tactic backfired: according to many critics, the building seemed more a symbol of Empire than a smokescreen for its difficulties.

The Opéra unveilings released a torrent of commentary from a press already in full spate (the combined printings of the daily papers had nearly reached one million).[59] Several standard forms for journalistic musing quickly developed, with their own tropes and small conceits. The art critics usually maintained a professional protocol: they confined themselves to a patient review of the three academic groups, only to let restraint fall as they turned to Carpeaux's effort. "As for Carpeaux", they wrote; this phrase—the contrast it established and the invective it unleashed—will occupy us before too long. Yet the professional opinions pale before the multiple comic or pseudo-comic efforts of the journalists at large. There was a general concensus that the Opéra—and more particularly *La Danse*—was the natural site, that summer, for all manner of journalistic "play": imagined dialogues, invented ballads, ersatz letters to the editor (these last, in *Le Charivari*, mimic the reaction of a befuddled Terpsichore to the way Carpeaux had rendered her art).[60] Most of this material is interesting because it exists, more than for what it says.

It exists because reacting to the Opéra, especially *La Danse*, was seen and represented as a collective experience, an urban prerogative and pleasure. As a result, there is a marked self-consciousness to many responses. The press repeated itself and each other with heightened frequency: "on lit dans *la Patrie* . . ."; "on lit dans *le Rappel* . . ."; such phrases introduced great chunks of opinion, lifted whole cloth from another newspaper. (*Le Charivari* mimicked this phenomenon as well; it invented false opinions and blithely attributed them to the declared enemies of *La Danse*.)[61] Journalists developed ways to describe the phenomenon of "seeing the Opéra" which depended entirely on a consciousness of the urban spectacle for their effects. For example, there is the rhetorical question, "How, from where, should one see the Opéra?" It is asked most pointedly in the opposition paper *L'Electeur Libre*. And the answer follows: from Meudon, miles away, where at day's end the tired Parisian could survey the great panorama of his city and compare its proud monuments—the Panthéon, the Invalides, the Arc de Triomphe de l'Etoile. Each one was a symbol, and in fact this sweeping display made Meudon the perfect site for *critical* seeing, since it allowed the Opéra to suffer by comparison. "Then one sees a shapeless mass . . . which dominates everything. It is the Opéra, the temple of pleasure. The monument is enormous and will be splendid, it is said. What is sure is that it will cost our pockets dearly."[62]

Or there is the conceit of seeing the Opéra from the boulevard, through the eyes of an approaching *flâneur*. This is the note struck by *La Vie Parisienne*, a weekly whose masthead summarises as its aim the illustration of "elegant customs, novelties, fantasies, theater, music, fine arts, sport, and fashion." We read:

At five hundred paces, one sees white, nothing more, bright white on a grey ground . . .

A little closer, some people think they can see a boat full of laundresses with lots of laundry drying in the open air.

Closer again, and one thinks no longer of the Alpine glaciers but of a neapolitan ice . . .

Closer still, among the white masses one distinguishes certain details, and one in highest relief, above all: these are wings, wings and more wings . . .

At a hundred paces, it becomes a corner in the studio of a plaster caster . . .

At ten meters, one is just about sure of the truth: these are statues, in profusion, and brand new; a troop, or better, because of the wings, a flight of statues . . .

There is a crowd all around, a crowd of the curious.[63]

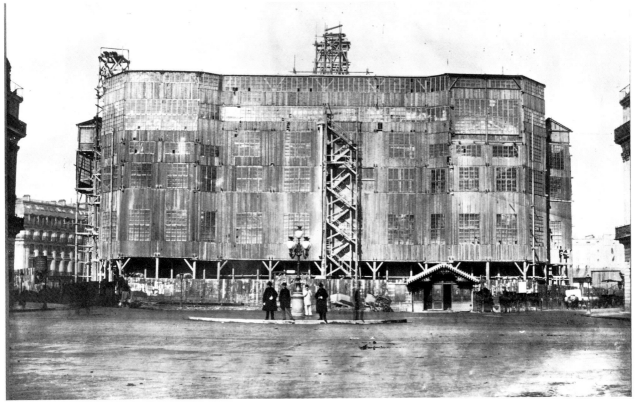

232. Delmaet and Durandelle, photograph of the Opéra under construction, c. 1865. Bibliothèque Nationale, Paris.

233. Delmaet and Durandelle, photograph of the dome of the Opéra, c. 1867. Bibliothèque Nationale, Paris.

Seeing the Opéra meant, above all, seeing *La Danse*; and a whole sub-category of journalism developed to retail that phenomenon. There were the usual rhetorical questions: "Have you seen *La Danse*?" Or a journalist would let his readers know whether he had done so, and how and why:

> I should and will say a few words on the question of the group *La Danse* by M. Carpeaux. . . . First of all—*I have not seen the group* . . .[64]

This is Charles Yriarte speaking to the readers of *Le Monde illustré*; oddly enough, his profession of ignorance leads to a lengthy defense of an artist whose skill he admired. In fact, he believed he knew enough about Carpeaux's talent in general to dispose of the various charges made against it in 1869, without clouding the issue by a description of *La Danse* itself. This is a peculiar defensive strategy; it is hard not to wonder if Yriarte adopted it simply because he *had* seen the group, and was as bemused as anybody else. Certainly the same kind of evasive tactic could be used not to defend *La Danse*, but to attack it:

> When the four groups were rid of the sheds constructed to shelter the sculptors, we were . . . unable to make the trip to the Opéra. But the clamor raised against the group *La Danse*, by M. Carpeaux, quickly came to our ears. "You have not seen Carpeaux's group!" one man exclaimed to us. "Oh, my friend, what filth. It's base, it cannot stay there." "For heavens sake, go see Carpeaux's group!" another exclaimed, "but go, I beg you." "I've just come from the Opéra," said a third. . . . "Oh, what a bungle," cried another, "What a downfall for that boaster, that intriguer Carpeaux! Go and see his group, my friend, it's pitiful. No style, no elegance, just common forms. There's truth in the saying: the style is the man, and when one knows Carpeaux, one is amazed that a work which demands above all, grace and beauty, was commissioned from him; he is ugly and vulgar, he will always produce ugly, vulgar things. Believe me, he is done for, he will never recover from this fiasco."[65]

234. Cham, "Ne les regarde donc pas!" 1869, wood engraving. *Le Charivari*, 1869.

235. Gilbert, "Ah! ma fille . . .!" 1869, wood engraving. *Le Charivari*, 1869.

— Ne les regarde donc pas, ça les excite encore!

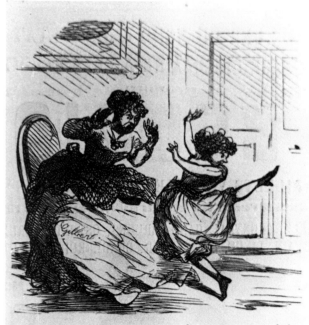

— Ah! ma fille, où as-tu vu danser comme cela!
— Mais dans la statue qui est devant l'Opéra.

Sometimes fictional characters were invented just to be shown seeing *La Danse*. Take for example a pair of Parisian men, connoisseurs both, and caricatures; their creator, an English correspondent for the *Continental Gazette*, no doubt meant their summer ensembles—white hats, blue spectacles, green-lined umbrellas—to be outlandish. He showed them standing for hours under the August sun, discussing the finer points of Carpeaux's rendering of anatomy and its relationship to that of real dancers, which they profess to know empirically. Are dancers all muscle, or do they have legs like matchsticks (*des mollets*)? One speaker is sure that Carpeaux's young women are utterly, impossibly musclebound. The other disagrees:

> Fictitious, my dear Monsieur. It stands to reason that Carpeaux has studied the question on living demonstration [*sic*]; and have you not lately read polemics on the subject in one of our recent dailies, in which a writer declares that the most hideous thing *au naturel* is the lower part of the leg of an *assoluta* ballet dancer? Of course the weight of the body always being on the lower joint must in time define the—
>
> Sir, art is not anatomy. I am not a realist.[66]

In the short-lived opposition paper *L'Universel*, it was a fictional worker who was shown doing the seeing:

> Going, like everyone else, to see the ink spot on the Nouvel Opéra, I heard a worker say to his comrade:
>
> Look, there's the Empire.
>
> He pointed to Carpeaux's group.
>
> I myself looked, mechanically, for the twentieth time . . .[67]

This kind of commentary is hardly criticism. It is mostly pure journalism, penny paper stuff, even though sometimes the papers cost several pennies instead of one. It naturally makes the reader want to "do it in different voices" as Dickens says, so critic and worker and toff will all stand out. This is not to say that real problems and issues are not sometimes

236. Cham, "Tiens, mon ami," 1869, wood engraving. *Le Charivari*, 1869.

237. Gilbert, "La furia de la danse," 1869, wood engraving. *Le Charivari*, 1869.

— Tiens, mon ami, nous pouvons maintenant conduire notre fille au bal Valentino ! Elle vient de regarder le groupe de M. Carpeaux.

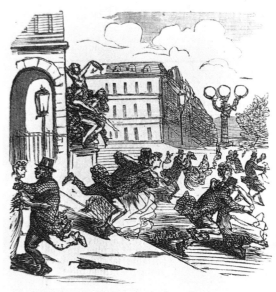

HORREUR !

La furia de la danse qui se trouve dans le groupe de M. Carpeaux finissant par se communiquer aux passans !

carried along in the general flow of drivel. The word *realist*; the aspersions cast on Carpeaux's reputation; the equation of *La Danse* and the Empire: these topics recur in more thoughtful contexts. Here, though, they are nearly submerged in a more homogenous discourse, the language of the Spectacle. It helped to send people to see *La Danse*.

The caricaturists, not surprisingly, used the same devices, albeit with rather more flair. All their responses to *La Danse* center on seeing. First there is the exhortation not to look: "Ne les regarde donc pas—ça les excite encore" (fig. 234). And the good Monsieur whisks Madame away from the awful sight. Then there are the consequences if looking does occur: the little girls who lose all sense of decorum (fig. 235), or their slightly older sisters, who are initiated into the habits of the music hall by way of the Opéra (fig. 236). Worse still, there is the population gone mad and reduced to marathoning beneath the lampposts (fig. 237). *La Danse* was thought to show things one ought not to see, or ought not to see in public, and caricaturists regale us with the results. Yet it is not an entirely idle exercise to wonder just how Monsieur knew that looking at dancers "excites" them even further.

Comic criticism and caricature are soft versions of a hardcore genre, the practiced columns written by professionals. It is comedy's particular strength, when it succeeds, to seize the essence of notoriety, the thing that makes a person or event worth satirizing. This occasion was no exception. The art critics were bedevilled by the very issues which the cartoonists send up. For instance: they too devised a version of the seeing trope, and used it seriously to measure *La Danse* against the building and its fellow groups. More important, there was a widespread effort not just to *see*, but to *say* what *La Danse* represented and why it should not be looked at. The task carried with it its own hazards, however. The word *bacchante*, the critics' name for sculpted dancing women, goes only so far, and in any event seemed only moderately effective. Other efforts—*La Ronde, La Kermesse, La Choréographie*—were equally inappropriate. One newspaper went so far as to print Carpeaux's (real or invented) response to a question about the kind of dance he had depicted, as if the artist might offer a name to put an end to the discussion.[68]

Sometimes a critic's column is the record of the difficulty he unwittingly found in giving the sculpture a name at all. This is the case with the response of Arthur Duparc, an old hand at viewing sculpture. Writing in the liberal Catholic review *Le Correspondant*, he began bravely enough, carefully maintaining a tone of decent restraint and self-control: his aim, he wrote, was an "impartial judgement," and he pursued it carefully through seven long paragraphs. In the eighth, however, his resolve began to slip:

> From everything we have just established, it follows that M. Carpeaux has made a very remarkable work which one would like to admire without reservation and call a masterpiece, if beauty, the splendor of truth, which alone makes a masterpiece, had not been systematically excluded from the group.
>
> In fact, the selection of forms has been neglected, and nobility of feeling and thought are found nowhere in it; instead there is a familiarity, a lowering of inspiration, which are painfully shocking and which force one's judgement to exercise vigorous severity, despite the qualities which I have noted. Without reminding M. Carpeaux that the dance is a noble art as the Greeks practiced it, without asking him to confine himself to a severe style, without forgetting that the Opéra is a monument to pleasure and entertainment, I would at least reproach him—and rightly—with the deplorable triviality of his characters.[69]

At this point, despite all the brakes Duparc had built into his remarks, his restraint finally gave way. He continued:

The women he has chosen as types are neither goddesses nor even bacchantes as the poets have characterized them, and dance as he has expressed it has no name in any language; it addresses itself only to the lowest instincts of humanity, and if it were necessary to characterize these women and their dance, I would be obliged to borrow from the repulsive vocabulary of the *barrières* and *bals publics* terms which would make this review blush.

Here Duparc stopped. He turned away, in the end, from naming the things that could be uttered only in argot, and the pure cheek of *Le Correspondant* remained unstained.

Other critics were less reticent, more impervious to blushes. They did not mind dipping into that "repulsive vocabulary" when decency demanded it. For them the carved stone women were not bacchantes, but courtesans, even *filles*. They were not just joyful, but frenzied with drink; their flesh was used, soft, flaccid, thick, swollen. In a word, a critic wrote, "They stink of vice and reek of wine."[70] These were women who used the words Duparc would not say, women whose dance told the same tale as their bodies. Their language was the slang of the public balls, their habitat, and their dance was equally common, equally debased.

Such charges were usually rather boldly stated. Carpeaux "sculpted some dancers of the bal Mabille in their most daring postures."[71] The group is the "apotheosis of the can-can,"[72] or, worse still, it enacts the "licentious can-can of Carpeaux's loose women."[73] This dance, of course, was familiar enough to need no explanatory preamble: it was the idiom of the bal Mabille or the Eldorado, those fixtures of modern, decadent Paris. For many writers the connection between *La Danse* and the dance hall was unavoidable. Thus when *Le Nain Jaune* described the group's defenders as ready to resort to blows "tout comme à Mabille," the phrase was doubly appropriate; its opponents likewise were identified by their resistance to equally modern (and debased) manners: "For them, what is called 'the modern nude' is too immodest; these women are not even bacchantes; these are wantons from the brothel whose very dimensions—thin or sturdy—evoke the lewdness of the Roman bacchanale. In the end, to use the modern terms, they are Tourne-Crême and Fifine of the Casino, la Markowich and other cocottes from our public balls and theater boards, dancing before their 'protectors' after a carnival supper."[74] No wonder that time and again the proposal was made to pack the group off to a *bal public*, where its rhythms and paces were in use and a more suitable audience had gathered. *La Danse* was art for can-can dancers, who were already inured to its excesses. La Comète, the famous Rigolboche, la Normande, Flageolet, Clodoche: these dancers too are named in reviews of *La Danse*, made witness not only to the license of Carpeaux's sculpture, but also to its contemporaneity.[75]

Identifying *La Danse* with infamous dancers and notorious night spots was one way which critics found to describe the group's qualities. But other epithets were also useful. Critics wrote about the group's *realism*, its *modernity*, its *modern feeling*, repeating these terms in both admiration and condemnation. The group was said to be using its hands and feet to perform "the most realistic pantomime imaginable."[76] "What cultivated spirit could applaud this attempt at gross realism in sculpture?"[77] "The sight of beauty, the ideal, contrives to be a more powerful way of moralizing than these realist exhibitions to which M. Carpeaux has given the surprising consecration of his talent."[78] The group was "too realist, too modern";[79] its reality was "trivial, but quick with life."[80] And so on.

To call *La Danse* realist or to propose its consignment to a café or *bal* were different ways of addressing the same phenomenon. The work could be termed both immoral and modern, with the same formal qualities leading to each conclusion. Sometimes a critic

could be attracted to its modernity—but repulsed by the baseness of the morals which accompanied that quality. For most critics the two readings were not easily compatible; they competed for primacy, sometimes with curious results.

This is the case with Georges Lafenestre, critic for the *Moniteur Universel*. His opinion of *La Danse* preserves the record of just such a struggle. Morality wins.

> We can only applaud in the presence of such rare, individual artistic force which no medium can resist, and which knows how to extract from the hardest stone creatures as nervous and alive, as supple and passionate as these. *La Danse* is a bacchanale, the most violent, unbridled, impetuous bacchanale ever to have shattered a voluptuous night of an antique summer. . . . Standing on a rock, a nude man, tambourine in hand, quivers frenetically, arousing the circle of howling dishevelled maenads which boils around him. Shivering, feverish, exhausted, these drunken women whirl at random, smiling with a lascivious, dazed air. As if at the point of exhaustion, holding one another by the hand or on the flank, they collapse into each other, ready to roll in the dust, while already under their cruel feet a little putto writhes. Ah, if only these lost dancers were Greek women with their splendid bodily attitudes and forms. But no, no, look at those hard faces which provoke the passerby with their furious rictus. Look at those tired, sagging legs, those flaccid and deformed torsos, and admit it, we are in the midst of the 19th century, in the midst of a diseased and undressed Paris, in the midst of realism. This realism is ardent, passionate, strong, I admit it readily—but it has absolutely no place on the facade of a monument consecrated to the arts.[81]

This is impassioned writing, among other things—far superior to the ordinary run of sculpture criticism, and far above anything Lafenestre himself produced in response to the other three groups. Although he thought Guillaume's the most successful, he could summon only the words *plain, direct*, and *suitable* to make his case. With *La Danse*, however, his writing ran away with itself and with him. He began with applause and ended with refusal; he moved from "supple" and "passionate" figures to sagging flesh and deformed torsos. He first saw bacchantes, only to replace them with diseased, undressed Paris—a synecdoche for whores. (The obligatory reference to *bals publics* follows apace in the next paragraph.) The entire passage is typical of criticism which engaged with *La Danse*, even abandoned itself to the not-so-onerous task of description, only to catch itself up and interdict public consumption of pleasures it had just tasted at length.

It is clear that the urgency to put a name to *La Danse* could lead into dangerous territory. Some critics refused to take the journey; others went willingly, only to try to bar the path to the public at large. The problem was not that this was an unknown, uncharted province; on the contrary, it was only too familiar. The references to Rigolboche and the can-can came unhesitatingly, and words like *modern* and *realist* were wielded with equal aplomb. Not surprisingly, Maître Courbet was sometimes brought on as a point of reference; his name served as a kind of shorthand for the same ideas.[82] Its use, however, should point us to the origins of the critical vocabulary I have cited, which Lafenestre employed to such effect. Words like *soft* and *swollen* and *used*, when applied to the female body, are the vocabulary of sex, but they are also terms which had already entered the critic's lexicon to describe nudes from Baudry to Manet.[83] By 1869 this phraseology was common enough to make individual inflections—a particular adjectival combination—seem meaningful. *La Danse* offers an instance where nudes were read as if intercourse was a barely concealed subtext to the issues already at hand. For George Maillard, accordingly, *La Danse* was "a madwoman, drunk and in heat."[84] His personification is absolutely vivid, entirely sex-

238. Gustave Courbet, *La Source*, 1868, oil on canvas (128 × 97). Musée du Louvre, Paris.

ualized, yet it slides over one aspect of the group which other critics found impossible to take: *La Danse* united two sexes in one work. For some viewers this was a disorderly, wasting union spoiled by a lack of fit between the male and his female companions. This issue could be broached only obliquely, it is true, yet the critics' language betrays their sense of a dangerous imbalance between the genders. For example: Ferdinand de Lasteyrie, critic for the Catholic daily *L'Opinion Nationale*, complained that "the dancers were too stout, especially in relation to the charming figure of the Génie who launches himself from the bosom of the circle and whose importance is thus significantly reduced."[85] For this writer, the difference is a matter of the respective *weights* allotted man and women; the latter are simply "too well nourished" to allow the Génie to surface from their embrace. No wonder it was female pleasure which seemed inescapable to other viewers: "These muscles contract, these breasts swell. This flesh shivers. These really are women drunk with pleasure."[86] Sometimes the dance can be said to depend, somehow, on the *Génie*: "With one hand he shakes a tambourine, with the other he makes a gesture to arouse the dancers who whirl around him."[87] Yet even for this writer, Maurice Chaumelin in *La Presse*, the contrast between the sexes cannot be avoided: "the chest and flanks of the *Génie* are emaciated, as befits a dancer who is unrestrained; his visage, though little aged, wears the imprint of debauchery; his eyes, which he lowers to the dancers, and his smiling mouth express lewdness. As for the dancers, they have taken on only the drunkenness of antique bacchantes; they are modern courtesans with huge haunches and buxom charms." These are features which Chaumelin—a Salon regular—recognized all too well: "The one at the right, the one falling backwards and supported by one of her companions whose hand sinks into her thick, soft flesh, that one reminded us of the famous *Baigneuse* by M. Courbet . . ." (fig. 238).

In *La Danse*, artistic issues and matters of sexuality seemed hopelessly commingled. And for most writers in 1869 their admixture was entirely unnatural, if not unfamiliar, a corrup-

tion of the noble purposes of public sculpture. Thus it is satisfying that for *La Danse*'s supporters—they did exist—its triumphant, public sexuality was the important thing. Two champions were especially vehement on this point. Both were professional writers; neither was an advocate Carpeaux himself would have chosen. One, Emile Zola, needs no introduction here, except to say that in 1869 and 1870 he was conducting a campaign of gadfly anti-imperial journalism, most often from the base of a newspaper in Marseilles. The other, Eugène Vermersch, was the first to take up the sculptor's cause.

The son of a Lille police officer, and a former medical student, Vermersch had turned his back on this heritage to contribute, during the mid-1860s, to a whole string of left-leaning publications—*La Fraternité, Paris Caprice, L'Eclipse.*[88] In 1866 he founded *Le Hanneton* and a year later was twice briefly imprisoned for his columns, once on the charge of inciting the military to riot, and once for offending public decency with an article called "Les Deux Pudeurs"—an exploration of the discrepancies between bourgeois morality and bourgeois conduct.[89] In this context he repeated the axiom which introduces this chapter: "A picture which represents a nude woman is only immoral by virtue of the stratagems which a painter invents to hide the things that the whole world knows." Yet Vermersch was not writing as an art critic: life concerned him more than art. And his view of the present was black: "Today shame is widespread, soaking into the whole fabric of life like a stain of oil." A catalogue of contemporary ills followed: bored and lifeless men; painted, doll-like women; their syphilitic, scrofulous children, who inherit their parents' diseases, and their stupidity; whores; pimps; pornography. Vermersch was twenty-two when he wrote this article; "atomiste et anarchiste" by his own admission, he compiled a list of his personal heroes—Hugo, Michelet, Sainte-Beuve, Littré, Wagner, Courbet, and Proudhon—while cooling his heels in prison.[90]

When in 1869 the editors of *Le Figaro* used Vermersch as the author of their lead article on *La Danse*, they must have known the kind of thing he was likely to supply, even if they may not have anticipated completely the fury it would arouse. (In any event, they could count on printing it, since censorship had been relaxed.)[91] Perhaps they felt justified by the fact that, like Zola, Vermersch considered *La Danse* a masterpiece, and for much the same reasons: its vital plasticity, its dynamic arhythmia, its blatant sexuality were forms of truth-telling only great art can achieve.

Yet the two reviews are otherwise different. Vermersch's column is, first of all, pure enthusiasm. The opening paragraph, for example, has five sentences; four end with exclamation points, and the staccato rhythm continues at the same rate, as if Vermersch was bent on telegraphing his reaction in graphic terms. The tone is hortatory, like a speech from a platform:

Finally, here is a living, quivering, passionate work, here is flesh, here is modern force and modern form! No longer are these Greek women, copied from the Museum of Antiquities, recomposed from ruined fragments like some antedeluvian animal put together from scattered debris. These are not the women of Phidias, of Cleomenes, of Praxiteles, or of anybody else—women, that is, whose model is lost or has never existed. No! These are women of the nineteenth century, women as we know them to be, Parisians of Paris in 1869! The chorus leader who backs them and excites them to dance is by the same token a man of our age, our immediate contemporary, and not one of those pretenses for muscles which smooth-talking chisel-wielders go to copy yearly at the Louvre for the Salon! And here is the miracle! M. Carpeaux has found the means to create a marvellous thing without recourse to antiquity; it's hard to believe![92]

240

239. Jean-Baptiste Carpeaux, *La Danse*, detail.

Or later in the article:

> The group is the irrefutable proof of the force of modern art and of the aesthetic resources of this century. Finally here is sculpture which is ours! Here is a national art! and a national art of 1869!

In 1869, these sentiments were fraught. A call for a national art, an art *à nous*, could only be a call to a republic separate from *them*, the empire. Such phrases are meant to be remembered like slogans and rallied around. And Vermersch's column, of all the dozens

of published reactions, was the one most often quoted by other journalists. His best phrases—the untranslatable "décolletage et déculotage" and "artistic lubricity", both of which he uses to describe contemporary dance—surface again and again.[93] Or long passages were introduced with the phrase, "On lit dans *Le Figaro*"; scathing condemnation followed. The Catholic daily *L'Univers* spat disgust at the writer: "Here is a man with a stout heart; he plunges himself into this work, and there pleasures himself, caressing with his hand what we would not touch with a foot."[94]

One explanation for Vermersch's enthusiasm for *La Danse* lies in his politics. In his essay "Les Deux Pudeurs," he condemned a bourgeois morality whose practice and preachings were radically opposed. More important, his imagery of the decay rotting every corner of society was tied back to clear causes, particularly a government which constrained the liberty necessary to any improvement. But art too was equally culpable, equally duplicitous in its prurient prudery. *La Danse* appeared within this context of duplicity. With its full, erect nipples and swelling pudenda it concealed nothing (fig. 239). For Vermersch, the group stood as the truth of the diagnosis he himself had made two years before. In representing what he saw—Parisian woman, Parisian dance, in 1869—Carpeaux had shown something which Vermersch himself considered corrupt. But exposing the truth of such corruption, saying the unsayable, was a political act which alone could lead to change. After the Commune, Vermersch was condemned to death *in absentia*.

His opinion of *La Danse* lent itself to a variety of transformations. For example, it lay behind the comment of that fictional worker who called the group the Empire. It colored the words of a song, "Le Groupe de Carpeaux," which *L'Eclipse* proposed be set, subversively, to the republican strains of *Marianne*.

> Faire vrai, c'est le pont-aux-ânes;
> Faire beau n'est pas si fréquent.
> Quoi? vous avez des courtisanes
> Et des pinceaux de can-can.
> Et des crèvés
> Mal élevés
> Et des agents de change décavés
> Et les ponteurs
> Et des sauteurs
> Des gens qui vont voir manger des dompteurs,
> Et vous voulez que l'art s'inspire
> Des grands principes éternels?
> Allons, messieurs les solennels
> Venez danser et rire.[95]

(To make something true, anyone but a fool can do that; to make something beautiful is not done so frequently. What? You have courtesans and can-can dancers, and ill bred swells, and failed stock brokers and gamblers and tumblers, people who go to see lion tamers eaten [Lucas, who died in August], and you want to be inspired by great eternal principles? Come, you solemn gentlemen, come dance and laugh.)

Even here, contemporaneity meant fidelity to the falseness of modern life and to the corruption of a population which buys and sells bodies, sex, money, and death.

In April, 1870, Zola made these same ideas his theme, and took them to an even more explicit point. He was writing in response to the news that the group would finally be

removed (in the end the threat was never carried out, as we shall see). In fact, Zola took it upon himself to supply the reason for the administration's decision. Offense to public morality was not the cause, even if the *menu peuple* was made to think so. Administrative interest in the group was more directly motivated. Why? Zola wrote:

I've found the reason. Let anyone dare to contradict me. It's very simple: Carpeaux's group is the Empire. It is a violent satire of the contemporary dance, that furious ball of millions: women for sale and men who have sold out.

On the stupid, pretentious facade of the new Opéra, smack in the middle of that bastard architecture, in that shamefully vulgar *style Napoléon III*, the true symbol of the reign stands out.

The columns have a lying heaviness; the other groups are there, stiff, rooted to the spot, disguised to deceive history; the whole monument, with its cold lines, its bourgeois luxury, its air of Prudhomme in his Sunday best, seems built to say to our grandsons: "See these cardboard statues; your fathers were chaste; and see these colored marbles, so tastelessly cut; your fathers were wealthy, but honest." Everything lies in this vast shack, the Empire hides its hot nights here beneath the bright daubing of a ten cent toy.

But all at once, the bodies of living women leap from that huge mummy case made up in yellow and red.

Imagine a senator getting undressed in the middle of a session, showing his wounds, performing the happy somersaults he turns for some little miss tart in her box at the Opéra. Or imagine instead a minister gone mad, and kicking through the can-can of his youth in the middle of an official reception. That's exactly the effect that Carpeaux's group produces.

In the dreary facade it cries "So's your sister!" It tells the other groups, "Hey, friends, don't look like that—we're all drunk and you're just vulgar scum, still standing there on your dignity." It sways its hips and swoons, it alone lives the life of the Empire, beneath the great lie of the building.

Sometimes art makes these unconscious cries of truth. One thinks one has carefully closed the alcove curtains; one imagines having draped them in a grave, chaste way. And then, look, a whore's legs stick out suddenly—trembling.[96]

Zola continued in this same vein, mining the group's sexuality, approaching obscenity himself, and enjoying it. *La Danse* was a grand indiscretion, a minister gone mad, a senator without his clothes. It was what goes on behind the curtain, the leg which sticks out from behind its decent covering to give the game away. It was the essential truth in the matter of the Empire, even though Zola was careful, even ostentatious, about presenting that truth in allegorical terms:

I would not have the cheek to make the crude declaration that this gentleman [the *Génie*] is none other than the Emperor; but I am allowed to say, I think, that the god is the poetical personification of Napoléon III, shown at a ball in the Tuileries celebrating his victory of December 2 [1851]. As for the women who writhe around him, they too are goddesses, if you wish; a nude woman is necessarily a goddess or a whore; but if they are goddesses, grant me that it is necessary to see them as the deified images of certain great ladies whom respect forbids me to name.

The reference to Napoléon's coup d'état returns the reader to the beginning of the Empire, to the first paces of the dance. And Zola's satire, with its violent ironies and imagery of

the sham and shoddy, takes us back to Marx's analysis of the same "farce," *The Eighteenth Brumaire of Louis Bonaparte*. Marx's book was made relevant once again as the Empire waned: it was reprinted in 1869.[97] Zola, for his part, was sure that *La Danse* was about the *end* of the story: "But the time came when the god, tired, aged, no longer conducted the dance with so much vigor. The handsome dancers could scarcely revolve round his nude figure; his tired arm had let the tambourine fall. From that moment on, the mad dance was only a page of history." This is the meaning, Zola claimed, which the administration had divined: *La Danse* showed the final truth about the Empire. It had to be hidden.

<p style="text-align:center">* * *</p>

No document survives to say for certain why the decision to remove *La Danse* was not carried through. There is, however, plenty of information about why it was taken in the first place. Not only did the group provoke journalistic polemic and doggerel, it touched off other, sometimes more violent reactions as well. *La Danse* was public sculpture, placed on the public thoroughfare, charged with the task of guarding and guiding public welfare. Thus the suggestion of shipping it off to a dance hall was not made entirely in jest. It had to be hidden. Some papers announced its impending purchase by a Turkish collector— perhaps the Khalil Bey, Courbet's outlet for pictures of nudes—as a satisfactory solution.[98] The public began to make its sentiments known directly in various ways. Garnier received anonymous letters from outraged citizens, while a certain M. de Salelles (the pun on dirt should not go unnoticed) gave vent to his anger in a thirty-page pamphlet considering *La Danse* "au point de vue de la Morale."[99] He gave as his motto the brave blazon, "J'appelle un chat, un chat."

240. E. Appert, photograph of *La Danse* stained with ink, August, 1869. Bibliothèque Nationale, Paris.

241. Gill, "L'Accident Carpeaux," *L'Eclipse*, 1869. Bibliothèque Nationale, Paris.

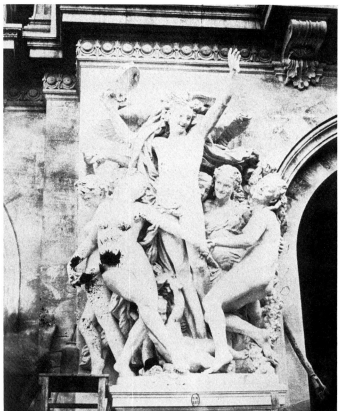

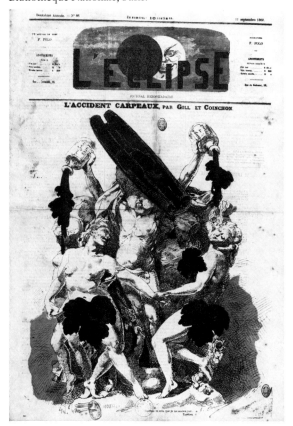

Pressure mounted. The group was vandalized, stained by an inky nocturnal ejaculation.[100] Rocks, placards, flowers, and laurel wreaths followed the ink bottle; five hundred people paid Carpeaux visits of condolence, while a hundred and fifty let letters suffice. A photographer appeared to document the damage, resting his oh-so-correct bowler virtually inside the incorrect statue as he released the shutter (fig. 240). Prints of the sullied group were sold illicitly on street corners and Carpeaux organized a police raid against the rival photographer in order to protect his own right to sell pictures of his group.[101] The press indulged in a new paroxysm of comedy and invective, and although the Catholic papers were on the side of the vandal, more responses now stood in defense of the group than against it. Bad puns flourished. "De l'encre sur la statue de Carpeaux. Comme on va *en crier!*" What kind of ink? *Encre de la petite vertu* or *encre de l'empereur et l'impératrice*—both, apparently, real brand names.[102] The ink spot could soon stand alone in place of the group, and Gill played amateur psychologist, Rorschach *avant la lettre*, transforming blots into fig leaves for the readers of *L'Eclipse* (fig. 241). Writ small, beneath his drawing, was the slogan of the day, an apposite line from *Tartuffe*: "Couvrez ce sein que je ne saurais voir" (Cover this breast I cannot bear to see).[103] Molière's motto prevailed. The decision was finally taken to remove the group; podsnappery held the field. The removal had been rumored almost immediately after the unveiling, though at that point Garnier had quickly denied the possibility in a letter to Carpeaux.[104] By late November, however, the architect had a different message to convey, and Carpeaux was forced to make his peace with it.

My dear friend,

There is something more explicit than the wishes of an architect, the good will of an administration, and the Emperor's order; that is public opinion, and it is that opinion which constrains us all to remove your group.

If it were a purely artistic question, we would have all resisted, and no one more than me, since for three years I have said to whomever wished to hear that your effort is a work of art and I do not deny it today. But it is a question of fitness and morality which is at issue, and this question goes over my head. I regret a decision which deprives the Opéra of a remarkable group, but from the moment that it does not have to do with an artist's talent, I have no grounds from which to fight it, and I must submit to a defeat which we share in common, but to which one can yield with dignity because artistic honor is safe.

As for the right which you seem to deny the administration—that is, of having your work removed—I believe you make a mistake. The administration can act like any private citizen, that is, it can dispose of works for which it has paid in any way it sees fit. It is that common right which it can exercise outside of any formal order from the Emperor.

I am sorry that you thought it necessary to lay your rather precipitate refusal before the press, a refusal which no doubt does you credit, but which ought not to have been unconditional.[105]

Once again Garnier was pointing out the boundaries of an artist's privileges: he must submit to money and to the authority of the administration which has employed him. The public patron exercised all the rights of the private citizen, even while constraining the artist with limitations irrelevant to purely artistic, i.e., private, commissions. The same conditions governed both architect and sculptor, Garnier claimed, but it goes without saying that he had already made his separate arrangements with the administration to which he conceded. Other letters indicate that these included smoothing matters over with Car-

peaux. The administration wished the sculptor to execute another group; or more properly speaking, the *model* for another group. The plan was to convince him to consign its execution to someone else, thus avoiding both the delays and the quick, vivid carving that were Carpeaux's trademark. Together Garnier and the government worried over the scheme, and tried to keep the newspapers from announcing it prematurely, before the deal was settled. Their caution was justified, though unsuccessful: Carpeaux publicly refused the plan, and even challenged the Administration's right to act without explicit authorization from the Emperor.[106] He agreed only to choose, with Garnier, a new site for *La Danse*—this time, inside the Opéra.[107]

For a new group Garnier turned to another old friend, the sculptor Charles Guméry, already the author of twin statues on the Opéra roof. (The two men had been taking the waters together in the south of France, when news of the inkspot reached them.) Guméry took on the task of replacing *La Danse*. By late February, 1870, he was ready to arrange an appointment for the administration to approve his sketch.[108] He got the go-ahead: his sketch offended no one. Both a plaster model and a stone version were finished (fig. 242); the design was even published in *L'Illustration*. The group itself, however, was never made public, at least until 1885, when the two versions were packed off to the museum in Angers.[109]

It is hard to see Guméry's "groupe de Carpeaux" (his name for the work) as anything more than a corrective to his colleague's errors—unless one rates it as something rather less. He pared the conception back down to three figures, now all the same gender, and clothed them in drapery which curves arbitrarily over and through their chaste, stolid lines. Guméry's dancers are bacchantes too, but that information is supplied as it should be: decently, through attributes—tambourine and thyrsus—and not through the figures themselves. Even though arms are lifted and legs bent, these women do not dance wildly or with abandon; they do not dance at all. Guméry has returned dance to the academic fold, to the province of standard Salon fare. Thus the resemblance between his effort and a mediocrity like A. Courtet's *La Danse Ionienne* (Salon of 1866; fig. 243) is more than coincidence. The two sculptures speak the same language, of proportion, of figure type, of interrelationship of parts—both with the "affreux barbarismes" about which Zola complained.

There was one essential language, however, which Guméry used even less effectively. This was the language of architectural sculpture as it was enunciated on the Opéra facade. Chaste though it may be, the group does not conform to the symmetrical system which Garnier had imposed on his artists. Perhaps it was a tardy recognition of this error (how did it slip through the initial inspection?) that finally stopped its installation. Perhaps it was simply that Guméry's dull attempt seemed to vindicate Carpeaux's group. Or the reason may lie in the fact that during the spring and summer of 1870, the administration had other fish to fry. The plebiscite of May 8, 1870, by which the government successfully sought ratification of its liberalizing reforms; its effort to counter increasing radical and worker opposition and their fruit of strikes, demonstrations, and the International; the war with Prussia, begun on July 19: *La Danse* must have seemed like small beer in comparison.

Where was Carpeaux in all of this? With his artistic honor intact, as Garnier assured him, because he had created a great work of art but conceded to public opinion? The suggestion was obviously meant to be soothing, although after months of journalistic accusations, it may have seemed to Carpeaux like too little, too late. He stood accused of vile thoughts and deeds, immorality and vulgarity, and these charges were explored

in depth. There were the salacious dreams he must have had as he carved the group; the profits he took from the scandal (his sales of photographs of the group did not help); even—so it was said—his effort to prolong his notoriety by himself arranging to have the group defaced.[110] (A caricaturist could address such a charge only obliquely, but Gilbert's sculptor-cum-miner who extracts *his* statue from a lump of coal to avoid the "inconvenience" of ink makes the point without too much evasion; fig. 244.)[111] Public memory was jogged by reminders of his authorship of *Ugolin et ses fils* and the portraits of the Prince Impérial, since such references invoked both controversy and obsequiousness.[112] The latter charge, which made Carpeaux out a lackey of the court, was pursued with a vitriol which says as much about the shifting fortunes of the regime as do the polemical responses to the group. Thus even a non-political review like the *Chronique des arts et de la curiosité* could declare: "The proud and independent man never appeals to the sovereign decision of the personage whose ear he thinks he has; he yields only before public opinion or the verdict of enlightened men." This description of moral integrity was patently inapplicable to Carpeaux; his conduct belonged to a different era. "The Emperor has nothing to do with the whole affair; it's not his purse which pays for the Opéra. . . . M. Carpeaux thinks himself still at Compiègne."[113]

Despite the vicious tenor of the hue and cry, Carpeaux was not called seditious. The label would have been incongruous, given the facts of his career. And Zola, for one, revelled in the disparity between the artist and his creature:

> The most curious fact is that Carpeaux, I am told, does not detest the empire. It appears that he has pursued the young prince with his friendship. And I am very grieved to trouble the quiet of an artist whose talent I like. Clearly he didn't think he was doing the job of an irreconcilable. But it is not my fault if God has made use of his chisel, unbeknownst to Carpeaux, as a revolutionary tool. The spirit strikes where it will.[114]

As Zola painted him, Carpeaux could only be called a naive traitor, if a traitor at all. But the writer nonetheless advised the first train to Brussels, for safety's sake.

Needless to say, Carpeaux did not take this pseudo-advice. His position with the imperial

242. Charles Guméry, *La Danse*, 1870, marble. Musée des Beaux-Arts, Angers.

243. Lithograph after Augustin Courtet, *La Danse Ionnienne*, marble. Reproduced from *L'Artiste*, 1866.

244. Gilbert, "Les sculpteurs remplaçant le marbre par le charbon de terre . . .," 1869, wood engraving. *Le Charivari*, 1869.

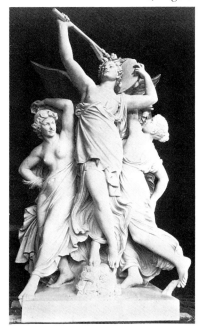

Les sculpteurs remplaçant le marbre par le charbon de terre pour éviter l'inconvénient des taches d'encre.

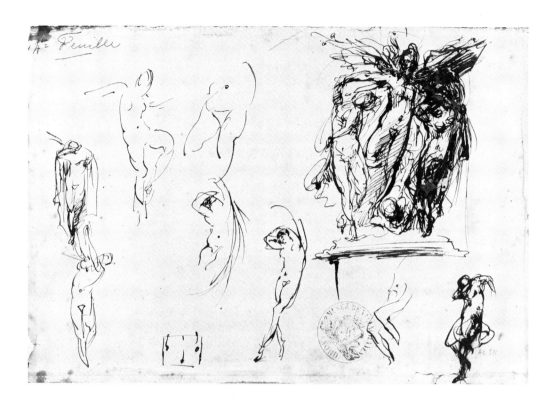

245. Jean-Baptiste Carpeaux, *Plusieurs croquis pour la Danse*, c. 1866, pen on cream colored paper (19.8 × 30.4). Musée des Beaux-Arts, Valenciennes.

246. Jean-Baptiste Carpeaux, *Sketches of Three Female Figures*, c. 1866, black crayon on greyish white laid paper (26.8 × 20.5). Art Institute of Chicago.

247. Jean-Baptiste Carpeaux, *Five Dancing Female Figures*, c. 1866, pencil, red and black chalks (20.5 × 12.8). Art Institute of Chicago.

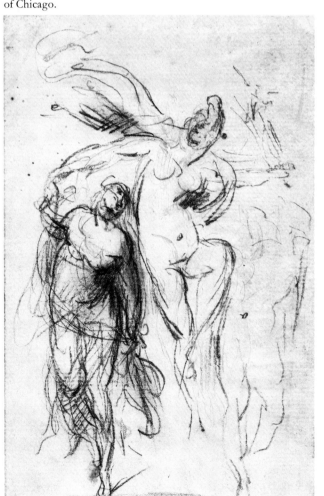

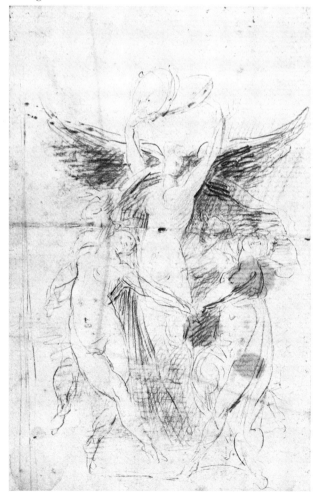

family remained secure enough to merit a summons, in 1873, to undertake a final, posthumous portrait of the deposed emperor. Nonetheless Zola's assessment of the relationship between artist and work has its own force, and its basic conceit is one much used by later criticism in other contexts. The artist's intentions are not strictly pertinent to the question of a work of art's meaning; the reaction to *La Danse* could be cited as evidence to prove this case. Does it matter whether the official sculptor of the Second Empire actually *meant* to create an anti-imperial work? The answer depends on what we mean by *meaning*. Perhaps, as Zola claimed, this is a case of the cunning of Reason knowing no limits, or the Lord working in mysterious ways.

And yet there is a real problem lurking behind Zola's conceits. It is not exactly the problem of artistic intention, though even that intractable issue takes on a little concreteness if we look more closely at Carpeaux's working method—at the various stages of his conception. Those stages are necessarily tied to the development of Garnier's Opéra scheme. They trace Carpeaux's effort to work with the various fragments of information—format, location, subject—which Garnier sent along piecemeal. The definitive scheme finally began to fall into place in drawings now at Valenciennes and Chicago (figs. 245–46). Nude women dance alongside a winged figure; the small groundplan mapping the relation of figures to base on one of those sheets testifies to Carpeaux's effort to keep Garnier's orders in mind. Two later drawings, also in Valenciennes and Chicago, work to regularize this first

248. Jean-Baptiste Carpeaux, *Etude pour la Danse*, c. 1866, pencil on white paper (13.8 × 9.3). Musée des Beaux-Arts, Valenciennes.

249. Jean-Baptiste Carpeaux, *La Danse: sketch*, c. 1866, plaster (54.5 × 34 × 29.8). Musée d'Orsay, Paris.

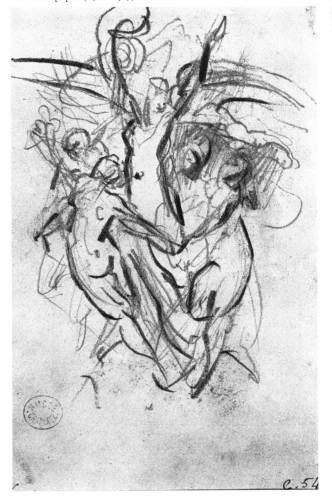

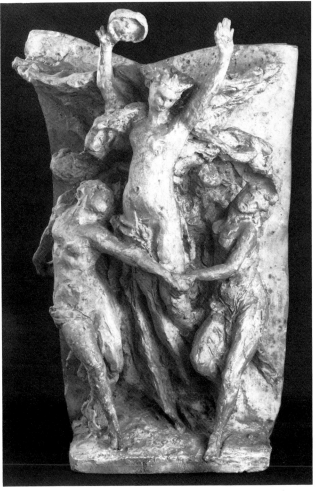

idea, even while expanding it into that fatal dancing circle (figs. 247–48). And the surviving clay sketch seems quite purposefully to translate drawing into three dimensions (fig. 249). Only two crucial aspects of the final work have not yet made an appearance there: the little putto with his belated attribute, and the sexuality of the *Génie*. *He* is a *she*, even this far into the development of the composition; the sex change happened relatively late in the day. That it happened at all I suspect is somehow the result of Garnier's evolving decorative scheme. Remember that Carpeaux's early drawing of Guillaume's *La Musique* shows a *génie* with breasts: originally all the personifications were meant to be feminine. In the end, though, the four groups are equally and symmetrically divided between the genders, so that Jouffroy and Perraud designed female figures, while Guillaume and Carpeaux both switched theirs to males.

A small point, perhaps—yet in the end the sheer recalcitrant *difference* between the sexes was one of the aspects of *La Danse* which viewers found most difficult to accept in 1869. What if that difference entered the group late in its development, after its decidedly phallic order had already been established? The change might help to explain why Garnier did not anticipate the scandal the group would ignite. And it also helps to interpret what seems to be a particularly charged set of "aesthetic" decisions on Carpeaux's part. For example: it puts the old story that two models—the cabinetmaker Sebastien Visat and the countess Hélène de Racowitza—posed for the *Génie* in a rather different light. The evidence is still anecdotal; still out of the "I-remember-when-I-sat-to-the-master" mold; yet such epicenism was hardly accidental. Nor were Carpeaux's studies as he worked on the group. He consulted Rude's *La Marseillaise* and Raphael's *St. Michael* and

250. François Rude, *Le Départ des Volontaires en 1792*, 1833–36, stone (h. 12m70). Arc de Triomphe de l'Etoile, Paris.

251. Jean-Baptiste Carpeaux, *Study after Rude's "Le Départ des Volontaires,"* c. 1866–67, black chalk on cream paper (12.7 × 8.7). Musée des Beaux-Arts, Valenciennes.

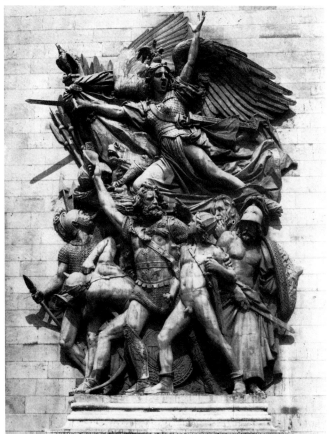

Michelangelo's drawings of the *Risen Christ*; these are great prototypes, and Carpeaux clearly chose them for the grand illusions of movement he could find there (figs. 250–51). But is it an accident that each one contains a markedly androgynous figure: Rude's warrior France; Raphael's delicate saint; Michelangelo's nude, electric Christ?

Such questions might not be raised had Carpeaux's group not been received so worriedly in 1869. They certainly have not been raised since. It is altogether more usual to read of the group's "energy," or to encounter H. W. Janson's self-declared "sense of embarrassment at 'real people' acting out a Rococo scene."[115] In 1869 a very few critics mentioned Clodion: one was Théophile Gautier, who had made a career insisting on "art" as art's prime content.[116] It is not that either Janson or Gautier was wrong in his choice of precedent: the requisite gaiety and garlands abound to certify the relationship. And it is surprising that no critic in 1869 thought to point out another parallel which comes to mind easily today: I mean the similarity between Bernini's ability to give the illusion in stone of soft flesh yielding to the touch and Carpeaux's emulation of such bravura effects (figs. 252–53).[117] These references are today easily decipherable because they were never meant to be obscure. Carpeaux intended his ambitions to be legible to the group's first audience, just as in the end he included the attributes—the faun and putto—on which an academic reading of the group might have been based.

Evidently Carpeaux in some sense *intended* to produce a great work of art, using techniques which ultimately were not so far distant from those which had proved their efficacy for the *Ugolin*. One conclusion which might follow is that the reaction to *La Danse* was arbitrarily, casually imposed on the work. The enthusiasm and vituperation it provoked in 1869 would then simply be signs that it was being used as a pawn in a battle entirely external to it. Yet this does not seem to me to do justice to the case. Many of *La Danse*'s critics really looked at it. And what they saw was the way figures have no obvious center of gravity; the way one movement—a bending head, for example—is checked and contradicted by another; the way these mobile parts violate a sense of containment and control; the way any even pace or tempo is disregarded by figures which instead seem to travel at their own rates; finally, the way female flesh is dwelled on, savored, given marks and folds and swellings by the chisel. Those drawings of real dancers which Carpeaux made through Garnier's kind offices seem absolutely irrelevant here. Then he showed ballerinas as weightless, unchecked by gravity; he encoded each woman as a cipher for movement (fig. 254). The stone dancers, by contrast, are all flesh, weighted to the earth by their own bodies: their quite particular heaviness needs special attention just because it threatens to bring them down. It cannot help but contrast with the levitating *Génie*; he seems simultaneously to launch himself, yet still to be caught in his companions' overpowering grasp. Their blatantly displayed sexual parts (the critics here liked the word *étaler*) make the modesty of his "casual" piece of drapery seem pathetic. The particularity and excess of contemporary responses to *La Danse* are reactions to just these excesses in the sculpture. Such vehemence does not erase the sculpture's grand manner, or its amplitude and vigor, but it does ask us for reasons why the realist reading was preferred for a work which is, if not multivalent, then at least ambivalent.

* * *

Providing an answer to this question involves more than recapitulating the ground this chapter has covered. The reasons are rooted in a wider context: the conditions under which sculpture was produced in the nineteenth century. In the task of outlining those conditions

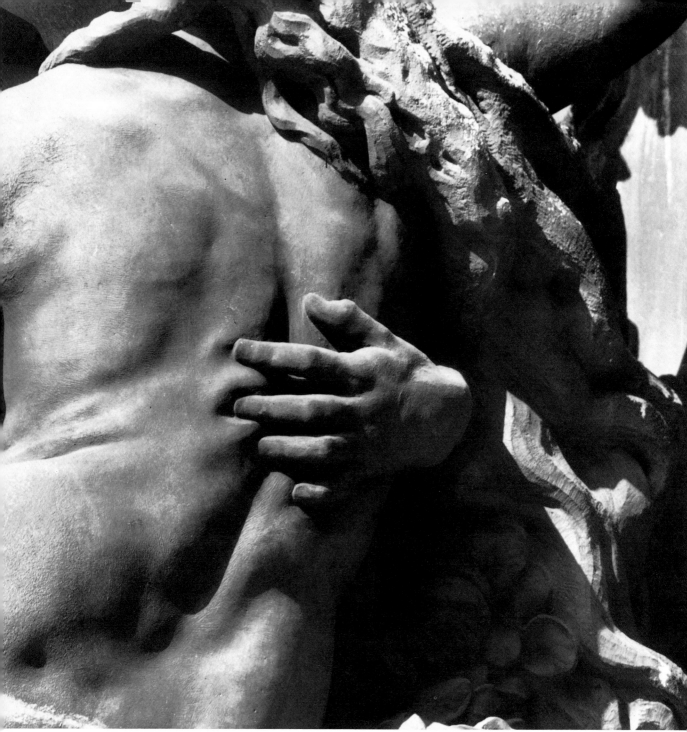

252. Jean-Baptiste Carpeaux, *La Danse*, detail.

La Danse presents a defining case, because its history shows it coming into contact with limitations which for other artists and sculptures usually remained tacit or only half-expressed. Those limitations became legible time and again in the controversy the group touched off: in the disjunction between *La Danse* and the norm for architectural sculpture; in the way *La Danse* was seen to infringe on another territory, a popular, immoral language of expression; in accusations and disagreements about Carpeaux's relationship to the public, to art, and to the state. In every case, moreover, the controversy was exacerbated by the fact that *La Danse* was public sculpture. Actions and artistic forms which would have

252

been unexceptionable—even applauded—in another, private context were proscribed in a public one.

The case of *La Danse* involves us in an historical situation which (like any other) made its own particular uses of art and artists. Within it, Carpeaux appeared in an equivocal light; no wonder Zola speculated about his personal attitude. The sculptor was certainly an artist whose gift rendered him, in certain instances at least, unwilling to conceive of artistic achievement in anything but an absolute sense, and disinclined to concede to the basic academic tenet that each artistic problem allows only of its own preordained solution—even though he had been schooled in this precept. But, as we have seen, that academic notion had also come coupled with a peculiar sense of rivalry and relationship to art's great tradition, a sense which shaped him more profoundly than had any notion of the academic hierarchy.

Yet there were some dominant notions to which Carpeaux subscribed wholeheartedly: the profit motive, for example. He was not above receiving condolences as the author of a vandalized work, even while selling photographs—stamped with his personal monogram!—of the damaged masterpiece. The old instinct to capitalize on his art never faded. At the same time, however, Carpeaux had complete, and exaggerated, confidence in his rights as an artist. He trusted, mistakenly, that the stages of authorship and approval through which his work at the Opéra had passed possessed a quasi-contractual status which only an imperial order could dissolve: "I believe it is impossible for the administration to remove my group without a formal order of H.M. the Emperor, since the model for the group was examined and approved by the administration and the architect."[118] Brave

253. Gian Lorenzo Bernini, *Pluto and Persephone*, detail, 1621–22, marble. Galleria Borghese, Rome.

254. Jean-Baptiste Carpeaux, *Study of a Dancer*, c. 1866, black chalk on cream colored notebook paper. Musée des Beaux-Arts, Valenciennes.

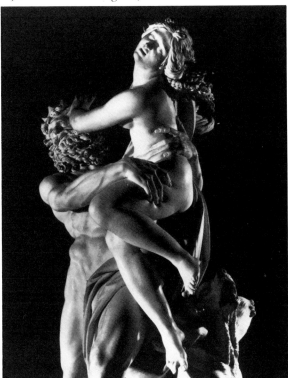

words: but Carpeaux actually had about as much control over the fate of his work as poor Houguenarde and Corboz; that is, none at all. Like them, he was subject to Garnier's implacable maxim: "Le rôle de l'artiste finit où le modèle se finit." His creative work done, Carpeaux should have retired with his artistic honor intact.

And *La Danse*? It was the real offender, and to some Carpeaux seemed soiled simply by his association with it. The image of the artist keeping company with his indecent statue makes him a modern, debased Pygmalion: the danger, of course, was that its pleasures had been made available to all. In 1869 it was believed that any sculpture placed within the city's open spaces had clear, though limited, representational functions. It was to be used to name the individuals or the concepts which could stand as values within the official culture: Truth, Navigation, Napoleon, Justice—even Dance. It was to confirm by its very presence that the fundamental values were still holding firm.

If sculpture had a decorum to observe, so did daily life. Both had their private and public faces. It was agreed that *La Danse* might do very nicely for a private collector; the 100,000 franc offer supposedly made by a foreign prince was noised about by the press as a satisfactory solution to a nagging problem. And men could enjoy lascivious behaviour if they did so in the places and relations established for that purpose, in *bals* and bars and brothels. The suggestion that *La Danse* would be more appropriate to the bal Mabille than the Opéra made a contrast between two languages, two decorums, two codes of conduct—the private and the public, the official and the popular. *La Danse* was thought suitable for a place where the private language was in use.

The implications of this assertion can be better seized if we say more precisely what that language was. At one level the answer is simple: the critics in 1869 provided it. The private language of the Empire was the can-can; but to grasp what was meant by that assertion, a notion of rouged high-kicking cocottes is not enough. Here is how Larousse characterized it:

> a licentious deformation of the quadrille; it is the quadrille disordered, contorted to the point of becoming epileptic. The most grotesque leaps, the most furious jumps, the most unbelievable leg kicks, linked with gestures, contortions, fabulous swayings, make it a crazy distraction. It has been rightly said that the can-can is to dance what slang [*argot*] is to language.[119]

Dance in slang meant popular dance, in nineteenth century France. The can-can was born in the public *bals* sometime in the 1830s, perhaps brought into being by the famous dancer Chicard. He was a man, but his step was soon taken up by women dancers, particularly at the bal Mabille, the dance hall founded by a former dancing master who attracted crowds with gas illuminations, the *puff*, and the *réclame*. The bal Mabille was the haunt of Rigolboche, born Marguérite Badel, the Second Empire can-can queen: "Mabille est à peu près pur de Rigolboche." Even as transcribed by her biographer/ghost writer Ernest Blum, her definition of the dance has an authoritative ring.

> The can-can neglects, disdains, rejects everything which can recall rules, regularity, method.
>
> To dance the can-can it is necessary to have an individual temperament, an exceptional spirit: the moral philosophy of a can-can dancer must be as fantastic as her limbs, because it is not a case of reproducing this or that conventionalized, regularized movement.
>
> It is necessary to invent, and create—create instantaneously.
>
> That is to say, the right leg cannot know what the left is doing.
>
> At any given moment, and without knowing why, one must be somber, melancholy,

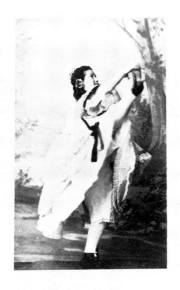

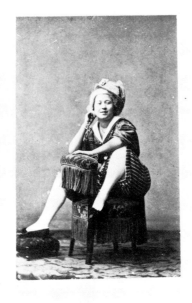

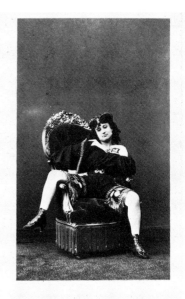

Alice la Provençale, (Danseuse)
Bal Mabille, etc, 1860.

Rigolboche, Délas-Com..
Folichons & Folichonnettes, 1859.

Finette, (Danseuse)
Bal Mabille, etc, 1860

255. Photograph of Alice la Provençale, 1860. Bibliothèque de l'Opéra, Paris.

256. Disderi, photograph of Rigolboche, 1859. Bibliothèque de l'Opéra, Paris.

257. Photograph of Finette, c. 1860. Bibliothèque de l'Opéra, Paris.

and fantastic, then suddenly become wild, raging, and delirious.

To be in an extreme state, and all this simultaneously.

To show oneself sad and wild, serious and furious, indifferent and passionate.

That is—to Rigolboche.[120]

I cite this passage not as some truth about the can-can, though it should be clear that there are some points about the dance on which Larousse and Rigolboche agree, despite their very different interests in the task of definition. The can-can scorned regulation; its only rule was to have none. It destroyed the decorum of dance: Larousse's entry on *danse* proper is a recitation of the prescribed steps and figures which then made up the formal French repertoire.[121] Yet it was not that *La Danse* looked like the can-can. The can-can looked like a great, anti-gravitational release of energy, at least when Alice la Provençale performed it (fig. 255). The can-can had no rules: that is why *La Danse* became a can-can.

To break the rules is to be free, arbitrary, seditious, and sexual. As Rigolboche wrote, describing her feelings when she danced: "C'est une volupté . . . je lutte contre mes instincts banals . . . J'ai peur de moi . . ."[122] Even if these phrases have passed through the medium of Blum, they are evidently appropriate to a person who made sexualized defiance the rule for her physical comportment. So did her colleagues (figs. 256–57).

In the end what is striking about *La Danse* is the chain of associations it produced and the way they circled around the issues of woman, sexuality, and the state. *La Danse* was free, it was alive, it was sexualized, it was seditious, it was corrupting. All these words could equally well be applied to Woman in 1869, and were, with a usage resulting from the longstanding habit, in western culture, of making its own peculiar uses of the female body. In that body's pleasures—and their repression—were found metaphors for value and debasement in general. They were terms which allowed for description and control.

In 1869, *La Danse*, that official decorative work, seemed to be invaded by new influences even while being asked to perform a holding action against them. It was speaking a new language, to use the contemporary image once again, its own hybrid version of high and low, the artistic and the popular. Given the vehemence with which the charge was repeated,

it is tempting to press the question: what *was* the language of the *bal publique*? Is it sheer coincidence that already for two years proprietors of Paris *bals* had made their premises do double duty, renting them out for public meetings on the nights there was no dancing? The audience apparently stayed pretty consistent even when the topic under discussion shifted from the can-can to social change. As the police observers reported, on meeting nights there was openly seditious language in the *bal*, not just the metaphoric kind. How many critics or readers were conscious of the double meaning of a phrase like "the language of the *bal publique*" when it described *La Danse*? One certainly was: Auguste Vitu, a violent opponent of Carpeaux's group and the author of the first pamphlet to report the disquieting substance of the meetings to the public at large.[123]

But perhaps I probe too deep. It is enough to establish that in 1869 the borderline between obscenity and other forms of insubordination was dangerously unclear.

According to a decision of the Tribunal de la Seine, "Obscenity exists where art does not intervene to raise up the ideal, and where the appeal to the instincts and the gross appetites is not opposed or defeated by any superior sentiment."[124] We might argue along different lines: obscenity exists where there is a rule to define it, and not where art has failed to do its job. Yet the legal decision had a venerable nineteenth century pedigree. Its roots can be traced to such milestones as the speech delivered in 1857 by Ernest Pinard, the state prosecutor at Flaubert's trial for obscenity:

> This moral philosophy stigmatizes realist literature, not because it paints the passions—the world lives out of hate, vengeance, love—but when it paints them without restraint, without measure. Art without rules is no longer art; it is like a woman who undresses completely. To impose on art the single rule of public decency is not to enslave but to honor it. One cannot grow without a rule.[125]

This is a speech which is often quoted; it provided one of the epigraphs for this chapter. Of course Pinard is more or less in control of his similes; he does not wish the court to confuse art and womanhood; yet following his view, Art and Woman end up being terribly alike. They are both signs; both are used by men as indices to locate something: public morality, public decency—either name will do. Why? The answers are not easy. There is no one answer, at any rate. Because there was no other formation or structure to do the job, for one reason. The state and the church were hopelessly enmired in political struggles, and were incapable to boot. Each clung to its role as guardian of the public good—the story of *La Danse* shows how tenaciously—even as the left was diagnosing their part in the general malaise, and calling for a remedy. But perhaps the answer should be stated differently: because such constructions of Art and Woman helped to mask, at least partly, the troubles of which they were only a symptom. And by these lights there is a terrible logic linking art, woman, and the truth about Empire which *La Danse* seemed to tell. To both its champions and its detractors, *La Danse* seemed to mask nothing about life under Napoléon III: a product of the state, it became an image of the state; it was inescapably an image of sex and class. So much was certain: critics disagreed only about whether it was the role of art to utter such truths. Could they be said in public, where the Empire, despite itself, became responsible? *La Danse*, like the rest of the Opéra facade, like other imperial initiatives, was put on a bill of grievances fast falling due. Those big bronze *N*'s seemed like insufficient guarantees. In any case, the views of critics and supporters alike could be advanced only where there was a notion of the direct, causative relation between art and the society in which it was created. Such a conception existed in the Second Empire.

CHAPTER SEVEN

CONCLUSION

It would have been perfectly possible to bring this book to a close with the chapter which precedes this conclusion. *La Danse* does present a defining case, to repeat my own phrase; what it defines, as I tried to suggest, are the conditions under which sculpture was produced in the nineteenth century, the conditions which this book has gone to some lengths to elucidate. Yet if Carpeaux's great group is exemplary, it is also entirely exceptional, and the reader may well be wondering how I shall make the two halves of my argument fit together. It is time to recall that this study began with the rather straightforward intention of explicating the contradictions inherent in Carpeaux's reputation. The path this book has followed—its inclusions and omissions—was directed by that aim. I meant to reckon with the sheer status assigned the artist by both contemporaries and later critics. After all, it is no small feat for an individual to provide the example which could return his art "to the unspoken tradition of the most illustrious artists." De Chennevières's phrase made Carpeaux part of the great tradition; the sculptor's work has held his place secure.

It is easy enough to state this aspect of the case: the works de Chennevières mentioned—the *Ugolin*, the *Flore, La Danse*, the busts, the *Pêcheur*—give it some authority. Its other components, however, need rather more careful phrasing. Granted that Carpeaux was a great artist—so the argument might begin—he also lived out a career somehow paradigmatic of nineteenth century sculpture: from birth in the working class to death as an artist, with the way in between allowed, supported, *shaped*, by the great institutions of bourgeois society: schools and exhibitions, government commissions and private sales, and the quite particular phenomenon of the artistic reproduction. Carpeaux was the creature of these institutions—and then again, he was not. His belonging was always undermined by a few decisive factors which declared his difference from the norm. To remark on his worker's voice and manner was one way to indicate that lack of fit, but the recurrent questions about the "purity" of the beauty which he created seem to me to carry the same implications. Both are devices to suggest the measure of difference between Carpeaux and the paradigm he is thought to represent. These differences may be located in the person or in his art, but both are ways of marking him off from some more whole, more complete category which he can never enter.

For the most part these representations of Carpeaux exist side-by-side—uneasily, edgily, their borders sometimes overlapping—yet with only the most restricted causal links between them. The Goncourts do not claim, for example, that Carpeaux was a great artist *because* he stayed his father's son, because his eyes retained their angry worker's gaze. Nor does Charles Blanc assert that the sculptor's greatness rested on his career's conformity to the typical pattern. If causal links are forged, their logic proceeds in a different direction.

It *was* possible to claim that because Carpeaux was great, he was official. Was that not the gist of de Chennevières's eulogy, even though the climate of the early Third Republic made "national" the more advisable term? Carpeaux, he argued, was part of art as it really was, sculpture that really counted; in short, the real French tradition. And the point comes almost as a confession: "Messieurs, whatever the ultimate law of sculpture may be in theory, even though its ideal conditions may be simplicity and sobriety, we really must admit to ourselves that French sculpture—which has cut a fairly good figure among all the other modern schools— has never been a very tranquil art."[1] Perhaps it is not surprising, by these lights, to find that already in 1870 Henri Delaborde, at pains to defend the Villa Medici against "certain ill-considered attacks," cited its most atypical product, Carpeaux, as his proof:

> Sometimes it can happen that, far from showing themselves too docile towards academic traditions, the works of the former guests at the Villa Medici appear to retain what at best can be called a mixed memory of the experience. Without mentioning *La Danse* on the facade of the new Opéra, the statue of Watteau and the bust of Mlle Fiocre which M. Carpeaux has exhibited this year are enough to show the point to which talents disposed to set themselves free can go, and how light is the burden of those supposed chains. And even so, those who like M. Carpeaux appear to break most violently with the doctrines and examples imposed on them during their youth are careful not to forget, in the end, what they owe them. They know that without that apprenticeship in Rome, face to face with the great examples, they never would have been able, when the time was ripe, to act on their own inspiration or to find anywhere but in that acquired experience, the force necessary to an original act.[2]

It is not that Delaborde—or de Chennevières, for that matter—were mistaken in their insistence on Carpeaux's relation to great examples and institutions. If there is such a thing as "the French tradition," Carpeaux fits into it as surely as do Goujon and Caffieri, Houdon and Rude.[3] Yet Delaborde means more by his assertion; he means to prove the continued vitality of a traditional institution by laying claim to the artist who to all appearances is the least stamped with its mark. Not a bad strategy. It depends utterly on two facts which any observer would be forced to concede: Carpeaux's originality (to make this point Delaborde needed only a brief mention or two); and his success in the contest for the Prix de Rome. The victory Delaborde obtained by this strategy is only apparently Pyrrhic; it is won on a field where originality holds the highest honor.

There is one text which is willing to go further in the matter of the relationship between Carpeaux's achievement, his art, and his social origins. The essay was not written by a contemporary; its author was ten years old at the artist's death. A quarter of a century later, Louis Dimier was teaching at a *lycée* in Valenciennes; a sense of time well spent in the municipal gallery permeates the article, "Carpeaux," which Dimier would publish in 1909.

It is important for my argument that Dimier too took Carpeaux as exemplary. In the growth of the artist's reputation in the early twentieth century, he saw "a proof of the greatness of his talents. The truth is that these talents are the kind which dominated the late century; the recital of their success makes for one of the most curious chapters of its history."[4] And so Dimier proceeded to tell the singular tale, placing the emphases such an introduction demanded. The story is by now familiar; it does not need telling once again. Yet it must be said that in Dimier's account, the "rude beginnings" of the artist necessarily made a prompt entrance; they were "inevitable for an artist who was born

so low, in a century where the weakening of the old ateliers and the ruin of provincial académies left the poor artist without resources."[5] In such circumstances, Carpeaux passed from his "natural condition of worker" to that of sculptor—at the price of generous efforts, yet successfully. "In his burst of fortune and newfound relations, he wore all the degraded manners of a man outside his class."[6] This is not to say that Dimier does not see the merits of Carpeaux's work; as an artist—that is, from a technical point of view—nothing made Carpeaux unworthy to be the founder of a school of art.

> Yet everything suggests that his education rendered him unfit for this role. He was entirely lacking in any education at all. He did not know things which in the old French society men of modest extraction learned very quickly when they were endowed with superior talents. He lacked every general concept. Even the lessons of the atelier taught him the opposite of the truth in this regard. They filled his consciousness with all the grandiloquent idiocies which for the past twenty years had been dragging around the cheap restaurants. "Humanity," he wrote to his friend Chérier, "humanity raised up as if by a gale, clashing generation against generation, as the wind makes dust boil about—there, I think, is the expression of our epoch." This backwards education [*éducation à rebours*], taking root in such a genuine artistic temperament, left practice intact but ruined theory, which alone can give a man a definite point of view. At best, Carpeaux's works could establish a fashion; they could never revitalize a school.[7]

I should hasten to point out the extent to which Dimier's view is a case of special pleading. Seeing Carpeaux as exemplary here meant tying him to a century which the writer deplored. It is no wonder that he considered Carpeaux's metaphor an "idiocy." For twenty years Dimier was an associate of Charles Maurras, and with him a founder of *L'Action française*; as an art historian he valued above all the stability of tradition and viewed true culture as the property of an intellectual elite.[8] An artist like Carpeaux, irrevocably betrayed by "the misfortunes of his age," could not supply that culture. There were no institutions, Dimier argued, which could gear him to make great art: no proper patrons, no intelligent Maecenas, no provincial Académies. Little wonder that Dimier brought on Napoléon III for a symbolic appearance in this context; a prisoner of the bureaucracy, the emperor was simply not "allowed" to encourage real masters.

My aim in citing Dimier is to point to the ways the same questions which critics during Carpeaux's lifetime took as crucial reappear decades later (perhaps I do not need to state that they have cropped up again in this book). The questions seem to me inevitable, even if the answers Dimier supplies are not. They are questions about class and creativity, about the proprietorship of culture, and about the province peculiar to art. When art is construed as an elevated, absolute quality, in the way that Mantz or Dimier perceived it, it is evident that Carpeaux, with his education *à rebours*, could not supply it. For Dimier, finally, these connections are *causal*: they result from Carpeaux's low birth in a "democratic" century, in an age which sent him, unprepared, on the road to a new social class.

These are Dimier's conclusions, not my own. Yet I too want to put my stress on Carpeaux's relationship to his historical moment, as I understand it, and further, to emphasize that this relationship had been seen as problematic decades before Dimier. Carpeaux was taken as a type, in some sense a symbol of times changing for the worse. "Carpeaux lived in a bourgeois age, when capital, instead of occupying itself with great works of art, takes profits at the Bourse, and a partner in a brokerage house becomes the highest expression of the contemporary Maecenas. The flame of genius carried Carpeaux towards the most noble works, but this busy century dragged him down to lower regions where the artist

has to double as a kind of wholesaler."[9] These observations may read like clichés—they are the efforts of the critic Albert Wolff—but their familiarity cannot obscure the fact that they are being provided, quite deliberately, in a context—Carpeaux's obituary—which ensures that they will be taken quite particularly to be *about* Carpeaux.

Views like these can be understood as both utterly conventional and very expressly intended; the contradictions unite in the fact that Carpeaux was taken to represent—to be identical with—that peculiar modern phenomenon, the great sculptor in the era of high capitalism. And it is important to realize that this formulation went deeper than its journalistic presentation. It marked the private man as well: the man his friends knew and talked to, the man whose actions they discussed. Yet somehow familiarity with the public version of Carpeaux does not quite prepare us for the violent ironies of a private manifestation of it; I mean a letter written by J.–B. Foucart to his son Paul:

> I can only tell you that the *great* Carpeaux was there, that we had the *great* honor of seeing him at home for three and a quarter minutes, that he could certainly not stay in Valenciennes, and that at four fifteen he left for Paris where at the present moment he is making a statue of the heir to the Empire, and that of the subject who after the debacle will be the most faithful—his favorite dog. Fortune favors the brave; it appears that the present Dynasty does not at all detest people who put themselves forward and proclaim their own merit, even in an incongruous fashion. One thought that Compiègne would be Carpeaux's tomb; instead he left it in triumph, like the victorious candidate of December 10, despite Boulogne, Strasbourg, and Ham. He has pulled himself up out of a crack in the earth, without the esteem of our official world, which never asks what a man is worth, but whether or not he is good at court. So much the better for his career, but I don't know if it's the better for his character; as you know, he is not the kind of person whom property improves. Since he only has time for people he can use, he is bound to change; if he was one of those people who put their practice into theory, the maxim "live for others" would become another precept, "live *by* others."[10]

Once again, of course, this is a case of special pleading; the old republican Foucart was as hostile to the "élu du Dix-Décembre" as Dimier was distressed at the thought of a ruler whose hands were tied by bureaucracy. Yet Foucart's worries about his friend (they *were* friends, of a sort) date back to well before the portrait of heir with dog. They were the burden of that letter he wrote to François Sabatier, years before, while Carpeaux was in Rome. Then, with almost evangelical fervor, the lawyer presented his friend as a soul to be saved—with Sabatier's aid: "the renovation of his thoughts and the conversion of his heart will be difficult. Carpeaux has had too much contact with that hateful milieu of men and women which has destroyed so many artists in our day. It is rather difficult to make someone see the noble side of life when he has had only too many occasions in it to encounter those vulgar passions which initiate a woman on a studio mattress, only to finish her on the marble slab of an amphitheater."[11]

I do not want to seem to be manipulating bits and pieces of opinion in such a way as to obscure the very real differences between them, or to suggest that complaints about modernity were anything but commonplace among republicans and conservatives alike. But in a century so prone to diagnose its own malaise, it is remarkable how Foucart's description of Carpeaux was echoed by the critics of *La Danse* when they discussed the debased contemporary morals the group was thought to depict. It is notable that Wolff's artist-as-wholesaler gibe is no mere metaphor, but a response to Carpeaux's efforts to commercialize his work. Dimier, for his part, points to the falsity of Schnetz's promise that

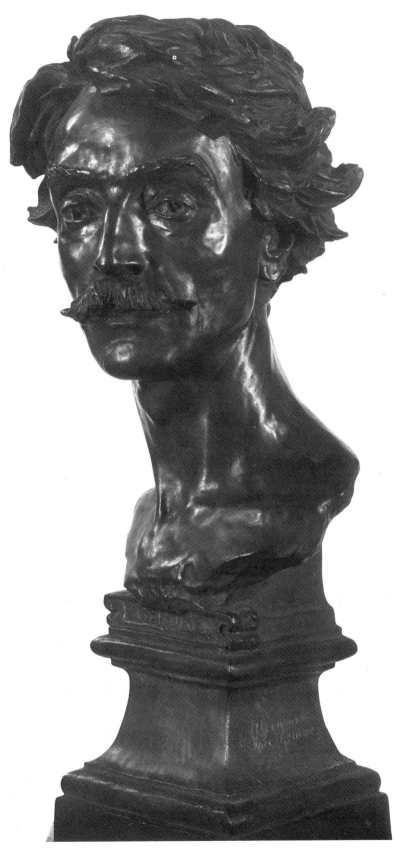

258. Jean-Baptiste Carpeaux, *Jean-Léon Gérôme*, 1871, bronze (h. 60.2). Ecole Nationale Supérieure des Beaux-Arts, Paris.

Carpeaux too "would shape up in the end," even while backing the old academic claim that Carpeaux's execution was unmatched by his conception. These are the factors which made Carpeaux the sculptor of the Second Empire—the term becomes increasingly equivocal as an understanding of its implications accumulates.

Add to this the evidence—it is not infrequent—which allows some sense of the impact of Carpeaux's ambitions on his identity to be read directly in the record itself. There are, for example, the entries he made in a notebook used in 1853: "Ah, it's you who made this; it's good, very good; we saw it at the city hall in Valenciennes." Or, a few pages later: "Sire, the mayor and the municipal council of Valenciennes advised me to present to you once again the bas-relief which attracted your attention."[12] This is Carpeaux rehearsing, taking the sovereign's gracious part, then his own, as he fantasized about selling the Abd el-Kader relief to his future patron. In the back cover of another book there is this brief warning: "I find myself indisposed fairly frequently. People who find me in such a state are asked to take me home."[13] Or there are the terms of his marriage to the general's daughter, Amélie de Montfort, which insisted that she need not be brought into contact with her husband's relatives.[14] And there is the final, pathetic observation of the police operative who covered the exhumation of Carpeaux's body for its last trip to Valenciennes: "M. Carpeaux *père*, who evidently was trying to go unnoticed, kept himself within one of the groups of bystanders; but at the end of the service, three or four people whom I had noticed around the General de Montfort approached him and appeared to attempt a reconciliation between him and the General. There were some backings and forthings in this direction, but nonetheless M. Carpeaux *père* went away in tears."[15]

This is an odd and pathetic assortment of personal circumstance—though perhaps no more so than the details other artists' biographies might provide. Yet the story is still noteworthy in its disposition of the matters of class and anxiety, of illness and success. Can this be what is meant by "sculptor of the Second Empire"? The answer is surely yes, even if the more intimate details of Carpeaux's existence were not read into the public account (some certainly were). Taking Carpeaux as a paradigm is not just a matter of facts and dates; it rests on the way Carpeaux's biography, his achievements, and his notoriety seem to coincide with the beliefs and worries generally taken to represent the day and age.

The case was certainly less clear when the time came for Carpeaux's contemporaries to judge of the representative qualities of Carpeaux's art, or even to locate its qualities at all. The artist's reputation was genuinely problematic, with the main topics of concern most often being sorted into antinomies which set public against private, conception against execution. These were contemporary categories: they were the language of assessment of the *Ugolin* and *La Danse*. And they were tenacious. The same terms were still at work, for example, in 1872, when Carpeaux sent to the Salon a bust of the painter Jean-Léon Gérôme and the model of his centerpiece for the Observatoire fountain (figs. 258–59). Once again Carpeaux got mixed reviews; again his art was seen as flawed. The writer Paul Mantz presented what seems to me a representative criticism:

> We arrive at the picturesque sculptors, at the pure decorators, at the archaeologists, but who knows in what category to class M. Carpeaux, the author of a complicated and unhealthy *machine*, the *Quatre Parties du monde soutenant la sphère*. This group, destined to top a fountain, is not reassuring. It represents four savage and ill-nourished women who, cheerful to no purpose, hand in hand dance a mad sarabande, under the pretext of carrying a globe they are about to drop. The Jardin du Luxembourg, where the

259. Photograph of the Fontaine de l'Observatoire in the course of installation, 1874. Musée d'Orsay, Paris

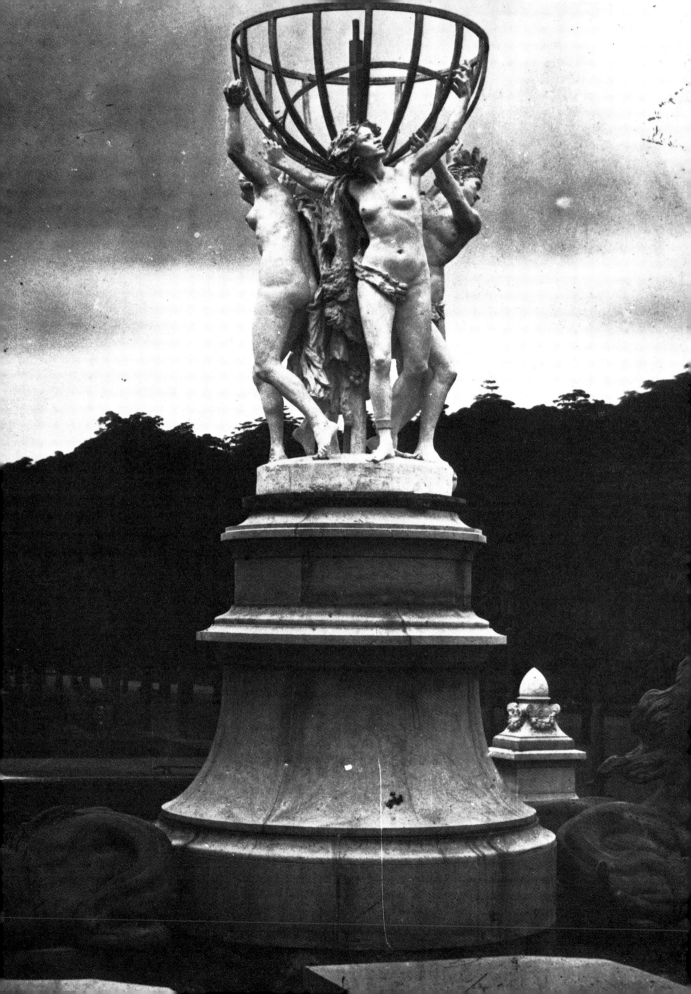

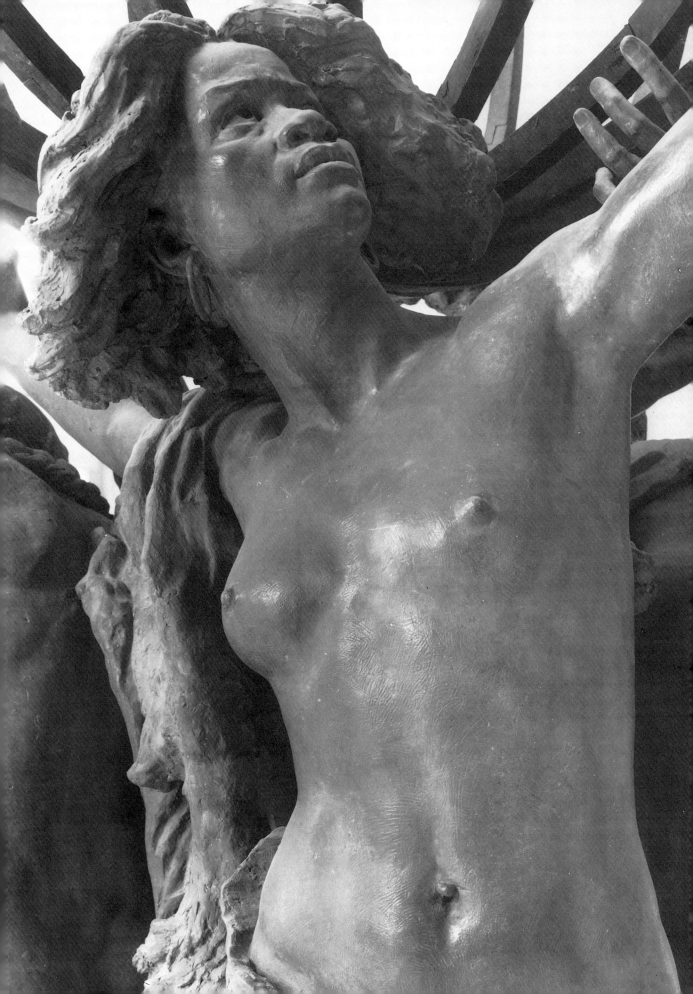

catalogue would like to place these awkward hoppings, will be embellished in only the most mediocre way. M. Carpeaux, let me say very quickly, has something else than gaiety—he has a feeling for the portrait, and he is exhibiting an excellent bust of M. Gérôme. This bronze, where the character of the modelling is ingeniously studied, is surprisingly life like; it moves, it breathes, and freedom in execution here has a wonderful aspect.[16]

It must be said that if this is a representative review, it is also an insulting one, and not very accurate besides. In 1872 Mantz still seems haunted by *La Danse*, yet simultaneously not quite able to *remember* Carpeaux—hence his pretense of worry about exactly how, in what secondary category, to classify him. But we can put the insults aside; we know enough about Mantz's viewpoint to be able to take them with the requisite amount of salt. The review becomes interesting when it is seen as an implicit comparison between two types of work, the public and the private. One is all excess, all disorder, all incongruity. The other is vivid; it lives; it breathes. Yet put these judgements against the works in question—compare Gérôme's finely drawn, mobile features with the characterization of any of the continents, with *Africa*, for example (fig. 260), and it becomes apparent that in execution they are more alike than different, enough alike to have Mantz's divergent reading seem grossly overdetermined.

260. (left) Jean-Baptiste Carpeaux, *Les Quatre Parties du Monde*, detail, 1868–72, terra cotta. Musée d'Orsay, Paris.

261. Photograph of the sculpture installation, Salon of 1872.

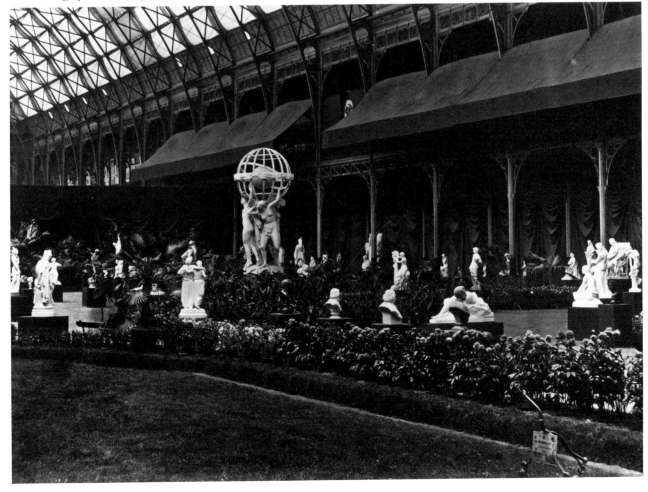

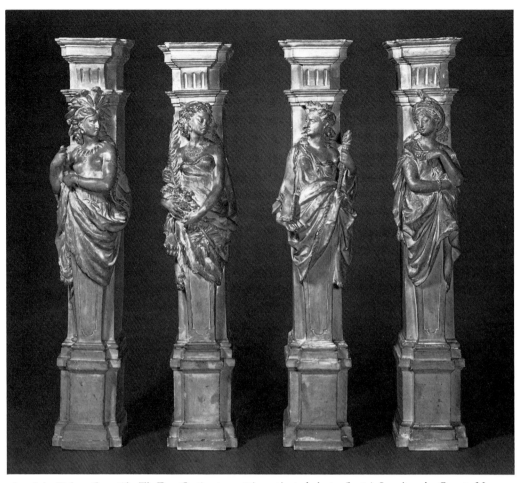

262. Jules Dalou, *Caryatids: The Four Continents*, c. 1867, patinated plaster (h. 89). Los Angeles County Museum of Art.

It was the space of the Salon which allowed for comparisons like Mantz's (fig. 261). There public and private were regularly, purposefully juxtaposed, even though, as usual with Carpeaux, the boundaries between the two states were rather fluid. He sold Gérôme's portrait commercially and extracted busts from the fountain for the same purpose. But it is in the Salon's levelling atmosphere, among the potted plants and against the dark cloth swags, that Mantz could refuse to see a resemblance between bust and group. Never mind that the continents were portrayed as if they in fact were people. Never mind that Carpeaux departed enough from the familiar conceit of his assigned subject to invent both a physical and a narrative pretext for its action. The group's strained, laborious movement was not essential to the theme; neither was its amateur anthropology, which locates racial difference in veristic physiognomy (though not in bodily type). Compared to the pretty details which the young Dalou gave his version of a similar subject—he designed four chic continents for placement on a Paris *hôtel* (fig. 262)—the particular physicality of Carpeaux's group is only too apparent.[17] Again Carpeaux worked towards bodily specificity, stripping down each figure to a bare minimum of signs meant to convey ethnic difference. Once again he let these signs be registered chiefly in physical presence; in this case he aimed to make that presence inescapable by patinating each body to the skin tone of the race it represents.

266

263. Jean-Baptiste Carpeaux, *Le Docteur Batailhé*, 1863–64, plaster (h. 46.5). Musée des Beaux-Arts, Valenciennes.

264–65. Jean-Baptiste
Carpeaux, *Le Docteur
Achille Flaubert*, 1874,
plaster (h. 36). Musée
des Beaux-Arts,
Valenciennes.

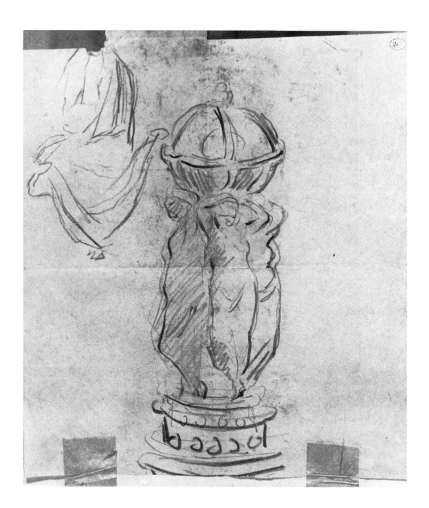

266. Jean-Baptiste
Carpeaux, *Projet pour
la maquette avec le socle*,
1867–68, black chalk
(16.8 × 13). Musée du
Louvre, Paris.

If anything, the group is more animate than the bust which Mantz preferred to it; in
the *Gérôme*, Carpeaux had to convey a sense of presence without reference to the body
on which it otherwise might be based. The sculptor devised a range of techniques to accom-
plish the illusion: the less formal the commission—as in his portraits of Dr. Batailhé and
Dr. Flaubert (figs. 263–65)—the more dependent his effects on the possibility of our equat-
ing a belabored surface, with its marks of tools and fingers, with the presence of real
individuality. It *is* possible to make the equation, and also to understand, following Mantz,
how the *Gérôme*'s tamer version of such effects—its "freedom of execution" and the
mobility and animation that free surface suggests—can be taken as real terms of value.

Less obvious, perhaps, is the reason behind Mantz's different reactions to each work.
Why does he castigate the one, and appreciate the other? Why is the particular presence
of the *Gérôme* for him a claim to beauty, while the same qualities in a monumental fountain
group provoke dismay? Apparently Carpeaux's audience was perfectly prepared to see
itself as alive, vivid, breathing—but not to regard the same experience as proper to the
content of public art. Yet there was Carpeaux, taking the demands of statuary very seriously,
as if his subjects were about something real, as if the sculptor's job was simply to find
terms for the physical reality of whatever subject was handed him—a person, a continent,
a way of dancing.

It is tempting to assert that Carpeaux's decision to let his sculpture rest on communicating
the actuality of his subjects was the backhanded result of an education *à rebours*; only an

artist incompletely versed in contemporary culture, we might argue, could take its standard themes as anything more than formal categories. But if Carpeaux, in his ignorance, approached such subjects without the sense that he was already possessed of their solutions, this does not mean that he felt it unnecessary to learn those solutions as he went along. He worked through, and went beyond, the standard formulae—past the demure symmetry of the obvious globe-bearing rondel (fig. 266)—towards a conception of a sculpture which made use of his own particular kind of knowledge and expertise. The result is an art which presents the body as its index of truth and unit of value, but which simultaneously asserts that the body must be taken in all the weakness and imperfection of its flesh, in all its impermanence and contingency. The body is Carpeaux's alternative to Culture; his counter-proposal to Art's ideal, absolute terms. It is no wonder that when Rodin, testing out his own range and ambitions as an artist, first made an *Ugolin* (fig. 267–68), he began from the implications of Carpeaux's own hyperactive realism, to push the body's substance and surface even farther out of true with absolute forms. Hegel would have called such exaggerations the "deficiencies of what is merely sensuous." The Second Empire sometimes accepted them willingly, when they could be taken as a confirmation of its own sensual existence, as an image of the Self; it was not yet entirely ready to believe in the physical as a stand-in for a culture beginning to die. The trade-off was quickly accomplished; the "idiocy" that Carpeaux uttered to Chérier, which took conflict as the defining condition of modern life, soon enough became a credo which modern art never tires of repeating.

267. Bodmer or Pannelier(?) photograph of *Rodin's "Seated Ugolino,"* 1877, albumen print with ink notations (17 × 12.9). Musée Rodin, Paris.

268. Bodmer or Pannelier, photograph of *Rodin's "Seated Ugolino,"* back view, 1877, albumen print (14.5 × 10). Musée Rodin, Paris.

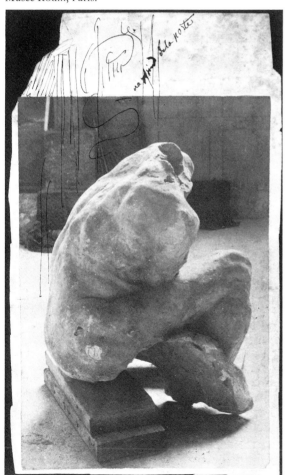

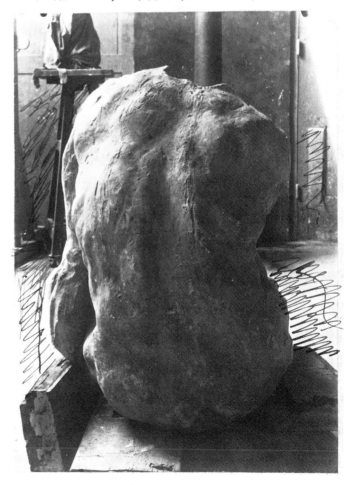

CHRONOLOGY

1827 Birth in Valenciennes (Nord) of Jules Jean-Baptiste Carpeaux, May 11, son of Joseph Carpeaux, a mason, and Adèle Carpeaux, née Wargny, a lacemaker.

1838 Probable date of a brief attendance at the Académie des Beaux-Arts, Valenciennes. Departure of Carpeaux family for Paris as a result of Joseph Carpeaux's appointment as a foreman for the Chemin de fer de Versailles.

1840–43 Carpeaux follows courses at the Ecole Gratuite de Dessin, Paris.

1844 Enters Rude's studio; is inscribed at the Ecole des Beaux-Arts, Paris, where he competes as Rude's student for the next six years.

1845 First Ecole success: he is received sixteenth in the preliminary contest for the Prix de Rome with his relief *Joseph reconnu par ses frères*. Friendship during these years with Jean-Baptiste Foucart and Victor Liet.

1846 Carpeaux is expelled from the Prix de Rome competition for cheating. At about this time, his family leaves for San Francisco and he supports himself with commercial work and, more regularly, with stipends awarded by the Société des Enfants du Nord, the Département du Nord, and the Ville de Valenciennes. These stipends continue into the early 1850s.

1848–49 During a lengthy sojourn in Valenciennes, Carpeaux executes several works for local patrons, including *Les Quatre Saisons* for Louis Hollande; a collection of five statues for the church at Monchy-le-Preux; *Le Maréchal de Croy*, a bust commissioned by the Société d'Agriculture, Sciences, et Arts, as part of an historical gallery of local notables; and *La Sainte Alliance des peuples*, part of a dining room decor for Foucart.

1850 Carpeaux leaves Rude's teaching for that of Francisque Duret. He completes *Achille blessé au talon* in the Prix de Rome competition, and receives an honorable mention.

1851 Appointed as *répétiteur* at the Ecole Gratuite.

1852 First Salon exhibition, under the name of a friend, Ernest Blagny: "1302. *Un poête de la nature*, bas relief, plâtre. 1303. Buste de Mme. Delerue, plâtre." In the Prix de Rome competition receives a second place award for his figure *Philoctète à Lemnos*.

1853 At the Salon exhibits (under his own name) the bas-relief, *L'Empereur reçoit Abd el-Kader au Palais de Saint Cloud* (no. 1260), and ultimately receives a commission to execute the work in marble. No prize is awarded that year in the Prix de Rome contest.

1854 One of the dozens of sculptors employed in the renovation and expansion of the Louvre under H. Lefuel, Carpeaux executes a decorative figure, the *Génie de la Marine*, for the balustrade of the Pavillon de Rohan. He wins the Grand Prix de Rome for his figure *Hector et son fils Astyanax*.

1855 Carpeaux stays in Paris, rather than taking up residence in Rome; ostensibly he is occupied with finishing the marble of his Abd el-Kader relief, but, perhaps as a result of an eye illness, does not complete it. Signs his first contract with a founder for the commercial exploitation of a design for a sculpture.

1856	In January, arrives at the Villa Medici, Rome. In August, travels to Naples; falls ill, and, during the autumn, returns to France.
1857	By February, Carpeaux is back in Rome, involved in his project of artistic self-education, working sometimes with his friend, the engraver Joseph Soumy. Begins his figure of the *Jeune Pêcheur à la coquille* and completes it early the following year. Announces that he has found a subject from Dante as the theme of his final *envoi*.
1858	The *Jeune Pêcheur* is exhibited in Paris with the Rome *envois* (the only one of Carpeaux's works to be so displayed). In August, travels to Florence, then returns to Rome to work seriously on *Ugolin et ses fils*.
1859	Exhibits a bronze cast of the *Jeune Pêcheur* at the Salon; it is purchased by the Baron James de Rothschild. Continues to work on the *Ugolin*, despite the opposition of Schnetz, then Director of the French Académie in Rome. December sees the official end of his Roman stipend, and he returns to France to try to negotiate continued financial support.
1860	Sojourn in Paris; Carpeaux wins the necessary subvention to complete his group. In May and June visits Valenciennes; from the visit results his first offer to execute a monument to Watteau in recompense for his city's support of his career. In August, returns to Rome and to the final stages of work on the *Ugolin*.
1861	On the group's completion, it is exhibited in his Roman atelier; its success wins Carpeaux commissions from a number of French residents in Rome, including the Marquis de Piennes, secretary to the French ambassador, the Marquise de la Valette, the ambassador's wife, and the Blount family. Later, the *Ugolin* is cast, packed, and shipped to France.
1862	In March–April, *Ugolin et ses fils* is exhibited in the chapel at the Ecole des Beaux-Arts; the Section de Sculpture of the Académie des Beaux-Arts writes a lukewarm opinion of the work and for a time it seems that the government will not support its execution in more durable material without changes in its form. Yet a bronze is finally commissioned, cast by Victor Thiébaut, and by December, 1863, is placed in the Tuileries Gardens as a pendant to the *Laocoön*. Introduced to haute bourgeois and imperial milieu: executes busts of Princess Mathilde, the painter Eugène Giraud, the banker Ernest André and his son Edouard (the latter, with his wife, founder of the Musée Jacquemart André).
1863	In February, during a visit to Valenciennes, gives a cast of *Ugolin* to the local museum. At the Salon, exhibits the bronze version of the group (no. 2272), flanked by marbles of the *Jeune Pêcheur* (no. 2273) and the bust of Princess Mathilde (no. 2274). Briefly returns to Rome to complete a funerary relief commissioned by the Blount family (S. Luigi dei Francesi). In July, visits Brussels, Bruges, Anvers, and Ghent. Carpeaux's mother returns from America. The Commission des Beaux-Arts of the city of Paris awards the sculptor a commission for a figure of *La Tempérance* for the Eglise de la Trinité, begun in 1861 by Théodore Ballu.
1864	At the Salon, shows *Jeune Fille à la coquille* (no. 2534) and *La Palombella, souvenir de la Sabine (Italie)* (no. 2535). In the spring, visits the Duchesse de Castiglione Colonna (Marcello) at Givisiez, near Fribourg, Switzerland. Receives official notification of a commission to execute an elaborate decorative scheme for the Pavillon de Flore, at the Louvre. The year is spent on this and the other major commissions already in hand. Yet Carpeaux competes unsuccessfully for two other monumental commissions, commemorative statues to Don Pedro, Emperor of Brazil and King of Portugal, destined for Lisbon, and to the Maréchal Moncey, for Paris. He is invited to imperial receptions and parties.
1865	Receives official commissions for his portraits of the Prince Impérial, as well as formal notification of his participation in the Opéra decoration. Much of his time is occupied in finishing the Louvre decor, and he does not exhibit in the Salon.
1866	At the Salon, shows the half-size models for his Louvre figures (no. 2667: *La France impérial portant la lumière dans le monde et protégeant l'Agriculture et la Science*), and his standing portrait of the Prince Impérial (no. 2668). In August, is named Chevalier de l'ordre impérial de la Légion d'Honneur.

1867	The year marks the artist's first serious attempt, in collaboration with his brother, Emile, to market his portraits of the Prince Impérial. A marble version of the standing portrait is shown at the Exposition Universelle, as well as marbles of the *Ugolin* and the *Jeune Pêcheur*. These are flanked by a decorative bust, the *Rieuse Napolitain* and portraits of Giraud, Vaudremer, and Beauvois, these last three products of the early 1860s. Becomes further involved in executing formal portraits of individuals within the imperial court, like the Duchesse de Mouchy and Comtesse Armand. In August, receives a commission for a group, *Les Quatre Parties du Monde*, the crowning element of a fountain to be placed at the southernmost tip of the Luxembourg Gardens, near the Rondpoint de l'Observatoire.
1868	Works on *La Danse*, as well as on his design for the decor of the Valenciennes Hôtel de Ville, *La Ville de Valenciennes défendant la Patrie*. His first project for the latter work is refused by J. Batigny, the city's architect. At the Salon, exhibits a silvered bronze version of the Prince Impérial statue (no. 3464) and a marble of his portrait of the Duchesse de Mouchy (no. 3465).
1869	In April, is married to Amélie de Montfort, twenty-two year old daughter of Philogène, Vicomte de Montfort, a retired general, and the Vicomtesse de Montfort. At the Salon, shows the *Négresse*, a marble bust derived from his studies for the Fontaine de l'Observatoire (no. 3283) and a portrait of the architect of the Opéra, Charles Garnier (no. 3284, bronze). *La Danse* is unveiled late in July; a month later it is vandalized, and the brouhaha surrounding Carpeaux and his group grows even louder. In November, the sculptor refuses the official invitation to design another group.
1870	In April, the artist's brother Charles dies, and his son, named for the dead man, is born. Carpeaux models a bust, *Le Violoniste*, in his brother's memory. At the Salon, his marble portrait of the ballerina Eugénie Fiocre (no. 4329) is shown alongside the marble *Mater Dolorosa* (no. 4330). A model for the figure of Watteau, long since promised to Valenciennes, was shown *hors catalogue*.
1871	Leaves Paris for London to avoid the events of the Commune. There is associated with a number of French artists, including Charles Gounod and Jean-Léon Gérôme, whose portraits he models. In December, organizes, with Carrier-Belleuse, a sale of their works. Finds a certain amount of success with English amateurs, and receives commissions. By the end of the year, returns to France.
1872	Increasingly involved in the commercialization of his work, and mines architectural designs for small-scale, saleable versions. His brother Emile takes over direction of the atelier. At the Salon, shows plaster model of his group, *Les Quatre Parties du Monde soutenant la sphère* (no. 1586) and a bronze of the portrait of Gérôme (no. 1587). In October, pays a visit to Mme Pelouze at the château of Chenonceau.
1873	In January, is summoned to England by Eugénie, and commissioned to execute a posthumous portrait of Napoléon III. His English commissions have begun to pile up: a marble version of the Flore, for the Turners (whose busts he had previously executed, and a marble group, *Daphnis and Chloe*, for Lord Ashburton. His atelier continues to be active; terra cottas are produced for sale, and auctions are held in several European cities. The plaster model of *Les Quatre Parties du Monde* is put in place and approved. At the Salon, exhibits marble portraits of the philanthropists M. and Mme Chardon-Lagache (nos.1556–57). In December, M. Meynier takes over the direction of the atelier.
1874	The year sees the increasing erosion of Carpeaux's relations with his wife, despite the birth, in February, of a second son (Carpeaux denies paternity of this child and his sister, Louise, born November, 1872). In April, undergoes an operation for cancer of the prostate at the Maison Dubois, Paris. At the Salon, exhibits marble portraits of Mme Sipierre and Alexandre Dumas fils (nos. 2726–27), and a marble statuette, *L'Amour blessé* (no. 2728). This last is purchased by the Rumanian prince, Georges Stirbey, who will become the artist's protector during the final year of his life. Carpeaux lives first with

his parents, then with the painter Bruno Chérier. In July, visits Puys (home of Dumas fils) and Dieppe, and in the course of this sojourn executes the statuette, *La Pêcheuse des vignots*, and the bust of Dr. Achille Flaubert, whom he consults in Rouen. He maintains contact with his atelier and *praticiens* by letter. In late August, the Fontaine de l'Observatoire is inaugurated, but Carpeaux does not attend. In October, he is once again staying at Chérier's. At this time makes a rather desperate effort to establish a second studio, transferring his tools to Chérier's. In December, his wife wins a suit for libel brought against one of Carpeaux's *praticiens*, Alexandre Delcroix, who had publicly questioned the paternity of her children.

1875 In February, Carpeaux is at Nice with Georges Stirbey. At the Salon, exhibits a bronze portrait of Chérier and a marble bust of Mme Alexandre Dumas (nos. 2926–27). In June, takes up residence at Courbevoie, on the outskirts of Paris, in a small house lent by Stirbey and near his residence, the Château de Bécon. Throughout the spring, experiences increasing personal and legal difficulties regarding the running of his atelier, and in June, publishes a letter in *Le Figaro* which disclaims responsibility for works bearing his signature. In August, is awarded the Cross of the Légion d'Honneur. Dies on October 11, 1875. Is buried first in Auteuil, but his body is later exhumed and reinterred, on November 29, in Valenciennes.

NOTES TO THE TEXT

ABBREVIATIONS

AN	Archives Nationales, Paris
BNEST	Bibliothèque Nationale, Paris, Cabinet des Estampes
BNMSS	Bibliothèque Nationale, Paris, Département des Manuscrits
BO	Bibliothèque de l'Opéra, Paris
BSHAF	*Bulletin de la Société de l'Histoire de l'Art Français*
EBA	Ecole des Beaux-Arts, Paris
Fromentin	E. Fromentin, "Essai biographique sur Jean-Baptiste Carpeaux, Statuaire Valenciennois," Bibliothèque Nationale, Paris, Département des Manuscrits, NAF 24.291
GBA	*Gazette des Beaux-Arts*
IFA	Institut de France, Académie des Beaux-Arts, Archives
Lami	S. Lami, *Dictionnaire des sculpteurs de l'école française au XIXe siècle*, 4 vols. Paris, 1914–21.
LCC I, LCC II	L. Clément-Carpeaux, *La Verité sur l'oeuvre et la vie de J.-B. Carpeaux*, 1, Paris, 1934; 2, Nemours, 1935.
Mabille	A. Mabille de Poncheville, *Carpeaux inconnu ou la tradition recueillie*, Paris and Brussels, 1921.
VAM	Valenciennes, Archives Municipales
VBM	Valenciennes, Bibliothèque Municipale
VCD	Valenciennes, Musée des Beaux-Arts, Cabinet des Dessins
VMA	Archives de l'Académie de France à Rome, Villa Medici, Rome

CHAPTER I

1. E. and J. de Goncourt, *Journal: Mémoires de la vie littéraire*, Paris, 1959, vol. 2, p. 141.

2. During his lifetime, Carpeaux was described in a number of other journal entries: vol. 2: August 15, 1865 (p. 186), when the subject is the sculptor's omission from the list of nominees to the Legion of Honor; September 3, 1865 (p. 198), "Ce Carpeaux, une nature de nerfs, de violence, d'exaltation, une figure à la serpe, toujours en mouvement, avec des muscles changeant de place et des yeux d'ouvrier en colère. La fièvre du génie dans un peau de marbrier;" March 17, 1869 (p. 505); August 12, 1869 (p. 535); October 27, 1871 (p. 840); May 25, 1872 (p. 896); October 16, 1875 (p. 1085).

3. C. Blanc, "Carpeaux," *Le Temps*, October 15, 1875.

4. C. Garnier, cited in J. Clarétie, *Peintres et sculpteurs contemporains*, Paris, 1884, vol. 1, p. 175.

5. For a survey of sources relative to Carpeaux's misadventures at court, see M. Terrier, "Carpeaux à Compiègne," *Bulletin de la Société Historique de Compiègne*, 25, 1960, pp. 199–208.

6. Both *L'Illustration* and *Le Monde Illustré* covered Carpeaux's death extensively. On October 16, 1875, the former devoted its cover to a portrait of the dead man. On October 23 and December 11, news of his death and funeral followed. *L'Artiste*, ser. 9, 1875, pp. 363–65. *La Chronique des Arts et de la Curiosité*, no. 33, October 23, 1875, p. 301, and *La Gazette de France*, October 16,

1875, give accounts of the death and funeral. The police surveillance dossier (Archives, Préfecture de la Police de Paris, ser. BA, Carton 996, Dossier Carpeaux) communicates the official worry that a demonstration might erupt as the sculptor's body was being transferred to Valenciennes, in a display of emotion against the dead man's widow. Her father feared an action by students from the Ecole des Beaux-Arts. J. Clarétie produced the first book about the dead man, *J.-B. Carpeaux, 1827–1875*, Paris, 1875, and included some of these details.

7. *La Chronique des Arts et de la Curiosité*, no. 33, October 23, 1875, p. 301.

8. H. James, "Paris as it is: Letter from Henry James, Jr.," *New York Daily Tribune*, December 25, 1875.

9. P. Mantz, "Carpeaux," *GBA*, ser. 2, 13, 1876, pp. 573–631.

10. *Art Journal*, 38, 1876, p. 5.

11. *Bonnes Soirées*, February 17, 1957. Clipping conserved at the Musée d'Orsay, Documentation, Département des Sculptures, Legs Holfeld.

12. See, for example, A. Pingeot, in Association des Conservateurs de la Région Nord-Pas-de-Calais, *De Carpeaux à Matisse*, 1978, p. 112: "Carpeaux fut l'un des prototypes de l'artiste du XIXe siècle."

13. C. Blanc, *Le Temps*, October 15, 1875.

14. These descriptions of the burgeoning profession of sculpture are compiled on the basis of samplings taken from the *Almanach du Commerce*, Paris, at five-year intervals, 1830–60. Begun in 1818, the Réunion of bronze founders published the *Almanach de messieurs les fabricants de bronzes réunis dans la ville de Paris*.

15. E. Charton, ed., *Guide pour le choix d'un état; ou, Dictionnaire des professions*, 2nd ed., Paris, 1851, p. 552.

16. P. Larousse, ed., *Grand Dictionnaire universel du dix-neuvième siècle*, Paris, vol. 13, II, p. 36.

17. Charton, p. 548.

18. E. Kris and O. Kurz, *Legend, Myth, and Magic in the Image of the Artist*, New Haven and London, 1979, pp. 13 ff.

19. T. Zeldin, *France, 1848–1945*, Oxford, 1973, vol. 1, pp. 87–89. The statistic tabulating sculptors' fathers' professions is based on Lami's biographies for two samplings: sculptors who won the Prix de Rome from 1806 to 1860, and sculptors who exhibited in the Salon of 1853. As such it is incomplete, simply because Lami does not always give a sculptor's father's profession.

20. M. Claudet, *La Jeunesse de J. J. Perraud, statuaire, d'après ses manuscrits*, Salins-les-Bains, 1886, p. 59.

21. L. de Fourcaud, *François Rude, sculpteur, ses oeuvres et son temps*, Paris, 1904, pp. 31–35, and P. Quarré, "François Rude, Grand Prix de Rome," *Mémoires de l'Académie des Sciences, Arts et Belles Lettres de Dijon*, 112, 1958, p. 43.

22. J. Salmson, *Entre deux coups de ciseau: Souvenirs d'un sculpteur*, Geneva, 1892, p. 70.

23. The best sources for information about Carpeaux's background are the manuscript by Fromentin, a contemporary of Carpeaux and a Valenciennes native, and the three studies by A. Mabille de Poncheville, *L'Enfance de Carpeaux*, Paris, 1913; *Carpeaux inconnu ou la tradition recueillie*, Paris and Brussels, 1921; and "Les Origines et les débuts de Carpeaux," *Bulletin des Beaux-Arts de Belgique*, 39, 1957, pp. 46–54.

24. This discussion of the differences between the sculptor's and painter's genius is found in F. Guizot, "Essai sur les limites qui séparent et les liens qui unissent les Beaux-Arts," originally written as a preface to the catalogue of the Musée Royale, and reprinted in *Etudes sur les beaux-arts*, Paris, 1853, pp. 120–21. Guizot cites Diderot as his authority, quoting his Salon of 1765, where a distinction between two types of *génie*, the painter's and the sculptor's, is drawn specifically in terms of Michelangelo.

25. E. Zola, *L'Oeuvre*, Chapter 8. See *Oeuvres complètes*, ed. H. Mitterand, Paris, 1967, vol. 5, p. 617.

26. See R. J. Niess, *Zola, Cézanne and Manet: A Study of L'Oeuvre*, Ann Arbor, 1968, p. 49. It should be added that this opinion is by no means shared by all Zola scholars. P. Brady, *"L'Oeuvre" d'Emile Zola: Roman sur les arts; Manifeste; Autobiographie; Roman à clef*, Geneva, 1967, pp. 436–37, reprints Zola's *ébauche* for the book, including his plan to fabricate a sculptor character out of a "not very modern" artist, Carpeaux, and a more modern one, his friend Valabrègue.

27. *L'Oeuvre*, Chapter 3. *Oeuvres complètes*, vol. 5, p. 484.

28. As in a letter to a friend, Masquelez, June, 1866, BNEST, SNR Boîte Carpeaux 114: "J'ai été bien épuisé par l'excessif labeur que j'ai accompli la saison dernière. J'ai dû abandonner le travail pendant deux mois car mes jambes se refusaient à me tenir. Quel métier que celui du sculpteur!"

29. Carpeaux to Napoléon III, February 11, 1868. AN F²¹ 124.

30. T. Gautier, "Salon de 1841," *Revue de Paris*, ser. 3, 28, p. 155.

31. F. de Mercey, "Salon de 1844," *Revue de Paris*, ser. 3, 31, p. 209.

32. T. Thoré, "Salon de 1847," *Salons de T. Thoré, 1844–1848*, Paris, 1868, p. 531.

33. *Journal des Artistes*, 3, parts 1–2, 1846. *La Liberté* was produced through the collaboration of artists

and writers like J. Duseigneur, A. Decamps, G. I. H. Laviron, P. A. Jeanron, etc. The tone of the relevant paragraph is typical: "l'armée est prête, les cadres remplis, les soldats exercés, et le mot d'ordre, qui n'avait été que bégayé, que prononcé, tout bas, nous le crions aujourd'hui à voix haute : *Mort à l'Institut ! Mort au professorat !* Ainsi, nous ne jetterons les armes que quand nous aurons fait à l'Académie royale des Beaux-Arts une large tombe avec les pierres démolies du Palais des Quatre-Nations." Or further in the same article : "C'est du pain, c'est de la réputation que nous demandons, et nous n'en voulons pas miette à miette, comme on consentirait peut-être á nous l'accorder ; mais à tous, la vie entière, à tous libre et sans entraves, le champ du combat où se dispute la gloire."

34. C. Blanc, "Rapport au citoyen Ministre de l'Intérieur sur les arts du dessin et sur leur avenir dans la République," *Moniteur Universel,* October 10, 1848.

35. Cited in J. C. Galley, *Antonin Moine, un statuaire romantique oublié,* St. Etienne, 1898, p. 65, as reported in *Le Moniteur Officiel,* April 3, 1849. For Hugo's description of Moine's financial and professional difficulties, his fruitless attempts to secure state patronage, and the events leading to his suicide, see V. Hugo, *Choses vues, 1849–1869,* Paris, 1972, pp. 135–37, entry for March, 1849.

36. Cited by Galley, p. 71, from *L'Artiste,* ser. 1, 7, 1834, p. 29. Also cited by Thoré, in exactly the same words, *Revue Républicaine,* 1834, p. 403. It is difficult to establish sculptors' incomes, since money was received from diverse and often undocumented sources. But relying on sums cited by Lami, vol. 3, Moine received 58,300 francs from state commissions between 1834 and his death. His widow was paid an additional 5,300 francs for works left in her husband's studio. These figures compare strikingly with amounts paid to Marochetti, for example : between 1835 and his departure for England with Louis Philippe in 1848, he earned 349,000 francs for six different public commissions. Pradier, whose first transaction with the government was the sale of his fifth-year *envoi, Les Fils de Niobe,* in 1822, for 8,000 francs, received more than 424,500 francs in state funds during his lifetime (240,000 alone were paid for the twelve *Victoires* to be executed for Napoleon's tomb, and which remained unfinished at his death in 1852). From his first public commission in 1827, the *Vierge Immaculée* for S. Gervais et S. Protais, Rude received 3,000 francs from the state, and, as is well known, completed two of his most important works, the *Napoléon réveillant à l'Immortalité* (Fixin) and the bronze

gisant for the tomb of Godefroy Cavaignac (Cimetière Montmartre, Paris), without pay.

37. These adjectives are representative of a vocabulary frequently employed by critics. The phrases quoted are from A. Guillot, "Salon de 1848, Premier Article," *Revue Indépendante,* 19, 1848, p. 231.

38. T. Gautier, "Salon de 1841," *Revue de Paris,* ser. 3, 28, p. 155.

39. Thoré, "Salon de 1846," *Salons,* p. 278.

40. Gautier, "Salon de 1841," p. 155.

41. P. E. Mangeant, *Antoine Etex, Peintre, Sculpteur et Architecte, 1808–1885,* Paris, 1894, p. 42. F. Aubert, reviewing sculpture at the 1861 Salon, reported on this longstanding project. See *L'Artiste,* 11, 1861, pp. 273–74.

42. C. Baudelaire, *Oeuvres complètes,* Paris, 1968, pp. 257–58 (1846); 418–19 (1859).

43. D. Diderot, ed., *Encyclopédie ; ou, Dictionnaire raisonné des sciences, des arts, et des métiers,* Neufchâtel, vol. 14, 1765, p. 834.

44. In an undated letter to Ernest Hébert, Musée Hébert, Paris.

45. See J. Wasserman, ed., *Metamorphoses in Nineteenth Century Sculpture,* Cambridge, 1975.

46. P. Malitourne, "Le Salon : La Sculpture en 1846," *L'Artiste,* ser. 4, 6, 1846, p. 185. For Moine's commercial activity, see Galley, p. 68; For Pradier, L. Gielly, "Les Pradiers du Musée de Genève," *Genava,* 3, 1925, p. 347; For Barye, G. F. Benge, "Antoine-Louis Barye," in *Metamorphoses,* pp. 76–107.

47. M. Du Camp, "Exposition Universelle : Beaux-arts (Sixième Article) : France, la sculpture," *Revue de Paris,* 27, 1855, p. 261.

48. V. Schoelcher, "Salon de 1831 : Sculpture," *L'Artiste,* ser. 1, 1831, p. 313.

49. "Fronton de l'Institution des Jeunes Aveugles," *L'Artiste,* ser. 3, 3, 1843, pp. 17–19.

50. Du Camp, "Exposition Universelle," p. 267.

51. *Ibid.,* p. 264.

52. A. Guillot, "L'Exposition annuelle des beaux-arts : I. Sculpture, marbres et bronzes," *La Revue Indépendante,* ser. 23, 8, March 26, 1847, p. 259.

53. Apollonie Sabatier, the well-known courtesan and formerly Clésinger's mistress, posed for the work. Some critics protested, however, that they recognized "a young actress from the Odéon." See E. J. Delécluze, "Salon de 1847 : La Sculpture," *Journal des Debats,* April 3, 1847; G. Planche, "Salon de 1847," *Etudes sur l'école française,* Paris, 1855, vol. 3, pp. 262 ff.; T. Gautier, *Salon de 1847,* Paris, 1847, pp. 206 ff.; Thoré, *Salons,* pp. 534 ff.; P. Malitourne, "La Sculpture en 1847," *L'Artiste,* 9, 1847, pp. 170–71.

54. E. Zola, *Mon Salon, Manet : Ecrits sur l'art,* Paris, 1970, p. 170.

CHAPTER II

1. BNEST, Boîte Carpeaux 114, draft of a letter by J.-B. Foucart to M. Sabatier, unpag.

2. A. Perdiguier, *Mémoires d'un compagnon*, Moulins, 1914, pp. 18, 72–76.

3. Kris and Kurz, passim.

4. A. Corbon, *De l'enseignement professionel*, Paris, 1859, unpag.

5. Mantz, *GBA*, ser. 2, 13, 1876, pp. 593–631.

6. Paris, Grand Palais, *Sur les traces de Jean-Baptiste Carpeaux*, Paris, 1975, unpag.

7. Cited in R. Balze, *Ingres, son école, son enseignement du dessin, par un de ses élèves*, Paris, 1880, p. 3.

8. A. Perdiguier, *Le Livre du compagnon*, Paris, 1840, p. 46.

9. C. Blanc, *Grammaire des arts du dessin*, Paris, 1867, p. 22.

10. To cite just one example, drawn from a contemporary *physiologie*: "Il est une règle sur laquelle tout le monde est d'accord, c'est que le dessin proprement dit est la base fondementale de reproduire la nature." *Paris vivant par des hommes nouveaux: Le Pinceau, le crayon et le ciseau*, Paris, 1858, p. 18.

11. G. Flaubert, *Le Dictionnaire des idées reçues*, in *Bouvard et Pécuchet*, Paris (Gallimard), 1979, p. 506.

12. Comte de Rambuteau, in a speech at the awards ceremony of the Ecole Gratuite de Dessin, December 21, 1834, p. 2 (printed pamphlet, Bibliothèque Historique de la Ville de Paris).

13. R. Rosenblum, "The Origins of Painting: A Problem in the Iconography of Romantic Classicism," *Art Bulletin*, 39, December, 1957, pp. 279–90. Compare the version given by T. Eméric-David, *Histoire de la sculpture antique*, Paris, 1853, p. 23.

14. Diderot, ed., vol. 4, pp. 889 ff.

15. F. A. David, *Elémens du dessin; ou, Proportions des plus belles figures de l'antiquité, à l'usage de ceux qui se destinent aux beaux-arts*, Paris, 1798.

16. For an initial survey of these courses, based on those conserved in the Cabinet des Estampes, Bibliothèque Nationale, Paris, see D. Harlé, "Les Cours de dessin gravés et lithographiés du XIXème siècle conservés au Cabinet des Estampes de la Bibliothèque Nationale: Essai critique et catalogue," thesis, Ecole du Louvre, [c. 1975], directed by J. Adhémar. This thesis is useful for the order it gives to a large, unwieldy mass of material, and I thank M. Melot for bringing it to my attention.

17. Publication of the *cours de dessin* and supplements can be summarized as follows (by decade and numbers of courses):

 1790–99 — 5
 1800–09 — 46
 1810–19 — 53
 1820–29 — 85
 1830–39 — 107
 1840–49 — 136
 1850–59 — 153
 1860–69 — 64

 (based on Harlé's catalogue).

18. E. Guillaume, "Idée générale d'un enseignement du dessin," *Essais sur la théorie du dessin*, Paris, 1896, p. 2. Text of a speech originally delivered to the Union Central des Arts on May 23, 1866.

19. The elimination of teachers was considered a boon in a climate where their competence was often criticized. See, to cite one example, F. Ravaisson, *De l'enseignement du dessin dans les lycées*, Paris, 1854, pp. 72–73.

20. A. Faure to H. Belloc, August 24, 1848, AJ[53] 105.

21. *Ibid.*

22. E. Delacroix, "Le Dessin sans maître, par Mme Elisabeth Cavé," *Revue des Deux Mondes*, September 15, 1850, p. 1140.

23. See A. Boime, "The Teaching Reforms of 1863 and the Origins of Modernism in France," *Art Quarterly*, n.s., 1, no. 1, 1977, pp. 3, 4, 28, for a brief discussion of such courses.

24. H. Lecoq de Boisbaudran, *Education de la mémoire pittoresque*, Paris, 1848, pp. 6–8.

25. *Ibid.*, p. 9.

26. A. Dupuis, *Enseignement du dessin: Méthode A. Dupuis, approuvée par la Société des Méthodes, l'Institut, etc.*, Paris, n.d.

27. AN F[21] 497, Dossier "Procédé du dessin pour faciliter l'étude des arts par M. Rouillet." See also N. A. Rouillet, *Nouveaux Principes de dessin, divisions de la tête et de la figure académique suivies de quelques notions de perspective pour servir de complément au procédé du même auteur acquis et publié par le gouvernement en 1844*, Paris, 1863; "Rapport adressé à M. le Ministre de l'Intérieur par la commission chargée d'examiner l'appareil de M. Rouillet," *Moniteur Officiel*, January 22, 1844.

28. Rouillet's method was simply a piece of gauze or tarlatan stretched on a frame; the drawing was thus a kind of tracing of a figure as it could be seen through the gauze. The *essentiel* was pounced by rubbing it into a piece of paper; two or three proofs could be made in this fashion.

29. F[21] 497, "Rapport."

30. *Ibid.*

31. Raoul Rochette to the Ministre de l'Intérieur, February 24, 1843, F[21] 497.

32. Ingres, *Réponse au rapport sur l'Ecole Impériale des Beaux-Arts*, Paris, 1863, pp. 4–5. Cited in Boime, "Teaching Reforms," p. 19.

33. See "Report made by Mr. Dyce, consequent to his journey on an inquiry into the state of schools of design in Prussia, Bavaria, and France," House of Commons, Parliamentary Papers, 29, 1840, pp. 25–28. For more information on one of the schools he mentions, that maintained by A. Dupuis, see Ravaisson, pp. 32–35, and A. Dupuis, *De l'enseignement du dessin sous le point de vue industriel*, Paris, 1836, and note 26 above.

34. *Almanach des messieurs les fabricants de bronzes réunis de la Ville de Paris pour l'année 1857*, Paris, 1857, p. 5. This *école de dessin et de sculpture* was begun June 1, 1835. In 1857 it was open from the morning until 10 p.m. at 14, rue Ménilmontant. The members of the Réunion or their employees were received as students at two francs per month.

35. Dyce, p. 28.

36. J. P. Guénot, *Formation professionelle et travailleurs qualifiés depuis 1789*, Paris, 1946, pp. 92–93.

37. There are several basic texts on the history of drawing instruction: L. J. Van Peteghem, *Histoire de l'enseignement du dessin, depuis le commencement du monde jusqu'à nos jours*, Brussels, 1868; G. Duveau, *La Pensée ouvrière sur l'éducation pendant la Seconde République et le Second Empire*, Paris, 1947; F. Artz, *The Development of Technical Education in France, 1500–1850*, Cambridge, Mass., 1966, esp. Chapters IV, V. For a specific consideration of drawing instruction at the Ecole polytechnique, see G. Pinet, *Notice historique sur l'enseignement du dessin à l'École polytechnique*, [Paris, c. 1907], esp. pp. 34 ff. (on Charlet). For a discussion of the 1853 law, see Ravaisson. This law, signed December 29, 1853, by Hippolyte Fortoul, stipulates the grade levels at which drawing is to be taught, the content of the courses, in terms of the models to be used ("emprunter aux grands maîtres de l'art" as reproduced in casts, prints, or photographs), and the payment to be given professors (Lycées de Paris, 2,500 fr.; Lycées des départements: 1re classe [10] 2,000 fr., 2me classe [20] 1,800 fr., 3e classe [nombre indéterminé], 1,500 fr.) Note that this pay scale maintained a hierarchical relationship of Paris above the provinces.

38. Boime, "Teaching Reforms," is a study of those changes.

39. VAM, Statuts et règlements de l'Académie Communale de Peinture et Sculpture de la Ville de Valenciennes, GG 121.

40. VAM T3/4, Règlement de l'Académie Communale de Peinture et Sculpture de la Ville de Valenciennes, 1811.

41. G.-B. Depping, *Les Jeunes Voyageurs en France; ou, Lettres sur les départements*, Paris, 1824, pp. 142 ff.

42. Girault de Saint-Fargeau, *Guide pittoresque, portatif et complet du voyageur en France*, Paris, 1851, pp. 20 ff. For rather more authoritative statistics on industry and workers in Valenciennes, see Ministre du Commerce, *Statistique de la France: I. Industrie*, Paris, 1847. Its tables indicate the distribution of 340 industrial establishments in 65 communes, employing 18,781 workers (13,378 men, 2,194 women, 3,000 children).

43. The most devoted local historians of Carpeaux include Paul Foucart, Edouard Fromentin, and André Mabille de Poncheville.

44. VAM T3/12. The contestants, four of whom were residents of Paris, underwent three *épreuves*: (1) an *esquisse* executed in eleven hours of a subject requiring no more than four figures from Greek, Roman, or French history; (2) a drawing of a head executed after a cast; (3) a figure painted after the living model. Potier's prizewinning works were incorporated into the collections of the Académie.

45. VAM T3/12.

46. *Ibid.*

47. VAM T3/13, Académie de Valenciennes, Inventaire des matériels année 1834 (with additions from 1838), "Les Lithographies ayant fourni des modèles préférables aux gravures qui étaient copiées par les élèves, j'ai l'honneur de proposer à M. le Maire de Valenciennes de vendre une partie . . ."

48. *Ibid.*

49. Compare this type of *envoi* to the material sent to the Villa Medici. See Chapter 4.

50. VAM T3/13.

51. VAM T3/12.

52. J.-B. Bernard, "Cours de géométrie appliquée à l'art de bâtir: Discours d'ouverture prononcé le 18 November 1833," Valenciennes, 1833, VAM T3/11 bis.

53. *Ibid.*, p. 7.

54. VAM T3/19, "Considérant que les heures actuelles de leçons ne concordent pas avec celles fixées pour les classes dans les écoles primaires et du collège; qu'en conséquence les jeunes gens ne peuvent profiter à la fois des avantages qui leur offre cet établissement; considérant que beaucoup d'ouvriers qui voudraient étudier le dessin ne peuvent se consacrer à cette étude que le soir . . ." The decision of March 18, 1841, established an evening architectural course, 6:30–8 p.m., to teach math. Sculpture and drawing courses were to be held from 12 until 2 p.m. and from 6 to 8 p.m. Classes for cast drawing and drawing from the living model would be held in the morning from April 1 through

August 20, and from October 1 through March 31, in the evening. Beginners were not admitted to evening classes.

55. One of the most interesting documents in the archives of the Valenciennes Académie is a *Liste nominative des élèves de l'Ecole d'Architecture, dirigée par M. J. Bernard, architecte à Valenciennes*, published in 1852 when Bernard retired from teaching. It lists the names and professions of the more distinguished of Bernard's students (cited here in abbreviated form): eight at the Ecole des Beaux-Arts, Paris; nine at the Ecoles d'Art et Métiers at Châlons and Angers; one at the Ecole Centrale d'Art et Métiers; five architects; four inspectors of public works, one at the Château de Blois, two in Algeria, one in Valenciennes; three *chefs d'usine*, at Trith, Auchy and Valenciennes; thirteen *maîtres ouvriers, chefs d'établissements*, and *entrepreneurs*, of which are cited six *menuisiers*, two masons, one sculptor, one stonecutter (*tailleur de pierre blanche*), three painters; five draughtsmen employed in the Administration des Ponts et Chaussées; four draughtsmen working in the mine in Anzin; six draughtsmen in the administration of the Chemin de fer du Nord; four in Bernard's office in Valenciennes; eight *chefs d'atelier*, with specific reference here to men who work *chez un menuisier, chez un peintre, chez un charpentier-mécanicien, chez son père couvreur, chez son père serrurier*. The view presented by this evidence contrasts with the characterization of education in Valenciennes by other authors. There the presence of any professional education in Valenciennes is discounted. See for example: P. Pierrard, "L'Enseignement primaire à Valenciennes, de la loi Falloux (1850) aux Laïcisations (1891)," *Valenciennes et les anciens pays-bas: Mélanges offerts à Paul Lefrancq*, Valenciennes, 1976, vol. 9, p. 129. See also Pierrard, "L'Etablissement des Frères des Ecoles Chrétiennes à Valenciennes, 1824 à 1848," Ms., Mémoire d'études supérieures présenté devant la Faculté des Lettres de Lille, November, 1949, for a general background to primary education in Valenciennes. I am grateful to M. Pierrard for his kindness in allowing me to consult his paper.

56. As interesting as the material cited in the text, is another document formulated within the administration on the subject of the advisability of charging students a fee. The report weighs the question in terms of the history and aims of the school: "Considérant que les écoles académiques qui, à leur origine, ont pu être considérées comme écoles d'art et d'agrément, sont devenues d'une utilité immédiate et ont pris depuis quelques temps un accroissement consi-

dérable, au point que les inscriptions dans la dernière année ont monté jusqu'à à 300; considérant que cette extension s'est faite sentir notamment dans les cours d'architecture, d'ornements, de perspective linéaire et de géométrie descriptive, qui ne sont pas fréquentés que par des enfants d'ouvriers ou d'artisans; que même dans la classe de dessin l'immense majorité des élèves (les pensionnaires des collèges exceptés) est composée de jeunes gens des classes inférieures de la société, parce qu'il est bien reconnu aujourd'hui de quoi que profession ce soit ce n'est pas un ouvrier complet s'il ne possède au moins les premiers éléments du trait." The conclusion of the report was that it would be a "very ill-chosen moment to institute a charge for such a societal necessity"; it was written in 1849. VAM T3/28, "Extrait du registre des délibérations du conseil d'administration de l'Académie de peinture, sculpture et architecture de Valenciennes, séance du 23 Octobre 1849."

57. AN F[21] 293, Dossier Ecoles de dessin, 1845–66.

58. F21 293, letter of December 13, 1850.

59. Dyce, p. 25.

60. P. de Chennevières, "L'Ecole de Dessin de Rouen de 1839 à 1857," *Nouvelles Archives de l'Art Français*, ser. 3, 1888, pp. 216–20.

61. L. Alvin, *Les Académies et les autres écoles de dessin de la Belgique*, Brussels, [c. 1865], pp. 210–11.

62. AN AJ[53] 105, Mayor of Châlons to Belloc, July 30, 1850; administration of Vitry-le-François to Belloc, November 25, 1850; E. Cavé to Belloc, September 28, 1846, referring to a demand from the city of Nantes for a collection of *modèles* from the Ecole; Préfet de la Corrèze to Belloc, February 20, 1844.

63. "Nous donnons ce règlement en entier parcequ'il deviendra naturellement le type des règlements de toutes les écoles analogues de province, et qu'il intéressera, nous le savons, nos lecteurs à l'étranger," *Revue Générale de l'Architecture et des Travaux Publics*, 6, 1845–46, cols. 120–24. The editor of the *Revue*, César Daly, maintained his interest in the school, continuing to publish reports of its curriculum and prize day speeches, sometimes under the motto: "Solidarité entre l'industrie et l'art."

64. AN AJ[53] 105, E. Texier to H. Belloc, October 20, 1844.

65. AN AJ[53] 105, letter of June 18, 1858.

66. AN AJ[53] 105, Bracq to Belloc, December 2, 1856.

67. Cited in L. Courajod, *L'Ecole royale des élèves protégés, précédé d'une étude sur le caractère de l'enseignement de l'art français aux différentes époques de son histoire, et suivie des documents sur l'Ecole Royale*

Gratuite de Dessin, Paris, 1874, p. 197. The speech by Bachelier, Courajod explains, is usually dated 1766, but he argues that it must be at least several years later.

68. *Ibid.*, pp. 199–205.

59. *Ibid.*, p. 211.

70. AJ[53] 3, Procès Verbaux des délibérations du conseil d'administration, Ecole Royale Gratuite de Dessin. Meetings of December 13, 1829, December 19, 1830, September 20, 23, 26, October 4, 25, 1831.

71. For biographies of Hilaire and Louise Swanton Belloc, see *La Grande Encyclopédie*, Paris, n.d., vol. 6, p. 92, and G. Vapéreau, *Dictionnaire universel des contemporains*, Paris, 1858, p. 156.

72. A friendly letter from David d'Angers to Belloc is found in the Petite Ecole archives, AJ[53] 105. See also J. Michelet, *Journal*, ed. P. Viallaneix, Paris, 1959, vol. 1, pp. 326, 401.

73. H. B. Stowe, *Souvenirs heureux: Voyage en Angleterre, en France et en Suisse*, transl. E. Fourcade, Paris, 1857, vol. 4, pp. 311–14.

74. *L'Illustration*, April 26, 1848, pp. 387–89: Porte d'entrée de la Rotonde; Salle d'étude de la figure et de l'Ornement pour les commençants; Salle d'étude pour le modelage de la figure et l'ornement d'après les plantes vivantes; Salle d'étude pour le dessin et le modelage d'après la bosse. Woodcuts by E. Renard, H. Valentin.

75. See L. Marx, *The Machine in the Garden*, Oxford, 1964, p. 208.

76. In September, 1858, Belloc was asked by a journalist, A. Berger, for sources for material to be used in an article on the school the latter was to publish in the *Journal des Débats* (October 29, 1858). Belloc complied, and compiled a list which is the basis for the public image of the school in the 1850s (found in AJ[53] 98). These include the article in *L'Illustration* (cited above); *Magasin Pittoresque*, 8, March, 1850, pp. 97–98; *L'Ami de la Maison*, 1, 1856, p. 141; *Revue Générale de l'Architecture et des Travaux Publics*, 11, 1853, p. 243; Rapport du directeur, 1857 (probably not a published source; unlocated); F. Halévy, *Moniteur Officiel*, July 8, 1858. Other contemporary sources include accounts in the *Revue Générale* of prize-giving ceremonies, written by C. Daly: 7, 1847–48, cols. 290–96; 15, 1857, cols. 145–51; A. Guillot, "Ecole Royale Gratuite de Dessin, de Mathématiques et de Sculpture Ornementale," *L'Artiste*, ser. 2, 2, 1839, pp. 204 ff., 329–31; H. Vermot, "Distribution des Prix: Ecole Royale de Dessin," *L'Artiste*, ser. 4, 7, 1846, pp. 156–57; T. Gautier, "Ecole Impériale et Spéciale de Dessin," *L'Artiste*, ser. 7, 5, 1858, pp. 7–8.

77. AJ[53] 3.

78. *Ibid.*

79. F[21] 643, Dossier Collections.

80. AJ[53] 98.

81. One of these initiatives involved an artist named Jean Philippe Schmidt. At the Salons of 1830 and 1831, he exhibited drawings titled "Principes de l'ornement" and identified as examples from a course Schmidt planned to publish for the use of drawing schools. It is probably on the basis of these works that Belloc contacted Schmidt; the latter replied in a letter of December 2, 1831, AN F[21] 497: "Vous m'avez invité à vous exposer par écrit le plan de mon ouvrage élémentaire de l'ornement, ainsi que les conditions auxquelles je consentirais à l'exécuter." The course was eventually published as *Cours de dessin d'ornement à l'usage des ecoles des arts*, Paris, 1842, with Belloc's endorsement as an "ouvrage adopté pour l'Ecole royale et gratuite de Paris." Belloc's sanction is significant, because it testifies to approval of the course's innovations: ornament is isolated as a valuable area of study, and both Gothic and Renaissance models are included as worthy of emulation. This opinion was by no means widely shared; an annotated copy of Schmidt's letter preserved in the archives of the Ministère des Beaux-Arts includes the words "Non, jamais!" next to these proposals. Belloc endorsed Schmidt's course, because he agreed with its author's estimation of it as "un système élémentaire raisonné, comme il pouvait convenir d'en adopter un pour l'enseignement à l'Ecole gratuite, destinée plus encore à former des ouvriers qu'à préparer des artistes."

82. *Revue Générale de l'Architecture et des Travaux Publics*, 7, 1847 48, col. 296.

83. AJ[53] 36, Registre d'émargement par quittance des appointements de Messieurs les professeurs et employés commencé le Ier janvier 1841. By March, 1844, the full staff of the school was listed as director, secretary, professors of construction, mathematics, figures, *animaux*, *fleurs* (later *plantes*), *ornement*, *composition d'ornement*, *sculpture d'ornement*, and *répétiteurs de construction*, *mathématiques*, *sculpture d'ornement* (2).

84. On Texier and his role, see F[21] 643, Dossier Commission de surveillance des écoles royales de dessin, and F[21] 563, "Note à Son Excellence Monsieur le Ministre d'Etat sur l'administration des écoles des beaux-arts," Texier to Ministre d'Etat, April 21, 1863.

85. *Revue Générale de l'Architecture et des Travaux Publics*, 6, 1845–46, col. 123.

86. AN AJ[53] 100. The list dates from 1849, and gives seventeen names. It concludes a report written

by Lecoq meant to summarize two years of experimentation with his method: "En resumé; on peut conclure . . . que la mémoire des formes est susceptible d'un très grand développement par l'exercise gradué et méthodique, et que cet exercise a la propriété d'exciter vivement l'observation et l'intelligence. Enfin on peut déjà entrevoir les immenses avantages qui pourront résulter pour les différents arts du dessin de la faculté de se rappeler nettement les formes si variées, les effets si fugitifs de la nature; car ce sont les impressions pittoresques conservées qui forment l'individualité non seulement des artistes proprement dits mais encore des artistes industriels." For Viollet-le-Duc's account of the advantages of this method, see "Un cours de dessin," *L'Artiste*, ser. 7, 5, 1858, pp. 154–56.

87. *Education de la mémoire pittoresque*, p. 7. In the report cited above (note 86) the usefulness of Lecoq's course for industry is couched in terms of its contribution to students' mastery of the human figure, since French industrial arts were thought to excel in just this area.

88. The course in ornament developed by Viollet-le-Duc was considered by many members of the contemporary architectural community to be a key contribution of the school. It was Ruprich-Robert, however, who through the cooperation of Daly did most to advertise it. See *Revue Générale de l'Architecture et des Travaux Publics*, 11, 1853, cols. 242–46, 387–91; for the valuation of Belloc's attention to ornament, see *Discours prononcé le 11 Décembre 1866 au cimetière du Père Lachaise par MM. les professeurs Jäy et Laemelin sur la tombe de M. Belloc*, Paris, 1866, p. 2.

89. AN AJ[53] 100.

90. Dyce, pp. 33–34.

91. V.-M.-C. Ruprich-Robert, "Cours de composition d'ornement à l'Ecole Impériale et Spéciale de Dessin," *Revue Générale de l'Architecture et des Travaux Publics*, 11, 1853, cols. 242–43.

92. Dyce, p. 32.

93. P. Chu, "Lecoq de Boisbaudran and Memory Drawing," in G. P. Weisberg, ed., *The European Realist Tradition*, Bloomington, Indiana, 1982, p. 243. See also J. K. T. Varnedoe, *The Drawings of Rodin*, New York, 1971, p. 31; and J. M. Hunisak, *The Sculptor Jules Dalou: Studies in his Style and Imagery*, New York, 1977, pp. 19–20, where the emphasis falls on the school's so-called "eighteenth-century" character.

94. Dyce, p. 32.

95. *Ibid.* The anxious comparison of English and French instruction in the arts was standard in the nineteenth century. For a later French point of view, see C. d'Henriet, "L'Encouragement populaire des arts du dessin en Angleterre et en France," *Revue des Deux Mondes*, 77, 1868, pp. 193–212.

96. Vermot, p. 156.

97. *Ibid.*

98. Comte de Rambuteau, *Distribution des Prix à l'Ecole Royale et Gratuite de Dessin*, Paris, December 11, 1836.

99. See, for example, the speeches delivered in 1853 and 1854, when the upcoming Exposition Universelle of 1855 was presented as a goal towards which these future *soldats du travail* would battle: *Distribution des Prix*, August 28, 1853, August 27, 1854.

100. Some subjects for competition themes are cited in AN AJ[53] 147; others are mentioned in the course of speeches at the awards ceremony. The year 1847, when ornamental panels for a locomotive were assigned, provides a telling example of the tone of such occasions. Not only was the year's prizewinner, F. Carpezat (a friend of Carpeaux), urged to take up a career in the applied arts, but the sole problem with the design submitted by Cugnot was cited as being that it too clearly revealed *le nu de la locomotive*!

A list of the numbers of students who participated in the *Grand concours* for 1839 gives some idea of the varying sizes of the competitions, and the subscription of each course: *architecture*, 18, *coupe de pierres*, 8; *charpente*, 7; *arithmétique*, 12; *géométrie*, 11; *dessin copié, figure*, 75; *dessin copié, animaux*, 78; *ornement*, 65; *fleurs*, 64; *dessin, architecture*, 11; *dessin graphique*, 16; *dessin d'après nature, plante vivante*, 20; *dessin après la bosse*, 29; *dessin au trait*, 6, *soir*, 57.

101. Cited in Clarétie, *Peintres et sculpteurs contemporains*, vol. 1, p. 175.

102. These statistics were compiled at the government's behest. See AN AJ[53] 134. The table for 1843 shows a total of 866 students enrolled in the day and evening courses. The youngest students in the day course were aged ten, the oldest, thirty-one; the youngest at night were aged eleven; the eldest, forty-six. Professions ranged from the 205 students "sans description" to stonecutters (21); lithographers and compositors (35); gilders (5); clockmakers (3); cooks (29); saddler (1); *mécaniciens* (11); and so on.

103. Fromentin, p. 3.

104. EBA, Album Stirbey I, no. 239, pencil on white wove paper, 20.3 × 12.5 cm.

105. Musée de Melun, *Tige végétale*, black chalk and crayon, 61.2 × 47.2 cm., inscribed: Ier Prix, with signatures of Belloc, Gault de Saint Germain, and Faure. Inv. No. 912.1.2. *Tige florale*, black chalk and crayon, 61.2 × 47.2 cm., inscribed:

2me accessit, with stamp of Ecole Gratuite, and signatures of the jury: Augustin Dumont, Lemaire, Lecoq, H. Debary, Schnetz, A. Faure, Jäy, Peron, Gault de Saint Germain, Belloc. By the provisions of the 1843 rules, jurors were drawn from the greater artistic community.

106. See Chapter 3.

107. Mabille, pp. 40–41.

108. The large collection of anatomical drawings now at MBA VAL probably date from this period.

109. Cimetière Montparnasse, Paris. The stele marks the burials of Claude-François Carpezat (1793–1879), his son François Louis Carpezat (1828–1876), and his daughter, Mme Gruyer (1841–1916). Carpeaux's medallion portrays the son. A plaster is at the Los Angeles County Museum of Art.

110. *Distribution annuelle des Prix*, Paris, 1840.

111. MBA VAL, *Catalogue de l'Exposition Centenaire de Carpeaux*, Valenciennes, 1927, no. 5, p. 10; also Mabille, pp. 62–63; Fromentin, p. 4.

112. Gautier, "Ecole Impériale," p. 8.

CHAPTER III

1. O. Merson, *De la réorganisation de l'Ecole Impériale et Spéciale des Beaux-Arts*, Paris, 1864, p. 13 (offprint from *L'Opinion Nationale*).

2. N. Hawthorne, *The Marble Faun*, 3rd ed., New York, 1899, p. 140 (first published in 1860).

3. Undated fragment of a letter to Bruno Chérier, late August or early September, 1850. BNEST, SNR, Boîte Carpeaux. The addressee of this letter is sometimes given incorrectly as J.-B. Foucart because it is found amont papers collected by the Foucart family. Yet the letter concludes with greetings to Foucart which rule him out as its recipient.

4. *L'Illustration*, 16, 1850, p. 233.

5. IFA, Registre des Concours, 1H4, 1846–52, Jugement Préparatoire, September 7, 1850.

6. Huet, "Notes adressées à messieurs les membres de la commission chargée des modifications à apporter aux règlements de l'Ecole des Beaux-Arts et de l'Académie de France à Rome," *L'Artiste*, 1, 1831, p. 51; F²¹ 613. The 1848 commission included David d'Angers, Rude, Barye, Ingres, Drolling, Vernet, Delacroix, Jeanron, Calamatta, Henriquel Dupont, Domard, H. Labrouste, Charpentier, G. Planche, F. Halévy, F. David; their first charge, established by a decree of March 2, 1848, was to examine the extant form of the Ecole, and its harmony with the institutions of a republic.

7. H. Delaborde, *L'Académie des Beaux-Arts depuis la fondation de l'Institut de France*, Paris, 1891, p. 197.

8. P. J. David d'Angers, *Les Carnets de David d'Angers*, ed. A. Bruel, Paris, 1958, vol. 2, p. 285.

9. Mabille, pp. 74–75.

10. Tabulated on the basis of IFA, Registres IH 3, IH 4 (Jugements de concours).

11. Contestants were necessarily identified by their teachers' names in the contest records, and although competitions were supposed to be anonymous it is evident that in practice they were anything but—witness the excerpt from Carpeaux's letter that opens this chapter. It is difficult to compare this distribution of prizewinners to teachers with the relative sizes of ateliers in Paris. Yet from the registers of names of students who applied for *cartes d'élèves* to copy at the Louvre (Archives du Louvre, Registres des cartes d'élèves délivrées aux élèves, LL6, 1834–40; LL7, 1840–45; LL8, 1845–49; LL9, 1850–60), it is apparent that the largest atelier—David's—must have had about twenty-five or thirty students annually. Rude's students approached this number—he probably taught fifteen to twenty-five students a year—so their exclusion was aimed at one of the most populous ateliers.

12. For studies of the shifting population of Paris and the *départements*, see L. Chevalier, *La Formation de la population parisienne au XIXe siècle*, Paris, 1950; and J. Vidalenc, *La Société française de 1815 à 1848*; vol. 2 "Le Peuple des villes et des bourgs," Paris, 1973.

13. Carpeaux's biographers hand down these traditions: Fromentin, p. 2, reports that from Auvray Carpeaux learned "à monter et à masser un buste en terre cuite." The stay with Abel de Pujol is usually dated 1843; two other boys from Valenciennes, Henri Coroenne and Louis Sellier, supposedly preceded him there. Documents in the Archives du Nord, 1T 291/3 Dossier Carpeaux, offers some confirmation: in a letter of July 12, 1845, Abel de Pujol calls Carpeaux "mon élève"; a similar claim is advanced by H. Lemaire, letter of July 20, 1845.

14. Claudet, *Jeunesse de J. J. Perraud*, pp. 58–64.

15. Perraud's manuscripts make it clear that the choice of atelier also involved at least some consideration of the sculpture the master produced. In describing his decision to work with Ramey (although the two artists Ramey and Dumont shared a studio, they taught on alternate days), Perraud claimed that he was first attracted to Dumont, since his "jeune et svelte Génie" (1836; Colonne de Juillet) seemed the work of a more receptive person than the *Thésée terrassant le minotaure* (1822; marble, 1827; Jardin des Tuileries), for which Ramey was known. The end of the story showed that appearances were deceiv-

ing; yet I suspect that some such naive assessment of sculptor and sculpture often figured in a student's choice.

16. The story of the closure of David's atelier and Rude's consequent opening of a studio is reported in de Fourcaud, pp. 217–28; M. Legrand, *Rude, sa vie, ses oeuvres, son enseignement: Considérations sur la sculpture*, Paris, 1856, pp. 81–83. See also H. Jouin, ed., *David d'Angers et ses relations littéraires*, Paris, 1890, p. 201, for a letter to Victor Pavie, June 19, 1842, expressing David's sense of injury at the loss of his students. It is impossible to say exactly how many students made the change of atelier. Jouin, David's biographer, gives a list of 141 names as David's pupils; it covers his entire career. Of the students he cites, 106 were sculptors. *David d'Angers: Sa vie, son oeuvre, ses écrits, et ses contemporains*, Paris, 1878, vol. 1, Document XXVIII, pp. 581–83.

17. de Fourcaud, p. 279.

18. Legrand, p. 82, reproduced the students' letter of June 14, 1842, but not its signatories.

19. AN AJ52 322, Elèves sculpteurs II, antérieurs à 31 Décembre 1892. Carpeaux was number 4392 in the Registre matricule; he was inscribed on October 2, 1844, under number 2180.

20. For information on Liet, see Mabille, pp. 37–40; LCC I, pp. 6–8; Fromentin, pp. 4–5. The official record of his death, on August 19, 1847 (Archives de Paris, Actes de Décès, Etat civil reconstitué), gives his address as rue du Marais, no. 4, though Clément-Carpeaux says he lived on the rue d'Enfer, where Rude also lived. His widow Sophie practiced homeopathic medicine and wrote tracts on the subject for working-class readers. Carpeaux visited her during his final illness.

 Carpeaux's portrait of Liet was apparently a posthumous tribute. MBA VAL, *Catalogue de Peintures et sculptures de Jean-Baptiste Carpeaux à Valenciennes*, Valenciennes, 1978, no. 49, repr. pl. 16.

 A biography for Foucart is given in Fromentin, "Hommes et Choses," MS. VBM; this writer state specifically that Foucart studied with Jacotot from 1830 to 1836.

21. J. Jacotot, *Musique, dessin et peinture*, Paris, 1839, 4th ed., p. 331. See also F. and H. V. Jacotot, *Manuel de la méthode Jacotot (enseignement universel): Extraits textuels des oeuvres de J. Jacotot comprenant l'étude de la lecture, l'écriture des langues, etc.*, Paris, 1841.

22. Jacotot, *Musique*, title page.

23. T. Silvestre, *Histoire des artistes vivants*, Paris, 1856, pp. 305–28. For example: "Sa vie fut calme, retirée, solide et pure au milieu d'un siècle frivole, corrompu et maladif. Ses moeurs, simples et

droites, semblaient taillées sur le patron de celles des anciens. Rude était un Romain qui fumait la pipe. Mais cette austérité d'un autre âge limitait son intelligence et lui fermait des issues lumineuses que la pratique de la vie moderne n'eût pas manqué de lui ouvrir," p. 306.

24. BNEST, SNR Boîte Carpeaux 114. Foucart continued to be uneasy about the changes in his friend's moral makeup: see below, conclusion.

25. The 1861 article by H. Castets, "Rude et son école," *L'Artiste*, ser. 8, 3, pp. 7–10, thus explored the characteristics of Rude as the "véritable maître de ce temps-ci"—as opposed to both David d'Angers and Pradier. Able to attract students and to hold them by his example and his rich store of practical good sense, Rude was the *real* teacher. Yet Castets also found it necessary to warn against the danger of Rude's method, imitative realism. His worry was entirely in keeping with other criticisms of Rude's teaching, and like them was contingent on the longstanding argument between imitation and idealism, which the re-edition in 1863 of T.-B. Eméric-David's *Recherches sur l'art statuaire* only fuelled. First published in 1805, the book became Rude's bible; it argued the primacy of nature as the origin of the great Greek sculptural style. Its reappearance in 1863 touched off just the kind of critique often levelled at Rude. See C. Levêque, "Les destinées de la sculpture et la critique moderne," *Revue des Deux Mondes*, January 15, 1864, pp. 334–61.

26. Baudelaire, *Oeuvres complètes*, pp. 420–23. The section ends with Baudelaire's poem, *Danse macabre*, dedicated to Rude's student Christophe; Baudelaire distinguishes him from "ces artistes faibles, en qui l'enseignement positif et minutieux de Rude a détruit l'imagination," p. 422.

27. Silvestre, "Rude," in *Artistes vivants*, p. 322. It is worth mentioning that Silvestre cites Rude's debt to Eméric-David, p. 320.

28. *Ibid.*, pp. 321–22.

29. Legrand, p. 13. The following discussion of Rude's method is taken from Legrand, pp. 225–45. It is also worth noting that Rude had run an atelier during his stay in Brussels: see P. Landowski, "Rude à Bruxelles: Ses méthodes et son enseignement considérés dans leurs rapports avec les théories esthétiques contemporaines," *Académie Royale de Belgique: Bulletin de la classe des beaux-arts*, 37, 1955, pp. 126–41.

30. Legrand, p. 234.

31. Silvestre, "Rude," in *Artistes vivants*, p. 323.

32. Thoré, *Salons*, pp. 356–57.

33. The works exhibited were no. 2111, Charles Auguste Arnaud, *Buste de M . . .*, plaster; no. 2126, Paul Cabet, *Jeune grec aux Thermopyles*,

marble; no. 2205, Jacques Jean Mirande, *St. Jean*, plaster; no. 2218, Auguste Poitevin, *Le Dévouement de Viala*, plaster.

34. Rejected were Blanc, *Vierge immaculée*, plaster; Charles Capellaro, *Ange funèbre*, plaster; Mme Anna Clément, *Portrait de Mme A.*, *S. François d'Assise*, paintings; Jules Louis Franceschi, *S. Pierre*, plaster; Charles Iquel, *Buste de M.P.*, plaster; Guy Lhomme de Mercey, *Le Démon*, plaster; Jean-Esprit Marcellin, *M. Guillaume*, wood, and *Buste de M.L.*, plaster; Etienne Montagny, *L'Enfant prodigue*, plaster.

35. See J.-B. Bulliot, "Guy-Bernard Lhomme de Mercey, statuaire," *Mémoires de la Société Eudéenne*, 20, 1892, pp. 161–89. According to the curator of sculpture at the Musée des Beaux-Arts, Dijon, the sculpture has been destroyed (letter from C. Gras, conservateur chargée des sculptures, July 26, 1984).

36. The chief sources for information about Duret are Lami, vol. 2, Duret, q.v.; C. Blanc "Francisque Duret" *GBA*, 20, 1866, pp. 97–116; and Mme B. Favre, "François-Joseph Duret, dit Francisque, statuaire," thesis, Ecole du Louvre, 1968. I am grateful to Mme Favre for her generosity in allowing me to read her work.

37. Duret to Dumont, March 19, 1829, letter, Bibliothèque Jacques Doucet, Paris, carton 38, sculpteurs.

38. For reviews of the works, see, for example, L. N. M. Artaud, "Salon de 1833: 4e Article," *Le Courrier Français*, April 15, 1833; E. Delécluze, "Salon de 1833," *Journal des Débats*, April 3, 1833; G. Laviron and B. Galbaccio, *Le Salon de 1833*, Paris, 1833, pp. 327–28; F. Chatelain, *Prométhéides: Revue du Salon de 1833*, Paris, 1833, pp. 157–58. All writers agree on the works' *verité*, but it should be mentioned that both sculptures took a back seat to works like Duseigneur's *Roland furieux* and Etex's *Caïn et sa race maudite*.

39. For the letter to David d'Angers, see Jouin, *David d'Angers et ses relations littéraires*, p. 226. The other letter, undated and to an unknown correspondent, is at the Bibliothèque Jacques Doucet, Carton 38, sculpteurs.

40. VCD 5, p. 30v, for the *Molière*; VCD 6, p. 16, for the *Venus*.

41. EBA, Album Stirbey II, no. 499, 15.4 × 8.7 cm.

42. For Duret and Carpeaux, see Mabille, pp. 76–78 and passim; LCC I, pp. 20–22.

43. VBM, Dossier Carpeaux à l'Ecole des Beaux-Arts, conserves three undated letters which help to document the character of this relationship: (1) "M. Carpeaux, no. 6 rue Jacob. Si Carpeaux est libre je le prie de venir demain *matin*, mercredi, pour me faire un mannequin de près de trois pieds

de proportion, d'après mon esquisse de Chateaubriand. Il obligera son affectionné, F. Duret. *à demain 10 heures, le temps presse*, mardi gras" (2) "Monsieur Carpeaux, no. 3 rue de l'Abbaye. Si Carpeaux peut venir me voir aujourd'hui ou demain je le prierais de me donner un coup de main pour terminer mon esquisse. Il obligera, son affectionné, F. Duret." A third letter asks for permission for Carpeaux to copy "la statue de Michelange" at the Ecole for Duret's use. The support also went the other way; Duret wrote to the administration in Valenciennes to testify to his pupil's progress and to encourage the continuation of his funding, September 21, 1850, VAM T3125.

44. For the drawings by Delacroix in Carpeaux's possession, see *Atelier J.-B. Carpeaux: Catalogue des sculptures originales*, Paris, Manzi-Joyant, December 8, 9, 1913, nos. 160–292. These were probably purchased in the Delacroix atelier sale of 1864; they bear the atelier stamp.

45. C. Beulé, *Notice sur la vie et les oeuvres de Francisque Duret lue à l'Académie des Beaux-Arts, Séance du 10 novembre 1866*, Paris, 1866, p. 9.

46. The annual Ecole calendars can be found in AJ[52] 39. For Carpeaux's notes of contests, see for example VCD 5, p. 2v, list of 16 students received into 2ème *essai*, Prix de Rome, May, 1853, or VCD 19, p. 69, where the same information is listed for the following year.

47. Fromentin, p. 18, letter to L. Dutouquet, April 13, 1852. The first prize was awarded to Maniglier. The subject was *L'Attention*.

48. Letter to B. Chérier, Fromentin, pp. 20–21.

49. All information on the *règlements* of the Ecole from AJ[52] 1 and 2 unless otherwise noted.

50. Statistic compiled from AJ[52] 235, Registre matricule d'enregistrement des élèves de la section de peinture et de sculpture.

51. AJ[52] 39.

52. See AJ[52] 51.

53. See Eméric-David, *Recherches*, pp. 298–99. This was a longstanding criticism.

54. Merson, p. 15. For discussions of the reorganization of 1863, see Boime, "Teaching Reforms," and A. Pingeot, in Association des Conservateurs, *De Carpeaux à Matisse*, pp. 23–24, 30. The impact of the reforms on the teaching of architecture is discussed in R. Chafee, "The Teaching of Architecture at the Ecole des Beaux-Arts," in *The Architecture of the Ecole des Beaux-Arts*, in ed. A. Drexler, New York, 1977, pp. 101–05.

55. AJ[52] 12, decision of December 24, 1843. Most notorious of the professors for favoritism—even misconduct—in the *concours* was Pradier. He was accused of supplying competition programs and

drawings to students, of stretching the rules to allow contestants more time, and even of reworking the entry of his pupil Lequesne. "Des Praticiens et M. Pradier," *Journal des Artistes*, n.s. 1, 2, no. 6, December, 1845, pp. 471–72.

56. H. Jouin, "Liste des élèves peintres et sculpteurs de l'Ecole Nationale des Beaux-Arts couronnés de 1760 à 1862 dans le concours de la tête d'expression," *Nouvelles Archives de l'art français*, ser. 2, 1, 1881, pp. 195 ff.; and for the names of winners from 1862 to 1881, see Jouin, *Nouvelles Archives de l'art français*, ser. 2, 1880–81, pp. 484 ff. The Prix de Rome winners are listed for 1663 to 1857 by A. Duvivier in *Archives de l'art français*, vol. 9, 1857–58, pp. 273 ff., and for 1858 to 1881, in *Nouvelles Archives de l'art français*, ser. 2, 2, 1880–81, pp. 451 ff.

57. Programs for the *tête d'expression* competitions are found in AJ52 67. AJ52 453 is a catalogue of the *têtes d'expression* formerly conserved in the Salle Caylus at the Ecole des Beaux-Arts. The some twenty which have survived were in 1976 housed in the school's basement.

58. AJ52 64, Section de sculpture, Programmes des concours de composition, 1819–1900, as for the following citations.

59. IFA 1H4, Registre des concours, 1846–52, May 15, 1851.

60. The following description of the rules governing the Grand Prix is taken from AJ52 438, Règlement pour les concours aux grands prix de l'Académie Royale des Beaux-Arts.

61. IFA 5E33 1846, correspondance relative aux concours de Rome.

62. Mabille, p. 52.

63. IFA 1H5, Registre des concours, 1853–60.

64. "Concours pour le Prix de Rome: Sculpture," *L'Artiste*, ser. 3, 4, 1853, p. 177.

65. T. Gautier, "Concours: La Sculpture," *La Presse*, September 21, 1838.

66. AJ52 75.

67. Institut Impérial de France, Académie des Beaux-Arts, *Dictionnaire de l'Académie des Beaux-Arts*, Paris, 1859, vol. 1, p. 149.

68. Tabulated from AJ52 194, Programmes des concours des Grands Prix.

69. IFA 1H4, Registre des concours, 1846–52.

70. T. Thoré, "Ecole des Beaux-Arts," *L'Artiste*, ser. 2, 1838, pp. 220–22, 305–07, citation, p. 307.

71. AJ52 445, Rapport au Ministre de l'Intérieur, Projet d'organisation du Musée des Etudes à l'Ecole des Beaux-Arts, March, 1836. Peisse eventually published his plan in "Ecole des Beaux-Arts: Musée des Etudes," *Revue des Deux Mondes*, ser. 4, part 1, October 15, 1840, pp. 232–45. Peisse also wrote criticism for *Le National* in the 1830s

and 1840s.

72. AJ52 445.

73. AJ52 445, Rapport sur le Musée des Etudes à l'Ecole Royal des Beaux-Arts (1847).

74. AJ52 445, Rapport fait au nom de la commission de moulage assistée de la section de sculpture à l'Assemblée Générale de 27 Octobre 1853.

75. See above, n. 43.

76. AJ52 445, Comte de Forbin, letter of August 29, 1816.

77. VCD 1, 2. Among these copies of *concours* reliefs are included sketches and tracings from the masters: Raphael's Loggie and Stanze, Poussin's *Et in Arcadia Ego*, Drouais's *Marius at Minturnae*, etc.

78. P. Mantz, "L'Ecole des Beaux-Arts: Les Concours, Les Envois de Rome," *GBA*, 1859, pp. 121–23.

79. AJ52 194.

80. *L'Artiste*, ser. 3, 4, 1843, p. 178.

81. A. Guillot, "Grands Prix de l'Ecole des Beaux-Arts," *La Revue Indépendante*, 10, September–October, 1843.

82. *L'Artiste, loc. cit.*

83. E. J. Delécluze, "Grand Prix de Sculpture," *Journal des Débats*, September 2, 1852.

84. E. J. Delécluze, "Grand Prix de Sculpture," *Journal des Débats*, September 7, 1854.

85. IFA 1H5, Registre des concours, 1853–60.

86. VCD 19, 63v.

87. Delécluze, 1854.

88. P. Dumoitier, "Concours des Grands Prix—paysage historique, sculpture," *Revue des Beaux-Arts*, 5, 1854, pp. 285–86.

89. IFA 5E38, 1854. The petitioners who signed a letter Carpeaux sent in were Chapu, Doublemard, Rolland, Irvoy, and Moreau.

90. Salmson, p. 70.

91. L. deLaborde, *De l'union de l'art et de l'industrie*, Paris, 1856, vol. 1, p. 275.

92. AJ52 15, Registre des procès-verbaux, Conseil d'Administration, Meeting of May 19, 1860.

93. Romieu, Directeur des Beaux-Arts, at the annual award ceremony of the Ecole des Beaux-Arts, 1853.

94. AJ53 134.

CHAPTER IV

1. S. Rogers, *Italy: A Poem*, London, 1830, p. 157.

2. G. Varenne, "Carpeaux à l'Ecole de Rome et la Genèse d'Ugolin," *Mercure de France*, 1908, p. 579.

3. LCC I, p. 113.

4. Carpeaux to the Section des Beaux-Arts, Institut de France, March 24, 1855, IFA 5 E 39, 1855.

5. Schnetz to de Mercey, March 31, 1855, cited in Varenne, p. 578.

6. AN O^{55} 1708 (1854), Ordonnage de paiement,

Maison de l'Empereur. Carpeaux was paid 2,000 francs on April 26, 1854, and the same amount again on August 10, 1854; a final payment of 1,000 francs was made on December 30, 1854.

7. de Mercey to Schnetz, December 1, 1855, cited in H. Lapauze, *Histoire de l'Académie de France à Rome*, Paris, 1924, vol. 2, p. 312.

8. Schnetz to de Mercey, December 16, 1855, cited in Varenne, p. 579.

9. VCD 8, endpaper.

10. VCD 3, pp. 70v, 71.

11. VCD 10, p. 53.

12. C. Blanc, *Le Temps*, October 15, 1875.

13. *Art Journal*, 38, 1876, p. 5.

14. Institut de France, Académie des Beaux-Arts, *Rapport sur les ouvrages envoyés de Rome par MM. les pensionnaires pour l'année 1841*, Paris, 1842, p. 16.

15. *Règlement de l'Académie de France à Rome*, 1846. VMA, correspondance 1841–46, Carton 45.

16. *Rapport sur les ouvrages*, 1842, pp. 16–17. "Laissez la sculpture se réduire à la statuette et s'abaisser jusqu'à la charge, et ce bel art, qui fut, dans la Grèce antique, le patrimoine de la vertu, du patriotisme et du Génie, dégénérer en métier et en industrie, pour de vulgaires usages. [...] Oubliez, en franchissant le seuil de la Villa Médicis, ce que vous pourriez y porter d'idées du monde et de vues d'intérêt, avec tout ce que nos discussions sur la préférence de l'antique ou de la renaissance ont pu jeter dans vos esprits de trouble et d'indécision."

17. *Rapport sur les ouvrages*, 1848, p. 56.

18. H. James, "From a Roman Notebook," in *Italian Hours* (1st printing, New York, 1909), New York, 1979, p. 206.

19. J. Whiteside, *Italy in the Nineteenth Century*, London, 1848, vol. 2, p. 84.

20. L. Veuillot, *Le Parfum de Rome*, Paris, 1862, vol. 2, p. 228.

21. G. Planche, "De l'éducation et de l'avenir des artistes en France," in *Portraits d'artistes* (essay first published 1848), Paris, 1853, pp. 329–38. For another view of the question, see T. Thoré, "De l'Ecole Française à Rome," *L'Artiste*, ser. 4, 11, 1848, pp. 214–17.

22. J. Michelet, *Voyages en Italie*, Paris, 1891, esp. pp. 137 ff., 167 ff.

23. H. Rochefort, "Le Salon de 1863: Dernier article," *Le Nain Jaune*, July 8, 1863, p. 5.

24. Cavelier to Ottin, June 18, 1837, Archives du Louvre, 2 HH 7, cited in A. LeNormand, *La Tradition classique et l'esprit romantique: Les Sculpteurs de l'Académie de France à Rome de 1824 à 1840*, Rome, 1981, p. 102.

25. G. Bizet to his parents, January 27, 1858, G. Bizet, *Lettres de Georges Bizet: Impressions de Rome, 1857–1860. La Commune, 1870*, Paris, 1905, p. 23.

26. VMA, Cartons Contes.

27. E. About, *Rome contemporaine*, Paris, 1860, 4th ed., 1861, p. 63. About lived at the Académie for several months in 1858.

28. Duret to his family, March 11, 1826, cited in LeNormand, p. 79.

29. For the architectural history of the Villa Medici, see G. F. Andress, *The Villa Medici in Rome*, 2 vols., New York, 1976.

30. James, *Italian Hours*, p. 206. In *Rome contemporaine* About also gives a lengthy description of the Villa, pp. 59–65.

31. J. P. M. Soumy to Bouvier, February 28, 1855, cited in Auquier and Astier, *La Vie et l'oeuvre de Joseph Soumy, graveur et peintre*, Marseilles, 1910, pp. 25–26.

32. These and details above from the inventory of the contents of the Villa Medici made under the *directorat* of Jean Alaux and dated December 31, 1851. VMA, Carton 55, Alaux.

33. Thus the standard history of the Académie, H. Lapauze's two volume account, is written according to the tenure of the directors.

34. For descriptions of Schnetz's directorship, see About, pp. 64–65, Lapauze, 2, pp. 262–87, 314–72, and Bizet, p. 64.

35. These details and following discussion of required works from *Règlement de l'Académie de France à Rome*, 1846. VMA, Correspondence 1841–46, Carton 45. The *Règlement* was modified again in 1866.

36. The term comes from the chisel which it specifies. The tracks left by its teeth were not considered a finished surface. See Ministère de la Culture et de la Communication, *La Sculpture: Méthode et Vocabulaire*, Paris, 1978, pp. 598–99.

37. *Rapport sur les ouvrages*, 1857, p. 5.

38. Cavelier to Ottin, October 13, 1837, LeNormand, p. 104.

39. Loubens to Ottin, February 24, 1838, LeNormand, p. 107.

40. Ottin to his parents, May 25, 1838, LeNormand, p. 109.

41. *Rapport sur les ouvrages*, 1841, p. 33.

42. Ottin to Sabatier, February 2, 1842, LeNormand, p. 136.

43. *Rapport sur les ouvrages*, 1842, p. 5.

44. *Rapport sur les ouvrages*, 1851, pp. 36–37.

45. Probably destroyed; exhibited at the Salon of 1844, acquired by the State in 1853 (note the long delay), removed from the Tuileries Gardens in 1868. Reproduced from *L'Illustration*, 2, October 14, 1843, p. 104.

46. *Rapport sur les ouvrages*, 1843, pp. 69–70.

47. G. Eyriés, *Simart*, Paris, [1858], p. 116.

48. *Ibid.*, p. 95.

49. *Ibid.*, pp. 95–96.

50. *Ibid.*

51. *Ibid.*, p. 115.

52. "Rapport sur les ouvrages," 1839, MS., VMA, Carton 37.

53. *Rapport sur les ouvrages*, 1856, p. 29.

54. *Etude pour le Christ aux anges*, pencil, pen, and brown ink with brown wash, 44 × 57.7 cm., inscribed "Le Christ aux Anges: Etude de la pose de l'Ange," Musée de Melun 912.1.31. Other studies are in Cabinet des Dessins, Musée du Louvre, CD 23037 (notebook) 12 × 20 cm., pp. 3, 4, 4v, 5, 6v, 7, 10, 18, 23v, 29.

55. For summaries of critical positions on Manet's *Dead Christ*, see C. Stirling and M. Salinger, *French Paintings*, New York, 1967, vol. 3, pp. 38–39; G. H. Hamilton, *Manet and his Critics*, New York, 1969, pp. 55 ff.; Réunion des Musées Nationaux, *Manet*, 1983, no. 74, pp. 199–203.

56. Duret to Chapu, undated letter cited in O. Fidière, *Chapu, sa vie et son oeuvre*, Paris, 1894, p. 22.

57. *Rapport sur les ouvrages*, 1858, p. 33.

58. Fidière, pp. 31–32. The note from Degas is enclosed in one of Chapu's notebooks (Cabinet des Dessins, Musée du Louvre, CD 23037). It reads: "Comme les modèles manquent voyez si cet homme qui a l'air très beau pourrait poser. Je vous salue. E. Degas."

59. Fidière, p. 31.

60. Cited in Fidière, p. 39.

61. The Académie's commentary on Duret's *Mercure inventant la lyre* is cited in Favre, p. 44. For observations on Chapu's *Mercure inventant le cadeuce*, see *Rapport sur les ouvrages*, 1861, pp. 33–34.

62. This of course was a consistent theme of the Académie. For example: "Mais cette influence morale qu'exerce sur le génie d'un artiste la vue de tant de Chefs-d'oeuvre; mais ce spectacle des grandeurs de Rome, qui parle si puissamment à l'imagination, dans le calme solennel qui les entoure, dans le silence des passions mondaines et des intérêts matériels; mais cette vie, toute vouée à l'étude, toute dégagée des soins de la fortune et des soucis de la famille, ce sont là des avantages inappréciables de la pension de Rome . . ." Raoul Rochette, *Notice historique sur la vie et les ouvrages de M. Pradier*, Paris, 1853, p. 58.

63. Bonnassieux to Augustin Dumont, December 31, 1837, cited in LeNormand, pp. 151–52.

64. VMA, Carton 37, Alaux.

65. Lapauze, 2, pp. 256–57.

66. M. Vachon, *W. Bouguereau*, Paris, 1900, p. 24.

67. M. Du Camp, "Exposition Universelle: Beaux-Arts (Sixième Article) France: La Sculpture," *Revue de Paris*, 27, 1855, p. 274.

68. A. Ottin, *Esquisse d'une méthode applicable à l'art de la sculpture*, Paris, 1864 (an extract from *La Presse Scientifique des Deux Mondes*).

69. See H. Adhémar and S. Gache, *L'Exposition de 1874 chez Nadar*, Paris, 1974, unpag.

70. C. Beulé, "Un sculpteur contemporain et le principe du concours," *Revue des Deux Mondes*, June 1, 1861, p. 668.

71. Perraud sent two other *envois* that year, a copy of the *Discobolus* and a *tête d'expression, Cornélie*. These were reviewed rather more critically than was *Les Adieux* in the manuscript version of the Académie's report; see IFA 5E84. In the printed version, *Rapport sur les ouvrages*, 1850, those opinions, though mentioned, were quickly passed over, as if not to detract from the reception of the other work.

72. IFA 5E34.

73. *Rapport sur les ouvrages*, 1853, pp. 36–37.

74. When the sculpture was exhibited in 1855 at the Exposition Universelle, non-academic critics apparently found little which disturbed this equation. The work was mentioned infrequently; comments, when they occur, are brief and essentially repetitive of the Académie's remarks. For example: C. Vignon, *Exposition Universelle de 1855: Beaux-Arts*, Paris, 1855, p. 177: "L'Adam de M. Perraud est une oeuvre estimable et une figure fièrement campée"; T. Gautier, *Les Beaux-Arts en Europe*, Paris, 1857, p. 186: "L'Adam, de M. Perraud, montre sa vigoureuse et savante musculature"; E. Loudun, *Le Salon de 1855*, Paris, 1855, p. 191: "On peut reprocher à M. Perraut [*sic*] un peu de recherche dans l'attitude de son *Adam*. Le Faune de M. Guméry, Le Faucheur de M. Guillaume, ne sont guère que des pastiches de l'Antiquité; mais l'*Adam* de M. Perraut n'en a pas moins un air de grandeur qui décèle une intelligence élevée." In each case, I have included all the author has to say about Perraud.

75. F. Halévy to the Ministre d'Etat, November 24, 1856. This letter repeats a request first made in a letter of October 25, 1855. AN F²¹ 102.

76. Beulé, "Un sculpteur contemporain," pp. 666 ff.

77. J.-J. Perraud to J. Taballon, January 19, 1868, in *Nouvelles Archives de l'art français*, 16, 1900, pp. 315–16.

78. The account of the sculptor's daughter is unmatched for its involvement in all the story has to offer, and her self-appointed position as her father's defender gives her narrative a certain ferocity. See LCC I, pp. 53–156. She is, for example, particularly scathing about one of the more romantic versions of the story, Boyer d'Agen's *La Palombella de Carpeaux*, Paris, 1933, published

in the collection entitled "Les Amours des Dieux." The book considers Carpeaux's involvement with a young woman named Barbara Pasquarelli; Clément-Carpeaux responded: "How many sorry rhymesters there are of his stamp, who act without discernment and are only eager to associate their sick incubations with a glory they pretend to serve" (p. 143).

79. VAM, Contes, Carton 71, 1856.

80. Schnetz to de Mercey, in Varenne, p. 579.

81. Carpeaux to his parents, July 7, 1857, Fromentin, pp. 32–34.

82. For a more restrained version of Carpeaux's eye trouble, witness this excerpt from a letter to Dr. Batailhé, by all appearances the physician who helped him: "Serais-je indiscret en vous demandant de vouloir bien m'accorder vos soins si précieux pour me rendre l'usage d'un oeil qui me fait souffrir horriblement et qui me prive de travailler depuis un mois?" (May 19, 1855) *Revue historique, scientifique et littéraire du Département du Tarn*, ser. 2, 25, July–August, 1909, p. 181.

83. Carpeaux to Mme Foucart, BNEST, Boîte Carpeaux.

84. VCD 14, p. 62.

85. Schnetz, draft of a report concerning *envois* of *pensionnaires* for 1858, to be exhibited in Paris in 1859. VAM, Carton 65, Envois de pensionnaires, 1853–61.

86. The connection among Carpeaux, Degas, and Moreau is documented by a brief line in a letter of September 28, 1858, from Degas to Moreau which conveys the information that Carpeaux had left Florence. See T. Reff, "More Unpublished Letters of Degas," *Art Bulletin*, 51, no. 3, 1969, pp. 281–82. It is probably not coincidental that both Carpeaux and Moreau copied a fragment of a fresco by Raphael, the putto on view in the Accademia de San Lucca. Moreau called the fresco "the most beautiful bit of painting in Rome," and his distemper rendering was much admired by the *pensionnaires*; Schnetz joked with jocular vulgarity that Moreau had come to Rome "pour faire un enfant." See P. Mathieu, *Gustave Moreau, sa vie, son oeuvre: Catalogue raisonné de l'oeuvre achevée*, Paris, 1976, pp. 59–60, repr. p. 58. Carpeaux's black crayon version, MBA VAL CD 1662, 24.3 × 17.3 cm., may well have been drawn directly from Moreau's copy, since there is no record of his having applied for permission to work at the Accademia.

87. L. Delâtre, "Promenades artistiques dans Rome," *L'Illustration*, 33, 1859, pp. 117–18, 179–80.

88. For a description of the custom, see Whiteside,

3, p. 205.

89. For Chapman and Rome, see National Gallery of Art, Washington, D.C., *John Gadsby Chapman, Painter and Illustrator*, Washington, 1962–63, p. 17.

90. Of the 106 pocket notebooks conserved at the Musée des Beaux-Arts, Valenciennes, some fifteen can be said to have been used all or partly in Rome.

91. Department of Drawings, Metropolitan Museum of Art, 61.136.2, *Scene in a Tavern*, pen, pencil, and brown ink on white paper, 17.6 × 22.2 cm. The preliminary sketch is found in VCD 26, p. 40v.

92. VCD 7, pp. 5, 8.

93. Carpeaux to Mme Foucart, July 16, 1858, BNEST, Boîte Carpeaux.

94. Carpeaux to Charles Laurent-Daragon, December 19, 1858, in "Lettres inédites de J.-B. Carpeaux," *Le Figaro, supplément littéraire*, June 16, 1906.

95. The works are reproduced in *L'Illustration*: 9, 1847, p. 196; 13, 1849, p. 413; 20, 1852, p. 12; 30, 1857, p. 237. The versions included in the Salon of 1859 were by Marius Durst (no. 3209, *Jeune pêcheur*), Gustave-Alexandre Garnier (no. 3259, *Pêcheur endormi*), Charles Gauthier (no. 3261, *Pêcheur lançant l'épervier*), Louis-Charles Janson (no. 3320, *Petit Pêcheur*).

96. There is evidence in Carpeaux's notebooks that he knew both examples. Sopers' name and address is noted in one (VCD 15, p. 1v): "A. Sopers scultore via di St. Nicolo dei Tolentino 23, montée della Piazza Barberini." A version of Maniglier's *pêcheur* is sketched in VCD 26.

97. Letters of December 19, 1857, and March 27 and 29, 1858, in "Lettres inédites de J.-B. Carpeaux," *Le Figaro*, June 16, 1906. In a later letter of February 23, 1859, cited in the same article, he urged that the first cast be patinated *la couleur du Danseur de Duret*.

98. See E. B. de Bourdonnel, "Le Pêcheur napolitain," *L'Artiste*, 3, 1832, pp. 171–72. By 1851 the idyll had become a theme for popular entertainments, e.g., the pantomime in ten tableaux by Charles Charton, *Les Pêcheurs napolitains*, first performed in the Théâtre des Funambules on April 22, 1851.

99. This status was only apparent, however, at least within the context of academic exercises. Such themes had not yet become customary for Villa students.

100. "L'Académie aurait désiré que le modèle dont M. Carpeaux faisait librement le choix lui eût permis de montrer l'heureux alliance de la beauté et de la vérité. Toutefois le regret exprimé par

l'Académie ne l'empêche pas de reconnaître dans l'ouvrage du jeune lauréat l'étude fine et vraie de la nature. C'est une qualité précieuse, que M. Carpeaux la conserve dans tous les travaux et qu'il cherche en même temps à élever son style en exerçant son talent sur de nobles sujets," *Rapport sur les travaux*, 1858, pp. 33–34.

101. Schnetz to de Mercey, October 30, 1858: "Je vous envoie une lettre de M. Carpeaux qui remercie beaucoup M. le Ministre d'avoir bien voulu prendre sa petite figure pour 2,000 francs et est très reconnaissant de cette bienveillante attention. Mais une personne de sa connaissance s'est chargée de faire le bronze de cette petite figure avec tout le soin possible, dont un de ses amis s'est chargé de surveiller l'exécution. Il prie donc Monsieur le Ministre de vouloir bien lui conserver sa bonne volonté pour le salon prochain, où son bronze doit figurer," Varenne, pp. 581–82.

102. The first bronze of the *Pêcheur* was cast under the supervision of the painter Emile Lévy, and Charles Laurent-Daragon, and placed on view at the Salon of 1859, no. 2119. See Archives du Louvre, X Salon de 1859, for a letter from Lévy arranging the entry. The bronze was acquired by James de Rothschild for 4,000 francs. Excerpts from two letters to his parents convey Carpeaux's attitude towards the sale: "Cette figure sera très bien en bronze, il me faudrait la première avance pour en faire les frais. L'argent employé à cela peut me rapporter cinq à six mille francs, ce qui pourra me permettre d'exploiter cette oeuvre, tant en bronze qu'en marbre, on a vu des artistes gagner 80,000 francs avec la même statue, mais il faut que la statue soit en marbre," March 10, 1858, in Fromentin, p. 43; "Je suis encore en correspondance pour la vente de ma statue de l'enfant à la coquille avec M. de Rodschild [*sic*], il veut m'enlever ma propriété et ne me donner que cinq mille francs, certes j'aime mieux végéter auprès de mon oeuvre que de l'abandonner, aussi je ne veux rien céder. Je lui ai repondu aujourd'hui, je lui fais l'abandon de 1000 francs afin de conserver mon droit d'auteur. Du reste aujourd'hui je ne puis rien céder car on ébauche le marbre qui dois me servir de dernier envoi de Rome," October 15, 1858, in Fromentin, p. 45. In the early 1870s Carpeaux designed and sold an inkwell topped with the head of the *Pêcheur*, and another model in a female version.

103. P. Mantz, "Ecole des Beaux-Arts: Les Concours, Les Envois de Rome," *L'Artiste*, September–December, 1858, p. 72.

104. P. Mantz, "Le Salon de 1859," *GBA*, 2, 1859, pp. 364–65.

105. The biography published in 1910 by Auquier and Astier is the chief source of information about him. It cites a few other sources, the most important the article published by Burty in the *Gazette des Beaux-Arts* in April, 1865, and reprinted in *Maîtres et petits maîtres*, Paris, 1877, pp. 30–50. Among the Burty papers at the Bibliothèque Jacques Doucet, Paris (Carton 35, Graveurs, Soumy), are Burty's notes for the article, collected from people who knew the dead man, as the Goncourts relate. He interviewed Chifflart, Cadart, the publisher for whom Soumy worked, and Carpeaux himself, who seems to have given Burty a drawing by Soumy which he cut from the notebook which he and Soumy used together in Rome, VCD 18. Soumy's Prix de Rome and the *Têtes Italiennes* are conserved in the Bibliothèque Nationale, Paris, Ad 96 fol. The Musée des Beaux-Arts, Lyons, possesses two paintings by Soumy, *Tête de Moine* and *Le Dédain*, as well as the black crayon copies after Michelangelo. The painting *La Carolina* is in Marseilles at the Palais Longchamps. Some members of his family survive in the town of LePuy. The most complete list of his work is found in Aubin and Vial, *Dictionnaire des artistes et ouvriers de l'art lyonnais*, vol. 2, pp. 235–37.

106. Auquier and Astier, p. 33.

107. *Ibid.*, p. 12.

108. VAM Bibliothèque de l'Ecole Française, Sortie des livres. The entries for Soumy and Carpeaux are as follows (they are cited literally).

Soumy

19 Mai 1855	Poussin les sacrements gravés par pesne 1 vol.
28 Juin 1856	Coll du Panthéon Pittré Oeuvres de S. Gérôme 1 vol.
28 Juin 1856	Homère Iliade-Bon Charpentier 1 vol.
28 Juin 1856	Homère Odysée-Bon Charpentier 1 vol.
28 Juin 1856	Quatremère de Quincy. Vie de Michelange 1 vol.
28 Juin 1856	Flaxman Dante 1 vol.
28 Juin 1856	Coll Nisard Tite-Live Historia romaine 1, 2
22 Juillet 1856	Coll du Cabinet du roi Poussin Oeuvres 1, 2
29 Juillet 1856	La Ste bible 1
29 Juillet 1856	Lebrun Paysage du g . . .
15 Nov. 1858	Paret Catacombes de Roma 2 vol.

Carpeaux

17 Avril 1857	Bonnard Costumes des 13e, 14e, 15 siècles 1, 2
10 Juillet 1857	Coll du Cabinet du Roi Ecole française Poussin 1
4 Nov. 1857	DeVinci Traité de la Peinture 1 vol.
4 Nov. 1857	Dante Le Banquet
4 Nov. 1857	Le Sueur, E. LaVie de St. Bruno Gravé par Chaveau 1 vol.
4 Nov. 1857	Reverchon Anatomie d'un cheval 1 vol. in fol.
4 Nov. 1857	Baltard Le Louvre monumental de Paris 1
1 Avril 1859	Van Dick Eaux fortes 1 vol.
1 Avril 1859	Vasari vite dei pittor 1e
1 Juillet 1859	Voltaire romans, essais sur les moeurs 14, 16, 26, 32
1 Juillet 1859	Fénélon Dialogue 1 vol.
5 Oct. 1859	Condillac Oeuvres 1, 2, 3, 4
5 Oct. 1859	Vasari Vite dei Pittor 5–10
5 Oct. 1859	Longin Traité de 1
5 Oct. 1859	Longus Daphnis et Chloé

109. See for example VCD 24, p. 67 bis verso. Roussel is frequently mentioned in Carpeaux's letters to Dr. Batailhé. See *Revue de Tarn*, pp. 187 ff.

110. This is suggested by a receipt from the firm of Charpentier, couleurs et toiles, rue Halévy 9, for payment of bills for framing of a canvas by M. Roussel, April 22, and its return from the Salon, July 4, 1869.

111. This and the following descriptions of artists from VBM, Papiers Carpeaux, Dossier Michelange.

112. VBM, Papiers Carpeaux, Dossier Michelange.

113. VCD 26, Henry Penney Patent no. 8, "Second quality," 9.1 × 15.8 cm.

114. VCD 26, endpaper, "Sig. Alfonzo Bernoud, photographe, Firenze, via Matucci, Sta Maria in Campo 434."

115. See, for example, the list on a drawing at the Art Institute of Chicago, 1974.43, pen, and ink on a piece of writing paper dated "Florence ce 25 Aôut 1858":

6	bouclier (?)
3	écorché
1	main
16	Laocoön
6	faune
2	plâtre chanteur
3	Venus au bain
3	Venus accroupie
3	orphé [*sic*]
6	enfant donatello [*sic*]

These notations probably refer to plaster casts, not photographs, and the numbers are prices.

116. Noted on p. 89v, VCD 26, "Minervo del Monte direttore della galerie [*sic*]," next to a list of works at the Palazzo Pitti. For an account of the drawings then on view at the Uffizi, see L. Lagrange, "Catalogue des dessins des maîtres exposés dans la Galerie des Uffizi, à Florence," *GBA*, ser. 1, 12, 1862, pp. 538 ff.

117. *Studies for Ugolino and after Michelangelo*, pen and ink on blue writing paper, 27.9 × 20.5 cm., Art Institute of Chicago, 1974.45.

118. A free pencil copy of one of the Sistine prophets, Jeremiah (whose chin is cushioned on his right hand), is in the Collection Granville, Musée des Beaux-Arts, Dijon. Carpeaux reversed the position and movement of the figure, so the left arm is raised.

119. A prime example is one of the several copies by Carpeaux after the figure of Minos in Michelangelo's *Last Judgement*, EBA, Album Stirbey II, 526, pen and brown ink on green paper, 17 × 11.6 cm. The drawing is hemmed in by inscriptions: "Où est donc ma mémoire ô Raphael . . . Je ne sais rien et toi, Michel-ange, que ne m'aides tu, génie sublime! Je suis un âne, un sans coeur . . . Heuxeux ce qui savent!" A Louvre drawing CD2015, *L'homme au serpent d'après Michelange*, which reproduces the same figure is inscribed: "Je vous aime ô mon dieu." A poem inscribed on the same sheet is reproduced in Guiffrey Marcel, *Inventaire général des dessins du Musée du Louvre et du Musée de Versailles*, Ecole Française III, 1909, p. 31.

120. Carpeaux to Laurent-Daragon, December 19, 1857, *Le Figaro, supplément littéraire*, June 16, 1906. The letter in question is published here with the date 1859 but a date two years earlier seems likely on the basis of internal evidence: 1. "Ma figure du *Jeune Pêcheur* est déjà applaudie de mes collègues; tous m'assurent un succès pour la composition et j'espère bien mener l'exécution au degré de l'arrangement." By December 19, 1858, the *Pêcheur* was finished and had been exhibited in Paris. 2. Later in the letter Carpeaux thanks Laurent-Daragon for his willingness to send his watch, lorgnette, and a cast of the head of Rude's *Pêcheur*. These arrived in Rome in May, 1858.

121. Carpeaux to Bruno Chérier, December 28, 1858, Louvre, Cabinet des Dessins.

122. Carpeaux's letters are the chief source for this saga; despite their often extreme tone, the story

293

they tell is confirmed by the sheer length of time it took to finish the group. It is possible to say that by mid-November, 1858, Carpeaux had found a model for Ugolino; the sculptor claimed to have mounted the central figure in six days. By December 27, 1858, the caster Malpieri had submitted a bill for a mold and plaster cast of Carpeaux's *bozzetto* (VAM Carton 78, Contes 1858; bill dated December 29, 1858). This probably is the sketch model so frequently recast after Carpeaux's departure from the Villa; see J. Wasserman, ed., *Metamorphoses*, pp. 115–16, repr. figs. 4–8.

123. The caricature was drawn by one of Carpeaux's contemporaries at the Villa Medici and sent to J.-B. Foucart. BNEST Boîte 115.

124. *Projet de bas-relief cintré*, pencil on paper, 14.6 × 11.7 cm. EBA Album Stirbey II, no. 410.

125. *Reclining Figures in Lunettes*, black ink on wove paper, 22 × 29.1 cm., Art Institute of Chicago, 1974.32. Other versions of the same composition include: *Premier Projet pour le groupe d'Ugolin et ses enfants*, black crayon heightened with white on blue paper, 18.6 × 30.7 cm., Cabinet des Dessins, Musée du Louvre, RF 1260, repr. Grand Palais, 1975, no. 58; *Projet pour le groupe d'Ugolin*, pencil on white paper, VCD 1756; *Etude pour le bas-relief d'Ugolin, premier projet*, pen on blue paper, 22.7 × 29.1 cm., EBA Album Stirbey II, no. 541, repr. Grand Palais, 1975, no. 62.

126. *Ugolin rampant sur les corps de ses enfants*, pen and ink and wash on blue paper, 14.0 × 21.5 cm., VCD 115.

127. *Study for Ugolino*, pen and ink on white paper, 9.2 × 12.4 cm., Department of Drawings, Metropolitan Museum of Art, 1975.98.3.

128. The Flaxman source was one to which the Villa Medici library gave Carpeaux access. The former attribution of Pierino da Vinci's relief to Michelangelo would help to ensure that Carpeaux would have sought it out. According to travellers' handbooks of the day, it was on view in the Palazzo della Gherardesca. See F. Fantozzi, *Nuova guida ovvrero descrizione storico-artistico-critica della città e contorni de Firenze*, Florence, 1842, p. 291. J. J. Ampère in *La Grèce: Rome et Dante*, Paris, 1848, 3rd ed., 1859, p. 216, says that the relief was little known, yet emphasizes the importance of Dante to a real understanding of Italy. The relief is presently in the Bargello, Florence. See E. Kris, "Zum Werk des Pierino da Vinci," *Pantheon*, 1929, pp. 94–95. My thanks to Nicholas Penny for his helpful response to my questions concerning the wax version of the relief in the Fitzwilliam Museum, Cambridge.

129. Dante, *The Divine Comedy*, transl. C. H. Sisson, New York, 1983, pp. 186–88.

130. See pp. 169–70.

131. Carpeaux to J.-B. Foucart, December 10, 1859, BNEST, Boîte Carpeaux.

132. For example, see *Ugolin avec trois enfants*, pen and brown ink over pencil on grey paper, 42.4 × 29.2 cm., Cabinet des Dessins, Musée du Louvre, RF 1259, rep. Grand Palais, 1975, no. 72; or the highly finished gouache of the full composition, *Ugolin et ses enfants*, grey and white gouache, pen and brown ink, 62.2 × 48.0 cm., Art Institute of Chicago, Joseph and Helen Regenstein Collection, 1963.260.

133. A. Hildebrand, *The Problem of Form in Painting and Sculpture*, transl. M. Meyer, R. M. Ogden, New York, 1945, p. 34.

134. See n. 108 above.

135. Schnetz to de Mercey, May 23, 1859, cited in Varenne, p. 582.

136. The details of the story are contained in the official dossier, AN F^{21} 124, unless otherwise noted. On November 2, 1861, Carpeaux wrote from Rome to the Comte de Nieuwerkerke, Surintendant des Beaux-Arts, thanking him for the opportunity to exhibit his group in London and announcing his imminent arrival in Paris with his group. On November 26, 1861, Carpeaux sent a formal letter to the Comte, asking to ship his group at government expense: "en réalité, c'est de mon dernier envoi dont il s'agit en ce moment." The letter concludes with Schnetz's postscript: "Le directeur de l'Académie de France à Rome a l'honneur de recommander tout particulièrement la demande de Mr. Carpeaux à l'obligeance de Monsieur le Comte de Nieukerke [*sic*]; le talent remarquable avec lequel ce jeune artiste vient d'exécuter le groupe d'Ugolin et ses enfants mourants le rend digne de cette faveur: ce groupe s'il figure à l'exposition de Londres, comme je l'espère, sera une des oeuvres, qui feront le plus d'honneur à la sculpture française." On January 8, 1862, Schnetz wrote from Rome to the Académie (IFA 5E44): "Le groupe de Carpeaux est enfin moulé; aussitôt que le plâtre sera sec je l'enverrai à Paris. C'est un ouvrage très considérable, qui a été jugé très favorablement ici, je désire beaucoup qu'il ait les suffrages de l'Académie." On January 18, 1862, the Académie des Beaux-Arts decided to exhibit the statue in the chapel of the Ecole des Beaux-Arts and to inform Carpeaux of their decision. On January 25, 1862, the Académie decided that contrary to its decision of the previous week, which had been based on the assumption that the *Ugolin* was Carpeaux's fifth year *envoi*, Car-

peaux had satisfied the Ecole's regulations with his *Jeune Pêcheur*; as a result the *Ugolin* was "étranger à la juridiction de l'Académie" (IFA 2E13, Registre des procès verbaux, 1860–73). On February 11, 1862, Carpeaux wrote to the Académie to request their evaluation of his group: "je viens vous prier, Messieurs, de vouloir bien m'honorer d'un rapport qui sera pour moi le jugement le plus précieux que je puisse attendre" (IFA 5E44 1862). On February 15, 1862, the Académie decided "exceptionelle-ment" to report on the group. The report was first read on February 22 and those who had not seen the group were encouraged to do so. A second reading was held on March 1, and several members called for its abridgement. The final report (see below) was entered, in its abridged form, into the procès-verbaux on March 8, 1862 (IFA 2E13). About April 15, 1862, Carpeaux wrote to the Ministre d'Etat saying that he had learned from M. Courmont, Chef de la Division des Beaux-Arts, that there were no plans to acquire the *Ugolin*, and asking for his help. The response was to set aside 15,000 francs for "une statue", and to begin payment at once in 3,000 franc installments. On May 28, 1862, Bracq, mayor of Valenciennes, wrote a four-page letter to the Ministre d'Etat protesting the decision not to acquire the group either in marble or in bronze. The following day, May 29, Carpeaux wrote to disclaim any association with Bracq's letter. On June 7, 1862, Courmont prepared a note for the minister which finally brought the saga to an end: "La Commission Consultative des Beaux-Arts à laquelle l'Administration avait soumis la demande du M. Carpeaux relative à son group d'Ugolin a émis l'avis que ce groupe méritait d'être acquis par l'Etat; mais quant à la reproduction, soit en marbre, soit en bronze, tout en donnant la préférence au bronze, elle a exprimé le voeu que cette reproduction n'eût lieu qu'après que M. Carpeaux aurait fait à son modèle des modifications. En même temps pour indemniser l'artiste du préjudice que pourrait lui causer cet ajournement de l'exécution de son groupe et au besoin pour tenir lieu de cette exécution, la commission a demandé que le gouvernement achètât la petite figure de pêcheur en marbre formant l'envoi de dernière année de M. Carpeaux.

"Mr. Carpeaux, que j'ai vu, ne tient pas essen-tiellement à vendre son petit pêcheur à l'Ad-ministration. Il a reçu déjà des offres de plusieurs personnes au sujet de cet ouvrage et il n'est nulle-ment embarrassé d'en trouver le placement. Mais ce qui l'intéresse par dessus tout c'est la reproduction de son modèle, et il attache une certaine importance à ce que ce modèle soit exécuté dans son état actuel. Pour ma part je ne comprend pas trop quelles modifications on pourrait demander à Mr. Carpeaux, à moins de l'engager à recommencer son groupe, et la sous-Commission Chargée de faire à la Commission des Beaux-Arts un rapport sur ce groupe, l'a sans doute compris ainsi puisqu'elle n'a pas indiqué ces modifications.

"En résumé, le groupe en question n'en est pas moins malgré ses défauts, une oeuvre remarquable qu'on regretterait de ne pas voir reproduite. J'estime donc qu'il faut, au con-traire, prendre des mesures pour que ce groupe puisse figurer, reproduit en bronze, à l'Exposi-tion prochaine. Une somme de Trente mille francs me paraîtrait suffisante pour le prix du modèle et les frais de la fonte. Si Monsieur le Ministre approuve ma proposition, je m'enten-drai avec Mr. Carpeaux et on soummettra à la signature de S. Exc. un projet d'arreté en consé-quence. Mr. le Ministre voudra bien remarquer d'ailleurs qu'il ne s'agirait en définitive que d'un encouragement nouveau de 15,000 francs puisque Mr. Carpeaux a déjà reçu une commande de 15,000 francs qui se confondrait dans celle de son groupe." The documents informing the Ecole des Beaux-Arts of these decisions are found in AN AJ52 322, Elèves. Sculpture, II. Présence antérieur au 31 Décembre 1893.

137. Rapport de la section de sculpture à l'Académie des Beaux-Arts, March 8, 1862, IFA SE44. The French text of the final report is reproduced in LCC I, p. 130. The final version of the report shows a slight change from the draft, which has the effect of slightly softening the tone. The sen-tence in question is the first in the penultimate paragraph. In the draft it begins: "De l'exagéra-tion anatomique trop généralement répandue dans cette oeuvre . . ." The final version starts: "Un désir trop peu modéré, de la part de l'auteur, de montrer ses études anatomiques . . ."

138. For criticism of the *Ugolin*, see: G. Lafenestre, "La Sculpture au Salon de 1863," *Revue Con-temporaine*, 1863, p. 822; Castagnary, "Salon de 1863: IX. Sculpture," *Le Courrier du Dimanche*, July 26, 1863; L. Leroy, "Salon de 1863: XVI. Les Deux Soeurs," *Le Charivari*, June 4, 1863; P. Mantz, "Salon de 1863," *GBA*, 15, 1863, pp. 48–59; E. Chesneau, "La Sculpture, 1863," *L'Art et les Artistes Modernes*, Paris, 1864, pp. 293 ff.; G. Dumesnil, "La Sculpture à l'ex-position de 1863," *Le Courrier Français*, May 16, 1863, pp. 95–96; H. Rochefort, "Le Salon de 1863, Dernier Article," *Le Nain Jaune*, July 8,

1863, p. 5; G. de Rivaille, *L'Art contemporain à travers le Salon de 1863*, Paris, 1863, pp. 133–34; C. A. Dauban, *Le Salon de 1863*, Paris, 1863, p. 6; H. de Callias, "Le Salon de 1863," *L'Artiste*, ser. 8, 1863, pp. 3–8; C. de Sault, *Le Salon de 1863*, Paris, 1863, pp. 125 ff.; M. du Camp, "Le Salon de 1863," *Revue des Deux Mondes*, 1863, pp. 909–10; C. Vignon [née Noémi Cadiot], "Le Salon de 1863," *Le Correspondant*, 59, n.s. 23, June, 1863, pp. 387 ff..; T. Thoré, *Salons de W. Bürger*, Paris, 1870, p. 435; see also for reviews of the Ecole exhibition E. Filloneau, "Ecole Impériale des Beaux-Arts. Le Groupe d'Ugolin par M. Carpeaux," *Le Courrier Artistique*, March 15, 1862, year 1, no. 14, pp. 74–75; E. J. Delécluze, *Journal des Débats*, May 2, 1862.

139. Cham, *Le Charivari*, no. 9, June 12, 1863; Bertall, *Le Journal Amusant*, July 11, 1863.

140. Mantz, "Salon de 1863," pp. 55–56.

141. See above, n. 136, report of N. Courmont, June 7, 1862.

142. Dauban, p. 6.

CHAPTER V

1. Carpeaux to the Marquis de Piennes, November 10, 1864, in LCC I, p. 170. R. de Lano, historian and scandalmonger of the Second Empire, gives a less sympathetic account of Carpeaux's stay. See *La Cour de Napoléon III*, Paris, 1893, pp. 139–40.

2. LCC I, p. 170.

3. LCC I, p. 171.

4. Carpeaux to his parents, November 13, 1864, in Fromentin, p. 99.

5. Carpeaux to his parents, November 13, 1864, Fromentin, p. 99. This letter was written only hours after the one just cited.

6. The marble version of the bust is inscribed "Pâques 1865"; that of the statue, "15 Août 1865." For further information on the statue, see *The Second Empire: Art in France under Napoléon III*, Philadelphia Museum of Art, 1978, pp. 215–16, no. V-7 (entry by A. Pingeot).

7. A. Baignères, "Journal du Salon de 1866," *Revue Contemporaine*, ser. 2, 11, 1866, p. 338.

8. J. de Caso, "Serial Sculpture in Nineteenth-Century France," in Wasserman, ed., *Metamorphoses*, p. 6. This is the fundamental study of the industrial production of sculpture in the nineteenth century.

9. The workshop rules are reproduced in LCC I, p. 413. A rough estimate of the number of workers there in 1875 puts them at twenty-three. The figure is taken from a list of those who subscribed to the purchase of a memorial wreath at Carpeaux's death. The collection came to 106.5 francs; Solari (presumably the sculptor from Aix,

friend of Zola and Cézanne) contributed the least, one franc, towards the total. VBA, Dossiers Intimes.

10. As has been pointed out by de Caso, in Wasserman, ed., p. 7, the disputes over the direction of Carpeaux's atelier are an index of the potential profits the various claimants envisaged. LCC II, pp. 304–15, reproduces a series of legal documents relative to this contretemps. The chief dispute was engendered by the suit of Mme Carpeaux to secure a separation of property from her husband; as a result the Civil Tribunal the Seine appointed M. Nicquevert as administrator of the atelier, in possession of Carpeaux's atelier stamps, in order to keep production at the atelier underway (decisions of the civil tribunal of the Seine, March 6, April 1, May 15, 1875). The burden of Clément-Carpeaux's reporting of these events is to demonstrate that Carpeaux's artistic control of his studio never lessened, and in fact the legal decisions are written as if to guarantee that control. Yet Carpeaux himself responded as if the opposite were the case. The following letter of June 18, 1875, was printed in *Le Rappel*, June 22, 1875.

"Un référé du président du tribunal a remis l'administration de mon atelier à M Nicquevert, avoué, en me réservant la direction artistique. J'étais donc autorisé à croire que cette direction me conférait le droit exclusif de pouvoir seul signer les oeuvres dignes d'être vendues, puisque comme artiste, j'en suis responsable devant le public.

"Le 16 juin, menacé d'une perquisition domiciliaire, je fus obligé de remettre au commissaire de police mes poinçons, c'est-à-dire ma signature.

"Je me vois donc forcé, pour l'honneur de mon nom et la garantie des acheteurs, de déclarer qu'à partir de ce jour cette signature n'est plus apposée par moi. Ma santé me force aujourd'hui de cesser momentanément toute composition. Je décline donc la responsabilité des modèles qui porteraient ma signature et je déclare que les reproductions, marbres, terres cuites ou bronzes, qui me seraient attribués, ne sont ni revus, ni surveillés, ni retouchés par moi.

"En un mot, je suis complètement étranger à tout ce qui sortira désormais de l'atelier dirigé par M. Nicquevert, et je ne suis pour rien dans les oeuvres qu'on signerait désormais du nom de Jean-Baptiste Carpeaux."

11. The photograph is found among the Carpeaux papers, Documentation, Département des Sculptures, Musée d'Orsay.

12. The extant copy of the contract, dated December 12, 1855 (VBM, Dossier Statuettes), is published

by de Caso, in Wasserman, ed., p. 16, n. 12, and pp. 18–19, n. 31.

13. de Caso, in Wasserman, ed., pp. 9–11.

14. See Chapter IV, n. 102.

15. The Thiébaut et fils accounts (VBM, Dossier Atelier) were drawn up March 31, 1881, for submission to Carpeaux's widow; apparently they comprise a complete record of the transactions of sculptor and foundry. The Pêcheur casts cost 105 francs apiece.

16. Interest on the unpaid bill had climbed to 2,835.15 francs.

17. Barbedienne to Carpeaux, October 10, 1869: "A ce propos, je veux vous dire que cette figure, composée pour une destination spéciale, ne porte pas en elle-même de grandes conditions de succès auprès du public. En acceptant de l'éditer avec droits de l'auteur, je risque une affaire très douteuse."

18. The bookkeeper's name is not easily decipherable; I take it to read *Maumce*; letter to Carpeaux, July 31, 1869; the address on this document has been tampered with so that it reads *Madame* Carpeaux, statuaire; the salutation is still *Monsieur*. VBM, Dossier Atelier. Excerpts from the document have been reproduced by de Caso, in Wasserman, ed., p. 18, n. 32. The portion relevant to this argument occurs later in the letter: "En même temps je vais me permettre, en ma qualité de teneur de livres et pour tout l'intérêt que je vous porte, de vous démontrer que vous avez grand tort de ne pas donner plus d'activité à votre commerce.

"Avec peu de frais, seulement un mouvement constant des affaires, vous pouvez parfaitement faire un bénéfice annuel de 20 mille francs. Cette somme vous permettrait d'attendre le jour où vous voudrez étendre votre commerce sur une grande échelle, et vous pourriez entreprendre toutes vos grandes [?], poussé que vous seriez par l'argent de l'exploitation.

"Vous savez que l'art est si peu payé en ce temps d'administration partout, qu'il faut voir à se retourner—et chez vous cela vous est si facile. En effet, toutes les terres cuites se vendent facilement, surtout les bustes; eh bien, vous n'en avez pas dans les dépôts de Paris. Les bronzes il n'en reste presque plus. Vos marbres sont arrêtés. Cependant il serait facile de continuer vos commandes, puisque vous avez toujours un crédit de 6 mois. Ensuite, vous avez de nouvelles oeuvres à exploiter, telles que l'Espérance, La Négresse, l'Ugolin, la Cannelle [*sic*], La Candeur, et même la Flore, lesquelles certainement produiraient un immense effet."

19. H. James, *New York Daily Tribune*, December 25, 1875.

20. *Ibid.*

21. List on an undated letter from M. Rainbeaux, VBM, Dossier Bustes.

22. For references to Emile and Carpeaux, see LCC I, pp. 213 ff., 222 ff., 347 ff., 412 f. Clément-Carpeaux dates the second contract 1872; I deciphered it as reading 1873. The date has been reworked by another hand. VBM, Dossier Atelier.

23. A contract betwen Meynier and Carpeaux dated July 16, 1873, covers the execution in marble of the following busts; prices are given in parentheses. Carpeaux paid for the marble from which each bust was produced: Rieur (300 francs); Rieuse (300); Génie (350); Bacchante aux Roses (375); Bacchante (300); Mater dolorosa (400); Candeur (380); Palombella (400); Rieur aux Pampres (350), Rieur aux Roses (350); Espiègle (350); Boudeur (220); Bacchante aux Pampres (400). Another excerpt from this contract, as well as two later contracts (November 5, 1873; after January 1, 1874), is cited by de Caso, in Wasserman, ed., p. 25, n. 73. See also LCC I, p. 373.

24. Carpeaux to Bernard, Puys, August 10, 1874, VBM, Dossier Bustes.

25. Carpeaux to Bernard, Puys, August 10(?), 1874, VBM, Dossier Bustes.

26. Carpeaux to Meynier, October 24, 1874, VBM, Dossier Bustes.

27. Meynier to Carpeaux, 1874(?), VBM, Dossier Statuettes.

28. For Clésinger's vexed business affairs, see de Caso, in Wasserman, ed., pp. 7, 19, nn. 35, 36, pp. 23–24, nn. 69, 70. The Barbedienne papers have been deposited at Archives Nationales, 368 AP Papiers Barbedienne, inventory established by Michel Guillot, 1976.

29. Carrier-Belleuse is held back from "les hauteurs du vrai style," according to P. Mantz, *GBA*, ser. 1, 1867, p. 544.

30. F. Lugt, *Répertoire des catalogues de ventes publiques*, The Hague, 1964, vol. 3, nos. 32736, 34444, 35086, 33961, 34380, 34924, 35252.

31. W. Benjamin, "The Work of Art in the Age of Mechanical Reproducion," in *Illuminations*, New York, 1969, p. 221.

32. Pencil on white writing paper, inscribed in sepia ink, "Paris le 23 janvier 1852," 13 × 21 cm. VCD 1673.

33. M. Agulhon, *1848; ou, L'Apprentissage de la République, 1848–1852*, Paris, 1973, pp. 235–37.

34. Plaster, 105 × 353 cm., Musée des Beaux-Arts, Valenciennes. The relief, based on the Béranger song *La Sainte Alliance des peuples*, was part of a dining room decor with seven painted panels also

based on Béranger songs and with smaller motifs inspired by La Fontaine's fables.

35. For a larger discussion of this imagery, see D. Bernasconi, "Mythologie d'Abd el-Kader dans l'iconographie française au XIXe siècle," *GBA*, ser. 6, 77, 1971, pp. 51–62. See also C. H. Churchill, *La Vie d'Abd el-Kader*, transl. M. Habart, Algiers, 1971, first published London, 1867, pp. 295 ff.

36. For example, VCD 2, notebook, p. 20, 5.1 × 9.3 cm.

37. Salon of 1853, no. 1260, Nadar (F. Tournachon), *Nadar Jury au Salon*, Paris, 1853, unpag.

38. Carpeaux took advantage of the imperial tour of northern France (fall 1853) to put the relief on show in the Hôtel de Ville, Valenciennes. When that tactic failed, he followed the rulers to Arras and finally to Amiens. See LCC I, pp. 36–39, and Mabille, pp. 118–27. He was paid 5,000 francs from the Budget of the Maison de l'Empereur, Titre Encouragement aux Arts. Still incomplete at his death, it was finished by Charles Capellaro, AN 1708, O^5 53, O^5 54.

39. Printed poster, January, 1853, Collection DeVinck, 16456, BNEST. For a nineteenth-century account of Eugénie's good works, see E. Knoeffler, *Les Bienfaiteurs des Pauvres au XIXe siècle*, Paris, 1862, pp. 265–72.

40. See above, n. 12.

41. VCD 4, notebook, 6.5 × 11.5 cm., pp. 30–38, and VCD 6, notebook, 7.4 × 13.5 cm., pp. 64–69.

42. VCD 11, notebook, 7.4 × 14 cm., pp. 10, 10v.

43. LCC I, p. 180; Fromentin, p. 102, letters to Bruno Chérier, April 27 and May 3, 1865.

44. See for another example, Paris, Grand Palais, 1975, nos. 176–79.

45. Carpeaux to de Piennes(?), undated fragment, LCC I, p. 172.

46. Salon de 1866, no. 2668; Exposition Universelle, no. 23.

47. VCD 1231, black chalk on graph paper, sheet torn from a notebook.

48. *Moniteur Universel*, November 7, 1852, p. 1816.

49. L. Duquit, H. Monnier, and R. Gonnard, *Les Constitutions et les principales lois politiques de la France depuis 1789*, 6th ed., Paris, 1943, pp. 458 ff.

50. A. Filon, *Memoirs of the Prince Imperial, 1856–1879*, Boston, 1913, p. 1. Filon was the Prince's tutor.

51. *Les Papiers secrets du Second Empire*, Brussels, 1870, vol. 6, "Le Baptême du Prince Impérial."

52. Filon, pp. 8–9.

53. C. Hibbert, *The Royal Victorians: King Edward VII, his Family and Friends*, New York, 1976, pp. 10 ff.

54. Filon, p. 10.

55. Again, Filon gives a good sampling. The standard biographies are compilations of such anecdotes.

56. *Les Papiers secrets*, pp. 51–52.

57. P. de la Gorce, *Histoire du Second Empire*, 5th ed., 1899, vol. 1, pp. 122–3.

58. *Bulletin des Amis de Gustave Courbet*, no. 45, 1971, p. 23; Lami, I, p. 395.

59. A. Hemmel, "Salon de 1866," *Revue Nationale et Etrangère*, 24, 1866, p. 100.

60. L. Auvray, *Salon de 1866*, Paris, 1866, p. 100.

61. T. Denis, *Les Artistes du Nord au Salon de 1866*, Douai, 1866, p. 481.

62. C. Beauvin, "Salon de 1866," *Revue du XIXe Siècle*, 1866, p. 481.

63. T. Gautier, "Salon de 1866," *Moniteur Officiel*, August 3, 1866.

64. E. About, *Le Temps*, May 29, 1867.

65. J. M. Thompson, *Louis Napoleon and the Second Empire*, New York, 1955, pp. 284–85.

66. E. About, *Salon of 1866*, Paris, 1867, pp. 294–95.

67. About, *Le Temps*, May 29, 1867.

68. LCC I, p. 182; Lami, I, p. 267.

69. Carpeaux employed the Paris firm of Cajani *mouleurs* to execute casts for him and to modify sculptures. Records of his account (VBM) note extensive work on the *Prince Impérial* sculptures. See A. M. Wagner, "Art and Property: Carpeaux's Portraits of the Prince Impérial," *Art History*, 5, no. 4, December, 1982, p. 468, n. 69, for the relevant document.

70. AN F^{21} 479, pen and brown ink on blue writing paper, 21 × 13 cm.

71. Bill submitted by Verseron to Carpeaux, VBM: "Doit Monsieur Carpeaux statuaire à Verseron. 1865 Octobre 20. Avoir passé 20 journées pour baser et Epurer un Bloc de marbre qui n'a pas servi à l'exécution de la Statue du prince Impérial 20 journées à 8 160. 9bre id. passé 20 journées pour épurer le second bloc 160. Fait la Mise au point du groupe. Prix convenue 1700 Pour le transport de la tête du buste à la statue 5 journées 40. Pour l'escompte de deux billets de chaqu'un 500 0040. Total 2100. 1866 janvier 14 reçu de Monsieur Bernard pour Monsieur Carpeaux deux billets à ordre de 500 fr. chaque 1000. totale 1500. Reste du 600 fr. Paris 30 avril 1866." The bill indicates that the bust served as the model for the head of the full-scale statue. In 1866 one critic noted a disturbing disjunction between head and body, and recommended that Carpeaux work on that part of his statue (which he seems to have done). See C. Clément, *Journal des Débats*, June 30, 1866. For a discussion of wages paid stonecutters and other kinds of sculptors, see *Exposition Universelle de 1867; Rapports de délégations ouvrières*, Paris, 1869, vol. 3, "Rapport addressé à la commission d'encouragement par la délégation des sculpteurs," pp. 14–15.

72. Bill submitted by B. Bernäerts to Carpeaux, VBM, Dossier Praticiens.

73. Carpeaux to Dr. Batailhé, October 23, 1866, *Revue historique*, pp. 186–87.

74. For a discussion of Barbedienne's business, see de Caso, in Wasserman, ed., pp. 8–9 and *passim*. He cites the firm's accounts for the *Prince Impérial* edition for 1868, no. 11, pp. 15–16. Further records are given in Wagner, "Art and Property," p. 469, n. 49.

75. The relevant references in the Barbedienne accounts are: "11 juillet 1863 réduction d'un pêcheur 240; réduction d'un buste d'homme 90; réduction d'un groupe Ugolin 110; 16 novembre à la 1/2 buste Princesse Mathilde 210; réduction à la 1/2 buste Marquise de la Valette 150."

76. AN F²¹ 124, Dossier Statuettes, bustes du Prince Impérial.

77. Carpeaux to Napoléon III, March 1, 1867, AN F²¹ 124.

78. Arreté, April 6, 1867.

79. For an account of the labor associations formed by the *bronziers* in the 1860s, see J. Barberet, *Le Travail en France*, Paris, 1886, vol. 2, pp. 121 ff. For a discussion of the strike and Barbedienne's role in opposing it, see Barberet, pp. 126 ff. It is important to note that the orgization of *patrons* headed by Barbedienne tried unsuccessfully to use the imminent opening of the Exposition Universelle and the demand for a strong showing of French industry there as a means to force the *bronziers* back to work.

80. Letter from Carpeaux, March 20, 1867.

81. The Prince appeared at the opening ceremony and made official tours of the exhibits with his family. He presided at the awards presentation, which Carpeaux recorded in a painting (MBA VAL *Le Prince Impérial distribuant les recompenses à l'Exposition Universelle de 1867*, oil on canvas, 38 × 46 cm.

82. Information kindly provided by J. de Caso makes it possible to establish the destinations of some of the works acquired by the government.
 Ministère de la Maison de l'Empereur. Achats du government.
 1867: buste plâtre, Ecole Primaire de Garçons de Nancy; statuette en bronze, Marquis de La Valette, Ministre de l'Intérieur.
 1868: buste en plâtre, Société de Secours Mutuel à Embrun; buste en plâtre, Ecole Communale de St. Ismier; buste en bronze, Lycée du Prince Impérial, Vanves; buste en plâtre, Asile Impérial de Vincennes; 12 bustes en plâtre, "pour les douze fourneaux économiques"; buste en plâtre, Exposition permanente d'Alger.
 1869: buste en plâtre, Ecole Communale de St. Germain de Puch; buste en plâtre, Château de Blois; buste en plâtre, Bibliothèque de St. Lo; statuette en terre cuite, Hotêl de la Préfecture, Chambéry; buste plâtre, 2ème régiment de grenadiers de la garde impériale; buste plâtre, 3ème régiment des voltigeurs de la garde impériale; statuette en terre cuite, Comte de Nieuwerkerke; buste plâtre, Hôtel de Ville d'Amillis.

83. For information on Christofle et Cie., see *The Second Empire*, 1975, pp. 127-28; Comtesse d'Orr, "L'Art appliqué à l'Industrie; L'Orfèvrerie Christofle," *L'Artiste*, ser. 9, 4, January, 1868, pp. 132–38.

84. Christofle et Cie., *La Galvanoplastie dans la manufacture de MM. Christofle et Cie.*, Paris, 1866, pp. 9–11.

85. VBM, "Entre Monsieur J. B. Carpeaux statuaire demeurant à Paris, rue du Faubourg St. Honoré 235. Et Monsieur Christofle rue de Bondy 56 d'autre part: A été dit et convenu ce qui suit: Sur la demande adressée à Monsieur Carpeaux par M. Christofle, vous laisserez exécuter en galvanoplastie une épreuve de la Statue du Prince Impérial grandeur nature pour l'Exposition Universelle: Monsieur Christofle s'engage: 1. à payer à Mr. Carpeaux pour prix du moulage qu'il doit fournir à cet effet la somme de [incomplete] 2. De rendre l'épreuve en plâtre à Monsieur Carpeaux après l'opération dans l'état où elle était. 3. Le prix de reviens de la fabrication sera reconnu par M. Carpeaux sur la déclaration de la Maison Christofle. 4. L'épreuve sera mise après l'Exposition de Mr. Carpeaux pour la placer aux Expositions Françaises ou Etrangères, et il pourra en négocier la vente au besoin: Vente dont le minimum sera fixer double du prix de reviens: Conditions qui sera observé par la Maison Christofle si l'opération de vente se fait par elle. 5. Monsieur J. B. Carpeaux après avoir approuvé l'épreuve en galvanoplastie la poinçonnera de sa marque de propriété. 6. En cas de non vente pendant l'Exposition Universelle la vente sera effectuée à l'Hôtel Druot [sic] un an après la fermeture de l'Exposition Universelle et le produit devra couvrir les frais de Monsieur Christofle et le surplus sera partagé entre Monsieur Christofle et M. Carpeaux." The fifth stipulation of the contract is especially interesting because it indicates that Carpeaux had his *propriété* stamp, which in its earliest design was an eagle with the words PROPRIETE CARPEAUX without oval border, applied to casts which he did not actually produce himself.

86. The bill, dated February 29, 1868, gives the following prices for *galvanoplastie* version of the reductions: "Buste nu grandeur nature, 180 fr.;

1/2, 60 fr.; 1/4, 26 fr.; 1/8 10 fr.; Buste grandeur nature habillé, 210 fr.; 1/60 fr.; Statue du Prince Impérial grandeur nature 1650 fr.; 80 cm. 500 fr.; 65 cm. 250 fr.; 45 cm. 125 fr.; 28 cm. 50 fr." VBM.

87. Salon of 1868, no. 3464. For information on Thiébaut's foundry, see C. Coligny, "Paris-Nouveau: Exposition de la sculpture moderne au Faubourg Saint-Denis," *L'Artiste*, 1866, pp. 178–79. Thiébaut was active politically as well as commercially in the 1860s and was mayor of the 10th arrondissement. The question of the medium and form of the Hôtel de Ville version is confused. Some authors maintain that a modified version, also silver patinated and without the dog but wearing the *cordon* of the Légion d'Honneur, was destroyed in the burning of the Hôtel de Ville in 1871. Apparently there was some confusion surrounding it even in 1868; a notice in *Le Temps* of August 27, 1868, announced that, contrary to any rumors, the Préfet de la Seine, backed by the Conseil Municipal, had commissioned a bronze of the statue from Carpeaux, to be placed in the Hôtel de Ville. No record of payment for the work seems to survive in the Archives de la Seine; however, a letter from V. Baltard to Carpeaux, dated March 6, 1869 (VBM), indicates that the statue was delivered; "La commission des Beaux-Arts dans la séance du 16 février dernier a accepté à l'unanimité et avec éloges la statue de Prince Impérial que vous avez reproduite en bronze pour l'Hôtel de Ville." No mention of a payment is made. Carpeaux's widow, who was not always trustworthy, maintained staunchly in a letter to the Ny Carlsberg Glyptotek, November 18, 1907, that no other silver version of the sculpture was ever executed. See C. V. Petersen, "Jean-Baptiste Carpeaux og hans Arbejder i Ny Carlsberg Glyptotek," *Fra Ny Carlsberg Glyptoteks Samlinger*, Copenhagen, 1922. The Copenhagen bronze was cast by Thiébaut, and in 1869 a silver patinated version of the statue was in Thiébaut's atelier (see below). The catalogue of the Salon of 1868 clearly states that the version shown there was "Bronze argenté", but that version was without the dog. See C. Clément, *Journal des Débats*, June 20, 1868,: "Elle [the statue] a beaucoup de rapport avec celle que le même artiste a exposé il y a deux ans; seulement, le chien qui servait de support et d'accompagnement à la figure a été supprimé."

88. Peter Fusco and H. W. Janson, eds., *The Romantics to Rodin*, Los Angeles, 1980, no. 39.

89. These are noted in the 1869 ministerial inventory, F[21] 124. Carpeaux worked for Michel Aaron in the 1840s, supplying him with models for porcelain editions; Mabille de Poncheville misidentifies him as a *bronzier*, p. 41. Michel Aaron died in 1856 but the firm retained his name under the direction of his son Edouard. See de Chavagnac and Grolier, *Histoire des manufactures françaises de porcelaine*, Paris, 1906. It is likely that any porcelain version of the *Prince Impérial* without the Sèvres mark was produced from these molds.

90. F[21] 124. See also *The Second Empire*, 1978, pp. 154–55, no. III-23.

91. Carpeaux offered to sell the government a marble and a bronze version of this unedited bust for 2,500 and 350 francs respectively. Carpeaux to the Ministre des Beaux-Arts, February 27, 1869, F[21] 124. The sale was to be in addition to the main ministerial purchase. The original plaster of the bust was sold in the Vente Carpeaux, Paris, May 30, 1913, no. 55, and is now at the Musée National du Château de Compiègne. See M. Terrier, "Carpeaux à Compiègne," *Bulletin de la Société Historique de Compiègne*, 25, 1960, no. 8. Another plaster is in the Tannenbaum collection.

92. Arreté, December 30, 1868, F[21] 124.

93. *La Technologiste*, 30, 1869, p. 110.

94. F[21] 124.

95. *Ibid.*

96. Manufacture Nationale de Céramique de Sèvres, Registre Vr 1, ser. 3, no. 3, fols. 251–53, 258–59, 263, 277.

97. Manufacture Nationale de Céramique de Sèvres, Registre Vbb 12, fols. 56–57, 107–10, 112–13. And Registre de ventes au comptant de 1868 à 1872, Vz 12, fols. 156v, 168v, 171v, 178v, 182v, 191v.

98. Archives, Préfecture de Police de Paris, Series BA, Carton 996, Dossier Carpeaux.

99. Institut d'Art et d'Archéologie, Bibliothèque Jacques Doucet, Paris, MS. 101. An undated manuscript schedule of prices, an in-house draft which breaks down expenses of production, exists at the Bibliothèque Municipale, Valenciennes, Dossier Atelier. There are cited the costs for the various steps in the production of a statuette at 47 cm.: clay, 5 fr.; *estampage*, i.e. editing and repairs (the term applies to mold-made terra cottas), 20 fr.; general expenses, 20 fr.; total expenses, 45 fr.; and sale price, here given as 150 fr.

Chapter VI

1. E. Pinard, "Réquisitoire," pronounced February 7, 1857, published February 9, 1857, *Gazette des Tribunaux*, cited in G. Flaubert, *Madame Bovary*, Paris, 1972, p. 501.

2. E. Vermersch, "Les Deux Pudeurs," *Le Hanneton*, April 25, 1867.

3. It was replaced by a copy executed by Paul Belmondo. See P. Belmondo, "Que d'honneur et de joie à copier un tel maître," *Chefs-d'oeuvre de l'art, les grands sculpteurs*, ed. A. Ratcliffe, Paris, 1969, no. 136. The group was restored in 1932 and again in 1969: Documentation, Département des Sculptures, Musée d'Orsay, and AN F^{21} 6176.

4. AN F^{21} 6176.

5. C. Garnier, *Le Nouvel Opéra de Paris*, Paris, 1878, p. 434.

6. M. Steinhauser, *Die Architektur der Pariser Oper*, Munich, 1969, pp. 50–82, provides a discussion of the Opéra competition.

7. Mabille, p. 208.

8. From a report addressed to the Ministre de la Maison de l'Empereur et des Beaux-Arts by Garnier, December 5, 1863, AN F^{21} 6179.

9. A second report, from May, 1865, and likewise conserved in AN F^{21} 6179 preserves the record of these reallotments. The 1863 list was copied over; then several sculptors' names were crossed out and new names written in. The prices too were subject to modification.

10. Garnier to Maréchal Vaillant, December 5, 1863, AN F^{21} 6179.

11. See N. Levine, "The Competition for the Grand Prix in 1824," in *The Beaux-Arts and Nineteenth Century French Architecture*, ed. R. Middleton, Cambridge, Mass., 1982, pp. 66–123.

12. Archives de la Seine, VRI, Procès Verbaux de la Commission des Beaux-Arts. Though these records are incomplete, they nonetheless suggest the workings of the civic machine in charge of awarding sculpture. For example, at a meeting of May 20, 1863, commissions for the decoration of Paris churches were distributed by vote. The Vierge for Notre Dame de Clignancourt, for example, was awarded to Ottin after he received six votes (over Chapu's five and Carpeaux's three). The four top ranking artists in another vote were awarded groups on the facade of La Trinité: Crauck 10; Maillet and Carpeaux 9; Cavelier 8. On December 23, 1863, sculptors and commission reconvened to inspect the maquettes each artist submitted. On November 22, 1865, in the awarding of a commission for a statue of François I to be placed at the Hôtel de Ville, it was Cavelier who won with twelve votes; Carpeaux received one, beneath Guillaume (10), Dubois (6), and Mathurin-Moreau (2).

13. The history of the earlier opera houses is given briefly in C. Nuitter, *Le Nouvel Opéra de Paris*, Paris, 1875, pp. 1–16.

14. D. Van Zanten, "Architectural Composition at the Ecole des Beaux-Arts from Charles Percier to Charles Garnier," in *The Architecture of the Ecole des Beaux-Arts,* ed. A. Drexler, New York, 1977, p. 254. Garnier composed his own list of assistants, *Le Nouvel Opéra*, vol. 2, pp. 501–03; several went on to win the Prix de Rome.

15. For a contemporary account of the Opéra works, see G. Nast, "Le Nouvel Opéra," *Le Correspondant*, n.s., 42, 1869, pp. 688–702, 873–92. The chapter "The View from Notre Dame" in T. J. Clark, *The Painting of Modern Life*, New York, 1985, provides a vivid account of how the changes in Paris were represented by contemporary artists and writers. One form was the popular song, for example G. Nadaud's "L'Osmanomanie," a jingle about Osman, Préfet de Bajazet, who was in the grips of an "étrange délire": "Il démolissait pour construire et pour démolir, construisait." P. Barbier et F. Vernillat, *Histoire de France par les Chansons*, Paris, 1959, vol. 7, pp. 146–47.

16. AJ13 531, "Rapport annuel: Travaux de 1869," submitted in 1870. Tables A: Journées d'ouvriers employés à l'Opéra pendant l'année 1869; B. Journées d'ouvriers depuis l'origine des travaux; C. Ouvriers tués et blessés sur le chantier de l'Opéra; D. Matériaux employés dans la construction jusqu'au Décembre 31, 1869.

17. P. Burty, "Les Groupes du nouvel Opéra," *Le Rappel*, August 7, 1869.

18. In his response to a letter concerning Dantan from Perrin, Directeur de l'Opéra, Garnier stated that the sculptor had not been included among those asked to execute busts because those commissions only paid 500 francs, whereas Dantan certainly could command more. The request on behalf of the Maison Languereau came from Achille Fould (letter of August 14, 1866) via Perrin. The latter forwarded Fould's letter to Garnier (August 28, 1866): "En étant agréable au Ministre, vous serez également agréable au Directeur. Que pensez vous pouvoir faire?" Meantime Perrin wrote to Fould: "Votre Excellence ne peut douter, je pense, du plaisir que j'aurai à faire quelque chose qui puisse lui être agréable; je ne manquerai pas d'user de toute mon influence sur M. Garnier pour qu'il choisisse de préférence la personne à laquelle vous voulez bien vous intéresser," AN AJ13 531. The letter recommending the *marbrier*, a "brave homme," was from Carpeaux to Garnier, January 19, 1866, BO, Res. 880. Together these documents vividly suggest the various kinds of pressures on the architect. Add to this information that contained in a series of letters from Garnier's office to one Duburgeaud, an

entrepreneur en charpente employed at the Opéra site throughout its construction. Bibliothèque Historique de la Ville de Paris, C.P. 4418.

19. "Rapport annuel à son Excellence M. le Maréchal de France," February 24, 1866, AN AJ¹³ 531.

20. BO, Fonds Garnier 133. "Vous avez refusé de donner un prix pour l'exécution des modèles que vous n'avez pas faits. Je viens vous dire que je n'accepte pas ce refus et que lorsque je vous appelle, c'est pour que vous repondiez à ma demande et non pas pour que vous me donniez une leçon.

"Je ne sais si c'est l'amour propre ou l'intérêt qui vous a fait agir ainsi, vous et quelques uns de vos confrères, dans les deux cas vous avez tort. Votre amour propre ne doit aucunement être froissé de ma manière de procéder, et il me semble que dans les relations que j'ai eues avec les sculpteurs, je les ai toujours traités en artistes, mais le rôle de l'artiste finit où le modèle se finit, et lors de l'exécution, ils deviennent de simples entrepreneurs. Ils ne doivent donc dans aucun cas, se formaliser. Si j'emploie la concurrence, c'est un moyen légal, qu'il est non seulement de mon droit, mais encore de mon devoir d'employer, et votre amour propre ne doit aucunement souffrir.

"Quant à votre intérêt, il serait bien plus lésé si vous renonciez à la concurrence, car non seulement je ne pourrais vous appeler pour les lots dont vous n'avez pas fait le modèle, mais je serais forcé aussi de ne pas vous appeler pour ce que vous avez fait.

"Remarquez bien la différence: vous faites sous ma direction un modèle d'ornement, vous êtes artiste et devez être traité comme tel; mais le modèle fini et payé, il appartient à l'administration qui en use suivant son bon vouloir. Pour l'exécution, elle prend qui bon lui semble et appelle alors des praticiens. Vous êtes et devenez là des entrepreneurs de sculpture puisque vous ne faites plus vous-même et que vous faites exécuter par des hommes que vous payez pour cela à forfait ou à la journée.

"En résumé, je continuerai comme j'ai commencé, c'est-à-dire que j'appellerai toujours plusieurs exécutants pour les lots, puisque j'offrirai à celui qui a fait le modèle d'exécuter le travail au prix proposé le plus bas, et je donnerai à celui qui a fait le plus bas prix, soit une partie du lot, s'il est considérable, soit un autre lot.

"Mais soyez certain, Monsieur [*sic*], que je veux être maître et diriger mon affaire comme je le crois convenable, et que tous ceux qui refuseront pour une raison ou pour une autre, de suivre la marche que j'indique, seront immédiatement considérés comme démissionnaires, tant pour l'exécution que pour les modèles.

"Comme je m'aperçois d'une certaine coalition entre les sculpteurs, vous ferez bien de communiquer cette lettre à vos confrères pour qu'ils connaissent mes intentions."

Before 1866, conditions of work at the Opéra site had already become an issue between employer and employee. On May 11, 1862, for example, stonecutters had sent the Emperor a letter asking him to intervene on their behalf: "travaillant de notre état pour le chantier de l'Opéra, l'entrepreneur veut nous imposer des rabais sur des prix débattus et convenus dès l'origine des travaux, que nous mettent dans l'impossiblité de travailler. Pères de famille et hommes d'ordre, nous ne demandons qu'à gagner honorablement notre vie par notre travail et recevoir la balance qui nous appartient. Sachant l'intérêt que Votre Majesté porte à la classe ouvrière et dont elle voudrait le bien être, nous venons solliciter de votre inépuisable bienveillance, Sire, de vouloir bien prendre notre demande en considération." No reply to the letter is included in the dossier. AN F²¹ 830.

A decree of August 23, 1873, issued from the Préfecture of the Département de la Seine established officially that *only praticiens* would be used for execution of ornamental sculpture in the buildings of Paris and the *département*. Archives de la Seine, VRI.

21. See for example the anonymous program for the Opéra, AN F²¹ 830: "La construction des murs sera en pierre de taille, vigoureusement refouillée par de riches sculptures dans le genre de la Librairie de San Sovino [*sic*], à Venise." Or, from "Mémoire sur la reconstruction d'un Opéra," February 1, 1860, by Rohault de Fleury, then Architecte de l'Opéra (F²¹ 830): "L'exécution de ce grand projet exige de la richesse, du luxe, et surtout la satisfaction complète des données d'un programme compliqué."

22. AN F²¹ 830.

23. AN F²¹ 830.

24. F. Duban, "Rapport," July 16, 1861, AN F²¹ 830.

25. August 20, 1861, AN F²¹ 830.

26. C. Garnier, *A travers les arts*, Paris, 1869, p. 194.

27. *Ibid.*, p. 197.

28. *Ibid.*, p. 199.

29. December 5, 1863, AN F²¹ 6179.

30. See Chapter II, "Ornament as Art," in E. Gombrich, *The Sense of Order*, Ithaca, 1979, for a discussion of key texts.

31. *Ibid.*, Chapter I, and pp. 103–04.

32. "Rapport sur les travaux," 1866, AN AJ¹³ 531.

33. C. d'Henriet, "L'Art Contemporain: Les Sculptures de M. Carpeaux," *Revue des Deux Mondes*, 83, September 15, 1869, pp. 486–88.

34. Garnier to Carpeaux, undated letter, BO Res. 880.

35. Garnier to Carpeaux, undated letter, BO Res. 880.

36. *Study after Guillaume's La Musique*, pencil on graph paper, 24.0 × 17.1 cm., Cabinet de Dessins, Musée du Louvre, R.F. 8649; *Study after Perraud's Le Drame lyrique*, black chalk on cream colored paper flecked with grey, 14 × 9 cm., VCD 54, p. 106v. The drawing is closely juxtaposed to two copies of Rude's *La Marseillaise*, pp. 108, 107v. Proximity may have led D. Kocks to misidentify this drawing as a representation of Rude's group: D. Kocks, *Jean-Baptiste Carpeaux: Rezeption und originalität*, Sankt Augustin, 1981, p. 92, fig. 403. Other authors claim that Carpeaux was first assigned *Musique* as his subject, e.g. Fromentin, p. 108. P. Burty, by contrast, suggests in his notes on Carpeaux's career, that about 1874 Carpeaux was at work on a group, *La Musique*, as a pendant to *La Danse*: Bibliothèque Jacques Doucet, Carton 37, Sculptures.

37. Garnier to Carpeaux, undated letter, BO Res. 880.

38. Carpeaux to Garnier, March 7, 1866, BO Res. 880.

39. Carpeaux entrusted the execution of his group to "mes élèves" Duberteau and Armand, as well as Charles Capellaro and B. Bernaërts. A letter from Carpeaux to Garnier of October 22, 1868, states that six *praticiens* were then at work: BO Res. 880. One of these was apparently Capellaro's brother-in-law.

40. "Rapport sur les travaux pour l'année 1865," AN AJ¹³ 531.

41. "Rapport sur les travaux pour l'année 1866," AN AJ¹³ 531.

42. The terms of the official award engaged Carpeaux "à exécuter pour la décoration du bas de la façade principale du Nouvel Opéra, la sculpture en pierre d'Echaillon d'un groupe de 2m60 de haut, comprenant trois personnages moyennant le prix de 30,000 francs." The subject is mentioned only obliquely: "Vous voulez bien vous entendre avec M. Garnier, architecte, sur le programme à suivre, et lui soumettre votre esquisse," August 17, 1865. L. Clément-Carpeaux, "La Genèse du groupe de la Danse," *Revue de l'Art Ancien et Moderne*, 2, no. 286, May, 1927, pp. 286–87.

43. Carpeaux to Garnier, October 2, 1865, BO Res. 880.

44. Carpeaux to Garnier, November 9, 1865, BO Res. 880.

45. Garnier to Carpeaux, undated letter, BO Res. 880.

46. Garnier, *Le Nouvel Opéra*, vol. 1, p. 434.

47. Measured study for an Opéra group, pencil, heightened with white, on brown paper, 13.4 × 20.4 cm., VCD 31, p. 38. This notebook was used by Carpeaux on a trip to Givisiez, near Fribourg, to visit the Duchesse Castiglione-Colonna. One sheet, p. 53, is dated "10 janvier 1864," but the date does not provide more than a general anchor for this particular drawing. I take as significant in this matter of dating the fact that the drawing shows the final site Carpeaux was assigned—even though both his maquette and the 1863 list of sculpture assignments suggest he was first allotted a different position. These questions remain open to interpretation.

48. Garnier, *Le Nouvel Opéra*, vol. 1, p. 34.

49. A draft list suggesting names to be written into the Opéra decor is found in AJ¹³ 531. The suggestions are compendious, to say the least: they move from the obvious (famous operas and cities famous for opera and composers) to the abstract (twenty-four statues representing the qualities necessary to the arts) to the mundane (machinists, doctors, draughtsmen, accompanists).

50. A. Darcel, "Les Musées, les arts et les artistes pendant le siège de Paris," *GBA*, ser. 2, 4, 1870–71, p. 415.

51. Garnier, *Le Nouvel Opéra*, vol. 1, p. 424.

52. *Ibid.*, p. 426.

53. See for example the label on the contemporary photograph reproduced here, which opts for *La Déclamation*. *L'Europe Artiste* (October 10, 1869) called it *Poésie*.

54. Carpeaux to Garnier, letters of July 24, September 24, October 7, 1867, and January 5, 1868. The announcement that the group was finished came on January 14, 1868. On February 29, 1868, it still had not yet been completely cast in plaster.

55. E. Martin, "Les Statues du nouvel Opéra," *La France*, July 29, 1869.

56. "Le Nouvel Opéra," *Le Siècle*, August 13, 1869.

57. G. Lafenestre, "Les Sculptures décoratives du nouvel Opéra," *Moniteur Universel*, August 8, 1869.

58. A. Plessis, *De la fête impériale au mur des fédérés, 1852–1871*, Paris, 1973, pp. 217–19. For another authoritative account of the last years of the Empire, written particularly to characterize the

phenomenon of the public meeting and its relations to the political fortunes of the Empire, see A. Dalotel, A. Faure and J.-C. Freiermuth, *Aux origines de la Commune: Le Mouvement des réunions publiques à Paris, 1868-1870*, Paris, 1980.

59. Plessis, *De la fête*, p. 217. See also C. Bellanger et al., *Histoire générale de la presse française*, vol. 2, *De 1815 à 1871*. Paris, 1969, pp. 345 ff., for a discussion of the increasing influence of the press during this same period.

60. E. Pages, "Un paquet de lettres," *Le Charivari*, August 2, 1869.

61. "L'Ombre et la Danse," *Le Charivari*, September 3, 1869. Published after *La Danse* was stained with ink, this column pretends that the guilty party had been seized: the shade of the Abbé Gaume. Jean Joseph Gaume (1802-1879) was an immensely popular Christian writer; his *Caté-chisme* saw 35 editions, his *Lettres sur la Communion* 34. In this case the relevant work was *Le Ver rongeur des sociétés modernes; ou, le Paganisme dans l'éducation*, Paris, 1851, a text which fuelled the alliance of church and state on moral questions. Gaume considered contemporary literature pagan and proposed substituting the study of the writings of the church fathers.

62. "La Semaine," *L'Electeur Libre*, July 29, 1869. *L'Electeur Libre* was the successor to *L'Electeur*. Directed by Jules Favre, Henon, and Ernest Picard, it covered political, financial and agricultural news.

63. "XXX," "Les Charades sculptées du nouvel Opéra," *La Vie Parisienne*, July 31, 1869.

64. C. Yriarte, "Courrier de Paris," *Le Monde Illustré*, August 21, 1869.

65. L. Auvray, *Revue Artistique et Littéraire*, September 1-15, 1869.

66. G. Flax, "A Walk to see Fine Arts in Paris," *Continental Gazette*, August 5, 1969.

67. Alceste, "Lettres de Paris," *L'Universel*, August 31, 1869. The whole passage reads, "Je ne sais si, peu à peu, dans la population ne s'infiltre l'amère désillusion qui naît d'une politique si chimérique et si décevante: mais on surprend, ça et là, dans le peuple, des mots singuliers, des paroles d'une maturité hâtée, des taches morales dans l'esprit en même temps que le dard aiguisé des dystiques de Juvenal.

"Allant, comme tout le monde, voir la tache d'encre fait au marbre du nouvel Opéra, j'entendis un ouvrier qui disait à son camarade:

"—Regarde; voici l'Empire.

"Il montre d'un doigt le groupe de M. Carpeaux.

"Je regardai, moi, aussi machinalement, pour la vingtième fois, ce joli merlan tout nu, qui sem-

ble un petit capoul, et dansant autour de lui, ces belles paysannes perverties, telles qu'en amenaient jadis au gouffre parisien les conducteurs de diligence: la Normande, la Picarde, la belle Bourbonnaise. Je me demandais quel rapport cet homme pouvait trouver entre ce groupe lascif et le régime?

"Il est évident que lui-même il ne se rendait pas un compte exacte de ce qu'il venait de dire. Mais pourtant une pensée de railleuse morale s'en dégageait. Cet homme apercevait vaguement dans ce groupe si vivant, si palpitant, le seul défaut de l'oeuvre: la prédominance de la matière sur l'esprit, de la sensualité sur l'idéalité.

"Et par un tour de force intellectuel vraiment digne de ce vieux peuple imbu de l'esprit revolutionnaire, pensant à la liberté absente et au développement, en quelque musculaire de ce pouvoir énorme, il faisait de ce groupe un symbole."

68. The dance he named was the *cordace*—a kind of galliard from the days of Louis XIV; see *La Vie Parisienne*, August 14, 1869.

69. A. Duparc, "La Danse, par M. Carpeaux," *Le Correspondant*, n.s., 43, September 10, 1869, pp. 949-55; this citation, pp. 951-52:

"De tout ce que nous venons de dire, il résulte que M. Carpeaux a fait une oeuvre extrêmement remarquable, qu'on voudrait admirer sans restriction, qu'on aimerait à nommer un chef-d'oeuvre, si la beauté, cette splendeur du vrai, qui seule constitue le chef-d'oeuvre, qui en est la condition essentielle et indispensable, n'était systématiquement exclue de ce groupe.

"En effet, le choix des formes est négligé, la noblesse du sentiment et de la pensée ne se trouve nulle part; il y a là un sans-gêne, un abaissement de l'inspiration qui choquent péniblement et forcent le jugement, en dépit des qualités d'exécution que nous avons signalées, à se montrer d'une sévérité rigoureuse. Sans rappeler à M. Carpeaux que la danse était un art noble chez le Grecs, sans lui demander de s'astreindre à un style sévère, sans oublier que l'Opéra est un monument de plaisir et de fêtes, je lui reprocherai du moins, et avec justice, la déplorable trivialité de ses personnages. Les femmes qu'il a choisies pour types ne sont ni des déesses, ni même des bacchantes telles que les ont représentées les poètes, et la danse exprimée comme il l'a fait n'a de nom dans aucun langage; elle ne s'adresse qu'aux plus bas instincts de l'humanité, et s'il fallait caractériser ces femmes et cette danse, je serais obligé d'emprunter au vocabulaire repoussant des barrières et des bals publics des termes dont rougirait cette Revue."

70. C. A. de Salelles, *Le Groupe de la Danse de M. Carpeaux jugé au point de vue de la morale*, Paris, 1869, p. 9. For a similar turn of phrase, see R. Ménard, "Les Groupes du nouvel Opéra," *GBA*, 2, 1869, p. 266: "elles sentent le sueur. Louis XIV se serait bouché le nez devant ce groupe."

71. F. Bellay, "Le Groupe de M. Carpeaux," *Le Français*, August 31, 1869.

72. H. Viel Castel, "Chronique théatrale," *Le Dix-Décembre*, August 15, 1869: "Nous vivons à une époque de sans-gêne, c'est incontestable, et commode pour tout le monde, nous ne prétendons pas y redire; mais cette proclamation officielle, en pierre dure, du sans-culottisme à l'Opéra; cette apothéose du cancan au rang de danse nationale par l'Académie impériale de musique et de danse, parviennent à nous étonner: ce que nous ne croyons pas facile."

73. P. de Saint Victor, "Les Groupes et statues de la façade du nouvel Opéra," *La Liberté*, August 2, 1869: "Comment reconnaître cette danse symétrique, altière, élégante, où tout est nombre et mesure, dans le cancan dévergondé qu'exécutent les ribaudes de M. Carpeaux?"

74. A. Hans, "Le Groupe de Carpeaux," *Le Nain Jaune*, August 19, 1864.

75. The lists of names could even be given in verse; see M. Bayeux, "Le Groupe de M. Carpeaux au nouvel Opéra," *Paris*, August 27, 1869:

> Au moment d'entamer le bloc de sa
> commande,
> Il vit tourbilloner sur le lustre infernal
> Clodoche, Flageolet, La Comète et Normande
> Abrutis de bravos un soir de carnaval.

76. Pages, *Le Charivari*, August 2, 1869.

77. Duparc, *Le Correspondant*. For a similar sentiment, see H. Fouquier, *Revue Internationale de l'Art et de la Curiosité*, 2, no. 3, September 15, 1869: "Tout est pris, les formes vulgaires et les formes belles, et n'était le mouvement qui masque ce réalisme grossier, on ne pourrait arriver, par instants, à regarder sans un sentiment de répulsion une oeuvre exécutée cependant avec un extraordinaire mérite dans le maniement des outils du sculpteur."

78. E. Pignet, *L'Europe Artiste*, October 10, 1869.

79. E. Martin, "Les Statues du nouvel Opéra," *La France*, July 29, 1869.

80. X. Aubryet, "La Semaine dramatique: Le Nouvel Opéra," *Journal Officiel du Soir*, August 9, 1869.

81. Lafenestre, "Les Sculptures décoratives": "Nous n'aurons qu'à battre des deux mains en présence d'une force d'artiste, tout à fait singulière et rare, à qui nulle matière ne résiste, et qui sait arracher de la pierre la plus dure des créatures si vivantes et nerveuses, si souples et passionées. *La Danse* par M. Carpeaux est une bacchanale, la bacchanale la plus violente, la plus effrenée, qui ait jamais ébranlé par les nuits lascives des étés antiques. Debout sur un roc, un homme nu, le tambourin à la main, s'agite avec frénésie, excitant la ronde hurlante des ménades échevelées qui tourbillonnent autour de lui. Frémissantes, fièvreuses, épuisées, ces femmes ivres tournoient déjà à l'aventure, riantes d'un air lascif et hébété. Comme à bout de force et d'orgie, et se tenant, qui par la main, qui par le flanc, elles s'affaissent sur elles-mêmes, prêtes à rouler dans la poussière, où s'agite déjà foulé sous leurs pieds cruels, un petit amour tombé à la renverse, et qui ne lâche pas sa marotte. Ah! Si du moins ces danseuses éperdues étaient des femmes grecques par la beauté des formes et la splendeur des attitudes! Mais non, non; regardez-moi ces minois égrillards qui provoquent le passant de leur rictus furieux; voyez-moi ces jambes fatiguées et fléchissantes, ces gorges molles et tombantes, ces torses flasques et déformés, et avouez-le; nous sommes en plein XIXe siècle, en plein Paris maladif et déshabillé, en plein réalisme!

"Ce réalisme est ardent, passioné, fougeux, je le veux bien; il n'était nulle part moins à sa place que sur la façade d'un monument consacré aux arts."

82. In addition to the passage cited below, see R. Ménard, *GBA*, p. 266: "Ce que Courbet a rêvé dans la peinture, M. Carpeaux le réalise dans la sculpture: son marbre s'est fait chair"; P. Depelchin, *Le Monde*, September 1, 1869: "Nous ne prétendons nullement proscrire l'étude de nu. Il y a des nudités chastes mais il y a des nudités offensantes comme l'Odalisque de Courbet et la Danse de M. Carpeaux."

83. See Clark, *Painting of Modern Life*, pp. 79–146.

84. G. Maillard, "Chronique," *Le Peuple Français*, July 27, 1869.

85. F. de Lasteyrie, "Groupes et statues de la façade du nouvel Opéra, *L'Opinion Nationale*, August 19, 1869.

86. P. Gravier, *La Patrie*, September 1, 1864.

87. M. Chaumelin (pseud. for Gaston de Paray), "Les Sculptures de l'Opéra," *La Presse*, August 12, 1869.

88. For a biography of Vermersch, see J. Maitron, ed., *Dictionnaire biographique du mouvement ouvrier français*, vol. 9, q.v.

89. Vermersch, "Les Deux Pudeurs."

90. E. Vermersch, *Le Grand Testament du Sieur Vermersch*, Paris, 1868, p. 11.

91. See *Histoire générale de la presse française*, vol. 2,

pp. 345 ff.

92. E. Vermersch, "Le Groupe de M. Carpeaux," *Le Figaro*, August 12, 1869: "Enfin, voici une oeuvre vivante, frémissante, et passionée, voici de la chair, voici de la force et de la forme moderne! Ce ne sont plus des femmes grecques, copiées au Musée des Antiques, recomposées avec des fragments divers comme un animal antédiluvien avec des débris épars, des femmes de Phidias, de Cléomène, de Praxitèle ou de quelque autre, des femmes enfin, dont le type est perdu, s'il a jamais existé. Non! Celles-ci sont des femmes du XIXme siècle, des femmes telles que nous les savons, des Parisiennes de Paris en 1869! Le Coryphée qui les entraine et les excite à la danse est bien aussi un homme de notre temps, un contemporain de la dernière heure et non un de ces prétextes à muscles comme ces plaisantins de l'ébauchoir en vont copier tous les ans au Louvre pour le Salon! et voyez le miracle! M. Carpeaux a trouvé le moyen de faire une merveilleuse chose, sans le secours de l'antiquité; c'est à n'y pas croire!

"Ce groupe de *la Danse* est la preuve irréfutable de la puissance de l'art moderne et des ressources esthétiques de ce siècle! En dépit de ceux qui crient à l'indécence, à l'irrévérence, et même—les niais—à la réclame, M. Carpeaux a bien fait de nous montrer les femmes françaises du XIXme siècle! Et ne nous eût-il pas donné un chef d'oeuvre, comme celui qu'il vient de produire, au point de vue de la théorie, il faudrait le remercier encore de l'intention!

"Mais enfin voici de la sculpture qui est à nous! Voici de l'art national; et de l'art national de 1869."

The article continues at the same pitch: as he approaches his conclusion Vermersch invokes Rigolboche and Fifine, *le cancan* and *le chahut*. There and in a passage immediately following which describes contemporary dance as entirely given over "au caprice, au folie, au décolletage et déculotage," someone has marked the Bibliothèque Nationale copy with a great red slash of a crayon. The same mark appears in other contemporary periodicals, always, at least as I have observed it, indicating material that a censor might well have excised. For example, see the opposition paper *Le Casse Tête*, issue of September 11, 1869. A song, *A la Liberté* is marked by the same crayon. It begins:

"... que tu vois la fille impudique
Et publique
Qu'on retrouve sur les pavés
soulevés ..."

Later in the same issue a brief note which begins, "Les hommes qui cherchent à arranger pour le mieux les affaires du peuple, sont ceux qu'on dit être de l'opposition," is marked in the same fashion.

93. Apparently Carpeaux himself savored the *Figaro* article. He sent a copy of it to Bracq, Mayor of Valenciennes; Bracq responded with thanks for "cet excellent article." August 23, 1869, Documentation, Départment des Sculptures, Musée d'Orsay.

94. L. Veuillot, *L'Univers*, August 31, 1869: "Dans certains cas et pour certaines opérations, il faut avoir recours à des hommes spéciaux—En voici un qui ne partage point nos répugnances; il a le coeur ferme: il se plonge et se délecte dans l'ouvrage et caresse de la main ce que nous n'oserions toucher avec le pied."

95. A. Flan, "Le Groupe de Carpeaux," *L'Eclipse*, September 11, 1869. A second poem, "Les Demoiselles Carpeaux et la Grève," by Star, was published there on October 31, 1869.

96. E. Zola, "Une Allégorie," first published in *La Cloche*, April 22, 1870, in *Oeuvres complètes*, vol. 13, pp. 277–78.

97. K. Marx, *Der Achzehnte Brumaire des Louis Bonaparte*, Hamburg, 1869. Zola himself had already written about the course of the Empire in the weeks immediately preceding the publication of the column about *La Danse*. See in particular "La Fin de l'orgie," first published in *La Cloche*, February 13, 1870, in *Oeuvres complètes*, vol. 13, pp. 259–62.

98. *Correspondance libérale de Paris*, September 9, 1869; *Le Monde Illustré*, August 7, 1869.

99. de Salelles, *Le Groupe de la Danse*.

100. The group was stained during the night of August 26, 1869.

101. See *Gazette des Tribunaux*, September 18, 1869, April 1, 1870. The Tribunal de la Seine eventually decided against the legality of Carpeaux's seizures of photographs (September 2 and 6, 1869) from the shop of his competitor, Raudnitz. De Caso, in Wasserman, ed., p. 27, reproduces the text of that decision.

102. *Paris-Comique*, September 5, 1869.

103. *L'Eclipse*, September 11, 1869. This was not the only poetic tag produced, of course. *Correspondance Havas* printed the line from Racine reportedly uttered by someone who worked cleaning the spot: "Je n'ai fait qu'éponger; il n'était déjà plus," September 3, 1869.

104. Garnier to Carpeaux, undated letter, BO Res. 880: "Je ne sais qui a fait courir la bête de bruit qu'on voulait enlever ton groupe de l'Opéra. Hier soir, ça m'a été demandé plus de dix fois—les imbéciles!" The contents of the letter suggest

that it was written in mid-August; Garnier speaks of leaving for vacation the following day, and was in the south of France by late August.

105. Garnier to Carpeaux, undated letter, BO Res. 880.

"Mon cher ami,

"Il y a quelque chose de plus *formel* que le désir d'un architecte, la bonne volonté d'une administration et l'ordre d'un Empereur, c'est l'opinion publique, et c'est cette opinion qui nous contraint tous à faire retirer ton groupe.

"S'il ne s'agissait que d'une question purement artistique nous aurions tous aussi résistés [*sic*], et moi plus que les autres, car depuis trois ans je crie à qui veut l'entendre que ton travail est une oeuvre, et je ne m'en dédis pas aujourd'hui. Mais c'est une question de convenance et de morale qui est en jeu, et cette question passe au dessus de ma tête. Je regrette une décision qui prive l'Opéra d'un groupe remarquable, mais du moment qu'elle ne touche en rien au talent de l'artiste, je n'ai pas qualité pour la combattre, et je dois subir une défaite qui nous est commune, mais qu'on peut subir dignement puisque l'honneur artistique est sauf.

"Quant au droit que tu sembles dénier à l'administration de faire déplacer ton oeuvre, je crois que tu te trompes. L'administration peut agir comme tout particulier, c'est à dire qu'elle peut disposer suivant sa convenance des productions qu'elle a payées. C'est le droit commun qui peut s'exercer en dehors de tout ordre formel venu de l'Empereur.

"Je suis fâché que tu aies cru devoir saisir la presse d'un refus un peu précipité, refus qui t'honnore sans doute, mais qui alors ne devait pas être inconditionnel."

106. *Le Figaro*, November 29, 1869.

Monsieur le redacteur en chef du *Figaro*, Quelques journaux ont annoncé hier que mon groupe de *la Danse* au nouvel Opéra allait être enlevé, et que je serais chargé d'en exécuter un autre à sa place. J'ai l'honneur de vous informer:

1. que je crois impossible à l'Administration d'enlever mon groupe, *à moins d'un ordre formel de S.M. l'Empereur*, le modèle de cette oeuvre ayant été vu, examiné, et complètement approuvé par l'Administration et l'architecte.

2. que je me refuse formellement à entreprendre un nouveau travail en remplacement de celui qu'on veut supprimer aujourd'hui après l'avoir formellement accepté.

107. Garnier to Carpeaux, undated letter, BO Res 880: "La petite conversation amicale que nous aurons ensemble devra de toute façon se terminer par un rendez-vous à l'Opéra et il faut mieux peut-être ne pas scinder en deux une question importante et délicate et remettre le tout à l'époque où tu seras libre de passer une demi-heure dans mon bureau. Tu as certainement été affecté de la décision prise par le Ministère et il est inutile de revenir par deux fois encore sur un sujet qui doit t'être désagréable, comme rien ne presse en somme, et que je puis attendre encore quelques semaines avant d'étudier avec toi l'emplacement nouveau et convenable qui sera donné à ton groupe."

108. According to Garnier, *Le Nouvel Opéra*, vol. 1, pp. 454–55, the commission was granted by December 8, 1869. A letter of February 22, 1870, from Guméry invites Garnier to inspect his sketch: BO LAS Guméry.

109. AN F^{21} 145.

110. The question of who defaced the group is raised by Junibus Secundus, "La Tache d'Encre," *Le Globe*, September 4, 1869. Carpeaux's motivation, it is claimed, is to keep his work before the public eye, since he profits from notoriety.

111. "Les sculpteurs remplaçant le marbre par le charbon de terre pour éviter l'inconvenient des taches d'encre," *Le Charivari*, October 10, 1864. Even the great Daumier made a cartoon for the event; he showed a Tartuffe who has tried to throw ink on a statue of Voltaire, only to end up having besmirched himself: *Le Charivari*, September 22, 1869.

112. A. Duparc, *Le Correspondant*, cited the *Ugolin* to Carpeaux's credit, the better to contrast *La Danse* to it. A reference to the Prince Impérial statue begins François Bellay's article, "Le Group de M. Carpeaux"; the existence of this "statue dynastique" bought Carpeaux's right to work on the Opéra.

113. *La Chronique des Arts et de la Curiosité*, December 5, 1869.

114. Zola, "Une Allégorie," p. 273.

115. H. W. Janson, *History of Art*, New York, 1977, p. 603.

116. T. Gautier, *Journal Officiel de l'Empire Français*, August 2, 1869.

117. R. Ménard, *GBA*, p. 266, does mention Bernini, though in passing. But for him, as for most other writers, the *mention* of an older artist was not the important point; it was the fact they went on to condemn the group, despite any points of reference it offered.

118. Carpeaux, letter to *Le Figaro*, November 29, 1869.

119. Larousse, *Grand Dictionnaire*, q.v. can-can.

120. E. Blum, *Mémoires de Rigolboche*, Paris, 1860, p. 70.

121. Larousse, *Grand Dictionnaire*, q.v. danse.

122. Blum, p. 71.

123. See A. Dalotel, A. Faure and J. C. Freiermuth, *Aux origines de la Commune*, pp. 15–75 and passim.

124. Zeldin, *France*, vol. 1, p. 311. Decision of Tribunal of the Seine of 1889.

125. Flaubert, *Mme Bovary*, p. 501.

CHAPTER VII

1. *La Chronique des Arts et de la Curiosité*, no. 33, October 23, 1875, p. 301.

2. H. Delaborde, "Le Salon de 1870," *Revue des Deux Mondes*, June 1, 1870, p. 720.

3. D. Kocks's book *Jean-Baptiste Carpeaux* has done much to establish this relationship, by mapping out—and illustrating—the range of copies Carpeaux made during his career.

4. L. Dimier, "Carpeaux," first published in *Le Mois*, 1909; reprinted in *Faits et idées de l'histoire des arts*, Paris, 1923, pp. 28–57; this citation, p. 28.

5. *Ibid.*, p. 34.

6. *Ibid.*, p. 43.

7. *Ibid.*, pp. 49–50.

8. See the essay by Henri Zerner which introduces the volume, *Louis Dimier: L'Art français*, Paris, 1965, esp. pp. 11–15.

9. A. Wolff, *Le Figaro*, October 17, 1875.

10. J.-B. Foucart to P. Foucart, undated letter [1865], BNEST, Boîte 114.

11. J.-B. Foucart to F. Sabatier, undated letter [c. 1860], BNEST, Boîte Carpeaux 114.

12. VCD 6, pp. 66v, 69v. The pages in between are filled with drafts of other little speeches.

13. VCD 30.

14. These are not the terms of the marriage contract, but rather of its practice; one of Carpeaux's contracts with his brother Emile does stipulate that he is not to pass through the living quarters at Auteuil, but will use another entrance.

15. Archives, Préfecture de Police de Paris, series BA1, Carton 996, Dossier Carpeaux. Report of November 27, 1875, "Surveillance de l'exhumation du corps de Carpeaux."

16. P. Mantz, "Salon de 1873,' *GBA*, ser. 2, 6, 1872, p. 63.

17. These designs were apparently executed for the decorator Lefebvre, for whom Dalou worked in the late 1860s. Their original destination, so tradition recounts, was the Hôtel Menier, Avenue Van Dyck, Park Monceau, 1867–72.

BIBLIOGRAPHY

The following bibliography is divided into two sections. The first lists archival sources. The second includes references to general works on nineteenth-century France, sculpture, the education of sculptors, individual artists and studies of Carpeaux directly relevant to my investigations. Criticism of *concours* and *envoi* sculpture, Salon submissions, and *La Danse* which was published in article form is not included here; the interested reader is referred to the notes for those citations.

I. PRIMARY SOURCES

Lille	Archives du Nord	IT281 Ecoles Académiques
		IT290 Elèves artistes. Concours
		IT291/3 Elèves artistes. Dossier Carpeaux
Paris	Archives de Paris	Etat Civil reconstitué. Actes de Décès
	Archives du Louvre	Série LL—Répertoires alphabétiques des cartes delivrées aux artistes et élèves
		Série KK—Salons 1840–50, 1853, 1859, 1863

Archives Nationales
AJ[13] 531, 547–48 Documents relative to the Opéra

AJ[52] Archives de l'Ecole Nationale Supérieure des Beaux-Arts

AJ[53] Archives de l'Ecole Nationale Supérieur des Arts Décoratifs

F[21] Archives du Ministère des Beaux-Arts, especially cartons 1–261 Travaux d'art, commandes et acquisitions; 373 Demandes (Nord); 476–84 Marbres; 563 Ecoles de Dessin; 589–613 Académie de France à Rome; 614–41 Ecole des Beaux-Arts; 643–55 Ecole Nationale des Beaux-Arts; 830 Projets de l'Opéra; 1053 Correspondance, Directeur de l'Opéra et Ministre d'Etat; 1419–20 Bâtiments Civils, Ecole Nationale des Beaux-Arts; 3371–72 Opéra; 6176, 6179 Opéra, Sculpture d'Ornement.

O[5] Maison de l'Empereur, especially 1707–18. Encouragements aux Beaux-Arts

32 mi Letters by Carpeaux (microfilm)

Archives de la Seine
10 624/72h; Collection Lacaze t.71, YM92: Fontaine les Quatre Parties du Monde; VRI Commission des Beaux-Arts de la Ville de Paris

Archives, Préfecture de Police de Paris
Série BA1, Carton 996, Dossier Carpeaux; Dossier *La Danse*

Bibliothèque de l'Opéra
Fonds Garnier: LAS Louvet; LAS Guméry; Lettres relatives au groupe de *la Danse*; Res 880: Lettres autographes sur le groupe de *la Danse*; Dossiers d'artistes

Paris	Bibliothèque Nationale	Cabinet des Estampes
		Registres de permissions à copier données aux artistes et hommes de lettres, Ye 131, 132
		SNR Boîtes Carpeaux: three boxes of letters and documents concerning Carpeaux, given by P. Schommer
		Département des Manuscripts
		NAF 24.291
	Ecole des Arts Décoratifs	Bibliothèque
		Collection of 43 uncatalogued drawings by students of Lecoq de Boisbaudran
	Institut d'Art et d'Archéologie	Bibliothèque Jacques Doucet
		Carpeaux, MS 101—collection of letters and drawings formerly owned by L. Barnet
		MS 237—Lettres d'artistes à la famille Haro
		Carton 35 graveurs—Soumy
		Carton 37 sculpteurs—Carpeaux
		Carton 38 sculpteurs—Duret
		Carton 39 sculpteurs—Guméry
	Institut de France	Archives de l'Académie des Beaux-Arts
		Série 2E—Registres des procès verbaux; Series 5E—Correspondance
	Musée du Louvre	Cabinet des Dessins—autographes
		Collection of letters by Carpeaux
	Musée d'Orsay	Département des Sculptures
		Documents about Carpeaux formerly owned by L. Clément-Carpeaux. Legs Holfeld
Rome	Académie de France à Rome	Archives
		Carton Contes; Correspondance des Directeurs: Ingres, Schnetz I, Alaux, Schnetz II; Bibliothèque: Sortie des livres
	Ambassade de France au près de Saint Siège	Registres des passeports 1854–60; 1860–63
Valenciennes	Bibliothèque Municipale	Salle d'Etude
		Papiers Carpeaux: collection of manuscript material, letters, documents, by and about Carpeaux, together with notes by L. Clément-Carpeaux
		Manuscrits Fromentin: "Ecole valenciennoise"; "Dictionnaire des artistes valenciennois"; "Hommes et choses," MS dictionaries compiled by E. Fromentin
		Archives Municipales
		G121 Statuts et règlements de l'Académie de Peinture; Série T1 Expositions des arts et de l'industrie; T2 Musée et bibliothèque; T3 Académie de Peinture; R2/23 bis Séances du Conseil Municipal
	Musée des Beaux-Arts	Letters by Carpeaux; letters by Paul Foucart

II. PRINTED SOURCES

Adhémar, J. "L'Enseignement académique en 1820," *BSHAF*, 1933, pp. 270–79.

About, E. *Rome contemporaine.* Paris, 1861.

Agulhon, M. *1848; ou, L'Apprentissage de la république, 1848–1852.* Paris, 1973.

——. "Imagerie civique et décor urbain dans la France du XIXe siècle," *Ethnologie Française*, 5, 1975, pp. 33–56.

——. "La 'Statuomanie' et l'histoire," *Ethnologie Française*, 8, pp. 145–72.

Alaux, J. P. *L'Académie de France à Rome, ses directeurs, ses pensionnaires.* Paris, 1923.

Albert, P. *Documents pour l'histoire de la Presse de Province dans la seconde moitié du XIXe siècle.* Paris, n.d.

Alhadeff, A. "Michelangelo and the Early Rodin," *Art Bulletin*, 45, 1963, pp. 363–67.

Almanach de messieurs les fabricants de bronzes réunis de la ville de Paris pour les années 1830 et 1857. Paris, n.d.

Almanach du commerce. Paris, 1830–60.

Alvin, L. *Les Académies et les autres écoles de dessin de la Belgique.* Brussels [c. 1865].

Amaury-Duval, E. E. *L'Atelier d'Ingres: Souvenirs.* Paris, 1878.

Ampère, J. J. *La Grèce: Rome et Dante.* Paris, 1848.

Andress, G. F. *The Villa Medici in Rome.* 2 vols. New York, 1976.

Angers, Musée des Beaux-Arts. *Les Oeuvres de David d'Angers.* Angers, 1934.

Arsenne, L.-C. *Manuel du peintre et du sculpteur.* 2 vols. Paris, 1833. 2nd ed., 1858.

Artz, F. *The Development of Technical Education in France, 1500–1850.* Cambridge, Mass., 1966.

Association des Conservateurs de la Région Nord-Pas-de-Calais. *De Carpeaux à Matisse.* Lille, 1982.

Astruc, Z. *Les Quatre Stations du Salon.* Paris, 1859.

——. *Le Salon intime.* Paris, 1860.

Auquier and Astier. *La Vie et l'oeuvre de Joseph Soumy, graveur et peintre.* Marseilles, 1910.

Aucoz, L. *Institute de France, lois, statuts, de 1635–1889.* Paris, 1889.

Avennier, L. *J. J. Pradier, statuaire, 1790–1852.* Geneva, n.d.

Balze, R. *Ingres, son école, son enseignement du dessin, par un de ses élèves.* Paris, 1880.

Barberet, J. *Le Travail en France.* 7 vols. Paris, 1886–90.

Bardin, G. *Mémoire sur l'enseignement du dessin dans les écoles municipales d'enfants, d'apprentis et d'ouvriers de la ville de Paris et sur l'organisation de cet enseignement.* Orléans, 1863.

Barthet, A. "Le Sculpteur Clésinger," *L'Artiste,* 1859, pp. 24–26.

Baschet, R. *E. J. Delécluze, Temoin de son temps.* Paris, 1942.

Baudelaire, C. *Oeuvres complètes.* Paris, 1968.

Bellanger, C., Godechot, J., Guiral, P., and Terroul, F. *Histoire générale de la presse française.* vol. 2, *De 1815 à 1871.* Paris, 1969.

Bellet, R. *Presse et journalisme sous le Second Empire.* Paris, 1967.

Benjamin, W. *Illuminations.* New York, 1969.

——. *Charles Baudelaire: A Lyric Poet in the Era of High Capitalism.* London, 1973.

Benoist, L. "Le Sculpteur Clésinger, 1814–1883," *GBA,* 18, 1928, pp. 283–96.

——. *La Sculpture romantique.* Paris, 1928.

Bernasconi, D. "Mythologie d'Abd el-Kader dans l'iconographie du XIXe siècle," *GBA,* 77, 1971, pp. 51–63.

Bertrand, A. *François Rude.* Paris, 1888.

Beulé, C. *Notice sur la vie et les oeuvres de Francisque Duret lue à l'Académie des Beaux-Arts, Séance du 10 novembre 1866.* Paris, 1866.

——. "Un sculpteur contemporain et la principe du concours," *Revue des Deux Mondes,* June 1, 1861, pp. 666–85.

——. *Notice sur Victor Schnetz lue dans la séance publique de l'Académie des Beaux-Arts, le 1 novembre 1871.* Paris, 1871.

——. "L'Ecole de Rome au XIXme siècle," *Revue des Deux Mondes,* December, 1863.

Bizet, G. *Lettres de Georges Bizet: Impressions de Rome, 1857–1860; La Commune, 1870.* Paris, 1905.

Blanc, C. "Rapport au citoyen Ministre de l'Intérieur sur les arts du dessin et sur leur avenir dans la République," *Le Moniteur Universel,* October 10, 1848.

——. "Francisque Duret," *GBA,* 20, 1866, pp. 97–118.

——. *Grammaire des arts du dessin.* Paris, 1867.

——. *La Sculpture.* Paris, n.d.

Blum, E. *Mémoires de Rigolboche.* Paris, 1860.

Boime, A. *The Academy and French Painting in the Nineteenth Century.* New York, 1971.

——. "The Teaching Reforms of 1863 and the Origins of Modernism in France," *Art Quarterly,* n.s., 1, no. 1, 1977, pp. 1–39.

——. "Les Hommes d'affaires et les arts en France au XIXe siècle," *Actes de la Recherche en Sciences Sociales,* no. 28, June, 1979, pp. 57–76.

Bourdieu, P. "Systems of Education and Systems of Thought," *International Social Science Journal,* 19, 1967, pp. 338–58.

——. "Intellectual Field and Creative Project," *Social Science Information,* 8, no. 2, 1969, pp. 89–119.

de Bourdonnel, E. B. "Le Pêcheur napolitain," *L'Artiste,* 3, 1832, pp. 171–72.

du Bousquet, C. "Chapu, lettres, pages d'album et croquis inédits," *Revue de l'Art Ancien et Moderne,* 1911, pp. 55–72, 104–18.

Boutard, J.-B. *Dictionnaire des arts du dessin, la peinture, la sculpture, la gravure et l'architecture.* Paris, 1826.

Boyer d'Agen (A. J. Boyé). *La Palombella de Carpeaux*. Paris, 1933.

Bulliot, J.-B. "Guy-Bernard Lhomme de Mercey, statuaire," *Mémoires de la Société Eudéenne*, 20, 1892, pp. 161–89.

Burty, P. *Maîtres et petits maîtres*. Paris, 1877.

Butler, R., ed. *Rodin in Perspective*. Englewood Cliffs, 1980.

Calmette, J. *François Rude*. Paris, 1920.

———. *La Sculpture historique et patriotique de Rude*. Paris, n.d.

[Carpeaux, J.-B.] "Lettres inédites de J. B. Carpeaux," *Le Figaro Littéraire*, June 16, 1906.

Carette, Mme. *Recollections of the Court of the Tuileries*. New York, 1890.

de Caso, J. "La Sculpture en France du néo-classicisme à Rodin." Ph.D. dissertation, Yale University, 1962.

———. "Bibliographie de la sculpture en France, 1770–1900," *Information de l'histoire de l'art français*, 1963, pp. 151–59.

———. "Sculpture et monument dans l'art français et l'époque néoclassique," *International Congress on the History of Art*, 1, 1964, pp. 190–98.

———. "Jean-Baptiste Carpeaux," *Médecine de France*, no. 161, 1965, pp. 17–32.

———. "Re-examination of a Putto with the Instruments of War," *Bulletin of the Museum of Art, Rhode Island School of Design*, 54, November, 1968, pp. 3–8.

———. "Rodin's Mastbaum Album," *Master Drawings*, 10, no. 2, 1973, pp. 155–61.

———. "Duban et l'achèvement de la Galerie du Bord de l'eau: La Frise des frères l'Heureux," *BSHAF*, 1973, pp. 333–43.

Cassagne, A. *La Théorie de l'art pour l'art en France chez les derniers romantiques et les premiers réalistes*. Paris, 1906.

Castets, H. "Rude et son école," *L'Artiste*, ser. 8, 3, 1861, pp. 7–10.

Castille, H. *Les Hommes et les moeurs en France sous le règne de Louis Philippe*. Paris, 1853.

Charton, C. *Les Pêcheurs napolitains*. Paris, 1851.

Charton, E., ed., *Guide pour le choix d'un état; ou, Dictionnaire des professions*. 2nd ed. Paris, 1851.

Charvet, E. *Études sur les beaux-arts: Quelques Idées au sujet de l'enseignement professionel des arts décoratifs en province*. Paris, 1882.

Chatrousse, E. "François Rude, statuaire," *Revue des Beaux-Arts*, 6, 1855, pp. 441–43.

de Chavagnac and Grolier. *Histoire des manufactures françaises de porcelaine*. Paris, 1906.

Chesneau, E. *Le Salon de 1859*. Paris, 1859.

———. *L'Art et les artistes modernes*. Paris, 1864.

———. *L'Education de l'artiste*. Paris, 1880.

———. *Le Statuaire J.-B. Carpeaux, sa vie et son oeuvre*. Paris, 1880.

Chevalier, L. *La Formation de la population parisienne au XIXe siècle*. Paris, 1950.

Christofle et Cie. *La Galvanoplastie dans la manufacture de MM. Christofle et Cie*. Paris, 1866.

Churchill, C. H. *La Vie d'Abd el-Kader*. Transl. M. Habart. Algiers, 1971.

Clarétie, J. *J.-B. Carpeaux, 1827–1875*. Paris, 1875.

———. *Peintres et sculpteurs contemporains*. Paris, 1884.

Clark, T. J. *Image of the People*. London, 1973.

———. *The Absolute Bourgeois*. London, 1973.

———. *The Painting of Modern Life*. New York, 1985.

Claudet, M. *La Jeunesse de J. J. Perraud, statuaire, d'après ses manuscrits*. Salins-les-Bains, 1886.

———. *Perraud statuaire et son oeuvre: Souvenirs intimes*. Paris, 1877.

Clément-Carpeaux, L. "La Genèse du groupe de la Danse," *Revue de l'Art Ancien et Moderne*, May, 1927, pp. 285–300.

———. *La Verité sur l'oeuvre et la vie de J.-B. Carpeaux*, 2 vols. Paris and Nemours, 1934–35.

Clément de Ris, L. *De l'oppression dans les arts et de la composition d'un nouveau Jury d'examen pour les ouvrages présentés au Salon de 1847*. Paris, 1847.

Cougny, G. *L'Enseignement professionelle des beaux-arts dans les écoles de la ville de Paris*. Paris, 1888.

Courajod, L. *L'Ecole royale des élèves protégés précédée d'une étude sur le caractère de l'enseignement de l'art français aux différentes époques de son histoire, et suivie des documents sur l'Ecole Royale Gratuite de Dessin*. Paris, 1874.

de Courmenin, L. "Pradier," *Revue de Paris*, 10, July 1852, pp. 127–38.

Cousin, V. *Du Vrai, du Beau et du Bien*. 3rd ed. Paris, 1853.

Cummings, F. "The Selection of 'Style' in Neo-Classical Art as exemplified in Antonio Canova's Hercules and Lichas," *International Congress on the History of Art*, 1, 1964, pp. 232–38.

Dalotel, A., Faure, A., and Freiermuth, J.-C. *Aux origines de la Commune : Le Mouvement des réunions publiques à Paris, 1868–1870.* Paris, 1980.

Daly, C. "L'Ecole Gratuite de Dessin," *Revue Générale de l'Architecture et des Travaux Publics,* 7, 1847, cols. 292 ff.; 9, 1850, cols. 204 ff.

Dauban, C. A. *Le Salon de 1863.* Paris, 1863.

Daumard, A. "Les Elèves de l'Ecole polytechnique de 1815 à 1848," *Revue d'Histoire Moderne et Contemporaine,* July, 1948, pp. 226–34.

———. *La Bourgeoisie parisienne de 1815 à 1848.* Paris, 1963.

David d'Angers, P. J. *Les Carnets de David d'Angers.* Ed. A. Bruel. 2 vols. Paris, 1958.

Dayton, Ohio, Dayton Art Institute. *French Artists in Italy, 1600–1900.* Dayton, 1973.

Delaborde, H. *Etudes sur les beaux-arts en France et en Italie.* Paris, 1864.

Delacroix, E. *Oeuvres littéraires.* 2 vols. Paris, 1923.

de la March, A. L. *L'Académie de France à Rome.* Paris, 1874.

Delâtre, L. "Promenades artistiques dans Rome," *L'Illustration,* 33, 1859, pp. 117–18, 170–80.

Delbourgo, S. "Note technique sur la restauration des dessins de Carpeaux," *Bulletin des Laboratoires du Musée du Louvre,* 2, 1966, pp. 31–33.

Delestre, J. B. *Discours prononcé sur la tombe de François Rude, par J. B. Delestre.* Paris, 1855.

Delord, T., Frémy, A., and Texier, E. *Le Petit Paris XXII : Paris–Rapin, par les auteurs des Mémoires de Bilboquet.* Paris, 1855.

Depping, G.-B. *Les Jeunes Voyageurs en France ; ou, Lettres sur les départements.* Paris, 1824.

"Des Praticiens et M. Pradier," *Journal des Artistes,* n.s. 21, 2, no. 6, December, 1845, pp. 271–72.

Devigne, M. *La Sculpture belge, 1830–1930.* Brussels, n.d.

Dimier, L. *Faits et idées de l'histoire des arts.* Paris, 1923.

———. *Louis Dimier : L'Art français.* Ed. H. Zerner. Paris, 1965.

Diderot, D., ed. *Encyclopédie ; ou, Dictionnaire raisonné des sciences, des arts, et des métiers.* Paris and Neufchâtel, 1751–72.

Dijon, Musée Municipal. *François Rude : Catalogue de ses oeuvres.* Dijon, 1947.

———. *François Rude : Exposition centennale.* Dijon, 1955.

Dolent, J. *Petit Manuel d'art à l'usage des ignorants : La Peinture ; La Sculpture.* Paris, 1874.

Drexler, A., ed. *The Architecture of the Ecole des Beaux-Arts.* New York, 1977.

Drouot, H. "Rude imagier de la légende napoléonienne," *Annales de Bourgogne,* 28, 1956, pp. 233–52.

———. *Une Carrière : François Rude.* Dijon, 1958.

Dubois, P. *Notice sur Perraud lue dans la séance du 1er décembre 1877.* Paris, 1877.

Duclaux, L. "La Sculpture monumentale dans l'oeuvre dessinée de Carpeaux." Thesis, Ecole du Louvre, 1962.

Du Camp, M. *Le Salon de 1859.* Paris, 1859.

———. *Le Salon de 1861.* Paris, 1861.

Dumas, A. "L'Ecole des Beaux-Arts," *Paris Guide,* 1, Paris, 1867, pp. 855–73.

Dupin, C. *Enseignement et sort des ouvriers avant, pendant et après 1848.* Paris, 1848.

Dupuis, A. *Enseignement du dessin : Méthode A. Dupuis, approuvée par la Société des Méthodes, l'Institut, etc.,* Paris, n.d.

Duquit, L., Monnier, H., and Bonnard, R. *Les Constitutions et les principales lois politiques de la France depuis 1789.* 6th ed. Paris, 1943.

Duveau, G. *La Pensée ouvrière sur l'éducation pendant la Seconde République et le Second Empire.* Paris, 1947.

Eaton, C. *Rome in the Nineteenth Century.* London, 1852.

"Ecole Nationale de Dessin, de Mathématiques et de Sculpture d'Ornement," *L'Illustration,* 11, 1848, pp. 387–89.

Ecole Royale de Dessin. *Calendrier pour l'année 1790 à l'usage des élèves qui fréquentent l'Ecole Royale Gratuite de Dessin.* Paris, 1790.

Elsen, A. *In Rodin's Studio.* Ithaca, 1980.

Elsen, A. and Varnedoe, J. K. T. *The Drawings of Rodin.* New York, 1971.

Eméric-David, T.-B. *Recherches sur l'art statuaire.* Paris, 1805.

———. *Vie des artistes anciens et modernes.* Paris, 1853.

———. *Histoire de la sculpture antique.* Paris, 1853.

———. *Histoire de la sculpture française.* Paris, 1872.

Estignard, A. *Clésinger, sa vie et ses oeuvres.* Paris, 1900.

Etex, A. *Cours élémentaire de dessin appliqué à l'architecture, à la sculpture, à la peinture, ainsi qu'à tous les arts industriels.* Paris, 1859.

——. *Les Souvenirs d'un artiste.* Paris, 1877.

"Exposition des travaux des élèves de l'Académie de Valenciennes," *Echo de la Frontière,* October 2, 1852.

Exposition Universelle. *Rapport du Comité de l'arrondissement de Valenciennes.* Valenciennes, 1855.

Eyriès, G. *Simart.* Paris [1858].

Fau, J. *Anatomie des formes extérieures du corps humain à l'usage des peintres et des sculpteurs.* Paris, 1845.

Favre, Mme B. "François-Joseph Duret, dit Francisque, statuaire." Thesis, Ecole du Louvre, 1968.

Fidière, O. *Chapu, sa vie et son oeuvre.* Paris, 1894.

Filon, A. *Memoirs of the Prince Imperial, 1856–1879.* Boston, 1913.

Flaubert, G. *Madame Bovary.* Paris, 1972.

——. *Bouvard et Pécuchet.* Paris, 1972.

Florian Parmentier. "Lettres inédites de Carpeaux," *La Nouvelle Revue,* 1912, pp. 25–39.

Fleury, Général Comte E.-F. *Souvenirs.* 2 vols. Paris, 1871–98.

Foucart, J. B. *Souvenir de la terre natale : Les Incas à Valenciennes.* Valenciennes, n.d.

——. "Fête des Incas à Valenciennes," *L'Illustration,* 17, 1851, pp. 327–31, 377–78.

——. *La Toussaint.* Paris, 1864.

——. *La Cité nouvelle.* Paris, 1865.

——. *Funérailles de Carpeaux à Valenciennes le 29 novembre 1875 : Dernières paroles.* Valenciennes, 1875.

——. *L'Exécution testamentaire d'Auguste Comte, à tous les positivistes.* Paris, 1895.

Foucart, P. *Ville de Valenciennes, Catalogue de sculptures, peintures, eaux-fortes et dessins composant le Musée Carpeaux.* Paris, 1882.

——. "Le Monument à Watteau," *Almanach de Valenciennes,* 1881.

——. "Notre Dame du Saint Cordon, par Carpeaux," *L'Art,* 53, 1892, pp. 96–98.

Fouquier, H. *L'Art officiel et la liberté : Salon de 1861.* Paris, 1861.

de Fourcaud, L. *François Rude, sculpteur, ses oeuvres et son temps.* Paris, 1904.

Fromageot, P. *Victor Schnetz, directeur de l'Ecole de Rome : L'Insubordination de son pensionnaire Carpeaux.* Paris, 1916 (from *Mélanges offerts à M. Jules Guiffrey,* 8, 1914).

"Fronton de l'Institution des Jeunes Aveugles, par M. Jouffroy," *L'Artiste,* ser. 2, 2, 1842, pp. 129–30; ser. 3, 1, 1843, pp. 17–19.

Fusco, P. and Janson, H. W., eds. *The Romantics to Rodin.* Los Angeles, 1980.

Gaillard, J. *Paris la ville, 1852–1870.* Paris, 1976.

Galley, J. C. *Antonin Moine, un statuaire romantique oublié.* St. Etienne, 1898.

Garnier, C. *A travers les arts.* Paris, 1869.

——. *Le Nouvel Opéra de Paris.* 2 vols. Paris, 1878–81.

Garnier, J. and Bonnin, G. *Almanach dramatique, pittoresque et physiologique des écoles.* Paris, 1845.

Garraud, R. "L'Oeuvre réligieuse de Rude," *Bulletin d'Histoire et d'Architecture Réligieuse du Diocèse de Dijon,* 1886, pp. 165–74.

Gautier, T. *Zig-Zags.* Paris, 1845.

——. *Italia.* Paris, 1852.

——. *L'Art moderne.* Paris, 1867.

——. "Ecole Impériale et Spéciale de Dessin : Distribution des Prix : Discours M. J. Pelletier," *L'Artiste,* ser. 7, 5, 1858, pp. 7–8.

Gielly, L. "Les Pradiers du Musée de Genève," *Genava,* 3, 1925, pp. 347–57.

——. "Les Dessins de James Pradier au Musée de Genève," *Genava,* 7, 1929, pp. 242–50.

Gigoux, J. *Causeries sur les artistes de mon temps.* Paris, 1885.

Girault de Saint-Fargeau. *Guide pittoresque, portatif et complet du voyageur en France.* Paris, 1851.

Gombrich, E. *The Sense of Order.* Ithaca, 1979.

de Goncourt, E. and J. *Journal : Mémoires de la vie littéraire.* 4 vols. Paris, 1959.

——. *L'Italie d'hier : Notes de voyage, 1855–1856.* Paris, 1894.

Grate, P. *Deux critiques d'art de l'époque romantique, Gustave Planche et Théophile Thoré.* Stockholm, 1959.

Great Britain. House of Commons. Parliamentary Papers. 29, 1850, Report 98. "Report made by Mr. Dyce, consequent to his journey on an Inquiry into the state of schools of design in Prussia, Bavaria, and France."

Guénot, J. P. *Formation professionelle et travailleurs qualifiés depuis 1789*. Paris, 1946.

Guettier, A. *Histoire des écoles impériales d'arts et métiers: Liancourt, Compiègne, Beaupréau, Châlons, Angers, Aix*. Paris, 1865.

————. *Cours élémentaire de dessin linéaire, appliqué aux ornements, à l'usage des écoles royales d'arts et métiers*. Angers, 1846.

Guillard, A. *Biographie de J. Jacotot, fondateur de la méthode d'émancipation intéllectuelle*. Paris, 1860.

Guillaume, E. *Essais sur la théorie du dessin*. Paris, 1896.

Guillerme, J. "Anatomie artistique," *Encyclopédie universalis*, Paris, 1968, 1, pp. 100–08.

Guillot, A. "Ecole Royale Gratuite de Dessin, de Mathématiques et de Sculpture Ornementale," *L'Artiste*, ser. 2, 2, 1839, pp. 329–31.

Guizot, F. *Etudes sur les beaux-arts*. Paris, 1853.

Halévy, F. *Notice sur la vie et les ouvrages de M. Simart lue dans la séance publique de l'Académie des Beaux-Arts le 12 octobre 1861*. Paris, 1861.

Hamerton, P. J. *Modern Frenchmen: Five Biographies*. Boston, 1878.

Hargrove, J. *The Life and Work of Albert Carrier-Belleuse*. New York, 1977.

Harlé, D. "Les Cours de dessin gravés et lithographiés du XIXème siècle conservés au Cabinet des Estampes de la Bibliothèque Nationale. Essai critique et catalogue." Thesis, Ecole du Louvre [c. 1975].

Haskell, F. *Rediscoveries in Art*. Ithaca, 1976.

Haussmann, Baron G. *Mémoires*. 3 vols. Paris, 1890–93.

Hawks le Grice, Count. *Walks through the Studii of the Sculptors at Rome*. Rome, 1841.

Hawthorne, N. *The Marble Faun*. New York, 1899.

Henry, C. "Donation du Comte de Caylus à l'Académie de Peinture pour la fondation du concours dit de 'la Tête d'expression,'" *Nouvelles Archives de l'Art Français*, 1880–81, pp. 210–19.

Huet. "Notes addressées à messieurs les membres de la commission chargée des modifications à apporter aux règlements de l'Ecole des Beaux-Arts et de l'Académie de France à Rome," *L'Artiste*, 1, 1831, pp. 51 ff.

Hymans, L. "Vue des contemporains: Le sculpteur Rude," *La Libre Recherche*, 1855, pp. 440–48.

Hugo, V. *Choses Vues, 1849–1869*. Paris, 1972.

Hunisak, J. M. *The Sculptor Jules Dalou: Studies in his Style and Imagery*. New York, 1977.

Institut de France. Académie des Beaux-Arts. *Rapport sur les ouvrages envoyés de Rome par MM. les pensionnaires à l'Académie de France à Rome*. Paris, 1830–65.

Institut Impérial de France. Académie des Beaux-Arts. *Dictionnaire de l'Académie des Beaux-Arts*. Paris, 1859, vol. 1.

Jacotot, J. *Musique, dessin et peinture*. 4th ed. Paris, 1839.

Jacotot, F. and H. V. *Manuel de la méthode Jacotot (enseignement universel): Extraits textuels des oeuvres de J. Jacotot comprenant l'étude de la lecture, l'écriture, des langues, etc.* Paris, 1841.

James, A. R. W. "La 'Fraternité des Arts' et la revue 'L'Artiste,'" *GBA* ser. 6, 65, March, 1965, pp. 169–80.

James, H. "Paris as it is: Letter from Henry James, Jr.," *New York Daily Tribune*, December 25, 1875.

James, H. *Italian Hours*. New York, 1979.

Jamot, P. "Carpeaux peintre et graveur," *GBA*, ser. 3, 50, 1908, pp. 177–87.

Janson, H. W. "Observations on Nudity in Neo-Classical Art," *Stil und Uberlieferung in der Kunst des Abendlands*, International Congress on the History of Art, 1964, vol. 1, pp. 198–206.

————. "Nineteenth Century Sculpture Reconsidered," Mellon Lectures, National Gallery of Art, Washington, D.C.

Johnson, R. "Really Useful Knowledge," *Working Class Culture*. Ed. J. Clarke. London, 1979.

Jardin, A. and Tudesq, A. J. *La France des notables*. 2 vols. Paris, 1973.

Jouin, H. *David d'Angers: Sa vie, son oeuvre, ses écrits et ses contemporains*. 2 vols. Paris, 1878.

————. "Liste des élèves peintres et sculpteurs de l'Ecole Nationale des Beaux-Arts couronnés de 1862 à 1881, dans le concours de la tête d'expression," *Nouvelles Archives de l'art français*, 1880–81, pp. 484 ff.

————. "Liste des élèves de l'Ecole des Beaux-Arts qui ont remportés les Grands Prix de Peinture, Sculpture, Architecture, Gravure en taille douce, gravure en medailles et en pierres fines et de paysage historique," *Nouvelles Archives de l'art Français*, 1880–81, pp. 451 ff.

————. ed. *David d'Angers et ses relations littéraires*. Paris, 1890.

————. *Antoine Chrysotome Quatremère de Quincy*. Paris, 1892.

————. *James Pradier, anecdotes*. Paris, 1894 (from *La Nouvelle Revue*, August 1, 1894).

————. *Lettres inédites d'artistes français du XIXe siècle*. Macon, 1901.

Julien, B. R. *Exercices élémentaires*. Paris, 1865.

Jullien, A. *Les Beaux-Arts et leur administration*. Paris, 1868.

Knoeffler, E. *Les Bienfaiteurs des pauvres au XIXe siècle*. Paris, 1862.

Kocks, D. *Jean-Baptiste Carpeaux: Rezeption und originalität*. Sankt Augustin, 1981.

Kris, E. and Kurz, O. *Legend, Myth, and Magic in the Image of the Artist*. New Haven and London, 1979.

Kulstein, D. *Napoleon III and the Working Class: A Study of Government Propaganda*. Los Angeles, 1969.

de Laborde, L. *De l'union des arts et de l'industrie*. 2 vols. Paris, 1856.

Labourieu, T. *Organisation du travail artistique en France*. Paris, 1863.

Lacroix, P. "T.-B. Eméric-David," *Biographie universelle*, Brussels, 1844, vol. 12.

de La Gorce, P. *Histoire du Second Empire*. 7 vols. 12th ed. Paris, 1921.

Lagrange, L. "Simart," *GBA*, 1, 1863, pp. 97–123.

Lami, S. *Dictionnaire des sculpteurs de l'école française au XIXe siècle*. 4 vols. Paris, 1914–21.

Landowski, P. "Rude à Bruxelles: Ses méthodes et son enseignement considérés dans leurs rapports avec les théories esthétiques contemporaines," *Académie Royale de Belgique: Bulletin de la classe des beaux-arts*, 37, 1955, pp. 126–41.

de Lano, R. *La Cour de Napoléon III*. Paris, 1893.

Lapauze, H. "Une Académie des Beaux-Arts Revolutionnaire," *Revue des Deux Mondes*, December 15, 1905, pp. 882–903.

——. *Histoire de l'Académie de France à Rome*. 2 vols. Paris, 1924.

Larousse, P., ed. *Grand Dictionnaire universel du dix-neuvième siècle*. 17 vols. Paris, 1865–90.

Laviron, G. and Galbaccio, B. *Le Salon de 1833*. Paris, 1833.

Le Breton, G. "Schnetz et son époque: Lettres inédites sur l'art," *Réunion des Sociétés des Beaux-Arts des Départements*, 9, 1885, pp. 316–52.

Lecoq de Boisbaudran, H. *Prélude à l'unité réligieuse*. Paris, 1848 (from *La Démocratie Pacifique*, April 18, 1847).

——. *L'Education de la mémoire pittoresque*. Paris, 1848.

——. *Coup d'oeil sur l'enseignement des beaux-arts*. Paris, 1874.

——. *Lettres à un jeune professeur: Sommaire d'une méthode pour l'enseignement du dessin et de la peinture*. Paris, 1876.

——. *L'Education de la mémoire pittoresque et la formation de l'artiste*. Biographical note by L. Luard and letter by Rodin. Paris, 1914.

Legrand, M. *Rude, sa vie, ses oeuvres, son enseignement: Considérations sur la sculpture*. Paris, 1856.

LeNormand, A. *La Tradition classique et l'esprit romantique: Les Sculpteurs à l'Académie de France à Rome de 1824 à 1840*. Rome, 1981.

Léon, P. and Landowski, P. *Deux fondateurs de l'association des artistes peintres, sculpteurs, architectes, graveurs et dessinateurs*. Paris, 1955.

Lethève, J. *Daily Life of French Artists in the Nineteenth Century*. Transl. H. E. Paddon. New York, 1972.

Levêque, C. "Les Destinées de la sculpture et la critique moderne," *Revue des Deux Mondes*, January 15, 1864, pp. 334–61.

Lièvre, P. "Pradier," *La Renaissance*, 15, no. 1, January, 1932, pp. 25–30.

——. "Pradier," *Revue de Paris*, August 15, 1932, pp. 807–27; September 1, 1932, pp. 172–201.

Locquin, J. "Un grand statuaire romantique, Auguste Préault," *La Renaissance de l'art français et des industries de luxe*, 1920, pp. 454–63.

Lucas-Debreton, J. *Le Culte de Napoléon, 1815–1848*. Paris, 1950.

Mabille de Poncheville, A. *L'Enfance de Carpeaux*. Paris, 1913.

——. *Carpeaux inconnu ou la tradition recueillie*. Paris and Brussels, 1921.

——. "Les Origines et les débuts de Carpeaux," *Bulletin des Beaux-Arts de Belgique*, 39, 1957, pp. 46–54.

——. "Les Carnets de Carpeaux," *Revue des Deux Mondes*, 39, 1927, pp. 794–818.

Mahalin, P. *Les Mémoires du bal Mabille*. Paris, 1894.

Maîtron, J., ed. *Dictionnaire biographique du mouvement ouvrier français*. 21 vols. Paris, 1966.

Mangeant, P. E. "Antoine Etex, peintre, sculpteur et architecte, 1808–1885," *Réunion des Sociétés des Beaux-Arts des Départements*, 18, 1894, pp. 1363–1402. Reprinted Paris, 1894.

Mantz, P. "Carpeaux," *GBA*, ser. 1, 13, 1876, pp. 573–611.

Marx, K. *Surveys from Exile*. Ed. D. Fernbach. London, 1973.

Marx, L. *The Machine in the Garden*. Oxford, 1964.

Mathieu, P. "Gustave Moreau en Italie," *BSHAF*, 1974, pp. 173–94.

——. *Gustave Moreau, sa vie, son oeuvre: Catalogue raisonné de l'oeuvre achevée*. Paris, 1976.

Menn, C. *De l'enseignement des arts du dessin en Suisse au point de vue technique et artistique comparé à ce qui fait les autres pays.* Paris, 1874.

Merson, O. *De la réorganisation de l'Ecole Impériale et Spéciale des Beaux-Arts.* Paris, 1864.

Michelet, J. *Voyages en Italie.* Paris, 1891.

———. *Journal.* Ed. P. Viallaneix. 2 vols. Paris, 1959.

Middleton, R., ed. *The Beaux-Arts and Nineteenth Century Frnech Architecture.* Cambridge, Mass., 1982.

Ministère de la Culture et de la Communication. *La Sculpture: Méthode et vocabulaire.* Paris, 1978.

Ministro della Pubblica Instruzione. *L'Italia visita dei pittori Francesi del XVIII e XIX secolo.* Rome, 1961.

Mirolli, R. B. "The Early Work of Rodin and its Background." Ph.D. dissertation, New York University, 1966.

Missinne, L. "Un pedagogue Bourguignon: Joseph Jacotot, 1770–1840," *Annales de Bourgogne,* fasc. I, 1964, pp. 5–43.

Monnet, C. *Etude d'anatomie à l'usage des peintres par Charles Monnet, peintre du roi.* Paris, n.d.

Mower, D. "Antoine Augustin Préault, 1809–1879," *Art Bulletin,* June, 1981, pp. 288–307.

Muntz, E. *Guide de l'Ecole Nationale des Beaux-Arts.* Paris, 1889.

———. "L'Art français au XVIIème siècle et l'enseignement académique," *Revue de l'Art Ancien et Moderne,* 1897, pp. 31–48.

Nadar [F. Tournachon]. *Nadar Jury au Salon.* Paris, 1853.

Naef, H. "Die Villa Medicis und der Prix de Rome," *Du,* no. 9, 1972, pp. 625–757.

Nast, G. "Le Nouvel Opéra," *Le Correspondant,* n.s., 42, 1869, pp. 688–708, 873–92.

Nice, Musée de Ponchettes. *J.-B. Carpeaux, 1827–1875.* Nice, 1956.

Noli, R. *Les Romantiques français et l'Italie: Essai sur la vogue et l'influence de l'Italie en France de 1825 à 1850.* Dijon, 1928.

Norlyng, Ole. "Den Patetiske og Politiske Ugolino," *Meddelelser fra Ny Carlsberg Glyptotek,* 35, 1976, pp. 53–74.

Nuitter, C. *Le Nouvel Opéra de Paris.* Paris, 1875.

d'Orr, Comtesse. "L'Art appliqué à l'industrie: L'Orfèvrerie Christofle," *L'Artiste,* ser. 9, 4, January, 1868, pp. 132–38.

Osler, P. "Gustave Moreau: Some Drawings from the Italian Sojourn," *Bulletin de la Galerie Nationale de Canada,* 6, no. 1, 1968, pp. 20–28.

Ottin, A. *Esquisse d'une méthode applicable à l'art de la sculpture.* Paris, 1864 (from *Presse Scientifique des Deux Mondes,* 1864).

———. *Méthode élémentaire du dessin.* Paris, 1868.

Pailhas, Dr. "Le Dr. J.-F. Batailhé et le statuaire Carpeaux," *Revue Historique, Scientifique et Littéraire du Département du Tarn,* ser. 2, 16, 1909, pp. 181–205.

Paillot de Montabert, J. N. *L'Artistaire, livre des principales initiations aux beaux-arts.* Paris, 1855.

Paris, Bibliothèque Nationale. *La Légende Napoléonienne, 1796–1900.* Paris, 1969.

Paris, Ecole Nationale des Beaux-Arts. *Exposition des oeuvres originales et inédites de J.-B. Carpeaux.* Preface by M. Guillermot. Paris, 1894.

Paris, Galerie Manzi-Joyant. *Atelier J.-B. Carpeaux: Catalogue des sculptures, terre cuites, plâtres, bronzes, par Jean-Baptiste Carpeaux* . . . May 20 (first sale); December 8–9, 1913 (second sale).

Paris, Grand Palais. *Sur les traces de Jean-Baptiste Carpeaux.* Paris, 1975.

Paris, Hôtel de Rohan. *Les Français à Rome: Résidents et voyageurs dans la ville éternelle de la renaissance aux débuts du romantisme.* Paris, 1961.

Paris, Petit Palais. *Catalogue Exposition J.-B. Carpeaux, 1827–1875.* Paris, 1955–56.

Paris, Salon des Artistes Français, Grand Palais. *Exposition retrospective Carpeaux (Centenaire de sa naissance).* Paris, 1927.

Peisse, L. "Ecole des Beaux-Arts: Musée d'Etudes," *Revue des Deux Mondes,* ser. 4, part 1, October 15, 1840, pp. 232–45.

Perdiguier, A. *Le Livre du compagnon.* Paris, 1840.

———. *Mémoires d'un compagnon.* Moulins, 1914.

Perego, E. "Delmaet et Durandelle ou la rectitude des lignes," *Photographies,* no. 5, June, 1984.

Petersen, C. V. "J.-B. Carpeaux og hans arbejder i Ny Carlsberg Glyptotek," *Fra Ny Carlsberg Glyptoteks Samlinger,* Copenhagen, 1922, 2, pp. 1–59.

Pevsner, N. *Academies of Art, Past and Present.* London, 1940.

Philadelphia Museum of Art. *The Second Empire: Art in France under Napoleon III.* Philadelphia, 1978.

Pierrard, P. "L'Etablissement des Frères des Ecoles Chrétiennes à Valenciennes, 1824 à 1848." Mémoire d'études supérieures présentée devant la Faculté des Lettres de Lille, MS., November, 1949.

——. *La Vie ouvrière à Lille sous le Second Empire*. Paris, 1965.

——. *La Vie quotidienne dans le Nord au XIXe siècle*. Paris, 1976.

——. "L'Enseignement primaire à Valenciennes, de la loi Falloux (1850) aux Laïcisations (1891)," *Valenciennes et les anciens pays-bas: Mélanges offerts à Paul Lefrancq*. Valenciennes, 1976, vol. 9, pp. 129–39.

——. "Valenciennes et la formation du Département du Nord," *Cahiers de l'U.E.R. Froissart*, no. 2, 1977, pp. 126–30.

Pierron, S. *Etude d'art: François Rude et Auguste Rodin à Bruxelles*. Brussels, 1903.

Pingeot, A. "Rôle de la sculpture dans l'architecture: A propos de l'Opéra de Paris," *Revue Suisse d'Art et d'Archéologie*, 38, 1981, pp. 119–84.

Pinkney, D. *Napoléon III and the Rebuilding of Paris*. Princeton, 1972.

Planche, G. *Portraits d'artistes*. 2 vols. Paris, 1853.

——. *Etudes sur l'école française*. 2 vols. Paris, 1855.

——. "L'Art grec et la sculpture réaliste," *Revue des Deux Mondes*, October 1, 1856, pp. 533 ff.

Plessis, A. *De la fête impériale au mur des fédérés, 1852–1871*. Paris, 1973.

Poisot, C. *Notice sur le sculpteur François Rude, né à Dijon le 4 janvier 1784—mort à Paris le 3 novembre 1855*. Dijon, 1857.

Polzer, J. "Rodin et Carpeaux," *Information de l'Histoire d'Art*, 16, 1971, pp. 214–24.

Pool, P. "Degas et Moreau," *Burlington Magazine*, 105, no. 723, 1963, pp. 251–56.

Quarré, P. "François Rude et le milieu artistique dijonnais," *Le Dessin*, 1948, pp. 24 ff.

——. "La Vierge deuillante de Rude," *La Revue des Arts*, December 1957, pp. 217–22.

——. "François Rude: Grand Prix de Rome," *Mémoires de l'Académie des Sciences, Arts et Belles Lettres de Dijon*, 112, 1958, pp. 43–49.

——. *François Rude à Bruxelles*. Brussels, 1962 (from *La Revue Industrie*, no. 10, October, 1962).

Quatremère de Quincy, A. C. *Considérations sur les arts de dessin en France*. Paris, 1791.

——. *Recueil des notices historiques lues dans les séances publiques de l'Académie Royale des Beaux-Arts à l'Institut*. Paris, 1834.

——. *Suite du recueil des notices, etc.* Paris, 1837.

——. *Essai sur l'idéal dans ses applications pratiques aux oeuvres de l'imitation propre des arts du dessin*. Paris, 1837.

Raoul Rochette. *Notice historique sur la vie et les ouvrages de M. Pradier, lue dans la séance de 2 octobre 1853*. Paris, 1853.

——. *Notice historique sur la vie et les ouvrages de M. Ramey, lue dans la séance de 2 octobre 1853*. Paris, 1853.

Ravaisson, F. *De l'enseignement du dessin dans les lycées*. Paris, 1854.

Reff, T. "Copyists in the Louvre, 1850–1879," *Art Bulletin*, 46, no. 4, 1964, pp. 552–59.

——. "More Unpublished Letters of Degas," *Art Bulletin*, 51, no. 3, 1969, pp. 281–89.

Régamey, F. *Horace Lecoq de Boisbaudran et ses élèves*. Paris, 1903.

——. *L'Enseignement du dessin aux Etats-Unis: Notes et documents*. Paris, 1881.

Rheims, M. *La Sculpture au XIXe siècle*. Paris, 1972.

Rhodes, J. "Ornament and Ideology: A Study of Mid-Nineteenth Century British Design Theory." Ph.D. Dissertation, Harvard University, 1983.

Rogers, S. *Italy: A Poem*. London, 1830.

Rome, Palazzo Braschi. *L'Accademia di Francia à Roma*. Rome, 1966–67.

Rosenblum, R. "The Origins of Painting: A Problem in the Iconography of Romantic Classicism," *Art Bulletin*, 39, 1957, pp. 279–90.

Rostrup, H. "Historien om 'Dansen,'" *Meddelsen fra Ny Carlsberg Glyptothek*, 1962, pp. 19–34.

Rouchès, G. *L'Ecole des Beaux-Arts: Apeçu historique et guide à travers les collections*. Paris, 1924.

Rougerie, J. "Remarques sur l'histoire des salaires au XIXe siècle," *Le Mouvement Social*, April–June, 1968.

Rozier, V. *Les Bals publics à Paris*. Paris, 1855.

Rubin, J. H. *Eighteenth Century French Life Drawing*. Princeton, 1977.

Ruprich-Robert, V. M. C. "Cours de composition d'ornement à l'Ecole Impériale et Spéciale de Dessin," *Revue Générale de l'Architecture et des Travaux Publics*, 11, 1853, cols. 241–46, 387–92.

Saint Chéron. "De la décadence de l'Ecole des Beaux-Arts," *L'Artiste*, ser. 1, 8, 1834, pp. 69 ff.

de Salelles, C. A. *Le Groupe de la Danse de M. Carpeaux jugé au point de vue de la morale; ou Essai sur la façade du nouvel Opéra*, Paris, 1869.

Salmson, J. *Entre deux coups de ciseau: Souvenirs d'un sculpteur.* Geneva, 1892.

Sarradin, E. *Carpeaux.* Paris, 1927.

de Sault, C. *Le Salon de 1863.* Paris, 1863.

Schapiro, M. "On some Problems in the Semiotics of Visual Art: Field and Vehicle in Image-Signs," *Semiotica*, 1, no. 3, 1969, pp. 223–42.

Schneider, R. *Quatremère de Quincy et son intervention dans les arts, 1788–1830.* Paris, 1911.

Schommer, P. "Un carnet de Carpeaux au Cabinet des dessins," *Bulletin des Musées de France*, 1948, pp. 29–33.

——. "Les Dessins de Carpeaux," *Médecine de France*, no. 72, 1956, pp. 17–27.

Silvestre, T. *Histoire des artistes vivants.* Paris, 1856.

——. *Les Artistes français.* 2 vols. Paris, 1926.

Soulié, E. *Notice du Musée Impérial de Versailles.* Paris, 1859.

Stanford University. *Rodin and Balzac.* Exh. Cat. Palo Alto, 1973.

Steinhauser, M. *Die Architektur der Pariser Oper.* Munich, 1969.

Stowe, H. B. *Souvenirs heureux: Voyage en Angleterre, en France et en Suisse.* Transl. E. Fourcade. 4 vols. Paris, 1857.

Stranahan, C. *A History of French Painting from its Earliest to its Latest Practice; including an account of the French Academy of Painting.* New York, 1888.

Terrier, M. "Deux Bustes inconnus par François Rude," *Bulletin de l'Art Français*, 1932, pp. 100–08.

——. "Lettre de Thiers, Ministre des Travaux Publics commandant à Rude le trophée de l'Arc de Triomphe: 1792; ou, Le Départ des Volontaires," *BSHAF*, 1932, pp. 102–03.

——. "Carpeaux à Compiègne," *Bulletin de la Société Historique de Compiègne*, 25, 1960, pp. 199–208.

Texier, E. *Tableaux de Paris.* Paris, 1853.

Thompson, J. M. *Louis Napoleon and the Second Empire.* New York, 1955.

Thoré, T. *Dictionnaire du phrénologie et de physiognomie.* Paris, 1836.

——. "Etudes sur la sculpture française depuis la Renaissance," *Revue de Paris*, n.s., 26, 1836, pp. 231 ff.

——. "L'Ecole des Beaux-Arts," *L'Artiste*, ser. 2, 1838, pp. 220–22, 305–07.

——. *Salons de T. Thoré 1844, 1845, 1846, 1847, 1848.* Paris, 1868.

——. *Salons de W. Bürger.* 2 vols. Paris, 1870.

——, ed. *Bulletin de l'Alliance des Arts.* Paris, 1842–48.

de Tolnay, C. "Michelange dans son atelier par Delacroix," *GBA*, ser. 6, 59, 1962, pp. 43–52.

Tortébat, F. *Nouveau Traité d'anatomie.* Paris, 1826.

Touchard, J. *La Gloire de Béranger.* 2 vols. Paris, 1968.

Tourneux, M. *Salons et expositions d'art à Paris, 1801–1870.* Paris, 1919.

Tudesq, A. "La Légende Napoléonnienne en France en 1848," *Revue Historique*, 218, September, 1957, pp. 64–85.

Vachon, M. *W. Bouguereau.* Paris, 1900.

Valenciennes, Musée des Beaux-Arts. *Catalogue de l'Exposition du Centenaire de Carpeaux.* Valenciennes, 1927.

——. *La Jeunesse de Carpeaux.* Valenciennes, 1954.

——. *Dessins de Jean-Baptiste Carpeaux à Valenciennes.* Valenciennes, 1975.

——. *Catalogue des peintures et sculptures de Jean-Baptiste Carpeaux à Valenciennes.* Valenciennes, 1978.

Van Péteghem, L. J. *Histoire de l'enseignement du dessin, depuis le commencement du monde jusqu'à nos jours,* Brussels, 1868.

Vapéreau, G. *Dictionnaire universel des contemporains,* 2 vols. Paris, 1858.

Varenne, G. "Le Monument de Watteau et le fronton de l'Hôtel de Ville de Valenciennes," *L'Art*, 9, 1907, pp. 97–111.

——. "Carpeaux à l'Ecole de Rome: et la genèse d'Ugolin," *Mercure de France*, 1908, pp. 577–93.

Vattier, G. *Augustin Dumont: Notes sur sa famille, sa vie et ses ouvrages.* Paris, 1885.

Vermersch, E. "Les Deux Pudeurs," *Le Hanneton*, April 25, 1867.

——. *Le Grand Testament du sieur Vermersch.* Paris, 1868.

Vermot, H. "Distribution des Prix: Ecole Royale de Dessin," *L'Artiste*, ser. 4, 7, 1846, pp. 156–57.

Veuillot, L. *Le Parfum de Rome.* 2 vols. Paris, 1862.

——. *Les Odeurs de Paris.* Paris, 1867.

Viardot, L. "Beaux-Arts. Exposition des ouvrages de l'Ecole Gratuite de Dessin, suivant la méthode de M. Alexandre Dupuis," *Le Siècle*, October 4, 1837.

——. *Les Musées d'Italie : Guide et memento de l'artiste et du voyageur*. Paris, 1859.

Vidalenc, J. *La Société française de 1815 à 1848*. 2 vols. Paris, 1970, 1973.

Viltart, L. "Les Pères de l'Eglise: Statues en pierre par Carpeaux," *L'Art*, 21, 1880, pp. 73–76.

——. "Une oeuvre inconnue de Carpeaux," *L'Art*, 57, 1894, pp. 32–33.

Vinet, E. *Catalogue méthodique de la bibliothèque de l'Ecole Nationale des Beaux-Arts*. Paris, 1873.

Viollet-le-Duc, E. "Un cours de dessin," *L'Artiste*, n.s., 5, 1858, pp. 154–56.

——. *Lettres d'Italie, 1836–37, adressées à sa famille*. Paris, 1971.

Vitet, L. "La Salle des Prix à l'Ecole des Beaux-Arts," *Revue des Deux Mondes*, ser. 4, 28, 1841, pp. 937–54.

——. "De l'enseignement du dessin en France," *Revue des Deux Mondes*, November 1, 1864, pp. 74–107.

Vitry, P. "Une lettre de David d'Angers à son Maître Roland (1812)," *BSHAF*, 1929, pp. 108–11.

——. "Documents inédits sur Rude," *BSHAF*, 1929, pp. 30–42.

——. "Liste des bustes d'artistes commandés pour la Grande Galerie et les Salles de peinture du Louvre," *BSHAF*, 1930, pp. 137–41.

——. "Les Dessins de Rude du Musée de Dijon," *GBA*, ser. 6, 4, 1930, pp. 113–27.

——. "Le Thesée de Rude," *Bulletin des Musées*, 1932, pp. 166 ff.

——. *La Danse de Carpeaux* (Séries documentaire de l'Art Alpina). Paris, 1938.

Wagner, A. M. "An Unknown Funerary Relief by Jean-Baptiste Carpeaux," *Burlington Magazine*, 121, no. 920, 1979, pp. 725–27.

——. "Learning to Sculpt: J.-B. Carpeaux, 1840–1863." Ph.D. dissertation, Harvard University, 1980.

——. "Art and Property: Carpeaux's Portraits of the Prince Impérial," *Art History*, 5, no. 4, December, 1982, pp. 447–71.

Washington, D.C., National Gallery of Art. *John Gadsby Chapman, Painter and Illustrator*. Washington, 1962–63.

——. *Rodin Rediscovered*. Ed. A. Elsen. Washington, 1982.

Wasserman, J., ed. *Metamorphoses in Nineteenth Century Sculpture*. Cambridge, Mass., 1975.

Weinshenker, B. A. *Falconet: His Writings and his Friend Diderot*. Geneva, 1966.

White, H. C. and C. A. *Canvases and Careers: Institutional Change in the French Painting World*. New York, 1965.

Whiteside, J. *Italy in the Nineteenth Century*. 3 vols. London, 1848.

Williams, R. *Marxism and Literature*. Oxford, 1977.

Zeldin, T. *The Political System of Napoleon III*. London, 1958.

——. *Emile Ollivier and the Liberal Empire*. Oxford, 1963.

——. *France, 1848–1945*. 2 vols. Oxford, 1973 and 1977.

Zola, E. *Oeuvres complètes*. Ed. H. Mitterand. 15 vols. Paris, 1966–70.

——. *Mon Salon, Manet : Ecrits sur l'art*. Paris, 1970.

INDEX

Figure numbers are italicized

Aaron, Michel, 10, 180, 203
Abd el-Kader, 186–87
About, Edmond, 115, 149
 on *Jeune Pêcheur*, 146
 on *Prince Impérial*, 197–98
Académie de France, Rome. *See* Villa Medici
Académie de Peinture, Sculpture et Architecture,
 Valenciennes, 30, 62
 art and industry at, 44–46
 art teaching at, 43–46
 history of, 42–47
Académie des Beaux-Arts, Paris, 39–41, 64–65, 111, 116,
 294n.136
 taught a fixed sculptural code, 119–27
Académie Royale d'Anvers, 46
Action française, L', 259
Almanach du Commerce, 8
Art and Industry, 62
 at Académie, Valenciennes, 44–46
 at Ecole Gratuite, 47
 Ingres on, 41–42
Art establishment
 opposition to, 17
Art Journal, 5
Artiste, L', 17, 21, 93, 101, 300n.87
Assemblée Nationale, 231
Aubin, 57
Auvray, Louis, 69, 197
 on *Prince Impérial*, 195–96

Bachelier, Jean-Jacques (first director of Ecole Gratuite),
 47–48
Bal Mabille, 237, 254
Ballu, Théodore, 217
Baltard, Victor, 202
Barbedienne, Ferdinand, 182, 183, 199–200, 203
 and the bronze workers strike, 201, 299n.79
Barberet, J.
 Le Travail en France, 299n.79
Barnet, Louis, 141–43
Barye, Antoine-Louis, 17, 20, 22
Baudelaire, Charles, 21, 71
 Salon of 1846, 19
Baudry, Paul, 238
Beauvin, C., 196
Belloc, Jean-Hilaire (director of Ecole Gratuite), 48–52,
 57–59, 283n.81
Belloc, Louise (née Swanton), 48–49

Belvedere Torso, 118, 132, 161
Benjamin, Walter, 185
Benouville, Léon, 139
Béranger, Pierre-Jean, 49
Bernaërts, Bernard (Carpeaux's *practicien*), 199
Bernard, Jean-Baptiste (teacher at Académie, Valenciennes),
 43, 44–45, 53, 61, 282n.53
Bernini, Gian Lorenzo, 96
 Pluto and Persephone, 251, 253
Bertall
 caricature of *Ugolin et ses fils*, 173, 173
Berthélémy, Raymond
 Oreste se refugiant à l'autel de Minerve, 122, 104
Beulé, Charles, 132
Bibliothèque Royale, 39
Bizet, Georges, 114
Blanc, Charles, 3, 6–7, 9, 17, 31, 196, 257
Blum, Ernest (biographer of Rigolboche), 254, 255
Boisbaudran, Horace Lecoq de (teacher at Ecole Gratuite),
 38–39, 50, 51
Bologna, Giovanni
 La Fiorentina, 153–55
Bonaparte, Mathilde (Princess), 205, 207
Bonaparte, Napoléon-Eugène-Louis-Jean-Joseph (Prince
 Imperial), 175, 185, 191–94, 206
 opened Exposition Universelle (1867), 201
Bonnardel, Pierre, 115
Bonnassieux, Jean-Marie, 127–28
 David tendant la fronde, 119, 100
Bonnes Soirées
 cartoon series on Carpeaux's life in (1957), 6, 5
Bonnet, Guillaume
 L'Attention, 87, 76
Borel, Petrus, 118
Bosio, François-Joseph
 Henri IV enfant, 190, 192, 193, 196, 197, 192
Bouilhet, Henri, 201
Bracq (Mayor of Valenciennes), 294n.136
Brian, Jean-Louis, 15
Burty, Philippe, 1, 2
 on Joseph Soumy, 292n.105

Caffieri, Jean-Jacques, 258
Camp, Maxime du, 129, 196
 on the Exposition Universelle (1855), 20–21, 23–24
Canova, Antonio, 96
Capellaro, Charles (Carpeaux's *practicien*), 56
Capitoline Museum, Rome, 128
Carlier (Mayor of Valenciennes), 45–46
Carpeaux, Amélie (née Montfort), 206, 262, 296n.10

Carpeaux, Emile (brother of Carpeaux)
 atelier supervisor for Carpeaux, 183
 undertook marketing of *Prince Impérial*, 200
 dismissed for mismanaging Carpeaux's affairs, 203
CARPEAUX, JEAN-BAPTISTE
 class origin, 1–4
 at Académie, Valenciennes, 30, 42
 at Ecole Gratuite, 52, 55, 56
 first decorative commission, 60–62, *42–44*
 at Ecole des Beaux-Arts, 63–64, 84
 his work with Rude, 67, 70–71
 his work with Duret, 67–68, 80–81, 82–83, 98
 importance of anatomy to, 82, 103–05, 166, 170, 173–74
 his opinions on methods of learning art, 67–69, 70, 94,
 98–100
 competitions at Ecole des Beaux-Arts, 84, 88–89
 Prix de Rome, 91–93
 at the Villa Medici, 109–10, 133–38, 140–43, 158,
 292n.108, *159*
 importance of Michelangelo to, 136, 150–53, 156–57
 his commercialization of art, 20, 180–85, 199, 201–03,
 206–07
 relations with Imperial family, 175, 180, 185–88, 192–94,
 196–97, 199, 203–04, 207, 247–49
 Opéra commission, 216, 223–24, 227–29, 244–46, 253–54
 accused of gross immorality, 237–39, 246–47, 254, 255–56
 opens his atelier at Auteuil, 180, 183–84, 206, 296n.10,
 180–82
 photographs of, *Frontispiece, 1*
 portraits of, 1–3, 11–13, *9–13*
 his relation to French sculptural tradition, 4–6, 180, 195,
 249, 257–66, 270–71
 critical reputation, 4–5, 183, 257–60
 his death, 4
 Carpeaux sur son lit de mort, 3
 Les Funérailles de Carpeaux à Valenciennes, 4
 La maison mortuaire de Carpeaux, 2
CARPEAUX, JEAN-BAPTISTE: works
 Achille blessé au talon, 63, 103, *47*
 after Maréchal's *La Mort d'Epaminondas*, 101, *91*
 after Chapu's *Le Départ d'Ulysse, 86*
 after Duret's *Molière, 58*
 after Duret's *Venus, 60*
 after Duret's *Christ, 62*
 Autoportrait, 13, *9*
 Coriolan chez Tullus, 88–89, 95, *77*
 La Danse, 5, 13, 209, 214, 216–17, 223–24, 227, 229–31,
 234–35, 254–56, 257–58, 260, 262, 304n.61, *206, 208–11,*
 239, 252
 antecedents of, 250–51
 caricaturists' reactions to, 236
 clashed with accepted ideas of sculpture, 251–53
 critics' responses to, 236–44
 decorative nature of, 215, 224
 development of, 249–50
 male and female in, 239, 250–51
 realism of, 237, 251
 scandal surrounding, 210–13
 sex and morality in, 236–44, 246–47
 vandalized, 212–13, 245, *212–13, 240*
 Génie de la Danse, 239, 250–51
 La Danse: sketch, 250, *249*
 Le Docteur Achille Flaubert, 270, *264–65*
 Le Docteur Batailhé, 270, *263*
 Le Drame lyrique et la Comédie légère, 229
 L'Empereur reçoit Abd el-Kader au palais de Saint Cloud,
 105, 110, 186–88, 262, *185*
 L'Espérance, 183
 L'Espiègle, 183

Etude pour la Danse, 250, *248*
Five Dancing Female Figures, 250, *247*
Flore (pavillion of), 183, 195, 203, 257
Génie de la Marine, 105
Head of a Woman, 137, *118*
Hector et son fils Astyanax, 93, 95, 102–05, *93–94*
L'Impératrice Eugénie protégeant les orphelins et les arts,
 187–88, *186*
Jean-Léon Gérôme, 262, 265, 266, 270, *258*
Jeune Pêcheur à la coquille, 133, 153, 172, 182–84, 203, 257,
 292nn.101, 102, *132–33, 140*
 financial benefits from, 149
 contemporary treatments of the theme, 146
 originality of, 149–50
 starts work on, 143–46
Mlle Fiocre, 184, *258*
Modestie, 183
Napoléon III, 183
Page from a Notebook, 55, *34*
Palombella, 183
Philoctète à Lemnos, 103, *97*
Philoctète à Lemnos (sketch), 82, *69–70*
Pifferari, 141, *125*
Plusieurs croquis pour la Danse, 249, *245*
Portrait of Alphonse Roussel, 151, *142*
Le Prince Impérial, 180, 182, 188, 190, 195–96, 198, 201,
 204–05, 247, 300n.87
 artistic choices in production of, 188–90
 broke the conventions of Imperial sculpture, 194–95
 commercially exploited, 175–80
 commission awarded, 175
 comparison with Winterhalter's *Prince of Wales*, 192–93
 critical reaction to, 196–99
 public indifference to, 195–96
 techniques used on, 193
 bust version, 175, *179*
 Sèvres version, 205, *205*
 Le Prince Impérial en uniforme des Grenadiers de la Garde,
 203, *204*
 Le Prince Impérial et son chien Néro, 175, *175–78*
 Le Prince Impérial et son chien Néro (silvered bronze
 version), 203, *202*
 Le Prince Impérial et son chien Néro (sketch model), 189,
 189–90
 Prince Impérial au chapeau, 203
 Proportions de la statue du Prince Impérial, *201*
Princess Mathilde, 172, 207
Projet d'un bas relief cintré, 160, *160*
Projet pour la maquette avec le socle, 271, *266*
Quatre Parties du monde soutenant la sphere (Observatoire
 fountain), 262–70, *259–60*
Les Quatre Saisons, 61, *44*
 l'Automne et l'Hiver, 43
 le Printemps et l'Eté, 42
Reclining Figures in Lunettes, 160, *161*
Rieur, 203
Rieuse, 203
La Sainte Alliance des Peuples, 186, *184*
Scene in a Tavern, 141–43, *128*
sketch after Duret's *La Douleur d'Evandre, 80*
sketch after Gruyère's *Serment des sept chefs, 84*
Sketches of Concours Sculpture, 63, *45*
Sketches of Three Female Figures, 249, *246*
Studies after Michelangelo and for Ugolin, *I*
Studies for Bas-reliefs, 185, *183*
Studies in a notebook used in Rome and Florence,
 153–56, *144–56*
Studies of Italian Peasants, 141, *126*
Study after Rude's "Le Départ des Volontaires," 251, *251*

Study for "Hector et son fils Astyanax," 103, 96
Study for Ugolino, 160, 163
Study of a Dancer, 251, 254
Study of a Man, Woman, and Dogs, 143, 130
Study of a Seated Boy, 138, 123
Study of a Singer, 143, 129
Study of an Opéra Group, 230
Study of Classical Statuary, 187
Study of La Musique, 227
Study of Le Drame lyrique, 228
Study of the central group for the Abd el-Kader relief, 188, 188
Study of Women and Children, 143, 131
La Tempérance, 217
Tête de faune, d'après Michelange, 151, 143
Tuérie des Porcs, 141, 127
Ugolin et ses fils, 110–11, 113, 133, 153, 182, 230, 247, 251,
 257, 262, 294n.136, 167–71, II, III
 academic reactions to, 169–70
 caricaturists' impressions of, 158, 173, 159, 172–73
 critics avoided mentioning the subject of, 172–73
 critics saw over-exaggerated anatomy in, 173–74
 development of artistic intelligibility in, 160–61
 discovery of the composition of, 157–61
 experienced difficulties in completing, 158
 gained fame for, 166–69
 importance of anatomical fidelity in, 166
 initially conceived as a bas-relief, 160, 160–63
 narrative structure of, 165–66
 Ugolin et ses fils (terra cotta), 161, 166
Ugolin rampant sur les corps de ses enfants, 160, 162
Vase statuettes, 56, 37
Watteau, 258
Carpezat, François-Louis, 56–57, 284n.100
Carrier-Belleuse, Albert, 10, 66, 184
Caso, Jacques de, 180, 296n.10
Cavé, Mme Marie Elisabeth
 Le Dessin sans maître, 38–39
Cavelier, Pierre-Jules, 114, 133, 216, 227, 301n.12
 La Contemplation céleste, 87, 71–72
 La Verité, 23–24, 27, 17
Cavour, Count (Camillo Benso), 146
Cham
 caricature of Ugolin et ses fils, 173, 172
 caricature of Préault's Hecuba, 174, 174
 "C'est Splendide!" 215, 214
 "Ne les regarde donc pas!" 234
 "Tiens, mon ami," 236
Chambard, Louis
 Oreste poursuivi par les Furies, 120–22, 103
Chapman, John G.
 Pifferari playing before a Shrine of the Virgin, 140–41, 124
Chapu, Henri, 56, 62, 123–27, 128–29, 138, 195, 301n.12
 Le Christ mort aux anges, 123–24, 105
 Cleobis and Biton, 123
 Le Départ d'Ulysse et Pénélope, 85
 Etude de modèle, 138, 122
 Etude pour la pose de l'ange, 106
 Head of a Man, 137, 117
 Mercure inventant le caducée, 127, 109
 Study of the Artist's Bedroom at the Villa Medici, 115, 99
 Tige florale, 56, 36
 Tige vegétale, 56, 35
 Triptolème or Le Semeur, 125–26, 108
 Two Studies of an Italian Woman, 137–38, 119
Charivari, Le
 on La Danse, 232, 304n.61
Charton, Edouard
 Guide pour le choix d'un état ; ou, Dictionnaire des professions,
 8–9

Chatillon, Henri Guillaume
 Académie d'une femme in Cours, 26
 Cours élémentaire de dessin, 34, 35, 44
Chaumelin, Maurice
 on La Danse, 239
Chennevières, Marquis Philippe de, 257, 258
 funeral oration for Carpeaux, 4–5
Chérier, Bruno, 63, 259, 271
 J.-B. Carpeaux dans l'atelier de Chérier, 13, 12
Chicard, 254
Chifflart, François-Nicolas, 115
Christofle, Charles, 201–02, 207
Christofle, Paul, 201
Christofle et Cie.
 display at Exposition Universelle (1867), 201, 203
Christophe, Ernest, 81
 La Douleur, 23–24, 18
Chronique des arts et de la curiosité, 247
Cité des Italiens, 58, 38–41
Clément-Carpeaux, Louise (Carpeaux's daughter), 290n.78,
 296n.10
Clésinger, Auguste, 184
 Les Enfants de M. le Marquis de Las Marismas, 194, 196
 Femme piquée par un serpent, 16, 26–27, 20
 Hercule enfant, 194, 195
Clodion (Claude Michel), 251
Clodoche, 237
Commission des Beaux-Arts, 301n.12
Commune, Paris, 194, 242
Conseil d'Administration, 84
Conte, Emile le
 L'Album de l'ornemaniste, 44
Continental Gazette
 on La Danse, 235
Corboz, Jules, 220–21, 254
Correspondant, Le, 172,
 on La Danse, 236
Courbet, Gustave, 194, 238, 240, 244
 Le Sculpteur, 11, 7
 La Source, 239, 238
Courmont, Victor (Chef de la Division des Beaux-Arts),
 294n.136
Cours de dessin, 38, 62
 encouraged a uniform style, 35–37
Courtet, Augustin
 La Danse Ionnienne, 246, 243
Couvent des Petits Augustins, 95
Crauk, Gustave, 63–64, 301n.12
Cugnot, Léon
 Mézence blessé, 100–01, 98

Dalou, Jules, 52, 56
 Caryatids: The Four Continents, 266, 262
Dance
 nature of popular, 254–55
Dantan, Antoine-Laurent, 218
Dante, 169, 172, 173
 The Divine Comedy, 158, 161–65, 166
David, François-Anne
 Elémens du dessin, 32–34
 Introductory lesson, engraving from Elémens, 33, 21
 Mercure, engraving from Elémens, 33, 22
David, Pierre-Jean (called David d'Angers), 16, 19, 21, 49,
 66–67, 68, 69, 85, 91, 94, 285n.11, 286n.25
 Aux Grands Hommes La Patrie Reconnaissante, 22, 15
 La Mort d'Epaminondas, 102, 92
Davioud, Gabriel, 52, 56
Debaisieux, 10
Debret, François

started renovation of Palais (Musée) des Etudes, 95
Decamps, Alexandre-Gabriel, 21
Degas, Edgar, 126, 138, 290n.58
Delaborde, Henri
 defended Villa Medici, 258
Delacroix, Eugène, 21, 38, 40, 82
 Michelange dans son atelier, 11, *8*
Delécluze, E. J., 102–03
Delmaet and Durandelle (photographers of Nouvel Opéra),
 220, 231–33, *216–18*
Dépôt des Marbres, 199
Desachey, 205
Dibutades
 legend of, 32
Dickens, Charles, 235
Dimier, Louis, 260
 "Carpeaux," 258–59
Donatello
 St. George, 153–55
Doublemard, Amédée-Donatien, 123
 Hector et son fils Astyanax, 102–03, *95*
Drawing
 and industry, 41–42, 58–59
 Dibutades, legend of, 32
 Flaubert's definition of, 31
 nineteenth-century attitudes to, 31
 Académie des Beaux-Arts and Ministère de l'Intérieur
 interested in, 39–41
Drawing instruction
 importance of *cours de dessin* in nineteenth century, 34–37
 loi Fortoul, 281n.37
 methods dominant in mid-nineteenth century, 30, 32–36
 schools provided students with an image of their social
 role, 52–54
Drolling, Martin, 85
Duban, Felix (Inspecteur Général des Bâtiments Civils), 98,
 221–22
 renovated the Palais (Musée) des Etudes, 95–96
Dubois, 301n.12
Dubourdier, 57
Dumas, Alexandre, 184
Dumesnil, Georges
 on the *Ugolin*, 172
Dumont, Augustin, 68, 69, 76, 92
Duparc, Arthur
 on *La Danse*, 236–37
Dupuis, A., 38
Duret, Francisque, 3, 68, 71, 92
 advice to Chapu, 125
 at Villa Medici, 115
 Carpeaux's choice as teacher, 67–68
 comparison with Rude, 76–80, 83
 reputation based on early successes, 80
 teaching emphasized knowledge of anatomy, 82–83
 technique of working, 81–82
 ceiling of the Salle des Sept Cheminées, *63*
 Chateaubriand, *64*
 Chateaubriand (terra cotta), *66*
 Christ se révélant au monde, *61*
 La Douleur d'Evandre sur le corps de Pallas, *79*
 Jeune Pêcheur dansant la tarantelle, 77, 146, *52*, *55*
 Mercure inventant la lyre, 77, 127, *51*
 Molière, *57*
 Study for Chateaubriand, *65*
 Venus au milieu des roseaux, *59*
Dyce, William
 on political role of art tuition, 52–53
 studied schools of design on Continent for Houses of
 Parliament, 46, 52

Eclipse, L', 240, 242, 245
Ecole de Dessin, Dijon, 74
Ecole de Dessin, Rouen, 46
Ecole des Beaux-Arts, Lyons, 46
Ecole des Beaux-Arts, Paris, 6, 43, 44, 51, 66–71, 113, 217,
 294n.136
 admission tests for, 84–85
 art and industry at, 66, 106–08
 competitions at, 63–64, 84, 86–89, 95
 enrollment in an atelier at, 67–69, 285n.11
 principles of study incorporated into design of, 95–98
 taught academic style, 94–95, 100–01, 108
 teaching methods at, 67–69, 85–86
Ecole Gratuite de Dessin, Paris, 3, 6, 30, 31, 43, 62
 achievements of pupils at, 57–59
 beginners' class at, in *L'Illustration*, *31*
 changes in drawing instruction at, 37–38
 class in drawing and modelling at, in *L'Illustration*, *32*
 Comité d'Enseignement, 52
 entrance to the Rotunda at, in *L'Illustration*, *30*
 history of, 47–52
 importance in changing attitudes to art teaching of, 46–47
 modelling from figures etc. at, in *L'Illustration*, *33*
Electeur Libre, L'
 on *La Danse*, 232
Elschoecht, Carl, 68
Eméric-David, T.-B.
 Recherches sur l'art statuaire, 286n.25
Etex, Antoine, 17, 38–39, 68
 on the career of sculpting, 8–9
 Génie du XIXème siècle, 19
 La Résistance, 132, *114*
Eugénie (Empress, née de Montijo, consort of Napoleon
 III), 175, 189, 192
Evénement Illustré, L', 27–28
Exposition Universelle (1855), 20–21, 23
Exposition Unverselle (1867), 201
Exposition Universelle (1878), 206
 Salle des Ceramiques, 180, *180*

Falconet, Etienne-Maurice, 19
Falguière, Alexandre
 J.-B. Carpeaux, 13, *11*
 won Grand Prix with *Mézence blessé*, 100–01, 108, *87*
Faure, Amédée (Professeur du Dessin des Plantes, Ecole
 Gratuite)
 proposed changes in methods of drawing instruction, 37–38
Feuchère, Jean-Jacques
 Satan, 74, *50*
Fieuzal, Léonce de, 43
Fifine (a dancer), 237
Figaro, Le, 240, 242
Finette (a dancer)
 photograph of, 255, *257*
Fiocre, Eugénie, 184, 206
Flageolet (a dancer), 237
Flaubert, Gustave, 31, 113, 256
Flaxman, John,
 Dante, 151, 292n.108
 Ugolino and his Sons, 160, *164*
Forbin, Comte de (Directeur des Musées Royaux), 98
Foucart, Jean-Baptiste, 186
 analysis of Carpeaux's move from Rude to Duret, 70
 memories of Carpeaux, 29, 260
 role in Carpeaux's education, 70
Foucart, Mme, 136, 143
Foucart, Paul, 260
Fouquet, 57
Franceschi, Jules

Jeune Garçon, 195, *197*
Fraternité, La, 240
Frémiet, Emmanuel, 21
Friedrich, Caspar David, 11
Frison, Barthélémy
 Le Pêcheur des coquillages, 146, *136*
Fromentin, Edouard (biographer of Carpeaux), 55

Garnier, Charles, 3, 52, 54–56, 62, 217–21, 226, 245, 249,
 251, 302n.20
 and *La Danse*, 226–27, 244–46
 commissioned sculpture for Opéra, 216–17, 224–29
 commissioned to design Opéra, 215–16
 design of Opéra, 221–22, 223
 rejected Guméry's *La Danse*, 246
 A travers les arts, 222–23
 Nouvel Opéra de Paris, 209, *207*
 Preliminary Project for the Facade of the Opéra, 221, *219*
 *Preliminary Project for the Right Pavillion of the Opéra
 Facade*, 221, *220*
 Scheme for an Opéra Group, full face, 224, *225*
 Scheme for an Opéra Group, profile, 224, *226*
Gaume, l'Abbé Jean Joseph, 304n.61
Gautier, Théophile, 18, 19, 93, 251
 on Chapu's *Triptolème*, 126–27
 on *Prince Impérial*, 196–97
 sculptors as martyrs to their art, 16
Gazette des Beaux-Arts, 5, 149, 172, 292n.105
Germain, Gault de St (teacher at Ecole Gratuite), 50
Gérôme, Jean-Léon, 141, 184
 Carpeaux's portrait of, 184, 265, 266, 270, *258*
Gilbert
 "Ah! ma fille . . . !" *235*
 "La furia de la danse," *237*
 "Les sculpteurs remplaçant le marbre par le charbon de
 terre . . .," 247, *244*
Gill
 "L'Accident Carpeaux" in *L'Eclipse*, 245, *241*
Giotto, 222
Girardron, François, 96
Godefroi, Florimond, 61
Gombrich, Ernst, 223
Goncourt, Edmond de and Jules de, 1–2, 3, 4, 9, 10, 257,
 292n.105
Goujon, Jean, 96, 258
Gounod, Charles, 184
Grandfils, Laurent Severin (teacher at Academie,
 Valenciennes), 43
Grevenich, François Alfred
 La Pudeur, 87, *73*
Gros, Jean-Antoine, Baron
 Napoleon at the Pest House of Jaffa, 187
"Groupe de Carpeaux, Le" (song about *La Danse*), 242
Gruyère, Théodore
 Serment de sept chefs devant Thèbes, *83*
Guillaume, Eugène, 34, 224, 238, 250, 301n.12
 commissioned to produce a statue for Opéra, 216
 comparison of *La Musique instrumentale* with *La Danse*,
 229–30
 initial design for Opéra sculpture, 226, 227
 Anacréon, 119–20, 130, *101*
 La Musique instrumentale, 223, *V*
Guillot, Arthur, 93
Guitton, Gaston, 81
Guizot, François, 43
Guméry, Charles
 commissioned to produce a replacement for *La Danse*,
 246, *242*
 Achille blessé au talon, 64, *46*

Halévy, Fromenthal, 132
Hanneton, Le, 240
Haussmann, Georges Baron, 202
Hébert, Ernest, 128
Hébert, Pierre
 Enfant jouant avec une tortue, 146, *135*
Hegel, Georg Wilhelm Friedrich, 271
Heim, François-Joseph, 85
Herr (teacher at Ecole Gratuite), 50
Hildebrand, Adolf von, 166
Hittorff, Jacques, 80
Hollande, Louis
 awarded Carpeaux his first commission, 61
Hôtel de Ville, Paris, 300n.87, 301n.12
Houdon, Jean-Antoine, 115, 258
Houguenarde, 220–21, 254
Hugo, Victor, 240
 condemned state art support system, 17
Husson, Honoré-Jean-Aristide, 69

Idrac, Jean-Antoine
 Mater Dolorosa, 87, *75*
Illustration, L', 18, 49, 64, 246
Ingres, Jean-Auguste-Dominique, 21, 62, 85, 119, 121
 at Villa Medici, 116, 127–28
 on drawing, 31
 objected to combining art and industry, 41–42
Italy
 as symbol of exoticism for artists, 146–49
Itasse, Adolphe
 Jean-Hilaire Belloc, *29*

Jacotot, Joseph
 developed a theory of self-help through education, 70
Jacquot (teacher at Ecole Gratuite), 50
James, Henry, 28, 47, 183
 importance of Carpeaux's work, 5
 on the Villa Medici, 112, 115
Janson, H. W., 251
Jäy (teacher at Ecole Gratuite), 50
Jerichau, Jens-Adolf, 139
Jouffroy, François, 68, 118, 224, 250
 commissioned to produce a statue for Opéra, 216
 comparison of *L'Harmonie* with *La Danse*, 229–30
 initial design for Opéra sculpture, 226, 227
 L'Harmonie, 222
 pediment of Institution des Jeunes Aveugles, 22, *16*
Journal des Artistes, 17
Julien, Bernard-Romain
 produced a *cours de dessin*, 35, 44
 Studies of Eyes, *23*

Khalil Bey, 244
Klagman, Jules
 Enfant jouant avec des coquillages, 146, *134*

La Comète (a dancer), 237
La Normande (a dancer), 237
Laborde, Léon de
 urged curricular changes at Ecole des Beaux-Arts, 106
 Lachèvre brothers, 57
 Lafenestre, Georges
 on *La Danse*, 238
 on the *Ugolin*, 172
Lamy, Cyrille (Carpeaux's atelier supervisor), 183
Laocoön, 157, 161, 169
Larousse, Pierre
 on expenses for sculptor, 9
 on the nature of popular dance, 254–55

Lasteyrie, Ferdinand de
 on relative importance of male and female in *La Danse*,
 239
Laureau, 205
Laurent, 57
Laurent-Daragon, Charles (Carpeaux's *practicien*), 56,
 292n.102
Lavigne, Hubert
 La Mort d'Epaminondas, 101, *90*
Legrand, Maximin
 "François Rude, sa vie, ses oeuvres, son ensiegnement,"
 72–73, *48*
Lemaire, Henri, 17, 43–44, 68, 92
 La Douleur de l'âme, 87, *74*
 Froissart, 82, *67*
Lemaire, T. (architect), 57–58, *38–41*
Lequien
 ran drawing school for the bronze industry, 41–42
Levitsky
 photograph of Imperial family, *191*
Lévy, Emile, 292n.102
Lhermitte, Léon, 52
Liberté, La, 17
Liet, Victor, 70
Littré, Emile, 240
Loubens, 118

Mahoudeau (sculptor in Zola's *L'Oeuvre*), 15
 possibly based on Carpeaux, 16
Maignan, Albert
 Sketch for *Carpeaux – "A l'artiste mourant les Etres nés son
 Génie viennent donner le baiser d'adieu,"* 13, *13*
Maillard, George, 238
Maillet, Jacques, 301n.12
 Agrippina and Caligula, 130
 La Force, 217
Maindron, Hippolyte, 68
Maison Languereau, 218
Malitourne, Pierre, 93
Manet, Edouard, 238
 The Dead Christ with Angels, 124–25, *107*
Maniglier, Charles-Henri
 Pêcheur ajustant ses filets, 146, *139*
Mantz, Paul, 259, 270
 criticized Ecole des Beaux-Arts, 100–01
 on Carpeaux's artistic stature, 5
 on Jean-Léon Gérôme, 265, 270
 on *Jeune Pêcheur*, 149–50
 on Préault's *Hecuba*, 174
 on *Quatre Parties du monde*, 262–65
 on the *Ugolin*, 172
 reproduced sketches by Carpeaux, 30–31
Manufacture Impériale de Porcelaine, Sèvres
 reproduced *Prince Impérial*, 205–06
Marchi, Salvador, 20
Maréchal, Ambroise René
 La Mort d'Epaminondas, 101, *89*
Marianne (Republican song), 242
Marochetti, Charles, 16, 18
Marx, Karl
 The Eighteenth Brumaire of Louis Bonaparte, 244
Mercey, François de, 16, 292n.101
Mercey, Guy Lhomme de
 Le Démon du jour, 74–75, *49*
Mérimée, Prosper, 40
Merson, Olivier
 criticized sculpture teaching at Ecole des Beaux-Arts, 86
Meynier, Samuel (Carpeaux's atelier supervisor), 183–84
Michelangelo, 11, 96, 98, 125, 136–37, 155, 222, 231

 influence on Carpeaux, 150–53, 160
 Sistine *Adam*, 160
 Lorenzo de' Medici, 156–57, *157–58*
 Risen Christ, 251
Michelet, Jules, 49, 113, 240
Millet, Aimé, 216
Ministère de la Maison de l'Empereur et des Beaux-Arts,
 200–01, 216
Ministère de l'Intérieur, 39–41, 44, 45–46, 51, 66
Ministère des Beaux-Arts, 116, 128, 204, 226
Moine, Antonin, 20
 suicide of, 17
Molière, 245
Momal, Jacques-François, 43
Monde Illustré, Le
 on *La Danse*, 234
Moniteur Universel, 197, 231, 238
Monseux, Charles, 61
Montalivet, Camille (Ministre de l'Intérieur), 96
Montfort, Général Philogène de, 262
Moreau, Gustave, 138
Moreau, Mathurin, 301n.12
Mortry, Baron Pujol de
 founded Académie in Valenciennes, 42
Mouchy, Duc de, 205
Musée des Etudes. *See* Palais des Etudes
Musée des Monuments Français, 95

Nadar, 187
Nain Jaune, Le, 237
Nanteuil, Celéstin, 92, 118
Napoléon III (Charles-Louis-Napoléon Bonaparte), 16, 21,
 185, 186–87, 191, 194, 198, 203, 217, 221, 243, 247, 256,
 259, 302n.20
 attempted to construct a Bonapartist dynasty, 191–92,
 198, *199*
 influenced the production of copies of *Prince Impérial*,
 200–01
 photograph of, *191*
Nast, Gustave
 Pêcheur et son chien, 146, *137*
New York Daily Tribune, 5
Nieuwerkerke, Alfred-Emilien O'Hara, Comte de
 (Surintendant des Beaux-Arts), 16, 294n.136

Obscenity
 and sedition, 255–56
Opéra, Paris (Nouvel Opéra), 207, 216, 302n.20
 construction of, 217–21
 design of, 221–22, *219–20*
 facade of, 223, *IV*
 journalists' reactions to, 232–36
 photographs of, *207, 216–18, 231–33*
 relative importance of content and form in design of,
 229–30
 unveiling ceremonies at, 231–32
Opéra, Paris (rue le Pelletier), 217, *215*
Opinion Nationale, L', 239
Ottin, 114, 133, 301n.12
 at Villa Medici, 118–19, 128–29
Overbeck, Peter, 139
Ovid
 Metamorphoses, 229

Paillard, Victor, 180, 188, 201
Palais des Etudes (Ecole des Beaux-Arts), Paris, 95–98, *78*
Parent, Albert, 43
Paris Caprice, 240
Pasquarelli, Barbara, 290n.78

Patrie, La
on La Danse, 232
Peisse, Louis (Curator of Palais des Etudes), 96–98
Perdiguier, Agricol
drawing instruction and, 29–31
Peron (teacher at Ecole Gratuite), 50
Perraud, Jean-Joseph, 70, 132, 224, 250
Académie des Beaux-Arts approved of his work at Villa
Medici, 129–32
career, 129, 132
class background, 9
commissioned to produce a statue for Opéra, 216
initial design for Opéra sculpture, 226, 227
opinions of teachers at Ecole des Beaux-Arts, 69
Adam, 130–32, 112–13
Les Adieux, 129–30, 111
Le Drame lyrique, 224
Head of an Italian Woman, 138, 121
Soldat gaulois avant la domination romaine, 132, 116
Telémaque apportant à Phalante les cendres d'Hippias, 129,
110
Petipa, 226
Petit Journal, 192
Petite Ecole. See Ecole Gratuite de Dessin
Petitot, Louis-Messidor-Lebon, 69, 92
Pierino da Vinci
La Morte del Conte Ugolino, 160, 165
Pinard, Ernest, 256
Planche, Gustave
urged abolition of the Villa Medici, 113
Potier, Jules (teacher at Académie, Valenciennes), 43–44, 62
Praticien, 302n.20
relations with sculptors, 8–9, 220–21
Pradier, James, 16, 17, 20, 21, 68–69, 120, 141, 286n.25,
287n.55
Autoportrait, 11, 6
Le Duc d'Orléans, 82, 68
Préault, Auguste, 19, 160
suffered exclusion from Salon, 17
Guerrier Gaulois, 132, 115
Hecuba, 174
Ophelia, 125
La Tuérie, 24–26, 108, 19
Presse, La, 239
Prix de Rome
form of contest for, 89–91
rules for, 90–92
Prix Percier, 54
Proudhon, Pierre-Joseph, 240
Provençale, Alice la (a dancer)
photograph of, 255, 255
Puget, Pierre, 96
Pujol, Abel de, 68, 69

Quatremère de Quincy, Antoine Chrysostome
Vie de Michelange, 151
Quenot, J. P., 42

Racowitza, Hélène de
claimed she posed for the Génie de la Danse, 250
Rambuteau, Comte de, 53
on the importance of drawing, 31
Ramey, Etienne-Jules, 68, 69, 85
Raoul-Rochette, Désiré, 40–41
Raphael, 43, 222, 231
St. Michael, 250
Rapple, Le, 232, 296n.10
Republicanism
increase in left, 231

Réunion des Fabricants de Bronzes, 8, 41
Revue Générale d' Architecture
published statutes of Ecole Gratuite, 46
Revue Indépendante, La, 93
Rigolboche (a dancer, née Marguerite Badel), 237, 238,
254–55
photograph of, 255, 256
Rodin, Auguste, 19, 52, 56
Balzac, 210
Seated Ugolino, 271, 267–68
Rome
as a mecca for artists, 138–40
Rothschild, James de, 149, 292n.102
Rouillard, Pierre Louis, 57
Rouillet, Nicolas Amaranthe
Man Leaning on his Elbow, 39, 28
Procédé du Dessin pour faciliter l'Etude des arts 39–41
Standing Man, 39, 27
Roussäy, Comte G.
Simple esquisse d'un projet de plan pour la construction du grand
Opéra, 221, 221
Roussel, Alphonse
his friendship with Carpeaux, 151–52
Young Girl at a Fountain. Studied at Rome, 151
Rude, François, 21, 69, 81, 158, 231, 258, 285n.11, 286n.25
Carpeaux's opinions of, 67–68, 70–71
class background, 9–10
comparison with Duret, 76–80, 83
method of teaching, 71–75
pupils refused entry to Salon, 73–75
studio, 69–71
Le Départ des Volontaires en 1792, 74, 251, 250
Godefroy Cavignac, 125
Louis XIII, 190, 192–93, 196, 193
Mercure rattachant ses talonnières, 77, 53
Napoleon Reawakening to Immortality, 74
Petit Pêcheur napolitain, 77, 146, 54, 56
Ruprich-Robert, Victor-Marie-Charles (teacher at Ecole
Gratuite), 52

Sabatier, François, 29, 119, 260
Sainte-Beuve, Charles-Augustin, 240
Salelles, de
wrote a pamphlet attacking La Danse from moral point
of view, 244
Salmson, Jules, 10, 66, 106
Salon
exhibition conditions at, 18
Salon of 1843
engraving of sculpture installation, 14
Salon of 1866
photograph of sculpture installation, 195, 198
Salon of 1872
photograph of sculpture installation, 266, 261
Sansovino, Jacopo, 222
Scamozzi, Vincenzo, 222
Schmidt, Jean Philippe, 283n.81
Schnetz, Victor, 116, 118, 146, 149, 156, 157, 260, 292n.101,
294n.136
his attitude to students working in Rome, 128
his impressions of Carpeaux, 109–11, 134, 137
on the Ugolin, 158, 169
Schoelcher, Victor, 21
Sculptors
and praticiens, 8–9, 220–21
at Villa Medici, 128–29
class origins, 6–7, 9–10
financial situation of, 15–18, 279n.36
profession of, 8–10

Sculpture
 anachronistic status of, 18–19, 27–28
 as moral example, 19
 assessed by comparison with pre-existing standards, 22–27
 attempts to overcome financial dependence on State and Salon, 19–20
 decorative nature of architectural, 217
 search for a modern role for, 21–23
Sculpture contests
 importance of classical themes in, 101–05
Seurre, Gabriel Bernard, 92
Sèvres. *See* Manufacture Impériale de Porcelaine, Sèvres
Silvestre, Théodore (biographer of Rude), 70–71, 73
Simart, Pierre Charles, 92
 Oreste réfugié à l'autel de Pallas, 121–22, *102*
Solari, Philippe, 28
Sopers, Antoine
 Jeune Napolitain jouant à la rauglia, 146, *138*
Soumy, Joseph, 2, 114, 292n.105
 books borrowed from Villa Medici Library, 292n.108
 his friendship with Carpeaux, 150–51
 La Carolina, 138, *120*
 The Creation of Adam, 151, *141*
 J.-B. Carpeaux, 13, *10*
Story, William Wetmore, 139
Stowe, Harriet Beecher
 visited the Ecole Gratuite, 49
Strode, Nathaniel, 203

Temps, Le, 197, 300n.87
Texier, Charles, 51
Thiébaut, Victor, 182, 201, 300n.87
 produced silver-patinated bronze of *Prince Impérial*, 202–03
Thoré, Théophile, 18, 19, 20, 96, 102, 196
 on the financial dependence of sculptors, 16–17
 Salon (1846), 73–74
Thorwaldsen, Bertel, 96
Tourne-Crème (a dancer), 237
Toussaint, Armand, 68
Trezel, Félix
 Académie d'un homme in *Suite Graduée de figures academiques*, 24
 Académie d'un homme in *Suite Graduée*, 25
Trimm, Timothée, 192
Tuileries, Paris, 169, 175, 189, 192, 194, 199, 243, *200*

Union Centrale des Beaux-Arts, 34
Univers, L', 242
Universel, L'
 on *La Danse*, 235

Vaillant, Maréchal (Ministre de la Maison de l'Empereur et des Beaux-Arts), 201, 205
Vela, Vincenzo
 Italy thanking France, 146
Vermersch, Eugène
 on *La Danse*, 240–42
 Les Deux Pudeurs, 242
Vernet, Horace, 21, 116
Verseron (Carpeaux's stonecutter), 199
Veuillot, Louis, 113
Vie Parisienne, La
 on *La Danse*, 232
Vignon, Claude
 on the *Ugolin*, 172, 173
Villa Albani, Rome, 128
Villa Medici, Rome (Académie de France at Rome), 111–19, 127–28, 133, 258, *98*
 design of, 115–16
 difficulties in developing a personal sculptural style at, 118–19
 effect on young artists of, 113
 importance of director at, 116
 library at, 292n.108
 methods of study at, 116–17
 rites of passage at, 114–15
 role of, 111–13
 role of cast collection at, 127–28
 sculptors taught academic style at, 133
Villeminot
 produced plaster model of Opéra for Emperor, 221
Vinet, Ludovic, 113
Viollet-le-Duc, Eugène (teacher at Ecole Gratuite), 50
Visat, Sébastien
 claimed that he posed for *Génie de la Danse*, 250
Vitu, Auguste
 on *La Danse*, 256

Wagner, Richard, 240
Watelet, Claude-Henri
 article on drawing in *Encyclopédie*, 32–33
Whiteside, James, 113
Winterhalter, Franz-Xaver
 Albert, Prince of Wales, 192–193, *194*
Wolff, Albert, 260

Yriarte, Charles
 on *La Danse*, 234

Zola, Emile, 94, 240, 246, 247–49, 253
 on *La Danse*, 242–44
 article in *L'Evénement Illustré*, 27–28, 66
 L'Oeuvre, 13–16